Eyes of Time

PHOTOJOURNALISM IN AMERICA

Eyes of Time

PHOTOJOURNALISM IN AMERICA

by Marianne Fulton

With contributions by Estelle Jussim, Colin Osman and
Sandra S. Phillips, and William Stapp

A New York Graphic Society Book • Little, Brown and Company • Boston • Toronto • London
Published in Association with the International Museum of Photography at George Eastman House

FIRST EDITION

Library of Congress Cataloging-in-Publication Data

Eyes of time: photojournalism in America/[edited] by Marianne
 Fulton; with contributions by Estelle Jussim . . . [et al.]
 —1st ed.
 p. cm.
 "A New York Graphic Society book."
 Bibliography: p.
 Includes index.
 ISBN 0-8212-1657-0 (hc) ISBN 0-8212-1658-9 (pbk.)
 1.Photojournalism—United States—History. I. Fulton, Marianne.
 II. Jussim, Estelle.
 TR820.E845 1988
 778.9 907—dc19 88-9353
 CIP

This publication and the accompanying exhibition were supported in part by grants from the following: The Associated Press; AT&T Foundation; Eastman Kodak Company, Professional Photography Division; National Endowment for the Arts; and the New York State Council on the Arts.

New York Graphic Society books are published by Little, Brown and Company (Inc.)

Published simultaneously in Canada by Little, Brown & Company (Canada) Limited

PRINTED IN THE UNITED STATES OF AMERICA

This book is
dedicated to Hal Buell and Gilles Peress—
photojournalists with two distinctly different points of view,
involved in the same process and
committed to the same goal.

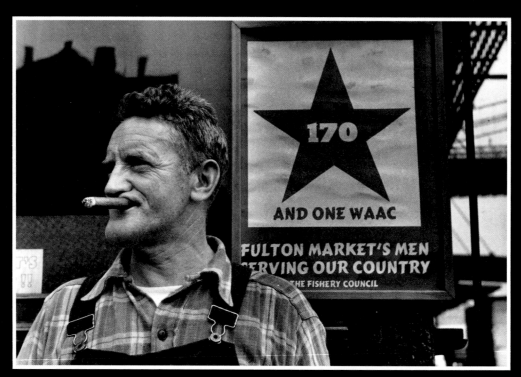

Gordon Parks, "Stevedore at the
Fulton Fish Market, New York
City," 1944; gelatin silver print
(Courtesy Gordon Parks)

Contents

THE MEASURE OF AMERICA'S conscience can be determined by its social pathos, and that pathos is given visible form by the thousands of photographs that appear in our daily and weekly newspapers and the multitude of magazines that fill the racks in our stores.

More precisely, it is the conscience of an editor and the insight of a photojournalist that turn the eyes of the world to a particular moment in history. Whether it is one thousandth of a second as a skyrocket bursts over the Statue of Liberty or a more lingering look into the haunted eyes of a starving mother as she tries to nurse her near-lifeless baby, the work of the photojournalist moves us.

"Eyes of Time: Photojournalism in America" presents many moments in history captured for posterity by the practiced eyes of some of the world's best photographers. It takes us back to the earliest days of photography and traces the advancements, both technical and intuitive, that have been made over nearly 150 years.

The International Museum of Photography at George Eastman House is proud to present to the public this book and the exhibition it accompanies. They represent several intense years of research, travel, and exciting interchange with many photojournalists by Marianne Fulton, curator of the exhibit, principal author of this book, and longtime staff member of the Museum. Helping her were Curatorial Assistant Nancy Levin and Museum Intern Jennifer Greenfeld, as well as many of the other staff members at the Museum. It is an outstanding achievement.

"Eyes of Time" joins a series of Eastman House traveling exhibitions devoted to portions of the broad history of photography. This exhibit, like those before it, demonstrates the range and breadth of the Museum's interests and collections. Many of the images that shape the exhibition are drawn from the Eastman House Photographic Collection. They date back to the days of the Civil War, when photographs served as the basis for woodcut reproductions in weekly newspapers, right up to today's horrifying exposés of bitter strife in far corners of the earth.

The Museum has had the support of several organizations in making it possible to organize this exhibition. Both the National Endowment for the Arts, a federal agency, and the New York State Council on the Arts provided financial assistance. Sponsorship by the Eastman Kodak Company and the AT&T Foundation also enabled the Museum to carry out this project. The Associated Press has been particularly helpful in allowing the Museum to present the public with the reality of Wirephoto transmission, showing how we can see so quickly the results of a photographer's work taken moments before, thousands of miles away. Our deep appreciation goes to those organizations for their help, as well as to the New York Graphic Society for its collaboration on producing another fine book to accompany an Eastman House exhibition.

As the International Museum of Photography at George Eastman House enters a new era—passing its fortieth anniversary as a public museum and opening a new research facility that will allow wide access to its important collections—we are pleased to share the efforts of our talented staff and the richness of our photographic collections with readers and exhibition visitors all over the world.

"Eyes of Time: Photojournalism in America" provides the essence of that unique relationship between photographers and the world around them. The pulse beat of our recent history is recorded here. Its images may at times haunt us, but they also remind us of the interconnectedness of our lives with those of others.

ROBERT A. MAYER
Director
International Museum of Photography
at George Eastman House

Acknowledgments

LOOKING BACK OVER the "Eyes of Time" book and exhibition, I am struck by the length and complexity of the project, but much more by the unstinting generosity of the people met along the way. Listing their names—lining them up like passengers about to board a bus—is scarcely recompense for the quality and quantity of the knowledge they freely shared, without which this undertaking would have been impossible. They shared their lives and their life's work, each telling me the story of photojournalism from his or her own perspective.

Especially important from the beginning were the contributions of Hal Buell, Assistant General Manager of Newsphotos, and Kelly Smith Tunney, Assistant General Manager for Communications at The Associated Press, and their staffs. Having access to the vast resources of the AP—photographers, editors, machinery, files, as well as photographs—allowed the project to cover far more material than would otherwise have been possible. The AP prints appearing in this book and exhibition have been donated to the Museum's collection—a gift that will richly amplify our photojournalism holdings. Also significant were Gilles Peress of Magnum and Robert Pledge of Contact Press Images, whose valuable insights and introductions got the research off to a good start.

The essential early support of Raymond H. DeMoulin, General Manager, Professional Photography Division, and Vice-President of Eastman Kodak Company, underwrote book production and generally determined the ambitious scale of our undertaking.

I particularly appreciate the essays by Dr. Estelle Jussim, Colin Osman and Dr. Sandra S. Phillips, and Will Stapp that were written for this publication. Their knowledge of the developmental years of news photography has been an indispensable addition.

Many people contributed their time and expertise during the last four years. I am especially grateful to Eddie Adams; Vin Alabiso, former New England Newsphoto Editor for The Associated Press, now Director of Photography at the *Boston Globe,* and his AP staff; Micha Bar-Am of the *New York Times* and Magnum; J. Ross Baughman, Founding Partner, Visions Picture Group; Jocelyne Benzakin, J. B. Pictures; Howard Chapnick, President of Black Star; Wendy Davis; Raymond Depardon, Magnum; Arnold Drapkin, Picture Editor, and Robert Stevens, World News Picture Editor, *Time*; David Douglas Duncan; Horst Faas, Photo Editor, Europe, Africa, and the Middle East at The Associated Press, London; Benedict J. Fernandez, Chairman of the Photography Department, New School for

Social Research/Parsons School of Design; Angel Franco; Peggy Freudenthal, copyeditor, Little, Brown and Co.; Philip Jones Griffiths, Magnum; Joan A. Kearney, Director of the Photography Library of The Associated Press, New York; Eliane Laffont, President, Sygma, New York; Don McCullin; Pedro Meyer; Sybil Miller; Julio Mitchel; John Morris; Karen Mullarkey, Picture Editor, and James K. Colton, Senior Photo Editor, *Newsweek*; Jim Nachtwey, Magnum; Larry Price, Director of Photography, the *Philadelphia Inquirer*; Paul Rayner; Nan Richardson; Fred Ritchin; Flip Schulke; Rick Smolan and David Cohen, *A Day in the Life of America*; Dr. Karl Steinorth, Director, Legal and Public Relations, Kodak A.G.; and David Turnley, the *Detroit Free Press* and Black Star.

Picture search was greatly facilitated by Dorsey Weber, Kevin Kushel, and Sheila Norman-Culp, The Associated Press; Yukiko Launois and Anne Stewart, Black Star; Aaron Schindler and Catherine Pledge, Contact Press Images; Caroline Ferreux and Elizabeth Bernard, Gamma Presse Images, Paris; Agnes Sire, Magnum, Paris; Elizabeth Gallin, Magnum, New York; the staffs at Sipa and Sygma, New York; and Leslie Goldman, Visions Picture Group.

I wish to thank the following individuals and institutions for providing information and photographs to the project: Carol Roark, Amon Carter Museum of Western Art; Larry Landis, Barker Texas History Center; Debra Goodsite, Bettmann Archive; Meredith Collins, Brown Brothers; Bob Hollingsworth, Burton Holmes International; Amy Doherty, The George Arents Research Library, Syracuse University; Johnny Hayes; R. C. Hickman; Alexander Liberman and Jaye Shore; Susan Oyama, Library Company of Philadelphia; Evelyn Nave, Library of Congress; Debra Cohen, Life Picture Service; Ellen Wallenstein, Museum of the City of New York; NASA; Berdeen Pigorsh, New York Public Library; Barbara Mancuso, New York Times Photo Service; Anna Novakov, Oakland Museum; Barbara McCandless, Photography Collection, Harry Ransom Humanities Research Center, University of Texas at Austin; David Travis, James Iska, and Sylvia Wolf, Chicago Art Institute; Mike Winey, Curator, U.S. Army Military History Institute, Carlisle Barracks; and John Rudy, Visual Studies Workshop.

The exhibition and present book could not have been realized without the continuous support of colleagues at the International Museum of Photography at George Eastman House. Several individuals provided invaluable help. I especially want to thank Robert Sobieszek, Director of Photography Collections, for increasing his own burdens so that I could have the time to complete my writing. Heather Alberts, my former curatorial assistant, began the project, and Nancy Levin took over from Heather. Nancy, in particular, marshaled the disparate elements of this book with great skill and enthusiasm. Jeanne Verhulst, Curatorial Assistant, assembled the exhibition prints and brought the project to a successful conclusion. My appreciation also goes to Robert A. Mayer, Museum Director; David Wooters and Caralee Aber, Archives; Greg Drake, Biography Project; Barbara Galasso and Marian Early, Darkroom; Marion Simon, Susan Kramarsky, Pat Musolf, and Barbara Hall, Development; Rick Hock, Carolyn Rude Zaft, James Via, and John Worden, Exhibitions; Morgan Wesson, Equipment Archives; Rachel Stuhlman, Becky Simons, and Barbara Schaeffer, Library; Michael Hager, Negative Archives; Jennifer Greenfeld, Project Intern; Ann McCabe and James A. Conlin, Registration; and volunteers Kathleen Kenyon and Sharon Zyga.

This has been a demanding project and it has greatly benefited by the attention of Terry Reece Hackford, editor at New York Graphic Society. I deeply appreciate her advice, support, and friendship.

M.F.

THIS IS THE CENTURY of the photojournalists. They have provided us with a visual history unduplicated by images from any comparable period of human existence. Where once we relied on cave paintings or artists' interpretations of events, photographic images have become transcendent. The camera, in the hands of better educated and better informed photographers, provides us with images of unprecedented power and indisputable information about the world in which we live—its agonies, its struggles, its accomplishments. It is the tool that gives us photographs, the ultimate in anthropological and historical documents of our time. To ignore photojournalism is to ignore history.

Photojournalism is rooted in the consciousness and consciences of its practitioners. The torch of concern, a heritage of humanistic photography, has passed from generation to generation, lighting the corners of darkness, exposing ignorance, and helping us to understand human behavior. It bares the naked truth and sometimes lies. It informs, educates, enlightens us about the present. It illuminates the past. It records beauty and ugliness, poverty and grandeur.

Communication and content are photojournalism's cornerstones. They communicate about people and emotions, about how we deal with celebration and suffering, about understanding nature and the physical environment. The finite, linear proportions of the photographic frame of whatever format dictate the limitations of content. Within those limitations the perceptive photojournalist communicates as much information as the frame will allow—from left to right, top to bottom, foreground to background.

The photographers represented in this book share a commonality in that their pictures communicate simply and directly, with a strong center of interest, dynamic body language, dramatic light, good composition, and technical proficiency. The great photojournalists of yesterday, today, and tomorrow aim for deeper revelation and insight through their capture of spontaneous, unplanned, unposed, and unpredictable moments.

Contemporary photographic wisdom owes a debt to the past. Dorothea Lange, humanist and photodocumentarian, based her photographic philosophy on Sir Francis Bacon's admonition that "the contemplation of things as they are, without substitution or imposture, without error and confusion, is in itself a nobler thing than a whole harvest of invention."

Photojournalists are journalistic nomads. Their arena is the world. That world is markedly different from the preconceptions and romantic illusions derived from film and television representations. Photojournalism is a tough and

demanding profession. It's "down and dirty" rather than "glamour and glitz." The dashing, madcap, trench-coated heroics of a Robert Capa, or Margaret Bourke-White's hobnobbing with the greats of the world, are romantic legends. Legends do not speak to the personal privation and loneliness of photojournalism or the incredible pressures to perform and deliver on demand.

Photojournalists need boundless energy, unflagging enthusiasm, incurable optimism, a spirit of adventure, the ability to survive under difficult conditions, and the courage to confront danger. Photojournalism is an all-consuming mistress, which makes for lonely wives and neglected children.

Photojournalists sometimes chronicle a world of simple pleasures and routine existence: a festival, a political campaign, a family reunion. And sometimes they explore private worlds, revealing the complex personalities of the great, the powerful, the simple, and the ordinary.

But more often, the photojournalists' concerns are centered around war, poverty, famine, drought, and the natural and man-made disasters afflicting this complicated planet. Their mind-searing images allow us to better understand the impact of these events on human beings and the human condition.

Photojournalists are a very special breed of photographer. Each photojournalist hears the click of a different shutter. Photojournalists are rarely objective. They have a collective commitment to truth and reality, bearing witness with their bodies and risking their cameras with confrontational photography. Most of the photojournalists I have known and observed over more than four decades have subscribed to Albert Schweitzer's dictum that "truth has no special time of its own. The hour is now—always."

Photojournalism is a wonderful, frenetic, exciting, challenging, and sometimes dangerous profession. It is also a calling—a remarkable profession with a responsibility to illuminate and inform with our words and pictures. Commitment, engagement, passion, and intensity are absolute prerequisites.

My eyes have seen the best of times and the worst of times for photojournalism. I have witnessed and shared the halcyon days when *Life* and *Look* were charting new photojournalistic waters. I have seen the meteoric rise of innumerable new stars in the photojournalistic constellation whose names today are unrecognizable. The 1950s and 1960s were years of heady optimism and exciting journalistic challenges. I have gloried in the new form of storytelling developed by photojournalists such as W. Eugene Smith and Leonard McCombe, who interwove pictures into photographic essays—a new communicative art form.

I recently read in a column that "contemporary photojournalism is but a few heartbeats away from death." I doubt that thesis, but if it's true, I agree with the writer that it is indeed "a shame." A shame because they tell us that people are reading less and looking at images more, and therefore the public is looking to be moved quickly and emotionally without having to work too hard at it. A shame because photojournalists today, in addition to being better informed, are more committed to and more concerned about the world in which we live than at any time in photographic history. Yet many newspapers and magazines flee from reality and see themselves as part of the entertainment media, seeking out escapist subject matter divorced from the reality of our times—a climate in which sex, sadism, and sensationalism are the order of the day.

Today's photojournalists are reaching deeper, pushing the camera and subject matter beyond what were considered finite limits. No subject matter, sacred or profane, has been excluded from their storytelling vision. These photojournalists are everywhere: at newspapers, working on their own as freelance magazine photographers, as magazine staff photographers, or working for photographic agencies. They have shown us to ourselves and they have shown us the world.

And sometimes in the process they die. And each time at the inevitable somber ritual memorials that follow their deaths, we are reminded that the photographic community is a small family.

Even bored and jaundiced eyes assaulted by and satiated with visual imagery cannot help excitedly responding to the sometimes profound, sometimes complex, sometimes painful, but always powerful pictures on these pages. They are by necessity only an infinitesimal fragment of photojournalistic history.

The social critics and observers, who use very sophisticated techniques to penetrate the collective mind, tell us that we have been overwhelmed with images of violence, desensitized by pictures of war and suffering, that we have reached the limit of visual obscenity in documenting the wars of the last fifty years. Some editors and publishers of our most successful magazines subscribe to that thesis. The result is a trivialization of the profound and glorification of the trivial.

By contrast, the photographers whose work is represented in this volume choose reality over escapism through their collective view that high-quality journalism presented with maturity, judgment, and analysis is preferable to blandness, shallowness, and vacuousness. Their concerns are not for the sensibilities of the viewers and their tolerance for images of death and violence. They do not shrink from

the unpleasant and controversial. They opt instead for the visual recording of some of the unspeakable actions of mankind in this supposedly enlightened century.

Still photographs have been characterized as "frozen moments in time." Frozen moments such as the mountain of discarded bodies in the charnel of Buchenwald, the My Lai massacre in Vietnam, and the Nick Ut photograph of the napalmed Vietnamese children running naked down the road reflect the circle of madness, death, destruction, and despair that too often afflicts mankind. The power of these images lies in their implausibility and inconceivability. Their importance lies in their recording of historical events that give the lie to those who do not accept the existence of a Holocaust or similar excesses committed in the name of patriotism.

For more than four decades as a photographic agent and picture editor, I have shared the great events of our times vicariously through pictures. Through the eyes of photojournalists I have expanded my world. I have been to Omaha Beach, Guadalcanal, and Saipan; I have walked alongside Martin Luther King and James Meredith in the glories of the civil rights struggle; I have grieved for the dead in the almost continuous wars in Korea, Vietnam, Afghanistan, Bangladesh, and a long litany of what were once remote countries with unrecognizable names. Photojournalists have taken me everywhere without physical risk to myself.

To photojournalists past and present, living and dead, I pay personal homage for having borne frontline witness to our times. They have enriched journalism, enhanced knowledge, and ennobled our profession.

HOWARD CHAPNICK
President
Black Star

PHOTOJOURNALISM is a medium of communication, and photojournalists have a story to tell. Whereas writers tell their stories with words and some photographers use only pictures, most often photojournalists put the story in one or more pictures and declare its context in a caption. Just as there are different sorts of articles in written journalism, there are types of photojournalism that fulfill different functions. Every newspaper carries both hard news, such as elections, events in war zones, royal visits, presidential press conferences, and soft news, such as human interest stories.

In 1952, Wilson Hicks, the former executive editor of *Life* who handled all the photography, wrote the book *Words and Pictures*. It is the basic text on photojournalism and still the best. In the preface he states that he found a definition for photojournalism "elusive." It is still difficult to construct a concise model that will cover all examples. Photojournalists have a tendency to tailor their definitions to their own work and look with some suspicion on the work of others if it doesn't fit their definitions. Since "photojournalism," like "commercial photography," embraces a variety of functions, problems arise when one tries to discuss it as a monolithic structure. Any discussion has to take into account the final uses of the photographs.

Unlike other forms of photography, in addition to final usage, the photographer's approach to work also plays a part in the definition. For example, some photographers think of themselves as documentary photographers, that is, they are working on long-term stories that may start as "hard news" but go beyond this category to deal with the underlying conditions. In this way the context is built with photographs as well as words. If these photos are individually published by newspapers or magazines, the product—a published print—becomes photojournalism. Other photographs, published daily, and made to be used daily, are, of course, also examples of photojournalism. These can range from international incidents, local fires, and building dedications to background stories on the construction business, the homeless, and high school activities.

Photographs are ambiguous. Changing the words under a picture can substantially change its meaning. For example, a photograph of a group of high school students yelling might depict an energetic team cheer or it might show students reacting to violence in the schoolyard. Published pictures and their captions should raise questions: What is the relationship of the words to the picture? Do they place it in a context? Is the language biased? What is the point of view of the photographer? Is it a positive image or a negative

one? Why? Who controls the context for viewing the published photograph?

The word *photojournalism* has passed through a period of debasement. Too often trivial pictures are used to illustrate a writer's equally trivial story, bringing the whole enterprise into disrepute. This approach contributes to a perception by some people that photojournalists are generally cynics and always nuisances—just trying to fill a hole on a page of a newspaper.

That kind of picture and that kind of photographer have little to do with the real vitality of photojournalism. For most photographers, photojournalism is an expression of their interaction with the world, their engagement with history and daily living. Not content with the merely aesthetic, they look for the essence of the situation. Not interested in inventing an alternative reality, they attempt to understand and reveal the world as they see it.

Both hampered and freed by the lack of any comprehensive history in existence, I began by meeting as many people in the field as possible in the United States and Europe, interviewing a number of them. The history was largely constructed by reading hundreds of magazine articles and listening to innumerable stories and anecdotes. In the process, my original need to understand the power of this pervasive use of the photographic medium grew into the conviction that photojournalism is the most important kind of photography. The content-oriented image is seldom self-referential, that is, it is not solely about the process of photography or the psyche of an individual photographer, but reaches out to ask questions about a larger world.

Making a photograph involves making choices, as does assembling pictures to tell the story of photojournalism in America. There were many ways to proceed. I felt the most direct way to bring together some of the great photographers, photographs, and the technology that made them possible was to make a connection with the major news events, showing how photographs were made, used, and disseminated to the largest number of people. This presupposes national and international news rather than local. It also means that much must be omitted. Many of the images here deal with conflict, such as the wars that punctuate our history, and are thus more serious than lighthearted. Photojournalism takes in both types; some of our best photographers, such as Alfred Eisenstaedt, to name only one, are known for their cheerful outlook. Many photographs of difficult subjects, though, are not necessarily sad and have galvanized a nation and been remembered decades after they were first published.

The essays illustrate how photography was used from the beginning to record significant events even when wide dissemination of the images was difficult, if not impossible.

Starting before the coming together of photographs and journals was technically possible, we have attempted to delineate a history of photojournalism in America and the significant influences that have shaped it.

Some of the photographs in this book could be said to transcend their immediate reading to become art. While that may be the case, it may be more useful to ask whether the designation "art" takes more away from photojournalism than it gives—negating caption information, and stripping it of its original context, with its concern for revelation, discovery, and information.

M.F.

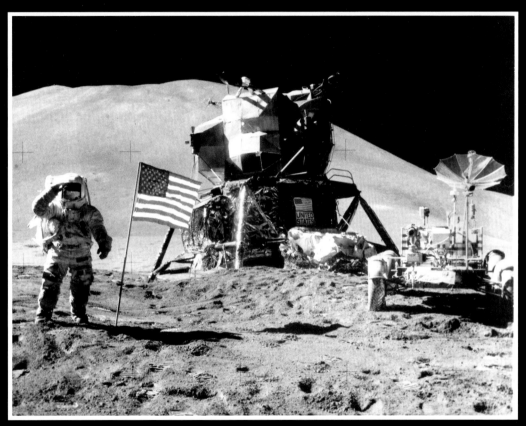

Cmdr. David R. Scott, "On the moon," 1971, gelatin silver print (AP)

Apollo 15 *lunar module pilot James B. Irwin salutes while standing beside the flag after the Stars and Stripes was planted on the surface of the moon.*

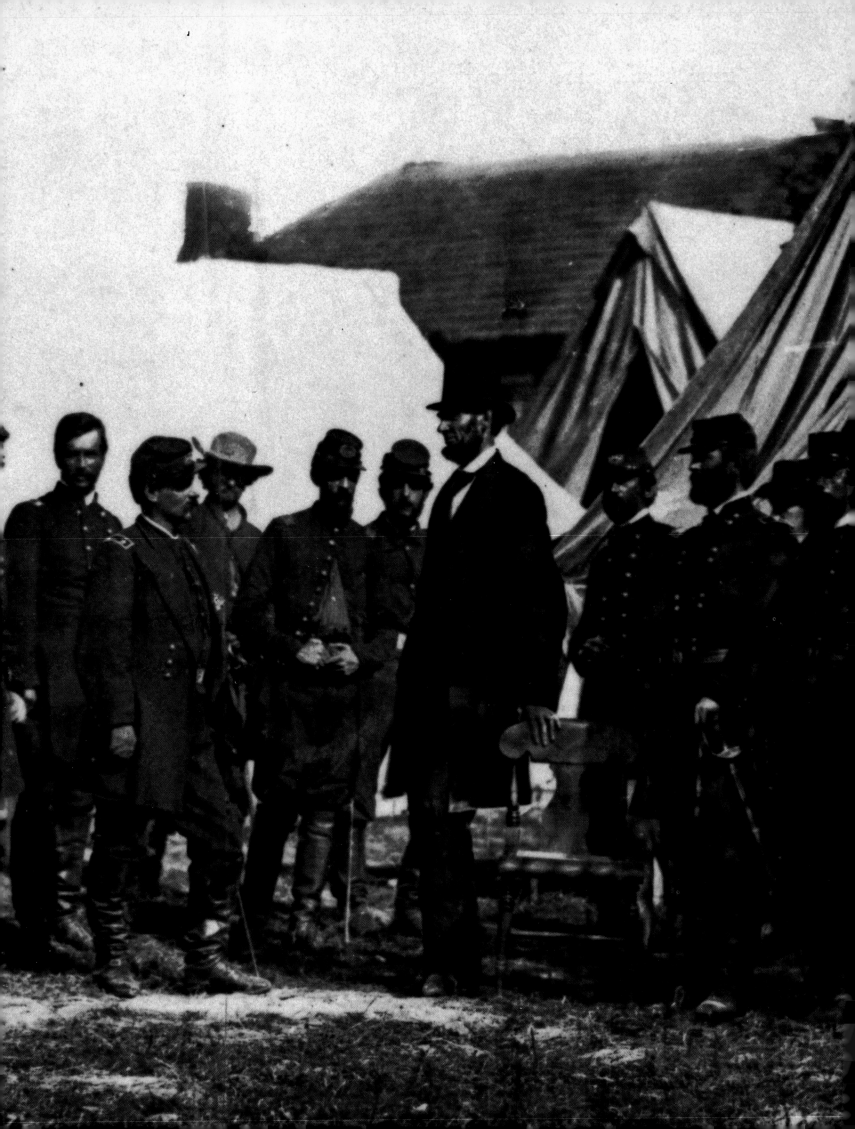

"SUBJECTS OF STRANGE... AND OF FEARFUL INTEREST"

Photojournalism from Its Beginnings in 1839

by William Stapp

PHOTOJOURNALISM IS THAT branch of photography that uses the camera to record and report on current events as they occur. This reportage became possible only when photographic technology (both films and camera equipment), communication systems (the means for getting photographic images from where they were taken to where they would be used), and reproduction technologies (the means of disseminating the images) had all evolved to the point of conjunction where the photography of action, in the field, was possible and easy; where photographic images could be reproduced quickly and accurately, in quantity and cheaply; and where the time lapse between the event and the publication of the images reporting it was minimal. Historically, this conjunction of technologies did not occur until late in the nineteenth century, almost fifty years after the introduction of photography in 1839. Nonetheless, reportage was understood to be one of the most significant potentials—and goals—of photography at the very beginning of its history. From the 1840s on, American photographers tested the available technologies against this goal and established important precedents for what has become one of the most significant applications of the medium.

Mid-nineteenth-century Europe premised the inevitable perfectibility of mankind and therefore assumed that the growth of knowledge both reflected and promoted moral progress. These beliefs lent an ethical purpose to scientific inquiry, justified the introduction of new technologies, inspired and legitimized the field of history as a scholarly discipline, and informed the critics' commonly held view that the arts should function as a universal vehicle to reaffirm and promulgate values. They were also reflected in the world's enthusiastic reaction to the introduction of photography—especially to Louis Jacques Mandé Daguerre's process—and they certainly influenced the uses of photography, as well as the interpretation of the photographic image, throughout the remainder of the century. "It will easily be conceived what resources, what new facility it [i.e., photography] will afford to the study of science," said France's Minister of the Interior in recommending Daguerre's process to the French Chamber of Deputies in August 1839; "and, as regards the fine arts, the services it is capable of rendering are beyond calculation."[1]

The early descriptions of photography all indicate clearly the awe engendered by the daguerreotype camera's unprecedented ability to record detail. "The exquisite minuteness of the delineation cannot be conceived," exclaimed Samuel F. B. Morse, who saw Daguerre's plates in Paris before the process had been made public. "No painting or engraving

Figure 1
Unidentified photographer,
"French troops returning from
Italy," c. 1859; ¼ plate daguerreo-
type (IMP/GEH)

ever approached it."[2] Edgar Allan Poe, the first American critic to comment seriously on the daguerreotype, had much the same reaction as Morse, but described the camera image in terms of its "truth": "The closest scrutiny of the photogenic drawing discloses only a more absolute truth, a more perfect identity of aspect with the thing represented. The variations of shade, and the gradations of both linear and aerial perspective are those of truth itself in the supremeness of its perfection."[3]

Even the earliest commentators, who presumed that the chemical nature of the process determined that the photographic image was impersonal, mechanically perfect, and therefore utterly factual, stressed photography's potential value as a documentary medium. This potential was mitigated only by early photography's inability to record motion: because of its insensitivity to light, its practical application was assumed to be limited to static subjects. Even so, the new medium's eventual contributions to the improvement of knowledge were foreseen as being genuine and invaluable. "To the traveller, to the archaiologist [*sic*] and also to the naturalist, the apparatus of M. Daguerre will become an object of indispensable use," predicted the French Minister of the Interior. "It will enable them to note what they see, without having recourse to the hand of another."[4] Lamenting that photography had not been avail-

able when Napoleon's troops first entered Egypt just forty years earlier, to record ancient monuments since destroyed or defaced, François Arago, the eminent French scientist who made the formal report on Daguerre's process to the Chamber of the Deputies, forcefully argued the same point: "To copy the millions and millions of hieroglyphics . . . scores of years, and whole legions of painters would be required. One individual, with a Daguerreotype, would effect the labour in a very short space of time."[5] Arago did acknowledge the camera's usefulness to artists, but as a scientist promoting the new discovery to the French government on behalf of the Academy of Sciences, he stressed its practical utility as an impersonal recording instrument of incontestable accuracy that he envisioned primarily as a new tool of science.

Other writers of the period had a broader vision of photography and predicted less utilitarian, but genuinely substantive, contributions to other fields of knowledge and to moral development. In 1843 an anonymous contributor to the *Edinburgh Review* summarized the full significance of photography to the nineteenth-century mind:

When the photographer has prepared his truthful tablet, and "held his mirror up to nature," she is taken captive in all her sublimity and beauty; and faithful images of

her grandest, her loveliest, and her minutest features, are transferred to her most distant worshippers, and become the objects of a new and pleasing idolatry. . . .

But it is not only the rigid forms of art and of external nature—the mere outlines and subdivisions of space—that are thus fixed and recorded. The self-delineated landscape is seized at one epoch of time, and is embalmed amid all the co-existing events of the social and physical world. . . . Thus are the incidents of time, and the forms of space simultaneously recorded; and every picture becomes an authentic chapter in the history of the world.[6]

In view of these widely held sentiments, it can be seen that "La Daguerreotypomanie," Theodore Maurisset's caricature of December 1839 satirizing the public clamor that followed the introduction of the daguerreotype process, was both humorously descriptive of the excitement and enthusiasm of that late summer, as well as amazingly visionary (Figure 2). The steamship being loaded with daguerreotype apparatuses and the train pulling its load of cars, each one a large camera, across the horizon, represented the rapid dispersal of the new technology around the world that occurred immediately; but they also symbolized the spread of photography on its global mission to take and bring back pictures of the monuments of nature and of man for the enjoyment, edification, and enlightenment of all. This, in fact, did happen almost at once: by early November 1839, the Frenchmen Horace Vernet and Frederic Goupil-Fesquet were making daguerreotypes in Egypt for the Parisian optician N.-M. P. Lerebours, and by mid-December, Lerebours was selling Italian and Corsican views that he had commissioned.[7]

In spite of this sophisticated vision of what photography might accomplish in terms of reporting on the world, however, the inherent limitations of the early photographic technologies restricted what could actually be achieved. The most inhibiting limitation was unquestionably the early processes' insensitivity to light. Exposure times varied in duration from several seconds to several minutes, depending on any number of factors, and therefore required stationary, static subjects; moving objects might be recorded as a blur or a ghost, but usually they were not recorded at all. The fact that the processes employed materials prepared entirely by the user, obliging the photographer to carry a cumbersome supply of plates or papers, sensitizing and developing chemicals, processing apparatus, as well as camera equipment, realistically restricted his mobility. In addition, until the late 1850s, the images were of limited reproducibility at best. The daguerreotype could only be copied, either by camera, to produce another daguerreotype, or by hand, usually as a lithograph or a

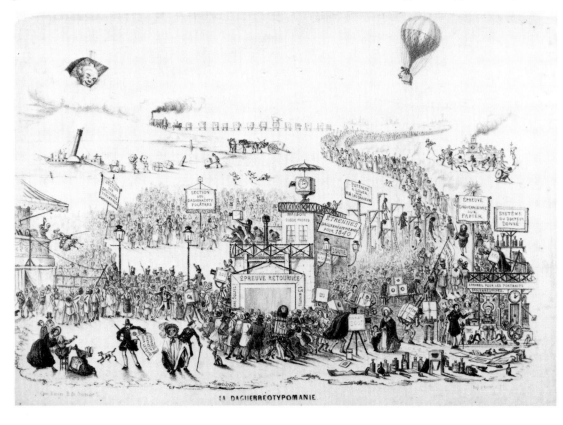

Figure 2
Theodore Maurisset, "La Daguerreotypomanie," 1839; lithograph (IMP/GEH)

LA DAGUERREOTYPOMANIE

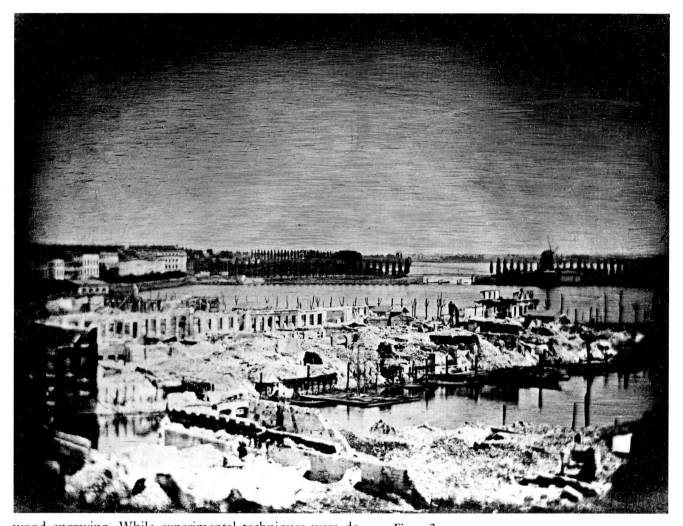

wood engraving. While experimental techniques were developed to utilize the original daguerreotype as a printing plate as early as September 1839, none appears to have been particularly practical.[8] Calotype negatives, on the other hand, could be used to make prints, each one virtually identical to the next; but calotype prints contained significantly less information than daguerreotypes because the texture of the paper negatives absorbed detail (even when waxed) and because the process itself was inherently very high in contrast. Editions of calotype prints, moreover, were necessarily small since printing, which was done by sunlight, was inevitably extremely slow. None of these problems prevented photography in the field, but they restricted photographers' options: they could not photograph activity, they could not photograph quickly nor take many pictures at any one time, and they could not photograph spontaneously. All these factors together impeded the systematic recording and reporting with the camera of ongoing or current events until late in the century.

In the late 1880s innovations in both photographic and printing technology revolutionized photographers' working methods, enlarged the range of possible subject matter, and expanded the ways in which images were used and disseminated. Before the introduction of the gelatin dry plate, photographs of events were necessarily mainly images of

Figure 3
Carl Ferdinand Stelzner, "Ruins around the Alster after the great fire of Hamburg," 1842; daguerreotype (Staatliche Landesbildstelle, Hamburg)

aftermaths; and until practical photomechanical reproduction techniques made the distribution of photographic images cheap, quick, and easy, photographic images were usually experienced only as original objects. Both these factors profoundly affected the use and meaning of photographic images in reporting the news.

Although the daguerreotype was particularly unsuited to reportorial work, the earliest photographs documenting events were taken using Daguerre's process. In May 1842, Hamburg was devastated by a fire that destroyed most of the city. Views of the ruins were made by Hermann Biow, who had opened a daguerreotype studio—one of the very first in Germany—in 1841, and by Carl Ferdinand Stelzner, a neophyte daguerreotypist who had trained as a miniature painter in Paris. Biow made forty-six plates, none of which has survived even in reproduction, but extant correspondence indicates that he consulted with a member of the Historical Society of Hamburg in choosing the sites he photographed and that the views represented a systematic attempt to document the path of the inferno that gutted the city.[9] Of Stelzner's views, one original plate has survived and two others are known from reproductions. They depict an eerie, desolated landscape of rubble punctuated by the burnt-out, but recognizable, shells of Hamburg's major landmarks[10] (Figure 3).

The immediate significance of these daguerreotypes as the first-ever photographic images of an important news event, however, was negated by the impossibility of exhibiting or distributing them at the time. Stelzner's views apparently were completely ignored; Biow's were mentioned once in the local press a month after the fire, but negotiations with the city's Historical Society to buy the entire collection foundered just a few weeks later, and Biow's own plans to produce a limited edition of steel engravings copied from the plates never materialized.[11] As a consequence, neither Biow's nor Stelzner's work had any impact on other photographers, and their efforts, like those of subsequent Daguerrean documentarians elsewhere, must be considered isolated instances of individual ingenuity and initiative. In spite of their failure to be recognized, the Hamburg fire pictures clearly indicate that photographers were impatient to attempt to record current events despite the severe limitations of the technology available to them.

One of the most notable examples of this "journalistic" impulse is the earliest American "news" photograph, a half-plate daguerreotype taken by William and Frederick Langenheim during the Native American riots in Philadelphia in 1844. The plate appears to document the occupation of the Girard Bank by troops of the United States Army, which had been called out to control the crowds[12] (Figure 4). The Langenheim brothers' presence at this particular event was fortuitous rather than deliberate, since

6

Figure 4
Frederick Langenheim and William Langenheim, "North-East Corner of Third and Dock streets, Girard Bank, at the time the latter was occupied by the Military during the riots," 1844; whole-plate daguerreotype (Library Company of Philadelphia)

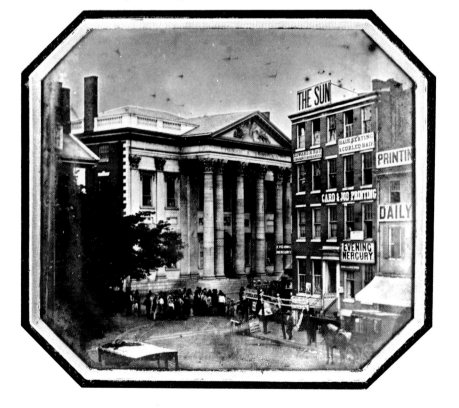

their studio was located in the Merchant's Exchange Building just across the street from the Girard Bank. The plate's perspective indicates that the view was taken from the studio window, which suggests that the Langenheims heard the commotion on the street, peeked out to see what was going on, and decided to chance an exposure simply because the opportunity was too good to miss. That they succeeded was a testament both to the Langenheims' skill and to their luck, for this plate represents a technical tour de force. Not only did it record distinctly the individual figures of the mob milling in front of the bank (indicating a short exposure time), but also the image was reversed in the camera (probably with a prism, which increased the required exposure by about a third) so all the shop signs are clearly readable. Unlike the Stelzner and Biow daguerreotypes, however, the Langenheim view was not a self-conscious attempt to report on the event or its consequences, but was simply an unpremeditated experiment at recording an occurrence. The fact that the plate soon became a possession of the great nineteenth-century Philadelphia antiquarian John McAllister denotes that it was appreciated at the time as an historical curiosity, but the view appears to have gone otherwise unnoticed when it was made.[13]

Scattered examples of similar daguerreotypes recording memorable local events around the country attest to the widespread appeal of making such pictures during the Daguerrean era, even though they could not really be used in any way, and interest in them did not long survive interest in the events they documented. Sometimes an image brought some recognition to the daguerreotypist involved, but most of them did not. Well-known examples of such news daguerreotypes are George N. Barnard's views of the fire at the Ames Mills at Oswego, New York, from 1853[14] (Figures 5–6) and Platt D. Babbitt's several plates of an unfortunate man named Avery stranded on the rocks of the Niagara River before being swept to his death.[15] Perhaps less well known are Marsena Cannon's 1853 view of the groundbreaking for the Mormon Temple in Salt Lake City[16]; Southworth and Hawes's circa 1848 daguerreotype of the reenactment of the first surgical operation performed using anesthesia[17]; and the occasional view of a wrecked train, burned building, or similar newsworthy local occurrence that may randomly surface in a collection[18] (Figure 7). What such images have in common is that they represent apparently spontaneous responses to unique opportunities, and—with the notable exception of the Barnard and Babbitt plates, which were actually made as the events were occurring—they typically depict aftermaths. (Barnard, in fact, did photograph the smoking ruins of the Ames Mills after the fire.[19]) Further, the photographers who took the

Two views of the same fire: the first with hand-colored flames; the second made after the buildings had been destroyed.

Figures 5–6
George N. Barnard, "Fire at the Ames Mills, Oswego, New York, July 5, 1853"; hand-colored, ⅙ plate daguerreotype (IMP/GEH)

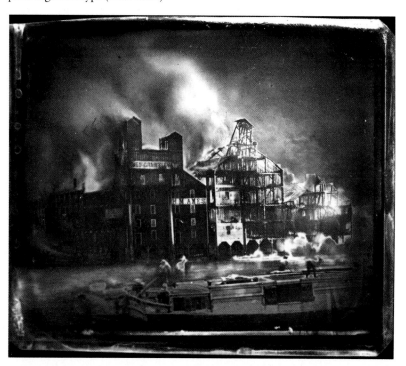

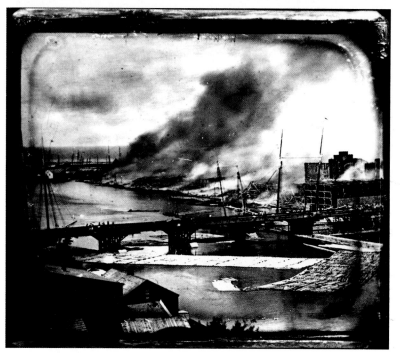

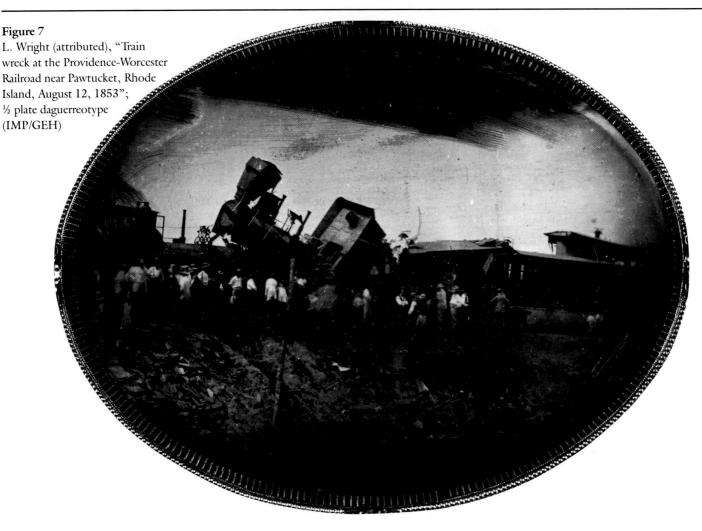

8

images apparently had no intention or interest in distributing them beyond their immediate local audiences, who had themselves been witnesses to the actual events. The pictures, therefore, were not taken for their inherent news value or even to illustrate a news story; rather they were conceived essentially as aides-mémoire of known facts or personal experiences. This was an exact analogue to the function of the personal daguerreotype portrait in American culture.

Perhaps the most significant and most historically important example of this phenomenon is the large group of daguerreotypes—about sixty plates are now known—taken in Mexico during the Mexican War by an as-yet-unidentified photographer who spent some time with the American troops. They are among the earliest war photographs known. The corpus includes a number of portraits (chiefly of officers with the American Army in Mexico, but also one of President Polk, which had to have been taken in Washington), but its most important images relate to the occupation of Saltillo by American troops and include street scenes of General Wool and his staff entering the city on horseback (Figure 8). They do not document a battle per se (Saltillo was taken without a fight), but a few images, such as the poignant view of the fresh grave of Henry Clay, Jr., refer to the battle fought at nearby Buena Vista, where

the popular senator's son had died.[20] It is obvious that these daguerreotypes would have made a sensational impact in the United States, where the public clamor for visual information about this popular expansionist war had created a flourishing market for portrait prints of its heroes and for fanciful lithographs of battle scenes. Yet these daguerreotypes never reached this audience. Indeed, their existence was totally unknown until a small group of them was discovered in the 1920s by H. Armour Smith and brought to the attention of pioneer photographic historian Robert Taft, who discussed them and illustrated one of them in *Photography and the American Scene*.[21] The remainder have come to light only very recently.[22]

Contemporary accounts of the Mexican War were often illustrated with engravings or lithographs copied from or based on daguerreotypes, but those illustrations were confined entirely to likenesses that derived from studio portraits, frequently via popular print renditions, while general views and battle scenes were based on paintings or sketches that at best imaginatively reflected eyewitnesses' verbal descriptions. John Frost's *Pictorial History of Mexico and the Mexican War* (1848) is probably the best example of these popular histories (Figure 9). The text was based on military dispatches and records and "on considerable personal intercourse with officers of rank who have taken an active and

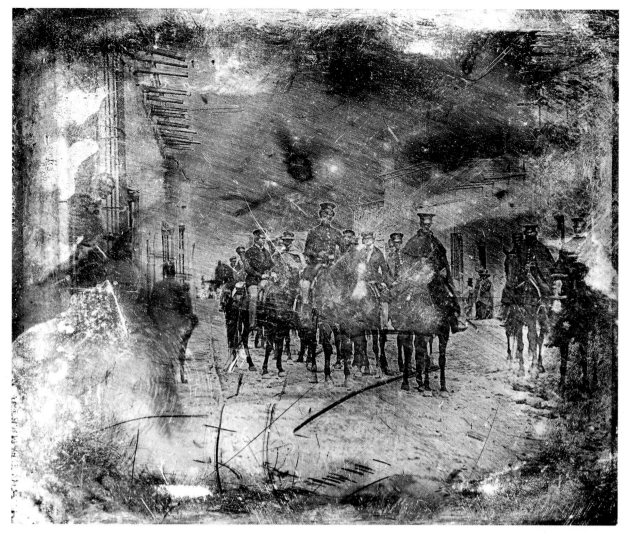

conspicuous part in the contest," and it was "embellished with five hundred engravings, from designs of W. Croome and other distinguished artists," with the officers' portraits copied from daguerreotypes by well-known studios "by which means a degree of authenticity in this department has been attained."[23]

As Robert Taft noted, the fact that Frost, whose treatment of the war is impressively thorough, did not utilize or even refer to the Mexican War daguerreotypes is a sure indication that they were not known at the time.[24] The plates were taken and brought back to the United States, presumably by their maker, and careful pains were taken to preserve them. When the second group of these plates was acquired by the Amon Carter Museum in 1981, they were still stored in their original slotted boxes: they had never been matted or cased. The photographer who made them clearly appreciated their historical importance; but whether he was uninterested in exploiting them or was unable to find a practical, profitable way to do so, he hid them away to be discovered generations later—long after his own identity had been lost.

But even in the event that the Mexican War daguerreotypist had been interested in reproducing and publishing his pictures, he would have faced considerable difficulties and expense. Since efforts to adapt the daguerreotype plate itself

Figure 8
Unidentified photographer, "General Wool leading his troops down the street in Saltillo, Mexico," c. 1847; ⅙ plate daguerreotype (Amon Carter Museum)

Figure 9
Unidentified engraver, "Death of Colonel Clay," 1848. From John Frost, *Pictorial History of Mexico and the Mexican War,* 1848, p. 381; engraving (Coll. W. F. Stapp)

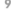

for printing were never really successful, hand-copied graphic derivatives were the only practical way to mass-produce and distribute daguerreotype images. Wood engravings, like those illustrating Frost's *Pictorial History,* were the most expedient reproductions, but they omitted details and were often quite crude. Lithographs were far more authoritative and, when drawn on the stone by a gifted copyist, could convey not only an astounding amount of the detailed visual information contained in the original picture, but could actually communicate a genuine sense of the tones and modeling of the source image.

In the 1840s and 1850s daguerreotype portraits of prominent personalities were often copied and sold as lithographs (Figure 11), frequently in direct response to some current event with which the individual depicted was associated. Portrait lithographs could be generated relatively quickly, since likenesses of already prominent personages were routinely collected by the studios; and since the images themselves were straightforward and, by convention, visually uncomplicated, they were easy to copy. Those who followed the news were the market for such lithographs, which functioned to evoke rather than record events by depicting the individuals identified with them. (These symbolic portraits remained popular into the Civil War years, although after the late 1850s derivative lithographic prints

Figure 10
Robert Whitechurch, "United States Senate, A.D. 1850 (Clay's Farewell to the Senate)"; engraving after photo by Peter Frederick Rothermel (National Portrait Gallery)

Figure 11
Francis D'Avignon, "John Jay Audubon," 1850. From *Mathew Brady, The Gallery of Illustrious Americans,* plate 18; lithograph after daguerreotype (IMP/GEH)

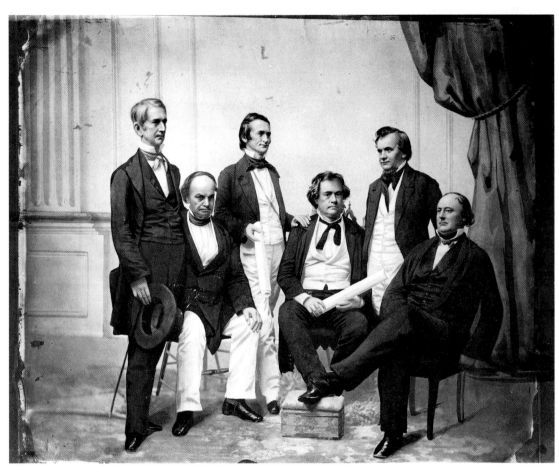

11

were increasingly supplanted by photographic prints made from negatives, particularly by the inexpensive, mass-manufactured cartes de visite of public personalities that became popular and widely available during the early 1860s. The craze for cartes de visite—so named because of their similarity in size to French calling cards of the period—was, in fact, a significant manifestation of this widespread tendency on the part of the public to identify events with personalities.)

The introduction of Frederick Scott Archer's wet-collodion or wet-plate negative process, along with the virtually simultaneous introduction of albumen-coated photographic printing papers in the early 1850s, represented a revolutionary advance in photography. Because of the apparently unlimited reproducibility of images made by this process and its ready adaptability to the mass production of photographic prints, the wet-plate process made photography aimed at a mass market possible and practical. In spite of its obvious advantages, the wet-plate process was not immediately adopted by American photographers, who continued to favor the daguerreotype into the mid-1850s, but by about 1856, use of the wet-plate process was growing among the major studios. By 1860 it dominated American photography.

The wet-plate process had a profound impact on pho-tography that went far beyond the studio and the well-established market for studio portraits. Until the Civil War, the United States did not have a significant tradition of photography in the field. If only from a mechanical point of view, the daguerreotype process had not been well suited for it, and the very real difficulty of publicly displaying daguerreotype images made it even less appealing. The reproducibility of the wet-plate negative made photography in the field significantly more attractive to photographers, in spite of the fact that the process, which required the photographer to prepare and process his materials on the spot, literally as the picture was taken, was considerably more complicated than the daguerreotype. Beginning in the mid-1850s, a few ambitious and dedicated American photographers began to make views with the wet-plate camera, often in the stereo format that was beginning to find a popular audience.

In stereo photography, a twin-lensed camera is used to take pairs of images that are alike except for their slightly different angles of view. When seen through a binocular-like stereo viewer, the images combine to produce a three-dimensional ("stereo") effect. Stereo daguerreotypes were made in the early 1850s but won only limited popularity. With the introduction of paper-print and glass stereographs in the mid-1850s, the format became more accepted. The

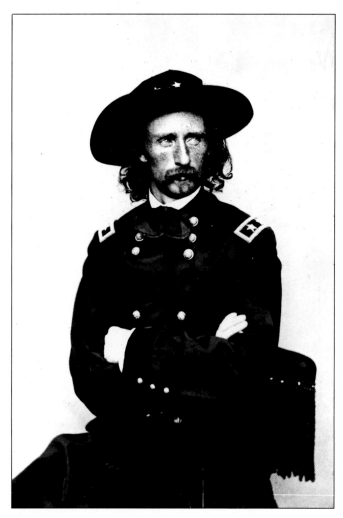

Figure 13
Mathew Brady, "George Armstrong Custer," c. 1864; albumen print (IMP/GEH)

popularity of the stereograph (also called stereoview or stereocard) grew steadily over the next two decades; by the 1880s stereographs were perhaps the most common form of mass-produced photograph on the commercial market.

Despite the success of stereographs, during the transition period of the late 1850s, use of the wet-plate process in America was still confined primarily to the studio, where most photographs had always been produced. Until national events generated newsworthy subject matter of compelling visual interest, there was little apparent market in America for any photographs other than portraits.

The first pioneering efforts at the self-conscious use of the camera to document events occurred abroad in the 1850s, using the wet-plate process, and while it is doubtful that many of those images were actually known in this country, detailed accounts of them were published in the American photographic journals. These accounts unquestionably influenced the extensive and ambitious drive of 1861–1865 to document the American Civil War with the camera, and it is in this effort that we can find the roots of photojournalism in the United States.

Probably the greatest influence on American photographers at the beginning of the Civil War were reports of Roger Fenton's photographs from the Crimea, where Britain and France were at war with Imperial Russia (Figures 14–17). Fenton's work comprised the first coherent documentary project of its kind, and it is significant that the influential American *Photographic and Fine Art Journal* reprinted both a long review of the London exhibition of his Crimean pictures from the *London Art-Journal* and Fenton's own account of his experiences as a photographer at the front.[25] *The Photographic and Fine Art Journal* also reprinted a review of a London exhibition of James Robertson's Crimean photographs taken after the fall of the Russian fort at Sebastopol, well after Roger Fenton's return to England.[26] These articles established that systematic photographic reportage had become feasible, even under extremely adverse conditions, and they endorsed it as historical documentation: "This series of photographs on the whole, constitutes much the most interesting and valuable memorial of the siege that could be given," wrote the reviewer for the *London Art-Journal*. "No verbal description can place before us with such palpable reality the persons who have figured in this memorable siege, or the localities which constitute the wide-spread theatre of operations."[27]

Expectations that the next European war would yield photographs of actual battles may also have encouraged American photographers to take to the field. Writing on the eve of a minor but bloody war fought between France and Austria in Italy in 1859, Oliver Wendell Holmes had been confident that "the next European war will send us

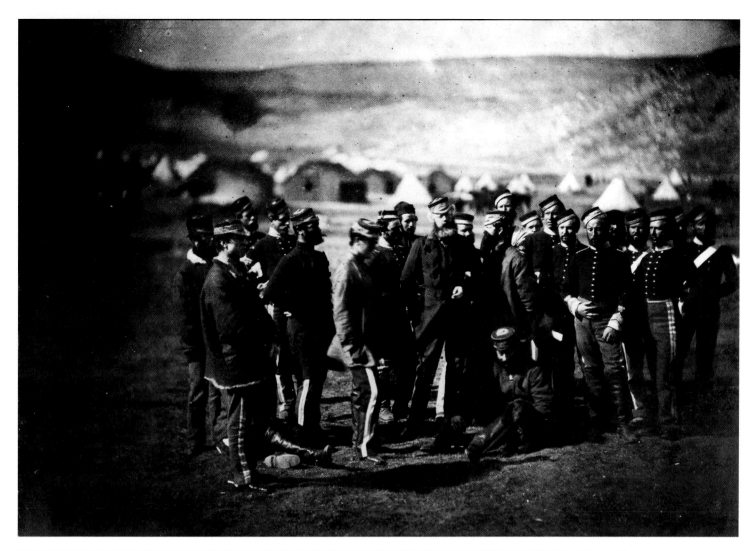

Figure 14
Roger Fenton, "Col. Doherty, officers and men, 13th Light Dragoon," c. 1856; albumen print (IMP/GEH)

Figure 15
Roger Fenton, "Into the valley of the shadow of death," 1855; albumen print (University of Texas at Austin)

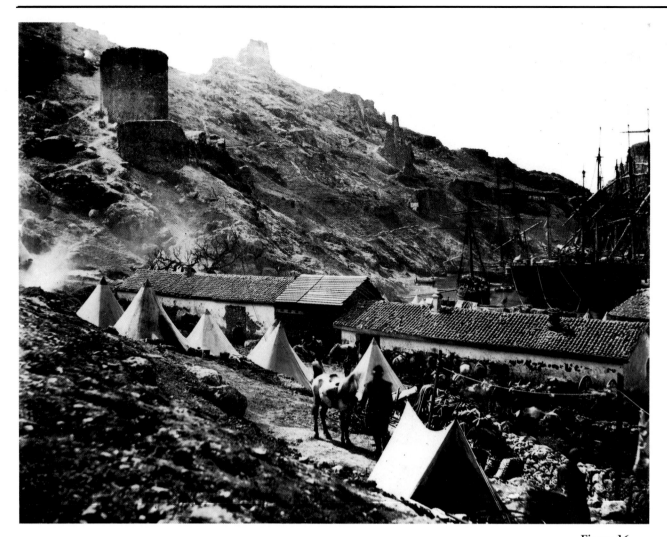

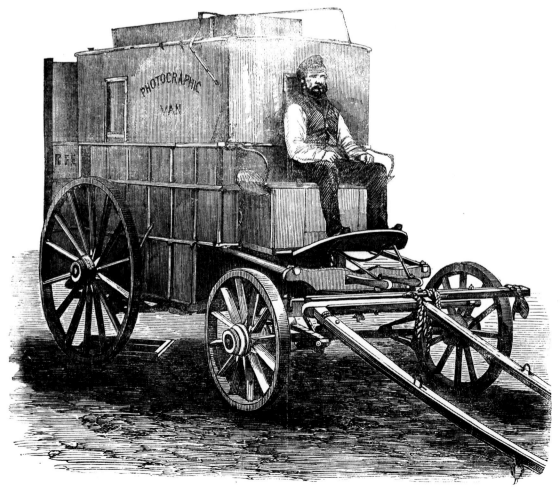

Figure 16
Roger Fenton, "The Genoese fort at the entrance to Balaclava Harbour," 1855; albumen print (IMP/GEH)

Figure 17
Unidentified engraver, "Mr. Fenton's photographic van.—From the Crimean Exhibition." From *The Illustrated London News*, November 10, 1855; engraving (after photo by Fenton) (IMP/GEH)

stereographs of battles. . . . The time is perhaps at hand when a flash of light, as sudden and brief as that of the lightning which shows a whirling wheel standing rock still, shall preserve the very instant of the shock of contact of the mighty armies that are even now gathering."[28] Holmes's prediction proved to be premature by several decades, but the stereographs from the Franco-Italian war that Holmes eventually did see and discuss in a subsequent article showed what were to become the standard subjects of American photographers during the Civil War: military camps, views of a battlefield "with its trampled grass and splintered trees, and the fragments of soldiers' accouterments lying about," and photographs of the dead. The emotional language Holmes used to describe images of the casualties of the Battle of Melegnano also presaged America's response to the Civil War photographs. "Who are those two fair youths lying dead on a heap of dead at the trench's side in the cemetery of Melegnano?" he asked rhetorically. "Some Austrian mother has perhaps seen her boy's features in one of those still faces."[29]

> And here . . . is the great trench in the cemetery of Melegnano, and the heap of dead lying unburied at its edge. Look away, young maiden and tender child, for this is what war leaves after it. Flung together, like sacks of grain, some terribly mutilated, some without mark of injury, all or almost all with a still, calm look on their faces. The two youths, before referred to, lie in the foreground, so simple-looking, so like boys who have been overworked and were lying down to sleep that one can hardly see the picture for the tears these two fair striplings bring into the eyes.[30]

Holmes's words foretold precisely how the photographs that would be taken during the imminent conflict at home would be perceived and described and what the response to them would be. Ironically, their publication preceded the Battle of Bull Run, the first serious engagement of the American Civil War, by only a few days.

The real antecedents of American photojournalism lie in the ambitious attempts by Mathew Brady, Alexander Gardner, and others to photograph the course of our Civil War. In retrospect, that war broke out at just that critical juncture in the history of American photography when advances in technology made reportage with the camera feasible, and a perceived demand for news-related images provided an economic incentive. By 1860–1861, American studios had completed the changeover to the wet-plate process, and a number of American photographers had become quite skilled in its use. In spite of the genuine difficulties of using the wet-plate process in the field, photography outside the studio now seemed a more worthwhile endeavor because the photographs could be mass-printed, published, and sold in galleries, bookshops, and even newsstands as original images in a variety of collectible formats. In 1861 popular standard formats ranged in size from the small, relatively inexpensive carte de visite and stereograph to the costly, large hanging prints called imperials. There was a substantial and increasing demand for such pictures from the American public, which had developed an insatiable appetite for visual information about current events. This market was already served to an extent by the national illustrated weeklies—the *Illustrated News, Leslie's Illustrated*, and *Harper's Weekly* were the most important—that had been established in the 1850s. The illustrated papers furnished their readers with a wide range of news stories, editorials, and serialized novels, and they were copiously illustrated with wood engravings depicting current events, prominent personalities, and other subjects of topical and popular interest. Since the mass-produced stereoviews and cartes de visite of public personalities appealed to this same audience, it was logical for photographers to assume, first, that they would find a similar popular market for photographic prints relating to current events; and second, that the illustrated weeklies themselves would be a potential market, since they already relied heavily on photographic sources for the portraits they published.

Mathew Brady, who was the most prominent American studio photographer of the pre–Civil War period and in 1861 had studios in both New York and Washington, is usually credited with originating the systematic photographic documentation of the Civil War, but the idea may, in fact, have come from Alexander Gardner. Gardner, a Scot, immigrated to the United States in 1856 and almost immediately went to work for Brady. Although where and how he learned photography is not known, Gardner was already an experienced photographer when he arrived in the United States; it seems likely that he was hired by Brady because of his expertise in manipulating large-format wet-plate negatives, which were extremely difficult to prepare and handle without streaking the negative or breaking the plate. His hiring coincides exactly with the introduction of large-format portrait prints into the Brady studio in the summer of 1856.[31] It is almost certain that Gardner had seen Roger Fenton's, and possibly also James Robertson's, Crimean War photographs, and it can be conjectured that he encouraged Brady to undertake a similar project when the inevitability of civil war became evident. Whether his own idea or Gardner's, however, Mathew Brady was unquestionably attracted to the possibility of profiting from images of the war, which everyone in the spring of 1861 assumed would be brief. From his early efforts to market the images, it is apparent that Mathew Brady envisioned a

15

great popular demand for war photographs. It is probable that the idea also appealed to Brady's innate sense of historical mission—that same genuine sense of mission that had impelled him to amass systematically the unequaled collection of likenesses of America's "Representative Men," for which he was already renowned.[32] With these motives, Brady made preparations to photograph the impending conflict.

Before the fighting began, Brady moved his headquarters from New York to his Washington gallery, to be close to the seat of war. He was therefore well situated to witness and photograph the first major fight of the war, the first Battle of Bull Run, fought within twenty-five miles of the Capitol. "I went to the first battle of Bull Run with two wagons from Washington," he reminisced in 1891. "We stayed all night at Centreville; we got as far as Blackburne's Ford; we made pictures and expected to be in Richmond next day, but it was not so, and our apparatus was a good deal damaged on the way back to Washington."[33] Blackburne's Ford was on the fringe of the fighting, and according to one contemporary account, Brady was "aiming the never-failing tube at friends and foes alike" when the tide of battle forced him to abandon his activity and flee.[34] The anticipated Union victory turned into a rout, and if Brady actually took photographs, all the evidence indicates they were lost in the chaotic retreat.[35] *Humphrey's Journal* nonetheless reviewed a purported exhibition of photographs taken by Brady on the Bull Run battlefield:

> This collection is the most curious and interesting we have ever seen. The groupings of entire regiments and divisions, within a space of a few feet square, present some of the most curious effects yet produced in photography. Considering the circumstances under which they were taken, amidst the excitement, the rapid movement, and the smoke of the battlefield, there is nothing to compare with them in their powerful contrasts of light and shade.[36]

Although "groupings" could refer to any of several regimental portraits taken in the field by Brady around the time of Bull Run, the vague language of the review suggests that the writer was not describing photographs that he had actually seen, but rather photographs that he imagined would have been taken on the battlefield. Since there are no other contemporary references to this exhibition, it may well be that the review was a premature attempt to "scoop" *Humphrey's* competition, published in confident expectation of a victory that did not occur and in anticipation of photographs that did not materialize.

In spite of these inauspicious beginnings, Mathew Brady soon formed a corps of photographers to cover the war. "I

had men in all parts of the army, like a rich newspaper," he told George Townsend in 1891. "I spent over $100,000 in my war enterprises."[37] Among his photographers in 1861–1862 were Alexander Gardner, Timothy O'Sullivan, and George N. Barnard, all of whom became major figures in the history of American photography because of the photographs they took during the Civil War; others are less well known today.[38] In the year that followed, up until the Battle of Antietam (September 1862), Brady's men photographed the camps and fortifications around Washington and in the nearby Virginia territory held by Union troops. Many of these images were printed for sale to the public in different series, which varied in their formats: "Scenes and Incidents of the War" were large prints, mostly camp scenes taken in and around Washington in the early stages of the war; "Photographic Views of the War" were published in both large and small formats, the latter as cartes de visite for assembling in albums ("Brady's Album Gallery"). A late-1862 catalog of Brady war views printed and distributed by E. & H. T. Anthony and Company lists over 570 titles, including pictures taken on the Antietam battlefield by Alexander Gardner that September[39] (Figure 18). The success of this venture is questionable, however, for by the end of 1862, Brady was no longer able to sustain the momentum he had established at the beginning of the fighting. His corps proved too expensive to maintain constantly in the field, and this and other financial difficulties, probably coupled with disputes with his photographers over crediting their work, resulted in the effective breakup of his organization by the early part of 1863. Sometime late in 1862 or early in 1863, Alexander Gardner, who had managed the Washington gallery since 1858 and whose financial acumen alone had kept Brady at least marginally solvent over the past several years, left Brady's employ, taking with him his two best and most experienced photographers (Timothy O'Sullivan and John Gibson) and all the Antietam negatives, prints of which had brought Brady a great deal of publicity when they were first exhibited.[40] From this point on, Mathew Brady was no longer a major figure in the photography of the war, although he did make forays to the front (or close to it) during the next three years. From 1863 on, the initiative was Alexander Gardner's and the photographers now associated with him, and together they were responsible for most of the significant photographs taken during the remainder of the conflict.

Gardner's photographs from the Antietam battlefield were pivotal images for American photography since they were the first to confront the horrible reality of war and its human cost. They were exhibited quickly and consequently had an immediate and sobering impact on a public still reeling from the news of the battle, which had cost over

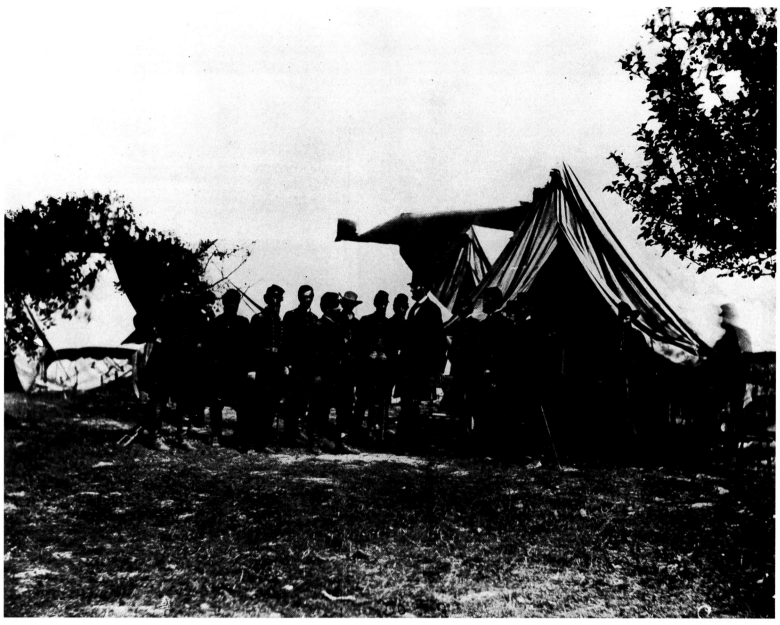

Figure 18
Alexander Gardner, "President Lincoln on battle-field of Antietam, October 1862." From A. Gardner, *Gardner's Photographic Sketch Book of the War,* Vol. 1, 1866, plate 23; albumen print (IMP/GEH)

twenty-six thousand Union and Confederate casualties in killed, wounded, and missing, without a clear victory for either side. The Battle of Antietam was the bloodiest clash of the American Civil War, and September 17, 1862, remains the bloodiest single day in American history.[41] Gardner photographed the detritus of the battlefield two days after the fighting.[42] When his images were exhibited and simultaneously offered for sale at Brady's gallery a month later, they literally stunned the American people. For unlike any popular pictures of war that had preceded them, most of the photographs dwelt relentlessly on the dead and made graphically tangible—in a way possible through no other visual medium—not only the unimaginable scale of the slaughter that had occurred, but its physical horror and its shabbiness. Gardner's photographs of rows of anonymous bodies lying as they fell or lined up for burial and his close-ups of grotesque clumps of bloated corpses powerfully and disturbingly challenged the public's long-nurtured belief that death on the battlefield was glori-

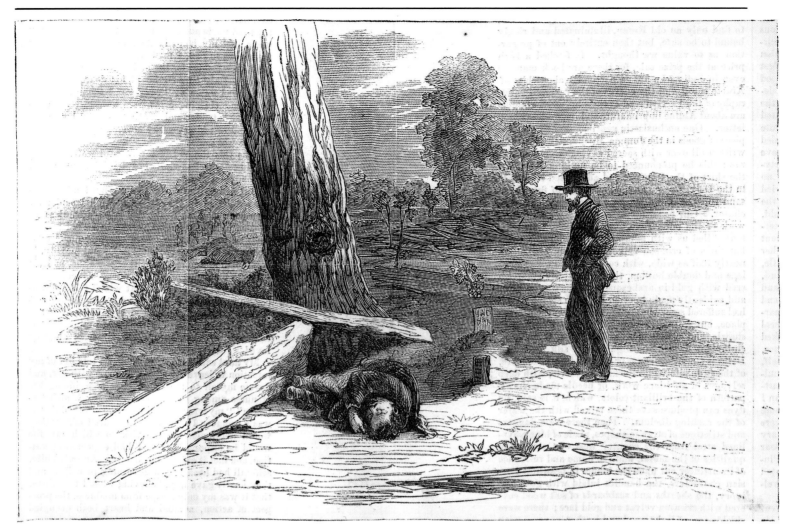

ous and heroic. So compelling was the content of these pictures that they generated a greater documentable response than any others taken subsequently during the remainder of the war, but so visceral and emotional was their impact that the contemporary reviewers who wrote about them could only note with morbid fascination that the features and expressions of the dead were visible enough to make them recognizable.

Eight images from the series were reproduced as wood engravings in the October 18, 1862, issue of *Harper's Weekly*. Wood-engraved reproductions characteristically had greatly simplified image content, since the transfer of the photographic image to the wood printing block was effected manually. To ensure their maximum effect upon the imaginations of *Harper's* readers, therefore, the commentary that accompanied these pictures carefully described details that had been necessarily obscured or deleted in making the wood engravings. It also supplied an extremely sentimental but entirely fictitious scenario for one image (Figure 19), investing it—and, by association, all the images—with redeeming moral content:

> A poetic and melancholy interest attaches to the next
> scene that we come to. There is such a dash of sentiment
> in it that it looks more like an artistic composition than

the reproduction of an actuality. A new-made grave occupies the centre of the picture, a small head and foot board, the former with lettering, defining its limits. Doubled up near it, with the features almost distinguishable, is the body of a little drummer-boy who was probably shot down on the spot. How it happens that it should have been left uninterred, while the last honors were paid to one of his comrades, we are unable to explain. Gazing on the body with a pitying interest, stands in civilian's attire one of those seedy, shiftless-looking beings, the first glance at whom detects an ill-spent career and hopeless future. It is some time, perhaps, since that blunted nature has been moved by such deep emotion as it betrays at this mournful sight.[43]

Gardner's caption for the photograph on which the engraving was based, "A Contrast: Federal buried, Confederate unburied, where they fell, on Battlefield of Antietam," accurately explained the actual scene. The grave belonged to a Union soldier (Civil War historian William Frassanito has identified it as the grave of Lt. John A. Clark, Company D, Seventh Michigan Infantry).[44] The "little drummer-boy" was, in fact, a young Confederate foot soldier whose body had been left to be buried until after the Union troops had interred their own dead. The figure characterized as a

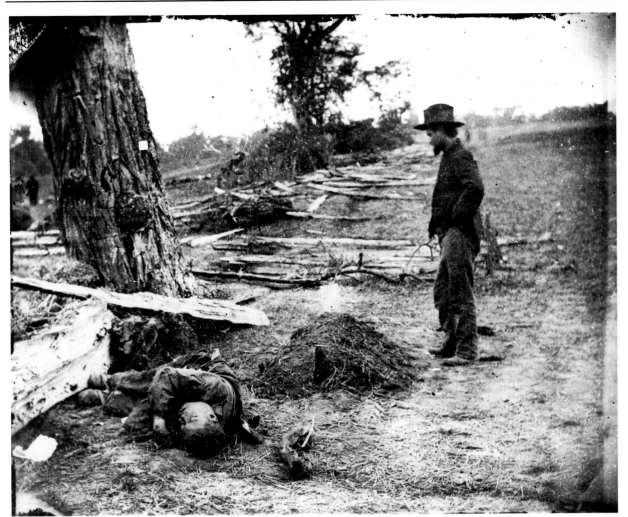

"seedy, shiftless-looking" civilian was probably a soldier from one of the burial parties, and he was, in fact, looking very impassively upon Lieutenant Clark's grave, where Gardner had probably posed him. But the *Harper's* writer ignored Gardner's caption and the factual content of the photograph in favor of a fictional, sentimental interpretation that made the image palatable by defining it as a visual parable describing the redemption of the lost through the sacrifice of the innocent.

The exhibition of the Antietam images at Mathew Brady's New York gallery was also reviewed in the *New York Times,* and sometime later, the same photographs were discussed by Oliver Wendell Holmes in the *Atlantic Monthly.* In these articles too the writers attempted to accommodate the discrepancies between the popular conceptions of the battlefield and the horrific visions of Gardner's photographs by extracting from them some moral lesson. "Mr. Brady [*sic*] has done something to bring home to us the terrible reality and earnestness of war," wrote the *New York Times.* "If he has not brought bodies and laid them in our door-yards and along streets, he has done something very like it."[45] The *Times* went on to envision the "widows and orphans, torn from the bosom of their natural protectors by the red remorseless hand of Battle" as "the one side of the picture that the sun did not catch." Noting, like *Harper's,*

Figure 19 (opposite)
Unidentified engraver, "Little Drummer Boy," 1862. From *Harper's Weekly,* October 18, 1862, p. 664; wood engraving, after albumen print by Alexander Gardner, "A Contrast: Federal Buried, Confederate Unburied . . . Antietam, 1862" (University of Rochester)

Figure 20
Alexander Gardner, "A Contrast: Federal buried, Confederate unburied, where they fell, on the battlefield of Antietam," 1862; modern gelatin silver print from original negative (Library of Congress)

that the bodies' facial features and expressions could be seen readily with a magnifying glass, the *Times* evoked the same emotional, almost maudlin, image of the grieving mother that Oliver Wendell Holmes had used in writing of the stereograph of the dead from the Battle of Melegnano:

> We would scarce choose to be in the gallery, when one of the women bending over them should recognize a husband, a son, or a brother in the still, lifeless lines of bodies, that lie ready for the gaping trenches. For these trenches have a terror for a woman's heart, that goes far to outweigh all others that hover over the battle-field. How can a mother bear to know . . . that in a shallow trench, hastily dug, rude hands have thrown him.[46]

In its reading of the images, the *Times* saw a universal human tragedy, but it also glorified the courage of the dead regardless of their cause:

> Union soldier and Confederate, side by side, here they lie, the red light of battle faded from their eyes but their lips set as when they met in the last fierce charge which loosed their souls and sent them grappling with each other to the very gates of Heaven. . . . But there is a poetry in the scene that no green fields or smiling land-scapes can possess. Here lie men who have not hesitated to seal and stamp their convictions with their blood—men who have flung themselves into the great gulf of the unknown to teach the world that there are truths dearer than life, wrongs and shames more to be dreaded than death. And if there be on earth one spot where the grass will grow greener than on another when the next Summer comes, where the leaves of Autumn will drop more lightly when they fall like a benediction upon a work completed and a promise fulfilled, it is these soldiers' graves.[47]

Oliver Wendell Holmes, who had been on the Antietam battleground searching for his wounded son at the very time that Gardner was photographing it, was equally emotional, but far less sentimental, about the same photographs:

> It was so nearly like visiting the battlefield to look over these views, that all the emotions excited by the actual sight of the stained and sordid scene, strewn with rags and wrecks, came back to us, and we buried them in the recesses of our cabinet as we would have buried the mutilated remains of the dead they too vividly represented.[48]

For Holmes, these pictures conveyed a powerful moral message:

> What a repulsive, brutal, sickening, hideous thing it is, this dashing together of two frantic mobs to which we give the name of armies. The end to be attained justifies the means, we are willing to believe; but the sight of these pictures is a commentary on civilization such as a savage might well triumph to show its missionaries. Yet through such martyrdom must come our redemption. *War is the surgery of crime. Bad as it is in itself, it always implies that something worse has gone before. Where is the American, worthy of his privileges, who does not now recognize the fact if never until now, that the disease of our nation was organic, not functional, calling for the knife, and not for washes and anodynes?*[49]

From these contemporary comments it is apparent that even while the events depicted in the photographs were still news, the meanings assigned to the images transcended their factual content. They were associated with uplifting sentiments that ameliorated, if not contradicted, their horrific content. They were judged, in effect, as *pictures*, as opposed to mere pictorial documents. But even with these attempts to render them palatable, they were still difficult to digest, and in spite of the fact that the exhibition of the Antietam pictures at Brady's gallery attracted large crowds and the attention of the press, and that similar pictures continued to be taken, printed, and sold throughout the war and immediately afterward, it is difficult to establish that they actually found a popular audience.

Whether the pictures found an immediate audience or not, photographers continued to work in the field throughout the war, albeit sporadically and unsystematically. After his split from Brady, Alexander Gardner sponsored the most extensive photographic coverage of the war, but it was largely confined to areas accessible from Washington. Only four subsequent battlefields (Gettysburg, Spotsylvania, Fredericksburg, and Petersburg) were actually documented as Antietam had been. Gardner, who was very careful to credit the photographer who had actually made the negative, published and sold these pictures as discrete original prints "mounted as stereographs or album cards" until the very end of the war.[50] More important, he assembled the negatives into the extensive collection of images from which he selected the one hundred plates illustrating his *Photographic Sketch Book of the War* (1866; Figure 26), which, along with George N. Barnard's *Photographic Views of Sherman's Campaign* (1866), was one of the two most significant photographic works resulting from the Civil War.

In spite of the demonstratedly incomparable impact of the photograph as a visual document, the wood engravings

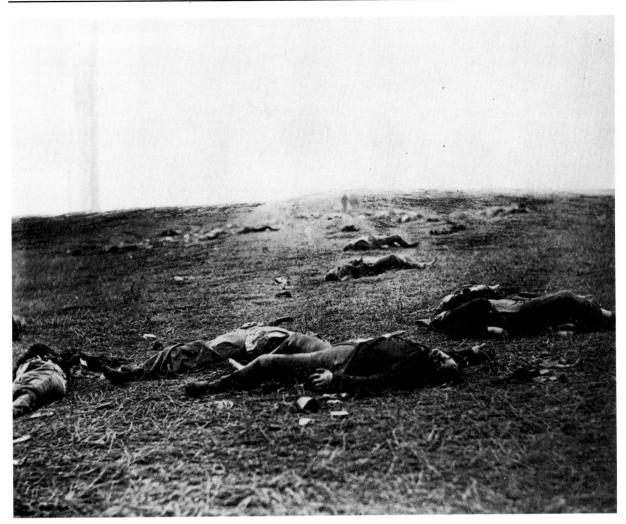

based on the work of sketch artists in the field that the illustrated weeklies commissioned and published were the main—and most comprehensive—source of the public's visual information about the war as it was being fought.[51] There were practical reasons for this. The sketch artists could depict action, which the photographers could not do successfully. The sketches, moreover, were artistically composed visual generalizations, not only far better suited to suggest the confusion and turmoil of battle than photographs, but also less affected by the simplification of the image inherent in the wood-engraving medium by which they were reproduced. The photographs relied upon their rendition of detail and their obvious link to physical reality for impact and usually did not translate well into wood engravings. The photographs, moreover, were often unappealing images that did not lend themselves to believable idealizations. The sketches were more dynamic and had more visual, aesthetic appeal as wood engravings than those derived from photographs, which were typically static and often seemed stark and uninformative by comparison.

After it published the wood engravings of the Antietam photographs—which were fairly literal translations but were so simplified that their contents had to be described and explained in the accompanying text—for the remainder of the war, *Harper's* reproduced only one significant image of

Figure 21
Timothy H. O'Sullivan, "A Harvest of Death, Gettysburg, July 1863." From A. Gardner, *Gardner's Photographic Sketch Book of the War,* Vol. 1, 1866, plate 36; albumen print (IMP/GEH)

the dead based on a photographic source, a print entitled "The Harvest of Death" that derived from images taken after the Battle of Gettysburg (Figure 22). This print, however, was not published until July 1865, two years after the battle, when it was used to illustrate a story on the dedication of the Gettysburg battlefield monument.[52] The wood engraving, moreover, was not a reproduction of Timothy O'Sullivan's well-known photograph "A Harvest of Death" (Figure 21), but rather a careful montage of three separate photographs taken at Gettysburg, with background details supplied by the artist. The foreground group of bodies came from "Field Where General Reynolds Fell" (Figure 23), the single dominating figure from "A Sharpshooter's Last Sleep" (Figure 24), and the caisson and dead artillery horse from "Incidents of the War" (Figure 25). This

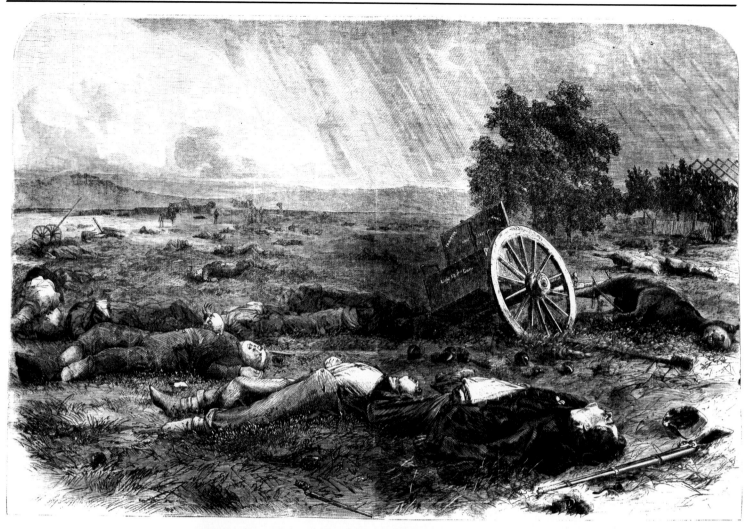

Figure 22
Unidentified engraver, "The Harvest of Death—Gettysburg, July 4, 1863." From *Harper's Weekly*, July 22, 1865, p. 452; wood engraving after albumen print by Timothy H. O'Sullivan (University of Rochester)

Figure 23
Timothy H. O'Sullivan, "Field Where General Reynolds Fell, Gettysburg, July 1863." From A. Gardner, *Gardner's Photographic Sketch Book of the War,* Vol. 1, 1866, plate 37; albumen print (IMP/GEH)

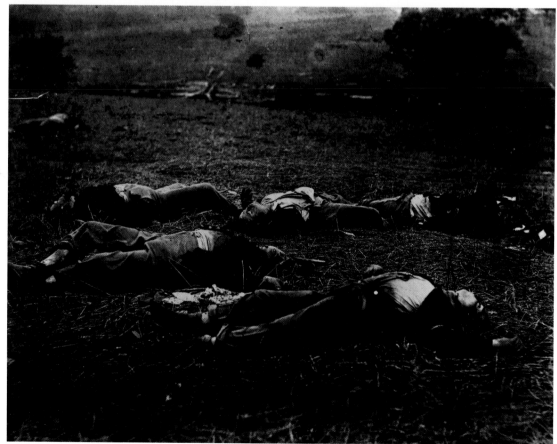

Figure 24
Alexander Gardner, "A Sharpshooter's Last Sleep, Gettysburg, July 1863." From A. Gardner, *Gardner's Photographic Sketch Book of the War,* Vol. 1, 1866, plate 40; albumen print (IMP/GEH)

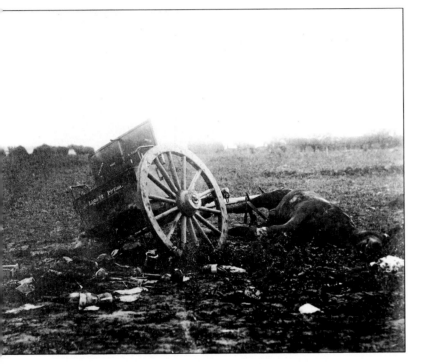

Figure 25
Alexander Gardner, "Incidents of the War. Unfit for service at the battle of Gettysburg," 1863. From *Military Order of the Loyal Legion of* *the United States, Massachusetts Commandery,* Vol. 28, p. 1376; albumen print (United States Military History Institute)

deliberate construction of the image from disparate sources was done to achieve a formally balanced composition (that is, for aesthetic reasons) that visually equated death with sleep, as was appropriate for a story on the dedication of the Gettysburg battlefield monument. In the context of the specific article, this manipulation transformed the factual content of Alexander Gardner's and Timothy O'Sullivan's photographs of gruesome casualties into an emotional evocation of the Union dead—pointed testimony to the powerful sentiments embodied in all the battlefield monuments erected in the years following the Civil War.

It was only after the Civil War, in 1866, specifically with the publication of Alexander Gardner's *Photographic Sketch Book of the War* and more obliquely with George N. Barnard's *Photographic Views of Sherman's Campaign,* that the photographs taken during it received any coherent, informed use as reportage. Both works were expensive publications, illustrated with original albumen prints, and the edition sizes were extremely limited. They nonetheless represent the most significant contemporary use of the Civil War photographs and comprise major documents in the history of American photography.[53]

Alexander Gardner's *Sketch Book* was the more ambitious work. Published in two volumes, it contained one hundred plates of tipped-in albumen prints made, with two or three exceptions, from the original negatives. In his preface, Gardner offered the pictures as "mementoes of the fearful struggle through which the country has just passed" and hoped that they would have "enduring interest" as "photographic presentments" of those "memorable fields, where thousands of brave men yielded up their lives a willing sacrifice for the cause they espoused."[54] Gardner selected the images, organized them into a kind of narrative structure, captioned them, and wrote the text explicating each of them. It is apparent that he conceived the *Sketch Book* as a coherent work. As a publication, therefore, it can be considered a pioneering photo essay, in which selected images were carefully ordered and combined with deliberately chosen words to stimulate a desired effect in the viewer/reader.

In reality the *Sketch Book* presents only a partial and very selective view of the Civil War. It covers the Maryland and Virginia theaters from the occupation of Alexandria, Virginia, in May 1861 to the dedication of the monuments on the battlefield of Bull Run in June 1865 and follows a rough chronological order: 1861–1863 in volume one and 1864–1865 in volume two. The majority of the images do not relate directly to the fighting but are scenes of encampments and camp life, views of fortifications, of fought-over ground well after the battles, and of other landmarks of the war. Only eleven images report specifically on battles, and only seven deal explicitly with death.[55] The photographs of

the Antietam dead were *not* used, but those already familiar images were evoked by the texts to the plates of Antietam views taken well after the battle: "The slaughter here [at the Dunker Church] was fearful. Each of the contending lines charged repeatedly across the field in front of the building, and strewed the ground with their dead. The terrible effect of canister was never more clearly demonstrated than in this vicinity."[56] The Dunker Church was one of the landmarks of the Antietam battlefield, and the several views of Confederate corpses strewn in front of it were among Gardner's most famous images from Antietam. He still had those negatives, therefore his choice not to use them must have been deliberately made, for two reasons. First, since they were in stereo format (that is, about 3½ inches square for a single image of a stereo pair), they would have required enlargement onto larger copy plates to fit the format of the *Sketch Book*. Second, and probably more important, their use so early in the book would have nullified the dramatic impact of the Gettysburg photographs, which appear at the end of volume one and around which the rest of the *Sketch Book* is organized. Gardner's compromise relied on the power of suggestion: the plate showed the church long after all evidence of the fighting around it had vanished, while the text recalled the litter of bodies that had surrounded it.

The Battle of Gettysburg dominates the *Sketch Book*. A sequence of ten images is given to it, and half of those—five

out of only seven such pictures in the entire work—depict the dead. The series was the work of Timothy O'Sullivan and of Gardner himself, both of whom began photographing on the Gettysburg battlefield on July 5, two days after the fighting stopped. The Gettysburg sequence is the most carefully structured segment of the *Sketch Book,* offering the most effective demonstration of Gardner's skillful manipulation of his audience through his deliberate choice and ordering of the images. The careful use of language in his descriptive texts defines and interprets the historical meaning of the images, invests them with emotional or sentimental content, and discovers or suggests the moral or lesson to be learned from them. The visual rhythm of the sequence maximizes the impact of the battlefield photographs. The first plate, a panoramic view of the relatively tranquil-looking town of Gettysburg (Figure 27), is immediately followed by Timothy O'Sullivan's "A Harvest of Death" (Figure 21) and "Field Where General Reynolds Fell" (Figure 23), two of the most powerful images any war has produced. They are balanced by "Interior View of Breastworks on Round Top, Gettysburg" and "Gateway of Cemetery, Gettysburg" (Figure 28), both of which are indirect visual references to the fury of the fighting that is described so colorfully in their captions. "A Sharpshooter's Last Sleep" (Figure 24) and "Home of a Rebel Sharpshooter" (Figure 31), which are poignant, evocative

24

Figure 26
A. R. Ward, *Gardner's Photographic Sketch Book of the War,* Vol. 1, 1866, title page; lithograph (IMP/GEH)

Figure 27 (top)
Timothy H. O'Sullivan, "Gettysburg, July 1863." From A. Gardner, *Gardner's Photographic Sketch Book of the War*, Vol. 1, 1866, plate 35; albumen print (IMP/GEH)

Figure 28
Timothy H. O'Sullivan, "Gateway of Cemetery, Gettysburg, July 1863." From A. Gardner, *Gardner's Photographic Sketch Book of the War*, Vol. 1, 1866, plate 39; albumen print (IMP/GEH)

Figure 29
Timothy H. O'Sullivan, "Headquarters Maj. Gen. George G. Meade, During the Battle of Gettysburg, July 1863." From A. Gardner, *Gardner's Photographic Sketch Book of the War*, Vol. 1, 1866, plate 43; albumen print (IMP/GEH)

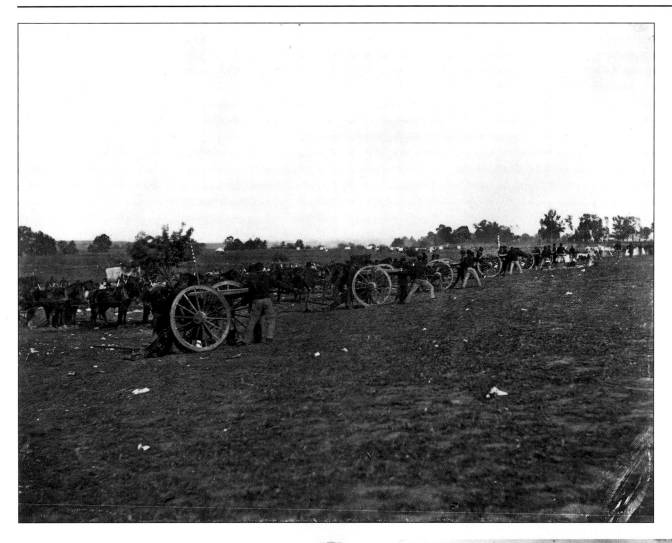

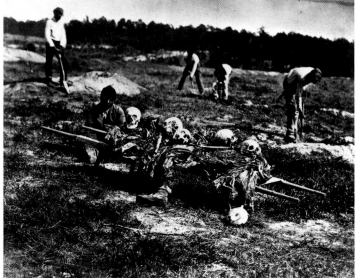

Figure 30 (top)
Timothy H. O'Sullivan, "Battery
D, 2D, U.S. Artillery in action,
Fredericksburg," 1863. From A.
Gardner, *Gardner's Photographic
Sketch Book of the War,* Vol. 1,
1866, plate 31; albumen print
(IMP/GEH)

Figure 31 (above)
Alexander Gardner, "Home of a
Rebel Sharpshooter, Gettysburg,
July 1863." From A. Gardner,
*Gardner's Photographic Sketch Book
of the War,* Vol. 1, 1866, plate 41;
albumen print (IMP/GEH)

Figure 32
John Reekie, "A burial party, Cold
Harbor, Va., April 1865." From
A. Gardner, *Gardner's Photographic
Sketch Book of the War,* Vol. 1,
1866, plate 94; albumen print
(IMP/GEH)

depictions of one individual casualty, are similarly paralleled by the two subsequent plates, "Trossel's House, Battle-Field of Gettysburg" and "Headquarters of Maj. Gen. George G. Meade, During the Battle of Gettysburg" (Figure 29), both of which were focal points during the battle. The sequence ends dramatically with a chilling picture of bodies scattered randomly in the "Slaughter Pen, Foot of Round Top."

The photographs of the dead of Gettysburg are the most visceral images in the *Sketch Book*, and their carefully orchestrated presentation reveals Gardner's advanced understanding of the full implications of the relationship between pictures and words. O'Sullivan's "A Harvest of Death" (Figure 21), an horrific image of paradoxical beauty, presents what appears to be a wide, unending swath of contorted bodies that disappears into the misty background. In his caption Gardner described it as a picture of rebel dead, whose fate, as he said, was

> to be buried unknown by strangers, and in a strange land. Killed in the frantic efforts to break the steady lines of an army of patriots, whose heroism only excelled theirs in motive, they paid with life the price of their treason, and when the wicked strife was finished, found nameless graves, far from home and kindred.[57]

In the succeeding plate, "Field Where General Reynolds Fell" (Figure 23), also by O'Sullivan, Gardner identified the dead shown there as Union troops and carefully described how they lay on the field that day:

> Some of the dead presented an aspect which showed that they had suffered severely just previous to dissolution, but these were few in number compared with those who wore a calm and resigned expression, as though they had passed away in the act of prayer. Others had a smile on their faces, and looked as if they were in the act of speaking. . . . The faces of all were pale, as though cut in marble, and as the wind swept across the battle-field it waved the hair, and gave the bodies such an appearance of life that a spectator could hardly help thinking they were about to rise to continue the fight.[58]

As Civil War scholar William Frassanito has convincingly determined, Gardner's factual information was largely erroneous. This "Field" was, in fact, in another part of the battlefield, nowhere near where General Reynolds, the highest-ranking Union casualty at Gettsyburg, actually fell. Further, the group of bodies that the camera focused on is actually the same group that is clustered in the foreground of "A Harvest of Death," where they are identified as Confederates. They were, in fact, Union soldiers.[59] All this was

unquestionably known to Gardner because he had been there. His misrepresentation of these images was therefore purposeful and transformed the photographs from mere historical documents into visual parables: the rebels paid for their sin of treason with an agonizing death, the loss of their human dignity (their bodies were looted), and an anonymous burial by uncaring strangers, while the righteousness of their cause had soothed the sufferings of the Union casualties until they "passed away." Even though Gardner's poetic description of the dead in "Field Where General Reynolds Fell" completely contradicted that horrid image of the clump of bloated, sun-blackened, three-day-old corpses in Timothy O'Sullivan's photograph, it nonetheless immutably fixed the meaning of this image for his contemporary audience, whose assumption that the photograph was inherently truthful resulted in an absolute and uncritical suspension of disbelief.[60] The photographic image was so obviously derived directly from reality that the purported identification of that reality went unquestioned, just as the American public's emotional need to believe the sentiments Gardner expressed in the *Sketch Book* guaranteed their acceptance. In this context, the photograph readily became the vehicle for moral truth. If expression of this truth required mistitling an image, misinterpreting it, or even interfering physically with what was being photographed to achieve a more effective image, it was entirely justifiable.

That Alexander Gardner understood and took advantage of this very modern concept is explicitly demonstrated in the two consecutive *Sketch Book* plates entitled "A Sharpshooter's Last Sleep" (Figure 24) and "Home of a Rebel Sharpshooter" (Figure 31), both photographs taken by Gardner himself. The first shows a dead soldier, his face turned away from the camera, stretched out alone in his emplacement. The corpse is described as having been found "in a secluded spot" where he had apparently established "a permanent position from which to annoy the enemy." Gardner identifies him as a sharpshooter, a sniper, and implies that he was a Northerner. To emphasize the poignancy of this man's lonely death, Gardner mused about other such casualties: "How many skeletons of such men are bleaching to-day in out of the way places no one can tell. . . . There are hundreds that will never be known of, and will moulder into nothingness among the rocks."[61] In the subsequent plate, "Home of a Rebel Sharpshooter," Gardner made this musing into an explicit example. He describes this photograph as that of the body of a "rebel sharpshooter" who had apparently died from a shell wound, still lying in the "covert" he had constructed from which to snipe at Union officers. In his text, Gardner

melodramatically envisioned this soldier's death:

> There was no means of judging how long he had lived receiving his wound, but the disordered clothing shows that his sufferings must have been intense. Was he delirious with agony, or did death come slowly to his relief, while memories of home grew dearer as the field of carnage faded before him? What visions, of loved ones far away, may have hovered above his stony pillow! What familiar voices may he not have heard, like whispers beneath the roar of battle, as his eyes grew heavy in their long, last sleep?

Gardner ended this caption by describing finding the soldier's remains still untended months later (in unexpressed contrast to the Union dead, who had been gathered into a battlefield cemetery) and by envisioning this soldier's grieving mother, who might never learn his fate:

> On the nineteenth of November, the artist attended the consecration of the Gettysburg Cemetery, and again visited the "Sharpshooter's Home." The musket, rusted by many storms, still leaned against the rock, and the skeleton of the soldier lay undisturbed within the mouldering uniform, as did the cold form of the dead four months before. None of those who went up and down the fields to bury the fallen, had found him. "Missing," was all that could have been known of him at home, and some mother may yet be patiently waiting for the return of her boy, whose bones lie bleaching, unrecognized and alone, between the rocks at Gettysburg.[62]

As has long been recognized, the same body figures in both images.[63] Gardner photographed it as found for "A Sharpshooter's Last Sleep," then dragged it on its blanket a distance of about forty yards and turned its head so that the face was toward the camera for "Home of a Rebel Sharpshooter."[64] This cannot have been a pleasant thing to do in the hot July weather, for the body shows clear signs of advancing decomposition and the identical postures of the legs and arms in both pictures suggests that rigor mortis was present. The fact that the body's head was deliberately turned to face the camera, probably against the resistance of rigor, clearly indicates that Gardner visualized the emotional impact of this young man's face to be an essential element of the picture he wanted to create. This in turn indicates that he had already decided how this image was to be used, or at least what feelings he wanted to evoke, when he composed it. This single photograph is conclusive evidence of Gardner's readiness to manipulate the scene as well as its interpretation for "effect": to subordinate literal, documentary truth to the stimulation of emotional responses

and redeeming moralistic sentiments, in this specific historical and cultural context.

The Gettysburg photographs are the most compelling segment of the *Sketch Book* because of their concentrated intensity and coherent and ordered presentation. As a whole, the *Sketch Book* was a visionary attempt to relate to the public the course of a major historical event through the presentation of a structured sequence of carefully selected and completely integrated images and words. But even though the combination of pictures and text catalyse the impact of the *Sketch Book*, the images are its heart. They are not illustrations; the text explicates *them*. Seen in this light, Alexander Gardner's *Sketch Book* is a sophisticated creation that demonstrates an advanced understanding of the principles of the photo essay. Gardner's obvious efforts to affect as well as inform his audience make him the direct forerunner of those twentieth-century photojournalists whose work is self-consciously charged with emotion in order to stress human values. That Alexander Gardner understood the essential working concepts of photojournalism is indicated first by the ambitious scope of his interest in documenting the war as systematically as available resources, technology, and logistics allowed; and second by the unified presentation that he achieved in the *Sketch Book* by careful picture editing. In photographing the Civil War and in creating his *Sketch Book*, Alexander Gardner made a major, but still inadequately appreciated, contribution to photography: he proved that the camera could both document events and be the instrument of assigning meaning to them.

Gardner continued to explore this application of the camera after the war, and at the execution of the four condemned conspirators in the Lincoln assassination he was able to record an event in sequence from beginning to end (Figures 33–35). This small group of photographs comprises what appears to be, as photographic historian Naomi Rosenblum has pointed out, "the first photographic picture story of an event as it happened."[65] Even so, it did not have any notable impact as a story because the images were not used that way. Only three of the seven photographs Gardner took during the hangings were reproduced in the popular press (*Harper's Weekly* used wood-engraved copies to illustrate its story on the executions), and the narrative element of the original sequence and the cumulative visual impact of the original images were thereby lost.[66]

George N. Barnard's *Photographic Views of Sherman's Campaign* was the other great photographic work of the Civil War, but it was very different in concept and implementation from the *Photographic Sketch Book of the War*. The sixty-five plates illustrating the book were not accompanied by descriptive or explicative text, and many of them were

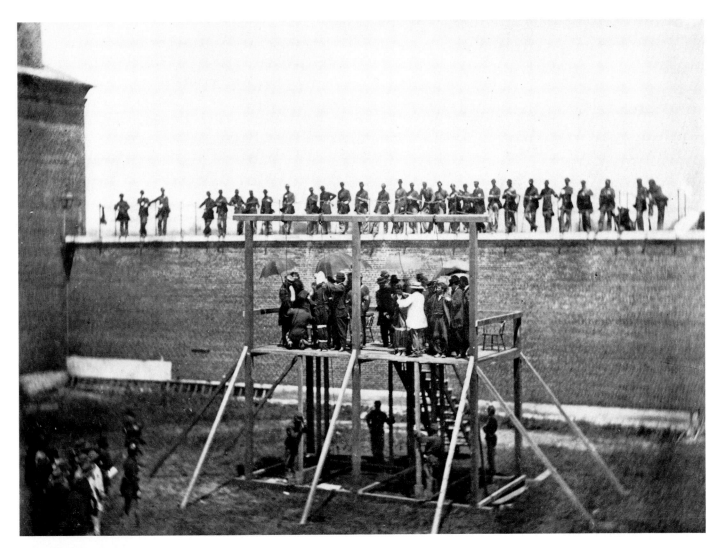

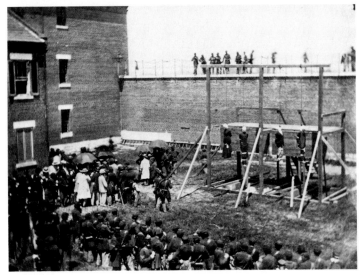

Figure 33 (top)
Alexander Gardner, "Adjusting the ropes for hanging the conspirators, Washington, D.C.," 1865. From Col. Arnold A. Rand, *The Lincoln Conspiracy Album, Alexander Gardner et al.*, 1865; albumen print (IMP/GEH)
Convicted of planning the assassination of President Lincoln, the guilty were hanged on July 7, 1865.

Figure 34
Alexander Gardner, "Hanging at Washington Arsenal; hooded bodies of the four conspirators; crowd departing, Washington, D.C.," 1865. From Col. Arnold A. Rand, *The Lincoln Conspiracy Album, Alexander Gardner et al.*, 1865; albumen print (IMP/GEH)

Figure 35
Alexander Gardner, "Coffins and open graves ready for conspirators, bodies at right of scaffold, Washington, D.C.," 1865. From Col. Arnold A. Rand, *The Lincoln Conspiracy Album, Alexander Gardner et al.*, 1865; albumen print (IMP/GEH)

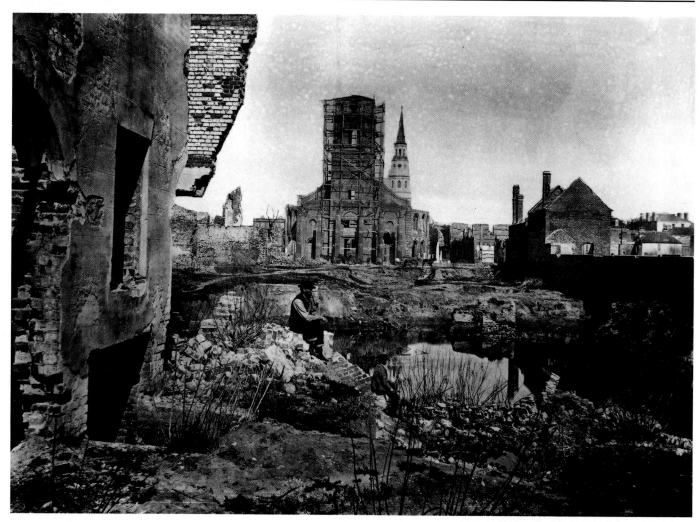

Figure 36
George N. Barnard, "Ruins in
Charleston, S.C.," c. 1865. From
G. N. Barnard, *Photographic Views
of Sherman's Campaign,* 1866, plate
60; albumen print (IMP/GEH)

quite obviously taken considerably after the fact, when the
battlefields they depicted had been well cleared of most de-
bris and after nature had already begun the process of repair.
As pictures, Barnard's images present the battlefields along
Sherman's route to the sea as picturesque, storm-torn land-
scapes, suggesting that the war should be viewed as a great
natural catastrophe that had passed over the land. His views
of the South's devastated cities closely resemble contempo-
rary views of the ruins of ancient Egypt and Greece and
Rome, implicitly comparing the conquered South to a great
classical civilization destroyed by the forces of time and his-
tory (Figure 36). Only one image, "Scene of Gen. Mac-
Pherson's Death," refers directly to a human casualty, but
the image itself is very oblique: it shows a horse's skeleton
in a wooded glade, and it requires a careful inspection to
identify the cannonballs that litter the ground, one of
which, we infer, hit and killed the general and his mount.
While *Harper's Weekly* used three of Barnard's views at the
end of the war as illustrations, it is apparent that his photo-
graphs are essentially nonreportorial in character. They are,
instead, romantic pictorial compositions, informed primar-
ily by the established tradition of landscape painting, which
allude to events but do not pretend to describe them.[67]
They were taken with the stated intention of being "a com-
plete series of photographs which should illustrate the prin-

cipal events and most interesting localities" of Sherman's campaign, and since most of the pictures were taken after the war, they comprise a very deliberately conceived, thematically and stylistically coherent body of work.[68] Only the titles of the photographs, printed directly beneath the images, provide the intellectual connection between the scene depicted and the event associated with it. *Photographic Views of Sherman's Campaign* is unquestionably a masterpiece and represents George N. Barnard's greatest contribution to American photography. It is nonetheless primarily an ambitious artistic effort to present a pictorial allegorical statement about the Civil War and its effect on the South and that civilization. In spite of their common subject matter, Barnard's *Photographic Views* and Gardner's *Photographic Sketch Book* (which depicted to the extent possible the scenes and events from the war as they were witnessed by the camera) were profoundly different creations in conception, in implementation, and in message.

More than any major national or international event preceding it, the American Civil War proved the camera's capability to record events and tell stories. As we have seen, this capability was blunted by the limitations of available reproduction technology, which automatically delayed the availability of those pictures and discouraged their effective use by the press. The photographs, however, were sold directly to the public as original images by photographers such as Brady and Gardner, and they were distributed nationwide by wholesalers such as E. & H. T. Anthony, who mass-produced stereocards and other formats from negatives they had commissioned, purchased, or acquired by exchange.[69] By the time the images became available to the public, however, they had lost their immediate relevance to current events. Consequently they assumed a significance that transcended their topical value and was more affective than informational. As shown in the Antietam and Gettysburg photographs, the images seem to have been invested with sentiments akin to those expressed in the other popular media of the time, probably because the most potent photographic images would not otherwise be acceptable or comprehendible to the American public. In the historical/cultural context of the period, moreover, these sentiments were equated with meaning: they were expressive of moral content, they were uplifting. How the American public actually responded to these images, whether a sizable contemporary market for them ever developed after 1862, however, is very uncertain. The Antietam photographs were news because they were innovations, albeit grim ones; subsequent photographs were often only grim.

The photography of the Civil War—particularly the activity sponsored by Mathew Brady and Alexander Gardner—is the direct antecedent of American photo-

journalism. It produced both individual images and collected works that are major monuments in American photography; but as a viable enterprise, it was of questionable success at best. The technology, not only of photography but also of reproduction and transmission, was simply inadequate to the full realization of the concept and would remain so for another three decades. Since no significant market for photographs as news had or could have developed by the end of the Civil War, the photographers who had been active in photographing it (and might therefore be expected to continue such work) went off to other pursuits. The war left Mathew Brady virtually bankrupt and he was never able to rebuild his organization or to regain the position he had held in American photography before 1861. Alexander Gardner returned to his studio, but retired from the profession in the early 1870s after trips west in 1867 and 1868. Timothy O'Sullivan went west, where he applied the expertise in field photography he had gained in the war to expeditionary documentation, but tuberculosis cut short his career. George N. Barnard also returned to the studio, but left it to document the destruction caused by the Chicago fire in 1871. The other photographers all more or less disappeared into obscurity.[70]

After the war, the use of photography to record and report on events returned for the most part to its prewar pattern. The illustrated journals continued to rely primarily on sketch artists for their illustrations of events. Photographs were used consistently as sources for portraits, but while they also provided occasional news images, coverage was random at best and dictated entirely by circumstances. No single photographer regularly supplied images used to illustrate news stories. Until late in the century, none of the illustrated journals had photographers on staff, but they would buy and reproduce photographs of subjects that captured their readers' interest—usually the aftermaths of catastrophes. These photographs were often otherwise available on the market, usually as stereographs.

It can be argued that stereographs provide the link between the pioneer journalistic photographers of the Civil War and the first professional photojournalists, who began to appear in the 1890s. Stereography had been introduced to the United States in the early 1850s, and it became increasingly popular as the century progressed. The public collected stereocards for viewing; it was a popular pastime promoted by enthusiasts such as Oliver Wendell Holmes for its educational (both intellectual and moral) value.[71] By the 1890s, the commercial manufacture and sale of stereocards to the public was a significant aspect of the photographic industry, with major firms such as Underwood & Underwood and Keystone View Company producing millions of cards annually. For photographers, even in the wet-

plate period, the relatively small size of the stereo camera made it attractively portable and convenient to use in the field, and the comparatively fast, short-focal-length lenses utilized for the smallish format (negative size for an individual image was approximately 5 x 5 inches) encouraged the photographer to attempt photographs that would be problematic with a large-plate camera. Many of the Civil War photographs had been published in stereo format as well as other sizes, and some important images (such as Gardner's Antietam pictures) had been taken only in stereo. The subjects available on stereocards in the late nineteenth century were infinite in variety, but included among the many titles of obvious educational, cultural, or entertainment content were those of topical/historical interest: the completion of the transcontinental railroad at Promontory Point, Utah, in 1869 (photographed by Charles Savage, A. J. Russell, and others); the Chicago Fire, 1871 (George N. Barnard); the Boston Fire, 1873 (John P. Soule, Charles Pollock, James Wallace Black, and others); the Modoc War, 1872–1873 (Eadweard Muybridge); and the Johnstown Flood, 1889 (George Barker; Figures 37–38) are among the many reportorial series made and sold before the introduction of photomechanical reproduction enabled publications to print photographic images. Even after this, however, and well into the twentieth century, the stereo houses produced topical series: the Spanish-American War (Figure 39); the

San Francisco Earthquake and Fire, 1906; and even World War I (Figures 40–45) were available in stereograph sets. Thousands of news-related titles were available during the heyday of the stereograph and were often quite popular: Keystone, for example, sold more cards from its series on the sinking of the U.S.S. *Maine* in Havana Harbor than any other title in its extensive catalog.[72] The stereoviews were often available for years after the event they recorded, which suggests that while initial sales depended upon the public's immediate curiosity to see and therefore know, later sales reflected a perception of the event's greater historical significance as well as a belief, which was probably virtually intuitive, in the iconic power of the photographic image to summarize and evoke the experiencing of that event.

In the early 1890s, photomechanical reproduction of images had become practical and was increasingly being utilized by the illustrated press, which still continued to rely on the studios for images to reproduce. By the mid-1890s, the evolution of photographic technology had eliminated all the difficulties associated with wet-plate photography. The introduction of commercially manufactured dry plates and roll films that were significantly more sensitive to light than the earlier processes made it possible for photographers to make images easily, and quickly, under conditions that would have been difficult if not impossible just ten years earlier. As a consequence, in the 1890s photographers

32

Figure 37
James Wallace Black, "Ruins of the Boston Fire," November 1872; albumen print (IMP/GEH)
Black photographed the Boston Fire in both single-frame images such as this one and in stereographs.

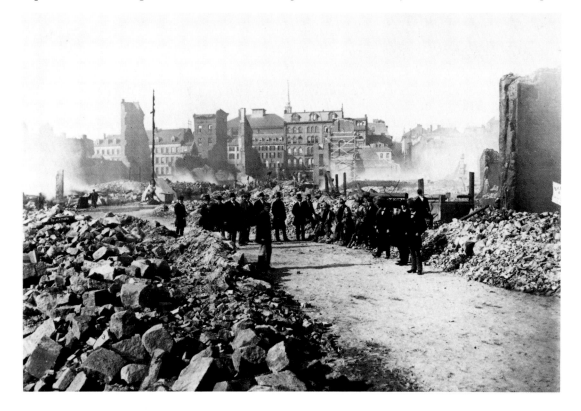

began to photograph events as news, with the realistic expectation of being able to sell their images to the public as stereocards or to the press for reproduction as halftones illustrating stories. Some of these photographers were primarily correspondents who took their own photographs to illustrate their stories, but others were primarily photographers who would occasionally write stories about the events they were photographing. In 1897, Bert Underwood, a photographer, covered the Greco-Turkish War for both Underwood & Underwood, the stereograph publishers, and *Harper's Weekly*, which also carried a story on the insurrection in Cuba written and photographed by "Special Correspondent" Thomas Robinson Dawley, Jr.[73]

It is at this precise historical point that photojournalism began to emerge as a distinct discipline within the field of photography. Only a year after Dawley submitted his stories from Cuba, professional cameramen-reporters working directly for the American press—Jimmy Hare and his assistant, George Parsons, of *Collier's;* J. C. Hemment of the *New York Journal;* Burr McIntosh of *Leslie's Illustrated Weekly;* James Burton of *Harper's Weekly;* Dwight Emmendorf of *Scribner's;* and freelancer Frances Benjamin Johnston—were there covering the Spanish-American War.[74]

From an historical perspective, the early development of American photojournalism is inexorably linked with war. Its real antecedents date from the Civil War, where events and the compelling images of them coincided with technological progress to create and satisfy an audience for such images to an extent theretofore impossible. If the postwar period could not sustain photojournalism as a genre, it is because history itself did not provide a series of events of sufficiently transcendent national interest to encourage the continued development of the genre. The relative stagnation of photographic technology, particularly of practical reproduction technology, in the 1860s, 1870s, and 1880s, also contributed substantially to this inertia. But just as the Civil War occurred at an especially opportune moment in photography's technological evolution, so did the Spanish-American War. By 1898 the increased facility of the camera and the ability to mass-produce images quickly and cheaply, while they were still relevant, had made modern photojournalism inevitable. The Spanish-American War catalyzed it into being. ⊙

Figure 38
George Barker, "A Slightly Damaged House, Johnstown, Pa., U.S.A.," 1889; gelatin silver, stereograph (IMP/GEH)

Figure 39
Underwood & Underwood, "Near view of the *Maine* wreck, showing tremendous force of the explosion, Havana Harbor," 1898; gelatin silver, stereograph (IMP/GEH)

Figure 40
Underwood & Underwood, "An American war photographer, Merl La Voy, ready for a motion-picture flight over the Serbian front," c. 1914–1918; gelatin silver, stereograph (IMP/GEH)

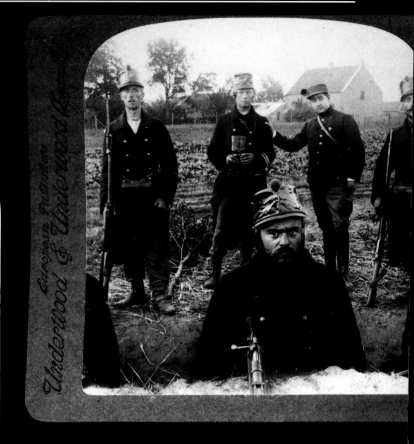

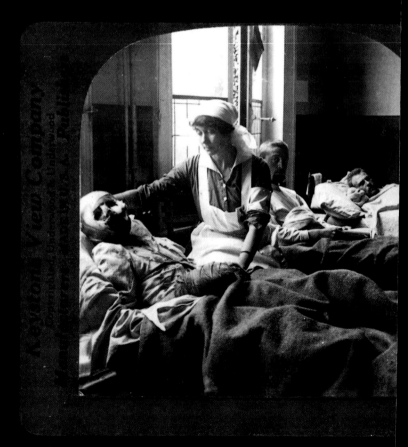

Figure 41
Underwood & Underwood, "The eyes of the army—view of German town from British aeroplane," c. 1914–1918; gelatin silver, stereograph (IMP/GEH)

Figure 42 (top)
Underwood & Underwood, "Brave Belgian Lange, who was decorated for killing 15 German soldiers singlehanded," c. 1914–1918; gelatin silver, stereograph

Figure 43 (bottom)
Keystone View Company, "Ghostly glimpse of wounded Belgians in hospital, Antwerp, Belgium," c. 1914–1918; gelatin silver, stereograph (IMP/GEH)

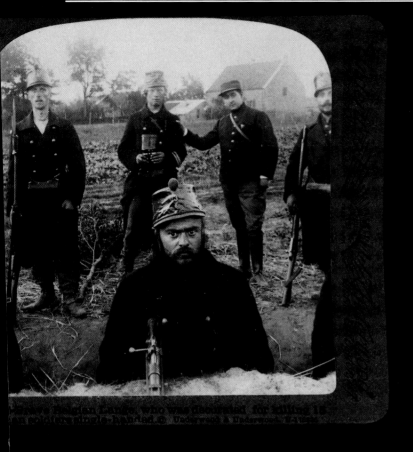

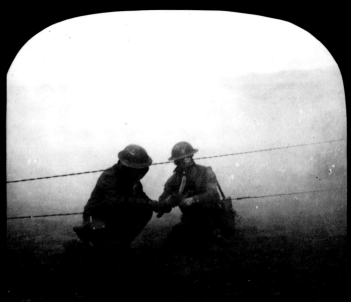

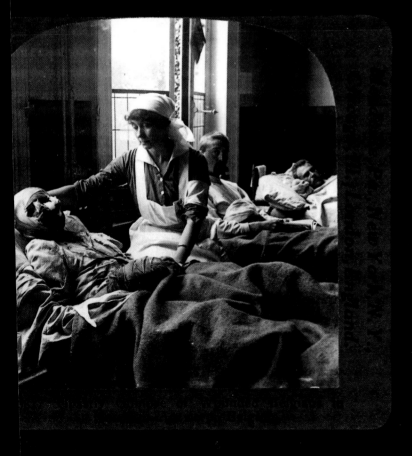

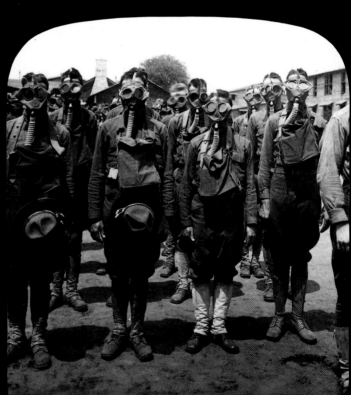

Figure 44 (top)
Keystone View Company,
"Repairing field telephone lines
during a gas attack at the front,"
c. 1914–1918; gelatin silver,
stereograph (IMP/GEH)

Figure 45 (bottom)
Underwood & Underwood,
"Soldiers of Co. M 312 Inf. with
gas masks adjusted, Camp Dix,
New Jersey," c. 1917; gelatin silver,
stereograph (IMP/GEH)

"THE TYRANNY OF THE PICTORIAL"

*American Photojournalism
from 1880 to 1920*

by Estelle Jussim

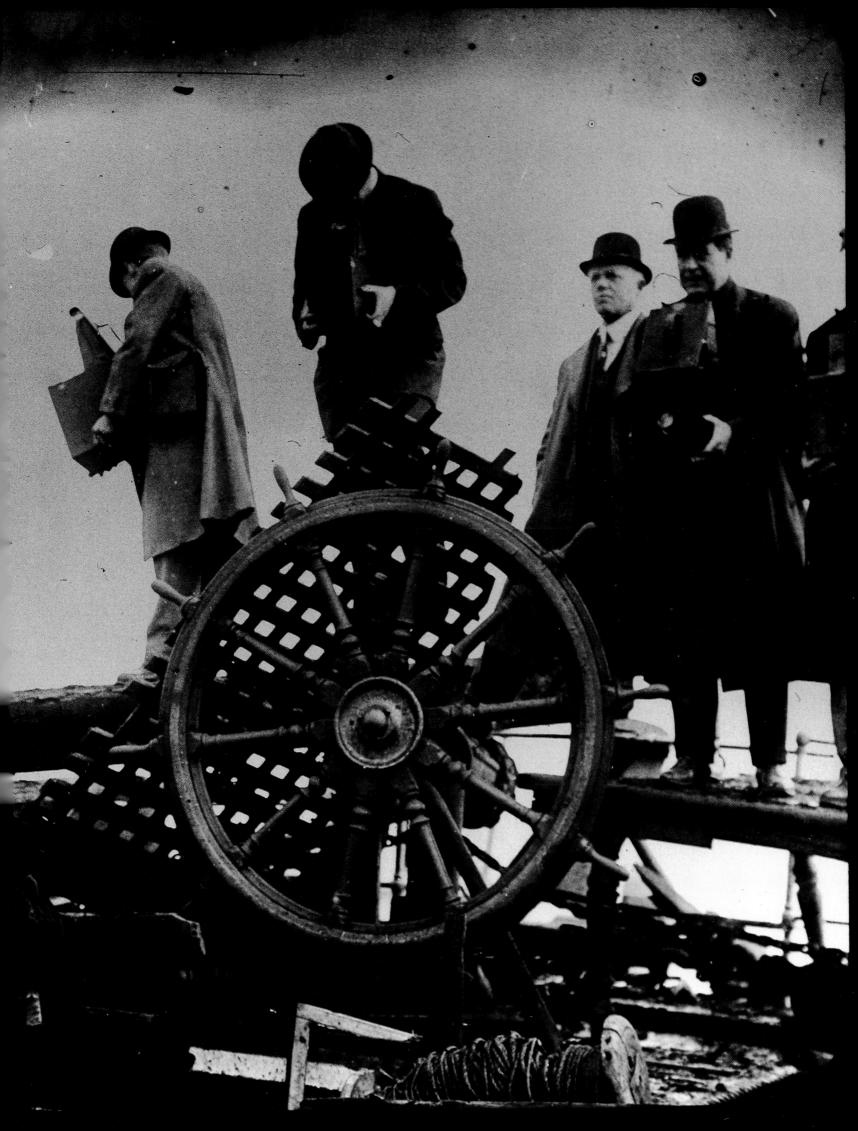

OF THE MANY ways to tell the story of the rapid development of photojournalism during its most significant period of origination in the United States, it might seem logical to begin with the multitude of technological advances in publishing. Certainly they were spectacular: the translation of the continuous tones of the photograph into printing-press-compatible processes; the application of steam power and electricity to the printing presses; the increase in the speed of typesetting by the Linotype and the Monotype. Before any of these journalism-related technologies could succeed, a primary need had to be met. This was the ever-burgeoning demand for mechanically produced paper as newspapers and magazines doubled and quadrupled their circulations. With the gradual establishment of paper mills in most of the populous states of this country, it became possible to supply the voracious hunger on the part of an increasingly literate public for news of their neighbors, their notables, their wars, and their natural catastrophes.

To say, however, that it was only the prodigious inventiveness of the Industrial Revolution that assisted in the appearance of photojournalism would be to oversimplify. Dwight MacDonald once noted that the relationship between the mass media and public demand could be likened to a reciprocating engine, or perhaps to the difficulty of deciding which came first, the chicken or the egg. Any instrumentation for the communication of ideas, wisdom, wit, knowledge, and information exists not only because ingenious minds created it, but because humans have a need to impart and receive communication, especially if they must succeed as social groups. Depending on the complexity of the instrumentation, an economic support system must be available. The political system of the group must accept the consequences of that instrumentation, or seek to control them. Above all, a public capable of interacting with that instrumentation must be present and, more important, willing to accept communication in that form. In turn, the public's capacity depends upon an educational infrastructure that inevitably relies on a viable distribution system to make packages of learning widely available.

All these factors seem obvious, but none of them can be ignored. Photojournalism existed—and still exists—in a context that includes economics, politics, technology, the attitudes of the public, the ideologies of critics, and, ultimately, teachers and purveyors of knowledge and information. Not everyone agrees that a reading public is desirable if, in fact, what it reads and looks at is trash. Tolstoy, for example, fulminated against indiscriminate reading when, in *War and Peace*, he decried that "most powerful engine of ignorance, the diffusion of printed matter."[1] To expand on such an attitude and apply it to photojournalism would be, unfortunately, all too easy. Yet the photograph delivers important information about the world that sometimes even the mighty word fails to do.

It was the photograph that altered our expectations of truth and changed our reliance on the word of a witness to the demand for documentation by the camera. What photojournalists then and now resent is that the meaning of an image can readily be altered by the words accompanying it. Little does it matter, then, if a technology perfectly transmits all the details of a picture if a caption or accompanying paragraph deliberately (or out of ignorance, perhaps) distorts its meaning. For all that the public in the period from 1880 to 1920 rejoiced in the cornucopia of information delivered daily by the picture press, it was a period that did not seem to question the inherent ambiguity of many types of images. As the history of this era unfolds, it should be kept in mind that it was a naïve era, with its people impressed more by the fact that a photograph could finally be made to appear in a newspaper or magazine than by the contents of that picture and the limitations of photography in general. It was an era deluged by the products of the press and manipulated by warring publishers who displayed few ethical concerns. Photojournalistic images would be perceived as visual fact, but were actually more often propaganda and pure sensationalism. The photojournalists themselves were most often self-made men who had attended no schools of photography: there were none.

Enterprising publishers of illustrated newspapers and magazines had been sending out "special artists," as they were called, even before Herbert Ingram's *Illustrated London News* established the species in 1843. A shrewd observer of public response, Ingram had noted that papers employing illustrations drew a larger readership than those whose pages offered only columns of print. His marketing concept—for such it would be called today—was to create a newspaper whose prime seduction for readers would be pictures. Pictures of what? The answer is evident in a very early issue of Ingram's paper: it is a lively wood engraving, full of rearing horses and agitated men pointing at a would-be assassin of Queen Victoria and Prince Albert as they rode in an open carriage through London. The pictures were not only to be considered artful; they were to be on the sensational side, if at all possible.

It is extremely doubtful that a special artist was on the scene as the assassin raised his gun at Her Majesty. An artist for the press was not only entitled to use his or her imagination, but was expected to do so. Although they were a stalwart breed, as cunning in their strategies to obtain

Figure 46
Unidentified photographer, "The
Maine Disaster." From *Scientific
American,* March 12, 1898 (Vol.
78, No. 11), cover; wood engrav-
ing (IMP/GEH)

pictures as any of today's paparazzi, special artists could use their sketchpads only as aides-mémoire at best. Often suspected of being spies when they were caught observing battle preparations or maneuvers, the special artists had to cultivate sharply detailed memories, quick and accurate visual notations, and an eye for the dramatic gesture or stirring scene.

Even if a photographer had happened to be present at the aforementioned assassination attempt, it would have been exceedingly unlikely that he or she could have recorded the incident. Before the 1880s, photographers were encumbered not only with heavy, large cameras, but with the wet-collodion glass-plate process, entailing the use of a dark-tent in which to apply the sticky light-sensitive emulsion immediately before placing the plate in the camera. What would-be photojournalists needed for swift response to events was a combination of easily portable cameras and plates that required no on-site manipulation.

Fortunately, manufacturers of photographic supplies were eager to create just such a combination in order to capture the vast amateur market, among whom they intended to number many interested women. By 1880, the gelatin dry plates developed during the 1870s had proved their stability, reliability, and value, and small cameras, often called "detective" cameras as they were considered sufficiently unobtrusive to avoid notice, came on the market in a variety of disguises, including doctors' medical satchels, books and albums, travelers' hand baggage, along with smaller versions that tucked into buttonholes, pocket watches, and pseudo-revolvers. By the end of the 1880s, photographers could avail themselves of George Eastman's flexible roll film, offering one hundred exposures, and his ingenious Kodak camera. Production of positive prints was also speeded up by the introduction of bromide papers in 1886, which, unlike albumen papers, required no sensitization by the photographer.

Electric light was very gradually replacing the guttering gas lamps inside buildings, but it was by no means ubiquitous, especially in poor neighborhoods and slums. What suddenly made indoor news photography possible was the invention by two German scientists of flash powder, a dangerously explosive mixture of magnesium, potassium chlorate, and antimony sulphide. Magnesium flares had been used as early as the 1860s by courageous photographers like Timothy O'Sullivan, who even took them deep into mineshafts in the Comstock Lode. But flash powder, which, unlike the flares, literally ignited in a flash, made short exposures more manageable at a time when cameras were not as yet equipped with shutters. Unfortunately, flash powder, ignited in an open metal holder called a flash-gun and set off by an explosive paper cap—the equivalent of a firecracker—frequently snatched not only the startled stares of subjects but also the photographer's own eyebrows, hair, cheeks, and fingertips. Since early indoor electric lighting could not supply the intense momentary illumination offered by the hazardous flash powder, few press photographers ventured forth without pan, powder, and igniter mechanisms. Sometimes they were seriously injured despite all precautions.

The man who popularized the use of flash powder was a police reporter and journalist, Jacob Riis. His was the first published account of the new technique. Appearing in the *New York Sun* on February 12, 1888, it was called "Flashes from the Slums: Pictures Taken in Dark Places by the Lightning Process." Subtitled "Some of the Results of a Journey through the City with an Instantaneous Camera," Riis's article proposed to illuminate the wretched lives of "The Poor, the Idle, and the Vicious." As recent critics have noted, Jacob Riis was not entirely the unselfish, socially conscious reformer that past histories of documentary photography and reporting might have us believe.[2] While he was eager to change slum conditions, he was ambivalent about the desperate creatures he described, first wanting to ameliorate their plight and later insisting that emigration from the Mediterranean countries and Eastern Europe be halted to keep presumed undesirables out of the crowded cities. He did not scruple to avoid racial or ethnic stereotypes, and much of his writing was characterized by a tendency to blame the victims instead of the system that produced them.

Nor was Riis the great cameraman he sometimes pretended to be. At least one-third, if not more, of the pictures ascribed to him were actually taken by Richard Hoe Lawrence and Henry G. Pifford, both respected amateur photographers who accompanied Riis on early expeditions into the slums (Figure 47). In "Flashes from the Slums," for example, the photographs were reproduced by twelve line drawings from originals by Lawrence and Pifford. When these gentlemen tired of late-night excursions into filthy hovels and crime-ridden alleys, Riis was forced to buy his own camera. He learned how to ignite the temperamental flash powder on what he described as a frying pan, with frequent near-disasters to his person.

Originally, Riis was more interested in securing slides for lucrative popular lectures than he was in advocacy journalism. At one of his lectures, an editor from *Scribner's,* a high-class illustrated journal catering to cultivated readers, invited Riis to submit a story with pictures. "How the Other Half Lives" appeared in *Scribner's* in December 1889, with nineteen of Riis's photographs transmitted by line drawings. From then on, Riis's national reputation was secure. When the book *How the Other Half Lives* appeared in 1890,

Figure 47
Richard Hoe Lawrence,
(co-worker with Jacob Riis),
"Bandit's roost," c. 1888; modern
gelatin silver print from original
negative (IMP/GEH)

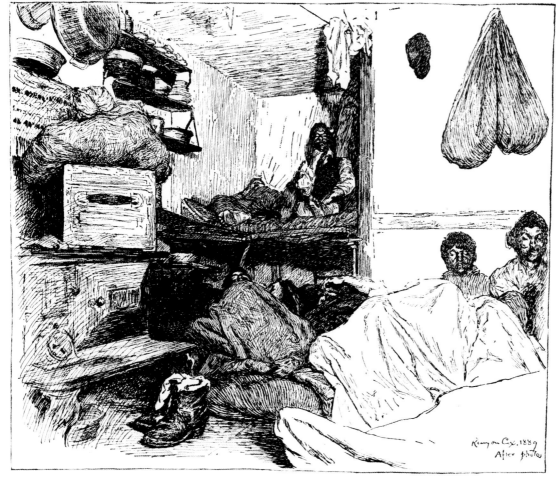

Figure 48
Jacob Riis, "Five cents a spot.
Unauthorized lodgings in a Bayard
St. tenement," c. 1889; modern
gelatin silver print from original
negative (Museum of the City of
New York)

Figure 49
Kenyon Cox after Jacob Riis,
"Lodgers in a crowded Bayard St.
tenement—'Five cents a spot.'"
From *How the Other Half Lives*,
1890; engraving (IMP/GEH)

it contained seventeen process halftones, making it one of the first books illustrated by the new photographic technologies.

Several Riis photographs also appeared in a book by Helen Campbell titled *Darkness and Daylight, or Lights and Shadows of New York Life,* published in 1892. Although all 252 reproductions were wood engravings based on photographs rather than process halftones, the preface insisted:

> On looking on these pages the reader is brought face to face with real life as it is in New York: *not* AS IT WAS, but AS IT IS TO-DAY. Exactly as the reader sees these scenes, just so were the scenes presented to the camera's merciless and unfailing eye at the moment when the action took place. Nothing is lacking but the *actual movement* of the persons represented.[3]

The miraculous veracity attributed to the camera here was a typical symptom of the increasing perception of photography as a model of truth and trustworthy realism. It was testimony to the belief that even a reproduction in wood engraving, so long as it was based on photography, was as good as seeing the real thing.

Seeing the real thing was important, but no less so was the notion that the reader was seeing something "TO-DAY." Yesterday's events had already paled in significance, relegated to history; today's events were news. News had to be reported and distributed immediately upon the event, therefore the speed of manufacture of newspapers was of utmost urgency. A series of nineteenth-century inventions had assisted this competitive enterprise, revolutionizing the slow single-sheet printing press that had survived almost unchanged since Gutenberg. The Fourdrinier machine, patented in 1807 and steadily improved, provided paper in large, continuous rolls instead of single sheets, making possible, in turn, a cylindrical type-revolving web press introduced by Richard M. Hoe in 1870. The web press had the capacity to print as many as 30,000 sheets per hour.

A crucial invention was stereotyping, a method of casting thick papier-mâché into molds to create plates that could fit around the circumference of the web-press cylinder, and that reproduced exact replicas of woodcuts or pages of metal-relief typography. These inexpensive replicas permitted the rapid distribution of preset news columns, advertising, pictures—eventually, process halftones from photographs—and even editorials via the railway system to printers in distant cities. Newspaper empires could thus be established across the United States, sharing not only Associated Press releases but the news photographs replicated by stereotyping. The enterprise of publishing newspapers and journals of commentary that could take advantage of these technological advances obviously depended upon vast capital resources and expert technical personnel.

Inventive ingenuity would be required to make something practical out of plans to transmit photographs by telegraph, a process that would be considerably simplified with the development of the screened halftone plate. Several inventions were put forth during the nineteenth century that seemed on the verge of solving the multitude of problems connected with facsimile transmission, but the sending of photographic images would have to wait until the 1920s, when work begun by such inventors as Dr. Arthur Korn—usually called Professor Korn in journals—saw fruition. Korn was well on the way to succeeding when World War I broke out, and his energies were directed to working for his German fatherland.

At the turn of the century, however, not every newspaper or journal was eager to accept photography as a news medium. Even as Jacob Riis was popularizing the flashgun soon to be adopted by every investigative reporter, there were curious rejections of photography among the high-class papers, and one snob even wrote, "Is it proper to sully the pages with rioting in the slums? . . . Is it in the interests of purity that society should hang its morally stained linen upon its lines to be stared at?"[4] Such reaction was not isolated. The would-be art photographers of the 1890s, desperate to establish their medium as one of the fine arts, were appalled by the increasing prevalence of photography in the journals. In September 1894, the prominent pictorialist photographer A. Horsley Hinton ranted:

> Photographic reproduction is almost everywhere accepted and applauded, but it is an acceptance *without intelligent appreciation*. Photography has a noisy way of making its presence felt, clamorous and self-satisfied, and the welcome extended to it is not less loud. There is novelty in it and something to talk about, and rapidity of its methods and its cheapness are quite in accord with the hurly-burly and scramble of the times.[5]

The *Boston Transcript,* for example, steadfastedly rejected photography on the grounds that its editors did not believe the public would accept such images. The influential journal *Century Magazine* also eschewed photography for as long as it could, claiming that the rotary press and cheap process plates were encouraging a general lowering of the standards of taste. Even *Lippincott's Magazine,* which as early as 1885 gave up using illustrations of any kind because of increasing costs and competition, pleaded with readers in 1895 not to abandon good writing and literature for "the Tyranny of the Pictorial."[6]

The popular pictorial press, however, having recognized the monetary rewards from pictures in terms of increased circulation, never complained of a tyranny of the pictorial.

America was rich in the picture press. *Gleason's Pictorial* had been established in 1850. *Leslie's Illustrated Weekly* followed in 1854, and the monumental *Harper's Weekly* in 1857. The *New York Daily Graphic,* founded in 1876, is considered to have been the first illustrated daily newspaper, and it promised readers the bounties of the newest pictorial technologies. To the *Daily Graphic* goes the credit of reproducing the first photographic halftone plate in a newspaper; this appeared on March 4, 1880.

What is usually omitted from that credit's history is the fact that this famous first, "A Scene of Shantytown, New York," did not, in fact, accompany any news story about that disreputable part of Manhattan. It was simply one of "Fourteen Variations of the Graphic Process" (Figure 50) that included wood engravings, pen-and-inks, copperplate engravings, and line reproductions of crayon drawings. At the lower left of a double spread was the modest picture of Shantytown, bearing the subcaption "Reproduction Direct from Nature" (Figure 51). This presumed direct contact with the phenomenological world, without the intervention of artists or wood engravers, was the astonishing portent of all that was to come and the signal that all the other image-making systems shown on that day were doomed either to extinction or to minor roles in the distribution of images.

"Shantytown" was printed not by relief process, as is

sometimes stated, but by lithography. If Stephen H. Horgan, the man responsible for this first successful newspaper halftone, deserves credit, it is for ingenuity in translating a photograph into a newspaper-compatible medium other than relief printing. Indeed, not until January 21, 1897, did Horgan manage to introduce screened halftone illustrations as a regular and demanded feature of newspapers. On that date, the *New York Tribune* demonstrated that Horgan's method of using stereotypes in its high-speed presses could be successful on a regular basis. The crucial feature was that the curved stereotype replica of a relief halftone could be printed in the rapidly revolving cylindrical web perfecting presses. Until then, despite his onetime success in 1880, Horgan had been considered a madman.

It was not simply the intelligent application of stereotyping that accomplished Horgan's journalistic miracle. For nearly two decades, numerous inventors, including Horgan and his main competitor, Frederick Ives of Philadelphia (Figure 52), had struggled to discover some means whereby the subtle, continuous halftones of photographs could be translated into lines or dots that would faithfully reproduce pictures taken from nature without further invention by artists or wood engravers. What finally succeeded was the use of a screen placed between a negative and a light-sensitized metal plate, causing a dispersion or diffraction of light. Light broken up by the screen produced a gradient

from opacity (the solid black line or dot that would print) to complete transparency between the lines or dots (the white space of the page). In the simplest terms, what had to be created for relief printing processes like wood engraving were dots or lines differing in size but of the same intensity of ink. The dots having the most white space (or transparency) around them appeared as highlights; those having the least appeared as blacks. For the intaglio printing processes of photogravure and the rotogravure that would come to dominate newspaper pictorial supplements by 1914, what had to be created were dots or lines of the same size but differing in intensity—actually in the amount of ink held in each minuscule pocket below the surface of the metal.

Horgan solved the basic problems for newspapers, with the adoption of the screened process to the making of halftone plates and then producing stereotypes from those plates, while Ives succeeded in producing halftone relief plates for journals using finer paper and slower printing technologies than newspapers. The efforts of the Philadelphians Max and Louis Levy also proved vital for the commercial development of what Ives called "a particularly good quality of crossline sealed screen,"[7] patented in 1893. Thus, by the end of the nineteenth century, many of the fundamental technological problems had been overcome, and the foundations were laid for the advent of photojournalism on a grand scale.

Figure 50 (opposite)
Unidentified engraver, "Fourteen Variations of the Graphic Process." From *New York Daily Graphic*, March 4, 1880; halftone (IMP/GEH)

Figure 51
Stephen Horgan, "A Scene of Shantytown, New York. Reproduction Direct from Nature" [detail of "Fourteen Variations of the Graphic Process"]. From *New York Daily Graphic*, March 4, 1880; halftone (IMP/GEH)

Figure 52 (bottom)
Unidentified photographer, "Portrait of Frederick Ives," c. 1910; gelatin silver print (IMP/GEH)

A SCENE IN SHANTYTOWN, NEW YORK.
REPRODUCTION DIRECT FROM NATURE.

45

Figure 53
Unidentified photographer,
"Hearst on vessel off Santiago,
snaps wrecked Spanish warship
after the battle," c. 1898; gelatin
silver print (Brown Brothers)
*Hearst as tourist during the Spanish-
American War.*

Of Wars, Yellow Journalism, and Advertising

A commercial revolution of the 1880s was largely responsible for encouraging cutthroat competition among the leading newspapers in the big cities of the United States. What happened was that many small retail outlets, characteristic of small towns and city neighborhoods, either joined together or were gobbled up by huge department stores. These new conglomerates had the financial clout to buy large amounts of newspaper space in which to advertise daily and weekly special sales. When pages and pages of display advertising began to crowd out the news sections of the papers, the number of pages per edition had to be increased. Newspapers of that time published many editions daily, and special editions when a sensation could be found to exploit—or invent. Newspapers therefore began to grow in size until the imbalance between advertising and news could be corrected at least sufficiently to quell any complaints by readers.

Advertising rates were a function of circulation, as they are today. The larger the circulation, the more substantial the rates. Inevitably, the relationship between advertising and circulation led to several unfortunate outcomes, some of which are still with us. First, there ensued a wild race among the dailies to capture ever greater readership by whatever means. Sensationalism being tried and true, it was to ever-increasing sensationalism that the publishers turned. News that might discomfort the advertisers, who were carrying the major costs of production, was squelched. While still claiming to be the vehicles for truth, newspapers became servile sycophants to their advertisers, unabashedly currying favor by carefully censoring potentially damaging stories.

To counterbalance such questionable activities, newspapers began to fund public welfare projects such as outings for poor city kids, summer camps, hospitals, and Christmas clubs. Jacob Riis wrote stories about the poor and downtrodden for the *New York Tribune*, the *Morning Journal*, and the *World*. The latter was purchased by Joseph Pulitzer in 1883, and it was surely no accident that Riis's stories "Secrets of the River," "Pestilence Nurseries," and "Cute Tricks of Thieves," along with six other sensations, were written for the *World* that year. Neither was it an accident that Pulitzer's marketing strategy was to juggle sensation with public crusades, themselves handily sensational. Pulitzer swiftly managed to achieve the highest newspaper circulation in the country, remaining unchallenged for twelve highly profitable years. When William Randolph Hearst became the new owner of the *New York Journal* in 1895, however, Pulitzer's hegemony was immediately threatened.

Hearst had owned the *San Francisco Examiner* before coming to New York. He intended to use the same methods that had brought him prodigious success with that paper. If Pulitzer's *World* was sensational, Hearst's *Journal* would outdo it. If Pulitzer embarked on social crusades, no crusader would be more fervent than Hearst. If Pulitzer indulged in Sunday features and comics, why, Hearst would have no hesitation in out-Sundaying him. As for comics, then beginning to be a popular entertainment, Hearst had no scruples about stealing Pulitzer's leading comic strip artist, Richard F. Outcault, whose "Yellow Kid" eventually gave his name to the species of publishing known as "yellow journalism." This abomination pretending to be news reporting was not sensation for sensation's sake, but sensation for circulation's sake, and, ultimately, for advertising profits' sake.

In his history of American journalism, Frank Mott summarized specific traits of yellow journalism, which included the usual potpourri of crime, scandal, sex, disasters, and sports; scare headlines sometimes covering half the front page—often screaming about relatively unimportant news; pictures and photographs whose significance as news was sometimes difficult to ascertain; frauds and fake stories; and a sympathy for the underdog shrewdly aimed at eliciting popular support in a Populist era. All of this was innocent enough compared to the real sensationalism, the fraud of frauds perpetrated by William Randolph Hearst, namely, the creation of an international crisis between Spain and the United States over Cuba. An exchange of cablegrams between Hearst and his artistic minion, Frederic Remington, illuminates his tactics. Remington is supposed to have cabled Hearst at the *Journal* in New York after spending some weeks pursuing action in Cuba: "Everything is quiet. There is no trouble here. There will be no war. Wish to return. Remington."[8] Hearst's reply to Remington in Havana: "Please remain. You furnish the pictures and I'll furnish the war."[9] Apocryphal or not, it is easy to imagine Hearst giving similar instructions to his photojournalists. In a very real sense, Hearst's obsession with building circulation had as one of its outcomes the establishment of photojournalism as the appropriate activity for war coverage.

By contrast to the recent invasion of the island of Grenada by United States forces, the American invasion of Cuba was accompanied by a veritable army of correspondents, special artists, and photographers who meticulously reported and recorded every tiresome move of the blockading navy, the armed forces training at Florida camps, and the invasion by General Shafter of the Cuban mainland. On the other side of the world, they went with Admiral Dewey to Manila to capture the Philippines. One estimate suggested that as many as 500 writers, photographers, and artists, representing dozens of newspapers and magazines, reported on the brief war, many more than accompanied

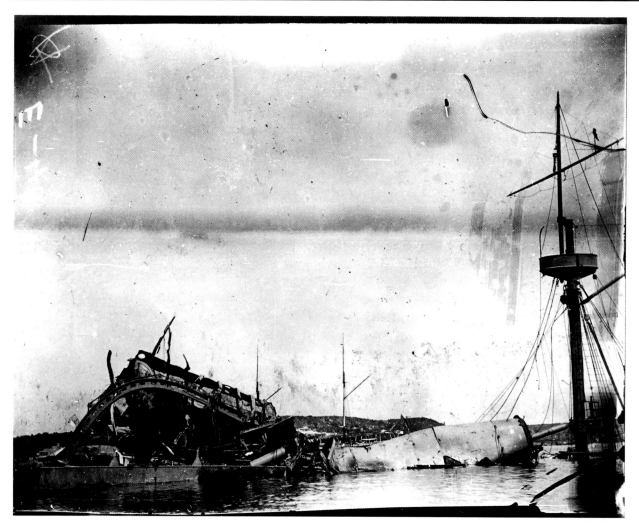

our own Civil War between 1861 and 1865.[10] This astonishing number propelled the weekly circulation of Hearst's *New York Journal* to 1.5 million, with as many as forty editions issued in one day. The cost of covering the shooting war was enormous, but it guaranteed high circulation during the publishing war.

The Spanish-American War, precipitated by the sinking of the battleship U.S.S. *Maine* in Havana Harbor, accorded the United States something that the government had longed for: imperial lands overseas and international recognition of the United States as a world power. For months before the outbreak of hostilities, newspapers and journals had featured photographs of the growing United States fleet. Blown up on February 15, 1898, the *Maine* became the center of photographic attention. Cameramen vied with each other to capture the most devastating pictures of the tragedy, which killed 2 officers and 270 men (Figures 54, 46).

Hearst's *Journal* was only one of the major publications that battened on the Cuban crisis as tailor-made sensationalism. Publishers of *Harper's,* a weekly that proclaimed itself as the paragon of news journals, issued a *Pictorial History of the War with Spain* in 1898, with a preface that strutted, "It would be difficult to select a more brilliant corps of gifted artists and correspondents who have contributed to these pages. . . . The result is a graphic description and a beau-

tiful picture of each event as it actually transpired."[11] To describe pictures of a bloody conflict as "beautiful" has overtones of jingoistic pride, a kind of confession that such photographs were being viewed in the full romantic flush of big-power intervention. Beautiful or not, the newspapers wanted more and more of them. An amazing flotilla of press boats rushed photographers and correspondents to the flagships for news of the day, then to suitable battle sites, then back to Florida to reach the railroads and the telegraph offices. Richard Harding Davis, one of Hearst's star reporters, who would be covering future wars as well, generously lauded the bravery of his fellow correspondents, a few of whom were seriously wounded.

One correspondent-photographer was first on the scene. He was John C. Hemment, little known today, but then praised as "the first photographer to obtain a complete pictorial description of an entire war, including not only the pictures of life in camp or on board the men-of-war, but also faithful views of actual engagements both on land and sea."[12] Hemment had been recognized earlier for the excellence of his instantaneous photographs (Figure 55). He carried special equipment to Cuba that had been originally designed to take pictures of difficult athletic events. As taking photographs had been declared illegal in Havana, punishable by imprisonment and even death, Hemment

49

was clearly a brave man. Fortunately, he had with him an equally brave assistant, to whose care and speedy legs was entrusted the carrying of Hemment's exposed plates to places of safety until they could be gotten aboard ship.

None other than William Randolph Hearst was intimately involved in Hemment's expedition, for it was he who chartered a special steamer, the *Sylvia,* which Hemment outfitted with a darkroom. The clue to the photographer's success was the fact that the steamer carried a large supply of ice, a necessity for developing film in the heat of Cuba's tropical climate. Hearst himself posed on the deck of the *Sylvia,* taking his own pictures with a box camera (Figure 53). His self-satisfied smile may have resulted from the knowledge that he had conveniently stowed on board a printing machine and all the materials needed to print the first newspaper in Cuba after the United States claimed it as a possession. The publisher, whose avid and apparently insatiable interest in a war he had helped to start brought him as close to actual conflict as possible, made sure to have all of Hemment's photographs copyrighted by the Hearst syndicate.

The determination of Hearst to overcome his competition with such close attention to the Cuban war was equaled by the publishers of two weekly journals: *Harper's* and *Collier's.* These two hired many special artists—Frederic

Remington was one of the most famous sent to Cuba—and many photographers. *Collier's* established its position as a national weekly by what Frank Mott considers to have been "the best 'picture coverage' given any war by a magazine up to that time."[13] The increasing technical ability of newspapers and journals to reproduce photographs *as photographs* began to force special artists like Remington off their pages, or used such men merely to improve poor original photographs by redrawing their contents or retouching them. For someone like Remington, who had a towering national reputation as a delineator of truthfully observed events, it was humiliating to have to admit an overwhelming reliance on photography. As the photojournalists continued to polish their professional skills, it was not long before Remington was ousted from his function as a reporter. What is curious is that in another ten years, talents like his would be greatly in demand to depict symbolic events that photographers could not depict, for example, the god of war hovering over supine European nations.

A New Species of Photographer

In 1895, *Collier's Weekly* changed its name to include the phrase *An Illustrated Journal* and deliberately set out to become a leader in using halftone reproductions of news photographs. Their greatest war photographer was undoubtedly the English-born James H. Hare, usually called Jimmy. Hare went to Cuba to photograph the conflict in the company of no less a celebrity than the writer Stephen Crane, but he was his own writer as well. For the *Collier's* "Cuban Number" of May 28, 1898, Jimmy Hare managed to fill nearly half the issue with his own photographs, in addition to writing the chief article. He had been connected briefly with a rival journal, the New York *Illustrated American,* before a disastrous fire razed that journal's plant and offices in the very month that its emphasis on photojournalism could have been put to good use in depicting the oncoming Cuban crisis. The demise of the *Illustrated American,* after less than a decade, undoubtedly opened the field for other publications.

When Jimmy Hare was ready to leave for Cuba, the art editor of *Collier's,* Walter Russell, shrewdly advised him not to take his highly visible 8 x 10 camera, giving him instead a discreetly smaller one with an f:6.8 lens, one of the fastest then on the market.

Himself a man of almost reckless bravado in pursuit of news pictures, Hare knew he had met his match when he encountered John Hemment in Havana. Hemment, bellowing commands at various Cubans while he manipulated his equipment, was probably even more of a dazzling exhibitionist and every bit as determined as Hare was. The competition between the Hearst photographer and the *Collier's* cameraman was conducted on a friendly basis, and, as in today's stories of journalists and photographers hunkering down in besieged hotels in Lebanon or Cambodia, there were many tales of the camaraderie of the correspondents in Cuba, as there would be pictures of them posing for each other in this and future wars.

Collier's was to dominate the picture field in the first decade of the twentieth century, with Jimmy Hare generally recognized as the world's finest war photographer. Immediately upon hearing rumors of a possible war between Tsarist Russia and Imperial Japan over disputed territory, Hare and other newsmen departed for Tokyo. Russia was in the process of acquiring Manchuria and wanted the open-seas harbor of Port Arthur. Negotiations became deadlocked in 1904, and while they waited impatiently in Tokyo for the expected outbreak of a shooting war, the journalists found themselves having to buy winter clothing to replace their summer suits. On February 8, 1905, Admiral Togo's torpedo boats made a surprise attack on the Russian fleet at Port Arthur, crippling it. A *Collier's* photographer, Robert L. Dunn, got the scoop on the first battle of the war and

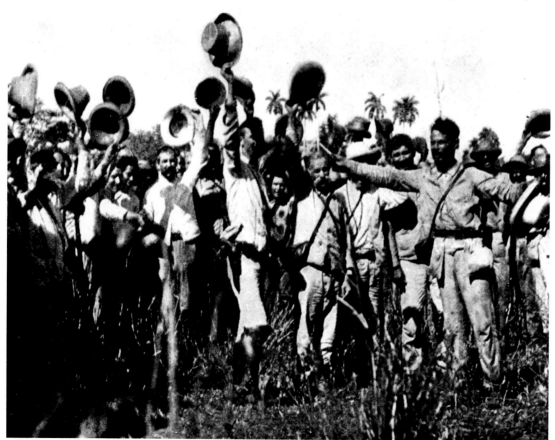

Figure 56 (left)
Unidentified photographer (Jimmy Hare attributed), "Viva Cuba Libre-Viva Americanos!" From *Collier's Weekly,* May 28,1898; photomechanical engraving (Library of Congress)

Figure 57 (opposite)
Unidentified photographer, "American correspondents with the First Japanese Army: (1) James H. Hare (*Collier's*), (2) J. F. Bass (*Chicago Daily News*), (3) Frederick Palmer (*Collier's*), (4) W. Dinwiddie (*New York World*), (5) R. M. Collins (AP and Reuters)." From J. H. Hare, *A Photographic Record of the Russo-Japanese War,* 1905; halftone (Visual Studies Workshop)

the landing of Japanese troops. Jimmy Hare meanwhile was following General Kuroki's army from its landing in Korea through the Yalu campaign. His were the first pictures from the front to be published.

Because no American troops were involved in any way, *Collier's* was free to make an important and unusual decision: it would attempt to cover *both* sides of the war story. In a book rushed into print by the publishers of *Collier's,* Jimmy Hare brought together the photographs of Victor K. Bulla, Robert L. Dunn, James J. Archibald (later accused of spying for Germany), Richard Barry, Ashmead Bartlett, and James Ricalton. The verso of the title page of *A Photographic Record of the Russo-Japanese War* acknowledged that the work of the photographers "under adverse conditions in the field, was greatly facilitated by the use of the films and developing machine of the Eastman Kodak Company."[14] While all of the photographs in the book had been taken exclusively for *Collier's,* many of them had never seen publication in the weekly itself (Figure 57).

Hare's description of the "adverse conditions" indicated how difficult it was for all the photojournalists covering this war. They were dependent on the help of Korean coolies, and even Japanese commissioned officers assisted them in the field with the Kodak developing machine. Coolie runners racing to the *Collier's* offices in Korea sometimes had to cover hundreds of miles. This was a war on a much vaster scale than the Cuban affair, with major powers testing new strategies, new armaments, and relatively new guarantees for the humane treatment of prisoners of war. Civilian defenses received adequate photographic treatment, and the scenes of friendship between soldiers in opposing armies seemed to delight the journalists.

Victor Bulla took most of the pictures of the Russians; as usual, he was under exclusive contract to *Collier's.* Hare covered the Japanese side of the story, earning a medal and a diploma from the Emperor of Japan, and a comradely encomium from Richard Harding Davis, once again working for Hearst's *Journal,* to the effect that no war was official until Hare was on the scene. He was fast becoming the role model for all intrepid overseas photojournalists.

Although no women have been identified as photographers during this war, as there would be in World War I, there was at least one woman who could be considered the equal of Jimmy Hare as a daring journalist. She was Anna Benjamin, a professional war reporter for *Leslie's Illustrated Weekly* during the Spanish-American War who had even gone on to the Philippines. She was in Tokyo at the start of hostilities in 1905, and from there she traveled through China and Russia, crossing Siberia by rail, and reporting all she saw to *Leslie's,* the *Tribune, Outlook,* and the *Atlantic Monthly.* Her premature death at age twenty-seven, from an incurable tumor, was lamented by all who knew her.

51

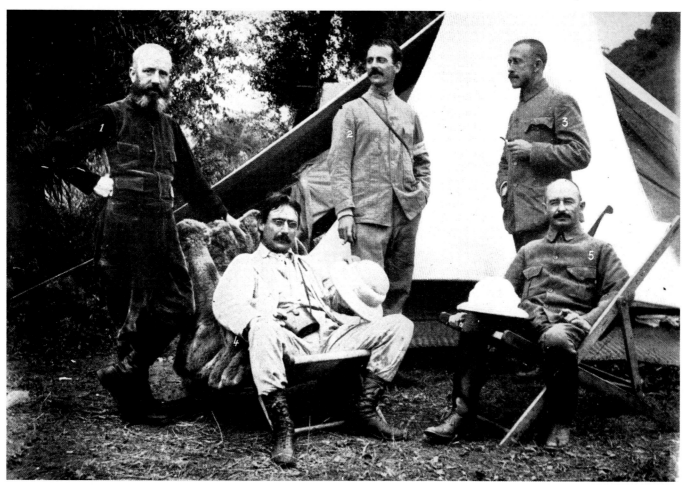

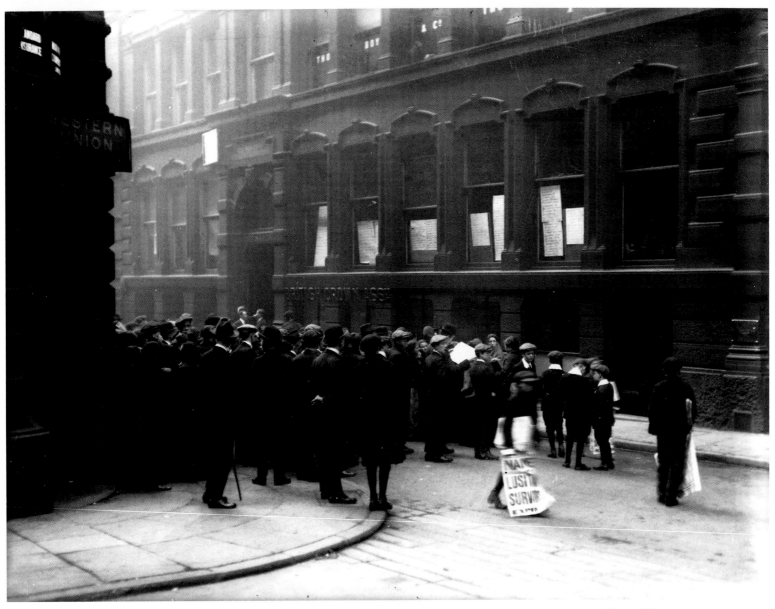

Figure 58
Jimmy Hare, "List of *Lusitania*
survivors outside British Crown
Office," 1915; modern gelatin
silver print from original glass
negative (University of Texas at
Austin)

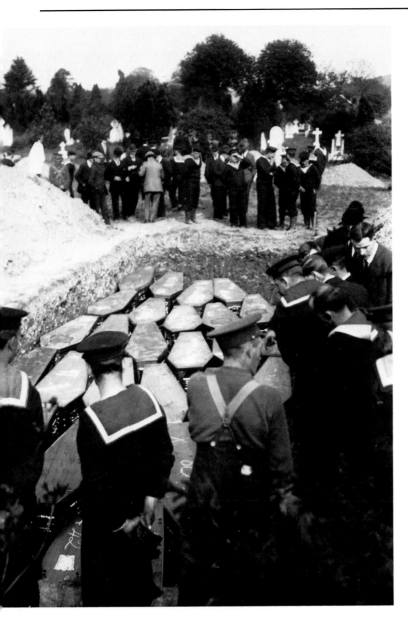

Anna Benjamin is mentioned here as a reminder that women were entering the field of journalism, greatly encouraged by William Randolph Hearst, who considered their "woman's point of view" as yet another means of increasing circulation. But if there was as yet no female battlefield photographer, there were several female photographers at this time who were engaging in another kind of enterprise. Among these were Jessie Tarbox Beals, generally thought to have been the first female press photographer on the staff of a newspaper, and Frances Benjamin Johnston, who achieved fame not only for extensive photoreportage of coal miners, ironworkers, and female textile operators, but ultimately for her aesthetic poses of blacks and Native Americans at the Hampton Institute. Beals managed to be given front page coverage by Hearst's *Journal* for her picture scoop of a Buffalo murder trial. Johnston's prodigious output was seen in many illustrated weeklies.

Journalistic photographs, along with the news stories they accompanied, had continued to receive harsh criticism from many concerned writers. Arthur Reed Kimball protested in the *Atlantic* for July 1900, for example, that something far more dangerous than sensationalism had invaded America. Noting that the coverage of the Spanish-American War had been so extensive that he suspected readers might die of a surfeit of news about that brief conflict, he remarked on the continuing exploitation of that war in the picture magazines. He believed that was merely a symptom of what he called "the quiet journalistic invasion of so much of the intercourse and thinking of life."[15] The mounting flood of reproduced photographs was no longer simply a tyranny of the pictorial, but an indication that publishers were exploiting the camera to elicit belief in the veracity of their sensational stories. A peculiar tension was becoming evident in the contrast between the violent emotionality of screaming headlines and the supposed calm impartiality of the photograph as witness to fact. Faked pictures became a frequent accompaniment to hyped stories. Yet when the camera could be trusted to convey the truth, no other medium was its equal.

It may have been at the turn of the century when the photograph became so familiar and so well reproduced that it began to be taken for granted as the standard for truth.

53

Figure 59 (top)
Jimmy Hare, "Mass grave for the dead, *Lusitania* victims," 1915; modern gelatin silver print from original glass negative (University of Texas at Austin)

Figure 60 (bottom)
Jimmy Hare "*Lusitania* coffins at Queenstown Harbor," 1915; modern gelatin silver print from original glass negative (University of Texas at Austin)

Muckrakers and Social Reformers

Brief overseas wars were hardly sufficient distraction to keep Americans from recognizing the political corruption and inhumane economic conditions at home. In the 1890s, Jacob Riis had realized that he must offer concrete material evidence for injustices—he had been a police reporter, after all—and had seized upon the camera as the best possible way of supplying it. He had been encouraged by Theodore Roosevelt, then a sternly reform-minded New York Police Commissioner on his way to the governorship and, not long after, the vice-presidency. The degradation of human life recorded by Riis and others was only a tiny symptom of the inequalities opposed by the Populists in the 1890s. The country was in tumult. Even the most conservative Americans could no longer ignore shocking revelations about the insatiability of the trusts or the disregard of free-market ideas by conniving monopolists. These were the signs of a murderously unfettered capitalism that had brought the country closer to a class revolution than is perhaps realized today. American workers were demanding freedom to unionize, to strike, and to enjoy the benefits of contracts arrived at by collective bargaining. When Roosevelt became president after the assassination of McKinley on September 6, 1901, his record of support for reform held out hope for the possibility of change.

One illustrated magazine achieved a singular reputation as an agent of reform. Founded by an enterprising editor in 1893, *McClure's Magazine* intended to capitalize on new developments in photoreproductive technologies and printing. Samuel Sidney McClure foresaw a mass market for a monthly that working men and women could afford. It was *McClure's* that made the word *graft* a commonplace of American speech. In its well-designed pages, Lincoln Steffens exposed urban political corruption, while Ida M. Tarbell simultaneously was writing her blockbuster series about the Standard Oil Company, an extraordinarily detailed exposé revealing John D. Rockefeller as the arch-villain of big business. The Steffens and Tarbell articles began in *McClure's* in the fall of 1902, accompanied by many photographic portraits of venal police captains and historical photographs of the Pennsylvania oil fields, all reasonably well reproduced but of generally pedestrian quality as images. Feature articles did not, could not, rely upon special correspondents snapping pictures of shady deals or ruthless competitors plotting to wipe out small businesses. For obvious reasons, photojournalism for muckraking articles had to cull picture morgues for illustration. Nevertheless, the photographs reproduced in *McClure's,* taken from whatever sources, helped to buttress the impression that absolute truth was being imparted.

Muckraking journalism was firmly established in the very year—1902—that Alfred Stieglitz, as champion of fine art photography, was planning the first issue of *Camera Work*, the exceptionally well reproduced journal that would studiously avoid any possible connection with the camera as social reformer. Yet in that same year, a modest man named Lewis Hine was beginning a career destined to demonstrate, beyond any possibility of doubt, that the work of the camera could be aesthetic, expressive, and reformist. Hine had recently begun teaching at the Ethical Culture School in New York City. Coming from a working-class background, he was naturally in sympathy with efforts to improve labor conditions. He also became interested in what was happening at Ellis Island, where thousands upon thousands of immigrants were arriving daily from the Mediterranean countries and Eastern Europe. These individuals, many of them ragged survivors of ferocious oppression and near-starvation, were considered to be dangerous hordes about to engulf the cities, even though they had been coaxed to come to America to provide factories with cheap labor. With flashgun in hand, Hine photographed these newcomers from 1904 to 1909, capturing the innate dignity of the immigrants seen as individuals (Figure 61).

In 1907, Paul Kellogg, managing editor of the journal *Charities and Commons*—later incorporated into *Survey*—invited Hine to join in an intensive survey of Pittsburgh, a rapidly growing industrial enclave manifesting many typical ills of congestion, poverty, and urban alienation. As Alan Trachtenberg has noted, the idea of surveying a city was "a key item in the reform outlook."[16] If a survey could provide a rational picture of social facts, it was presumed that social action would logically follow. In the Pittsburgh survey, Hine supplied the preponderance of the photographs, while the painter Joseph Stella made incisive sketches of steelworkers and miners. Having his work published in *Survey* led Hine to decide to devote his life to persuasive photography in the service of social reform.

Hine was not the first to notice the plight of children working long hours in the Pennsylvania coal mines (Figure 62). In February 1903, for example, *McClure's* published an article by Francis H. Nichols called "Children of the Coal Shadow," illustrated by the well-known magazine artist Frank E. Schoonover. But Schoonover's decorative paintings could not convey the grim realities of sunken cheeks, stooped shoulders, and mental fatigue. His pictures made generalizations out of the poignantly specific details that Hine's camera captured. It was for this generalizing ability of painted illustrations to depict imaginary events or symbolic ideas that magazines continued to employ artists rather than photographers to illustrate both fiction and nonfiction feature stories. What would prove surprising, perhaps, was that by about 1910, magazines such as

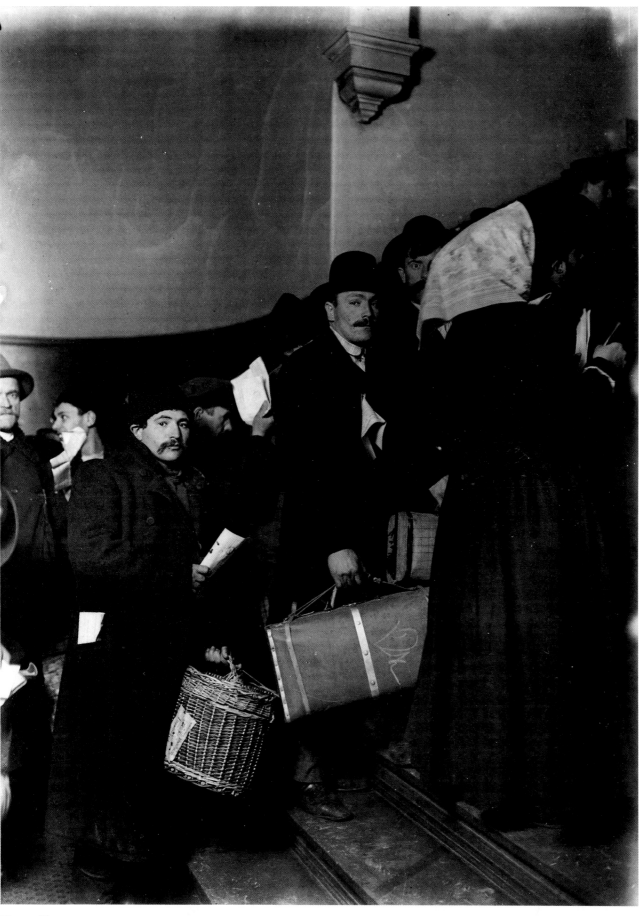

Figure 61
Lewis Wickes Hine, "Climbing
into America, 1908"; gelatin silver
print (IMP/GEH)

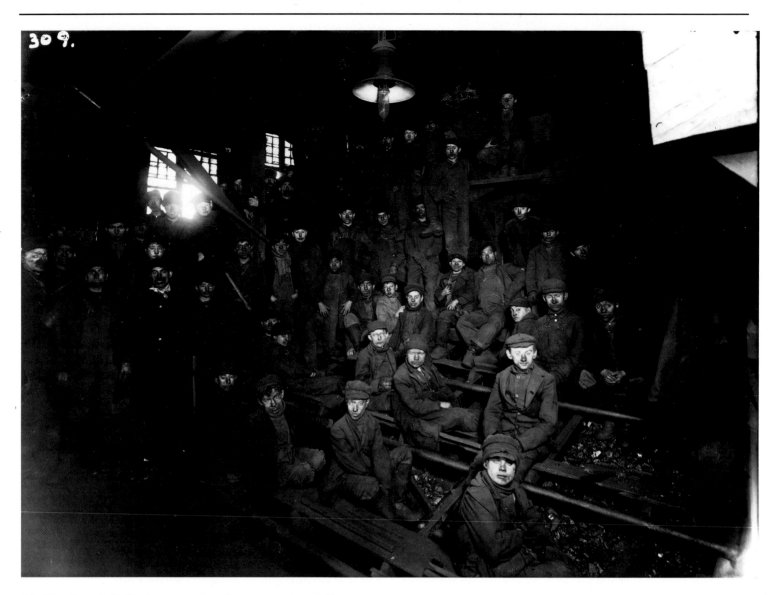

McClure's and *Collier's* were using far more painted illustrations than photographs, even though the technologies for reproducing photographs had continued to improve. There were two reasons for this at the very least: the first was the need to cut costs of production, and this led to the use of cheaper and cheaper paper, on which good photographic reproduction was impossible; the second was that advertisements were beginning to crowd out the news contents of these journals, and the publishers apparently decided to let the visual excitement of their magazines depend on the riotous typography, fantastic pictures, and surreal montages that characterized much advertising.

Although the greatest number of Lewis Hine's photographs appeared in *Survey,* they were also reproduced with articles on social conditions in magazines as diverse as *McClure's, Delineator, Everybody's, American Magazine, Outlook,* and *Photographic Times.* Hine went overseas during World War I, covering the Balkans for *Red Cross Magazine* (Figures 63–64). One of America's most influential and talented photojournalists who was also an artist with the camera, Hine unfortunately gained the respect of aesthetes only toward the very end of his penurious life in 1940.

Figure 62
Lewis Wickes Hine, "Breaker boys in coal chute, South Pittston, Pennsylvania, January 1911"; gelatin silver print (IMP/GEH)

Figure 63
Lewis Wickes Hine, "Refugees on railroad tracks en route to Gradletza, Serbia," 1918. From *American Red Cross Special Survey*; gelatin silver print (IMP/GEH)

Figure 64
Lewis Wickes Hine, "Refugee group, Lescowatz, Serbia," 1918. From *American Red Cross Special Survey*; gelatin silver print (IMP/GEH)

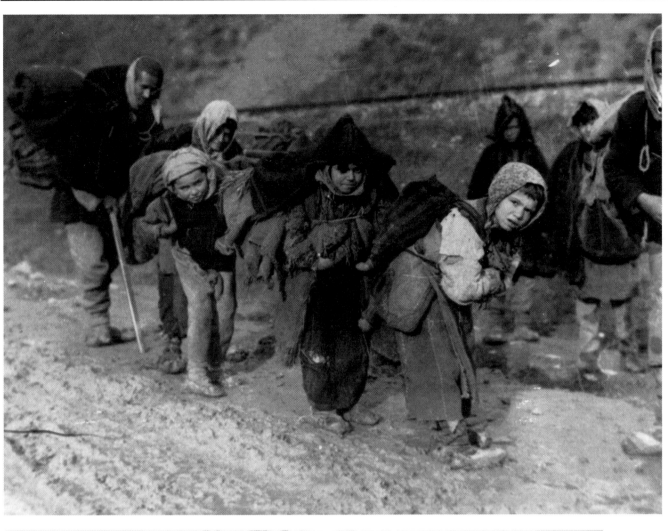

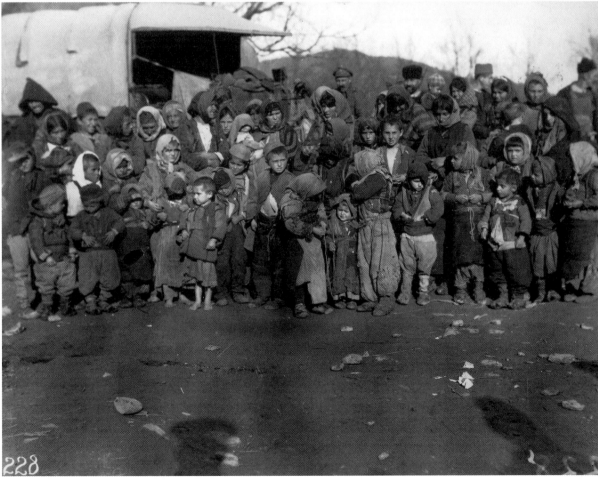

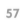

What the Public Wanted

Pictures of labor turmoil, girls in dangerous textile mills, or coal-dusted boys in the mines were not the best competition for pictures of wars, catastrophes, and famous persons. For a photojournalist to earn a living meant either being attached to the staff of a successful newspaper or magazine or actively pursuing a freelance trade. The freelancer's motto was no different from that of the publishers: "The first thing to think of is 'What the public want,' *not* what the photographer wants to give."[17] Typical advice to would-be news photographers insisted that "the experienced photographer will not be content to take a snap-shot of the burning building; he will plant his camera in position and wait until he can picture firemen climbing up ladders, or some thrilling scene of rescue."[18]

Catastrophes of any sort were the photojournalist's dream picture opportunities. A mob of newsmen with cameras would descend on any town in which a tragedy had occurred, such as the dynamite explosion that wrecked Communipaw, New Jersey, early in 1911 (Figure 66). In the aftermath of the San Francisco earthquake of 1906, for example, Arnold Genthe, a portraitist whose studio was completely demolished, managed to take the most famous picture of that event, looking downhill from Sacramento Street toward the bay (Figure 65). Burton Holmes, maker

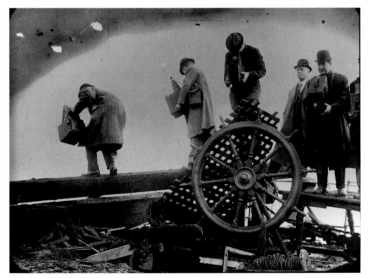

Figure 65 (top)
Arnold Genthe, "San Francisco, April 18, 1906"; gelatin silver print, negative printed by Ansel Adams (IMP/GEH)

Figure 66 (bottom)
Jimmy Hare, "News photographers covering dynamite explosion at Communipaw, New Jersey, in early 1911"; modern gelatin silver print from original lantern slide (University of Texas at Austin)

Figure 67 (opposite)
Burton Holmes, "An almost incredible train accident at the Montparnasse Railroad Station," 1891–1895; modern print from original hand-tinted lantern slide (Burton Holmes International)

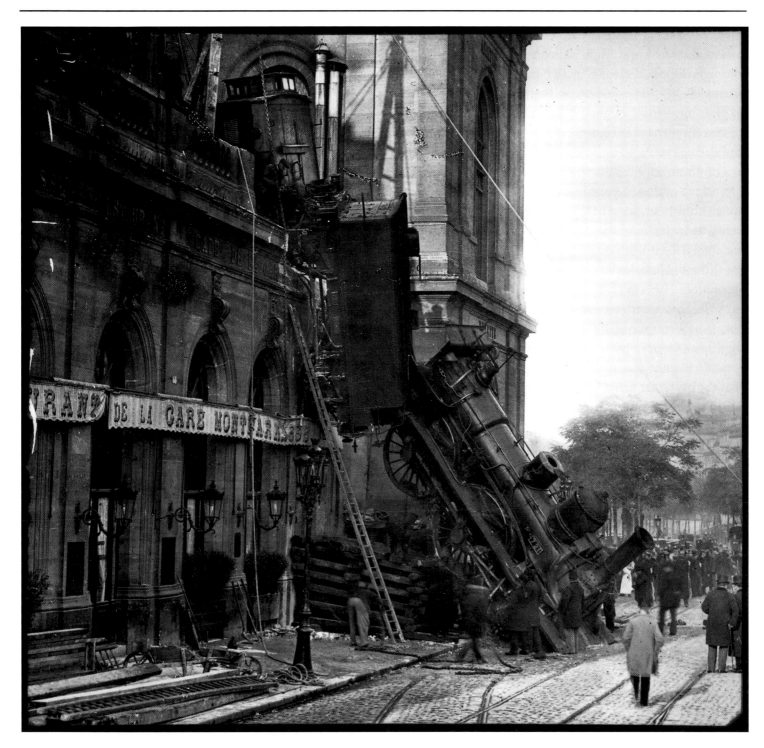

of travelogues and called "The Man Who Photographed the World," was in Paris in 1906 and rushed out to the Montparnasse Railroad Station to record "an almost incredible train accident"[19] that left a railroad engine dangling in midair (Figure 67). Soon after, Holmes, like every other photojournalist, rushed off to Naples to catch the spectacular eruption of Mount Vesuvius.

The dazzling white city of the 1893 Columbian Exposition in Chicago had attracted a great deal of public interest and therefore an excess of photographic coverage, including pictures taken at night of the electric lights—then a new invention—bordering the tops of each McKim, Mead, and White building. Night photography was still difficult, but publishers were keen to get any picture that symbolized the

progress of photography and, if possible, captured an event otherwise unattainable. Such an event was the night launching of a sailing-cup contender, the *Columbia,* a graceful yacht under construction in Bristol and kept deliberately secret by its owners. *Collier's* editors quickly rushed Jimmy Hare to the scene, asking of him the impossible task of photographing the launching despite Hare's protestations that ordinary flash powder—unless used in prodigious and prohibitively expensive amounts—could never accomplish the deed.

Fortunately for Hare, when he arrived in Bristol he found his old Havana rival, John C. Hemment, in the company of one Thomas Mills, a manufacturer of flash powder and a specialist in night photography. Hemment had hired

Franklin Price Knott seems to have inspired *National Geographic* to publish them in April 1916, albeit helter-skelter, without explanation. The series included pale landscapes, Hopi Indians, and two pictures of entwined dancers whom cognoscenti could identify as Ruth St. Denis and Ted Shawn, although their names were not given (Figure 71). Was this photojournalism, or a travesty implying that "the tyranny of the pictorial" had progressed from an overabundance of images to a raging idiocy of illustration, giving some credence to the opinion that stories were being written simply to provide an excuse for pictures? Any excuse for color, apparently, was used by publishers, but even into World War I, color was added primarily through fake process rather than by separations from three-color negatives.

Because the public was perceived, correctly, as wanting more and more pictures, publishers were constantly seeking new and cheaper ways of printing large runs of newspapers containing a plenitude of photographs. In 1911, *Penrose's Pictorial Annual* predicted that there would soon come "a combination of the intaglio and rotary offset processes,"[20] which would solve all problems of speed and reproduction. Rotogravure, or rotary intaglio printing, was hardly the equal of its parent process, photogravure, the medium beloved by masters such as Peter Henry Emerson and Alfred Stieglitz, as well as by publishers of fine-quality books. It had never been used directly for newspapers with any economic success. Rotary photogravure was photogravure only in the sense that it was an intaglio process, wherein the ink lay in etched cavities below the surface of the printing plate. As in etching, however, the ink had to be removed constantly from the surface of the plate before printing, and this was consummated by a knife-like instrument called the doctor, which shaved the plate clean of ink between impressions.

Rotogravure offered cheap printing, but it also had a significant problem: the screen used to translate the photographic print into etched cavities had also to be applied to the typography, as picture and words had to be printed together, in a manner much inferior in clarity to the relief-process halftone plates. Still, rotogravure's economic advantages were hard to resist:

> The rotary . . . can print good work for illustrated papers at the rate of not one plate, but sixteen pages of any size, with as many illustrations as one may wish to put on, from an inch square or less to the full size of the cylinder, with all the head lines, bottom lines, and pages of matter as desired, eight pages on one cylinder and eight on another, printing both sides of the paper at the same time.[21]

With the arrival of European hostilities in 1914, special rotogravure supplements to newspapers began to be produced regularly. These rotogravure sections were almost uniformly printed in a dark sepia, although sometimes purple or green inks were used. One can only imagine what the photojournalists thought about a process that degraded their hard-won battle pictures, but they were probably making more money than they had in the past. No doubt the war with Germany seemed like a pictorial bonanza, whatever its hazards. But if photographers were expecting the relative picnic they had enjoyed in Cuba or Korea, they were soon to discover that every possible difficulty would be encountered in their ambition to photograph actual battles at the front.

Figure 71
Franklin Price Knott, "The Poetry of Motion and the Charm of Color." From *National Geographic*, April 1916, p. 383; halftone from original autochrome color plate (Library of Congress. Courtesy National Geographic Society)

Outflanking the Censors

When news of the outbreak of war reached the front pages of newspapers in America in August of 1914, the public had little idea of the coming atrocities, the horrors of trench warfare, the agony of poison gas, the maddening noise of heavy artillery, or the wholesale destruction of small towns and their environs. Although photographers were explicitly forbidden to visit the battlefields, publishers were quick to seize on the war as an excuse to sell not only daily papers but special pictorial supplements reproduced by rotogravure, which would come to be expected by a public craving visual information about the war. The *New York Times,* for example, rushed into print with the following advertisement as early as November 5, 1914:

START A COLLECTION OF WAR PICTURES

> Start now to collect these magnificent illustrations of current history, the camera's story of churches in ruins, soldiers in trenches, sacked villages, fleeing refugees, armies on the march, faithfully portraying, week after week, the progress of the war. They will be treasured in years to come as no other souvenir of the conflict.[22]

Considering the suffering of the Belgians, who were being overrun, and the French, British, and German soldiers killing each other, such an advertisement seems almost too cold-blooded to be believed. As yet no Americans were involved, but it is nevertheless difficult to understand the callousness of the newspaper marketing staff who wrote this advertisement, or the greed of the publishers who offered special binders so their readers could preserve copies of the *New York Times Mid-Week Pictorial War Extra.* If the British were boasting that the war would be over by Christmas, the *Times* obviously thought differently and was preparing to wring every cent of potential profit out of the conflict that would kill one million of England's young men.

Newspaper and magazine photographers were eager to document activities at the front. This, naturally enough, the British and French censors would not let them do. The redoubtable Jimmy Hare, who had switched allegiance from *Collier's* to *Leslie's* for the duration of the war, had to resort to an adroit maneuver even to land his cameras on French soil. Roy W. Howard, a well-known publisher, volunteered to help him dismantle his camera, an Eastman 4 x 6 folding of the Graflex type, and even spirited Hare's lens past the censors by hiding it in his own luggage. Censorship was so severe that Allied command attached to each correspondent an officer "whose one and only function, apart from preventing him from seeing anything, was to waste as much of his time as possible."[23] So successful were these tactics that almost nothing of trench warfare or other

Figure 72
Underwood & Underwood, "Under bombardment on the heights of the Meuse." From *New York Times Mid-Week Pictorial*, April 13, 1916, p. 7; rotogravure (Visual Studies Workshop. Courtesy Bettmann Archive)

horrors reached the *Times,* and magazines such as *Collier's* were forced to employ artists to paint imaginary events.

By 1916, however, the *Times* managed to obtain, from Underwood & Underwood, one of many picture agencies, a photograph showing a scene of actual shelling at the front (Figure 72). The caption was explicit in explanation:

> Under bombardment on the heights of the Meuse. This remarkable photograph shows the heights of the Meuse while actually under fire from the German guns. In the foreground may be seen French soldiers crossing the shell torn space between the two hills on the narrow causeways built by the troops, near the top of the picture, at the right, a shell has just burst, another at the center, while the earth is literally pitted with holes torn by former explosions and every tree is shattered and splintered.[24]

By this time, recognizing that the war was not going to end quite as soon as the Allies had imagined, the *Times* dropped the phrase "War Extra" from the title of its *Mid-Week Pictorial.*

Censorship was not the only problem plaguing the news photographers, although it drove Jimmy Hare, among others, to leave France for what he hoped would be less guarded fronts in Italy and the Balkans. When he reached Salonika, however, Hare once again had his finest pictures refused publication by adamant French and British censors. On various Italian fronts, he discovered that it was not easy to take pictures of embattled heroes, for the flamboyant soldiers would stop what they were doing in order to pose, grinning, in picturesque attitudes. Hare complained, "To photograph a soldier fighting grimly for his King, his country and his family, and get the picture of a grinning ape!"[25] No one at home would believe for a moment that he had been photographing a dangerous battle, where shells exploded and bullets parted your hair, if he were ever foolish enough to submit such a picture to *Leslie's.* He sent only the most serious kind.

Without the European and American picture agencies, it is doubtful that any journal would have had much to publish by way of war pictures. Wide World, Times Photo, Keystone View Company, Acme Newspictures, Underwood & Underwood, Pacific and Atlantic Photos, the International News Service, as well as U.S. Signal Corps photographers and official photographs from French, Canadian, and Australian government agencies, were among those contributing pictures. Hundreds of ordinary soldiers were also snapping pictures at the fronts, illegally, but although hundreds of thousands of these often anonymous photographs exist in international archives, very few, if any, appeared in wartime publications. It was these images,

however, culled from the archives and reproduced in books about the war many years later, that give us an intimate view of daily life in the trenches.

Harper's Weekly, having become over the years much more sedate than the sensationalist periodical of, say, the Spanish-American War, ran a pictorial news competition for amateurs in May 1916. Reproducing a full double-spread of competition photographs, all of them more than adequate technically, *Harper's* editors commented, "As more and more amateur photographers . . . acquire skill in the manipulation of lens and shutter . . . they are making inroads on the hitherto exclusive field of the newspaper camera man and the professional photographer."[26] Small cameras, fast films, and a population eager to have its own pictures published boded ill for the professionals, especially since the bylines on their pictures no longer credited individuals as a rule, but cited the picture agencies instead.

The International News Service, frequently listed as the source of photographs in many journals, turned out to be a front for some of William Randolph Hearst's most unscrupulous chicaneries. An angry article by H. D. Wheeler in *Harper's Weekly* revealed that while Hearst's International News was boasting of its coverage of the war by no less than eighty correspondents, many of the cited individuals simply did not exist. "Frederick Warner," "Herbert Temple," and others were Hearst fakes. "Brixton D. Allaire, Staff Correspondent, Rome [was] not a romantic figure in khaki, braving untold dangers in the field, but simply a common, ordinary, contemptible Hearst fake."[27] Admitting that "Brixton D. Allaire" was a brilliant invention with great panache, Wheeler explained that Hearst depended on arrangements with papers including *The Times* of London, *Le Matin,* and *Lokal Anzeiger* of Berlin. Not just news stories came from these arrangements, but also many photographs, sometimes with credit lines attributing them to the "courtesy" of this or that journal.

While it might seem that photographs could not be invented with the same ease as the names of nonexistent correspondents, there were occasional notations to the effect that crowd scenes might possibly be faked; for example, in the Russian Revolution it was suggested that faking might have been done by superimposing a prior riot scene on a background shot of the Tsar's Winter Palace. Nothing, however, was faked about the enthusiasm with which several journals met what *Collier's* called "How Democracy Came to Russia" in its May 19, 1917, issue, which featured pictures of Alexander Kerensky and the new foreign minister, Paul Miliukov, said to be a great admirer of America. The photographs had been taken by Paul Thompson, a staff cameraman for *Collier's,* on March 12, 1917, during the first hours of the short-lived Kerensky revolution.

Figure 73
International Film Service,
"Alexander Feodorovitch Kerensky
(in the automobile) as Minister of
War, reviewing the Russian troops
at the front." From *National Geo-
graphic,* July 1917, p. 25; halftone
(Library of Congress)

The congratulatory legends, lauding the departure of the tyrannous Tsar and the promise of a democratic form of government under Kerensky, may be surprising to us today. It may be even more of a surprise to find the staid *National Geographic* publishing in July 1917 not only a fine picture of Kerensky but the complete text of his first speeches and proclamations (Figure 73). He was photographed reviewing Russian troops at the front, and one presumes that the reason he was so popular with the American press, which naturally sided with the Allies, was that he had sworn never to pursue a separate peace with Germany. That was, of course, the first thing that Vladimir Lenin did when he came to power in October 1917, ending three years of senseless slaughter. This time there were no pictures of an admired politician, only photographs of smashed church interiors and general destruction. This was in strong contrast to what *National Geographic* published while Kerensky ruled, a typical example being a picture of Russian guards parading before the Winter Palace in Petrograd (now Leningrad), with the legend assuring the reader that the Kerensky revolution had been most orderly, with no looting whatsoever (Figure 74).

National Geographic followed these issues with what they called "Our Flag Number" in October 1917. Paul Thomp-son's photographs of schoolchildren waving flags on "Americanization Day" were featured (Figure 75), as was a picture by Harlan A. Marshall, probably an amateur, of an enormous flag some 50 x 95 feet in size, with stars one yard in diameter (Figure 76). With such a showing, no one could question the *Geographic*'s patriotism—and nationalism.

Among the peregrinating photojournalists covering the Russian front was Arthur Ruhl, who patiently followed the fate of war prisoners captured by the Russians and deported to Siberia. Ruhl wrote his own articles, as did Stanley Washburn, who had been *National Geographic*'s Special Correspondent with the Russian Armies for three years. Ruhl had photographed the battles at Gallipoli, but his pictures were so badly reproduced in *Collier's* as to be almost unintelligible. By this time, *Collier's* had fallen from the high position it had held during the Cuban war and deteriorated into a five-cent weekly, printed on the shabbiest of chemical papers by rotogravure and so crowded with full-page and double-spread advertisements, some in fake color, of automobiles, insurance companies, and foodstuffs that there was very little room left for news or news photographs. If *Harper's Weekly* admitted a few ads, it maintained higher standards. Perhaps this was because the McClure Company had taken it over.

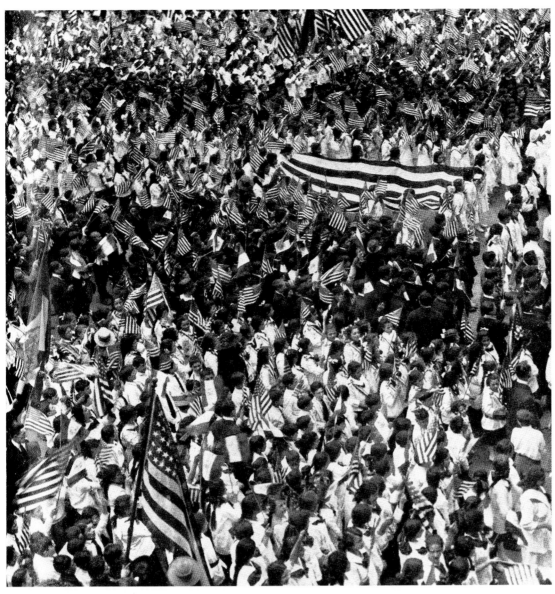

Figure 74 (opposite)
Stanley Washburn, "Parading before the Winter Palace in Petrograd." From *National Geographic*, August 1917, p. 119; halftone (Library of Congress)

Figure 75
Paul Thompson, "School children of New York, observing Americanization Day in City Hall Park." From *National Geographic*, October 1917, p. 409; halftone (Library of Congress)

Figure 76
Harlan A. Marshall, "Flag woven and made up by mill workers in Manchester, N.H." From *National Geographic*, October 1917, p. 410; halftone (Library of Congress)

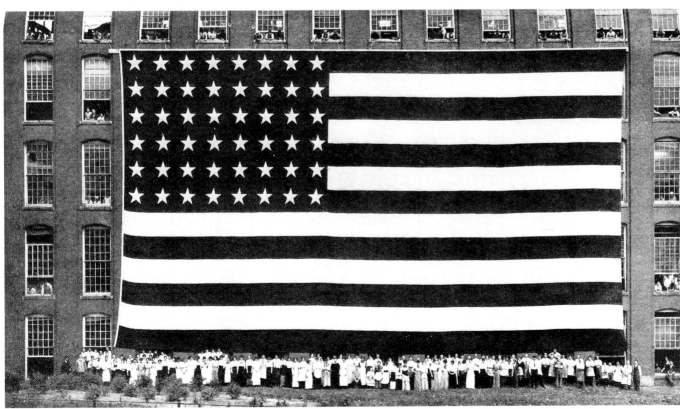

News photographs of the war could occasionally achieve a poetic romanticism equal to pictorialist aesthetics, even if printed by rotogravure. An outstanding example was a picture that appeared in the *New York Times Mid-Week Pictorial War Extra* for October 15, 1914 (Figure 77). It was of the interior of Rheims Cathedral, occupied only by a solitary soldier, hat in hand, who was somberly regarding the irreparable damage done by German bombs. In 1915, the same picture was reproduced in *The Nations at War: A Current History* with the title "The Glory that was Rheims." To dress it up for publication, fake process color was added, turning an otherwise respectable—if exceedingly sentimentalized—picture into a kitschy display suitable for calendars. Other photographs of lesser aesthetic value but of visual interest frequently made the rounds of various publications, a typical example being one of a Belgian cavalryman standing on his horse's back to sight the enemy (Figure 79). With no picture credits to establish the photographer's identity, it appeared in *Harper's Weekly* for October 24, 1914, and with the credit line "Underwood & Underwood" in the *Times Mid-Week Pictorial War Extra* on October 15, 1914.

Possibly nothing was more exciting to the public eye than the many photographs of airplanes and zeppelins that were often granted entire pages to themselves, sometimes even dominating the covers of journals (Figure 80). Occasionally, photographs such as "The Defenders of Verdun" (Figure 83) foreshadow pictures by Robert Capa or Carl Mydans in their boldness and precision. Some of these turn out to have been distributed by an agency called International Film Service, a reminder that the motion picture was already competing with the still photograph for ascendency in news reporting. As was usual with ever-proliferating visual technologies, no sooner had one medium established itself as a unique source of information—as the still photograph did superbly in World War I—than another one came along to displace it. For every reader of newspapers who enjoyed the photographs of airplanes, there would soon be dozens of moviegoers who would prefer the lively action of the aerial dogfights hurried onto film by canny cinematographers.

Figure 77 (top)
Underwood & Underwood, "Interior of the beautiful Rheims Cathedral. The medieval stained glass and many of the statues have been irreparably damaged in the bombardment." From *New York Times Mid-Week Pictorial War Extra*, October 15, 1914, p. 3; rotogravure (Visual Studies Workshop. Courtesy Bettmann Archive)

Figure 78 (bottom)
Unidentified photographer, "Miss Elfriede Riote is the only woman airship pilot in the Kaiser's service." From *Collier's Weekly*, September 12, 1914, p. 18; halftone (Library of Congress)

Figure 79
Underwood & Underwood,
"Belgian patrol watching the
German advance," 1914; gelatin
silver print (Bettmann Archive)
*This last member of the patrol is left to
watch the movement of the approach-
ing Germans. As soon as they come
within rifle range, he gallops off to
inform his main forces.*

PRICE TEN CENTS

MID-WEEK PICTORIAL

An Illustrated Weekly

PUBLISHED BY The New York Times COMPANY

THE NEW BIRD OF LIBERTY.
AN AMERICAN WARPLANE OF THE LATEST TYPE.
(Photo by U. S. Marine Corps.)

VOLUME 1. NO. 44.
PRICE TEN CENTS.

The New York Times

NEW YORK, THURSDAY,
JULY 8, 1915

MID-WEEK PICTORIAL

Published every week by The New York Times Company, Times Square, New York. Subscription rate, $3.50 for 3 months, $6.00 per year. Copyright, 1915, by The New York Times Company. Entered at the New York Post Office as second class matter.

THE KAISER, WITH HIS AIDE, RECEIVING REPORTS AT THE BATTLE FRONT IN THE SAN REGION.
(Photo from H. Ruschin.)

Figure 80 (opposite)
U.S. Marine Corps, "The New Bird of Liberty. An American warplane of the latest type." From *New York Times Mid-Week Pictorial,* July 4, 1918, cover; rotogravure (Visual Studies Workshop)

Figure 81 (left)
H. Ruschin, "The Kaiser, with his aide, receiving reports at the battle front in the San region." From *New York Times Mid-Week Pictorial,* July 8, 1915, cover; rotogravure (Visual Studies Workshop)

Figure 82 (bottom, left)
Paul Thompson, "Madame Thoumaian, the promoter of the Congress, displays the motto of the Three Musketeers." From *New York Times Mid-Week Pictorial,* May 27, 1915, p. 17; rotogravure (Visual Studies Workshop)

Figure 83 (bottom, right)
International Film Service, "The Defenders of Verdun . . . 'They shall not pass.'" From *New York Times Mid-Week Pictorial,* February 8, 1917, p. 9; rotogravure (Visual Studies Workshop)

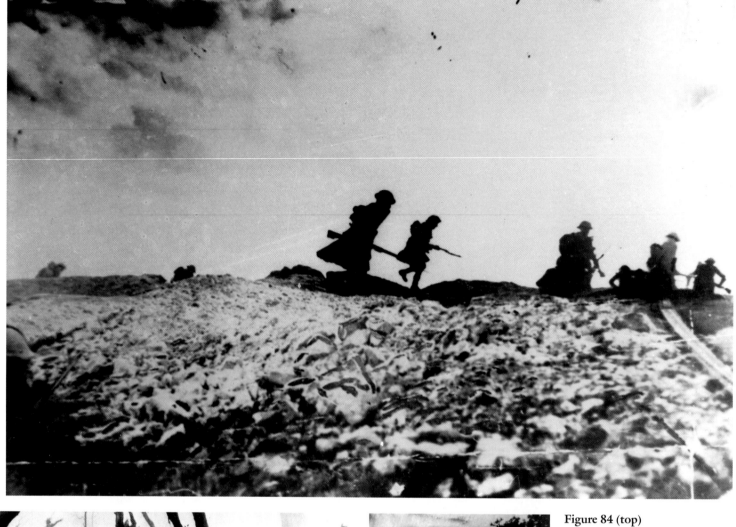

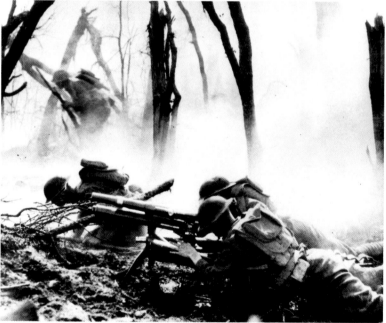

Figure 84 (top)
Wide World Photos, "A vivid picture showing early morning attack by the British on the Western Front," 1917; gelatin silver print (AP)

Figure 85 (left)
Wide World Photos, "The Argonne," c. 1914; gelatin silver print (AP)
Action on the Western Front. Twenty-third Infantry of the Second Division firing a 37mm gun at a German position in France.

Figure 86 (right)
Wide World Photos, "An aerial torpedo in flight photographed just after its discharge from a French trench," c. 1914; gelatin silver print (AP)

Figure 87 (opposite)
Wide World Photos, "A new model German trench captured by the French," c. 1914; gelatin silver print (AP)

End of a Fertile Era

The period of transition from wood engravings based on photography to the success of halftone engravings of photographs capable of newspaper and magazine publication began with Stephen Horgan's crude "Shantytown" in 1880. Although crusading special artists had preceded him as reporters for news publications, Jacob Riis probably deserves the credit for establishing photojournalists as recorders of scientific fact. Joseph Pulitzer and William Randolph Hearst knew how to exploit photography to increase the circulation of their sensationalist journals. Undoubtedly, it was the Spanish-American War that gave photojournalists their first major opportunity to prove their worth, since it coincided with Stephen Horgan's ingenious solutions to the problems of the stereotype and the screened halftone as applied to the cylindrical newspaper presses.

The need to document the social evils perpetrated by ruthless economic practices of monopolies fueled the use of the camera for reform. Increasing reliance on the camera for documentation of all kinds encouraged the belief that photography was a reliable witness to truth. At the same time, the turn of the century saw critics voicing their suspicions that the profligate and ubiquitous use of photographic images was having a detrimental influence on rational discourse. The cultivated public had its doubts, calling the threat to literature "the tyranny of the pictorial," while the masses thoughtlessly responded to every sensation.

Photojournalists such as Jimmy Hare, John Hemment, James Burton, Victor Bulla, to name only a few, distinguished themselves as valiant pursuers of visual fact, often at great risk to their lives. During World War I, it often seemed that their intrepid individualism would be totally obscured by the proliferation of picture agencies that failed to cite the names of photographers in credit lines. Photojournalism became dangerously anonymous.

In 1918, Eastman Kodak could advertise, "Today, news from all the world comes to your breakfast table with real pictures, fresh and accurate, made in the very thick of the fight. And these newspictures, by the aid of photoengraving and the printing press, are sped in a few hours into millions of homes."[28] No mention there that rotogravure was a gross medium, distorting photographs with dense inks on cheap chemical paper. No mention there of the superabundance of colorful advertisements competing with news photographs for space and attention, nor of pictures that might be censored not just in war but by the avarice of publishers unwilling to threaten their advertisers with possibly damaging stories.

While women were bold correspondents and dedicated investigative reporters, few became photojournalists during this era, possibly because the equipment was still cumbersome, more probably because the congeries of male photographers was rather like a private men's club with exclusive privileges. It would not have been seemly or acceptable for a woman to travel with correspondents to battlefields during actual conflict, for example, yet someday it may be discovered that female photojournalists found their way to the front, just as courageous nurses were there to aid the wounded.

To all intents and purposes, the era of transition ended with the establishment of America's first tabloid on June 26, 1919. The *New York Daily News* epitomized its pictorial goals with the outline drawing of a camera in the exact center of its masthead. Yet its ideology of publishing was not as new as the editors liked to pretend. They believed they were setting new ground rules for a tabloid: "to astonish, bemuse, dazzle, or horrify the reader."[29] Any historian of the picture press could have told them that such ambition had characterized illustrated journals since their earliest beginnings. ☉

EUROPEAN VISIONS

Magazine Photography in Europe between the Wars

by Colin Osman and
Sandra S. Phillips

IN THE TWENTIETH CENTURY, the period between the two world wars was a time of great social change and aesthetic challenge, which was reflected in the pictorial magazines. At the beginning of the 1920s *The Illustrated London News*, the originator of the form, was still the leader among the world's picture weeklies. Its editorial style and page design harked back to its nineteenth-century origins, the days of wood-engraved illustrations and dispatches from correspondents, even though updated by camera and press telegraph. Since the year of its inception, 1842, *The Illustrated London News* had stimulated the appearance of a picture weekly in every large European city beginning in Germany with Berlin and Munich. By the late 1920s a new revolution in picture journalism occurred and spread through Europe. After Hitler came to power, the changes would rapidly accelerate not only in continental Europe, but in Britain and America as well.

Although the illustrated magazine had slowly evolved in the mid-nineteenth century, the interwar period was the most important moment for these magazines because of two major but interrelated changes: the continuing development of a truly mass audience, mainly in the urban middle class but augmented increasingly by a literate lower class; and the discovery of the photograph's potential for illustration—not only a faster and cheaper means, but a more vivid and approachable one than drawn illustrations.

Germany was the first country of this period in which modern photojournalistic magazines evolved, and the Ullstein Press played a major role in this development. Economically uncertain times and political change had forced many young men out of the professions and art careers into work for these magazines (Erich Salomon is a leading example). Others moved to Berlin from what had been cultural capitals before World War I. They came from Prague, Vienna, Bucharest, but above all from Budapest, where territorial losses after the war helped to initiate the great Hungarian migration of photographers and journalists at this time. Among them were Martin Munkacsi, Robert Capa, and Stefan Lorant. Developments in faster printing presses, a refined rotogravure process, the availability of paper in quantity and quality at a reasonable price, combined with a literate urban audience and talented photographers, agents, and editors, produced a great surge of development in picture magazines, first in Germany, then in France, England, and, later, the United States, notably with *Life* and *Look*.

Articles in the *ILN* in the 1920s and indeed up until World War II differed little from many other contemporary magazines and newspapers. There were court notices (both social and royal), book reviews, theater reviews, and a string of short articles on topics of the day. The longer articles were often reports of battles in distant parts of the British Empire interspersed with other world reports, for, in spite of its name, *The Illustrated London News* was firmly empire- and world-directed. The difference between the *ILN* and other magazines was the many pages of illustrations between the pages of text. Inventions by the *ILN* and *The Times* (London) printers in the late nineteenth century had resulted in much faster rotary printing, followed later by electromechanical engraving, which had replaced the old wood engravings by the beginning of World War I.

The immediate success of *The Illustrated London News* in 1842 had led to similar publications throughout Europe. The earliest in Germany was *Illustrirte Zeitung*, first published at the great printing center of Leipzig, in 1843, the same year as *L'Illustration* debuted in Paris. The idiosyncratic spelling of the German name was copied by its successor, *Berliner Illustrirte Zeitung*, published in 1891 by one of the largest publishing organizations in the world, the Ullstein Press. Following Berlin, the major German cities—Frankfurt, Hamburg, Cologne—developed their own individual magazines or newspaper supplements (although not retaining the original spelling). The most notable of these was the *Münchner Illustrierte Presse* (founded in 1923), which immediately began a vigorous battle with the *Berliner*, partly competing for circulation (since both were nationally distributed), but also perpetuating the rivalry of the Prussian north and the Bavarian south. Coming from the equally illustrious Berlin publishing house of Scherl was *Die Woche*, founded in 1898. This never quite seemed to be in direct competition with the others, however. A smaller page size and a drawn cover in color made it seem less pressingly news-oriented, and its content was local rather than national and international.

The Ullstein firm acquired or developed a number of different titles, but photographically the most interesting were *Die Dame*, a fashion magazine, *UHU*, a popular illustrated monthly, and the literary *Der Querschnitt* (which Ullstein bought from the art dealer Alfred Flechtheim), among others. Both *UHU* and *Der Querschnitt*, although different in their aims, were small-format collections of stories, essays, and visual material and would later influence *Lilliput* and subsequently most pocket-sized magazines, including in the U.S. *Coronet* and *Parade*. Ullstein had other divisions, one of which published newspapers—addressed to both popular and elite audiences—and other magazines and books, and they even had their own news service.

But by far the most important of all the illustrated publications of the House of Ullstein was the *Berliner Illustrirte Zeitung* (BIZ). At its peak in the late 1920s and early 1930s, the magazine had a circulation of 2 million readers, in a

Figure 88
Willi Ruge, "With our war fliers in the air." From *Berliner Illustrirte Zeitung,* January 9, 1936 (No. 2), cover; rotogravure (Coll. C. Osman)

population of 40 million. The House of Ullstein was the largest and most powerful printing firm at that time, directly controlled by the five Ullstein brothers. It was a large corporation, and the *BIZ* was an important component under the editorship of Kurt Korff and his publishing director, Kurt Safranski. As Hermann Ullstein wrote:

My greatest triumph . . . was with Kurt Safranski, a draughtsman and art editor, who later became one of the best and most important members of the board of directors of our firm. A most remarkable man, an artist of

faultless taste with an extraordinary flair for publishing, full of good ideas, Safranski was for many years the highly successful manager of all our magazines. The sum of his good qualities, in fact, served as a perfect complement to the Editor, Korff, to whom Safranski felt very much attached. Together they formed a model team—Korff representing the literary element, Safranski the artistic. The latter indeed could be best described as a painter-editor, and his importance for the firm showed itself when many other pictorial magazines, periodicals for entertainment and trade journals—were added to the

Berliner Illustrirte Zeitung. It was then that the painter-editor was made director of the whole group, a post not unlike that of a film producer, whose position is superior to that of a stage manager.[1]

Very likely the transformation from the illustrated text to pictorial reportage for which Safranski and Korff were responsible was what now made the *BIZ* so successful.

The Ullstein brothers were interested in reaching as wide an audience as possible and designed the magazine basically as entertainment. Subjects included travel and sports, common local events, as well as news. Later, as a refugee, the youngest of the Ullstein brothers, Hermann, reflected on the fate of his only effort at changing this policy of noneditorial reportage: "[In about 1932 the *BIZ*] had a circulation of about 2 million, which meant a reading public of about 5 or 6 million. For forty years the *Illustrirte* had remained politically neutral, but it was now about time I insisted that it should be used to combat the menace of Hitler."[2] But his brothers and the other directors voted against his suggestion: they felt that the injection of politics would jeopardize the *BIZ*'s large circulation.

Over the years the *BIZ* developed a successful blend of pictorial and written matter, of the serious and the humorous. The first two pages consisted of assorted photographs of news from around the world, mainly culled from press agencies. Often these were made into consciously artistic if somewhat naïve photo collages. The illustration "Election Fever" is a dynamic example of this (Figure 89). Following the introductory two pages of newsworthy pictures would be the first of the photo stories, often a development of a news story, extending it by greater photographic coverage.

A story was frequently confined to one page but could be given two or three and sometimes as many as five. Considerable care and attention were given to the photo-story pages, unlike the first news pages. There were often complicated layouts and attempts to make coherently designed statements. The main photo story might be followed by another illustrated article on a contrasting topic, followed by the reading matter—usually a short story, a chapter from a novel, and finally a factual article. Novels were crucial to the magazines, and the *BIZ* paid well to acquire the rights of the novels of Vicki Baum, for example. (The film *Grand Hotel*, many times remade but originally starring Marlene Dietrich, appeared first as a serialized novel, by Vicki Baum, in the *BIZ*. Baum was one of the few who became a staff member.) The desire to read the next chapter of the novel was an important factor in readership continuity.

The written section in the center of the magazine always occupied at least half of the magazine's pages, and the section ended with a joke page, a crossword, and some odds

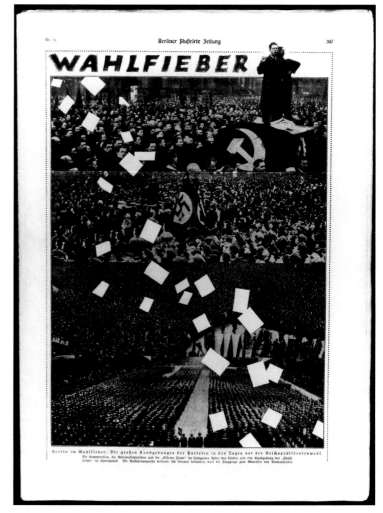

and ends of written material. The back page of the second, smaller visual section was usually devoted to show-biz personalities or visual jokes. Thus, the number of picture stories in any one issue rarely exceeded two or three, and it is doubtful if the management at the time regarded them as of major importance. If they had, they may well have decided to exercise greater control over them instead of allowing them to grow almost naturally under the guidance of innovative picture editors and innovative photographers.

The speed with which technical and conceptual advances happened also has to be considered. Both photographers and picture editors were completely immersed in magazine production: they watched closely what their rivals were doing, and they responded to and were stimulated by them. This is particularly the case with the *BIZ* and the *Münchner Illustrierte Presse*. The rate of change both in content and presentation was much greater than is apparent by looking at selected pages from these magazines. Taking 1927 as the departure point of the new thinking in picture journalism, the progress made by 1937 was far greater than in the whole of the previous history of press photography, and indeed was more rapid than perhaps has ever been seen in any form of photography. To call it "new thinking" might suggest a deliberate preplanning by photographers, but it was, in fact, a process of organic growth from uncoordinated

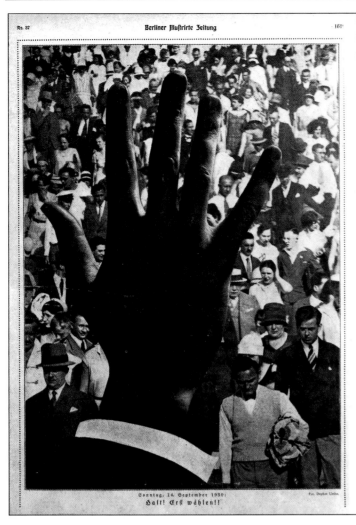

Sonntag, 14. September 1930:
Halt! Erſt wählen!!

Figure 89
Carl Schnebel, "Election Fever."
From *Berliner Illustrirte Zeitung,*
March 20, 1932 (No. 11), p. 307;
rotogravure, photomontage (Coll.
C. Osman)

Figure 90
Umbo, "Vote First." From *Berliner
Illustrirte Zeitung,* September 14,
1930 (No. 37), pp. 1618–1619;
rotogravure, photomontage (New
York Public Library)

picture-making to the creation of coherent and continuous picture stories based in an intellectual and sociological context.

There were essentially two photographic innovations manifested particularly at the *BIZ:* the "slice of life" photograph and the picture story. The "slice of life" photograph, later to be called with increasing irony "candid" photography, depended in part on the technical advances made by camera and film, which enabled pictures to be taken where previously there would not have been enough light for a movement-stopping exposure. It also depended on the subjects' lack of awareness that indoor photography without flash was possible. Erich Salomon caught the amused reaction of statesman Aristide Briand to a camera indoors at night (Figure 91, lower right image).

The great revelation of Erich Salomon's work is that although his photographs do not tell a developing or compelling story, these images are so vivid and real they still move us. By hiding his camera (or at least using it unostentatiously), Salomon discovered that it satisfied a voyeuristic curiosity in his viewers. Though he claimed he was an historian only making records, he saw the camera as a leveler. Everyone was very much the same: diplomatic negotiations were performed by interesting but unremarkable people. The pictures of statesmen are not impressive until we read that these are the people determining the future of the world. This leveling effect is found throughout the *Berliner Illustrirte* in the late 1920s and early 1930s in the photographs of Felix Man, Tim Gidal and his brother George, Kurt Hutton (Hubschmann, then), Wolfgang Weber, Alfred Eisenstaedt, and others. Everyone is an individual: the most common experience and ordinary people (as well as the most exotic) can be interesting and revealing. For Germany in the late 1920s, newly experiencing democracy, the camera became in this way almost symbolic. The radio operator in the photograph is as dignified as a statesman[3] (Figure 95).

The picture story evolved partly from a feature found early in the *BIZ,* the "Down Your Way" or "How Germany Lives" type of story. While this form probably reached its greatest development later in "How America Lives" published in *Ladies' Home Journal* in the 1940s (with photographs by Martin Munkacsi), it began much more modestly in the early 1920s. Sometimes the picture editor would use a handful of pictures given to him by a town council and produce a labored two pages. Later in the 1920s the brothers A. and E. Frankl specialized in visiting towns and cities and produced photographs that were then used by the *BIZ* or any magazine that would accept them. The results were more uniform stylistically than the town council product but the articles lacked any cohesive form; they were just a

79

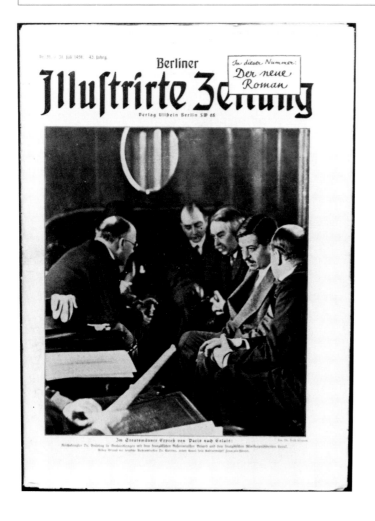

Figures 91–92
Erich Salomon, "Statesmen."
From *Berliner Illustrirte Zeitung*,
July 31, 1931 (No. 31), pp.
1274–1275 *(top)* and cover *(left)*;
rotogravure (Coll. C. Osman)
Included are Andrew Mellon,
Aristide Briand, Dr. Heinrich
Bruning, and Pierre Laval.

Figure 93
Erich Salomon, "Visit of German statesmen to Rome," 1931; gelatin silver print (IMP/GEH)

Figure 94
Erich Salomon, "William Randolph Hearst, San Simeon, California," 1930; gelatin silver print (IMP/GEH)

Figure 95
Ullstein Library Photo, "People of
Our Time, II: The Radio Opera-
tor." From *Berliner Illustrirte
Zeitung,* January 27, 1929 (No. 4),
cover (article commemorates 25
years of wireless telegraphy); roto-
gravure (Coll. C. Osman)

group of pictures. When Martin Munkacsi—later one of the most brilliant photographers of this era—first came to Berlin in 1927, he struggled with this type of story, moving it from an architectural to a humane look at the town, but even he was still an uninvolved observer and relatively unsuccessful in this format.

In the hands of a few men in Germany the picture story developed into something much more compelling and unique. There were many people involved in this evolution, but one of the most interesting catalysts and the one about whom we know the most is the picture agent Simon Guttmann. He was an educated man who had been the associate of Ernst Ludwig Kirchner, Eric Heckel, and other German Expressionist artists before World War I. During the war he was on the fringes of the Swiss Dada movement, and afterward he was involved in the German Communist revolution. By the midtwenties he was managing the Graudenz agency, handling both graphics and photographs. Like most German agencies at the time, it seems to have been short-lived. (The German magazines, fortunately for historians, listed the credits of both agencies and photographers, so their published activities can be roughly traced. But it is to be remembered that we are talking about a one-man agency, or, more exactly, a two-man agency of Graudenz and Guttmann, not with the mighty picture-story empires that were to come later.)

Around 1927 Guttmann became the secretary of the fledgling agency Dephot, an abbreviation for Deutsches Photo Dienst (German Photo Service), which employed a number of pioneers in the use of the newly developed miniature cameras: Umbo (Otto Umbehr), Harald Lechenperg, Walter Bosshard, Hans Baumann, Kurt Hubschmann, and Ignatz Gidalewitsch. The last three were still known by their original names but were later to achieve international fame when they were forced to leave Germany (because of the Nazis) and became respectively Felix Man, Kurt Hutton, and Tim Gidal.

Dephot acquired a reputation for examining difficult subjects, often those of leftist sympathy. Like Guttmann, almost all Dephot photographers would be regarded by the Nazi authorities as Jewish. Since the *BIZ* had Jewish directors, this was no hindrance until the Ullstein family was ousted when Hitler came to power. But an even more fascinating component of the group is the fact that none of them had been born in Berlin but had come there from the other German cities or the German-dominated capitals, Vienna, Munich, Budapest, and Prague. When the power center moved to Berlin, they, like other intellectuals, collected there for the excitement of urban living and the stimulation of fellow expatriates, but particularly for the city's economic opportunities.

It should be mentioned that much has been written about Dephot and its short association with Robert Capa, who arrived from Budapest on the doorstep as a teenager and made his start in professional photography in the darkroom. This brief contact has been romanticized, but it is certainly true that at Dephot he was initiated into the craft of photojournalism. Later this philosophy was to flower in the 1950s when Capa helped to form Magnum, a picture agency like no other—a cooperative of self-governing photographers with a sharp and active social conscience. At Dephot he was clearly shown the sometimes conflicting demands of social conscience and picture-selling.

Simon Guttmann was not motivated by any philosophical need to give birth to a new photojournalism. He simply wanted to sell stories against the competition provided by other agencies, staff photographers, and the cheapness of pictures already used overseas. Pictures, unlike the agency texts, needed no translation and could be passed quickly and cheaply around the world. Guttmann realized that to compete he had to make a unified, coherent presentation and therefore began to plan stories before the first picture was made. What he did was unique: preplanning a story in detail, not only to present the events coherently but to present them with an emotional point of view. He gave his photographers detailed briefings that included not only suggestions or instructions on picture content, but also in-structions about the subject interpretation so detailed that some of the photographers who worked with him argued that he overplanned and did not allow them enough independence to cope with the situation in the field. The two qualities he stressed were artistic unity (which could never have been achieved by a picture editor taking miscellaneous items from his files) and an emotional or intellectual layer, usually stressing the pleasures and concerns of the common man. The photographers worked actively with Guttmann to produce informative captions, and they also worked with a reporter when possible. But the essential information had to be found in the pictures themselves, directed by the captions.

Although Dephot, because of Guttmann, was probably the most innovative of the photographic agencies in Berlin, there were other important ones. Atlantic and Pacific's Berlin office, which became AP (Associated Press), was run by Leon Daniel using the young Alfred Eisenstaedt virtually as its sole photographer; Weltrundschau was run by Rudolph Birnbach using photographs by Neudin (Neudatschin) and those of one or two others; and there were some other agencies such as Keystone whose Berlin office consisted of just one man. With the inevitable bickering going on over either the allocation of assignments or the agent's percentage, many photographers changed agencies quite frequently and many chose to sell directly to magazines.

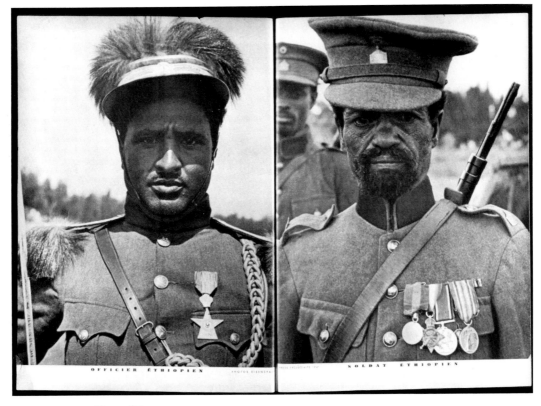

Figure 96
Alfred Eisenstaedt, "Ethiopian soldiers." From *Vu*, October 9, 1935 (No. 395), pp. 1318–1319; rotogravure (Coll. A. Liberman)

Eisenstaedt's work appeared in many European publications outside of Germany, including the French magazine Vu.

Staff photographers were very few: Martin Munkacsi was the only staff photographer on the *BIZ,* and even the great Salomon was a freelancer, although almost all of his work was used by the *BIZ.*

It was a small and stressful world for photographers: generally they were not well paid and existed in a situation where the production of a salable story could mean the difference between eating and not eating. Whatever the ideological or intellectual intentions of photographer or agent, they were controlled by the simple commercial fact that the story had to be bought by an editor. Of all the editors on German magazines, Kurt Korff paid the most for pictures and was therefore usually the first choice of agent and photographer. He was later to go to America to be one of the backroom boys for the founding of *Life.* How far his decisions can be separated from those of his superior, Kurt Safranski, can never now be established, for they worked very closely with each other.

Safranski had great influence even beyond his official position, which, insofar as it was defined, was Managing Director of the Magazine Division, with an overall responsibility for art direction. Safranski had been a skilled book illustrator in his youth and all his life had a deep interest in contemporary art and a willingness to encourage artists and photographers. In each issue of the *BIZ* there was usually a small reproduction of some work of modern art—indeed, art that under the Nazis was to be labeled degenerate.

In the development of the picture story, much, perhaps too much, has been made of the introduction of the Leica camera, but it needs to be viewed in a context of what people were using rather than the equipment that was in theory available. At the time of its invention in 1924, the impact Leica made was perhaps negligible because it did not have interchangeable lenses. Moreover, the very early Leica films did not produce an acceptable negative quality. Even the important development of the interchangeable Leica lens in 1930 can be overestimated, because the camera that was actually setting the pace then was the Contax. The Contax had an immediate advantage because the viewfinder and the coupled rangefinder were in the same eyepiece. Furthermore, the length of the rangefinder base was several times greater than that of the Leica, giving, theoretically, the advantage of more accurate rangefinding.

Many of the great photographers of this period, such as Kurt Hutton, used the Contax camera or Contax lenses on a Leica camera because the Contax lenses from Zeiss were regarded as superior at the large apertures to the Leica lenses. In practical terms, the dominance of the Leica and Contax belonged to the early 1930s, not to the late 1920s. Salomon established his fame with the Ermanox (invented in 1924), the plate camera with a minute plate

($4\frac{1}{2}$cm x 6cm) and a huge f:2 lens that extended the frontiers of available-light photography as no other camera had done before. The Ermanox was mostly used on a tripod, and there are endless stories of the elegantly dressed Salomon setting up his camera on its tripod and then moving discreetly a few yards away to operate the cable release. The secret pictures he was able to take inside courtrooms relied less on the convenience with which the camera could be hidden than on the fact that people were just not on their guard about interior photographs taken without flash but by available light.

Felix Man made his reputation with a Contessa Nettel camera using the relatively large plate size of 9cm x 12cm, again working from a tripod and by available light, but with a smaller lens than in the Ermanox. Kurt Hutton began with a huge studio camera, but in photographing his children he came to realize the virtues of a small-format camera because of its flexibility and because it encouraged ease in his sitters. When Guttmann persuaded Hutton to change from portraiture to photojournalism, the Leica and Contax became his preferred cameras because of their flexibility and also because of the advantages of 35mm film. The very first Leica camera had been developed as a test camera for 35mm cinema film. The unsatisfactory quality of the results in still cameras led to its replacement by special emulsions and a negative format of two-cinema-frame size to achieve acceptable image quality. However, most photojournalists needing consistent film quality preferred the glass plate to cut film in the larger cameras (though for a period Kodak no longer made plates, only sheet film, and Ilford plates were only obtained in Germany with difficulty).

Thus the Leica was not the predominant cause of the development of the new style of picture story. It made spontaneous photography easier. In the early 1920s, Simon Guttmann had briefly imported Soviet silent films and would be familiar with the dynamic montage techniques pioneered by Vsevolod Pudoukin and of S. M. Eisenstein and the "Camera Eye" of Dziga Vertov. Hutton and his wife spent many leisure hours at the cinema; his interest in contemporary German film with its own advanced editing methods may even have been heightened by association with Marlene Dietrich, a rising star whose dresses were made by his mother-in-law and his wife. The film influence was inescapable; some pioneers such as Wolfgang Weber were actually working for the great UFA studios in Berlin. Stefan Lorant had worked with film before becoming a magazine editor. These influences were from silent films. When sound came, the whole theory of image sequencing was abandoned. The sequencing of images was also perhaps influenced by the syndication of comic strips at that time.

The sense of the vividness of life, of the common

Figure 97
Felix Man, "Igor Stravinsky
rehearsing, Berlin," 1929; gelatin
silver print (IMP/GEH)

Figure 98
Felix Man, "Benito Mussolini in his enormous study at the Palazzo Venezia, Rome," 1931; gelatin silver print (IMP/GEH)

Figure 99
Felix Man, "Paul von Hindenburg, President of Weimar Republic, in his study, Berlin," 1931; gelatin silver print (IMP/GEH)

experience of humanity in its diversity, certainly was aided by the small-format camera and 35mm film. With these tools, photographs could as easily be made in a courtroom in The Hague as in a street in Bombay. Dr. Paul Wolff, a great popularizer of the new type of camera (particularly the Leica and the Rolleiflex), constantly extolled its ease and portability in popular textbooks and magazines throughout the 1930s, together with the equally industrious Dr. Walter Kross and Hans Windisch. The style of Wolff's images expresses their closeness to real life; you could easily take your Leica along with you on a vacation.

Travel photography, on vacations nearby or on expeditions to distant lands, also became easier and was much in demand. Having lost its colonies after World War I, Germany became especially fascinated by other lands and peoples. The portability of the miniature camera as well as the film's compactness and lightness made photoreportage of these subjects particularly appropriate. The small camera's unobtrusiveness also encouraged photographers to capture the naturalness of what they saw. This was also true of sports photography, which became very important at the *BIZ*, especially through the work of Lothar Rübelt.

The *BIZ* used stylistic conventions to stress this lifelikeness. Some of the photographs of travel and other subjects seem to burst the borders of the front page or they impose themselves on the print in the title. The cover of the issue

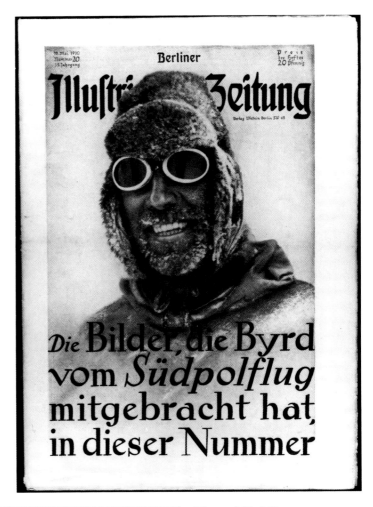

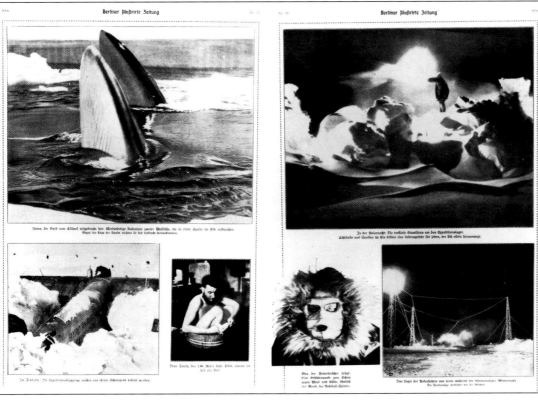

Figures 100–101
Various photographers, including Admiral Byrd, "Pictures . . . from South Pole." From *Berliner Illustrirte Zeitung,* May 18, 1930 (No. 20), cover *(top)* and pp. 858–859 *(left)*; rotogravure (Coll. C. Osman)

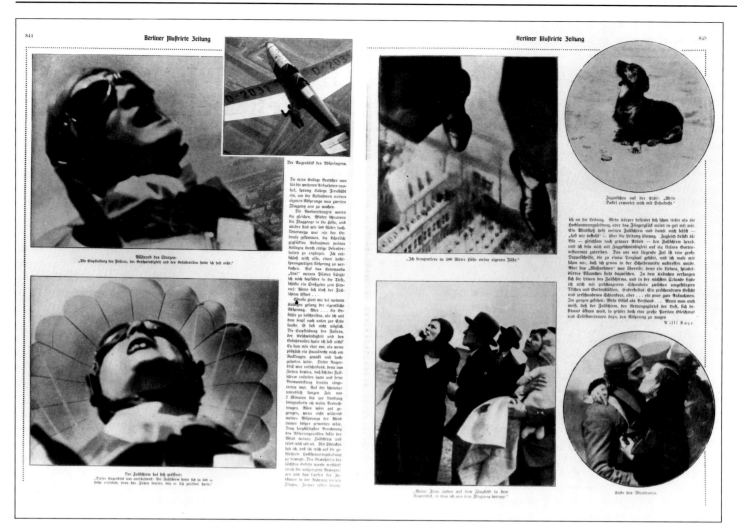

featuring Byrd's Antarctic expedition is dominated by his portrait, obscuring the title (Figure 100). This visual convention had been used in previous decades when the *BIZ*'s covers were drawings, but now it acquired an added impact with photographs. Other photographers made the spectator a more subjective participant by dramatic angles: we turn with the camera and look up at a subject or down from the zeppelin or other aircraft on the activities below (Figure 102).

The great florescence of German magazines coincided with the development in Germany of photography as a legitimate artistic expression, mainly, but not exclusively, at the Bauhaus. In some instances, the magazines reported on the work of the Bauhaus photographers as another facet of visual news, as when Thomas Mann's review of Albert Renger-Patzsch's book *Die Welt ist schön* was published in the *BIZ*. Many of the principles of the new photography—selective focus, views from above or below, extreme close-ups, montage, double exposure, and so on—were first discovered by Russian Constructivists such as Alexander Rodchenko and El Lisitsky in the Soviet Union and by Lázló Moholy-Nagy at the Bauhaus, who taught the new ideas that soon appeared regularly on the pages of special magazines and books. But in popular magazines, such devices were usually used to make the image more vivid, more lifelike, not more aesthetically accomplished. The viewer feels like a member of the audience when looking up at the circus strongman or like a traveler in the zeppelin when looking over the logs in a Soviet harbor. Moholy-Nagy's photographs employing these devices are generally more extreme, more abstract, less interested in the subject than their counterparts in the magazines.

Martin Munkacsi was the real star of the *BIZ*. He had no particular speciality in subject matter but was a curious observer of human beings in all places. In Hungary he began as a sports photographer and thus was perfectly suited to expressing the fleeting movement of vivid and commonly experienced life. His photographs are superior to many of his colleagues' in that they possess a secure sense of design encouraged by the large camera he invariably used. When he traveled, Munkacsi found a touching common denominator in the lives of people of other cultures. The black Liberians are seen as dignified, religious, humane—not as members of an inferior race.

Although as a Hungarian Jew he was not, like the German Jews, at immediate risk from the Nazis, he left Germany in 1934. Shortly before his departure, he was instructed to make photographs of the celebrations of Hitler's accession to the chancellorship. As in much of his best-known work, Munkacsi emphasized the momentary

Figure 102 (opposite)
Willi Ruge, "Parachute jump."
From *Berliner Illustrirte Zeitung*,
May 24, 1931 (No. 21), pp. 844–
845; rotogravure (Coll. C. Osman)
*Ruge, who specialized in images of
aircraft, photographed himself as he
parachuted. His colleague Boettcher
took pictures from the ground.*

Figure 103 (top)
Martin Munkacsi, "Liberia,
church scenes." From *Berliner
Illustrirte Zeitung*, July 13, 1930
(No. 28), pp. 1284–1285; roto-
gravure (Coll. C. Osman)

Figure 104 (bottom)
Martin Munkacsi, "In This Issue:
Four Weeks in a Modern Black
Country." From *Berliner Illustrirte
Zeitung*, June 22, 1930 (No. 25),
cover; rotogravure (Coll. C.
Osman)
*The Liberian pictures were a four-part
series in the magazine appearing
June 22, 1930, July 13, August 30,
and January 31, 1931.*

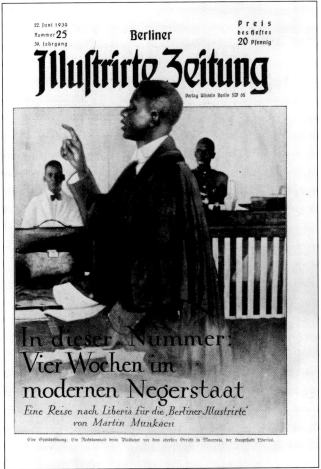

Figure 105
Willi Ruge, "Olympic trainers."
From *Berliner Illuſtrirte Zeitung,*
June 10, 1936 (No. 24), cover;
rotogravure (Ullstein Bilderdienst)

Figure 106 (opposite)
John Heartfield, "Hitler's dove of
peace." From *AIZ,* January 31,
1935, cover; rotogravure, photo-
montage (IMP/GEH)

image, framing his photographs in ways that indicated there
was more beyond what could be seen.

Munkacsi's perception of the peak moment of activity
and his cropping of it to indicate its continuum were crucial
when he came to the United States in 1934 to work as a
fashion photographer. There he developed a style based on
this same quality of vitality and natural activity. His ad-
mirer, the youthful Henri Cartier-Bresson, not only appre-
ciated the controlled design of a Munkacsi photograph but
was later to investigate the peak of activity with his concept
of the "decisive moment."

Despite Hermann Ullstein's retrospective protestations
that too little was done about internal politics, there was
some responsiveness to the crises of the times by the early
1930s: unemployment, France's fear of German rearma-
ment, and other external topics were covered. There were
no sudden changes in the magazines when the Nazis as-
sumed power in 1933. Slowly, however, the layouts became
less adventurous and the photographs more controlled and
less exciting. Although there was little overt propaganda as
found in the official *Illustrierter Beobachter,* the *BIZ* regularly
published pictures of a benign Führer. When James Abbé
photographed the chancellor in 1933 he showed a strangely
avuncular, almost tentative, and wholly undistinguished in-
dividual. Sports personalities had always been important in
the *BIZ,* as seen in the work of Lothar Rübelt. When Artur
Grimm, Rübelt, and others photographed the Olympic
Games three years later, they were dominated by the picto-
rial spectacle of this propaganda event and stressed the har-
moniousness of the mass of people, depersonalizing the
individual in favor of the more powerful group. Sports in
general and therefore sports photography in particular be-
came very important in the Nazi period. Rübelt was a
prominent photographer in the Nazi version of the *BIZ*
depicting the official image, the Nazi ideal of manliness.
Willi Ruge's earlier preoccupation with aircraft was easily
translated into glorification of the air force (Figure 88).

As the official organ of the Nazi Party, the *Illustrierter
Beobachter* displayed the crudest form of propaganda, while
Signal, nominally the foreign-language version of the *BIZ,*
was in fact an independent magazine controlled by the
Wehrmacht, the regular army, and therefore only indirectly
under the propaganda ministry. Although a propaganda
magazine in many languages, it published positive rather
than negative propaganda and was eventually translated into
thirty-five languages. Significantly, there was no anti-Jewish
material but plenty on the superiority of the German way
of life.

From the 1920s, Berlin had been the center of this pub-
lishing activity, but because its picture agencies and maga-
zines were national in their customers, the new ideas

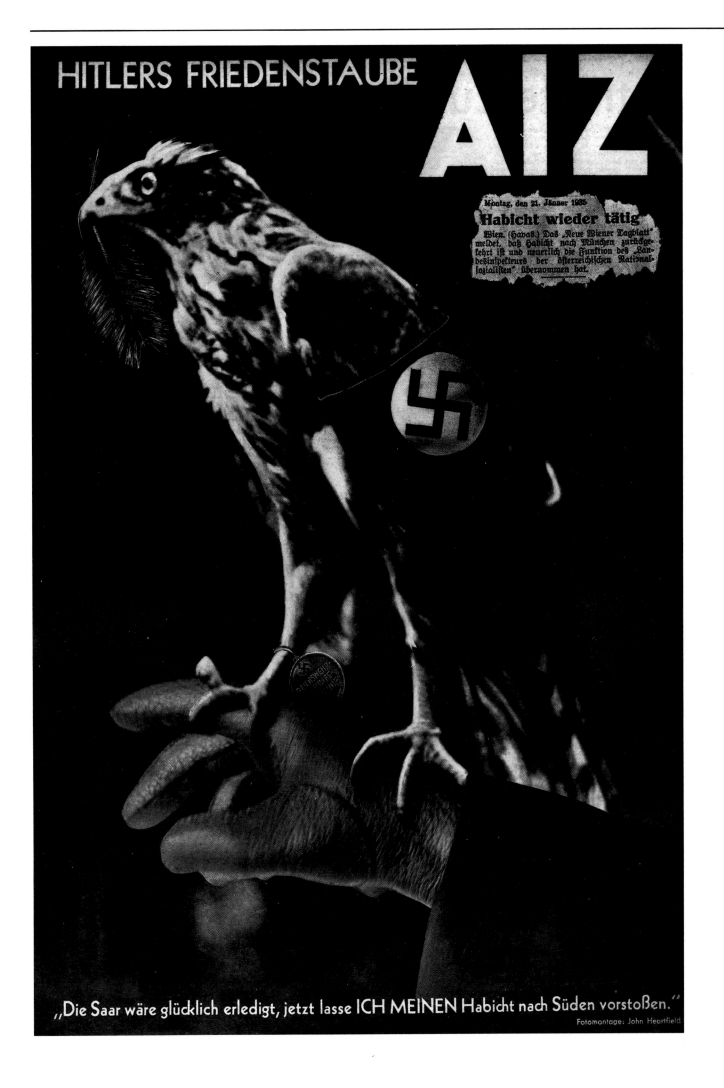

rapidly spread throughout the rest of Germany. For example, the Berlin editor of the *Münchner Illustrierte Presse,* Stefan Lorant, easily became its editor-in-chief while the previous editor, Paul Feinhals, went to the Kölnische Illustrierte. The Munich magazine was not notably dissimilar from its sister publications but became a little livelier and more experimental after 1931, since it did not have the deadening weight of the *BIZ*'s established reputation and circulation. They often shared photographers (except Munkacsi). Lorant also published the work of Felix Man, Tim Gidal, and Kurt Hutton, but he frequently used their more controversial and innovative work rejected by the *BIZ.* He also began to experiment with the comparisons he so brilliantly developed later in Britain in his magazine *Lilliput.* This use of photographs can be seen in the late 1932 issue, where the hard reality of the times is contrasted with aspirations for a better future on the opposite page. Lorant's Munich magazine tended to be more vivid, the message more clearly expressed and more sensitive to social themes. It published Eisenstaedt's reportage of London's Whitechapel slums in a direct, almost confrontational, layout.

Throughout the period from 1919 to 1933, running parallel to the mass-circulation media and profoundly influenced by it, was the noncommercial workers' photography movement. In Germany this was dominated by Willy Münzenberg, who saw from the beginning that Communist magazines needed Communist photographers. The realization fell far short of the conception, for many of the stories in the *AIZ* (*Die Arbeiter Illustrierte Zeitung,* founded in 1921) came from commercial photographers who chose not to do much work for the magazine, not so much on ideological grounds but because they were badly paid. To fill the gap, teams of photographers were trained in a rather naïve fashion by the Communists, particularly through *Der Arbeiter-Fotograf,* a magazine designed to teach workers how to take photographs. Shortage of materials and opportunities inevitably restricted the output, but it necessarily became the first example of community photography. The workers concealed their real names for fear of reprisals and often worked cooperatively because of limited means. The pictures were frequently ideologically sound but uninteresting. What was important was the emphasis by the Arbeiter movement on content, an emphasis that strengthened the rationale of some of the more commercial photographers, who began to see their own stories in a different context. The magazine also experimented adventurously with layout and is most remembered today for publishing John Heartfield's inflammatory photocollages (Figure 106).

But Münzenberg had to leave Germany when Hitler came to power, and in France he was denied a major role because Moscow forbade German Communists to work

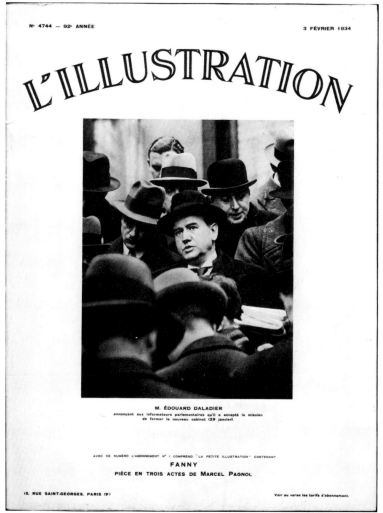

with their French counterparts. Thus the *AIZ* went to Prague, where, without Münzenberg's strong guiding hand, it declined, despite support from the small number of worker-photographer groups in other countries, such as Soziofot in Prague and Budapest.

In France, the world of magazine publication and photography differed greatly from that of Germany. There were fewer magazines, they had little or no relationship to the newspapers, and there was no comparable mass audience. The oldest, *L'Illustration,* a French version of *The Illustrated London News,* was conservative both politically and visually (Figure 107). Its picture editor was the photographer Emanuel Sougez. *Le Crapouillot* was probably closest to the chapbook style of *UHU,* the pocket magazine of pictures, short stories, and essays. During the 1930s there were some rather sensationalist magazines, notable among them *Voilà* (Figure 108), edited by Florent Fels, who founded it after the collapse of *L'Art vivant,* his art publication. *Voilà*'s layout was often lively, and the covers were inventive and humorous collages and resembled those of another, similar, publication called *Le Document.* There were some politically conscious magazines: one was *Marianne,* which often served as the forum for the collages of "Marius," and *Regards,* the Communist weekly founded in 1932. This printed John Heartfield's trenchant anti-Fascist collages,

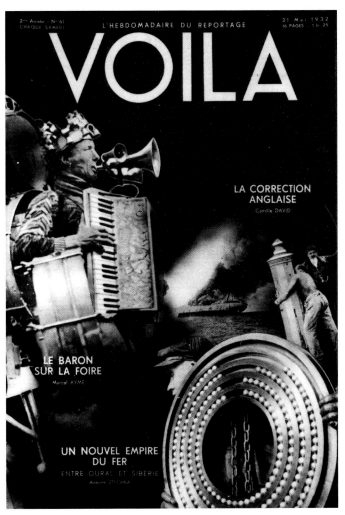

Figure 107
Unidentified photographer, "Mr. Daladier announcing to parliamentary newsmen that he has accepted the task of forming a new cabinet." From *L'Illustration,* February 3, 1934, cover; rotogravure (Coll. S. S. Phillips)

Figure 108
Unidentified photographers, [Photomontage with one-man band and various images]. From *Voilà,* May 21, 1932 (No. 61), cover; rotogravure (Coll. D. Travis)

which also appeared in its sister publication, the German *AIZ,* but *Regards* became known chiefly for the journalism of Robert Capa, Chim, and Henri Cartier-Bresson in the mid to late 1930s. It was edited by Paul Vaillant-Couturier, son-in-law of Lucien Vogel, the founder of *Vu.*

Another typical French magazine, probably intended for the tourist trade—since the captions were often written in foreign languages, chiefly English—was the "girlie" magazine. *Paris Magazine* and *Scandale* often published Brassaï and occasionally others, Erwin Blumenfeld and André Kertész, for instance.

But *Vu* was the most innovative and adventurous mass-circulation magazine in France. It was tiny compared to the *BIZ*: at its peak it reached a circulation of 300,000, compared to 2 million of the Berlin paper. It also differed by being under the direct personal control of Lucien Vogel, its founder. It was not part of a giant, family owned corporation. Carlo Rim, a friend and editor for Vogel, described him in this way:

> Splendidly unfashionable, nevertheless he is one of the most picturesque of magazine directors: he is an aesthete, but one of that rarest kind, a worker-aesthete, passionate, adventurous, who always fills his magazine with enthusiasm, risking everything and losing all except his honor. A sentimental *litterateur* like his father, Hermann Vogel, who, with Steinlen and Ibels was one of the glories of *L'Assiette au beurre,* Lucien Vogel, friend of Paul Poiret and Stresemann, of Coco Chanel and Maiakowsky, the creator in 1913 of the famous *Gazette du bon ton,* then founder of *Vogue* with Condé Nast, now the director of *Vu,* has launched himself into the fearful enterprise of conquering a resolutely conformist public, encrusted in ancient habit.[4]

Literally meaning "the butter dish," but more properly translated as "graft," *L'Assiette au beurre* was one of the greatest satirical magazines of the late nineteenth and early twentieth century. It had a strong socialist-anarchist position, and its guiding spirit was the editor, Gus Bofa. Every week the magazine dedicated its pages to one artist and to one theme: laundresses, the terrors of the new Metro, venereal disease, corrupt judges, the *clochards* or vagabonds. The unique features of *L'Assiette au beurre* included not only its strong political bias, but its completely pictorial content: there was no text except for the often witheringly pointed captions. Bofa was an ardent supporter of the common man against venality, corruption, and all the other evils of society, and he employed some fine artists to make these drawings; Juan Gris, Emile Bernard, Kees van Dongen are among those who worked for him. Clearly Hermann Vogel's son acquired both his political orientation and his

understanding of the importance of pictures in great part from this magazine.

Vogel also had close ties with another type of publication. The American publisher of *Vogue,* Condé Nast, had copublished a French-American magazine before World War I called the *Gazette du bon ton* because he wanted to use some of its highly decorative, modernist illustrators for *Vogue.* Lucien Vogel's *Gazette du bon ton* was a luxurious periodical, a review of contemporary arts and manners, splendidly illustrated and addressed to the cultivated aristocrat. After the war and the demise of *Bon ton,* Vogel and his wife, Cosette, edited *L'Illustration des modes,* a fashion supplement to *L'Illustration,* which became *Jardin des modes,* and again Nast had a controlling interest. When French *Vogue* began in 1920, Cosette Vogel was its editor, and later her brother, Michel de Brunhoff, assumed that position. French *Vogue* was never profitable, but it employed photographers such as Man Ray, Brassaï, as well as its staff photographers (such as Horst and Hoyningen-Huene); and artists such as Bébé Bérard, Pavel Tchilicheff, and Salvador Dali drew covers or fashion illustrations. It tended to be a relatively experimental counterpart of its American cousin and its direct link to Paris society and fashion.

Tired of fashion and keenly interested in politics, Vogel created *Vu* in 1928.[5] He wanted a magazine with a liberal bias that would appeal to the common man. He retained

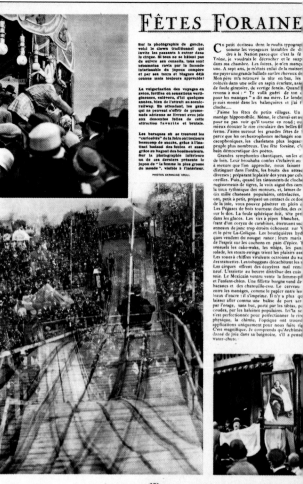

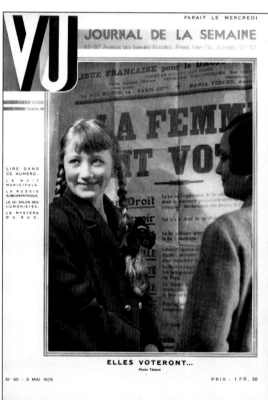

Figure 109
Maurice Tabard, "They will vote." From *Vu,* May 8, 1929 (No. 60), cover; rotogravure (Coll. S. S. Phillips)

the diversity of subjects from the German models, as well as the reliance on a core of serialized fiction. Like them also, *Vu* opened with news pages and closed with jokes and puzzles. At the same time, Vogel's training in fashion and interest in contemporary art did not desert him. *Vu,* from the beginning, was a very beautiful and eminently visual magazine. It was carefully printed in sepia neogravure and quite early published handsome covers using often brilliant, posterlike color. Cassandre, the most important commercial artist in France, designed the logo. Vogel employed first Irène Lidova and later Alexander Liberman (trained by Cassandre) as art editors. In this way he improved on the appearance of the German formula.

In *Vu,* photography was explored for its decorative aspects, its reportorial potential, its documentary and snapshot styles. It was definitely a picture magazine, as Vogel declared in the first issue, March 21, 1928:

> There doesn't exist a picture magazine which transmits the vital rhythm of everyday life: political events, scientific discoveries, disasters, exploration, sports, theatre, film, art and fashion. *Vu* is determined to fill this need.

The early reportages tended to be playful and casual and the layout similarly gentle (Figure 110). Vogel was a photographer himself, and he sometimes published his own work as well as that of his nonprofessional friends. He was aware of the seriousness attached to photography at the time and considered it a valid new art form. Many images published in *Vu* were also presented in galleries or published elsewhere as works of art. After the first year its editors reckoned up the number of photographs that had appeared: 3,324. No other magazine of that time even came close to publishing this quantity of photographs.

Vu reflected the changing taste of its owner. Whereas the other magazines were shaped by the personalities of their photographers, in this case Vogel's personality shaped and determined his magazine. The early photographers were James Abbé, Germaine Krull, and André Kertész. Most of them were not French, which suited their stance of curious, sympathetic observers of—in this case mainly French—civilization. Complementing the images were texts from some of

Figure 110
Germaine Krull, "Fairs." From *Vu,* April 11, 1928 (No. 4), pp. 92–93; neogravure (Coll. S. S. Phillips)

Figure 111
Henri Cartier-Bresson, "Spain speaks: 'On the threshold of the future.'" From *Vu,* November 29, 1933 (No. 298), pp. 1774–1775; neogravure (Coll. S. S. Phillips)

Figure 112
Alexander Liberman (Alexandre),
collage, and François Kollar, pho-
tography, "Hitler arms, a threat in
the sky." From *Vu,* May 24, 1934
(No. 323), cover; neogravure
(Coll. C. Osman)

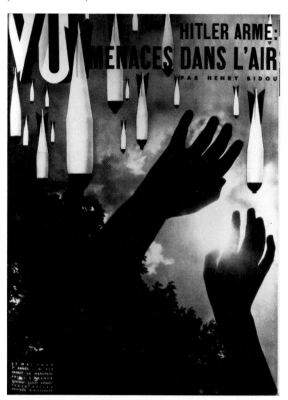

96

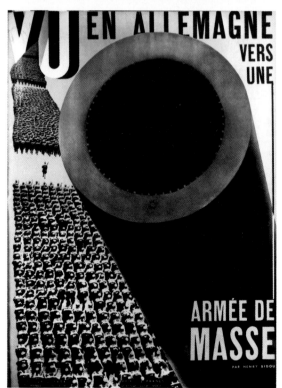

Figure 113
Alexander Liberman (Alexandre),
"In Germany, toward a mass
army." From *Vu,* April 25, 1934
(No. 319), cover; neogravure
(Coll. C. Osman)

the best writers available: Colette, Philippe Soupault, Pierre
Mac Orlan. But the magazine was certainly not all aes-
thetic. There were the necessary images of catastrophes and
endless weekly world events. In the beginning the layout
was unostentatious, and the photographs were used decora-
tively, evocatively, even humorously to supplement the
text—for Vogel also saw his magazine as essentially enter-
tainment in the early years.

But by the mid-1930s there was a change of style and
general content. Undoubtedly the crises of the period, the
many economic, social, and political problems, brought
forth this change. One of the younger photographers to
emerge was Robert Capa, whose coverage of the Spanish
Civil War was definitely partisan. Vogel supported both the
photographs and the sentiment behind them. Ardently left-
ist, Vogel tried to use his magazine as an instrument to
arouse the public to action in keeping with his sympathies.

This was in great part the result of Alexander Liberman's
innovative ideas about layout. Today still at the helm of the
Condé Nast enterprise, and an actively exhibiting artist in
his own right, by 1933 he had become a powerful personal-
ity at *Vu,* and his graphic energy both changed and greatly
enhanced the magazine. At this time, Liberman designed
under the name of "Alexandre." He had been born in Rus-
sia, but his parents sent him to boarding school in England
when the political situation surrounding the Revolution be-
came dangerous. He therefore had scant firsthand knowl-
edge of the avant-garde art of his native country, but he was
certainly familiar with constructivism. Through his mother,
who was active in the theater, he was made familiar with
contemporary art in France and vividly remembers visiting
Léger's studio with her and seeing a collage that incorpo-
rated photographs. From his interest in art, his work as a
graphic artist, and his love for film (he reviewed the cinema
for *Vu*), Liberman was aware of collage and became fasci-
nated with incorporating photographs into a dynamic de-
sign format. As he has said recently:

> The idea of photomontage was around, and I suppose
> my interest was aroused by the Soviet posters and pavil-
> lion at the 1925 exposition. There were articles on
> photomontage, and just as important, there was a dark-
> room right next to my office where prints were made.
> Since there were no photostats in those days, every pic-
> ture had to be projected on the layout to get the right
> size. The idea of photomontage could have come very
> easily. When you projected a negative or a positive over
> another picture, you got ideas, and it was the only way I
> thought of illustrating articles or covers. I was always
> interested in meaning, and maybe a certain poetic qual-
> ity that came ahead of design.[6]

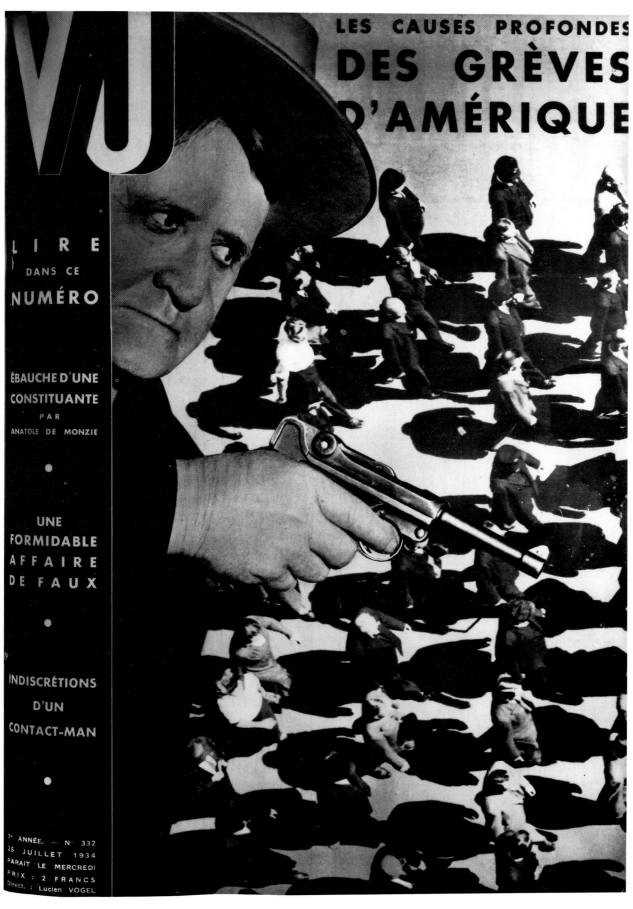

Figure 114
Unidentified photographer, "The
underlying causes of strikes in
America." From *Vu,* July 25, 1934
(No. 332), cover; rotogravure
(Coll. C. Osman)

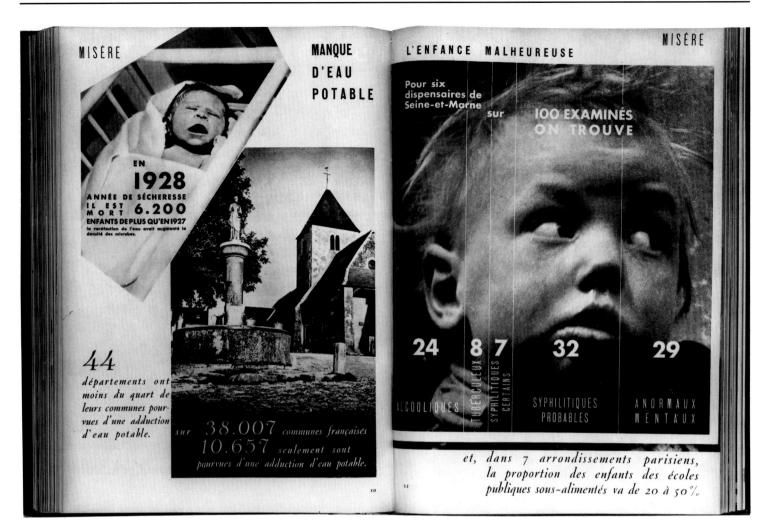

Figure 115 (above)
Alexander Liberman (Alexandre),
"'Misery in abundance': shortage
of drinking water, malnourished in
infancy." From *Vu,* May 30, 1936
(special no.); neogravure (Coll. A.
Liberman)

Figure 116 (opposite)
Alexander Liberman (Alexandre),
"'Misery in abundance': first
misery." From *Vu,* May 30, 1936
(special no.); rotogravure (Coll. A.
Liberman)

Because of the changed political situation, the photographers' work changed. Isaac Kitrosser, who had made charming pictures of the common people on picnics or enjoying an outing on a ferry boat, now covered the activities of French Socialist politician Léon Blum and the strikes in Lille. André Kertész no longer photographed children in the park but—rather surprisingly—documented the problems of inflation. Brassaï recorded from his window the death of a street bum (Figure 117).

Liberman was not interested in photographs as art, or in the evocative use of photography found in the earlier years of the magazine. Thus, photographs became increasingly used as documents in *Vu,* integrated as a component part of layout and typography, and as such they needed to be as sharp and as unequivocal as possible (Figures 115–116). Toward the end of Vogel's ownership of *Vu,* words and images were locked together to make as clear a point as possible. Shortly afterward in 1936, because of political pressure, Vogel sold his magazine. The intensity evaporated. *Vu* became a dull, glossy journal before it expired when the Germans entered Paris.

Although the tide of German technical photography and apparatus continued unabated throughout the 1930s, the talent of the prototype picture editors and photographers was scattered worldwide, mainly because of Hitler's acces-

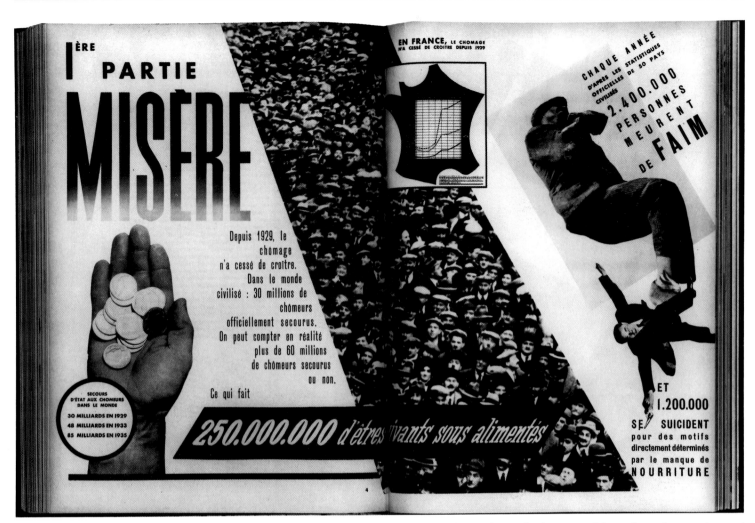

sion to power. In 1933 Felix Man and Kurt Hutton came to Britain and teamed up again with Stefan Lorant in 1934 to form first of all *Weekly Illustrated* and then in 1938 *Picture Post,* working together until Lorant left for America in 1940. Tim Gidal first went to Palestine, then came to London to work for *Picture Post,* and finally went to work in America as a book photographer but also for *Life* magazine. Although *Vu* was an important predecessor to *Life,* as Henry Luce acknowledged, another antecedent was *Weekly Illustrated,* the first modern picture magazine in English, but with its German origin evident in the layout. It was begun without much enthusiasm by the giant Odhams Press and was sustained when Lorant left by the young Tom Hopkinson. When relaunched in 1939 as *Illustrated,* it was to improve greatly with management support. Lorant had left after the first few months and in 1937 was to found another magazine, *Lilliput,* also based on German models.

Lorant was a gifted, impulsive editor with an incredible memory for images. At a time when most of the British press was applauding the policy of Nazi appeasement by the British government led by Neville Chamberlain, Lorant showed his opposition by finding a scrawny-necked image of Chamberlain and juxtaposing it with a striking image of an ostrich. In *Lilliput* Lorant perfected these double-page comparison pictures, but the magazines also featured good

short stories and good photographic series of portraits and landscapes as well.

Lorant's vision reached its maturity in *Picture Post* in 1938, where good printing, good photography, and good writing combined to produce a well-designed popular magazine with a firm political point of view (Figure 120). Lorant continued his anti-appeasement policy and *Picture Post* stridently demanded resistance to fascism. Tom Hopkinson rejoined Lorant and provided a deeply felt political conviction, which complemented Lorant's visually flamboyant approach. The two together succeeded where other magazines had failed in producing a weekly with both a clear political and social identity and popular support.

War in Europe officially began on September 3, 1939, but there was a period of negligible fighting, the "phoney war," until the signing of the Nazi-Soviet pact allowed German troops to overrun Europe. Britain stood alone in 1940, and its picture magazines *Picture Post* and *Illustrated* stood patriotically side by side. With the British defeat on continental Europe, their founder, Stefan Lorant, decided to leave for America. *I Was Hitler's Prisoner* was the autobiographical account of his arrest in 1934 in Munich, and he had no wish to become Hitler's prisoner again in 1940. With the evacuation of Dunkirk, Germany held all of continental Europe. While the Battle of Britain was fought in

If *Picture Post* was the brainchild of one man, Stefan Lorant, eminently gifted at picture selection, then *Life* was the product of a three-year-long committee of which Luce was the chairman. *Life* was to influence every picture magazine that followed except perhaps *Picture Post* and *Look*, which appeared almost simultaneously with *Life*. *Look* was a unique American adventure that employed mostly agency pictures. Originally there were no advertisements. It was the product of the Cowles brothers, who in 1925 had discovered (from a poll conducted by George Gallup) that the readers of the *Des Moines Register and Tribune* had great interest in photographs but even greater interest in grouped or sequenced pictures. Although Lorant founded *Picture Post* after *Life,* he was almost certainly uninfluenced by it. He had his own personal vision of a magazine, could not have worked with a committee, and needed no Gallup poll to feel the pulse of the public.

Lorant left journalism to produce picture books, first a biography of Abraham Lincoln and later a study of the steel town of Pittsburgh. Gidal produced books for younger readers featuring in each one a child's life in a different land. In one sense both Gidal and Lorant were moving to other aspects of picture journalism.

It is clear, therefore, that the emergence of pictorial journalism into the American consciousness—an emergence that reached fruition with *Life* magazine in the 1950s—had important and distinctive precedents in Germany, France, and England. German magazines tended to be Populist and news-directed and often used gritty, compelling photographs. In France, the strong visual tradition of illustrated magazines fostered the aesthetic use of photography, and French photojournalism tended to be more decorative, more attractively presented than its German counterpart. Spurred initially by the influx of German refugees, the British also developed important photojournalist magazines unique in being committed to political and social ideals. American magazines, especially *Life,* built on these examples to create a powerful new photojournalism of their own. ⊙

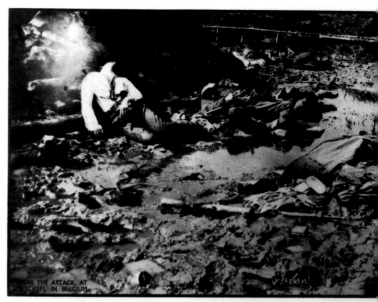

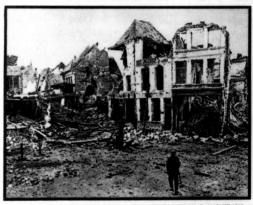

Figure 119
Tim Gidal, "A ballet dancer of tomorrow." From *Picture Post,* July 8, 1939, cover; rotogravure (Coll. C. Osman)
Gidal was asked to return to London from what was then Palestine by Stefan Lorant, the editor of the new Picture Post.

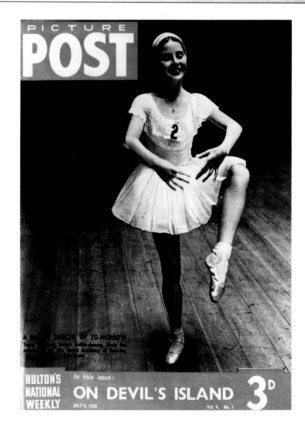

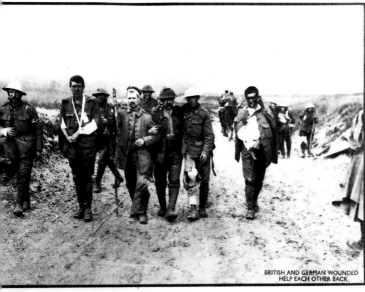

BRITISH AND GERMAN WOUNDED
HELP EACH OTHER BACK

OU FORGET THIS?

EN WHO WERE NOT REMEMBERED

people of a country decide to hand over
es to a single man, they do something
much simplifies their problems. All they
rom that time on is to close their eyes and
ad he leads them. But when the road runs
wnhill, it is time for those people to open
d to look up—while there is still time . . .
till time.

A LINE OF MEN BLINDED BY TEAR GAS AT A DRESSING STATION NEAR BETHUNE

PICTURE POST 13

Figure 120
Unidentified photographer—
Stefan Lorant, layout, "Hitler,
how can you forget this?" From
Picture Post, October 8, 1938, pp.
12–13; rotogravure (Coll. C.
Osman)

Figure 121
Kurt Hutton, "Planning the
march." From *Picture Post,* August
5, 1939, cover; rotogravure (Coll.
P. Hutton)
*Article by Winston Churchill was on
World War I, which had started
exactly 25 years earlier.*

Figure 122
Felix Man, "One of the king's
Indian orderly officers tries on his
full-dress uniform." From *Picture
Post,* May 13, 1939, cover; roto-
gravure (Coll. L. Man)

PLANNING THE MARCH
Boy Scouts on their way to Camp
See inside

HULTONS NATIONAL WEEKLY In this issue: HOW THE WAR BEGAN 3D
by Winston Churchill

ONE OF THE KING'S INDIAN ORDERLY OFFICERS
TRIES ON HIS FULL-DRESS UNIFORM
(See inside: pages 33 to 36)

HULTONS NATIONAL WEEKLY In this issue: WOMEN IN TRAINING 3D

BEARING WITNESS

The 1930s to the 1950s

by Marianne Fulton

PHOTOJOURNALISM IS INTERTWINED with the major events of the twentieth century. Indeed, the public's judgments about historical and contemporary incidents are often based on the photographs available to show them. It is a powerful medium, capable of focusing attention on the significant issues of our time; its descriptive ability is no less than that of words. As critic A. D. Coleman wrote, "We are becoming visually sophisticated enough as a culture to realize that photography is not a transcriptive process but a descriptive one."[1] Despite the increasing awareness that depiction does not embody truth itself, photography remains a principal medium for our understanding of the world. This trust and expectation give special significance to a two-dimensional medium, which in reality can only record the outward appearance of things. That it succeeds in seeming to go beyond the surface is a testament to our acceptance of its verisimilitude and the

Figure 123
Margaret Bourke-White, "At the time of the Louisville Flood," 1937; gelatin silver print (IMP/ GEH)

106

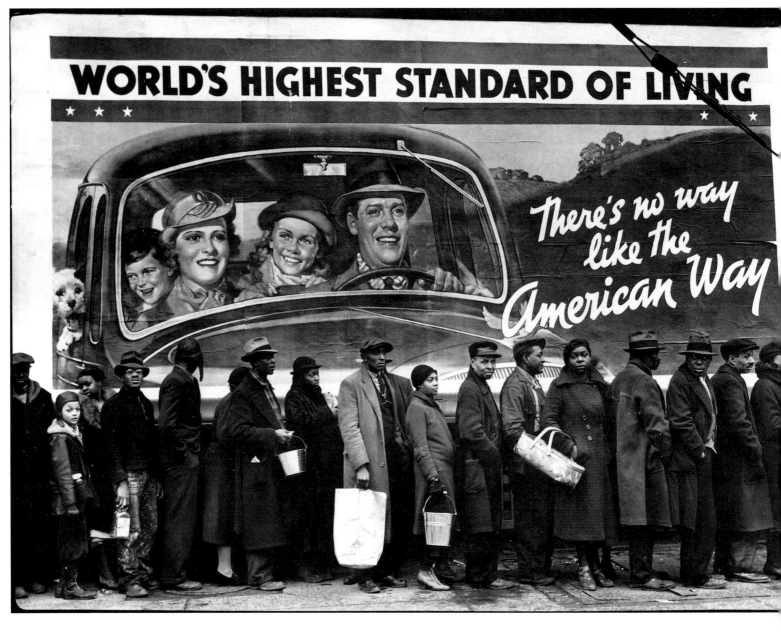

individual insight of the photographer. As a consequence, just as the Civil War became a shockingly real encounter through the work of Mathew Brady's studio, so photojournalism still provides important access to both feeling and facts.

Photojournalists, in the photographic tradition of Brady, are more than spectators in an historical grandstand. Being there is important, being an eyewitness is significant, but the crux of the matter is *bearing witness*. To bear witness is to make known, to confirm, to give testimony to others. The distribution and publication of the pictures make visible the unseen, the unknown, and the forgotten.

We've seen how in Europe the coming of the smaller camera influenced photographers' style and manner of working, and this in turn had an impact on picture editors' approach to magazine layout. At the same time, the rise of Hitler forced many of the prominent photojournalists to relocate, sending them to France, England, and subsequently the United States. The migration would have a profound effect on photojournalism. The European 35mm, candid style soon challenged the traditional large-format work of American newspapers.

In the United States newly developed printing methods allowed for large, high-quality magazines based on European models. Especially important in the days before television, the magazines, such as *Life* and *Look,* became a sort of national newspaper showing labor strife, political figures, and world conflicts. In the 1930s, as in other eras, technology, the picture-making it facilitated, and the worldwide political situation combined to shape our ideas of photojournalism and the world it pictured. One writer was moved to say, "All hell broke loose in the '30's and photography has never been the same since."[2] While referring to changes in camera design and specifically to the Leica, the quote aptly encapsulates the flux of events.

The urgency of World War II and the Korean war demanded constant coverage by newspapers, magazines, and news agencies, which strained their resources and spurred technological advances to meet their needs. Great photographers using more flexible equipment produced a moving war photo journal of the events that changed the map of Europe and Asia.

Because photojournalism is of the moment, it presents a sense of continual present, which in turn conditions our expectations of the medium and thereby defines the course of technological experimentation. For example, in the 1930s anticipation that photographs and stories could be published together resulted in the achievement of commercially transmitting photographs over telephone lines or radio waves, bringing the world into everyone's home.

Testimony to the humiliation of an American minority: reacting to the Japanese attack on Pearl Harbor, the U.S. government interned in armed camps thousands of Japanese-American citizens, feared to be potential traitors solely on the basis of their ancestry (Figures 124–126).

Figure 124 (top)
Dorothea Lange, "San Francisco, California," 1942; gelatin silver print (National Archives)

Figure 125 (bottom)
Seattle Post-Intelligencer staff photographer, "Soldier posting Civilian Exclusion Order No. 1 together with instructions for evacuation procedures, Bainbridge Island, March 23, 1942"; gelatin silver print (Courtesy *Seattle Post-Intelligencer*)

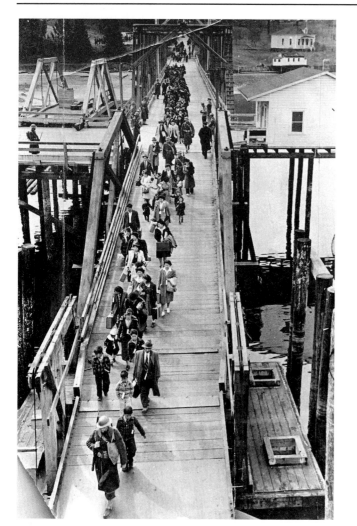

Figure 126
Seattle Post-Intelligencer staff
photographer, "Bainbridge Japa-
nese leave home, Bainbridge
Island, Wash., Evacuation Day,
March 30, 1942"; gelatin silver
print (Courtesy *Seattle Post-
Intelligencer*)

The Beginning of Wirephoto

The transmission of a photograph by The Associated Press
over telephone wires to its twenty-four-member network
on January 1, 1935, marked not only the opening of AP
Wirephoto, a significant step in the history of The Associ-
ated Press, but a dramatic advance in photojournalism.

Conceived as a news-sharing cooperative, The Associ-
ated Press was formed in May 1848 by six New York
newspapers—the *Herald*, the *Courier and Enquirer*, the *Jour-
nal of Commerce*, the *Tribune*, the *Sun*, and the *Express*—for
their mutual benefit.[3] Technology played an important role
in this decision: the development of the electromagnetic
telegraph and the Morse code in the 1830s and 1840s
meant the potential for rapid, long-distance news distribu-
tion for those who had access to the lines. However, in all
of the New York City vicinity, there was but one available
telegraph line. By establishing a cooperative, the news-
papers maximized their limited access to this valuable line,
defrayed the expense for its use, and soon shared the reve-
nue from selling information to smaller, nonmember
papers.

Into the 1920s the AP dealt solely with word journal-
ism, but before the decade was out, new General Manager
Kent Cooper changed all that. Cooper looked ahead: antici-
pating further advances in the infant business of image
transmission, he realized that for AP (then with 1,200
members) to remain a leader in the field of journalism, it
would have to provide members with a picture service. His
vision would not be accepted without controversy. Cooper
was aware of that: The Associated Press prided itself on its
reputation as a dependable and trustworthy source of word
journalism, but the use of photographs was often associated
with "yellow journalism." The very idea that breaking news
could be published in tandem with photographs taken at
the scene was revolutionary, although others had struggled
to make it a reality.

At the turn of the century, William Randolph Hearst
grabbed the public's attention by hiring boats and trains to
speed back from scheduled or ongoing events (his efforts
being not so much for high-quality news but for higher
circulation through novelty—a true case of the exception
proving the rule). For example, in 1897 he had a special
train bring back photographs of the Corbett-Fitzsimmons
fight from Carson City to San Francisco. A year later he
equipped an oceangoing tug to carry photographers to
Cuba to photograph battles of the Spanish-American War
and then quickly dash home to New York City with nega-
tives developed and printed in transit.[4] Although clearly im-
practical, it did surprise Hearst's readers.

This kind of precedent didn't really enhance Kent

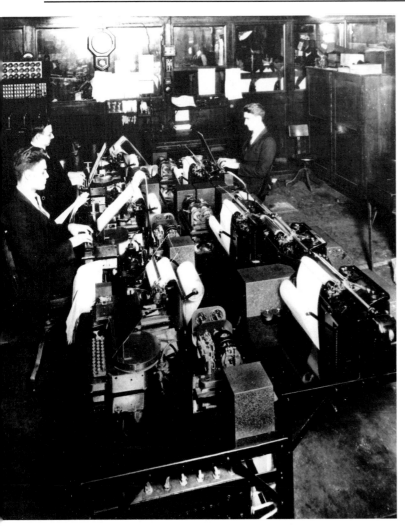

Figure 127
Unidentified photographer,
"Picture taken at 383 Madison
Ave., when AP first installed a
new model of Teletype," 1923;
gelatin silver print (AP)

Cooper's argument at The Associated Press: gimmicks used in what were considered "yellow" or sensationalist papers could hardly be expected to appeal to a board that included conservative newspapermen such as Adolph Ochs of the *New York Times*. Yet Cooper argued his case during board meetings of 1927: "I do not believe The Associated Press can be utterly oblivious to the trends that are making newspapers more appreciated by more people than ever before. Yet The Associated Press still will not do a great many things that some newspapers do and that many newspapers want it to do. It has kept to the standards."[5] He further warned the board to consider "what could happen to The Associated Press if competitive press associations were first to take the step of co-ordinating delivery of news in pictures with delivery of news in words."[6]

Cooper won the board over, and the AP News Photo Service began in 1927, making AP the pioneer in the field.

The handicaps of mailing packages of news photographs across the country presented by AP's pioneering News Photo Service were severe. For example, even by fast train, photographs took eighty-five hours cross-country and air express could take twenty-four hours, depending on the weather. Once AP became committed to providing pictures, these delayed delivery times became increasingly annoying. The early photo service thus made AP receptive to the transmission of photos by wire, the ultimate fulfillment of Kent Cooper's agenda.

Speed has always been a key consideration in any development in journalism. After the introduction of the telegraph and its successive improvements in transmitting words, experimentation began in the transmission of images. In a 1919 text on the possibilities of wireless transmission of photographs, the English author wrote hopefully: "In these progressive times it is only reasonable to expect that some attempt would be made to utilize the etherwaves for other purposes than that of telegraphic communication, and already many clever minds are at work trying to solve the problems of the wireless control of torpedoes and airships, wireless telephony, and, last but not least, the wireless transmission of photographs."[7] The author went on to marvel at the experiments being done in Germany by Prof. Alfred Korn, who had transmitted photographs between Paris and Berlin, and to predict that someday photographs would be received as easily as words.

Scientific American printed a photographic reproduction of the German Crown Prince in 1907 and announced in an article entitled "Korn's Photographic Fac-Simile Telegraph" that Prof. Alfred Korn of the University of Munich had transmitted the photograph over a telegraph wire (Figure 128). Even the photographic press normally devoted to pictorialism and photo club news recognized the significance of the event. The editors of *Photo-Era* immediately recognized its revolutionary impact:

> A Professor at Munich, the capital of Bavaria, has recently discovered a new method for transmitting pictures by electricity. The process is a distinct advance on all previous inventions in this line, and bids fair to revolutionize the science of Journalism. . . . [The process] is able to reproduce light and shade whilst the older processes could only reproduce black lines on a white ground. In other words, the new process is just as much an advance as is the modern half-tone block compared with the old line wood-engravings.[8]

Korn's transmitter was based on a cylinder around which a 5 x 7–inch transparency was wrapped (Figure 129). A point of light was projected onto the cylinder and passed

SCIENTIFIC AMERICAN

[Entered at the Post Office of New York, N. Y., as Second Class Matter. Copyright, 1907, by Munn & Co.]

Vol. XCVI. No. 7
ESTABLISHED 1845.

NEW YORK, FEBRUARY 16, 1907.

10 CENTS A COPY
$3.00 A YEAR.

From L'Illustration.

A Photograph of the German Crown Prince Electrically Transmitted to a Distance of Nearly 1,100 Miles. The Small Picture, from Which the Enlargement Was Made, is the Actual Result Obtained With the New Method.

KORN'S PHOTOGRAPHIC FAC-SIMILE TELEGRAPHY.—[See page 148.]

through the film, striking a selenium photocell, which converted it into electrical current. As *Scientific American* expressed it, the "possibility of this remarkable electrical mechanical feat is due to a peculiar property of the metal selenium which can translate variations of light into concomitant variations of an electric current."[9] The entire film was "read" in this manner; the procedure took 7½ minutes. The receiving set also had a cylinder, which was, however, wrapped with unexposed film. Korn's apparatus would remain the basic principle of design into the 1980s, when electronics began to take precedence over the original optical-chemical processes.

Experimentation with relaying photographs by telegraph wire and radio wave was curtailed during World War I, but after 1919 work began anew and networks were initiated in

Figure 128 (opposite)
Unidentified photographer, "A Photograph of the German Crown Prince." From *Scientific American*, February 16, 1907, cover; halftone (IMP/GEH)

Figure 129
Unidentified artist, "Diagram showing the working of Prof. Korn's latest apparatus for transmitting photographic images. A Photographic Fac-Simile Telegraph." From *Scientific American*, February 16, 1907, p. 148 (detail); halftone (IMP/GEH)

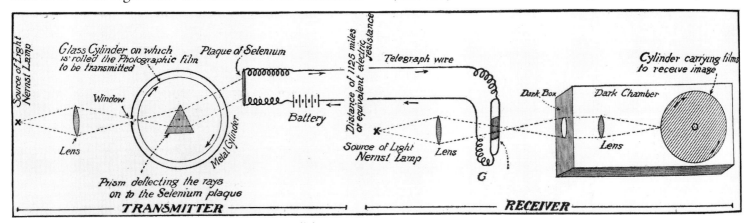

111

several countries. Among the earliest was an English system known as Bartlane, the name derived from those of its founders, Robert McFarlane, an English research engineer, and Harry Guy Bartholomew, head of the art department and later a director of the London *Daily Mirror*. In 1920 McFarlane and Bartholomew began working to put photograph transmission for the newspaper on a commercial basis. Unlike other methods in which an image was read by a beam of light and then transmitted over telephone lines, the Bartlane system utilized a punched tape looking much like a ticker tape. This tape was punched to correspond to the different shades in the picture being transmitted. That is, the photograph was translated into a variation of five-hole punches onto telegraphic tape, relayed, and reconstructed by reading the received telegraphic tape. The Bartlane system was transatlantic. It was also short-lived, being discontinued with the beginning of World War II (Figure 130).

Of more lasting importance was the Siemens-Karolus-Telefunken system of Siemens and Halske A.G., which was functioning between the German General Post Office in Berlin and the Austrian Post Office in Vienna in the mid-1920s. Another line ran between Berlin and Cologne. The sophisticated arrangement called for facsimile transmission of pictures and telephone traffic to travel the same lines.

Figure 130
Unidentified photographer, "A call to Il Duce, Fort Adigrat, Ethiopia," 1935; gelatin silver print from Bartlane transmission (AP)

The apparatus found swift success. Two installations were opened in Japan in November 1928 in time for the coronation of the emperor of Japan. This first Japanese installation was by the Nippon-Dempo Press Bureau, and transmission was made through overhead lines.

An English installation of the Siemens' equipment between London and Manchester was also set up in 1928. By December of that year transmitters were working in Glasgow and Newcastle, which could in turn transmit pictures simultaneously to Manchester, London, Paris, and Berlin.

American Telephone and Telegraph (AT&T) opened commercial wire service on April 4, 1925, between New York, Chicago, and San Francisco. While it was a breakthrough in this country, the problems it presented were similar to those faced in 1848 by the New York City newspapermen vying for access to the single telegraph line serving metropolitan New York and vicinity. Because the AT&T wire service was run on a first come, first served basis, it was impossible to plan on having access for urgent news. Representatives of news organizations lined up behind advertising agents, hospital employees (sending X rays), and law-enforcement officials for their turn on the wire. Added to those drawbacks was expense: the price for sending a 5 x 7–inch image from New York to Chicago was fifty dollars, and one from New York to San Francisco cost one hundred dollars.[10] More important, the system was unsatisfactory because, after spending the hour required to prepare the picture for sending, "the speed of transmission was slow, and the delivered picture invariably came out blurred, fuzzy, and indistinct. Detail disappeared and the total effect was a vague shadow of what the original had been."[11] After eight years AT&T closed its commercial service.

During this period, AP's News Photo Service was enjoying the success it had had since its inception in 1927. General Manager Kent Cooper was eager to transcend that service, however, but he had to wait for technology and AP Board consent to catch up to his vision of the future. The stock market crash in 1929 and the Depression that quickly followed seemed to put that future on hold, but in 1930 Cooper realized that despite the reasons for hesitation, his plans for simultaneous transmission of news photos with the news would have to be pushed through: "For it was in that year that David Sarnoff told me of the coming of television. I realized then that television, when it came, would completely antiquate the printing by newspapers of news photos of events received by mail from one to several days after television had flashed pictures of those events on screens directly into American homes."[12] So, anticipating the revolutionary changes that would come about in the public's expectations of the news media and the usage of the newspapers, Kent Cooper approached the engineering staff at Bell Labs in 1930 and asked them to perfect a system

Figure 131
Thomas Sande, "This airview of a plane crash deep in the snow-covered Adirondacks was the first picture sent on the new AP Wirephoto network in 1935 when it was only one hour old," 1935; gelatin silver print (AP)
Since the AP had no portable units at the very start of Wirephoto, film was taken to the nearest member newspaper, sometimes a great distance from the scene.

for transmitting photographs over telephone wires exclusively for AP. His objective was to duplicate the transmission of word journalism by having simple photographic machinery in each subscriber newspaper across the country.[13] Twenty-four member newspapers from across the country put up a total of $5 million to launch Wirephoto.

Even with this backing, controversy arose within the membership about the wisdom of starting this new venture. Cooper asked in his speech to the membership at the 1934 annual meeting, "Why in an electrical age that has brought to other industries wide public acceptance and acclaim should The Associated Press default to its members upon an opportunity to deliver pictures by wire when they are faced with the future of live pictures by television?"[14]

On January 1, 1935, the AP Wirephoto network was inaugurated. At 1:00 A.M. the first transmission, a photograph of an airplane crash in the Adirondack Mountains, was sent to the twenty-four members on the network (Figure 131). The initial network, originating in New York, reached Boston, Chicago, Dallas, Miami, St. Louis, Washington, and eighteen other cities.[15]

Successful, AP soon had competitors. That same year Hearst bought Soundphoto and transmitted halftones by ordinary telephone. In 1936, Wide World Photos, then a *New York Times* service,[16] began Wired Photos, and Scripps-Howard announced NEA–Acme Telephoto.

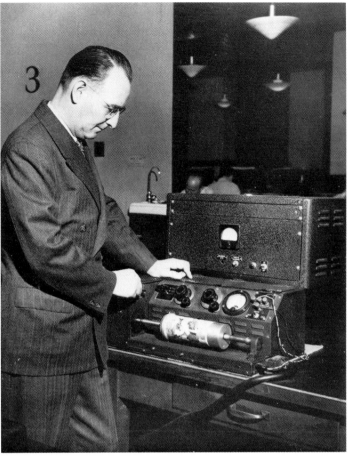

Figure 132
Unidentified photographer, "Harold King, Wirephoto operator," c. 1950; gelatin silver print (AP)
Positive prints are transmitted over the wire. Originally, the receiving member could choose to receive either a positive print or a negative, which was then tray-developed, fixed, and washed.

Figure 133
Unidentified photographer, "A portable Wirephoto transmitter from the late 1930s"; gelatin silver print (AP)
Today the transmitters are no bigger than a compact typewriter.

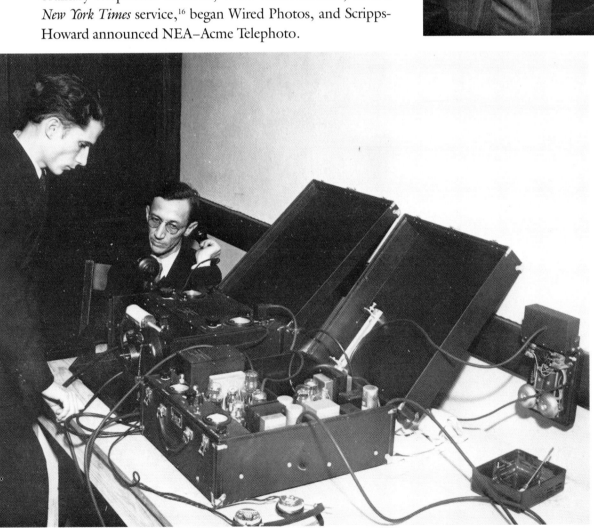

The basic operating principles of the first AP transmitters and receivers were not very different from Professor Korn's early prototype, and they remained unchanged throughout the subsequent developments in the optical-chemical machines—that is, from 1935 until the 1980s, when electronic machines began to eclipse them (Figure 132). The system, in use for well over fifty years, was described by AP in a 1949 letter to the Eastman House as

essentially a copy process. But unlike usual photographic copy methods, where the picture to be reproduced is viewed by a copying camera as one complete scene, the Wirephoto picture is viewed in a methodical procession of very small sections one-hundredth of an inch in area.

The heart of the transmitter is the photoelectric cell, a device sensitive to changes of light. A constant beam of light is concentrated at one very small section of the transmitting drum on which the picture is mounted, and the photoelectric cell is positioned so as to pick up reflected light from this section. As the drum turns, and the whites and blacks of the picture pass in front of the light beam, the intensity of light reflected in to the photo-cell changes accordingly. In this manner the tone scale of the picture is converted into electrical pulses. The transmitter and receiver have identical size picture drums, which revolve and move laterally at identical speeds. . . .

The receiver takes the incoming electrical pulses and feeds them to a special beam-type exposing lamp which is focussed onto a small section of the receiving drum. With drums of transmitter and receiver revolving in synchronization, and both drums moving laterally at the rate of one inch per minute, the same light and dark picture areas seen by the photo-cell of the transmitter are instantly reproduced onto the sensitized material on the receiver drum. The process is completed in 8 minutes.[17]

The equipment required to relay this electrical information weighed tons. Installations took up about thirty-five square feet of floor space and incorporated special power units with heavy batteries. The image used and received was 11 x 17 inches; the necessary developing tanks held gallons of chemicals. The handicap of gigantic, stationary equipment would be overcome within a year when portable (though still cumbersome at this early stage) transmitters were introduced (Figure 133).

Figure 134
Unidentified photographer, "Speed Graphic," 1933. From advertisement brochure, pp. 20–21; halftone (IMP/GEH)

The Speed Graphic and the American Press

Similar transitions from large, slow early equipment to smaller models designed for increased speed and ease of handling also took place in the development of film and cameras. We have already seen the progression from unique daguerreotypes to Brady's wet-plate field equipment to the dry plate. George Eastman introduced roll film in 1884, an invention that would greatly affect camera design from that time forward. The quality of the films improved steadily along with their sensitivity to light. In 1936 Kodachrome, a 35mm color movie film, became available.

The Speed Graphic, the most popular American press camera for virtually the first fifty years of the twentieth century, was introduced in 1912 by Folmer and Schwing, a division of Eastman Kodak. It could be used on a tripod,

SPEED GRAPHIC 4 x 5 x

IT is probable that more people have looked at pictures taken with a Speed Graphic than with any other camera in existence. This is due to the fact that the most extensively and widely used camera in the hands of newspaper photographers is the Speed Graphic.

In fact, the Speed Graphic needs little more to recommend it than this statement: The newspaper photographer **must** get his picture—at all times and under all conditions.

Life-long Construction

It is but natural that the Speed Graphic should have succeeded under these arduous and severe requirements. It was designed to meet exactly these conditions and is constructed with all the rigid adherence to perfection of workmanship, strength, and life-long service for which all GRAFLEX cameras are famous.

Direct View-finding and Focusing

To meet the particular and unusual needs of the newspaper photographer, the Speed Graphic omits the usual focusing hood, replacing this type of focusing equipment with other focusing or view-finding media. These are as follows:

A distance scale attached to the extension bed of the camera.

20

but unlike nineteenth-century cameras, it could also be held. One technological advance spawned another: faster photographic emulsions meant that camera and photographer were not tied to the stationary tripod but could move with events. Changes in apparatus changed the pictures made: events could be photographed as they happened, sometimes becoming dramatic tableaux rather than stilted portraits.

The Speed Graphic was the camera of the archetypal 1930s photographer (Figure 134). It was standard equipment for all press photographers. So expected was its use that it served as a pass to news events. The great press photographer Weegee confirmed that "with a camera like that the cops will assume that you belong on the scene and will let you get beyond the police lines."[18] Built for speed, it was vastly more efficient than the older, bulkier cameras, but a 4 x 5 Speed Graphic, outfitted with a flashgun and a holder, still weighed 9¼ pounds. The extra gear the photographer carried would be likely to include extra lenses, flashbulbs, plate holders, and a tripod,[19] but even then it was less cumbersome than the outfit with glass plates that Jimmy Hare used during the Spanish-American War.

The flashgun was, in fact, the second key item of gear for the 1930s photographer, and standard well into the 1950s. The large flash attached to a photographer's Speed Graphic led to the almost automatic assumption that this was a professional photographer. So, photographers had not only been freed from the tripod and slow film speed, but could now work virtually anywhere at any time of day. They controlled the light.

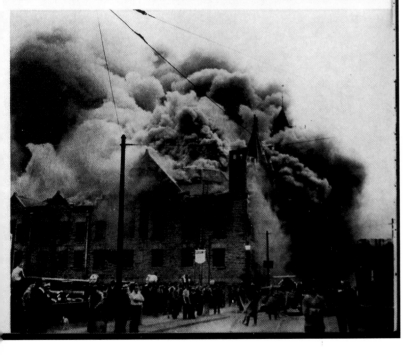

A rear ground glass mounted parallel to the lens.
A folding magnifying peep-sight on top of the camera.
A folding wire finder integral with the lensboard which encompasses the composition available when viewed through the folding peep-sight at the back of the camera.

Removable, Adjustable Lensboard
The Speed Graphic is equipped with a rising and falling lensboard which is also removable to accommodate the Kodak Anastigmat and other lens equipment, to provide for easy substitution of the desired lens. The lens mounting is constructed to accommodate a between-the-lens shutter as an auxiliary to the recognized GRAFLEX focal plane shutter.

Other Features
Regularly adapted for Graphic Plate or Film Holders and Film Pack Adapters, the Speed Graphic is also obtainable with the "GRAFLEX" Back to interchangeably accommodate cut film or plate magazines and roll film holders as well. The light and compact Speed Graphic, with its tremendous capacity for photographing difficult subjects, has recommended itself to the news photographer as a camera of positive accomplishment, and to the amateur as a camera of unlimited possibilities.

DETAILS Picture Size

	4x5	5x7
Bellows Capacity	13½"	16"
Lensboard	4"x4"	4"x4"
Shutter Speeds: Twenty-four from 1/10 to 1/1000, and "time."		

See supplement for camera, lens and accessory prices.

"E-X-T-R-A" Speed Graphic "Shot" by Joseph J. Durnherr. Actual 4 x 5 size.

Figure 135
Unidentified photographer, "Controlled lighting with G-E Mazda photo lamps," c. 1930. From G-E flash advertisement; halftone (IMP/GEH)

The flashbulb was invented in Germany in 1929 and introduced on the American market by General Electric in 1930 (Figure 135). The earliest were quite large and resembled light bulbs with foil wadded up inside. Although not altogether reliable, they were a revolutionary change from the frightening, extremely dangerous flash powder used earlier.

Flash powder, consisting mainly of magnesium, was ignited in a metal trough by setting off an exploding cap. A T-shaped apparatus held overhead, this mechanism was often faulty, and the powder was affected by atmospheric conditions. There are many horrifying stories about the power of the magnesium powder photographers were cavalierly carrying around with them in small wooden boxes. According to one writer, an incident occurred in Hearst newspaper offices in Chicago. Apparently to settle an argument among photographers about the explosiveness of flash powder, one photographer tossed a glass bottle of powder out the fourth-floor window, resulting in an explosion that blew out all the windows on that side of the building.[20] Another flash-powder accident took place right in front of William Randolph Hearst and convinced him to have his newspapers be among the first to use flashbulbs. A photographer covering a speech by Hearst was severely burned and lost two fingers when his "flashgun" blew up as he adjusted the explosive cap. Hearst immediately banned the use of flash powder on any of his newspapers. He then went so far as to order his publishers to buy up all supplies of the as yet little-known flashbulbs.[21]

The convenience and increased safety of the flashbulb made it much more likely that the photographers would cover news wherever and whenever it was happening. The flash announced the photographers' presence and intruded them upon the scene. This intrusiveness contributed to the image of photographers during the 1930s and 1940s. They became crude, stock comic figures in the mind of the public. This was helped by their own training, or lack thereof: many photographers had little formal education and were considered "the 'illiterate' of journalism."[22] Joe Costa, co-founder and longtime president of the National Press Photographers Association, has pointed out that they developed a "second-class citizen" mentality from always working for "word men"—editors and reporters. "The myth has been developed," Costa told newspaper editors, "that to be good, a cameraman must be a screwball."[23] Through the NPPA, Costa worked to counteract this negative image by emphasizing the photographers' accomplishments in getting the news to the public.

The competition for the low-paying, exhausting jobs was fierce. The photographers gathered at the police pre-cinct headquarters and other municipal buildings where they might get the first word of a breaking news story and beat the others to the scene. It was not unusual for this competition for jobs and space in newspapers to foster sabotage. Joe Costa recalled those early days:

Sabotage was standard practice, and no photographer with any street savvy at all would ever let his camera bag or equipment out of his sight. . . .

If he did turn his back on his equipment, he could be sure that he would be the victim of some sort of trickery. Ear wax would mysteriously be rubbed over his camera lens, with the result that when he developed his pictures he found them filled with ethereal ghost images. . . . Dark slides would be pulled and replaced in holders, fogging the emulsion on the glass, holders containing the best shots would mysteriously disappear from his camera bag, only to be seen published in the opposition newspaper.[24]

In this world every newcomer was a threat and photographers were loath to teach their trade. Any newcomer usually worked up through the apprentice system, starting as a copyboy, then moving from mixing chemicals in the darkroom to printing in the lab, and finally becoming a street photographer.[25] In the late 1930s the photographer's access to information improved somewhat with the formation of two- and three-day seminars in photography called "short courses" at two universities;[26] in 1949 the National Press Photographers Association held their first short course in Rochester, New York.

There was considerable truth to the stereotyped image of the newspapermen of the 1930s and 1940s; they were, by most accounts, a rough and rowdy lot. Broadway and Hollywood freely exploited this image in plays such as *The Front Page* (Figure 138). *The Front Page,* written by Charles MacArthur and Ben Hecht, a famous Chicago newspaperman, opened in 1928. The play takes place entirely in the pressroom of the Criminal Courts Building, Chicago. The authors set the tone in their description of the opening scene:

It is a bare, disordered room, peopled by newspapermen in need of shaves, pants pressing and small change. Hither reporters are drawn by an irresistible lure, the privilege of telephoning free. . . .

Here is the rendezvous of some of the most able and amiable bums in the newspaper business; here they meet to gossip, play cards, sleep off jags and date up waitresses between such murders, fires, riots and other events as concern them.[27]

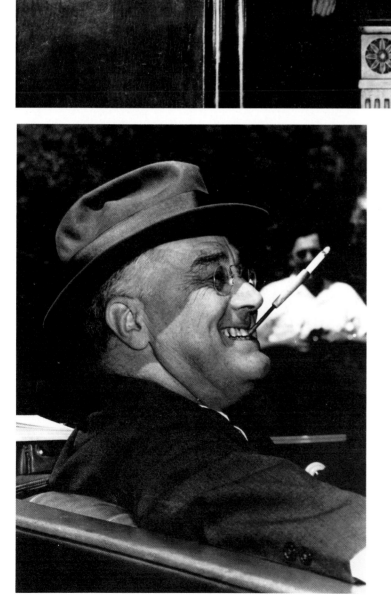

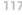

Figure 136
Unidentified photographer,
"Secretary of War Henry Stimson,
still blindfolded, holds out the
first capsule drawn October 29 in
Washington, D.C., in the nation's
first peacetime draft lottery," 1940;
gelatin silver print (AP)
*Left to right: President Roosevelt, who
announced the first number; Maj.
Edward Shattnick; Stimson; and Lt.
Col. Charles Morns. Note that the
president, though crippled by polio,
was rarely photographed on crutches or
in a wheelchair.*

Figure 137
Unidentified photographer, "FDR
in Warm Springs, Ga.," 1939;
gelatin silver print (AP)
*Seated at the steering wheel of his own
automobile, President Roosevelt par-
ried questions at an outdoor press
conference on April 4.*

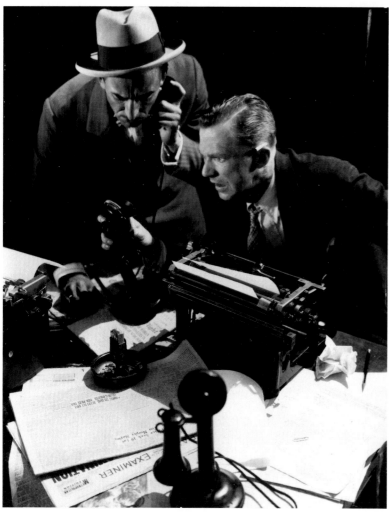

Figure 138
Edward Steichen, "Improvisation
—*The Front Page*—Osgood Perkins
and Lee Tracy, New York, 1928";
gelatin silver print (IMP/GEH)

These "amiable bums" are the reporters. Photographers worked for them, sharing their seamy reputation.

Photographers were seen by many as an intrusion—their numbers increasing at news events, carrying large cameras, flashguns, and bags. Considering their reputation for being journalism's poor relation, and a good deal worse, it isn't surprising that their access was often restricted. For example, in one case a Nevada legislator, referring to out-of-state photographers as "transients," tried to require those photographers who were covering atomic-bomb tests in the state to post a $500 bond and pay a $2.50-a-day license fee.[28] The effort was thwarted by a National Press Photographers Association publicity campaign.

Of longer-lasting effect, in 1932 the American Bar Association adopted what was called "Canon 35," banning cameras from the courtroom. Prior to this ruling, individual judges decided on whether the presence of photographers would be appropriate for a given case. The change in practice came in the wake of Bruno Hauptmann's trial for the kidnapping of Charles Lindbergh, Jr.

Ironically, even though the court was closed to photography in anticipation of the large numbers of photographers covering the proceedings, descriptions of trial coverage as rowdy and circuslike served to close future court trials to photographers. According to Joe Costa, long an advocate of open courtrooms, these descriptions were inaccurate and imply that photographers disrupted the trial. This was not the case: only three clandestine photographs were made with a small camera against the rules. What did happen, however, was that numbers of photographers waited outside the court building and the homes of participants, releasing a barrage of flashes as the witness came into range (Figure 139).

One of the best-known press photographers in the 1930s was Weegee. His uncanny ability to arrive first on the scene prompted others to claim that he must be receiving otherworldly help by using a Ouija board. The name stuck but he couldn't spell it, so Arthur Fellig became "Weegee."

Like other photographers of the time, Weegee learned his trade by working in the darkroom first. "Over the developing tray in the darkroom at Acme [Newspictures], history passed through my hands. Fires, explosions, railroad wrecks, ship collisions, prohibition gang wars. . . ."[29] The twelve years he was at Acme saw flashbulbs come into common use and the beginnings of picture transmission over wires. In 1935, Weegee quit his job, took up a Speed Graphic, and became a freelance news photographer for the next ten years. He slept during the day and worked at night (Figure 143). He thought the night life followed a time-

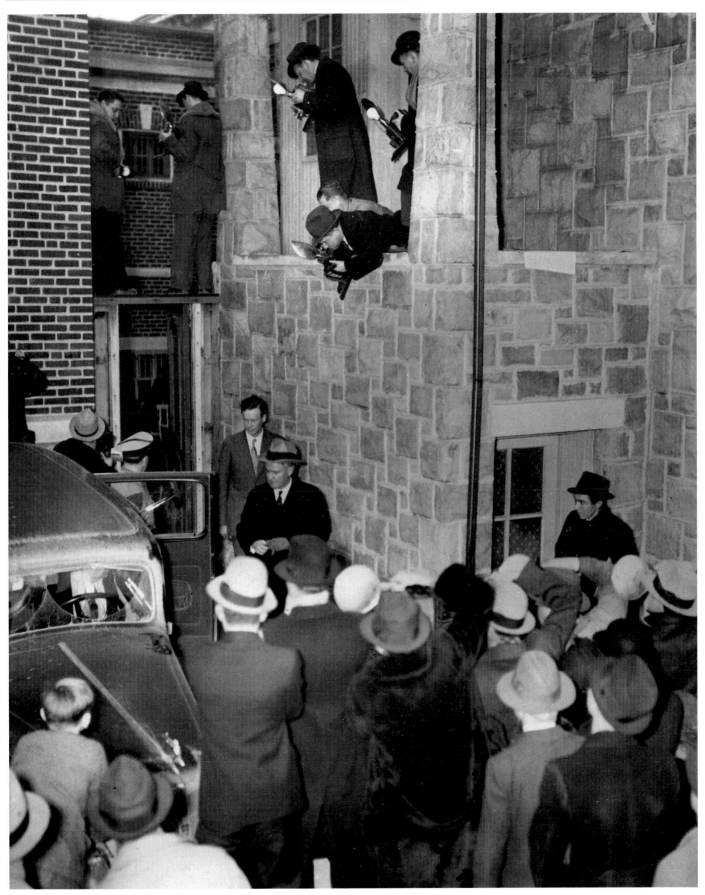

Figure 139
Unidentified photographer,
"Charles Lindbergh leaving the
courthouse for the noon recess, as
photographers try to get him from
every available angle possible,"
1935; gelatin silver print (AP)

table and listed each hour's dominant activities:

> From midnight to one o'clock, I listened to calls to the station-houses about peeping Toms on the rooftops and fire escapes of nurses' dormitories. The cops laughed those off . . . let the boys have their fun. From one to two o'clock, stick-ups of the still-open delicatessens . . . the cops were definitely interested in those. From two to three, auto accidents and fires. . . . Then, from four to five, came the calls on burglaries and the smashing of store windows.
>
> After five came the most tragic hours of all. People would have been up all night worrying about health, money, and love problems . . . and, finally, take a dive out of the window. I never photographed a dive . . . I would drive by.[30]

He was far from the only photographer working at the time, but he was among the best and his pursuit of famous gangsters and sensational events was relentless. He knew the limitations of the camera and flash and became expert at using them to emphasize the dramatic moment he sought to capture.

In "Murder in Hell's Kitchen," made circa 1940, the dead man's body emerges out of the blackness at the top of the photographic frame, his bloody face smashed against the pavement, a revolver shown laying on the cement

120

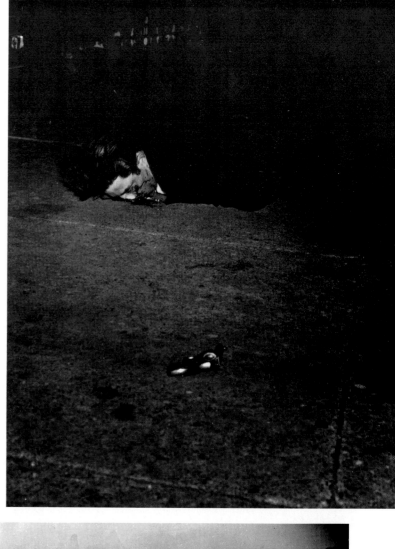

Figure 140
Weegee, "Murder in Hell's Kitchen," c. 1940; gelatin silver print (IMP/GEH)

Figure 141
Weegee, "Their First Murder" (also called "Brooklyn school-children see gambler murdered in street"), 1941; gelatin silver print (MOMA)

pointing toward the corpse (Figure 140). Made from a low angle, the photograph isolates the unidentified body from any crowd that might have been present. The tilted camera robs the picture of stability. The flash is brightest on the victim's head and the empty pavement immediately in front, further emphasizing the barren location. The structure of the photograph, then, reinforces the violence of the act, leaving the impression that the victim was shot in the face at point-blank range in concealing darkness.

Weegee's presence is clearly felt in "Their First Murder" (Figure 141). The children react both to the crime that has taken place outside the frame and to the photographer. Pushing away from the others, one girl tries to look around Weegee for a better view. The range of emotions running through the group at that instant seems to belie the presence of a corpse nearby. The flash reveals scuffling children being pushed into and out of range of the camera's lens, implying that a larger crowd also exists. Dark building facades, untouched by the flash, frame the struggle.

Literally hundreds of very good but unknown news-

Figure 142
Weegee, "The Critic," 1943; gelatin silver print (MOMA, Courtesy Wilma Wilcox)

Figure 143
Unidentified photographer, "Weegee at the trunk of his Chevrolet," 1942; gelatin silver print (Courtesy Wilma Wilcox) *A portable office for nighttime work, complete with a typewriter for captions.*

paper and freelance photographers used the Speed Graphic in this country. While Weegee pursued crime news—particularly the bizarre and outrageous, using these to create his own persona—photographic historian Sybil Miller points out in her research that there were many photographers "who worked very hard for very little, and received no recognition outside their own personal and professional community. These were the typical photojournalists and every newspaper in every city had one or more such pho-

Figure 144 (top)
Times Herald staff photograph, "Grand Champion turkey auction," 1951; gelatin silver print (Dallas Public Library)
The photographer is not always designated in the Hayes Collection.

Figure 145 (bottom)
Unidentified photographer, "Like father, like sons," 1951; gelatin silver print (Courtesy Johnny Hayes)
This picture of the Hayes family appeared in the Dallas Times Herald *on November 25,1951. Left to right the photographers are John (Johnny) Richard Hayes (b. 1914), James (Denny) Dennis Hayes (1892–1953), James Durwood Hayes (b. 1916).*

tographers working for them."[31] The focus of Miller's study is the Hayes family and R. C. Hickman of Dallas, emblematic of this generation of photojournalists.

Denny Hayes and later his two sons Johnny and Durwood worked exclusively as freelancers for the *Dallas Times Herald* between 1929 and the early 1960s (Figure 145). Denny Hayes began his career using an 8 x 10 studio camera and flash powder. By the time his son Johnny became a photographer in 1933 (Durwood joined the family photographers in 1939), the Graflex camera, the Speed Graphic, and flashbulbs were all available. The majority of their collection of approximately 75,000 negatives were taken with 4 x 5 press cameras. Flashbulbs were used consistently: indoors, at night, and as fill-flash in daylight photographs. Unlike Weegee, Johnny Hayes found brutal crime repugnant to cover, considering it "police work." He photographed crime only when the local police photographer was unavailable, preferring to record more positive aspects of the daily news.

As Miller points out, since the range of the flashbulbs was ten to twelve feet, the pictures taken with them show strong similarities or stylistic formulas. The effect of this is to convert the scene into a theatrical tableau, whether it is Weegee's crowd reaction to a murder victim or a picture from a local Adlai Stevenson campaign at the Texas State Fair (Figure 147). The flash's range determined the scope of the photograph. The artificial quality of the bright light source highlighted the subject, flattening and separating it from the rest of the scene, which became "background." Posed photographs also added to the artificial look of the period, a situation partly caused by the fact that the bulky camera used individual film holders. Each negative had to count because the time it took to pull out one holder and replace it with a second, plus the limited number of holders any one photographer could carry, meant that the photographer might have only one chance to capture an event (the introduction of small cameras, roll film, and, later, the motor drive to advance film radically changed the American photographer's working methods).

Another Dallas photographer Miller studied, R. C. Hickman, joined the staff of the *Dallas Star Post* after World War II (Figure 151). Like the Hayeses, he covered community events: awards ceremonies, parties, visiting celebrities, and parades.

Although working at the same time in the same city, the men were not acquainted or even aware of the others' work. Their photographs bear a strong stylistic resemblance, but the photographers lived in two different worlds. Hickman worked for the largest black newspaper in Dallas. He also worked as a freelance photographer for *Jet* magazine and for the NAACP. The black community is his subject

Figure 146
Durwood Hayes, "Dwight D. Eisenhower," c. 1952; gelatin silver print (Dallas Public Library)

Figure 147
Times Herald staff photograph, "Adlai Stevenson campaign," 1952; gelatin silver print (Dallas Public Library)

and its segregated life is clearly present in his work. Hickman's photographs

documenting public demonstrations against racial segregation are especially valuable because Dallas' major news media generally refused to report these events to their audiences. Hickman often worked under hostile, even dangerous conditions. Many times, Hickman later recalled, "I stood with one foot on the running board of a Buick and one on the ground. I had my camera cocked and the engine running."[32]

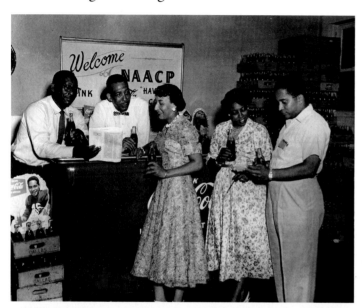

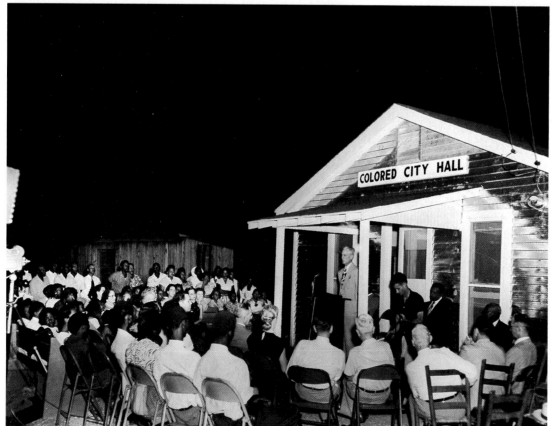

Figure 148 (top left)
R. C. Hickman, "Coca-Cola (NAACP meeting, Dallas, Texas)," 1954; gelatin silver print (University of Texas at Austin)

Figure 149 (top right)
R. C. Hickman, "Nat King Cole, Long Horn Ranch House," 1954; gelatin silver print (University of Texas at Austin)
This photograph was made September 30, 1954, on assignment for Jet *magazine.*

Figure 150 (bottom)
R. C. Hickman, "Colored City Hall, Italy, Texas. White city hall officers at installation of councilmen," 1953; gelatin silver print (University of Texas at Austin)
Photograph taken for Jet *magazine July 27, 1953.*

Figure 151
Unidentified photographer,
"R. C. Hickman," 1949; gelatin
silver print (University of Texas at
Austin)

Time Inc. and European Influences

Photojournalism in Europe during the same period was beginning to take on a different character than that in the United States. Both format and use of photographs was changing, as Sandra Phillips and Colin Osman show in their essay. By the 1930s many prominent European photographers and publications had switched to a much smaller format camera, thereby creating a whole new way of seeing and presenting the world. The Ermanox, a small camera using 1¾ x 2¼–inch glass plates, was introduced by the Zeiss Ikon Company in 1927 (Figure 152). Its large-aperture lens meant it was the most versatile camera of its time, able to take pictures in dimly lit rooms without reliance on flash. This becomes doubly important considering that flash powder was still required for low-light conditions until the introduction and acceptance of flashbulbs in the mid-1930s. No photographer could remain unnoticed after literally blasting his subject with this explosive light source. The Ermanox itself was soon to be superseded by the Leica—a camera that would eventually replace the Speed Graphic as the "classic" photojournalism camera.

The original Leica, the "Ur-Leica," was made in 1913 by Dr. Oskar Barnack, a design engineer for E. Leitz Optische Werke (Figure 153). It wasn't until after World War I that Leicas went into production. Unlike the Ermanox, the camera did not use individual glass plates. It also did not use the large roll film (first introduced by George Eastman in 1884) produced by Eastman Kodak for their own cameras but instead incorporated smaller-sized 35mm movie film introduced in the 1880s. The camera also established a new way of rolling film. Instead of going from one cassette to another, the 35mm film was wound from a reloadable cassette onto a fixed spool in the camera. The exposed film was then rewound into the original cassette and removed from the camera—a method taken for granted today because it was adopted after 1930 by most 35mm cameras.

Like the Ermanox, the Leica allowed for photography in low-light situations. Since both were small, unobtrusive mechanisms, they could easily be concealed or used without being noticed (Figure 154). Because of this, both cameras were used by Dr. Erich Salomon. Not only were his photographs known and appreciated in Europe, but his work also appeared in *Time* and *Fortune*. These publications brought Salomon to the United States in 1931 to photograph Premier Laval's visit to President Hoover. One rather overwritten explanation of the decision by Time Inc. said that the "'candid camera' seemed almost mothered by *Fortune*'s necessity. In Dr. Salomon there appeared for perhaps the first time a first class idea-fact journalist who hunted

125

living history with the camera. *Fortune* and *Time* immediately became partners in aiding and training young American photographers to follow, with many variants, his example."[33] *Time* reported on Nov. 9, 1931, that "President Hoover might never have allowed Dr. Erich 'Candid Camera' Salomon in the White House if Premier Laval of France had not politely insisted. Like Benito Mussolini, Ramsey McDonald and Chancellor Heinrich Brüning, Pierre Laval has become convinced that Dr. Salomon's unposed spontaneous snapshots are historic human documents to be preserved for posterity and school books."[34]

The editors' enthusiasm was not shared by everyone in the photographic establishment. One writer in 1942 complained that the mid-1930s were "the start of the so-called 'candid camera' epoch, when a picture was not esteemed unless it showed the subject eating corn on the cob, yawning, scratching his ear, or in some other way making himself as ugly as possible."[35] It would be another twenty to thirty years before Salomon's example was followed by most photographers in the United States.

By the year in which Salomon's photograph of the Hoover-Laval meeting was published, *Time* magazine was well established. *Time: The Weekly News-Magazine* was first published March 3, 1923. Its prospectus said in part:

> People in America are, for the most part, poorly informed . . .
>
> People are uninformed BECAUSE NO PUBLICATION HAS ADAPTED ITSELF TO THE TIME WHICH BUSY MEN ARE ABLE TO SPEND ON SIMPLY KEEPING INFORMED.
>
> *TIME* is a weekly news-magazine, aimed to serve the modern necessity of keeping people informed, created on a new principle of COMPLETE ORGANIZATION.[36]

Founded by young Henry R. Luce and Briton Hadden, the magazine consisted of twenty-two departments in thirty-two pages written to be read in one hour. This was an entirely new kind of invention—a weekly digest of the news, as recognized by David Halberstam in his book *The Powers That Be: "Time* arrived at almost the same moment as commercial radio and in several ways it was the direct and immediate beneficiary of it. For the coming of radio had by the late twenties changed the way most Americans got their news."[37] Starting a trend that television would continue, the radio news came in flashes: short, terse statements repeated during the day without elaboration.

Not having enough capital to afford either a wire service or their own reporters, *Time*'s small staff essentially rewrote selected parts of the *New York Times*. Luce's partner, Briton Hadden, created a distinctive, if peculiar, style for the magazine by consciously adapting the double epithet and in-

verted sentence structures used in the *Iliad* and the *Odyssey*. The well-known Wolcott Gibbs parody of *Time*'s style (or *Time*style, as it came to be known) in *The New Yorker* summed it up best: "Backward ran sentences until reeled the mind."[38]

Subjectivity was encouraged and stylistic flair sought after. For example, one report on the illness of Trotsky began: "Criticism to the left of him, enmity to the right of him, jealousy in front of him, the Red Army behind him, a high fever within him, all tried to blight him. He resolved to take a trip to the Caucasus."[39]

The early photographic reproductions in *Time* were a good deal less distinctive than the prose. The magazine's pictures looked to the humorist Robert Benchley "as if they had been engraved on pieces of bread."[40] Despite the poor printing, the editors were clearly aiming at European "candid" styles. One pamphlet about the pictures in *Time* reads: "A carefully posed photograph is likely to be about as revealing as a Congressman's framed statement to the Press.

Figure 154
Dr. Erich Salomon, "Supreme Court, Chief Justice Hughes presiding, 1932"; gelatin silver print (IMP/GEH)
This photograph was made secretly with a concealed camera.

Four examples of the new "candid" style of photojournalism.

Figure 155
Lucien Aigner, "A diplomatic conference at the Quai d'Orsay (left to right: Alexis Léger, Pierre Laval, Anthony Eden, François Pietri, Henri Berenger)," 1935; gelatin silver print (IMP/GEH. Courtesy Lucien Aigner)

Figure 156
Lucien Aigner, "Edouard Herriot, French Prime Minister," 1932; gelatin silver print (IMP/GEH. Courtesy Lucien Aigner)

Figure 157
Lucien Aigner, "Benito Mussolini at Stresa," 1935; gelatin silver print (IMP/GEH. Courtesy Lucien Aigner)

Figure 158
Lucien Aigner, "Austrian Chancellor, Dr. Kurt Schuschnigg," 1935; gelatin silver print (IMP/GEH. Courtesy Lucien Aigner)

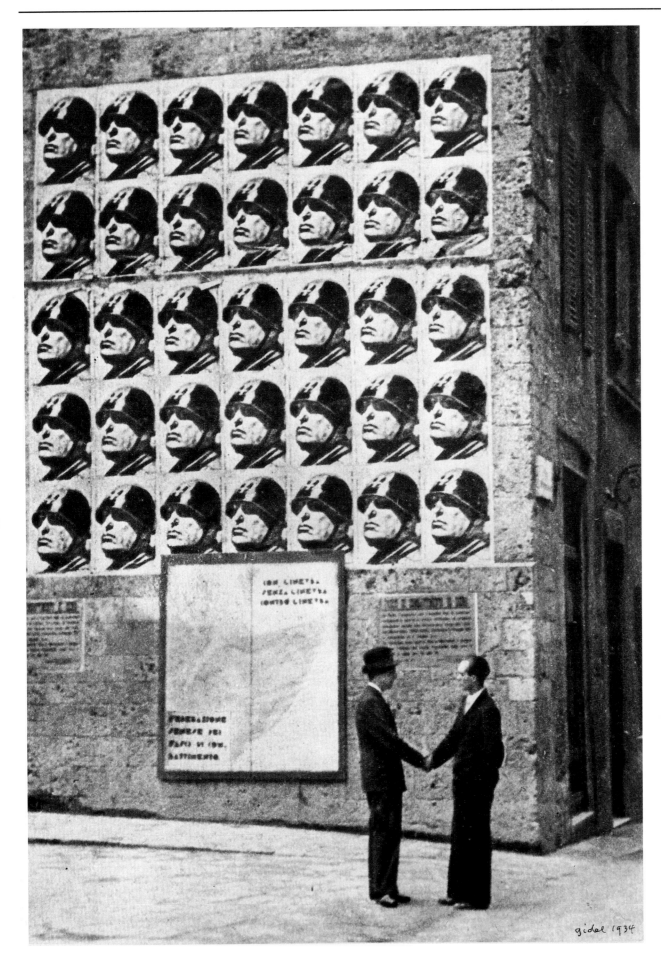

Figure 159
Tim Gidal, "Florence, 1934";
gelatin silver print (IMP/GEH.
Courtesy Dr. Tim Gidal)

As *Time* goes behind the statement, so *Time*'s cameraman must go behind the pose."[41]

Newsweek, Time's chief competitor, began publication in 1933. The magazine, whose title read *News-Week* until 1937, was founded by Luce's first foreign editor, T. J. C. Martyn, who wrote that "some people feel *Time* is too inaccurate, too superficial, too flippant and imitative."[42] *Newsweek* therefore stressed objectivity and featured signed opinion columns.

Luce's biographer, John Kobler, has written that Luce rejected objectivity as a journalistic ideal from the beginning of his career. He admonished his staff to make a judgment. "'Show me a man who claims he's completely objective,' he said, 'and I'll show you a man with self delusions.'"[43]

The question of photojournalism's objectivity is a recurring one. The pendulum of opinion swings from those who take photography for granted, believing that photography is truth itself, to others who discount any image as so completely a personal expression of the photographer as to be nearly useless for understanding the news. The real question is not one of quantifiable truth—how many apples in the basket—but one of fairness. Hal Buell, Assistant General Manager for Newsphotos at The Associated Press, points out that while photographers have different backgrounds and motivations, he believes that they can be trained as professional journalists. As reporters with a camera they "can be trained to do, if not a scientifically objective report, certainly an insightful, fair and intelligent one."[44] The issue of whether objectivity is attainable or even desirable came to the fore again in the 1960s, particularly in relation to coverage of the Vietnam war.

By 1936 Henry Luce had committed himself to a new publishing endeavor, a risky undertaking of an untried kind of publication for the American market—what he later described as a "very improper publishing decision."[45] It reached the newsstands in November 1936 as *Life* and the public loved it. The now-famous prospectus read:

> To see life; to see the world; to witness great events; to watch the faces of the poor and the gestures of the proud; to see strange things—machines, armies, multitudes, shadows in the jungle and on the moon; to see man's work—his paintings, towers and discoveries; to see things thousands of miles away, things hidden behind walls and within rooms, things dangerous to come to; the women that men love and many children; to see and to take pleasure in seeing; to see and be amazed; to see and be instructed.

The story behind *Life* goes back several years before its launch. Luce had been exploring various possibilities ac-

tively. Well informed and well traveled, thus aware of the success of the *Berliner Illustrirte Zeitung, Vu, L'Illustration,* and *The Illustrated London News,* he set up an Experimental Department in 1933 that was to concentrate on a picture magazine. As in the European examples, he sought a way to incorporate many photographs into a novel presentation to catch the attention of the public. By fall 1936 there were also precursors within Time Inc. itself.

The first of these precursors was not a pictorial medium—it was radio. In the tradition of *Time* magazine (*Time*style), a new word was coined to name the 1928 program: *Newscasting*. The program changed in 1931 and was called *The March of Time*, the title adopted from Harold Arlen's theme music by the same name. The radio program was not a news presentation as they would later be defined

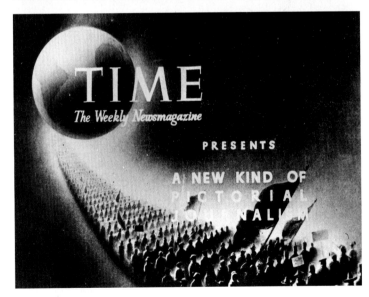

Figures 160–161
Unidentified Artist, "March of Time," c. 1935; halftone (Time Inc.)
Announcements of the newsreel appeared in Life *and other magazines.*

but rather a dramatic rendition of world events the show had no means to cover otherwise. Luce described it as "fakery in allegiance to truth."[46]

In February 1935 *The March of Time* became movies: Time Inc. went into newsreel production, proclaiming it "an attempt to make the cinema an instrument of more effective journalism."[47] The company viewed it as yet another publishing venture (Figures 160–161). Most of the newsreels lasted about twenty minutes and covered several short, unrelated subjects. One humorist described the format as "a series of catastrophes followed by a fashion show."[48] Reel number one of *The March of Time* contained five subjects: the Indianapolis auto race; Lloyd's of London; the Dionne quintuplets; Albert Einstein; as well as Tojo and the Pacific navies.

Two publications were also immediate predecessors of *Life*. These were *Fortune* magazine and *Four Hours a Year*, a picture book recording the achievements of Time Inc. in general and *The March of Time* in particular.

Planned in the late 1920s, *Fortune* began publishing after the stock market crash—at a time when fortunes were being lost, not made. It was a stunning presentation: a large magazine with bold design, heavy paper, and dramatic photographs reproduced in a rich gravure printing process rather than halftone. Henry Luce hired Margaret Bourke-White, an unknown young photographer from the Midwest, to do the photographs.

After Luce saw reproductions of Bourke-White's photographs of an Ohio steel plant, he sent her a wire asking her to come to New York within a week and promptly offered her a job. Her photographs became a significant part of the magazine's look, synonymous with the importance of industry and its power to regenerate itself. Initially published to cover the business news that did not fit into *Time*'s format, *Fortune* gradually broadened its concerns over the years. (In one such instance, it published photographs from "Harlem Document," a project of the Photo League in New York, which included photographer Aaron Siskind; Figure 163.) In the words of Bourke-White's biographer, she "became one of the chief instruments in the promotion of Luce's vision of the news. He had discovered her; he maintained her for years in the top ranks of his magazines. She held him in the highest respect, and by all accounts he returned the courtesy."[49]

The promotional book *Four Hours a Year* (1936) ostensibly publicized *The March of Time* (four hours being the total time of the twenty-minute newsreels released in a year). Not intended to become a regular publication itself, it became an occasion for the editors to show their insights into the new uses of photography in magazine journalism

132

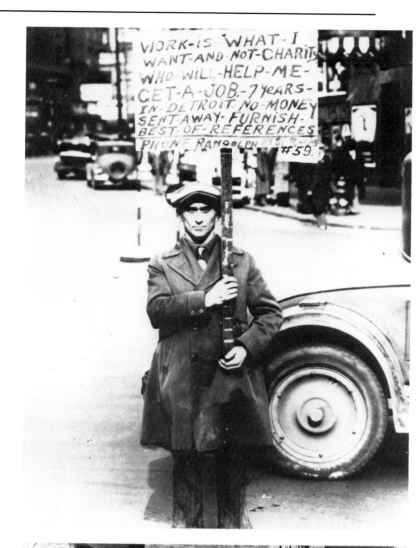

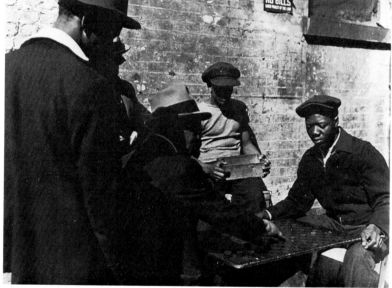

The Depression

Figure 162
Milton Brooks, "Desperate for work, a Detroiter advertises," 1932; gelatin silver print (FDR Library and Museum)

Figure 163
Aaron Siskind, "Checkers game," c. 1938. From "Harlem Document"; gelatin silver print (IMP/GEH. Courtesy Aaron Siskind)

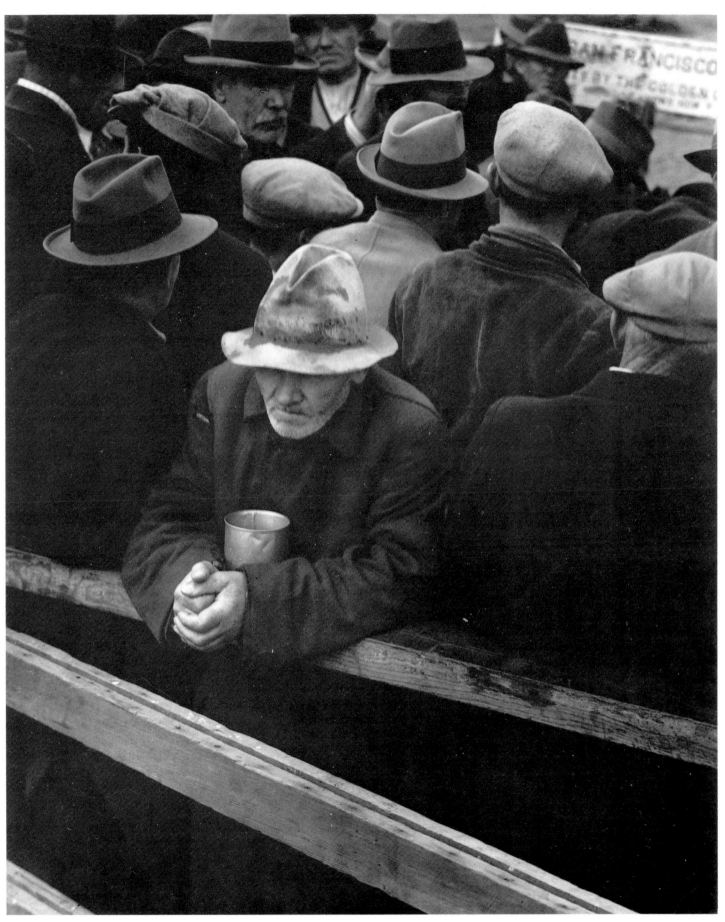

133

Figure 164
Dorothea Lange, "White Angel
bread line, San Francisco, 1932";
gelatin silver print (IMP/GEH.
Courtesy The Oakland Museum)

Figure 165
Joe Costa, "March on
Washington," 1932; gelatin silver
print (AP)
*When veterans marched on Wash-
ington, a pitched battle between
bonus-payment-seeking veterans of
World War I and Washington,
D.C., police took place on July 28,
1932, on a rubble-covered lot near
Pennsylvania Avenue where the
veterans had pitched camp.*

Figure 166
Dorothea Lange, "Oklahoma,
June 1938"; gelatin silver print
(The Oakland Museum)
*A homeless family of tenant farmers
on the road.*

and to do some experimentation with layouts of news pictures. Though written in a typical overblown 1930s advertising style, the ideas still come through: "Word journalism being senior in point of time and custom, photojournalism is still regarded as a sort of mechanical side-line to the serious business of fact-narration—a social inferior which, on certain regrettable and accidental occasions, may steal the show. The webbing of the news-photo into the woof of journalism is an evolutionary process barely begun."[50] The layouts were stodgy, nonnarrative clumps of photographs. *Four Hours a Year* hardly posed a threat to the great French and German magazines. But the page size had increased, the number of photographs used was impressive, and the writing clearly showed that the desire was there to have it all work. One staff member later referred to the book "both as *Life*'s 'Bible' and as its 'Magna Carta.'"[51]

Life also benefited directly from men who had worked with the great European periodicals: Kurt Korff and Kurt Safranski. Both were refugees from Nazi Germany and had worked for the Ullstein publishing house, Korff as editor of the magazine *Berliner Illustrirte Zeitung* and Safranski as Ullstein's managing director. Each helped Luce and the staff move closer to making a new American picture magazine a reality. Earlier Safranski and photographer Martin Munkacsi had made up a magazine dummy for publisher William Randolph Hearst that he had rejected. Safranski then gave the dummy to Luce for his consideration in 1934. Korff worked with the staff, showing them his methods for working with photographs. One recalls that he taught them "to look at pictures for a little something more than the content."[52] He also recommended photographers for consideration, such as German refugee Alfred Eisenstaedt. (Thanks to Eisenstaedt, Korff's influence could be said to have endured throughout the life of the magazine: as of 1987, the photographer had done an astounding 2,500 assignments for *Life* and provided 92 covers!)[53]

Technology played a vital part in the making and the near breaking of *Life*. Much has been written about the problems faced by the R. R. Donnelley printing firm. Suffice it to say that everything needed to print the magazine Henry Luce had in mind was hard to get and largely untried. The heavy coated paper stock was not available in the rolls needed for high-volume printing; the ink generally used couldn't soak into the coated paper and smeared on high-speed rotary presses; the presses themselves were not built to handle the new requirements of the new printing products. So, folded paper was used; Donnelley experimented with a new ink and jerry-rigged the presses; and *Life* began (Figure 167).

Life Itself

Life was a wild success on the newsstands. Overnight that success became a terrible financial burden. Advertising rates were based on a much slower growth rate. Finding enough paper and just keeping the modified presses rolling was a huge task. Losses ran to $50,000 a week. It wasn't until January 1939 that *Life* began to make a profit. *Life* had pulled through the long crisis and subscriptions poured in.

The early issues were an exuberant mix of stories and stylistic approaches. It is clear, in retrospect, that the magazine had yet to develop consistently effective layouts. The Margaret Bourke-White lead photo story on the Fort Peck Dam is justly famous. Her graphically bold photographs of the gigantic dam structures would have been equally at home inside *Fortune*. Her folksy bar scene sweeps dramatically across two pages by printing variations of the same group (Figure 168). Later in the same issue, however, the effect of the photographs is dissipated by lining them up in three rows across two pages, or jumbling them across the pages as if they were loose snapshots thrown down haphazardly. An article on NBC radio performers in the first number is typical of a self-conscious picture stylization that *Life* later abandoned (Figure 169). Six photographs of individuals fan diagonally across the two-page layout. Two other figures have been cut away from their backgrounds and

Figure 167
Margaret Bourke-White, "Fort Peck Dam, Montana." From *Life*, November 23, 1936 (Vol. 1, No. 1), cover; halftone (IMP/GEH)

assigned to stories by *Life* and some became *Life* staffers. Howard Chapnick, president of Black Star, elaborates:

> We supplied not only photographs, but photographers. . . . We had people like Philippe Halsman, Fritz Goro, Walter Sanders, and many other of the photographers who subsequently became staff photographers at *Life*. Wilson Hicks needed a reservoir of talent to go beyond the four photographers with whom he had started his staff and personally assigned these photographers through Black Star. . . . So, in a sense (and I'm not using this in a pejorative way), they stole or took this talent, most of which had come from Germany and become part of the *Life* staff.[60]

In its heyday, *Life* provided 30 to 40 percent of Black Star's business. The magazine assigned many more stories than they actually used. "*Life* felt that in order to cover the world, they had to cover a lot of marginal things in the hope that maybe something would come out of it. And that was what made *Life* great for the freelance photographer and for the magazine, because they didn't miss anything."[61]

Life had not been envisioned as a war periodical, yet it became the great chronicler of the world's upheaval. Mussolini and the soldiers of the Spanish civil war appeared in small reproductions in the first issue. The immense brutality of the conflict in China, first between the Nationalists and the Communists and then by the invading Japanese, was soon displayed frequently. Within three years the Germans invaded Poland. Each week the magazine showed the war spreading around the world.

Figure 172
Unidentified photographer, "Regiment of women at Valencia," 1938; gelatin silver print (AP)
A regiment of Communist women was organized at Valencia, Madrid's seaport. They performed patrol duties and acted as chauffeurs while the men were away fighting.

Figure 173
Unidentified photographer, "The struggle for bread," 1938; gelatin silver print (AP)
The caption continues: "The war is over for Barcelona, but the struggle to exist goes on. Thousands jam the streets daily around Franco bread distribution cars. Here a couple argued Jan. 31 over their rations."

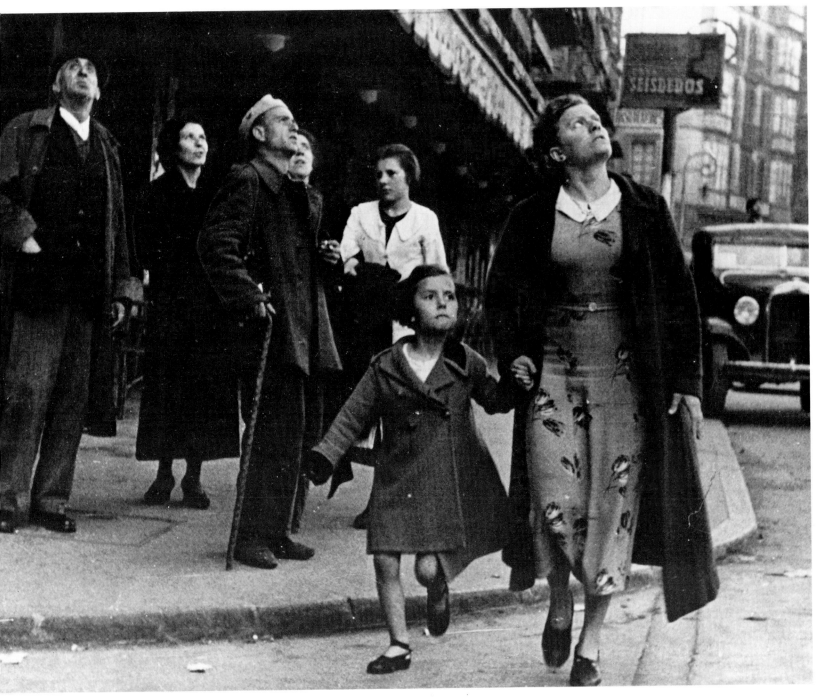

Figure 174
Robert Capa, "Air raid alarm, May
1937, Bilbao"; gelatin silver print
(Magnum)

Figure 175
Unidentified photographer,
"Bombs falling in Madrid," 1938;
gelatin silver print (AP)
*This photo shows an explosive bomb
falling in one of the streets of Madrid,
Spain, during an air raid. Bombs had
fallen in practically every square block
in the city since the start of the siege of
Madrid two years earlier.*

World War II and the Press

Covering news of the war was a colossal operation for news organizations. It taxed and tested the new technology of magazines and wire services to the fullest (Figure 128). *Life* magazine shifted from features to hard news of the fronts, with illustrated explanations of the war's progress, using photography, graphics, and painting to put the news in context.

Henry Luce stated his views on the responsibilities of the free press in a 1938 lecture. He warned about the popular publishing strategy that he characterized as "the give-the-public-what-it-wants theory." He saw the danger of this as not giving

> the people what they must have—what they will perish without. . . . The present crisis in world affairs may be described as a crisis in journalism. . . . Modern dictatorships are unspeakable [because] they corrupt the mind from within. They suppress the truth. They lead men by lies and fraud to desire and acquiesce in their own enslavement. And how is this corruption brought about? By the destruction of journalism.[62]

Debate and argument were needed, he said. "And to the great debate, the journalist must and will respond in his emotions and in his conscience."[63]

In December of 1938, *Life* began an article urging re-

Figure 176
Unidentified photographer, "Jesse Owens on victor's podium," 1936; gelatin silver print (AP)
Jesse Owens, center, of the USA, wears winner's oak-leaf laurel crown after he won the Olympic broad-jump event in Berlin. On right is Lutz Long of Germany, who came in second, giving the Nazi salute, and on left is Tajima of Japan, who won third place.

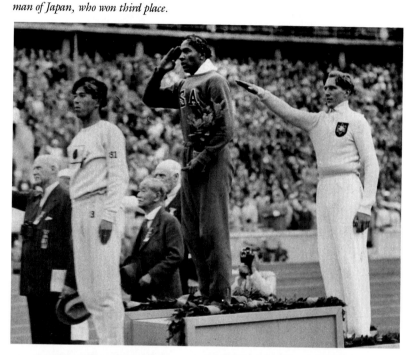

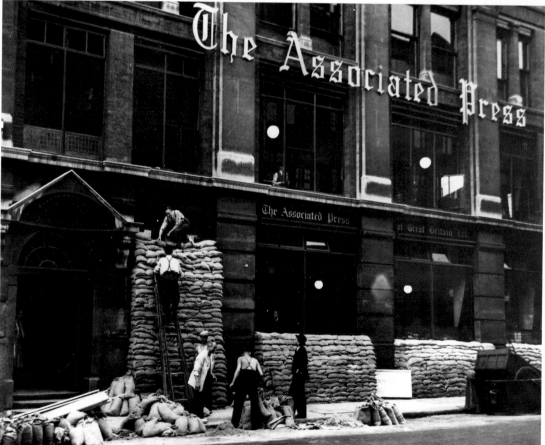

REARMAMENT

BOMB SIGHT ON THE BATTERY: NEW YORK CITY FROM A BOMBER

Figure 177 (above)
Unidentified photographer, "Bomb Sight on the Battery: New York City from a Bomber." From *Life*, December 19, 1938 (Vol. 5, No. 25), p. 44; halftone (Time Inc.)

Figure 178 (left)
Unidentified photographer, "London AP building," c. 1940s; gelatin silver print (AP)
The front of the London office of AP being sandbagged at the beginning of the war.

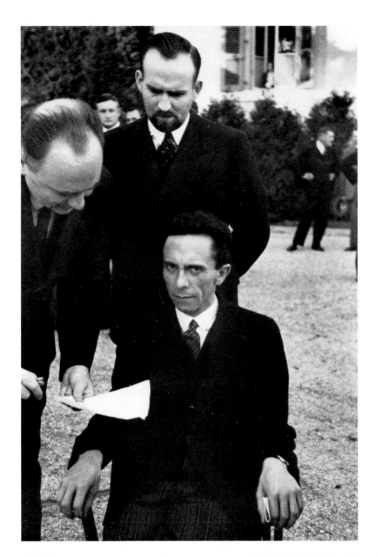

armament with a startling full-page picture titled "Bomb Sight on the Battery: New York City from a Bomber" (Figure 177). Largely pictorial, the article displayed individual pictures of American weapons, such as a 105 mm gun, an 81 mm mortar, and a 155 mm field howitzer, describing the range, value, and flexibility of each. More important, the number (or lack) in the arsenal was cited.

The illustrative photographs as well as renderings of diagrams and maps continued throughout the war and augmented material flown in or wired from the battlefields. After Pearl Harbor, *Life*'s pages were naturally filled with American military stories. In *"The Good War,"* Pauline Kael recalls in an interview that during "the war years, the whole spirit of the country seemed embodied in *Life* magazine. Its covers featured GI Joes, girls, and generals. The GI's were always clean-cut, wonderful kids. And so were the girls they dated."[64]

Luce and Time Inc. passionately supported the American cause as they had the Allied countries from the start. Patriotism at home, heroism on the front lines—these *Life* displayed in abundance. Among the many photographers the magazine sent to cover the conflict were Margaret Bourke-White and Carl Mydans. They were in military uniforms, as were all the photographers.

While some of the outstanding photographers of this era were officially in the armed services—such as Edward

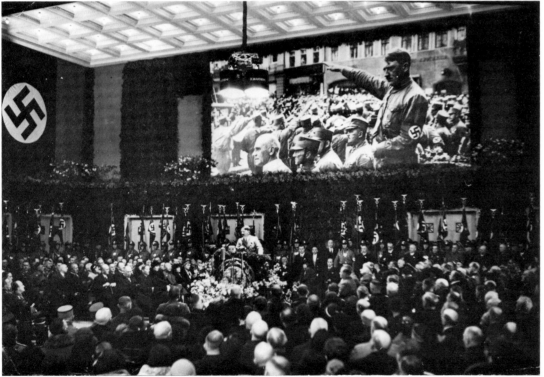

Figure 179
Alfred Eisenstaedt, "Geneva, September 1933"; gelatin silver print (Time Inc.)
Portrait of Joseph Goebbels, Adolf Hitler's propaganda chief.

Figure 180
Unidentified photographer, "Hitler speaks at the opening of the International Auto-Show in Berlin," 1933; gelatin silver print (AP)

Steichen and David Douglas Duncan—other war correspondents followed another system of accreditation, outlined by Bourke-White in her autobiography: "War correspondents had what is known as assimilated rank, which entitled them to officers' mess and officers' pay—except you had to be captured to collect the officers' pay. During the early part of the war, we were lieutenants and were swiftly raised to captains. Before the war ended, we had been promoted to lieutenant colonels."[65] Thus accredited to the air force, her pictures would be used by both *Life* and the air force.

Bourke-White herself was the first female photographic war correspondent, and a new uniform had to be designed for her by officers in the Army War College. The pattern

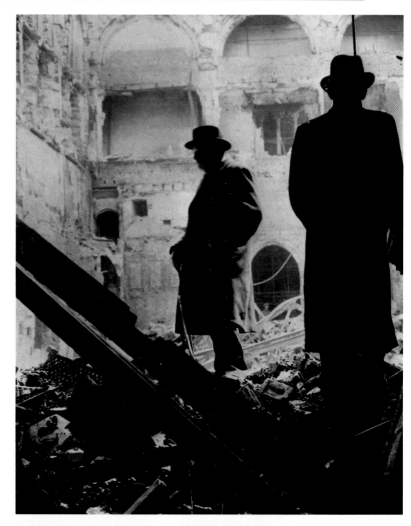

Figure 181 (left)
Unidentified photographer, "Margaret Bourke-White," c. 1945; gelatin silver print (Time Inc.)

Figure 182 (right)
Unidentified photographer, "Churchill views damage at House of Commons," 1941; gelatin silver print (AP)
Severe damage was done to the chamber in the heavy German air raid over London on May 10.

Figure 183 (left)
George Rodger, "V-1 Blitz, London," 1943; gelatin silver print (Magnum. Courtesy Time Inc.)

Figure 184 (right)
Unidentified photographer, "Fire of London 1940: burning buildings after raid," 1940; gelatin silver print (AP)
London firemen and AFS men at work on a blazing building that was set on fire by German incendiary bombs dropped on the capital.

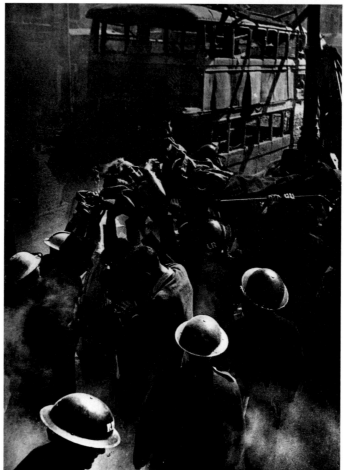

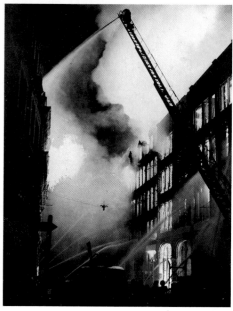

was based on an officer's uniform and included both slacks and skirts. To replace the insignia of army rank usually worn on the shoulders, the design included a war correspondent's insignia. Abercrombie and Fitch then manufactured the uniform (Figure 181).

Accreditation was only available to correspondents affiliated with major news organizations. With it came access to transportation and shipping—crucial elements to a photographer in the field. A great war picture is useless if it arrives too long after the action, is lost on the way, or arrives with no caption. Carl Mydans, who covered the war from its beginning in 1939 and later became a prisoner of the Japanese in the Philippines, said later,

> I made notes on everything, every roll of film I shot and, if I could, every frame on each roll, with enough background so that I could transcribe those notes into running captions of what the shipment contained, what outfit I was with, what the action was, the roll number and the frame number. . . . Many times the captions were just as important as the film. Many of us making very good pictures of action in very difficult circumstances were unable to get sufficient captions down between taking our film out of our camera and giving it to someone to take in for shipment. Then, even though the film got to New York, if someone could not make head or tail out of what you had, it was not usable, and so there was worship of captions in the field.[66]

He also sent a wire to alert the editors that work was coming, such as

> "from Mydans, shipment 16, leaving Southern Italy today with coverage of the Third Division in its attack on Velletri." Some of these words would be cut by censors, but there would be enough in there for the editors in New York to know what you were doing, and in return for that cable you would then get a cable from New York saying your shipment 16 arrived today. When you got that back you were comforted by two things—you know that they had gotten the shipment and, just as important, you saw nothing in the message that said you were having equipment trouble.[67]

In the Pacific war, the hot, moist atmosphere ruined cameras and film. Frank Filan, an AP photographer who won the Pulitzer Prize for his pictures during the Marines' landing on Tarawa in the Solomon Islands (Figure 222), wrote that the cardboard film boxes came apart, allowing the film to open up. While in the Pacific, he carried a Rollei and a Speed Graphic camera as well as a large load of film: "As it is almost impossible to get supplies, enough must be carried to last several months. When I felt my supply had

diminished to about a three months' surplus, I started writing for more. The film did not reach me before my supply ran out."[68]

Getting film back to the U.S. was another universal problem. Robert Capa lost his job at *Collier's* because he had to depend on shipping his work through military channels, which could take three months. There were at least three possible drawbacks to this situation, each one worse than the last, and all three affected Capa's pictures: his photographs were old news because they arrived late; some had already been published because the army had the right to transmit them by radio to the U.S.; this in turn made the radioed photographs available for distribution by the wire services.[69] At this rate, it was more efficient and certainly cheaper for *Collier's* to use wire-service photographs to begin with.

Capa then got a job with *Life*. The magazine circumvented some of the logistical problems by belonging to the U.S. Army-Navy Photographic Pool (also known as the Still Picture Pool). Membership didn't mean his troubles were over, but in general it meant that photographers could get transported to where they needed to be and get their work through censorship and shipped back to the U.S. on a priority basis.[70] The pool had been set up after Pearl Harbor to handle civilian camera coverage. The members were Acme Newspictures (picture agency for United Press), The Associated Press, International News Syndicate (later taken over by United Press to become UPI), and Time Inc.

With the declaration of war on December 8, censorship became a mandatory part of the routine editing process. The army declared that no faces of the dead could be shown. The formation of the Office of Censorship was announced shortly after the Japanese attack. Byron Price, a former AP editor, headed the operation. The American office was less restrictive than those operated by other countries and preferable to direct military censorship.[71] Going through its procedure was, however, an unnatural, time-consuming, and often frustrating step for the press to submit to. In her biography of Margaret Bourke-White, Vicki Goldberg wrote:

> Government censorship was tight. Dirty work by Allied troops could not pass the censors. John Morris, then *Life*'s London picture editor, recalls "the candor of the British censor through whom I attempted to pass some pictures of the charnel of air-raid victims in Berlin. 'Very interesting,' he said. 'You may have them after the war.'" The government forbade the publication of pictures of dead Americans until September of 1943, although the press could, and did, print photographs of dead Chinese, Britons, Japanese, Germans, long before.[72]

One censored image Goldberg refers to became famous. *Life*'s September 20, 1943, issue carried a full-page picture captioned "Three dead Americans on the beach at Buna" (Figure 185). It appeared opposite an editorial, "Three Americans: Where These Boys Fell, A Part of Freedom Fell: We Must Resurrect It." The photograph, by George Strock, was taken in New Guinea on "Buna Beach" (also known as "Maggot Beach"); it was one of the first pictures showing *American* dead that the censors permitted to be published.

The picture wasn't released without a struggle: the government had censored the image after it was taken in early 1943. *Life* protested the censorship of Strock's photograph in its February 22 issue. In highly melodramatic language, reminiscent of *The March of Time*, the magazine created a fiction, a soldier named Bill, a nervous Wisconsin boy "stalking Japs," running after them "blazing mad." In the September 20 recap when the image was actually printed, the editors wrote:

> We said then that we thought we ought to be permitted to show a picture of Bill . . . that if Bill had the guts to take it, then we ought to have the guts to look at it.
>
> Well, this is the picture.
>
> And the reason we print it now is that, last week, President Roosevelt and Elmer Davis and the War Department decided that the American people ought to be able to see their own boys as they fall in battle.[73]

The two-page combination of editorial and photograph clearly announced the image's importance by setting it off from the rest of the magazine. For its time, the image was a shocker. Instead of emphasizing the nobility of America's fighting men, it showed three bodies sprawled on the sand. The foreground figure, partially covered by sand, is infested with maggots. No wonder the censors held it back. Today, though, considering the work that came after it in Korea and Vietnam, to name only two instances, the image appears to be a sad, but hardly surprising, reminder of a war's consequences.

Six letters to the editor appeared in print two weeks later. Five approved of showing the picture, but one writer complained about "morbid sensationalism," saying that the photograph robbed the men of their dignity and mocked their sacrifice. Wilson Hicks observed later that they had sent Strock "into nowhere and he gets the one picture that stirs the whole country."[74]

Photographs of death were not new to *Life* magazine readers, however. Early issues of the magazine had displayed truly gruesome pictures from the war in China showing mutilated corpses, executions (Figure 186), and an impaled Japanese head. On September 9, 1940, the murdered

Trotsky's body was seen amid the crematorium flames. But these were not Americans.

The direction of the war was changed decisively with the D-Day (June 6, 1944) invasion of Normandy by the Allied forces. Robert Capa went in with the first assault wave, but he was not the only photographer on the beaches. With him were Peter Carroll (AP), Bert Brandt (Acme), and Bob Landry (*Life*). Other photographers included Bede Irwin (AP) and Frank Scherschel (*Life*), who flew over with bomber squadrons. Sonnee Gottlieb (International News Pictures), Ralph Morse (*Life*), Jack Rice (AP), and Dave Scherman (*Life*) were with the navy.[75] All these photographers produced memorable pictures of the conflict, yet Capa's photographs reproduced in *Life* remain some of the best-known documents of that attack.

In 1938, Capa was proclaimed "The Greatest War-Photographer in the World" by the English magazine *Picture Post*; he was only twenty-five. By 1944 Robert Capa was known as much for his flamboyant and daring lifestyle as he was for his stirring photographs of the Spanish civil war. His most famous image from that war, "Death of a Loyalist Soldier," shows a soldier who has been shot, falling

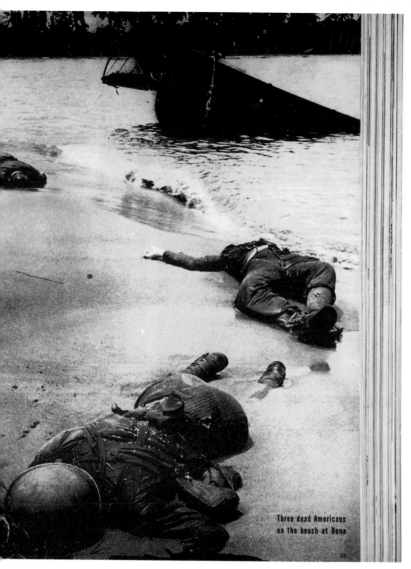

Three dead Americans on the beach at Buna

35

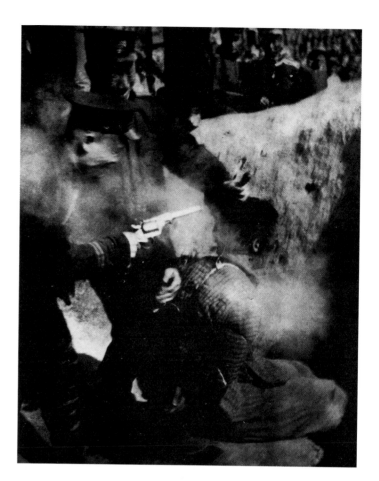

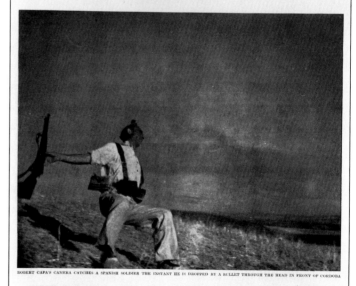

Vol. 3, No. 2

LIFE

JULY 12, 1937

ROBERT CAPA'S CAMERA CATCHES A SPANISH SOLDIER THE INSTANT HE IS DROPPED BY A BULLET THROUGH THE HEAD IN FRONT OF CORDOBA

DEATH IN SPAIN: THE CIVIL WAR HAS TAKEN 500,000 LIVES IN ONE YEAR

On July 17 the Spanish Civil War will be one year old. In that time it has brought Death to 500,000 Spaniards, has shattered such ancient cities as Madrid, Toledo, Bilbao, Irun and Durango, has kept Europe in a state of jitters.

When the war started, most U. S. citizens looked on the Loyalists as a half-crazy, irresponsible, murderous scum that had turned on its honorable betters. A year of war has taught the U. S. more of Spain.

The ruling classes of Spain were probably the world's worst bosses—irresponsible, arrogant, vain, ignorant, shiftless and incompetent. Some 20,000 landlords owned 50% of the land. They did not give their field hands modern machinery or their land modern irrigation. They refused to rent unused land to landless peasants for fear of giving the peasants dangerous ideas of ownership. The land was only about 25% efficient and much of it was idle. And Spain's mineral resources, among the greatest in Europe, lay almost entirely unexploited. The aristocracy of Spain was still living on the interest on wealth brought home from the Americas by the gold fleets in the 16th Century.

To the 20,000 landlords, add 21,000 Army officers, more than twice the total of British Army officers. There was one officer for every six privates, one general for every 150 men. For every $3 spent on soldiers' pay, food, barracks, ammunition, officers got $10 in pay—25% of the national budget. The national law made officers semisacred. Just for pushing a policeman of the swank Civil Guard, six Americans got six months in jail in 1935.

Add to the 41,000 landlords and officers, 100,000 clergy, the most top-heavy Church hierarchy in the world, next to Tibet. These also were paid by the State. The Church, with its enormous wealth, naturally took a capitalist's position. It was up to its neck in politics. Peasants were told that to vote against the Conservatives was usually a mortal sin. The Church was in charge of Spanish education. Result: the Spanish people were 45% illiterate. The reason for the civil war was simply that the people of Spain had fired their bosses for flagrant incompetence and the bosses had refused to be fired.

For a new movie of the Spanish war from the Government side, turn page.

Figure 185 (top)
George A. Strock, "Three dead Americans on the beach at Buna." From *Life,* September 20, 1943 (Vol. 15, No. 12), p. 35; halftone (Time Inc.)

Figure 186 (top right)
Unidentified photographer, "Note the pistol's kick, the body's slump as the executioner sends his bullet ploughing through the head of this captured Chinese Communist. Half the town swarmed out to watch his death with customary Chinese stoicism." 1936; gelatin silver print (Time Inc.)
This photograph and caption appeared in the December 28, 1936, issue of Life.

Figure 187 (right)
Robert Capa, "Death in Spain." From *Life,* July 12, 1937 (Vol. 3, No. 2), p. 19; halftone (Time Inc.)
Capa's most famous photograph as it appeared in Life. *Better known as "Death of a Loyalist Soldier."*

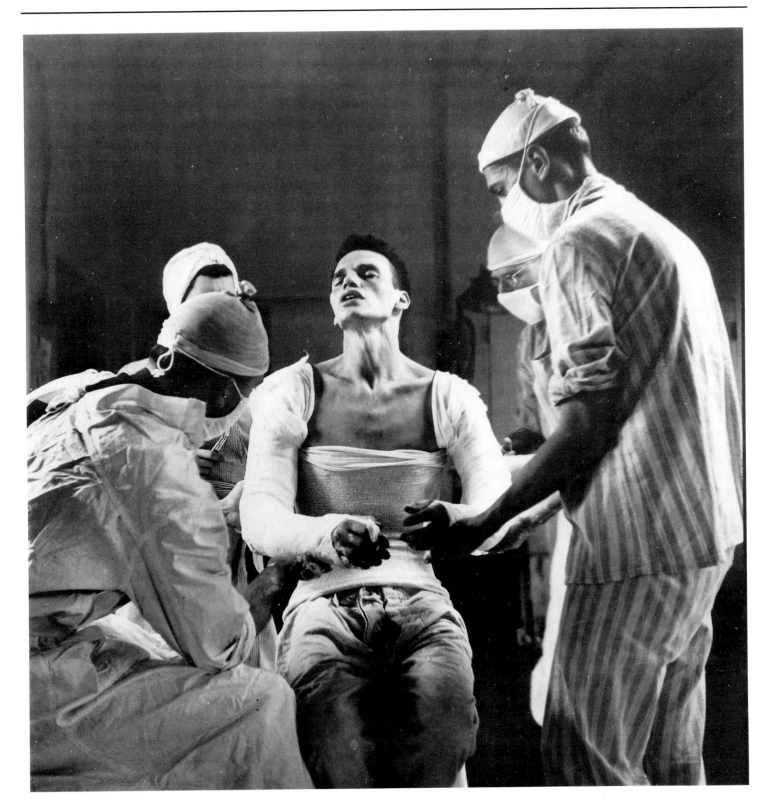

146

Figure 188
Ralph Morse, "A new plaster cast
is fitted to the body of George
Lott, who was wounded by mor-
tar shell in Lorraine with the 35th
division in November 1944,"
1944; gelatin silver print (Time
Inc.)

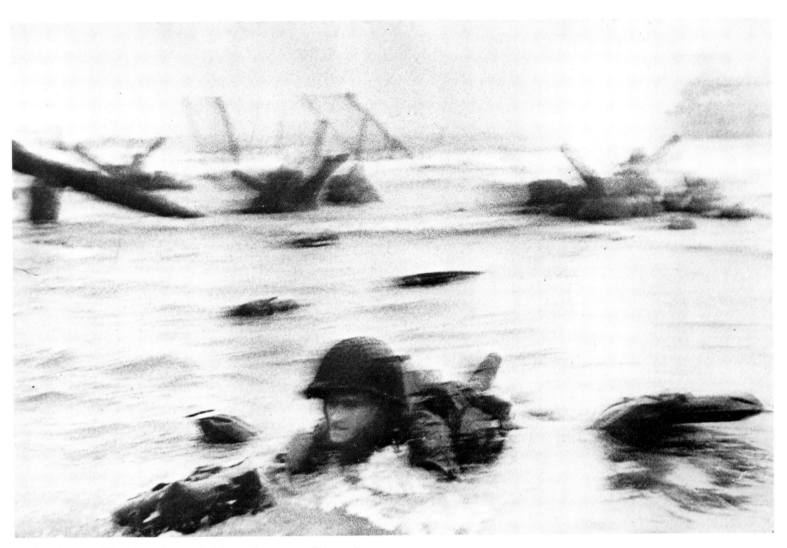

back (Figure 187). The picture is blurry because of the soldier's and Capa's movement. The soldier's body, on the left of the frame, is suspended in air and time. His shadow on the scrubby grass looks like that of a man still standing. No one else is visible in the frame. The photographic power of this lone soldier so recently alive collapsing into death, killed by an unseen hand, remains as strong as ever. It became a controversial photograph, with some critics claiming that Capa had staged it, although it seems unlikely that he would set up so pessimistic a view of a cause he was in sympathy with, let alone find a soldier agreeable to acting it out.

The ghostly images Capa made during the dawn of the D-Day assault were published in *Life*, June 19, 1944. Now in back of the men, now in front, Capa obviously pushed his way to the shore through the water with the troops. They are strange-looking photographs—gray and black streaks of men in action. We are lucky to have them at all. Capa wrote that he learned a week later that the pictures "were the best of the invasion. But the excited darkroom assistant, while drying the negatives, had turned on too much heat and the emulsions had melted and run down before the eyes of the London office. Out of one hundred and six pictures in all, only eight were salvaged."[76]

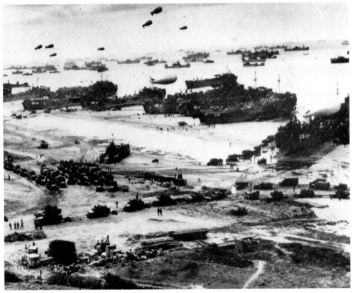

Figure 189 (top)
Robert Capa, "D-Day, Omaha Beach, June 6, 1944"; gelatin silver print (IMP/GEH. Courtesy Magnum)

Figure 190 (bottom)
Unidentified photographer, "D-Day on the Beach," 1944; gelatin silver print (AP)

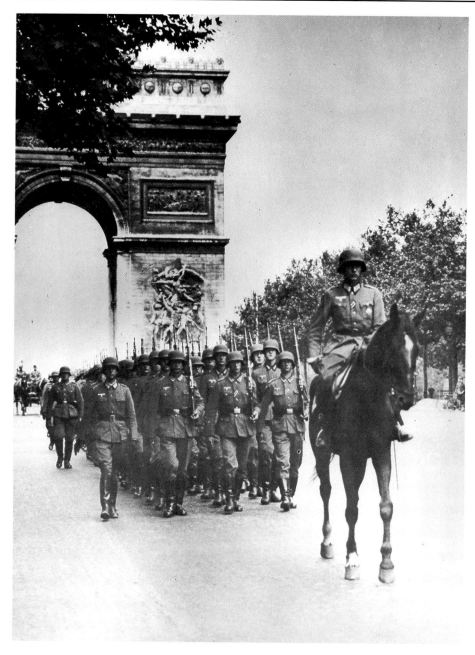

Figure 191
Unidentified photographer, "Nazis march on the Champs Elysees," 1940; gelatin silver print (AP)

Figure 192
Unidentified photographer, "Crying Frenchman: a study in expressions as the flags of France's historic regiments go into exile," 1941; gelatin silver print (AP)
Marseilles, France: The emotions of these spectators were unrestrained as they watched the historic flags of the French regiments leave to cross the Mediterranean.

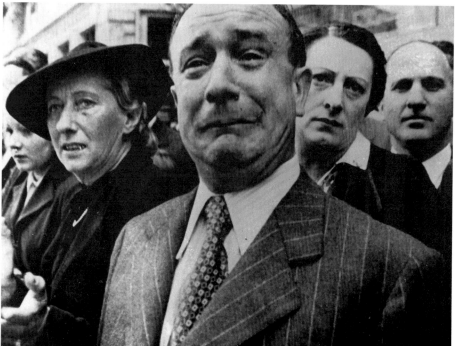

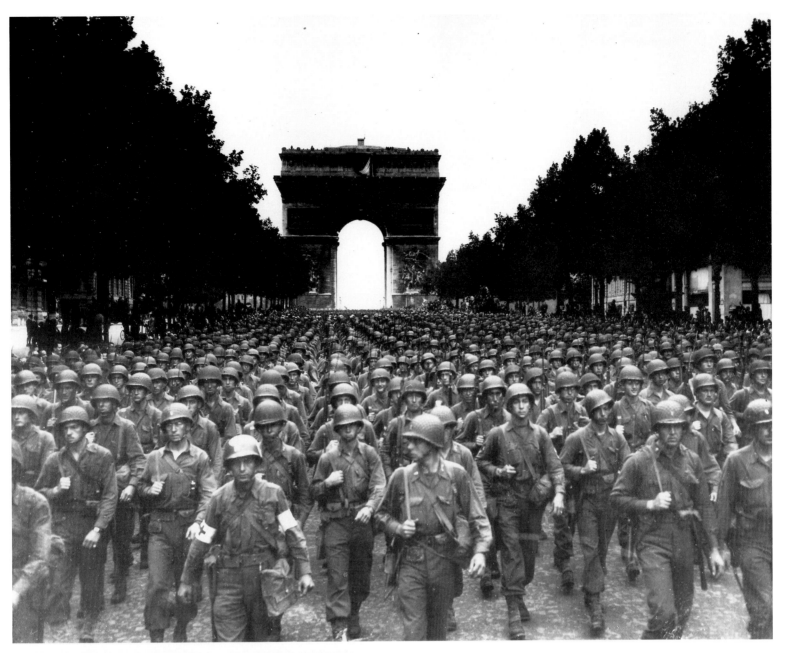

Figure 193
Peter J. Carroll, "Yanks parade through Paris," 1944; gelatin silver print (AP)
American soldiers, thousands strong, march along the Champs Elysées, with the Arc de Triomphe behind them during liberation celebration in the French capital on August 2. This picture was later used on a 3-cent stamp.

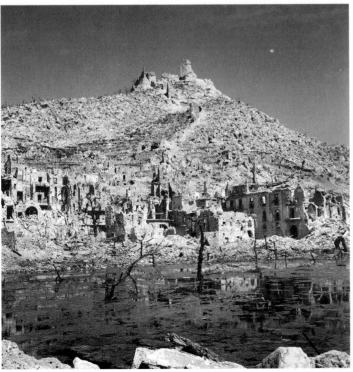

Figure 194
Carl Mydans, "The Abbey of Monte Cassino, Italy, after Allied bombing in spring of 1944," 1944; gelatin silver print (Time Inc.)

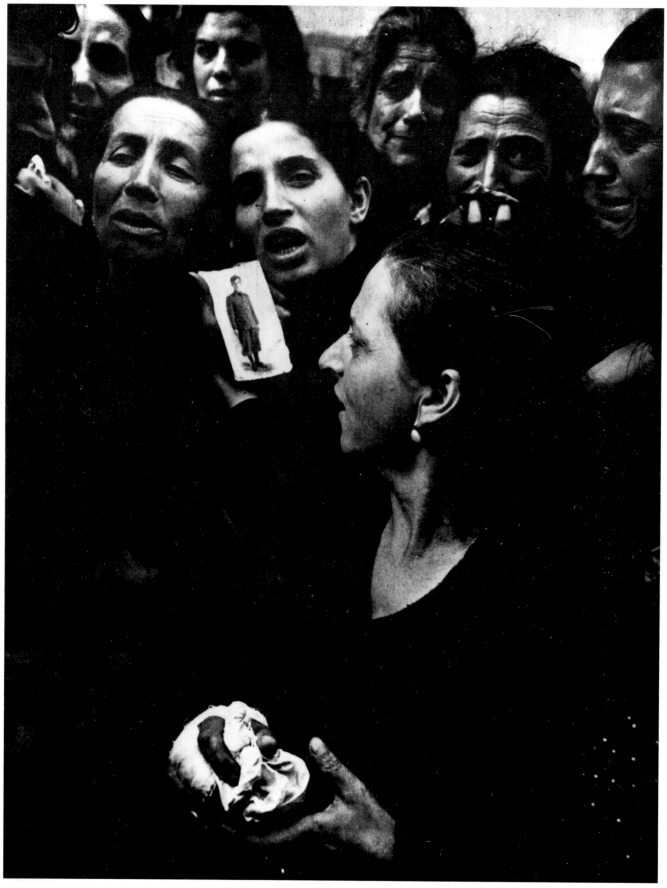

Figure 195
Robert Capa, "Mothers of
Naples," 1943; gelatin silver print
(IMP/GEH. Courtesy Magnum)
*Women grieving for children killed
while attempting to defend the city
from the Germans.*

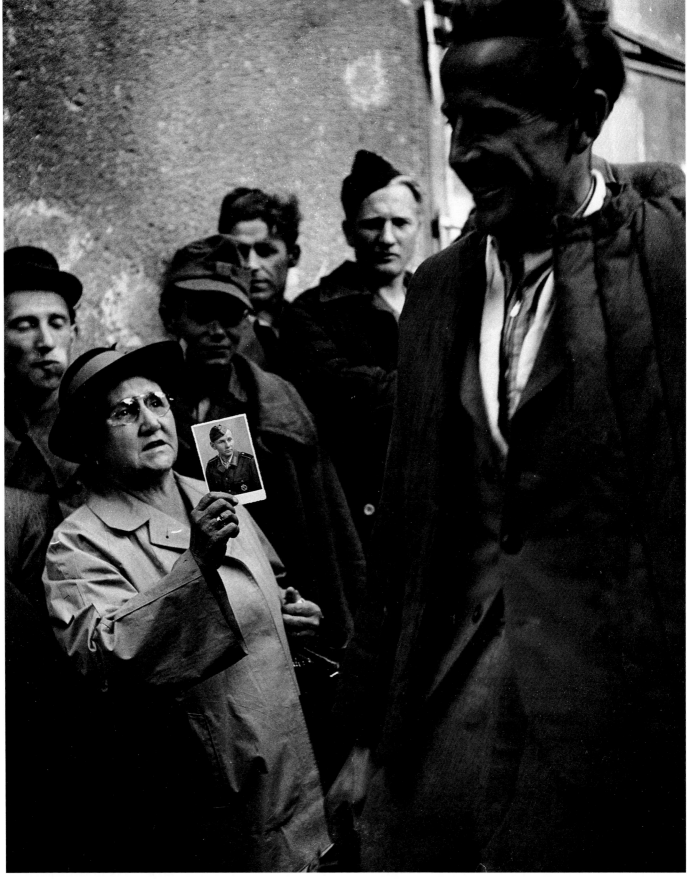

Figure 196
Ernst Haas, "Returning prisoner
of war, Vienna," 1945; gelatin
silver print (Magnum)

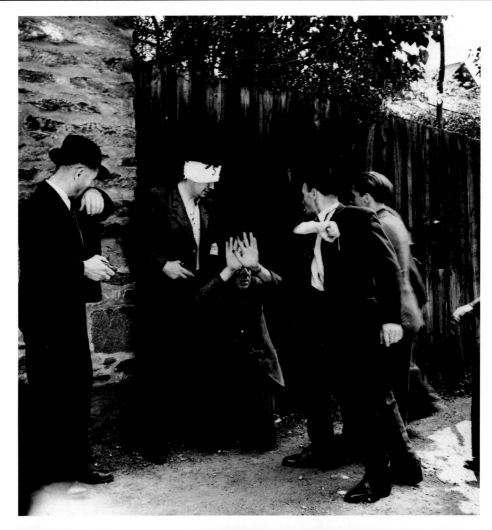

Figure 197
Robert Landry, "French partisans at Rennes get long-awaited inning with a collaborationist. Under the blows of his neighbors he whimpers, 'Vive la Gaulle!'" 1945; gelatin silver print (Time Inc.)
The caption appeared under the photograph when it was reproduced in Life, *Nov. 5, 1945.*

Figure 198
Carl Mydans, "French women accused of sleeping with Germans during the occupation are shaved by vindictive neighbors in a village near Marseilles," 1944; gelatin silver print (Time Inc.)

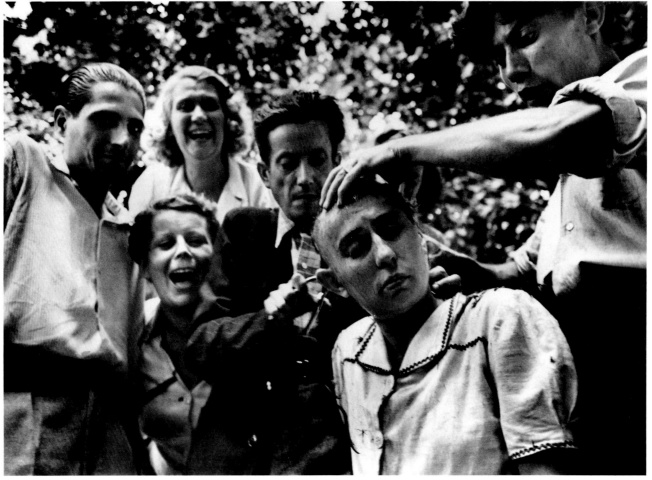

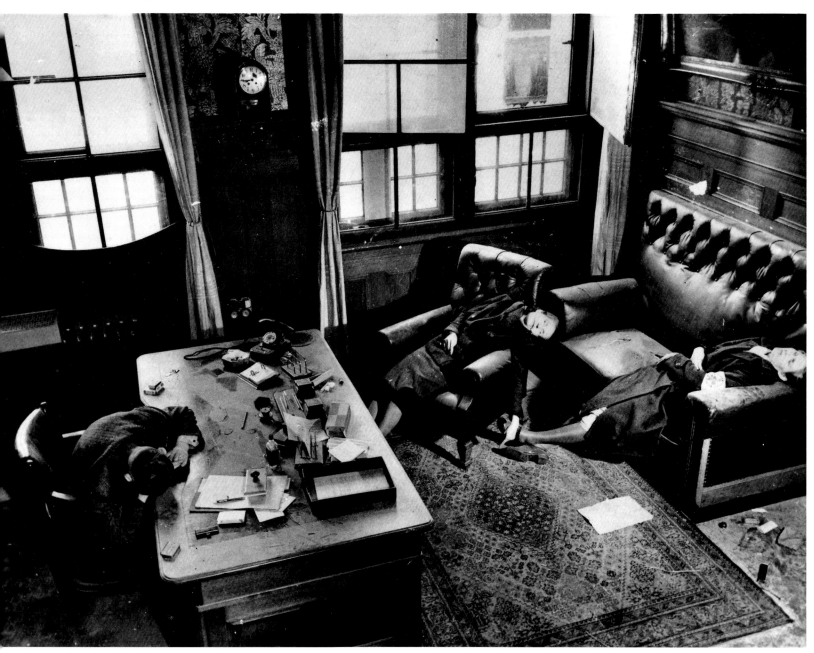

Figure 199
Margaret Bourke-White, "Nazi suicides, 1945"; gelatin silver print (Time Inc.)
The triple suicide of Dr. Kurt Lizzo, Leipzig's city treasurer, his wife, and his daughter (in Red Cross uniform). To avoid punishment by Allies, the family took poison as American troops entered the city.

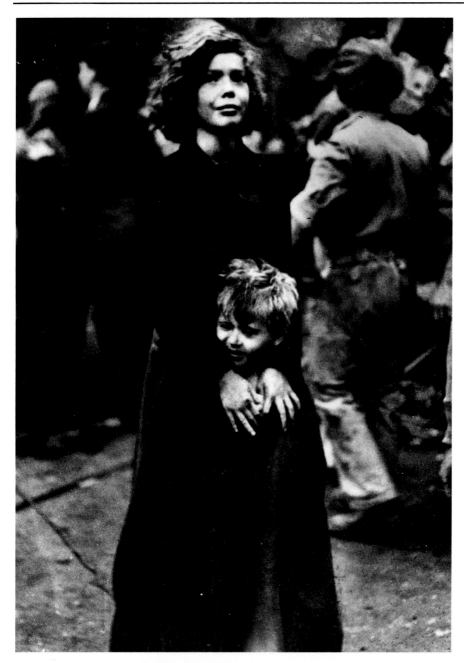

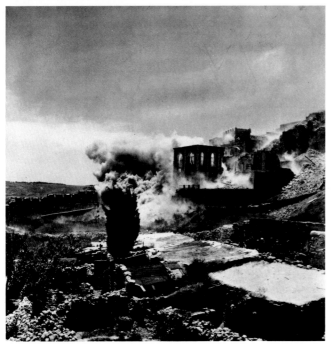

Figure 200 (left)
Cornelius Ryan, "The Dispossessed," c. 1946; gelatin silver print (Courtesy of the Estate of Cornelius Ryan)
Separated from their parents, a fearful sister and brother await deportation as illegal Polish immigrants in postwar Palestine.

Figure 201 (above)
David Seymour, "Poland, 1949"; gelatin silver print (IMP/GEH. Courtesy Magnum)
Taken in a home for disturbed children.

Figure 202 (left)
John Phillips, "Explosion blazes path into Jewish held buildings in the old city of Jerusalem," 1943; gelatin silver print (Time Inc.)

Some photographers were not working for the press or wire services but had enlisted and reported directly to their branch of the armed services. After the attack on Pearl Harbor, David Douglas Duncan came back from an assignment in Mexico and enlisted in the marines. Friends at Kodak and *National Geographic* wrote letters supporting him for a commission as a photographer. Duncan recalls: "I took a very dim view of being just a foot-slogging soldier and I thought that if the marines were giving away commissions, I would rather do that and work. . . . I went in as a combat photographer."[77]

Edward Steichen was commissioned as an officer in the U.S. Naval Reserve at the age of sixty-three and assembled a special photographic unit for Naval Aviation. The six men who began with him were Horace Bristol, Charles Fenno Jacobs, Victor Jorgensen, Charles Kerlee, Dwight Long (motion-picture unit), and Wayne Miller. Photographs produced by the group went far beyond navy use and were published in many magazines and newspapers. As Christopher Phillips points out in his book *Steichen at War,*

with the emergence of television as a mass medium yet a decade away, the image of the war that reached most American homes was supplied by the stream of photographs reproduced in the pages of newspapers and magazines. The papers and, especially, the big picture

magazines were always eager to provide an inside look at the Navy in action, and Steichen was able to furnish them with the kind of exciting, technically superb photographs that they wished their own photographers had made.[78]

Steichen's own photograph captioned "A Grumman F64 Hellcat takes off from the deck of the U.S.S. *Lexington.* November 1943" is a good example of one type of picture the naval unit was striving for (Figure 203). The plane, barely off the deck, is differentiated from its surroundings by its light tonality and blurred motion. The speed and thrust of the craft is enhanced by this contrast. The middle tones of the deck surface below indicate that the plane is pulling away. Part of the carrier looms in the background, bristling with antennae, guns, and other technical equipment. The modern fortress is redeemed from being a totally

Figure 203
Edward Steichen, "A Grumman F64 Hellcat takes off from the deck of the U.S.S. *Lexington.* November 1943"; gelatin silver print (IMP/GEH)

Figure 204
Lt. Victor Jorgensen, USNR, and Alphonso Ianelli, "Cmdr. Edward Steichen photographing from the U.S.S. *Lexington,*" 1943; photomontage, gelatin silver print (IMP/GEH)
Jorgensen's portrait of Steichen was coupled with the Ianelli picture of the carrier's deck to make a montage.

155

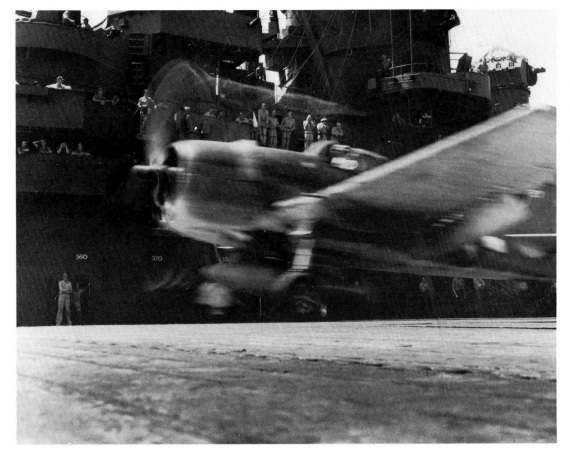

ominous, forbidding structure by the presence of sailors watching in the background. The photograph implies that the United States Navy wields awesome power, but this is not done blindly—men are in charge.

One photographer Steichen fought for and failed to have included in the unit was W. Eugene Smith. Because of poor eyesight and a broken eardrum, Smith was rejected by the navy. The review committee said that "although he appears to be a genius in his field, he does not measure up to the standards of the United States Navy."[79]

However, despite his inability to enlist in the navy, Smith was accredited in 1943 through Ziff-Davis publications to be a naval correspondent in the Pacific. He joined the staff of *Life* in 1944 and was assigned to cover the army.

On Saipan he made a photograph of a soldier drinking from a canteen, another soldier standing beside him (Figure 205). The tight composition reveals the head, in profile, of a sweaty, dirty man, helmet on but unfastened, taking a break. At his right side stands another soldier with his back turned. The second man's head appears above the foreground soldier. Gun on shoulder, head also turned in profile, he appears to be keeping watch. His helmet casts a shadow across his eyes; he is an anonymous figure. His presence, however, adds a tension and a sense of the violent circumstances that the man with the canteen would not have alone. Many of the finest war photographs, such as this one, acknowledged the importance of the anonymous foot soldier; others aided legends in the making.

156

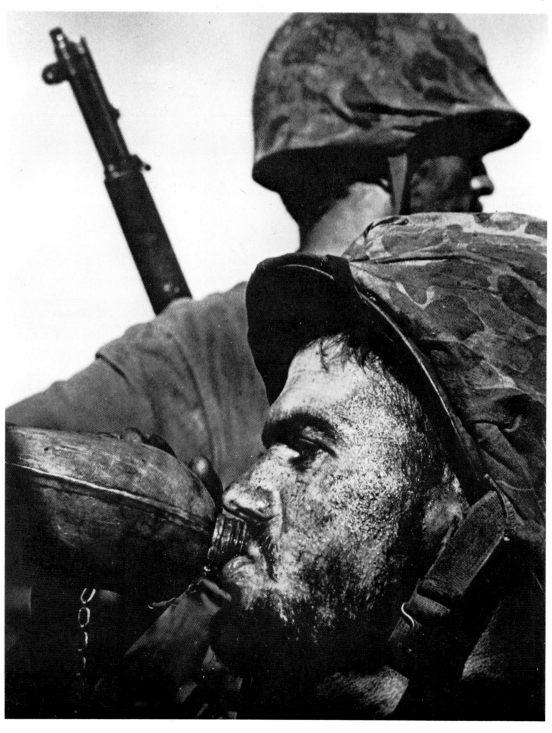

Figure 205
W. Eugene Smith, "Marines at Saipan," 1944; gelatin silver print (IMP/GEH. Courtesy Black Star)

On the homefront: President
Roosevelt died in 1945 before the
end of the war. He was succeeded
by Vice-President Harry S.
Truman (Figures 206, 207, 209).

Figure 206
Edward Clark, "As FDR's body is
carried to the train at Warm
Springs on the day after his death,
CPO Graham Jackson's tear-
stained face symbolizes the
nation's sorrow," 1945; gelatin
silver print (Time Inc.)

Figure 207
Charles Fenno Jacobs, "A crowd
gathered in front of the White
House awaits further news after
the announcement of FDR's
death," 1945; gelatin silver print
(National Archives)

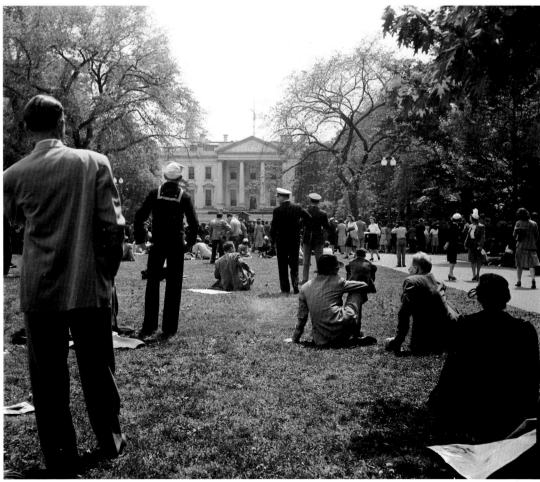

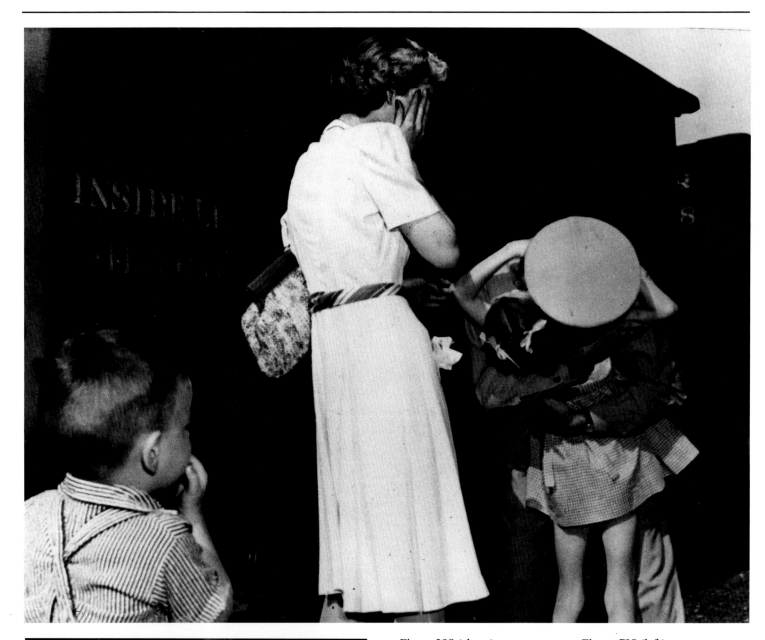

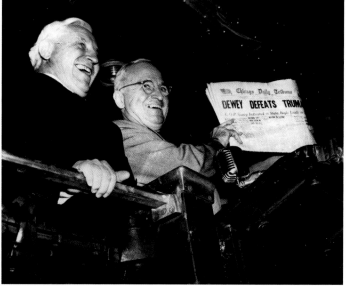

Figure 208 (above)
Earl Bunker, "Homecoming,"
1943; gelatin silver print (AP)
Lt. Col. Robert Moore of Villiosa,
Iowa, greeted by his family after an
absence of 16 months. This photo-
graph won the Pulitzer Prize for
domestic photography in 1944 (two
prizes were given that year).

Figure 209 (left)
Byron Rollins, "One for the
books," 1948; gelatin silver print
(AP)
President Truman holds a copy of the
Chicago Tribune, *published early*
election night with the headline
DEWEY DEFEATS TRUMAN, *for the*
benefit of the throng that turned out
to greet him at St. Louis's Union
Station, November 4. The president
told the crowd, "That is one for the
books." At left is Postmaster Bernard
L. Dickman of St. Louis.

Figure 210 (opposite)
Alfred Eisenstaedt, "V.J. Day at
Times Square, New York City,"
1945; gelatin silver print (Time
Inc.)

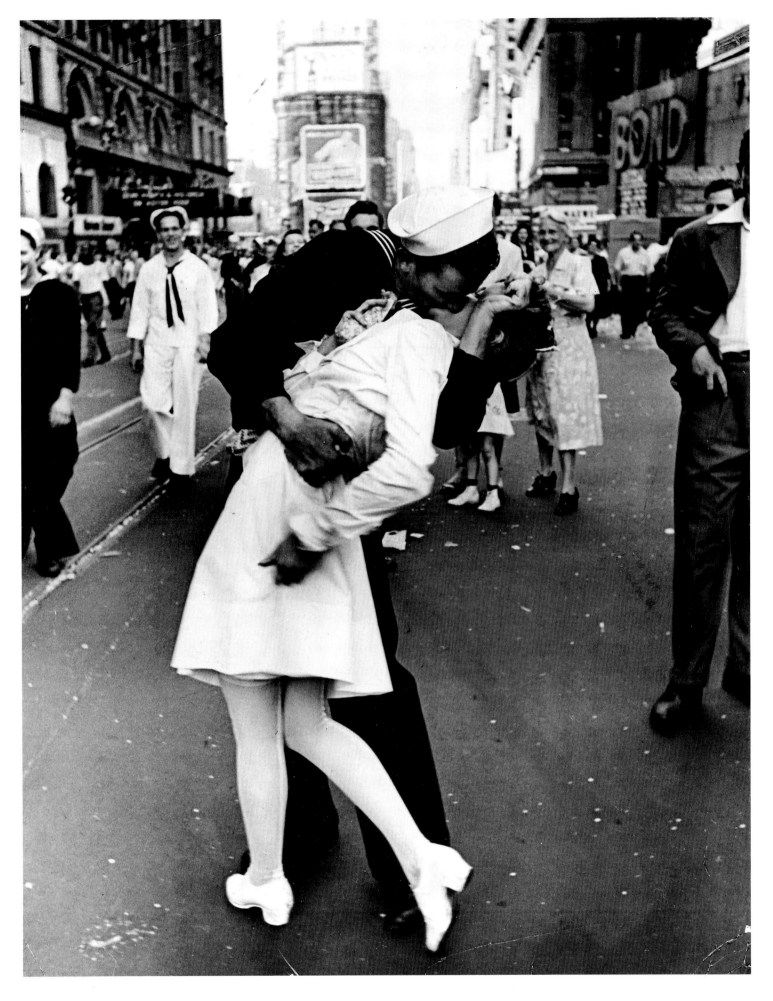

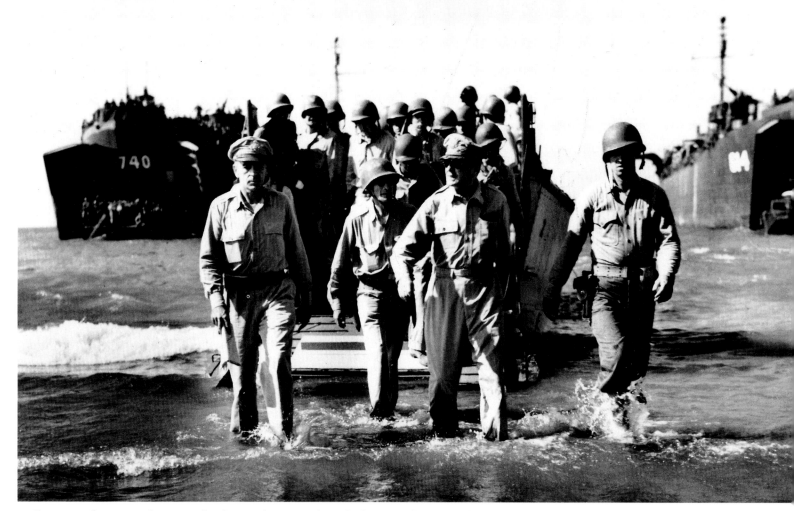

In one famous photograph from the war by Carl Mydans, the subject himself determined the telling circumstances of the setting (Figure 211). Mydans had been invited by Gen. Douglas MacArthur to photograph his promised return to the Philippines after the Japanese were overrun. The photograph shows General MacArthur striding from the landing craft toward shore through water a foot deep. Two large, dark ships on either side frame the figures coming ashore. MacArthur, in the center, is clearly unconcerned about the water or the inconvenience. One supposes greater things are on the famous general's mind. Mydans's story of this historic event gives the photograph a new slant:

> As our landing craft neared the beach I saw that the SeaBees had gotten there before us and had laid a pontoon walkway out from the beach. As we headed for it, I climbed the boat's ramp and jumped onto the pontoons so that I could photograph MacArthur as he walked ashore. But in the instant of my jumping I heard the boat's engines reversing and, swinging around, I saw the

boat rapidly backing away. Judging what was happening, I raced to the beach and ran dry-shod some hundred yards along it and stood waiting for the boat to come to me. When it did it dropped its ramp in knee-deep water and I photographed MacArthur wading ashore. No one I have ever known in public life had a better understanding of the drama and power of a picture.[80]

"Old Glory goes up on Mt. Suribachi, Iwo Jima," arguably the most famous photograph to come out of World War II, is an excellent example of the photograph as icon (Figure 212). People believed in the spirit it conveyed and were cheered by its sense of victory over adversity. It had an immediate, overwhelming impact on the nation. The powerful message of the men surging forward with the wind-whipped flag to raise in the sands of Iwo Jima as the fighting continued was communicated instantly.

The Americans had taken the high ground of Mt. Suribachi, a dormant volcano that the Japanese had fortified and held, after four days of intense combat in February 1945. (The battle continued another thirty-one days, and

Figure 211 (left)
Carl Mydans, "General Douglas MacArthur wades ashore at Lingayen Gulf in Luzon, the Philippines," 1945; gelatin silver print (Time Inc.)
MacArthur returned to the islands on January 9, 1945.

Figure 212 (right)
Joe Rosenthal, "Old Glory goes up on Mt. Suribachi, Iwo Jima," 1945; gelatin silver print (IMP/GEH)
This photograph won a Pulitzer Prize.

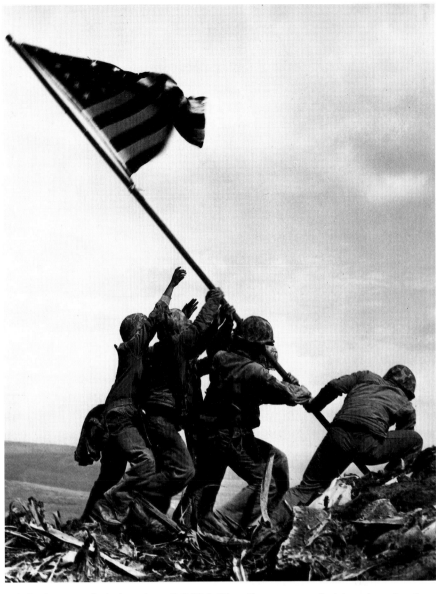

three of the marines shown in the photograph were killed.) One small flag had already been raised, and a small group of five marines and a navy corpsman were about to replace it with a much larger version. AP photographer Joe Rosenthal climbed up Suribachi and made three exposures with his Speed Graphic. AP was able to distribute the photograph a then fast 17½ hours later.

Questions of its authenticity, whether it had been set up, were there from the beginning, however. Rosenthal maintains that it is a candid view of soldiers raising the second, unofficial, flag. *Life* editors rejected the photograph when it first came in. The composition looked too perfect to be true: they suspected that it might be posed. Checking into it, they were told, contrary to Rosenthal, that the photographer himself was responsible for the larger flag and had in fact restaged the event.[81] *Time* used it, as did hundreds and hundreds of magazines and newspapers. Because of the tremendous significance given to the photograph, *Life* published it three weeks later. The magazine reasoned that, whatever the circumstances under which it was taken, it had become to the nation, and to the marines, a symbol of

their heroism.[82] "Old Glory" was accorded iconic value because people believed in its truthfulness. Believing came first. In 1945, Rosenthal was awarded a Pulitzer Prize for the photograph.

The image's separate existence as a symbol obscures the issue of credibility. Certainly AP believed it to be authentic. No news organization can risk jeopardizing its own believability with the public—witness the initial reaction of *Life*'s editors. *Life* was all for making movie stars look glamorous and frequently staged photographs, but this was hard news, and they wanted to be careful.

The picture was copied in paint and served as the official poster for the Seventh War Loan Drive (Plate 5). A statue modeled after the photograph was placed outside of Arlington National Cemetery in Washington, D.C., and a three-cent commemorative postage stamp appeared. It clearly transcended its creation as one news photograph by one man (neither the stamp nor the poster credited Rosenthal) and was embraced with nearly religious fervor. The editors of *U.S. Camera* wrote: "In a sense, in that moment, Rosenthal's camera recorded the soul of a nation."[83]

A month before the German surrender of May 1945, Gen. George Patton's Third Army reached Buchenwald, the first of the Nazi death camps to be liberated. Hearing of the atrocities and experiencing them firsthand were two entirely different things. Bourke-White arrived with Patton's troops (Figure 213). She wrote:

> I saw and photographed the piles of naked, lifeless bodies, the human skeletons in furnaces, the living skeletons who would die the next day because they had had to wait too long for deliverance, the pieces of tattooed skin for lampshades. Using the camera was almost a relief. It interposed a slight barrier between myself and the horror in front of me.
>
> Buchenwald was more than the mind could grasp.[84]

Photographs of the charred, bullet-ridden bodies of those killed as the Nazis withdrew, corpses thrown in stacks like old clothes, and the haunted faces of the living were published as the camps were liberated (Figure 214). Their effect was riveting. In *On Photography* Susan Sontag wrote:

> One's first encounter with the photographic inventory of ultimate horror is a kind of revelation, the prototypically modern revelation: a negative epiphany. For me, it was photographs of Bergen-Belsen and Dachau which I came across by chance in a bookstore in Santa Monica in July 1945. Nothing I have seen—in photographs or in real life—ever cut me as sharply, deeply, instantaneously. Indeed, it seems plausible to me to divide my life into two parts, before I saw those photographs (I was twelve) and after, though it was several years before I understood fully what they were about.[85]

Another kind of horror relayed to the U.S. by photographs was the bombing of Japan. On August 6, 1945, after the surrender of Germany, the United States dropped an atomic bomb on Hiroshima. One member of the bombing crew said: "We turned back to look at Hiroshima. The city was hidden by the awful cloud . . . boiling up, mushrooming, terrible and incredibly tall"[86] (Figure 216). The photographs taken in Hiroshima after the blast are deeply horrifying in their unblinking cataloging of the disaster. "They are not particularly unusual or outstanding photographs, in a stylistic and technical sense . . . ," as A. D. Coleman pointed out. "There is no artifice to hide behind, no re-enactment to place the carnage at one remove from conscience."[87]

It was believed that atomic weapons would make the foot soldier obsolete. But this was an assumption. Korea proved it wrong only five years later.

162

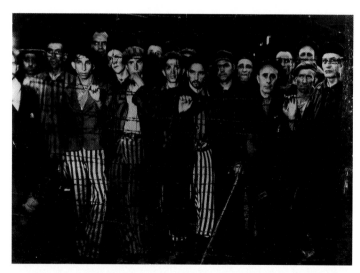

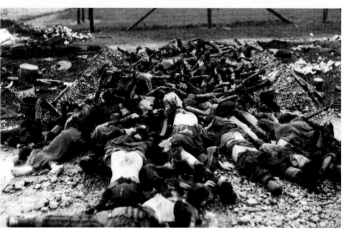

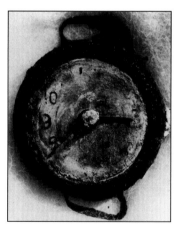

Figure 213
Margaret Bourke-White, "The living dead of Buchenwald," 1945; gelatin silver print (Time Inc.)

Figure 214
Unidentified photographer, "Another Nazi horror camp uncovered," 1945; gelatin silver print (AP)
General Patch's Twelfth Armed Division uncovered another Nazi concentration camp at Schwab-münchen, near the Austrian border, southwest of Munich.

Figure 215
Yuichiro Sasaki, "Time stopped by atom bomb," 1945; gelatin silver print (AP)
The Hiroshima explosion recorded at 8:15 A.M., August 6, 1945, on the remains of a wristwatch found in the ruins in this United Nations photo. The shadow of the small hand on the 8 of the watch was burned in from the blast, making it appear to be the big hand.

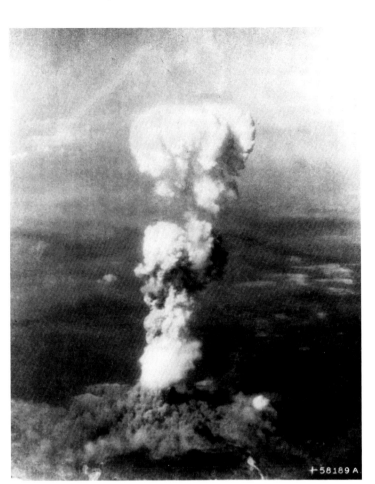

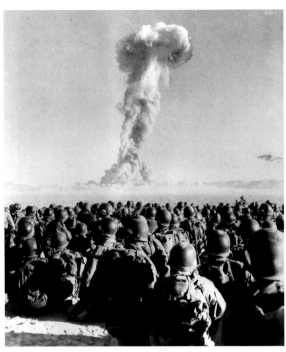

Figure 216 (top left)
Unidentified photographer, "Mushroom cloud, Hiroshima," 1945; gelatin silver print (AP)

Figure 218 (bottom)
Unidentified photographer, "Hiroshima's radiators remain, but not her houses—," 1945; gelatin silver print (AP)

Figure 217 (top right)
Unidentified photographer, "Troops get 'feel' of atomic warfare," 1951; gelatin silver print (AP)
Crouched down and watching, troops of the Eleventh Airborne Division see atomic explosion in the Nevada desert on November 1.

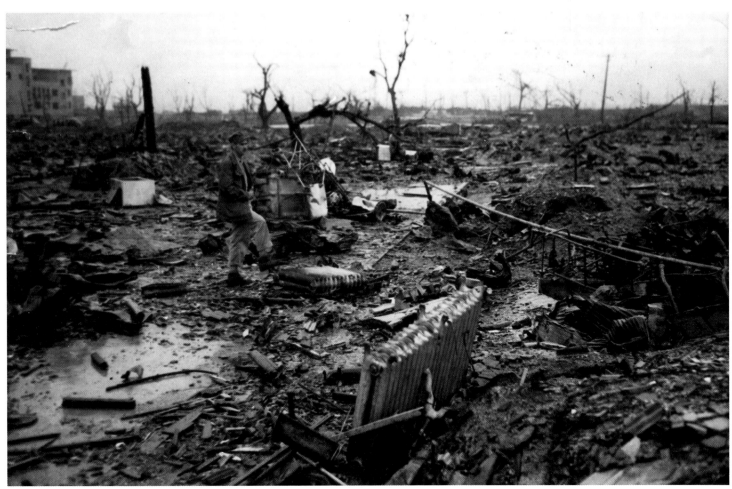

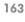

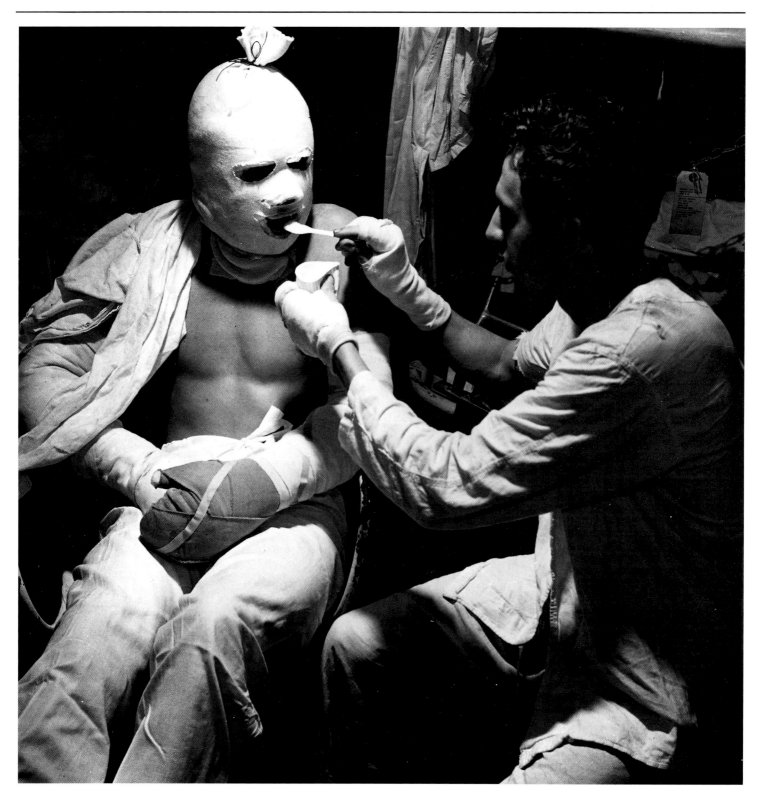

Figure 219
Victor Jorgensen, "WW II: Lunch
for a kamikaze victim, burn ward,
U.S.S. *Solace*," 1945; gelatin silver
print (IMP/GEH)

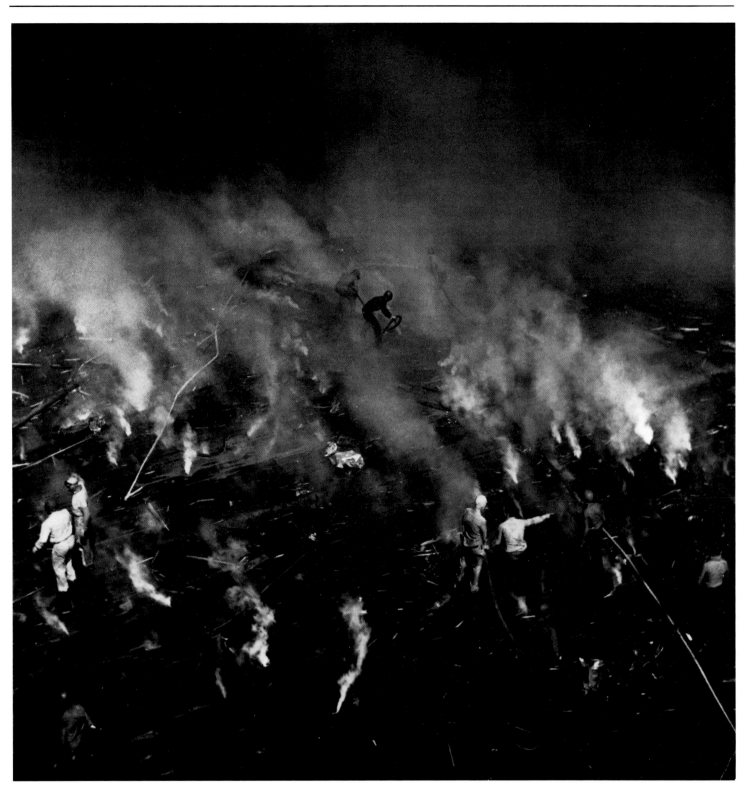

Figure 220
Barrett Gallagher, USNR,
"Firefighters of the U.S.S. *Intrepid*
battling blazes caused by kamikaze
hit during the battle for Leyte
Gulf," 1944; gelatin silver print
(IMP/GEH. Courtesy Barrett
Gallagher)

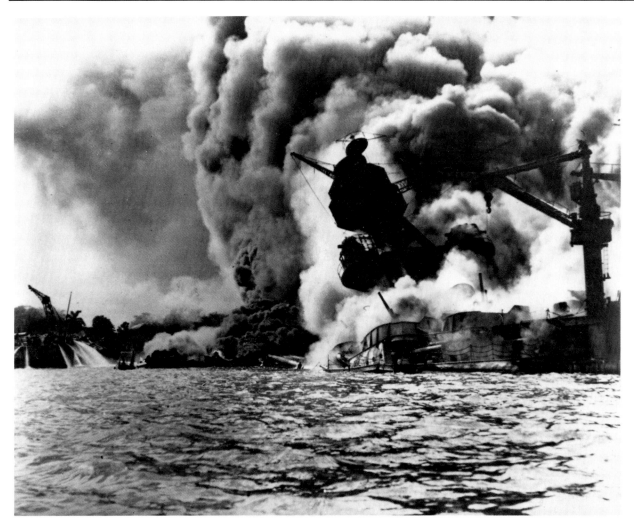

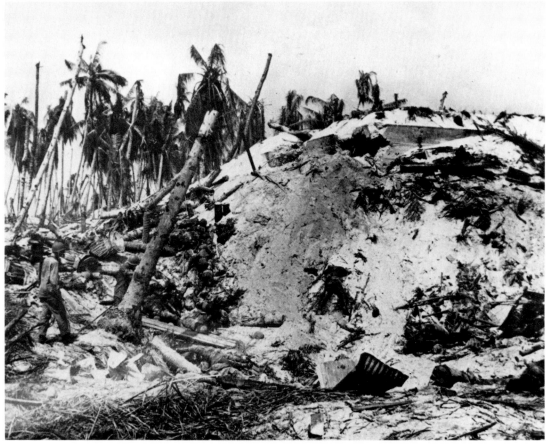

Figure 221
Unidentified photographer, "Pearl Harbor," 1941; gelatin silver print (AP)
On December 7, 1941, an air fleet of Japanese fighters, dive bombers, and torpedo planes attacked U.S. airfields and crippled the U.S. Pacific Fleet at Pearl Harbor on the Hawaiian island of Oahu.

Figure 222
Frank Filan, "Tarawa Island," 1943; gelatin silver print (AP)
A blasted Japanese pillbox on Tarawa in the South Pacific after the invasion of the island by U.S. Marines. This received the Pulitzer Prize in 1944.

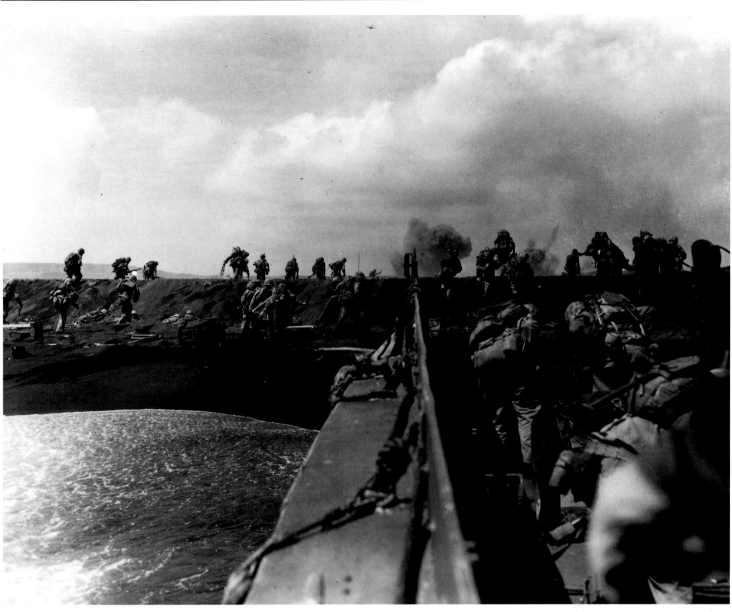

Figure 223
Joe Rosenthal, "Fourth Marines
hit Iwo Jima Beach," 1945; gelatin
silver print (AP)
*Fourth Division Marines dash from
landing craft, dragging equipment,
while others go over the top of a sand
dune as they hit the beach of heavily
fortified Iwo Jima, Volcano Islands,
February 19. The smoke of the artil-
lery fire rises in the background.*

Quint, his assistant, who simply did not miss. They stayed up day and night to back you up and you knew that—you'd take any chance."[90]

For the Korean war, many photographers had switched to smaller-format cameras. Many used a Rolleiflex while some still used the Speed Graphic. In 1950 Duncan, like most Americans, was not aware of the Japanese optical industry. Discovering the quality of Nikor lenses, he had them mounted on his Leica in Tokyo. The change was noted, and according to Duncan, within two months there was a major story in the *New York Times* about the great new Japanese lenses. The Speed Graphic and Rolleiflex had presented the same problem: the photographer had to be at least partially upright to look through the viewfinder. One could then, as Duncan observed, "get your tail shot off."[91] So, many photographers began to use smaller cameras.

As an AP photographer, Max Desfor officially used a Speed Graphic. According to Duncan, in Korea he also used a Leica/Nikor combination. The quality was good enough that he transmitted 35mm work without the home office spotting any difference.

In 1951 Desfor received a Pulitzer Prize for his photograph of Koreans climbing over a demolished bridge half in the water, half out, to flee the Chinese Communists sweeping down from the north (Figure 226). The view, taken from above, shows refugees inching their way along the top of the structure. The desperation is implicit in the dangerous balancing act of the figures receding from view, too many to count. The photograph's extraordinary subject is one example of the intensity that differentiates photography in a combat situation from much photojournalism.

Combat photography deals in extremes—populations and soldiers under pressure. More than just horrific pictures of wounded people and decimated towns, the awareness of conflict nearby heightens the sense of danger and makes even ordinary gestures extraordinary. Again, Smith's photograph of the soldier with canteen would function very differently if the soldier were instead a Welsh miner taking a break from his labors.

Photojournalism is involved in history; war photographs are our memories of great historical events. Because they often deal with people functioning on basic emotions, stripped of refinements, the great photographs describe what it is to be human. Up through World War II, important war photographs, like the grand historical paintings of other centuries, also dealt with the famous generals and heroes: Napoleon at the front or MacArthur returning to the Philippines. The character of future conflicts would change, policies would be altered, and public attitudes would shift, making heroes harder to come by or to accept. In 1970 David Douglas Duncan published a book of photographs titled appropriately *War Without Heroes*. ⊙

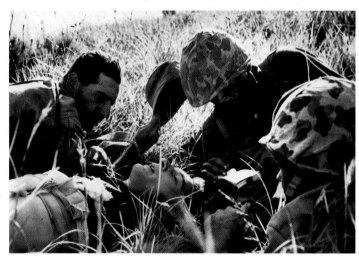

Figure 227
Unidentified photographer, "Aid for wounded correspondent," 1950; gelatin silver print (AP)
William D. Blair, Jr., correspondent for the Baltimore Sun, *lies on ground after being wounded in South Korea. Shading his face from the hot sun is Max Desfor (left), Associated Press staff photographer.*

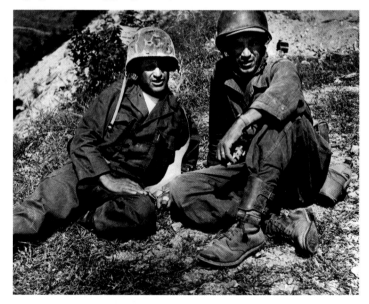

Figure 228
Carl Mydans, "Photo of Carl Mydans and David Douglas Duncan in Korea," 1950; gelatin silver print (Time Inc.)

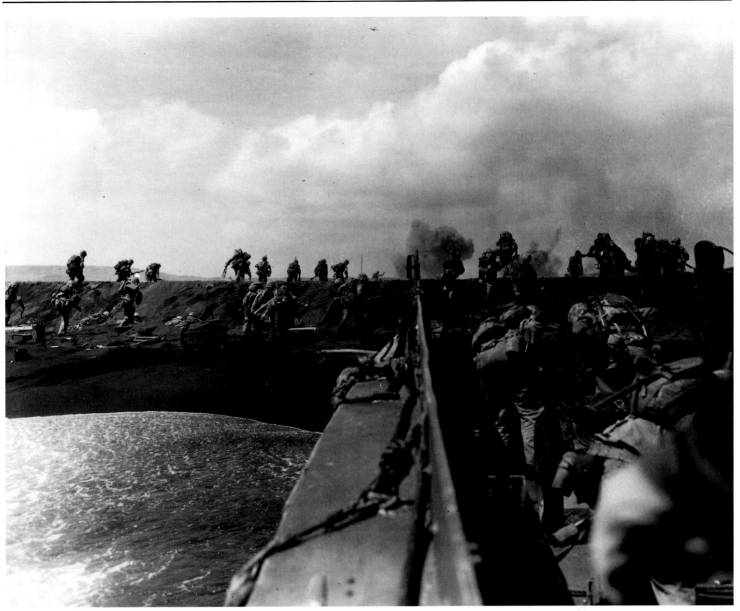

Figure 223
Joe Rosenthal, "Fourth Marines
hit Iwo Jima Beach," 1945; gelatin
silver print (AP)
*Fourth Division Marines dash from
landing craft, dragging equipment,
while others go over the top of a sand
dune as they hit the beach of heavily
fortified Iwo Jima, Volcano Islands,
February 19. The smoke of the artil-
lery fire rises in the background.*

Another War: Korea

In Korea the problems of conveying a sense of the situation were as difficult as they had been in other wars. Ironically, most great war photographs are not of "war," that is, open conflict. Unless adversaries are fighting hand-to-hand, only one side is available to the photographer at any one time. Succinct moments, like Smith's soldier with a canteen or the look on a man's face, tell the story (Figures 205, 230). War, the all-encompassing cataclysmic event, tears apart the lives of individual people, and it is with those people that photography deals. The clash of anonymous large armies facing off against each other becomes a closet drama—something only Hollywood conjures through fast cuts from one side to the other. Being there is much different.

The photographer whose work is most closely associated with the Korean war is David Douglas Duncan. Just as Robert Capa's name is linked irrevocably to photography of the Spanish civil war, so Duncan's is with the Korean. He, like dozens of other photographers who covered the conflict, had also worked in the preceding war.

Duncan covered the war for *Life* magazine. His photographs of soldiers are different from many published by that magazine during World War II, in ways that probably reflect certain characteristics of the Korean war itself. The war was different from World War II: it was undeclared. The United States troops were part of a United Nations "police action." It would also be the first time America fought a war it didn't clearly win.

Duncan's photographs show the muck and struggle of war. He often worked very close, the marines' individual faces crowding the edge of the frame. Pushed to the edge of their endurance, the men display utter exhaustion and the gamut of emotions. In his book *This Is War!* Duncan did not use explanatory captions because he believed "that the look in that man's eyes tells more clearly what he felt"[88] than the photographer could ever hope to surmise.

War photography, Duncan likes to say, is easy—meaning that the photographer is not hampered by the subjects' self-conscious posing: they're too busy trying to stay alive. Particularly when under fire, they are keeping low, returning fire, and trying to keep from getting shot. The presence of a photographer, also lying on the ground, or his particular photographic concerns are not an issue.[89]

In *Life*, such layouts as "There Was a Christmas" showed not celluloid heroes impeccably uniformed, but real men fighting a rough campaign in a hostile climate.

As for being a *Life* correspondent, Duncan felt it was worth the risk to get the tough pictures because the support at the home office was so strong: "[You] knew there were guys like Ed Thompson (managing editor), Peggy Sargent and Charlie Tudor, the art director, and Bernie

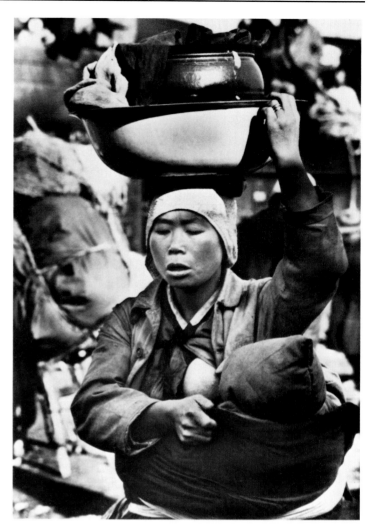

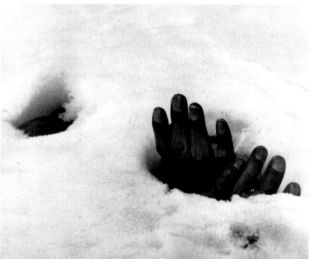

Figure 224 (top)
Carl Mydans, "A Korean mother carrying her baby and her worldly goods flees the fighting around Seoul in the winter attack on the Korean capital in 1951"; gelatin silver print (Time Inc.)

Figure 225 (bottom)
Max Desfor, "This pair of tied hands was found protruding from the snow at Yangji on the central front, Korea," 1951; gelatin silver print (AP)

Figure 226 (opposite)
Max Desfor, "Koreans flee Communists," 1950; gelatin silver print (AP)
Pyongyang residents and refugees from other areas crawl perilously over shattered girders of city's vehicular bridge on December 4, as they flee south across the Taedong River to escape Chinese Communists.

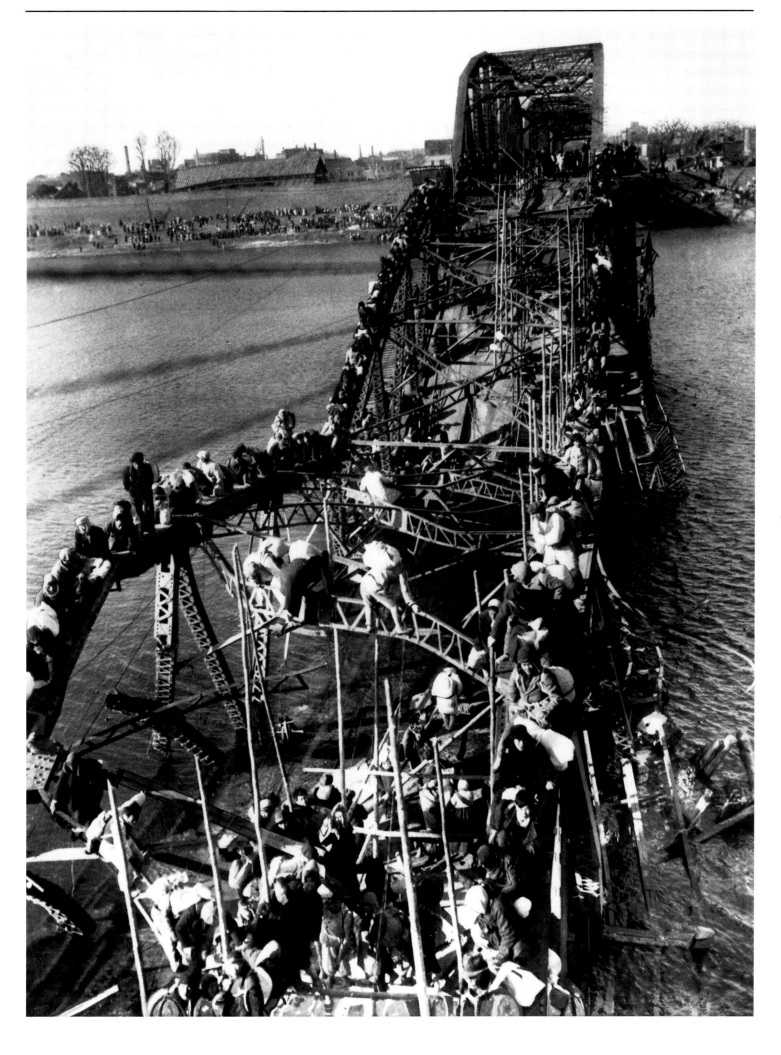

Quint, his assistant, who simply did not miss. They stayed up day and night to back you up and you knew that—you'd take any chance."[90]

For the Korean war, many photographers had switched to smaller-format cameras. Many used a Rolleiflex while some still used the Speed Graphic. In 1950 Duncan, like most Americans, was not aware of the Japanese optical industry. Discovering the quality of Nikor lenses, he had them mounted on his Leica in Tokyo. The change was noted, and according to Duncan, within two months there was a major story in the *New York Times* about the great new Japanese lenses. The Speed Graphic and Rolleiflex had presented the same problem: the photographer had to be at least partially upright to look through the viewfinder. One could then, as Duncan observed, "get your tail shot off."[91] So, many photographers began to use smaller cameras.

As an AP photographer, Max Desfor officially used a Speed Graphic. According to Duncan, in Korea he also used a Leica/Nikor combination. The quality was good enough that he transmitted 35mm work without the home office spotting any difference.

In 1951 Desfor received a Pulitzer Prize for his photograph of Koreans climbing over a demolished bridge half in the water, half out, to flee the Chinese Communists sweeping down from the north (Figure 226). The view, taken from above, shows refugees inching their way along the top of the structure. The desperation is implicit in the dangerous balancing act of the figures receding from view, too many to count. The photograph's extraordinary subject is one example of the intensity that differentiates photography in a combat situation from much photojournalism.

Combat photography deals in extremes—populations and soldiers under pressure. More than just horrific pictures of wounded people and decimated towns, the awareness of conflict nearby heightens the sense of danger and makes even ordinary gestures extraordinary. Again, Smith's photograph of the soldier with canteen would function very differently if the soldier were instead a Welsh miner taking a break from his labors.

Photojournalism is involved in history; war photographs are our memories of great historical events. Because they often deal with people functioning on basic emotions, stripped of refinements, the great photographs describe what it is to be human. Up through World War II, important war photographs, like the grand historical paintings of other centuries, also dealt with the famous generals and heroes: Napoleon at the front or MacArthur returning to the Philippines. The character of future conflicts would change, policies would be altered, and public attitudes would shift, making heroes harder to come by or to accept. In 1970 David Douglas Duncan published a book of photographs titled appropriately *War Without Heroes*. ⊙

Figure 227
Unidentified photographer, "Aid for wounded correspondent," 1950; gelatin silver print (AP)
William D. Blair, Jr., correspondent for the Baltimore Sun, *lies on ground after being wounded in South Korea. Shading his face from the hot sun is Max Desfor (left), Associated Press staff photographer.*

Figure 228
Carl Mydans, "Photo of Carl Mydans and David Douglas Duncan in Korea," 1950; gelatin silver print (Time Inc.)

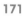

Figure 229
Al Chang, "Korea," 1950; gelatin silver print (AP)
A grief-stricken American infantry-man whose buddy has been killed in action is comforted by another soldier. In the background, a corpsman methodically fills out casualty tags, Haktong-Ni Area, Korea.

Figure 230
Michael Rougier, "The shock of freedom," c. 1953; gelatin silver print (Time Inc.)
Pfc John Ploch after his release from captivity in Korea.

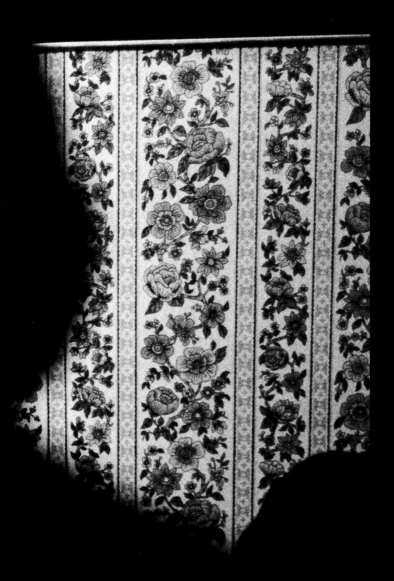

CHANGING FOCUS

The 1950s to the 1980s

by Marianne Fulton

PHOTOJOURNALISM changed markedly from the 1950s through the 1980s. Both stylistically and technically, the pictures began to look different. The decline of major picture magazines and the advent of large French agencies radically altered the market for photography. As the major national issues in the United States emerged, including McCarthyism, communism, the civil rights movement, the war in Vietnam, and the Middle East crisis, many photojournalists explored more personal approaches to the coverage of events. The coming of electronic cameras and satellite transmission of images in the 1980s changed the future of photography and photojournalism dramatically.

Figure 231
Unidentified photographer, "Home town greets Elvis," 1956; gelatin silver print (AP)
They turned out by the thousands to see Elvis Presley perform at the Mississippi-Alabama state fair.

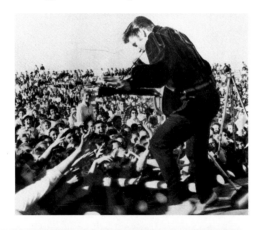

Figure 232 (left)
Unidentified photographer, "Berlin jitterbug champs," 1952; gelatin silver print (AP)
The first-place winners of Berlin's jitterbug championship, Helga Haier and Dieter Heidemann. Kurt Widmann, at left, was leader of one of Germany's top jazz bands.

Figure 233 (right)
Carl Mydans, "On the Nixon campaign trail in 1956"; gelatin silver print (Time Inc.)

The Photo Essay

The 1950s got off to an ominous start in the United States when Senator Joseph McCarthy made his first Red-baiting speech in Wheeling, West Virginia, on February 9, 1950. He claimed that 205 known Communists were currently working in the U.S. State Department. "While I cannot take the time to name all the men in the State Department who have been named as members of the Communist party and members of a spy ring, I have here in my hand a list."[1] So began "the curious wave of political vindictiveness and mass hysteria that came soon to be known as 'McCarthyism.'"[2]

McCarthy played on the country's shock over recent events: the Soviet Union's development of its own nuclear bomb only four years after Hiroshima; the subsequent spy trial of Julius and Ethel Rosenberg; the conviction in the widely publicized Alger Hiss trial; the sense that the United States had "lost" China to the Communists; and the start of the Korean war four months after McCarthy's initial speech. McCarthy's manipulation of these circumstances profoundly affected the United States long after his censure in 1954 and death in 1957.

McCarthy was helped considerably by the weaknesses of the press. As author David Halberstam points out, an uncritical press meant that the emptiness of his charges against

Figure 234
Carl Mydans, "Senator Joe McCarthy has his picture taken in 1951"; gelatin silver print (Time Inc.)

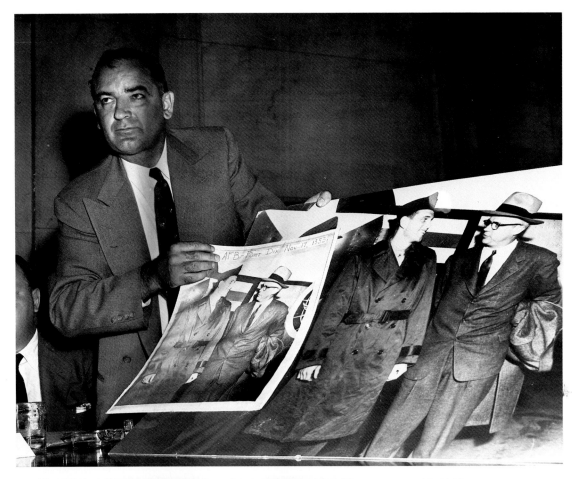

Figure 235
William J. Smith, "The Focus of Attention," 1954; gelatin silver print (AP)
Sen. Joseph McCarthy, key figure in the Army hearings in Washington, discusses a controversial photograph of Army Secretary Stevens and Pvt. G. David Schine late in April. The senator was answering charges that the photograph in the foreground, submitted as an exhibit at the hearings, had been altered.

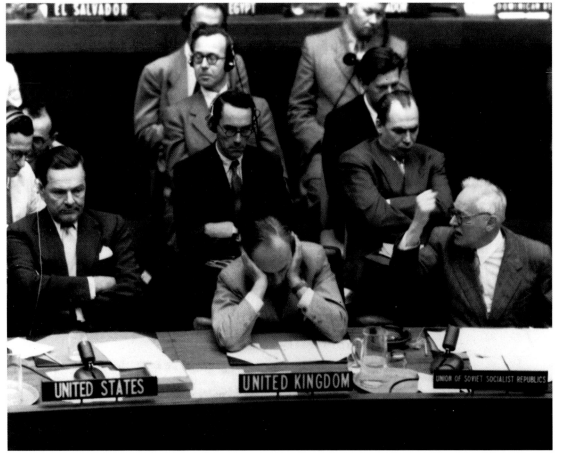

Figure 236
John Lindsay, "Soviet Sound Off," 1953; gelatin silver print (AP)
Listening to the Soviet delegate's charges are Henry Cabot Lodge, Jr., U.S. Representative to the U.N., and Britain's Sir Gladwyn Jebb, center. Russia's Andrei Vishinsky accused the Allies of trying to jam through an ultimatum to the Communists on the makeup of the Korean peace conference.

citizens did not catch up with him. The American press was "exploited in its false sense of objectivity (if a high official said something, then it was news, if not fact, and the role of the reporter was to print it straight without commenting, without assaulting the credibility of the incredulous; that was objectivity)."[3]

The uncertainties and suspicions of the period exploited by McCarthy had an effect on the photographs of Robert Frank. While Frank's book *The Americans* does not fit into the category of photojournalism as defined here, his influence can be seen in the work of later photojournalists. A Swiss citizen, he was disturbed by what he saw while traveling across the United States in 1955–1956. Later he said that his photographs "came naturally to show what I felt, seeing those faces, those people, the kind of hidden violence. The country at that time—the McCarthy period—I felt it very strongly."[4]

The work was published in Paris in 1958 as *Les Américains* because Frank could not find a publisher in the United States. "They wouldn't publish it," he said. "They thought it was terrible—anti-American, un-American, dirty, overexposed, crooked."[5] The next year it was published by Grove Press as *The Americans* with a new introduction by Jack Kerouac.

The book was a radical breakthrough in American photography. Though scarcely appreciated at the time, it raised important issues for the future of photojournalism. Although the book's photographs were made in the seemingly casual style of small-format photojournalism, they were pointedly nonobjective and carefully sequenced. Here the working method was dictated by the photographer's individual point of view, not by the editorial staff of a newspaper or picture magazine. "I wanted to follow my own intuition and do it my way, and not make any concession— not make a *Life* story. That was another thing I hated. Those goddamned stories with a beginning and an end."[6]

The Americans does not progress, it accumulates. In its pages people wait, they watch, they seldom participate. There are lonely highways, empty tables, glaring lights. Blacks sit in the back of a southern trolley car, children walk beneath a torn, transparent flag on the Fourth of July, and a black woman holds a white baby in South Carolina. Little by little a sense of alienation grows.

"Parade—Hoboken, New Jersey" is the first reproduction in the book (Figure 237). A woman's figure appears in each of two windows. The shade of the left window throws one woman's face into shadow. An American flag attached to the window frame blows across the right window, totally blocking the second woman's face. No parade is shown, only these isolated figures in an unremarkable brick facade, making the title's function heavily ironic.

Sequenced photographs are not necessarily a photo

177

Figure 237
Robert Frank, "Parade—
Hoboken, New Jersey," 1955;
gelatin silver print (IMP/GEH.
Courtesy Pace/MacGill Gallery)
The first plate from Frank's book,
The Americans.

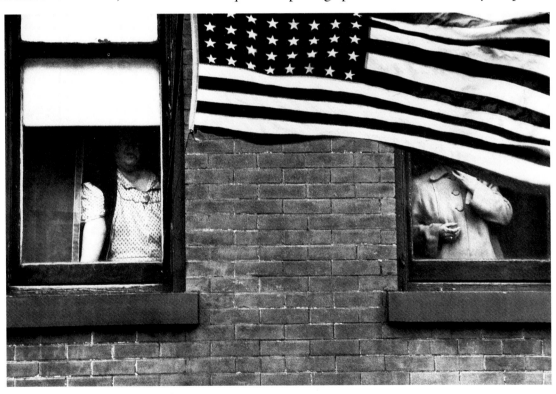

essay, and they are very different from what Henry Luce called a "strip sequence"; that is, they are not photographs in chronological order showing an unfolding event. A photographic sequence can function as words do in a sentence. The overall meaning of the sentence changes as the words change position within it. One word's nuances can be altered depending on its position in the sentence's structure. In the words of critic Alan Trachtenberg,

> In sequence, . . . each image becomes part of a chain, contributes to, and takes force from, the totality. Each is a moment toward the accomplishment of meaning, the fulfillment of the range of significance of each other. The totality serves as a wordless caption, the source of authority—and the determining whole through which the viewer encounters the rich, irreducible specificity of each particular moment. Greater than the sum of its parts.[7]

In *The Americans* then, while an individual image such as "Parade—Hoboken, New Jersey" may be strong, placed within the texture of the book it influences the meaning of the pictures that follow and also gains in meaning by their presence. The sequence, a procedure that continues to be used by photographers such as Don McCullin, Mary Ellen Mark, Susan Meiselas, Julio Mitchel, and Gilles Peress, provides the context for understanding the photographs both intellectually and emotionally.

178

Figure 239
Robert Frank, "Charleston, South Carolina," 1955; gelatin silver print (Courtesy Pace/MacGill Gallery)

Figure 240
Robert Frank, "Butte, Montana," 1955/56; gelatin silver print (Courtesy Pace/MacGill Gallery)

Figure 241
Robert Frank, "Yom Kippur—East
River, New York City," 1955/56;
gelatin silver print (Courtesy Pace/
MacGill Gallery)

Figure 242
Robert Frank, "Fourth of July—
Jay, New York," 1955; gelatin
silver print (Courtesy Pace/
MacGill Gallery)

The photo essay shares some points with the photo sequence: order and size of the photographs remain important considerations in the structuring of meaning. Smaller photographs, for example, might depict incidents leading up to and explaining a significant occurrence that would be reproduced larger. However, in other aspects a sequence and a photo essay differ considerably. The photo essay grew to prominence in the United States almost solely because of its use in *Life* magazine. W. Eugene Smith is one photographer linked with the maturation of the essay's evolution. In *Life*, the essays often stressed a narrative structure with a definite beginning, middle, and end. Wilson Hicks, in his book *Words and Pictures,* wrote: "A picture story was referred to as an 'act', and the description, borrowed from the theater, had a peculiar fitness; it implied the visual and concrete, and somehow made pictures seem more manageable. . . . Any given act could be laid out several different ways, but only one way was right with respect to what the editors intended it to say."[8]

The photo essay is a single, unified statement. Harold Evans, former picture editor of the London *Sunday Times Magazine,* believes that in a picture story the basic idea should be clear, starting with a key photograph to set the stage; the essay should flow from one point to the next, closing with a photographic statement almost as powerful as the beginning one; and it should employ suitable design techniques, such as coupling, sequence and contrast.[9]

The photo essay can tell a story in a fairly straight narrative fashion; it has meaning that can be understood by the viewer. Meaning can be imparted as much by the layout as by the photographs themselves. It is a "concentration of emotion, or in sight, or beauty, the coherence of a single point of view."[10] Usually it is the work of one photographer, increasing the chances for consistency.

Margaret Bourke-White saw the process as architectural: "In working on a large photo-essay . . . I always feel as though I am building a piece of architecture thinking of each subject not for itself alone, but as something to be integrated with the main theme. I am always nervous as a cat until the main building blocks are in place."[11]

The structure and internal relationships of the photographs do more than provide factual meaning to events or situations, they also imply certain values and interpretations of those circumstances.

The picture essay originated not with the photographer,

"Freedom's Fearful Foe: Poverty," *Life*, June 16, 1961. Parks's photo essay focused on the child Flavio and his family living in the slums of Rio de Janeiro.

Figures 243–244
Gordon Parks, "Flavio, 1961"; gelatin silver prints (Courtesy Gordon Parks)

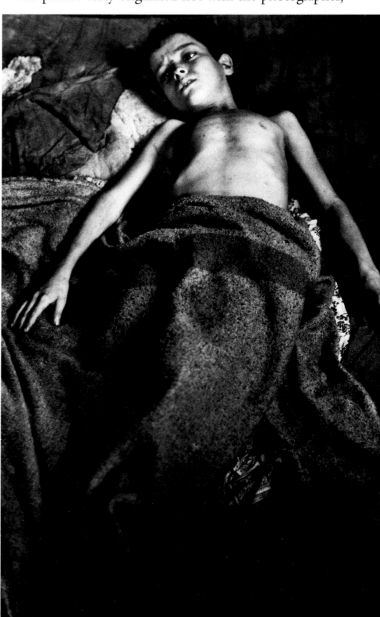

but with the writer. Hicks, for example, outlines the operation for assembling a photo essay around the writer who would "(1) suggest an event or an idea as a possible picture story, (2) present it for discussion, (3) take the lead in its planning, (4) direct the research, (5) help instruct the photographer, (6) study and organize the pictures after they were produced, (7) make a layout, and (8) write whatever text was required."[12]

The plus side of this is that good editor/writers have always been a vital part of the photojournalistic process and are not necessarily a drawback in and of themselves. But the problem inherent in the system devised by *Life* (and many other "word-driven" publications as well) was that non-photographers originated the story idea and oversaw it to completion. The photographer had little say about essay development and no control over the use of the photographs produced. Some photographers, such as Gene Smith, felt that the editors had no idea what was happening in the field and lacked the ability to change if the reality of the situation called for it.

Smith and other photographers found it ironic and frustrating that while working on the country's most prestigious *picture* magazine, they were subordinate to the *word* men and were still being treated like second-class citizens. One editor confirmed this later: "No matter how much Luce and Billings [*Life*'s first managing editor] and many of

the others raved about them and their vital importance to the magazine, the photographers, as a group, did not really enjoy the highest standing, even though their work made *Life*."[13]

Though employed by the magazine, Gene Smith tried to distance himself from the usual *Life* approach. He made a distinction between a picture story and a photo essay, saying that the first was something a photo editor put together and the second was the work of the photographer. While this is a reasonable difference stressing the origin of the work, it cannot be used when discussing his work for *Life* magazine (much to his chagrin). "I just simply wanted to give the time and the effort to take the superficiality out of a story. After I did, *Life* often would bring back that superficiality."[14]

Smith's association with the magazine and with Hicks, in particular, is a well-known, stormy story. Smith was a man passionately committed to a photography of responsible moral advocacy. *Life*'s autocratic structure was a constant irritation, but as his biographer William Johnson wrote, Smith realized "that *Life* was the most powerful and expressive news magazine of the day, and that it could bring him the power and prestige to strengthen his argument for a humanistic photography."[15]

At times Smith successfully fought *Life*'s hierarchical decision-making structure and its preconceived picture essay

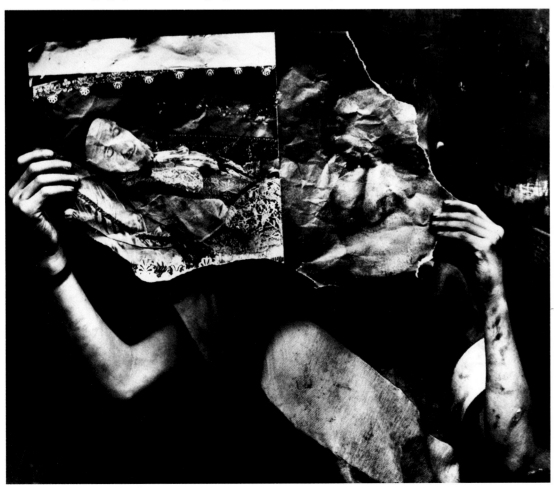

mold into which all stories were seemingly pressed. In 1948 he produced "Country Doctor," in which he, to quote Johnson, "replaced the traditional clichés of a well-constructed, dramatic presentation with an essay that convincingly relates the doctor's character and the quality of his world"[16] (Figures 245–250). The essay opens with Dr. Robert Ceriani walking through tall grasses past a worn picket fence under a glowering sky. His bulging black medical bag identifies his profession, and his humanity is evident in his worried, introspective expression. No opening better fulfills Wilson Hicks's dictum that "the frontispiece should 'set' a story and sum it up without giving too much away. It should lead the reader into the story."[17]

In the nine photographs on the next two pages the doctor wraps up broken ribs, makes house calls, deals with the elderly, and delivers a baby. The most dramatic images occur on the following pages as he tends to a child who has been kicked by a horse. Besides their photographic power, their placement within the story is important. If they had been first, the viewer might have been repulsed by the

Figures 245–250

W. Eugene Smith, "Country Doctor." From *Life*, September 20, 1948 (Vol. 25, No. 12), pp. 115–125; halftones (Courtesy Black Star. Time Inc.)

COUNTRY DOCTOR

THROUGH WEEDS GROWING RANK IN AN UNKEMPT DOORYARD, DR. ERNEST CERIANI OF KREMMLING MAKES HIS WAY TO CALL ON A PATIENT

HIS ENDLESS WORK HAS ITS OWN REWARDS

PHOTOGRAPHS FOR LIFE BY W. EUGENE SMITH

The town of Kremmling, Colo., 115 miles west of Denver, contains 1,000 people. The surrounding area of some 400 square miles, filled with ranches which extend high into the Rocky Mountains, contains 1,000 more. These 2,000 souls are constantly falling ill, recovering or dying, having children, being kicked by horses and cutting themselves on broken bottles. A single country doctor, known in the profession as a "g.p.," or general practitioner, takes care of them all. His name is Ernest Guy Ceriani.

Dr. Ceriani begins to work soon after 8 o'clock and often continues far into the night. He serves as physician, surgeon, obstetrician, pediatrician, psychiatrist, dentist, oculist and laboratory technician. Like most rural g.p.s he has no vacations and few days off, although unlike them he

has a small hospital in which to work. Whenever he has a spare hour he spends it uneasily, worrying about a particular patient or regretting that he cannot study all of the medical journals which pour into his office. Although he is only 32 he is already slightly stooped, leaning forward as he hurries from place to place as though heading into a strong wind. His income for covering a dozen fields is less than a city doctor makes by specializing in only one. But Ceriani is compensated by the affection of his patients and neighbors, by the high place he has earned in his community and by the fact that he is his own boss. For him this is enough. The fate of thousands of communities like Kremmling, in dire need of "country doctors," depends on whether the nation's 22,000 medical students, now choosing between specialization and general practice, also think it is enough.

CONTINUED ON NEXT PAGE 115

THE DAY'S FIRST OFFICE CALL is made by a tourist guide and his baby, who have come to Kremmling from an outlying ranch. Ceriani's patients are of all ages and income groups and come from doctorless areas as far as 50 miles away.

116

COUNTRY DOCTOR *continued*
HE MUST SPECIALIZE

HOME CALL at 8:30 a.m. starts Ceriani's day. He prefers to treat patients during office hours at the hospital, but because this printer had a fever and symptoms of influenza Ceriani thought it would be unwise for him to get up and make the trip.

MINOR EMERGENCY disrupts Ceriani's office routine. This 60-year-old tourist, suffering from a heart disturbance aggravated by a trip through an 11,000-foot pass in the Rockies, came to the hospital to get an injection of morphine.

ANOTHER HOME CALL turns up a feverish 4-year-old suffering from acute tonsillitis. Although a large proportion of his patients are children, Dr. Ceriani is still inexperienced in pediatrics and studies it whenever he has an opportunity.

IN A DOZEN FIELDS

X-RAY PICTURE is explained to a rancher by Ceriani, who developed the negative himself. In addition to the X-ray machine, the hospital contains about $20,000 worth of equipment, including a $1,500 autoclave and an oxygen tent.

BROKEN RIBS, the result of an accident in which a horse rolled on this patient, are bound with adhesive tape by Ceriani. Many of his hardy patients walk in with injuries which would make city dwellers call at once for an ambulance.

PROBLEMS OF AGE—in this case a slight deafness complicated by deposits of ear wax—are daily brought to the doctor. Here, in an operation chiefly important for its effect on the patient's morale, Ceriani removes the wax with a syringe.

WOES OF YOUTH fill Ceriani's office with noise. Above: he examines stitches in the lacerated hand of a squalling 7-year-old. Below: he uses a rubber tube to remove the mucous which clogs the throat of an infant he has just delivered.

CONTINUED ON NEXT PAGE 117

AN ACCIDENT INTERRUPTS HIS LEISURE

Dr. Ceriani's moments of relaxation are rare and brief. Last month, taking a chance that he would not be missed for three hours, he asked two employes of the Denver and Rio Grande to take him out on a railroad gasoline car to Gore Canyon. There he fished alone in the rapids of the Colorado, working expertly over the white water for almost 30 minutes. Suddenly he saw the car coming back up the canyon far ahead of time, and automatically he commenced to dismantle his fishing rod. Ceriani had no feeling of resentment at the quick end of his excursion; he merely stood still waiting for the car to reach him, wondering what had happened and hoping that it was not serious. When the car arrived Chancy Van

Pelt, the town marshal, hopped off and said, "Little girl at the Wheatly ranch got kicked in the head by a horse. Can you come now?"

Lee Marie Wheatly, aged 2½, was already in the hospital when Ceriani arrived. While her parents watched he looked for signs of a skull fracture, stitched up a great gash in her forehead and saw that her left eyeball was collapsed. Then he advised the Wheatlys to take their child to a specialist in Denver for consultation on removal of the eye. When they left Ceriani was haggard and profoundly tired. He did not remember that he had been fishing at all until, on his way out of the emergency room, he saw his rod and creel lying in the corner where he had thrown them.

AT 4:15 two friends start to give fisherman Ceriani a ride to Gore Canyon in a railroad motor car.

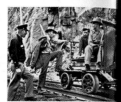
AT 5:00 Ceriani begins his day's fishing in the boiling, trout-filled rapids of Colorado River.

AT 5:30 Kremmling's town marshal has come after Ceriani and they start back to take care of an emergency case.

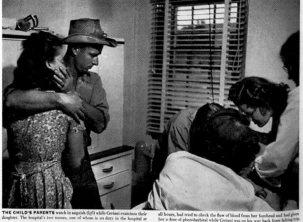
THE CHILD'S PARENTS watch in anguish (left) while Ceriani examines their daughter. The hospital's two nurses, one of whom is on duty in the hospital at all hours, had tried to check the flow of blood from her forehead and had given her a dose of phenobarbital while Ceriani was on his way back from fishing trip.

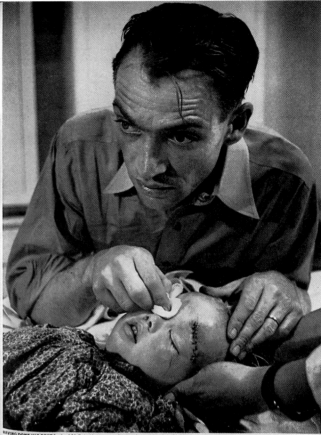
HAVING DONE HIS BEST for the child, Ceriani is worn out and tense as he completes the emergency treatment. He has stitched the wound in her forehead so that she will have only a slight scar, but already knows that nothing can be done to save her eye and tries to think of a way to soften the news for her parents.

CONTINUED ON NEXT PAGE 119

118

183

HE SETS A BADLY DISLOCATED ELBOW

Young Robert Wiggs had a dislocated left elbow. He had been to a rodeo in nearby Granby, had a few beers and tried to ride a wild horse. When he was brought by his friends to the hospital, he was in great pain and swearing loudly. "Don't tell my mother," he said.

Dr. Ceriani X-rayed the arm. Then, because it was necessary to give Wiggs ether, he questioned him about the beer he had drunk. Wiggs said, "Only a few," and the operation proceeded. The boy's friends and a nurse held him while Ceriani set the joint and made a cast for it (opposite page).

As the effects of the ether began to fade, Wiggs began groggily to repeat, "Don't tell my mother." At this Ceriani glanced across the table. There stood Mrs. Wiggs, who had been notified of the accident and had rushed to the hospital in time to hold her son's hand during the last of the operation. Ceriani grinned at her, trying to convey two ideas. One was that her son would be all right. The second was that Ceriani himself was a man who might not long ago have had a few beers and tried to ride a wild horse, and therefore did not think this affair was one of the utmost gravity.

CERIANI HELPS CARRY THE PAINFULLY INJURED BOY INTO THE HOSPITAL

HE PULLS AT THE BOY'S ARM TO BRING THE ELBOW JOINT BACK INTO PLACE

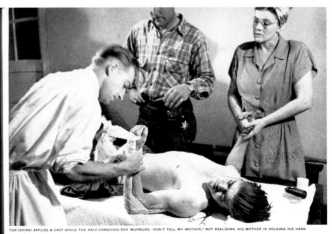
THEN CERIANI APPLIES A CAST WHILE THE HALF-CONSCIOUS BOY MURMURS, "DON'T TELL MY MOTHER," NOT REALIZING HIS MOTHER IS HOLDING HIS HAND

...AND AMPUTATES A GANGRENOUS LEG

Old Thomas Mitchell had a gangrenous left foot. He was 85, and when he was brought to the basement emergency room three months ago it seemed unlikely that he would live long. But he survived, and when Dr. Ceriani came to tend him he would say, "I want to see the mayor. When is the mayor coming?" as though such a visit would clear up the trouble.

For a long time Dr. Ceriani postponed the inevitable amputation, afraid that the old man could not survive it. Twice he told the nurses, "Tomorrow I will do it," but when tomorrow arrived Mitchell had grown weaker.

Finally the old man rallied and Ceriani hastily made his preparations. With great gentleness he carried his patient (opposite page) up to the operating room, gave him a spinal anesthetic and cut off his left leg below the knee. The old man, conscious but with his vision blocked by a screen, was not aware of what was being done and did not discover that his leg was gone until long after. He continued to say, "My foot hurts," while Dr. Ceriani, busy now with other cases, sighed in relief. Last week the old man was much improved and asking with increased spriteliness to see the mayor.

BEFORE THE AMPUTATION CERIANI CHECKS MITCHELL'S BLOOD PRESSURE

IN THE OPERATING ROOM THE OLD MAN RECEIVES A SPINAL ANESTHETIC

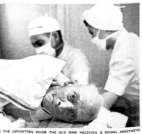
BECAUSE THE HOSPITAL HAS NO ELEVATOR, CERIANI PICKS UP HIS PATIENT IN THE BASEMENT WARD TO CARRY HIM UPSTAIRS TO THE OPERATING ROOM

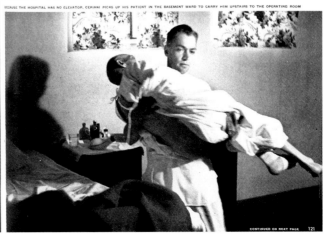

120

CONTINUED ON NEXT PAGE 121

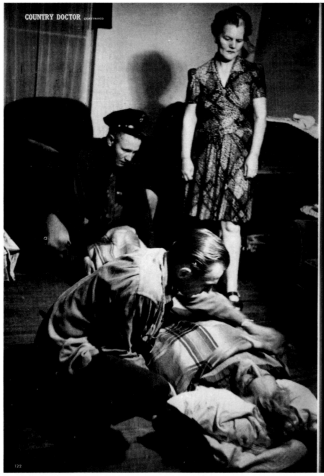

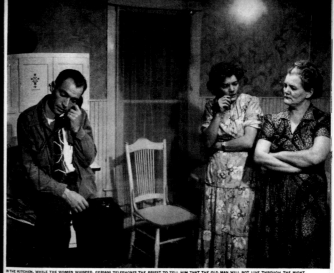

IN THE KITCHEN, WHILE THE WOMEN WHISPER, CERIANI TELEPHONES THE PRIEST TO TELL HIM THAT THE OLD MAN WILL NOT LIVE THROUGH THE NIGHT

AN OLD MAN DIES AT NIGHT

A few minutes before midnight the people in Joe Jesmer's house called Dr. Ceriani to tell him that Joe was very sick. Ceriani put on a cloth jacket, went over there quickly and found 82-year-old Joe dying after a heart attack. He was still conscious, but in his pain and bewilderment he felt that he was somehow trapped and needed freeing. He continually said, "Please, please get me out of here."

Ceriani and Chancy Van Pelt got Joe onto a stretcher (opposite page), while Helen Watson, a roomer in Joe's house stood watching quietly and without tears. Ceriani called the priest, asking him to come to the hospital. Chancy and he carried Joe out to the ambulance and drove off. There was nothing Ceriani could do except make Joe comfortable and watch him die. At about 2:30 it happened. He left the hospital then and went home, finding his wife asleep and his own house as quiet as all the rest in town.

IN THE PARLOR Ceriani tucks a blanket around the dying man before taking him out into the night.

CONTINUED ON NEXT PAGE 123

AT MIDNIGHT JOE JESMER'S WOMENFOLK STAND SILENTLY AROUND THE DOOR TO SEE HIM TAKEN AWAY

THE HOMELY WOODEN BUILDINGS AND WIDE TREELESS STREETS OF KREMMLING STAND ON A 7,000-FOOT PLATEAU BENEATH THE TOWERING ROCKY MOUNTAINS

COMMUNITY ABSORBS MOST OF HIS TIME

Kremmling lies on a 1½-mile-high plateau on the edge of the Rockies. Tourists and transcontinental travelers find the country beautiful, as does Ceriani, who also finds it advisable in bad weather to take chains, blankets, an ax and a can of beans with him on trips to ranches in the hinterland. The town itself consists of about 150 small buildings, including the hospital (below), and a few old log cabins. Mrs. Ceriani, who came from rural Colorado, was already familiar with this environment and adjusted easily to it. She faithfully reminds him to send out his bills—which are far lower than those of an urban physician—and has long since grown used to emergencies at all hours and to the sudden collapse of her plans to see a movie or play bridge. She has learned to accept all the problems of her husband's career except one. Even after four years of marriage, she is still unable to reconcile herself to the fact that his time is not his own. She and her two young sons must see him at unpredictable intervals, on special occasions (left) or simply fall asleep waiting for him to finish his work.

THE DOCTOR AND FAMILY watch a parade in Kremmling. Ceriani holds 11-month-old Gary, while wife Bernatha studies 3-year-old Philip on the rail.

THE HOSPITAL, one block away from Ceriani's house, is a neat white wooden building with three separate wards which can accommodate a total of 14 patients.

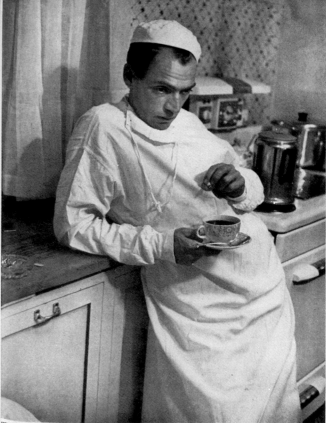

AFTER MIDNIGHT, after an operation which lasted until 2 a.m., Ceriani has a cup of coffee and cigaret in the hospital kitchen before starting home. The nurses constantly admonish him to relax and rest, but because they are well aware that he cannot, they keep a potful of fresh coffee simmering for him at all hours.

CONTINUED ON NEXT PAGE 125

child's stitched head and skipped over the story, never understanding what it was about. Instead the scene is set by the doctor and his myriad duties; the drama is not over-emphasized for effect. When it occurs, the scene can be taken seriously and put in perspective.

The essay does not end in worldly triumph but with the weary physician leaning on a hospital counter with a cup of coffee and a cigarette. He is no hero, no miracle worker. His life does not proceed from one satisfactorily concluded episode to another. He works hard and with intense concentration. He struggles to help those in need the best he can, with the tools available to him. He is a real person.

Expressing his concern for humanity, Eugene Smith said, "I try to take what voice I have and give it to those

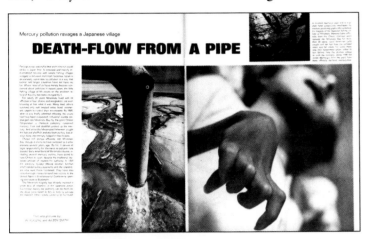

who don't have one at all."[18] His last and most powerful extended body of work clearly gave voice to the anguish of those dying of mercury poisoning in a Japanese fishing village. The story of Minamata was published in magazines and newspapers in Europe, Japan, and the United States. "Death-Flow from a Pipe: Mercury Pollution Ravages a Japanese Village" appeared in *Life* June 2, 1972 (Figure 251).

Unlike "Country Doctor," the article is not about one person but a vicious, unseen substance and the people whose bodies have been destroyed by it. It opens on a double-page spread displaying fragments: a factory discharge pipe; a shriveled, contorted hand; and the partial silhouette of a fisherman against the waters of Minamata Bay with a fish in his basket. The text and further reproductions revolve around these elements. Not until the last picture does the viewer confront the full horror of the contorted naked body of Tomoko Uemura tended by her mother. The mother and her child, trapped in a living death, resemble a tragic but ominously modern Pietà (Figure 252).

Here was a news story that in turn created news. Smith's vivid, horrifying photographs educated a generation in

Figure 251
W. Eugene Smith, "Death-Flow from a Pipe." From *Life,* June 2, 1972 (Vol. 72, No. 21), p. 74; halftone (Black Star/Time Inc.)

Figure 252
W. Eugene Smith, "Tomoko and Mother, Minamata, 1972"; gelatin silver print (Black Star)

185

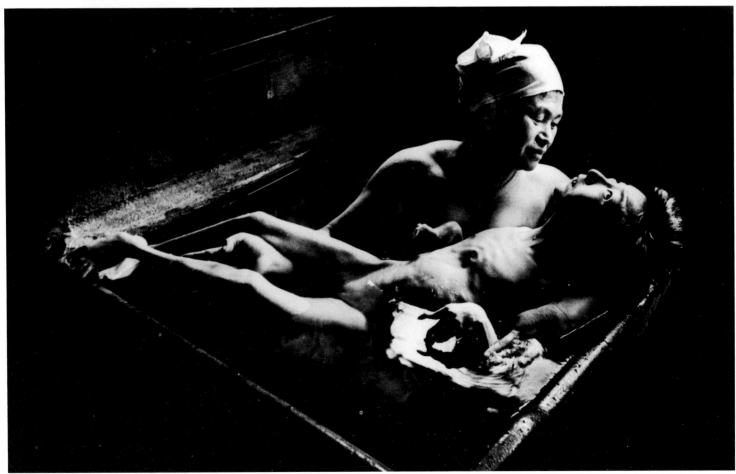

what would be, although they didn't know it at the time, a continuing crisis of the late twentieth century. Smith saw the work as a warning. Although he complained that every day "we are deluged with photography at its worst—until its drone of superficiality threatens to numb our sensitivity to image,"[19] he continued to believe that photography mattered and could make a difference. In the book on Minamata he concluded his prologue simply, "To cause awareness is our only strength."[20]

Another photographer who has had a substantial impact on the look of photography and on photojournalism in the twentieth century is Henri Cartier-Bresson. His name is intertwined with the words "the decisive moment," an English translation of the title of his book *Images à la sauvette,* published in 1952. In the American edition, *The Decisive Moment,* published the same year, Cartier-Bresson wrote, "To me photography is the simultaneous recognition in a fraction of a second, of the significance of an event as well as of a precise organization of forms which give that event its proper expression."[21]

Cartier-Bresson is careful to point out that what the photographer is trying to capture is the essence of an event. To understand what is happening, one must recognize "both the fact itself and the rigorous organization of visually perceived forms that give it meaning. It is putting one's head, one's eyes and one's heart on the same axis."[22]

This last—the coming together and equal importance of "one's head, one's eyes and one's heart"—is probably one of the best descriptions of latter twentieth-century photojournalism.

Although he stresses meaning, it is clear from his photographs and other statements that the *form* the visual moment takes itself plays an equally important if not predominant role. "This recognition, in real life, of a rhythm of surfaces, lines, and values is for me the essence of photography; composition should be a constant preoccupation, being a simultaneous coalition—an organic co-ordination of visual elements."[23] This then is his legacy to photojournalism: that one photograph bring together significant content at a telling moment in delicate balance. Cartier-Bresson is certainly not the first in photography to express meaning through form, but his writing and, more important, the continuous example of his photographs have been an important influence on many photographers.

Clearly, emphasis on graphic composition in photojournalism runs the risk of style superseding content. There is always a danger that style will obscure the issue at hand rather than revealing it—shrouding an event's uniqueness under the mannerisms of a particular photographer. This concern is expressed by Robert Frank, whose photographs are antithetical to the idea of subjects in flux implied by the phrase "the decisive moment." He objected that Cartier-

Figure 253 (left)
Henri Cartier-Bresson, "Cardinal Pacelli (later Pope Pius XII) at Montmartre, Paris," 1938; gelatin silver print (IMP/GEH. Courtesy Magnum)

Figure 254 (opposite, top)
Henri Cartier-Bresson, "Dessau: Exposing a Gestapo informer," 1945; gelatin silver print (IMP/GEH. Courtesy Magnum)

Figure 255 (opposite, bottom)
Henri Cartier-Bresson, "Chinese Parade," c. 1958; gelatin silver print (IMP/GEH. Courtesy Magnum)

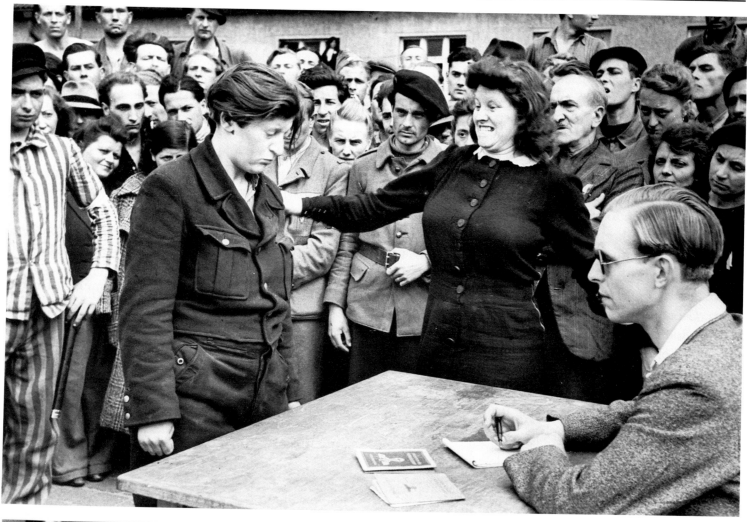

tional, it addressed a deeply ingrained, essentially racist worldview. It became more than a question of disruption and protest, but one of *whose* order was being disrupted and by whom.

Richard Valeriani of NBC television news covered some of the protests in the South. In an interview he said he feels that television accelerated the process of change and pushed other journalists to go beyond quotes from the local town officials and deal with the issues of the confrontation. He talked about the press's problems, including the condensing of a complicated story:

> A lot of people identified the press with the movement. We were in the middle. I used to get complaints all the time. The local whites said that we were helping outside agitators and that if we went away, they would go away. They said that in effect we were part of the movement, instigating the movement, encouraging them. . . . On the other hand, we'd get complaints from blacks that we were not encouraging the movement, that we were not doing enough to propagandize their cause. The best you could do was to juxtapose something that Bull Connor said with something that Martin Luther King said. . . . But we were constantly caught.[51]

Photographer Flip Schulke covered the civil rights movement from the 1950s. At the beginning, he has said, the press didn't recognize it as a movement at all. It was hard to work up interest at *Life* and other magazines because the small group of nonviolent churchpeople was not expected to command a following. His early assignments in the rural South were often from *Ebony*, a black-oriented picture magazine. Schulke explains:

> At that time the only people with good cameras were professional people, everybody else had the old Kodak Brownie. . . . So, when you got out of a car in a small southern town, you were instantly a professional. But when a black got out of a car [carrying] equipment in small towns, and even in larger ones, he would be arrested on the spot on the suspicion of stealing cameras. Most of that was harassment. [The stories they went to photograph] were all positive stories; they were not racist stories. They were about successful people.[52]

As a result, *Ebony* hired Schulke. Being white, he wasn't arrested when he arrived and could work in the white section of town. The blacks knew he worked for *Ebony* and helped him when he worked in their part of the segregated town. It was safe in the black area, but outside it was "unbelievably dangerous because everybody hated you except the blacks."[53] Snipers were one type of lethal hazard.

Ebony was less than ten years old when Schulke began to work for them. Founded in 1945 by John H. Johnson, the monthly magazine was, and is, the largest and most successful publication of the Johnson Publishing Company of Chicago, which also prints the weekly newsmagazine *Jet*.

Schulke first met Martin Luther King in 1956 on an assignment for *Jet* shortly before the bus boycott in Montgomery, Alabama, when Dr. King went to Miami (Schulke's home) to raise money for the Southern Christian Leadership Conference. During the conversation that went through the night, Schulke explained to King that the organization's ideas and activities wouldn't get covered if the press was unaware of them. The two men kept in contact and Schulke covered the entire civil rights movement.

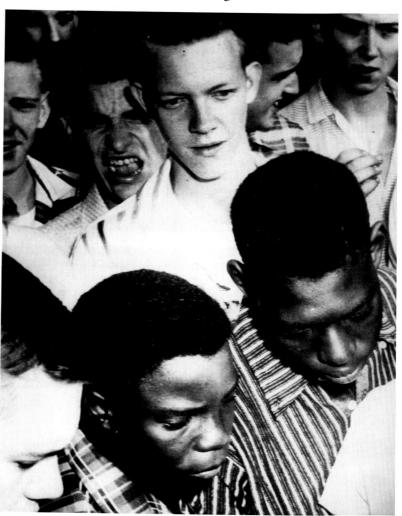

Figure 269
Unidentified photographer, "Stopped at school's door," 1957; gelatin silver print (AP)
Black students Richard Richardson, left, and Harold Smith were surrounded by jeering white students as the blacks attempted to enter North Little Rock High School in Arkansas, September 9. The race problem led to assignment of federal troops by President Eisenhower to enforce integration in Little Rock schools.

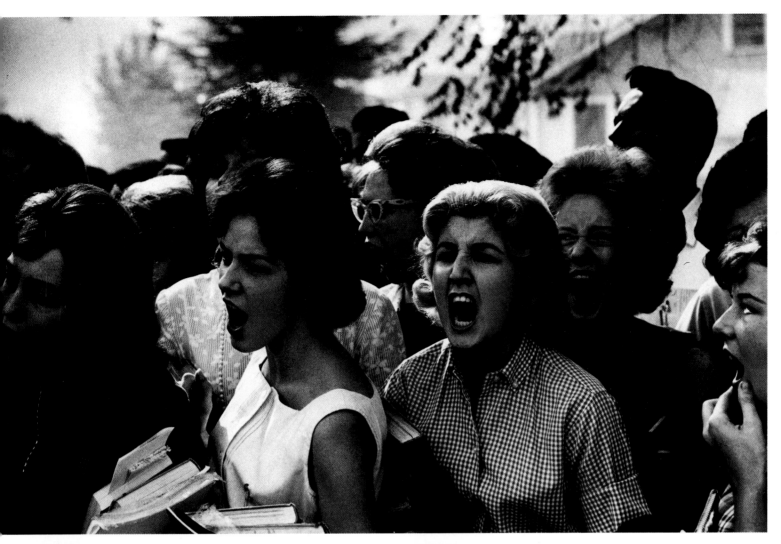

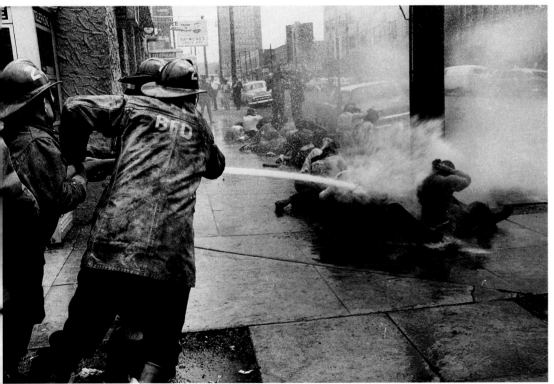

Figure 270
Flip Schulke, "White students in Birmingham demonstrate against integration in their high school," 1963; gelatin silver print (Courtesy Flip Schulke)
September 1963, at the largest central high school, white students left and gathered on the school's sidewalk to shout angry words at the first black students as they were escorted by federal authorities into Birmingham High for the first time.

Figure 271
Charles Moore, "Birmingham demonstration, May 6, 1963"; gelatin silver print (Black Star)
Many photographers, such as Moore, covered the movement. Among them were Bruce Davidson, Ben Fernandez, Bob Fitch, Leonard Freed, Declan Haun, Robert Houston, Flip Schulke, Moneta Sleet, Jr., and Dan Weiner.

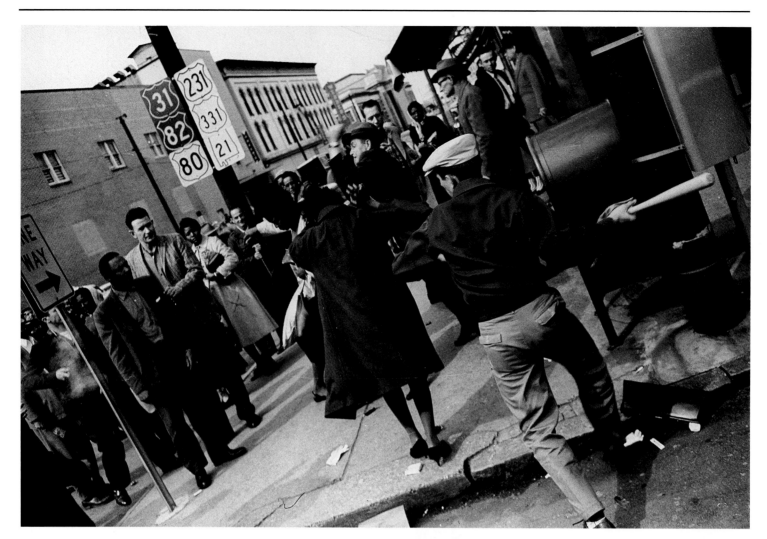

Figure 272
Charles Moore, "Man swinging club at black woman on Montgomery, Alabama, street corner," 1960/61; gelatin silver print (Black Star)

Figure 273
Flip Schulke, "The National States Rights Party encourages resistance to school integration," 1963; gelatin silver print (Courtesy Flip Schulke)
When the first group of young black students was escorted by federal authorities into Birmingham High School, many different anti-integration groups picketed and marched on the sidewalks outside the school and shouted encouragement to the white students.

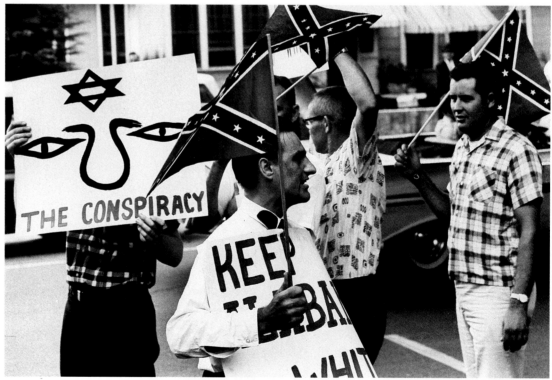

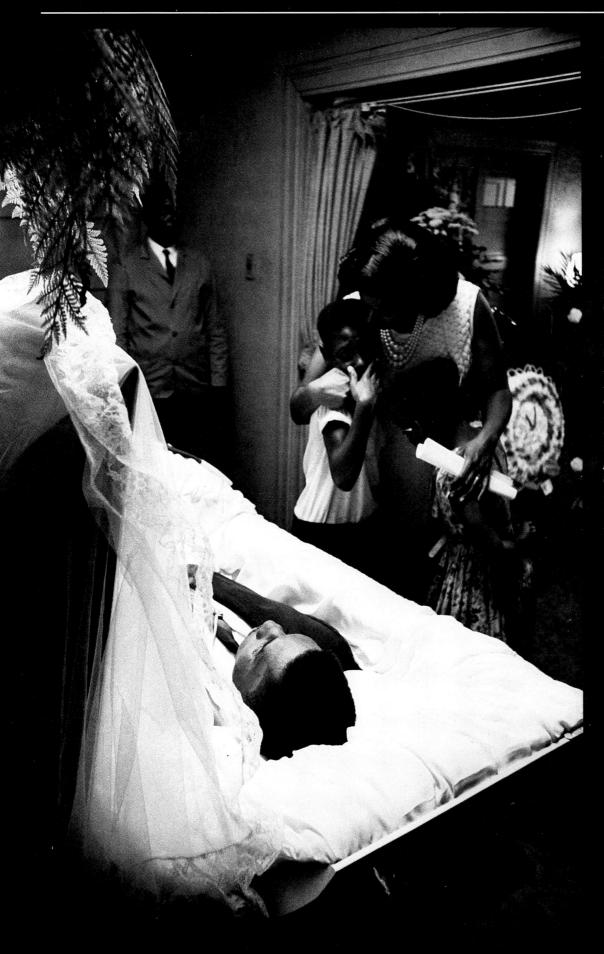

Figure 274
Flip Schulke, "Mrs. Myrlie Evers and two children, Darrell and Rena, view Medgar Evers' body at the funeral home," 1963; gelatin silver print (Courtesy Flip Schulke)
In her book, For Us the Living, *Mrs. Evers wrote that she sent the children from the room and was looking at the body of her slain husband. "And then I sensed that I was not alone. I turned and the Life photographer [Schulke] was there. His eyes were filled with tears. For the first time since Medgar's death the hatred that I had felt for all whites was gone. It never returned."*

Figure 275 (top left)
Bruce Davidson, "Alabama, 1963"; gelatin silver print (Magnum)

Figure 277 (bottom)
Leonard Freed, "Dr. Martin Luther King, Jr., is greeting his people after he received the Nobel Peace Prize in 1964, Baltimore, Md.," 1964; gelatin silver print (Magnum)

Figure 276 (right)
Flip Schulke, "The march on Washington—August 28, 1963"; gelatin silver print (Courtesy Flip Schulke)
More than 250,000 people joined in the largest demonstration in the history of the civil rights movement. Here the huge crowd is gathered in front of and on the steps of the Lincoln Memorial, as seen from the top of the Washington Monument.

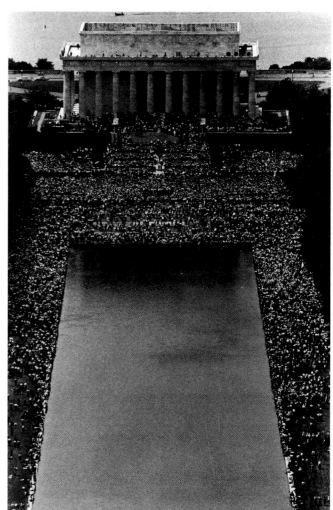

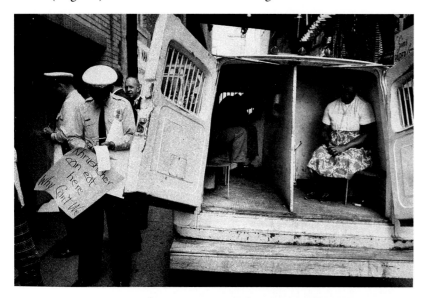

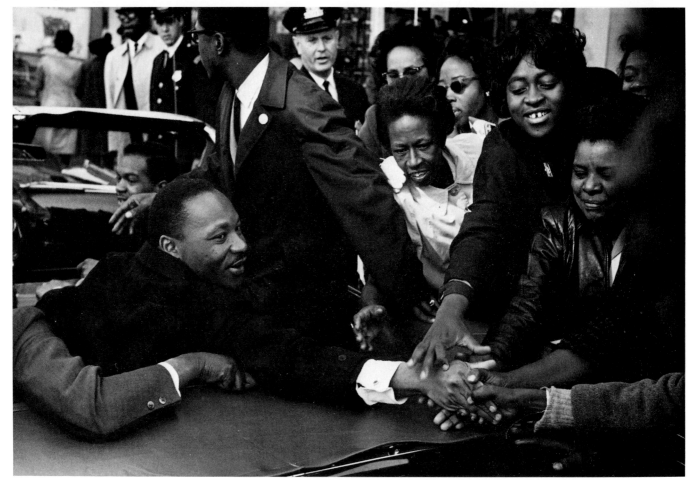

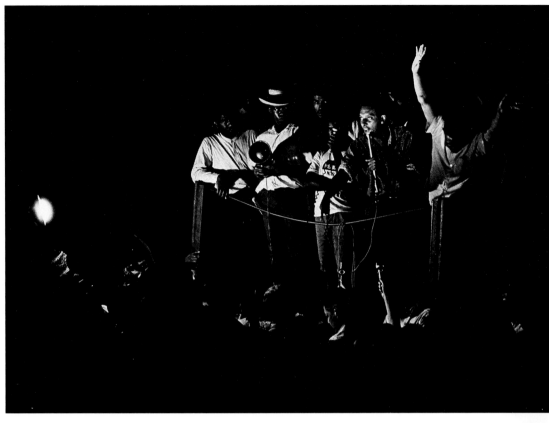

Figure 278 (left)
Bob Fitch, "Black power," 1966; gelatin silver print (Black Star)
During James Meredith's march through Greenwood, Mississippi, the night Stokely Carmichael announced to the world and television cameras a new philosophy of power.

Figure 279 (left)
Flip Schulke, "Selma, Alabama, demonstrations and marches," 1965; gelatin silver print (Courtesy Flip Schulke)
Reverend Martin Luther King, Jr., civil rights leader and president of the Southern Christian Leadership Conference (SCLC), leading the march from Selma to Montgomery, Alabama, March 1965, after 2 weeks of waiting and violence (2 deaths) in Selma. The march was to protest the lack of cooperation on the part of Alabama officials in the registration of black voters.

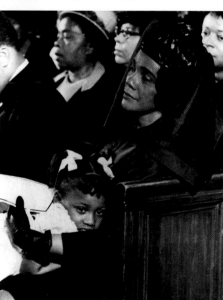

Figure 280 (right)
Moneta Sleet, Jr., "Mrs. Martin Luther King, Jr.," 1968; gelatin silver print (AP)
Mrs. King comforts her daughter, Bernice, age 5, during the funeral in Atlanta's Ebenezer Baptist Church for Dr. King.

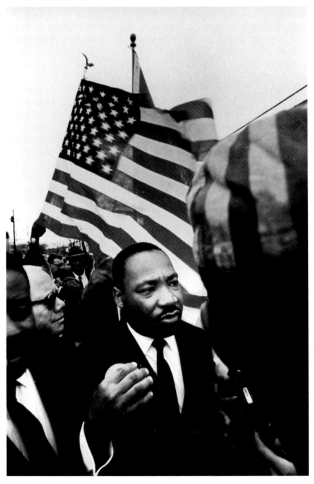

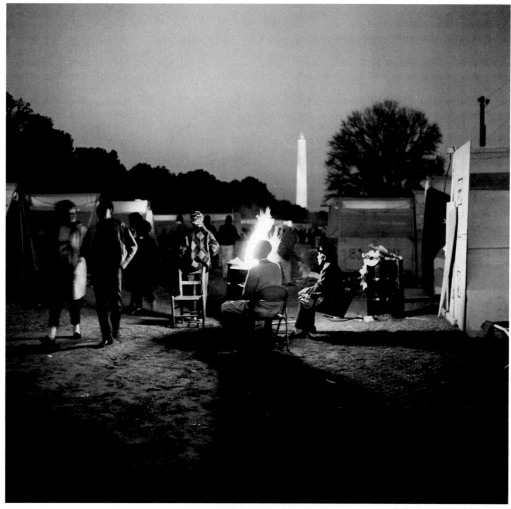

Figure 281
Robert Houston, "Resurrection City, Washington, D.C., Poor People's March," 1968; gelatin silver print (Black Star)

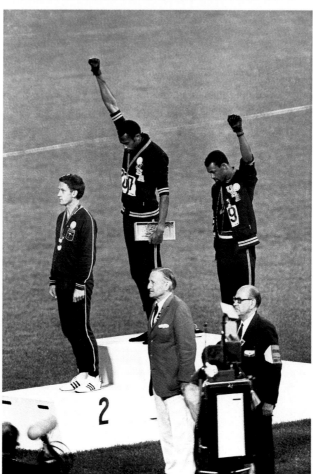

Figure 282
Unidentified photographer, "Olympic racial protests," 1968; gelatin silver print (AP)
Extending black-gloved hands skyward in racial protest, American runners Tommie Smith, center, and John Carlos stare downward during the playing of "The Star-Spangled Banner" after receiving gold and bronze medals, respectively, for their performances in the 200-meter run.

Along with the rest of the American press, Flip Schulke covered the Kennedy administration. He felt that it was an exciting time: John Kennedy made people realize that more could be done with the country. In terms of his own photography, Schulke said that "there has been no president that I have photographed who has stood out [as he did]. In every picture I have of Kennedy, your eye goes right to him [because of] the way he looked, the way he carried himself, and also the things he said. He became, I think, a friend to everyone in the United States."[54]

No American presidential family had been photographed as much as John and Jacqueline Kennedy's. Their children, relatives, houses, pets, and hobbies became a continuous picture story across the media. Partly because pictures of them had become an expected portion of daily life, the assassination of John Kennedy engulfed the nation in the shock of a very personal loss. The murder of Robert Kennedy seemed to bring the era to its ultimate, brutal end. It had been a quiet, hopeful time. The big wars were over and Vietnam was a distant place, not much discussed yet.

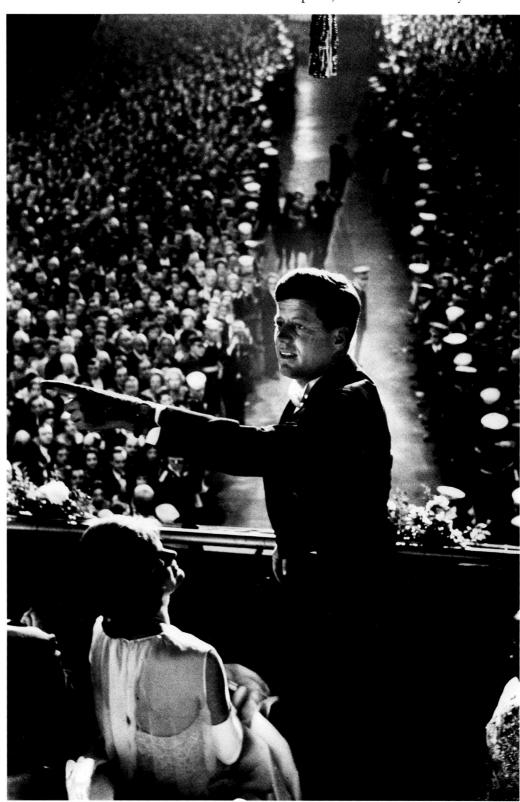

Figure 283
Paul Schutzer, "Day of triumph, Inaugural Ball," 1961; gelatin silver print (Time Inc.)

Figure 284
Jacques Lowe, "Little Caroline Kennedy kisses her father," 1960; gelatin silver print (AP)
One of the many hundreds of casual family pictures of the Kennedy family. Here Kennedy is seen during his presidential campaign with Jackie and daughter Caroline, then 2½ years old.

Figure 285
Robert H. Schutz, "Father and Son," 1963; gelatin silver print (AP)
President John F. Kennedy is greeted by his son, John Jr., on arrival at the airport in Hyannisport.

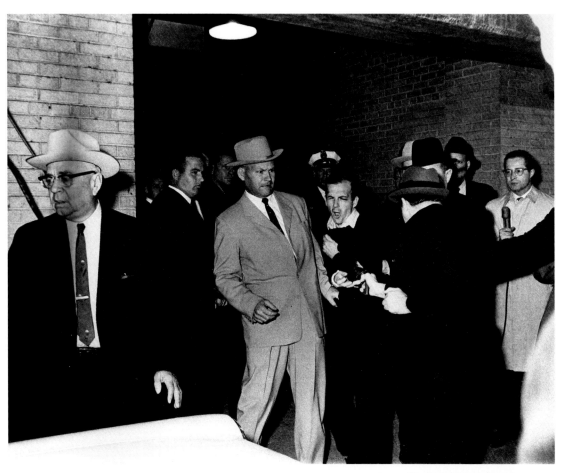

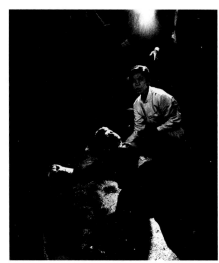

Figure 286 (top)
Bob Jackson, "Oswald shot," 1963; gelatin silver print (AP)
In the aftermath of the assassination of President John F. Kennedy, his accused slayer, Lee Harvey Oswald, is slain by Jack Ruby in a Dallas police station, November 24, 1963.

Figure 287 (bottom left)
Capt. Cecil Stoughton, "Johnson becomes President," 1963; gelatin silver print (AP)
Lyndon B. Johnson is sworn in as President of the United States of America in the cabin of the presidential plane as Mrs. Jacqueline Kennedy stands at his side. Judge Sarah T. Hughes, a Kennedy appointee to the federal court, left, administers the oath of office.

Figure 288 (bottom right)
Bill Eppridge, "Robert Kennedy after he was shot," 1968; gelatin silver print (Time Inc.)

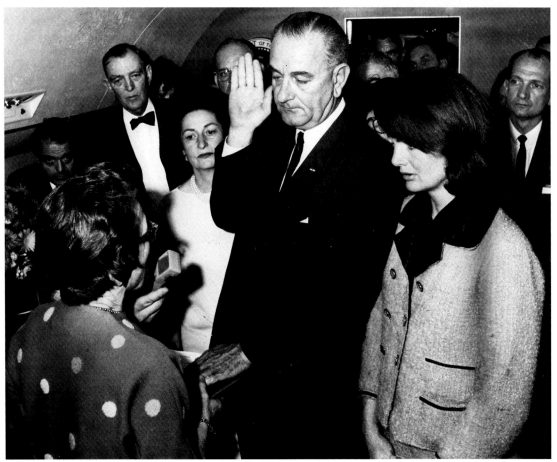

Vietnam grew into a war fought both thousands of miles away and in the streets of the United States, however. The complex and contradictory nature of the American presence in Southeast Asia slowly began to show itself in journalists' work. The mortal irony of a jungle conflict fought on World War II premises became increasingly apparent in the photographs of the men and women present. Their questioning of purposes, methods, and authority continued long after Americans withdrew and was transferred to other fronts. Henry Kissinger has said, "Vietnam is still with us. It has created doubts about American judgment, about American credibility, about American power—not only at home, but throughout the world. It has poisoned our domestic debate. So we paid an exorbitant price for the decisions that were made in good faith and for good purpose."[55]

Journalists' access to war action was comparatively easy. Unlike in World War II or Korea, they were not assigned to a specific service or unit and did not wear specific uniforms. Photographer Philip Jones Griffiths explains:

> The mechanics of the thing were very simple. If you were a bonafide journalist, you were given a card which explained who you were, and with that card you had the ability to travel and see. Back in 'sixty-six you couldn't go anywhere except by air; the Communists controlled most of the land. Even if you wanted to go somewhere fifty miles from Saigon, you would still have to go by helicopter.

Concerning how this loose system affected the journalists' views on the war, Griffiths continues:

> The fact is that the policy was "we-are-proud-of-what-we-are-doing-and-we-want-the-world-to-see," and it worked. At any one time, I would say 99 percent of all journalists in Vietnam approved of the war and 85 percent approved of the way the war was being fought. . . . So, the popular conception—*misconception*—by both the public at large and the Reagan administration, that allowing all the press into Vietnam caused us to lose the war [is incorrect]. In fact, for the most part, the press in those early years was instrumental in making the war continue because most of what was recorded by the press was very, very pro the military intervention there.[56]

On April 16, 1965, *Life* magazine published Larry Burrows's photo story "One Ride with Yankee Papa 13" (Figure 289). Burrows had been covering the war since 1962 and would continue to do so until the helicopter he was in (with photographer Henri Huet and others) was shot down over Laos in 1971, killing all aboard.

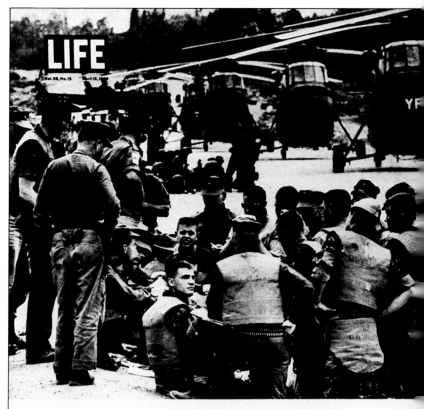

Photographer Larry Burrows' report from Da Nang, Vietnam

One Ride with Yankee

Larry Burrows

It was another day's work for the U.S. Marines' Helicopter Squadron 163 in Vietnam. In the sultry morning the crews huddled at Da Nang for the final briefing on their mission: to airlift a battalion of Vietnamese infantry to an isolated area about 20 miles away. Intelligence reports indicated that the area was a rendezvous point for the Communist Vietcong, who come down the Ho Chi Minh trail from the north.

Among those listening at the briefing were Lance Cpl. James C. Farley (*right*), crew chief of the copter Yankee Papa 13, and Life Photographer Larry Burrows (*left*), who had been covering the war in Vietnam since 1962 and had flown on scores of helicopter combat missions. On this day he would be riding in Farley's machine—and both were wondering whether the mission would be a contact milk run or whether, as has been increasingly the case in recent weeks, the Vietcong would be ready and waiting with .30-caliber machine guns. In a very few minutes Farley and Burrows had their answer, shown in his chilling photographs.

24

The essay centers on the experience of Lance Cpl. James C. Farley, aged twenty-one, the crew chief of the copter named *Yankee Papa 13*. The helicopter was one of seventeen airlifting a battalion of Vietnamese infantry to a position outside Danang. With the crew, Burrows, and troops (later replaced by wounded crew members of another helicopter), the story might have been a confusion of actions and emotions had Burrows not focused on one soldier. Burrows mounted a camera outside the copter on the machine gun that Farley would be using. This way the marine's expressions could be monitored as he fired.

Beginning with a photograph of an outdoor briefing for all the crews against a background of their helicopters places the young, smiling Farley in the context of his squadron. The story proceeds through twenty-two pictures, occasionally isolating the marine at different stages of the action as it develops. Burrows's photographs tensely packed with men rushing, huddling, slumping, and bandaging the wounded are sometimes used several to a page, leading up to a larger view, thus increasing the sense of pressure and strain. In the five climactic images of the death of rescued Lieutenant

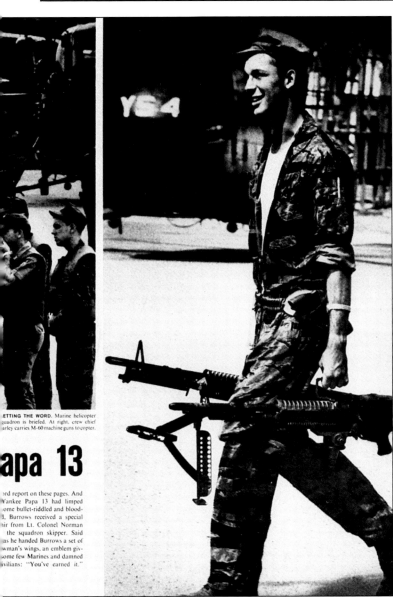

ETTING THE WORD. Marine helicopter
squadron is briefed. At right, crew chief
arley carries M-60 machine guns to copter.

apa 13

rd report on these pages. And
Yankee Papa 13 had limped
ome bullet-riddled and blood-
d, Burrows received a special
air from Lt. Colonel Norman
the squadron skipper. Said
as he handed Burrows a set of
wman's wings, an emblem giv-
some few Marines and damned
ivilians: "You've earned it."

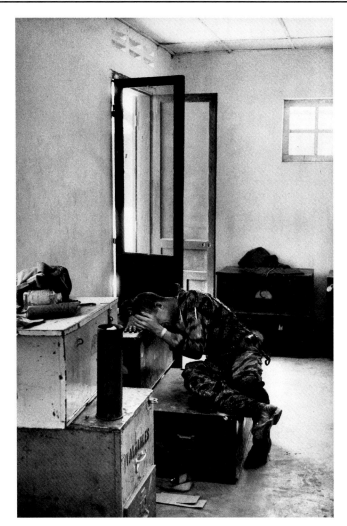

Figure 289
Larry Burrows, "One Ride with
Yankee Papa 13." From *Life,* April
16, 1965 (Vol. 58, No. 15), pp.
24–25; halftone (Time Inc.)

Figure 290
Larry Burrows, "Farley gives way,"
1965; gelatin silver print (Time
Inc.)

Magel, the pictures show only Farley's face reacting to the scene. The photographs and the construction of the essay allow the reader to feel Farley's anguish at the failure to rescue another pilot and the grief at the loss of Lieutenant Magel in the best tradition of W. Eugene Smith's "Country Doctor" (Figures 245–250). As Farley "gives way" to his emotions in the last image, the reader may recall that this was only "one ride": there would be more.

Burrows was well known for his color work also (Plates 7–10). Much of it was reproduced in the pages of *Life* at a time when war photographs in color were rare. He was an early master of the medium, setting a standard still hard to match. If the pictures were in color, they didn't work well in black and white. The subtlety of skin hues on wounded and dying men, red bandages against the earth's muck, make the four-color images melancholy masterpieces.

Another photographer working in Vietnam was Don McCullin (Figures 291–292). He had covered conflicts in the Congo, Biafra (with Gilles Caron), Cyprus, and Ireland by the time he got to Vietnam. He often says that his photography is about confrontation. Don McCullin is not

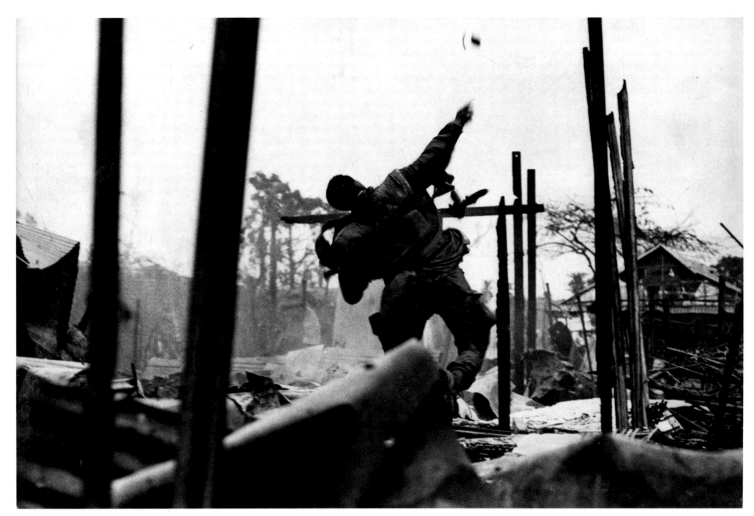

speaking of war as generic subject matter, but of making the public at large face the dark side of existence, acknowledge its presence, and do something about it. His book *Beirut: A City in Crisis* is an excellent example of his methods and his rage. It will be discussed later.

Of the photograph illustrated above, McCullin wrote: "A black American Marine just outside the gateway to the City of Hue. The Tet offensive. He looks like an Olympic athlete, except that he's throwing not a javelin but a grenade. Within seconds of this photograph, a sniper blew off his hand."[57]

When the Vietcong, said to be overwhelmed by American firepower, attacked sites in Saigon itself and infiltrated the American embassy grounds on January 31, 1968, during their Tet offensive, the public was profoundly shocked and questions about the war were raised in the press. As Karnow describes it, the Communists violated "a truce that they themselves had pledged to observe during Tet, the lunar New Year, they surged into more than a hundred cities and towns, including Saigon, audaciously shifting the war for the first time from its rural setting to a new arena—South Vietnam's supposedly impregnable urban areas."[58]

Philip Jones Griffiths went to Vietnam to produce a book, that is, a long work that would give him the space and time to elaborate on the situation as he saw it to be.

Along the way many of his photographs also appeared in *Life* and other magazines. In his book, *Vietnam, Inc.* (1971), Griffiths wrote that "Vietnam is the goldfish bowl where the values of Americans and Vietnamese can be observed, studied, and because of the contrasting nature, more easily appraised."[59] The photographs move from the pastoral life of the countryside and end with a look at the long-distance automated war represented by the Americans (Figure 293). Headings in the book are often American military jargon. These administrative definitions (military euphemisms) are countered by Griffiths's own biting descriptions of the effect of each of them on the Vietnamese people. Photographs are similarly juxtaposed: families working in the fields lead directly to helicopters and dead bodies. It is a very bitter book. Griffiths worked on it for five years—three of them in Vietnam, with a break in the middle to work on the layout and read more. The writing came together during the final six months. He acknowledges that some of the captions and statements come across as too direct and outrageous, but he considered the content carefully in terms of what he felt to be the facts about U.S. involvement. Asked about his feelings on journalistic objectivity, he replied that "you can be objective, I suppose, about the structure of the hydrogen atom or something—an individual brings all that baggage, all that emotional

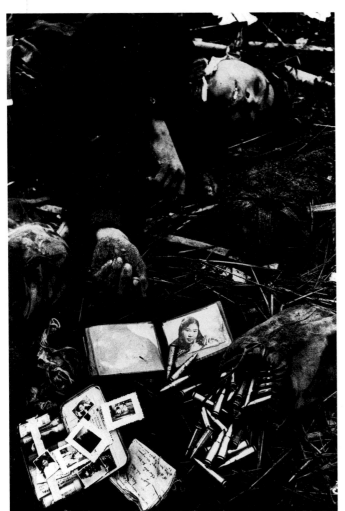

Figures 291–292 (opposite and left)
Don McCullin, "Tet Offensive, Hue," 1968; gelatin silver prints
(Courtesy Don McCullin)

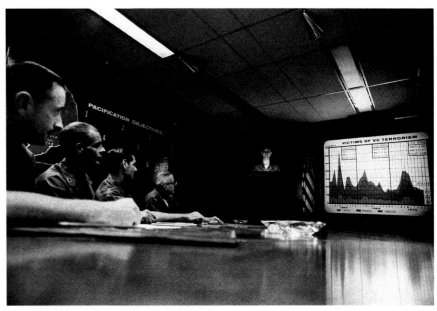

Figure 293 (above)
Philip Jones Griffiths, "Briefing room at MACV Headquarters," 1970; gelatin silver print
(Magnum)
Griffiths took many of his photographs in color originally, but then printed them in black and white.

Figure 294 (left)
Philip Jones Griffiths, "Company of U.S. 9th Division pinned down in some houses in District 8, Saigon," 1968; gelatin silver print
(Magnum)
Photograph made during the Tet offensive, 1968.

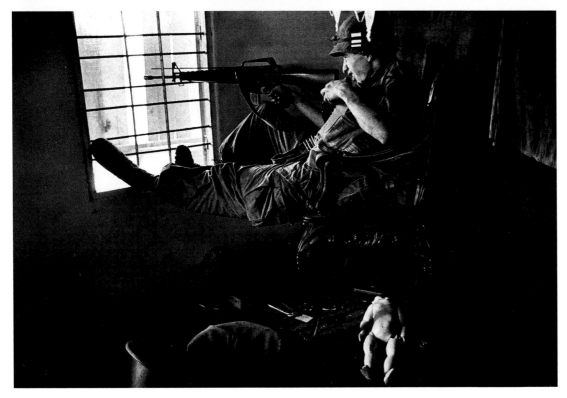

Figure 295
Philip Jones Griffiths, "Captured Vietcong," 1970; gelatin silver print (Magnum)

Figure 296
Philip Jones Griffiths "Napalm victim, South Vietnam," 1967; gelatin silver print (Magnum)

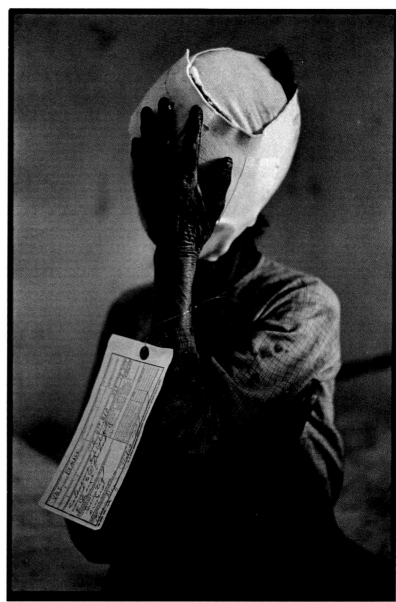

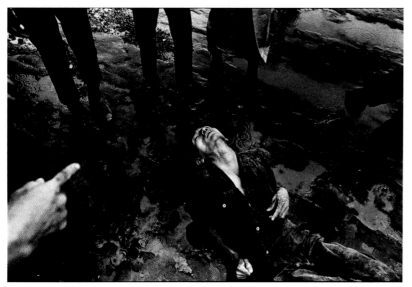

baggage."[60] To Griffiths the question is one of honesty: "The moment that you are dishonest, you will lose the whole game, you will lose everything. . . . You [must] put over information in a way that you sincerely believe to be truth, and there is not a single word in my book—or a picture—that I don't believe to be true."[61]

Griffiths's long-term project is a far different way of working than that of a wire service and newspaper photographer, who must meet ceaseless publishing deadlines. Journalists oriented to one method are sometimes deeply antagonistic toward the other camp's style. While in Vietnam, Griffiths says he saw that there were two valid approaches to the medium. He was deeply impressed by Kyoichi Sawada, a UPI photographer (Figure 299). Sawada

was as committed to Vietnam and to doing a job as I was; our methods were totally separate. He believed that the way to do good in Vietnam was to make sure that every morning on the front page of the *New York Times* and the *Washington Post* there would be a photograph that would really say something about the nature of the war. That was his method and he dedicated himself to that completely and got killed in the process.

Now I say, look, that doesn't happen to be my way. That doesn't mean that it's inferior or less good; it just

didn't happen to be my way. . . . The way my brain works and my body works is to take a long, calm look at things and try to answer and assess . . . [putting] it together so that under your arm you can have a document that will tell you clearly, truthfully, and as meaningfully as possible what actually happened there.[62]

Many of the most important images of the Vietnam war were single, often wire-service, photographs. Besides Nick Ut's chilling image of terrified, napalmed children running down the road near Trang Bang in South Vietnam (Figure 297), another Associated Press photographer, Eddie Adams, made a photograph during the Tet offensive that instantly captured the attention of the world. Stanley Karnow describes the killing of a captive by Gen. Nguyen Ngoc Loan as "the most memorable image of the upheaval in Saigon—and one of the most searing spectacles of the whole war." Adams made three exposures while the NBC cameraman Vo Suu also shot footage (Figures 300–302). The film footage shocked Americans but then passed

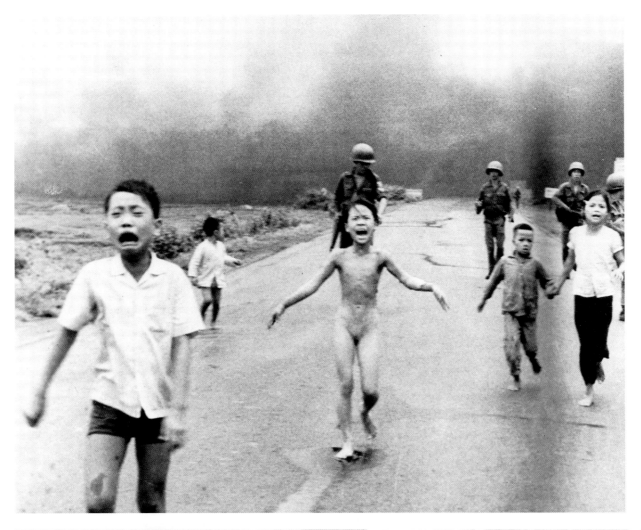

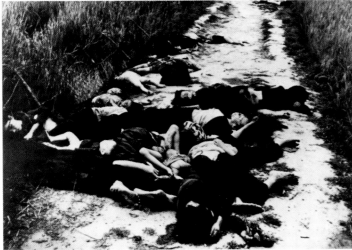

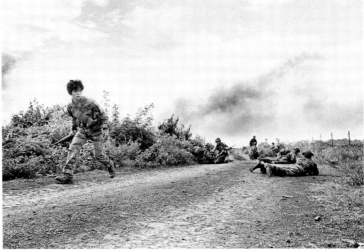

Figure 297 (top)
Huynh Cong "Nick" Ut, "Terror of War," 1972; gelatin silver print (AP)
South Vietnamese forces follow terrified children fleeing down Route 1, near Trang Bang, South Vietnam, June 8, after an accidental aerial napalm strike. Girl at center had ripped off her burning clothes.

Figure 298 (bottom left)
Ronald Haeberle, "My Lai massacre scene," 1968; gelatin silver print (AP)
Bodies of women and children lie on roads leading from the village of My Lai in South Vietnam in March 1968.

Figure 299
Kyoichi Sawada, "Vietnam," c. 1965; gelatin silver print (UPI/ Bettmann Newsphotos)

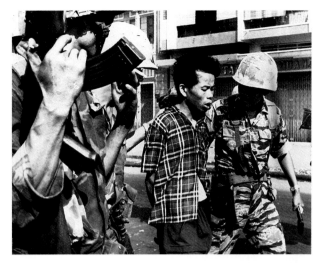

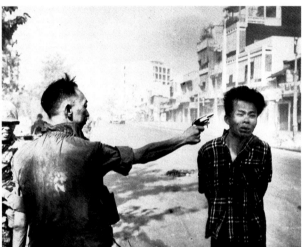

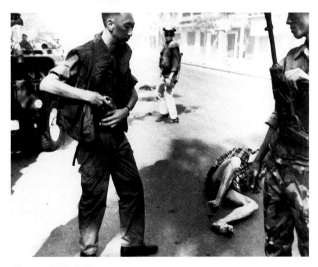

Figures 300–302
Eddie Adams, "Vietcong
arrested," "Vietcong executed,"
"After execution," 1968; gelatin
silver prints (AP)
*Carrying a pistol and wearing civilian
clothes, this Vietcong was captured
near Quang Pagoda during attacks on
Saigon February 1. Identified as an
officer, he was taken to South Viet-
namese National Police Chief, Brig.
Gen. Nguyen Ngoc Loan, who shot
him point-blank in the head.*

from view. Adams's photograph was reproduced in thou-
sands of newspapers, magazines, and books and retains its
power to move the viewer.

From the beginning the image took on symbolic propor-
tions. Umberto Eco, the great Italian writer, observed in his
essay "A Photograph" that the

> vicissitudes of our century have been summed up in a
> few exemplary photographs that have proved epoch-
> making: the unruly crowd pouring into the square dur-
> ing the "ten days that shook the world"; Robert Capa's
> dying *miliciano*; the marines planting the flag on Iwo
> Jima; the Vietnamese prisoner being executed with a
> shot in the temple; Che Guevara's tortured body on the
> plank in a barracks. Each of these images has become a
> myth and has condensed numerous speeches. It has
> surpassed the individual circumstance that produced it;
> it no longer speaks of that single character or of those
> characters, but expresses concepts. It is unique, but at
> the same time it refers to other images that preceded it
> or that, in imitation, have followed it.[63]

Photographer Horst Faas ran the AP photography sec-
tion in Saigon and covered the Vietnam war for eight years.
In 1966 he said:

> I think the best war photos I have taken have always
> been made when a battle was actually taking place—
> when people were confused and scared and courageous
> and stupid and showed all these things. When you look
> at people right at the very moment of truth, everything
> is quite human. You take a picture at this moment with
> all the mistakes in it, with everything that might be con-
> fusing to the reader, but that's the *right* combat photo.[64]

His war work over the years, like that in his 1965 Pulitzer
Prize–winning portfolio, often reveals people pushed to
emotional extremes: an aggressive, furious passion out of
control. Ordinary life has been blasted away; the people's
links with a familial past, gone. Each face carries a clear
story of terror, defeat, or hatred. Faas displays a world with-
out pity, a world *in extremis* (Figures 303–304).

Over time in Vietnam, Faas experienced America's with-
drawal of support for the war and the changing position of
the press.

> At that time, we were attacked for not putting out con-
> troversial things, for not being controversial enough, not
> showing enough bad things. [Earlier they had] said,
> "Why don't you show the people that build and create
> and help these people?" Later on they said, "Why are
> you optimistic? How can you, of all people, be optimis-

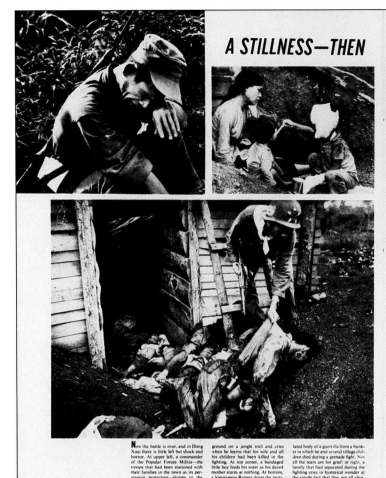

tic?" We said, "We never changed. We just report the damn thing. We do it and when it's over, we go somewhere else."[65]

In *Vietnam: A History,* Stanley Karnow also speaks about the changes in American outlook. Writing of the Vietnam Memorial in Washington, D.C., a black stone monument wedged into a rise of ground, he says that the dead soldiers whose names are carved into its surface—the only decoration—"bear witness to the end of America's absolute confidence in its moral exclusivity, its military invincibility, its manifest destiny. They are the price, paid in blood and sorrow, for America's awakening to maturity, to the recognition of its limitations."[66]

The quote is reminiscent of the rhetorical style used in Europe after World War I (the Great War, as it was

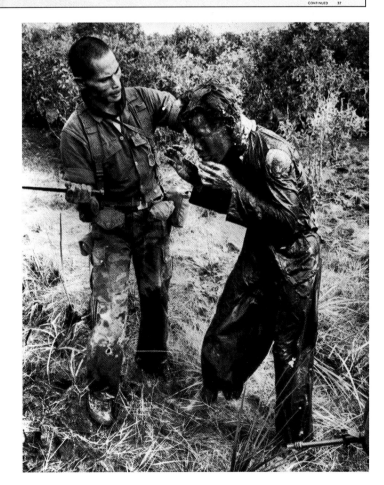

Figure 303
Horst Faas, "A Stillness—Then Shock, Pain, and Hysterical Wonder." From *Life,* July 2, 1965 (Vol. 59, No. 1), pp. 36–37; halftone (Time Inc. and AP)

Figure 304
Horst Faas, "The dirty, nasty war in Vietnam," 1964; gelatin silver print (AP)
A South Vietnamese Ranger punishes a farmer who allegedly gave troops wrong information on Communist guerrillas.

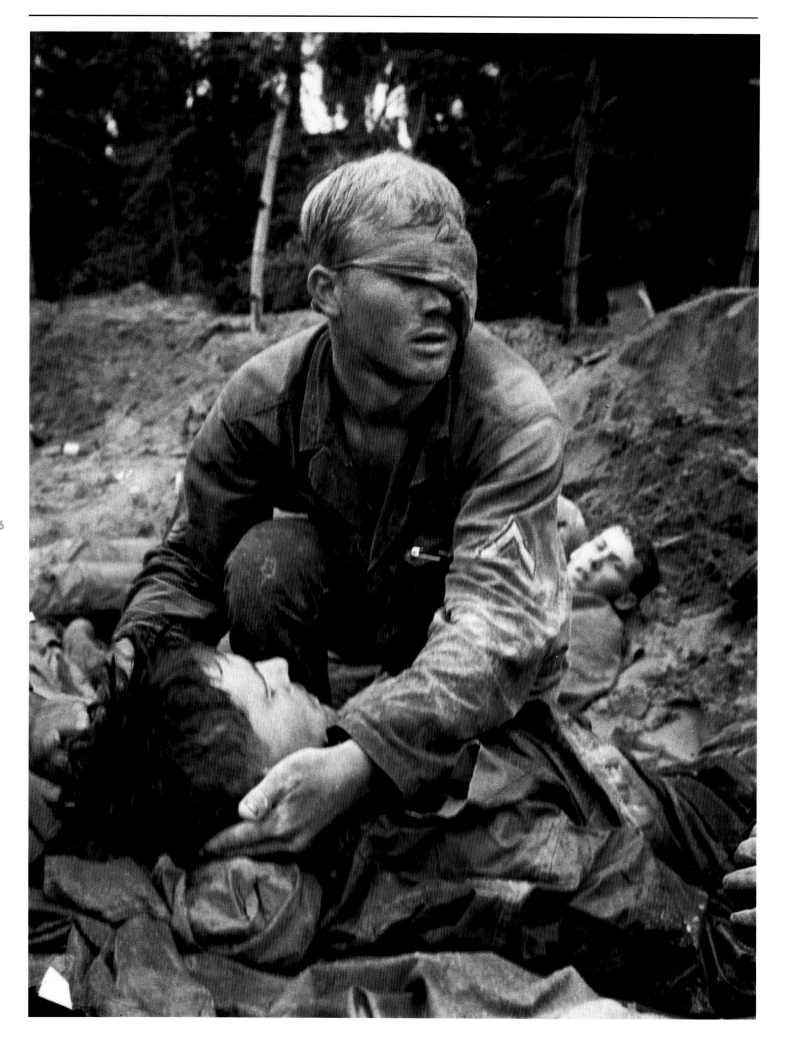

known then—the horror of it such that a second was inconceivable). Writing of World War I, one author observed, "Every war is ironic because every war is worse than expected. Every war constitutes an irony of situation because its means are so melodramatically disproportionate to its presumed ends."[67]

"The Faces of the Americans Dead in Vietnam: One Week," the cover of *Life* announced on June 27, 1969. "Here, for possibly the first time," wrote former editor Loudon Wainwright, "the magazine dropped its life-long posture as the earnest, cheerful broker of the high-mindedness and the good intention of the American establishment and declared itself on the side of the growing mass of dissidents, ready for a profound change."[68] Thus surfaced editorial doubts at *Life* that had begun as early as October 1967 with an editorial by the editor-in-chief, Hedley Donovan, expressing reservations about the war. (President Johnson signaled his understanding of the implications of Donovan's policy statement by declaring, "Hedley Donovan has betrayed me."[69]) *Life* was not the only member of the press to shift ground; in fact, its conservatism had held them back longer than some others. What mattered, though, was that this photographic example was published by a still powerful, highly visible, solid part of the middle class.

Portraits of the dead soldiers for the week of May 28 to June 3, 1969, were lined up across page after page. The story, as David Halberstam wrote, "was so plainly done, there was the air of a high school yearbook to it; one did not know these kids, but one did—they were the kids who went to work rather than college. . . . Their [i.e., the photographs'] very cheapness and primitive quality added to the effect, the pride and fear and innocence in the faces, many of them photographed in uniform, half scared and half full of bravado. It was almost unbearable."[70]

In July of 1943 *Life* had published twenty-three pages of nearly 13,000 names and addresses of those killed in battle during the first eighteen months of America's participation in World War II. It set a fine, somber tone. The pages were rimmed with stars in a band of gray. Only one photograph appeared. Reproduced on the first page was a simple outdoor funeral scene with a flag-draped coffin and a chaplain.

It could have been Kansas, but the caption identifies the place as "a field of Tunisian wheat." The article brought statistics one step closer, but like the war memorial list of a strange town, the realness of a particular life gone was still vague. But the 1968 story worked differently. The faces of the young were familiar. They were in photographs like those everyone owns, part of a known world, yet these kids were dead.

The story's very blandness instead of *Life*'s usual lushness startled the reader. *Life*'s photo statement became news in itself. Always a part of shaping, reaffirming, and echoing public opinion, *Life* now called attention to the government statistics and the very news process in which the press was engaged.

The war's continuation despite the federal government's pledges to end it sparked protest marches against American involvement and, conversely, marches and declarations of support for the government's policy. Vietnam was beginning to eat at the heart of the country, often splitting families along generational lines.

An important moment triggering new, more violent demonstrations, and the most riveting image of the turmoil at home, came on April 30, 1970, when President Nixon announced on television that the American military had invaded Cambodia, thus widening the war. He said in part, "If, when the chips are down, the world's most powerful nation, the United States of America, acts like a pitiful helpless giant, the forces of totalitarianism and anarchy will threaten free nations and free institutions throughout the world."[71] As Stanley Karnow points out, Cambodia "crystallized the unrest" already apparent at universities and colleges.[72] On May 4, 1970, Ohio National Guardsmen fired thirty-five to sixty rounds of M1 ammunition into a crowd of demonstrating students at Kent State University, killing four (Figure 311).

John Filo, who made the Pulitzer Prize–winning photograph, was then a student photographer on the campus yearbook staff. (Many photographers present were students associated with campus publications.) There had been no reason to believe that a small university like Kent State would erupt and become *the* major news story among all the schools whose students and faculty were protesting the war. Therefore, staff from major magazines, such as *Life*, were not covering the story. After any important news story breaks, if the national and international press is not present, news organizations quickly try to locate anyone who might have had a camera at the scene, in which case it's not a question of being there to take the photograph but of getting there and finding it. Filo took his negatives to a newspaper where he had worked and they were processed and sent immediately by AP Wirephoto.

Figure 305
Henri Huet, "Wounded medic works on soldier," 1966; gelatin silver print (AP)
Medic Pfc Thomas L. Cole of Richmond, Va., continues to aid other *wounded in a sandy trench during the long battle between the U.S. First Cavalry Division troops and combined Vietcong and North Vietnamese regulars.*

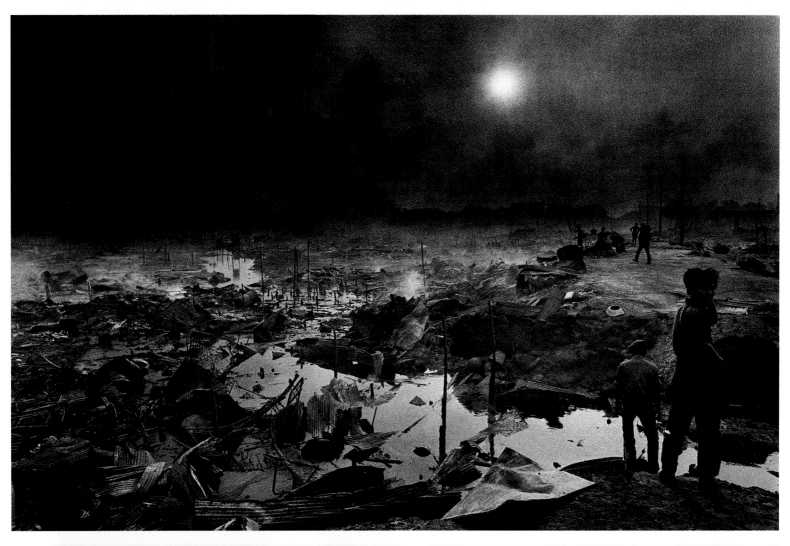

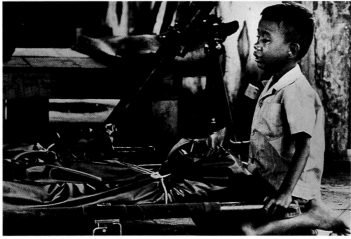

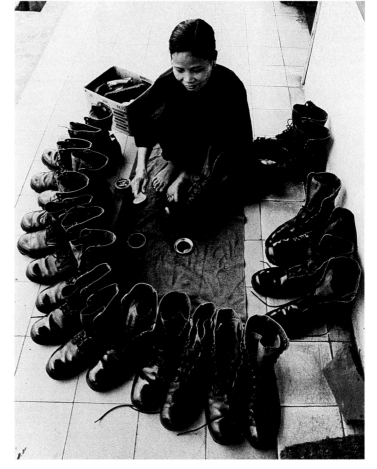

Figure 306 (top)
Christine Spengler, "The bombardment of Phnom-Penh," 1974; gelatin silver print (IMP/GEH. Courtesy Christine Spengler)

Figure 307 (bottom left)
Christine Spengler, "Cambodia, 1975"; gelatin silver print (Courtesy Christine Spengler)

Figure 308 (right)
Christine Spengler, "The departure of the Americans," 1973; gelatin silver print (Courtesy Christine Spengler)

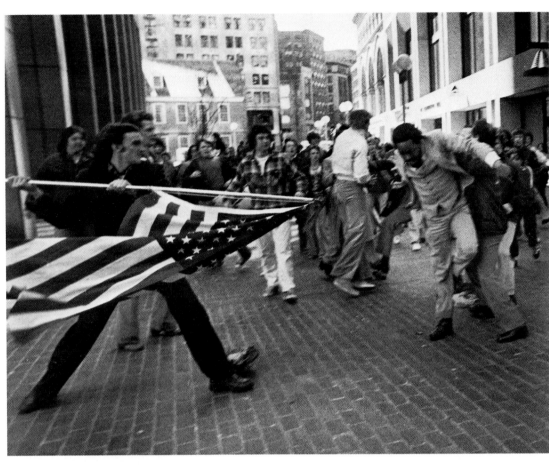

Figure 309
Stanley J. Forman, "The soiling of Old Glory," 1976; gelatin silver print (Courtesy *Boston Herald*)

Figure 310
Benedict J. Fernandez, "Union Square, New York, October 1967"; gelatin silver print (IMP/GEH. Courtesy Benedict J. Fernandez)

Figure 311
John Filo, "A God-awful scream, Kent State University, May 4, 1970"; gelatin silver print (AP)

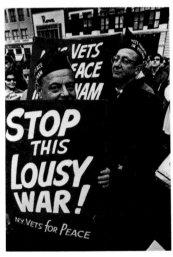

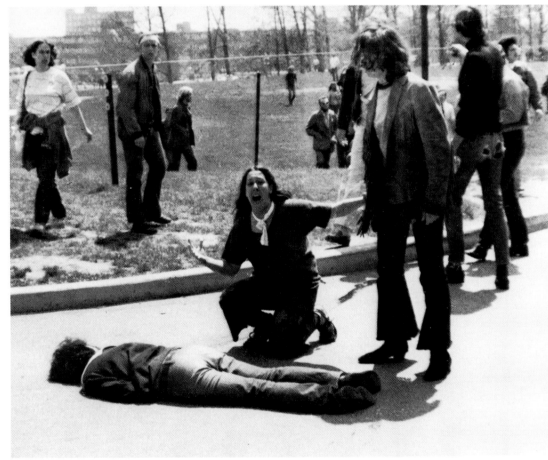

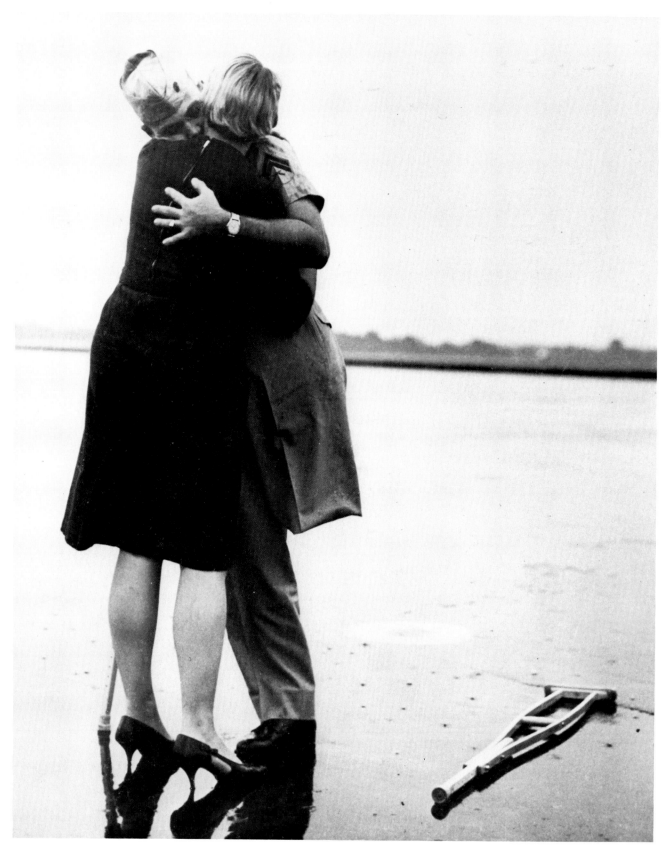

220

Figure 312
Ray Mews, "Home from
Vietnam," 1966; gelatin silver
print (AP)
*Lance Cpl. Perron Shinneman, who
lost a leg to a Vietcong mine in Viet-
nam, is greeted in the rain at his
home airport in Sioux Falls, S.D., on
leave from Bethesda Naval Hospital in
Maryland.*

Controlling Context: The Photographic Book

Many photographers continue to do work in a series or longer photo essay style. With fewer magazines presenting photographic sequences and, in any case, preferring to control the sequencing and meaning themselves, photographers pursue the book format, as Philip Jones Griffiths had. Two examples of this are Don McCullin in *Beirut: A City in Crisis* (1983; Figure 313) and Gilles Peress in *Telex: Iran: In the Name of Revolution* (1984; Figure 314; first published in France as *Telex Persan*).

Don McCullin first went to Beirut in 1965. During the next twenty years he returned many times, recording the beginning of the civil war in 1975. The photographs reproduced in his book bring the viewer close to the horror of the urban war: mental asylums bombed; huge buildings collapsing; city blocks razed (Figures 315–319). He also documents Palestinian families hunted down in the refugee camps, separated, the men killed. It is powerful work. McCullin seems less interested in achieving one photograph that brings everything together, as the wire services attempt to do—although he does this sometimes—but more often his photo essays are a sort of cinematic series that work best together rather than alone. The viewer progresses from picture to picture, making the connections between them, discovering the eventual outcome through time, as McCullin himself did. This approach gives the work a great sense of

221

Figure 313
Don McCullin, *Beirut: A City in Crisis,* 1970, cover; halftone (Courtesy New English Library)

Figure 314
Gilles Peress, *Telex: Iran: In the Name of Revolution,* 1984, cover; halftone (Courtesy Aperture Books)

Figure 315
Don McCullin, "One of the Lebanese nurses who stayed on was able to pacify some patients by her presence," 1982; gelatin silver print (IMP/GEH. Courtesy Don McCullin)
After the bombing of the hospital. McCullin's caption continues: "The staff were trapped in the hospital for 5 days. The boy on the ground had crawled along a corridor as a patient carried another child to a ward."

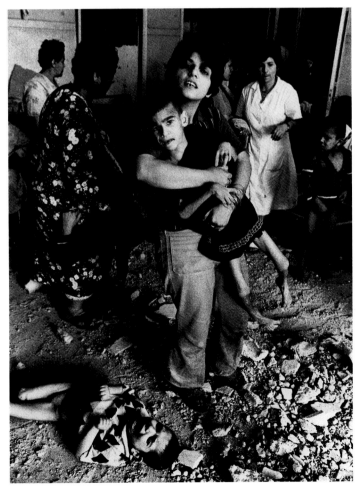

immediacy—it assaults the senses.

The chaos and madness of Beirut build to a crescendo in the book with the bombing of a geriatric and mental hospital. The filth, flies, debris, and the faces of the mad are overwhelming. Captions provide facts and hammer home the details: "The hospital was attacked with artillery, rocket and naval fire. Six patients were killed and twenty wounded. The survivors were left with their own madness and the madness of war piled upon it."[73]

From the beginning of his career in the mid-1950s, McCullin has tried to relay a difficult reality to a mass audience he feels is largely indifferent. Primarily concerned with revealing the lives of the people involved, often victims, he remains close to the central event. He is aware, however, of the ironies of his work—he has a luxury denied his subjects: he can leave.

Gilles Peress, in his book *Telex: Iran: In the Name of Revolution*, draws in the viewer in a different way. In Tehran during the seizure of the American embassy, Peress was very much aware of being an outsider in another culture. The photographs are his personal reaction to the situation (Figures 320–324). Brilliant light, deep shadows, skewed angles, and the enveloping blackness of women's veiled forms all elude analysis. The nightmarish pictures offer no facts, no conclusions. Peress went as an outsider and he stayed an outsider.

222

Figure 316 (top)
Don McCullin, "Palestinians surrendering to Phalange troops," 1976; gelatin silver print (Magnum. Courtesy Don McCullin)

Figure 317 (bottom)
Don McCullin, "Palestinian woman whose husband has been murdered discovering the destruction of her home," 1982; gelatin silver print (Courtesy Don McCullin)

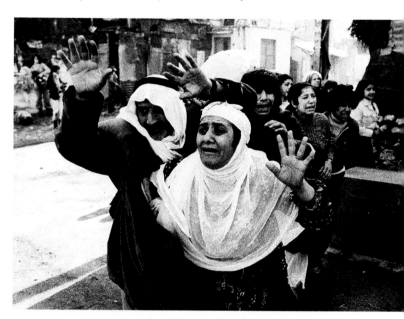

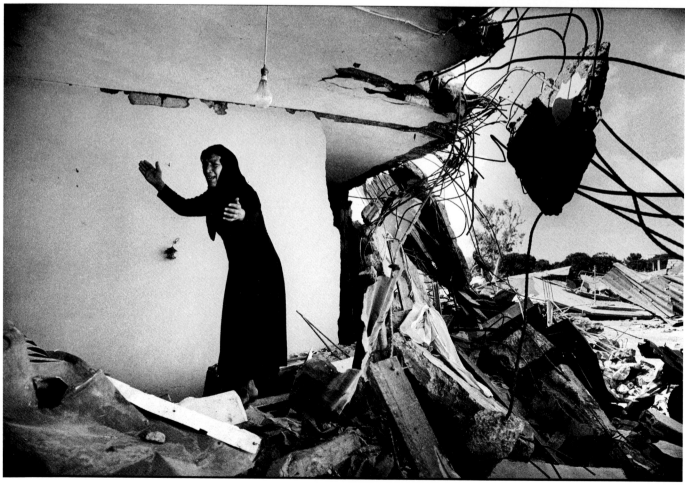

Figure 318
Don McCullin, "Christian fighters in the lobby of the Holiday Inn," 1976; gelatin silver print (Courtesy Don McCullin)
Pictures used in Beirut: A City in Crisis.

Figure 319
Don McCullin, "A Christian kicking a Palestinian who has been selected for death behind this factory wall," 1976; gelatin silver print (Courtesy Don McCullin)
McCullin's caption continues: "I rushed in and tried to stop them and was told, 'Go away, it is none of your business, anyway we are not killing these people,' and then they started booting these people up the road. In fact the next day we found a huge pile of dead bodies further up the road; the bodies had been set on fire."

Figure 320
Gilles Peress, "Street scene
reflected in a mirror, Teheran,"
1979/80; gelatin silver print
(Magnum)

Event and dream merge in pictures such as that of the street scene reflected in mirrors. A British double-decker bus seems to leave the ground on the right side of the photograph; a central building is rent in two, leaving a black triangle; and men mingle on the street. Overlooking this chaotic space, the face of the Ayatollah repeats three times across the sky. Photographs such as this adopt the style of photojournalism: they record events, real objects, but are constructed in such a way that the viewer becomes aware of the photographer as subjective onlooker. Through structure, then, an emotional meaning is overlaid on what, from a different angle, might have been seen merely as a busy street with a sidewalk vendor selling Khomeini kitsch.

Peress was deeply disturbed about what was happening in Iran; he shares that with us through the construction of both his book and the individual reproductions.

Telexes sent back and forth during his stay in Iran serve as text in the picture sequence. Concerned with practical problems of sending film, finding food, and selling the story to magazines, the messages are reminders of the West, of home, and further point up the psychological distance between Peress and his unfamiliar surroundings. Much closer to the sequences of photographers William Klein and Robert Frank, *Telex: Iran* is described by Peress as personal work in a photojournalistic place.

Publishing extended series in book form allows photographers to control the context in which their work appears. They are the final judges of how a sequence will run, how large the pictures will be, and what captions will appear. The publishing process can take years, however. First, photographers want to be satisfied that they've said what they have to say—Peress himself has been working nearly twenty years in Northern Ireland and is finally publishing *Northern Ireland: An Eye for an Eye*. Then, finding a publisher and financial backing is not easy. With all this, significant work continues to appear in book form by such photographers as Abigail Heyman, Mary Ellen Mark, Susan Meiselas, Eugene Richards, and Sebastiao Salgado.

Figure 321
Gilles Peress, "Peasants arriving at a protest in front of the U.S. embassy, Teheran," 1979/80; gelatin silver print (IMP/GEH. Magnum)

Figure 322 (middle left)
Gilles Peress, "Pro-Shariatmadari demonstrations, Tabriz," 1979/80; gelatin silver print (IMP/GEH. Magnum)
A selection from Telex: Iran.

Figure 324
Gilles Peress, "Street, Azerbaijan," 1979/80; gelatin silver print (Magnum)

Figure 323 (middle right)
Gilles Peress, "Posters in front of the U.S. embassy, Teheran," 1979/80; gelatin silver print (Magnum)

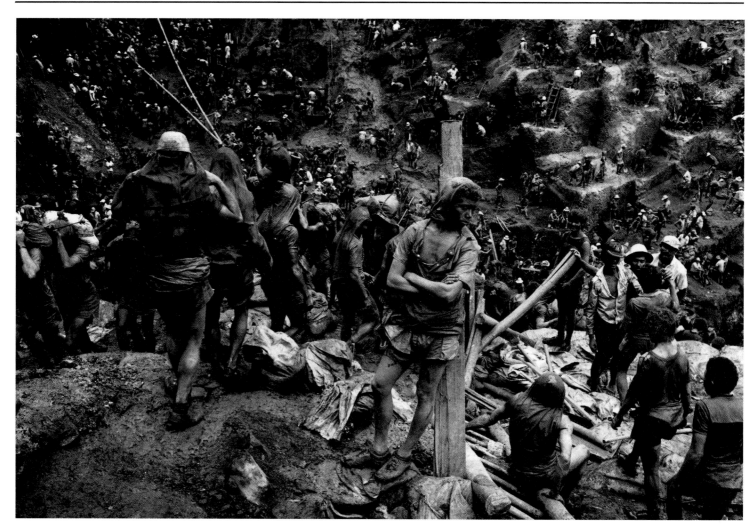

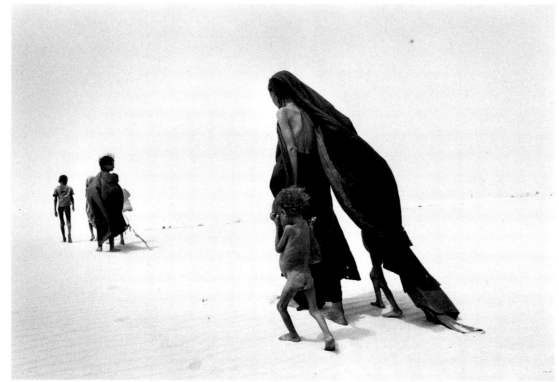

Figure 325
Sebastiao Salgado, "Serra Pelada, Brazil," 1987; gelatin silver print (IMP/GEH. Courtesy Magnum)
Fifty thousand men climbing up the edge of the open-top gold mine with heavy sacks of soil each weighing 30 to 60 kilos. The soil is lifted to an area about 400 meters away by this human chain.

Figure 326
Sebastiao Salgado, "Region of Lake Fagubian. These nomads have had to walk across wide expanses 'dehydrated' by a temperature of 50 degrees C. to come to the edge of the villages in hopes of finding shelter and nourishment. Here they are going to the more prosperous villages of the Azduerma, on the bank of the great lost lake," 1983/85; gelatin silver print (IMP/GEH. Courtesy Magnum)
This is from Salgado's book on the Ethiopian famine, Sahel: L'Homme en détresse.

These three images are from Mitchel's unpublished book on elderly and mostly poor Jews on the Lower East Side of New York City.

Figure 327 (top)
Julio Mitchel, "Synagogue staircase," 1982/83; gelatin silver print (Courtesy Julio Mitchel)

Figure 328 (left)
Julio Mitchel, "Man in Lower East Side apartment," 1982/83; gelatin silver print (Courtesy Julio Mitchel)

Figure 329 (right)
Julio Mitchel, "Vandalized synagogue," 1982/83; gelatin silver print (Courtesy Julio Mitchel)

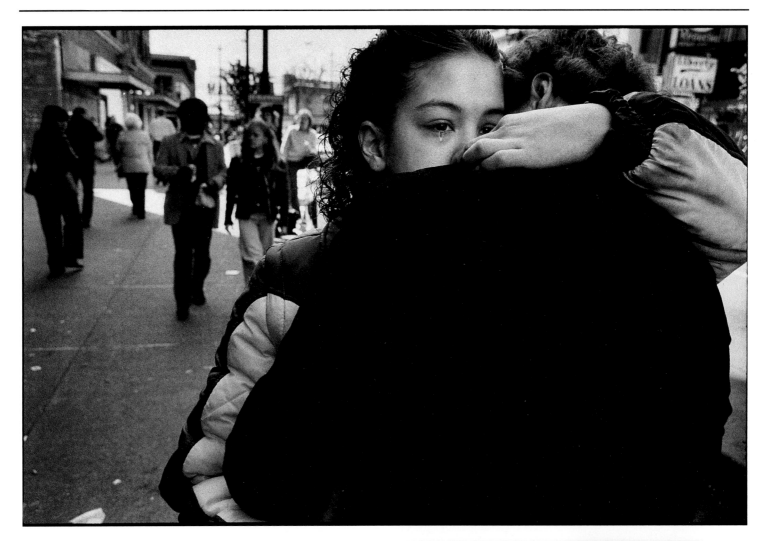

These photographs are from "Streetwise," a series on runaways.

Figure 330
Mary Ellen Mark, "Patti and Munchkin, Seattle, 1983"; gelatin silver print (Archive)

Figure 331 (right)
Mary Ellen Mark, "Tiny, Seattle," 1983; gelatin silver print (IMP/GEH. Courtesy Archive)

Figure 332 (opposite, top)
Mary Ellen Mark, "Rat and Mike, Seattle," 1983; gelatin silver print (Archive)

Figure 333 (opposite, bottom)
Mary Ellen Mark, "Lillie, Seattle," 1983; gelatin silver print (IMP/GEH. Courtesy Archive)

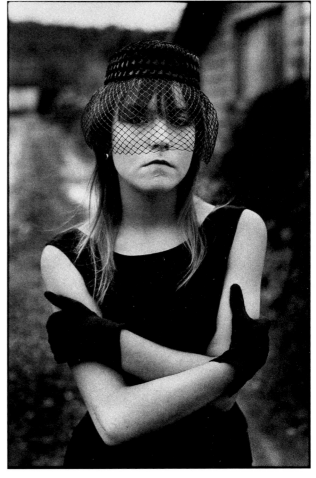

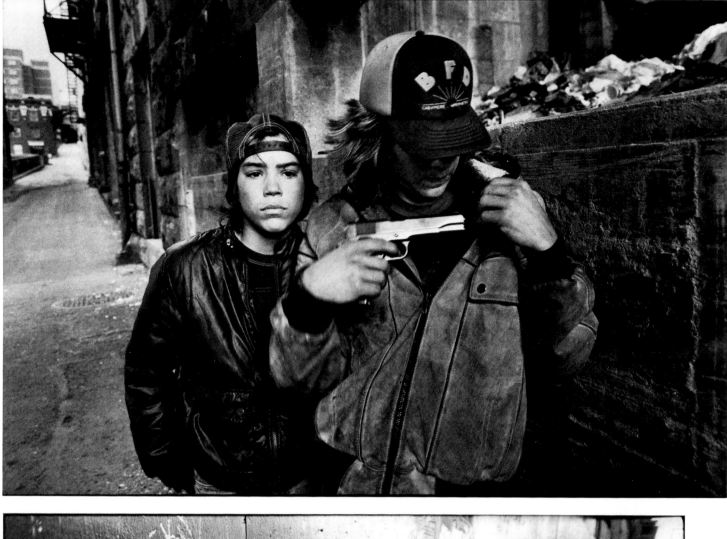

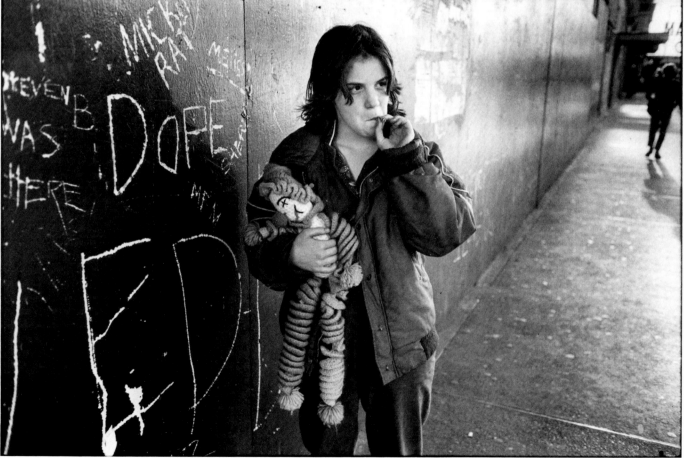

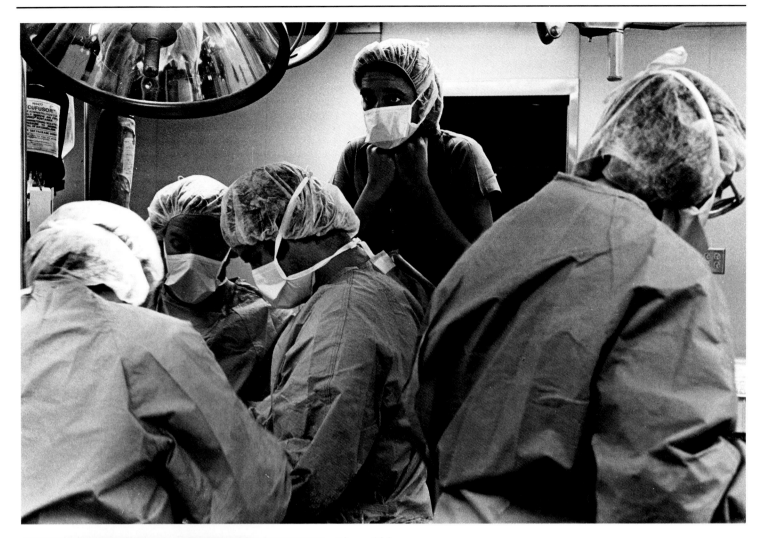

Figure 334
Eugene Richards, "Emergency room, 1981"; gelatin silver print (Magnum)
A nurse, weary after long hours in the operating room. From Richards's book Knife and Gun Club.

Figure 335
Jill Freedman, "Two policemen with backs turned," 1978; gelatin silver print (Archive)
Freedman writes in her book Street Cops: *"Some people stopped them. Man with a gun in there, they said. It was an old tenement. They banged on the door and told the man to come out. There was no gun. But if he had come out shooting, where could they have gone?"*

Newspapers Take On the Photo Essay

Books have been one vehicle for photojournalists working in depth to get their work out. In the 1980s a few newspapers have provided a platform for some of the decade's best work. While the well-known *New York Times Magazine* has published excellent photographic essays by Angel Franco, David Burnett, and Letizia Battaglia and Franco Zecchin, to name only four photographers, it is the regional papers that are making the biggest contribution. Newspapers such as the *Boston Globe,* the *Denver Post,* the *Detroit Free Press,* the *Louisville Courier-Journal,* the *Philadelphia Inquirer,* and the *San Jose Mercury News* have photographers covering local news and, increasingly, national and international events.

In 1987 the *Boston Globe,* for example, featured a six-part series titled "Refugees, the People of Flight," including articles on Africa, Guatemala, and Pakistan, with staff photographers Paul Benoit, Janet Knott, Joanne Rathe, and John Tiumacki, among others. "Irontown, U.S.A.," a series about Michigan's small towns by Manny Crisostomo, was published in the *Detroit Free Press.* David Turnley, another staff photographer at the *Free Press,* has won many awards for his work in South Africa: "There is a tradition today among American newspapers that does, for lack of a better way to put it, the old *Life* approach to photo essays . . . in terms of the duration of the project that the photographers pursue and picture quality and use."[74]

Turnley is an example of the new direction in newspapers and in the careers of young photojournalists. He calls himself a "hybrid" of the different domains and outlets of photojournalism: daily newspaper coverage of breaking news, in-depth photo essays, and agency distribution. Based in South Africa for the *Detroit Free Press,* he comments:

> I've been covering the situation not only in a long-term way, but also covering daily news events and transmitting pictures back to the newspaper during this whole time on a daily basis. . . . I'm also in the unusual situation that while I work for a newspaper, my work, after going to the *Detroit Free Press,* has been going in its entirety to Black Star, who has then distributed it all over the world.[75]

Turnley believes that because all three parties benefit from the arrangement, in the near future more newspapers will link up to agencies. Receiving a steady salary from the newspaper and selling work internationally through Black Star has allowed Turnley the freedom to pursue his coverage of South Africa without the debilitating financial and time problems faced by other photographers:

> One of the main problems that's most obvious in the world of photojournalism is the issue of supporting oneself to do the kind of work one wants to do. What that

231

Figure 336
Angel Franco, "Juvenile handcuffed," 1986. From the series "The Alamo, 46th Precinct, Bronx, N.Y."; gelatin silver print (IMP/GEH)

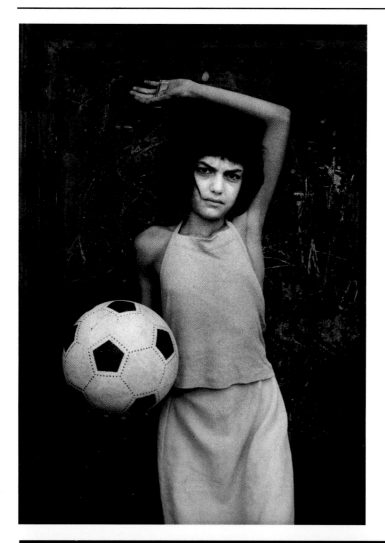

generally means is that agency photographers require guarantees from the big magazines like *Time* and *Newsweek,* etc., to send them someplace—but these kinds of guarantees generally don't last longer than a month or two, depending on the situation and how hot it is at the time, which means that unless people are prepared with their own money to stay someplace, which most people aren't prepared to do, it very much limits the kind of work they can do.[76]

In late 1986 the *Philadelphia Inquirer* asked photographer Donna Ferrato of Visions photo agency to come to Philadelphia and continue her series on domestic violence (Figures 339–342). She worked closely with Dick Polman, a staff writer, over a nine-month period, and together they conducted interviews, accompanied police on calls, and spent time in emergency rooms. Known for her work with abused women, in 1985 Ferrato received the prestigious W. Eugene Smith Award (sharing it with Letizia Battaglia) for her "Domestic Violence" photographs.

Donna Ferrato cares deeply about the people whose lives she enters, and the assignment from the *Inquirer* allowed her to follow her own direction. Published in two issues of the Sunday *Inquirer* magazine, her photographs show women with cuts, bruises, and stab wounds, hovering in the darkness of their own homes or displayed under the

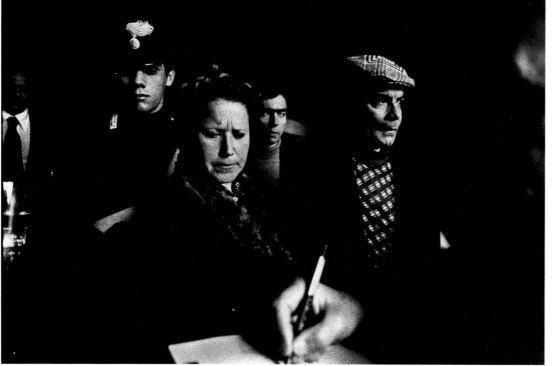

Figure 337
Letizia Battaglia, "Little girl with a ball," 1986; gelatin silver print (Courtesy Letizia Battaglia)
Photograph made in La Cala, the poor quarter of Palermo.

Figure 338
Letizia Battaglia, "Palermo, 1975. After a man was killed, the family is interrogated by the police," 1975; gelatin silver print (Courtesy Letizia Battaglia)

fluorescent lights of police stations and hospitals.[77] Writer Fred Ritchin has said that Ferrato "sees in absolutes. She hates men who abuse women. She is a champion of the cause, a crusader, a teacher. In this way she may save some of us from horror, from blackened eyes and broken bones and death."[78]

The *Philadelphia Inquirer*'s increasing commitment to high-caliber photojournalism began in the early 1970s when Gene Roberts left the *New York Times* and became the *Inquirer*'s executive editor. Since that time, the newspaper has won over fifteen Pulitzer Prizes. Larry Price, Director of Photography, says that the paper is interested in presenting "hard-core photojournalism" consisting of work that takes an advocacy stand or a geopolitical stand or that goes in depth on social problems.[79] With twelve picture editors and a staff of excellent photographers, Price feels that "there's no story in the world we can't cover." In 1986 the rotogravure magazine printed one photo essay every other week; in 1987 one essay appeared every week. Past subjects included the homeless in Philadelphia, on the streets during the coldest months of the year, by photographer Tom Gralish; an older couple dealing with the husband's deteriorating condition caused by Alzheimer's disease, by Sarah Leen; Stephen Shames's work on children in poverty; and Price's own work on the civil wars in El Salvador and Angola, his portfolio of these photographs winning a Pulitzer Prize.

These photographs (Figures 339–342) are from the series "Domestic Violence."

Figure 339
Donna Ferrato, "Rita, 25, two days after her nose was broken. Charges are pending." From "Domestic Violence," *Inquirer* [of the *Philadelphia Inquirer*], July 26, 1987, cover; halftone (Courtesy *Philadelphia Inquirer*)

Figure 340
Donna Ferrato, "Policeman answering domestic abuse call, Philadelphia, 1 A.M., February 13, 1987"; gelatin silver print (Visions)

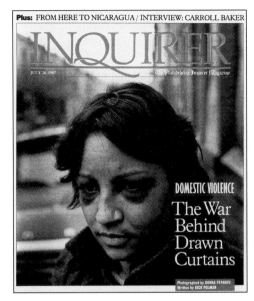

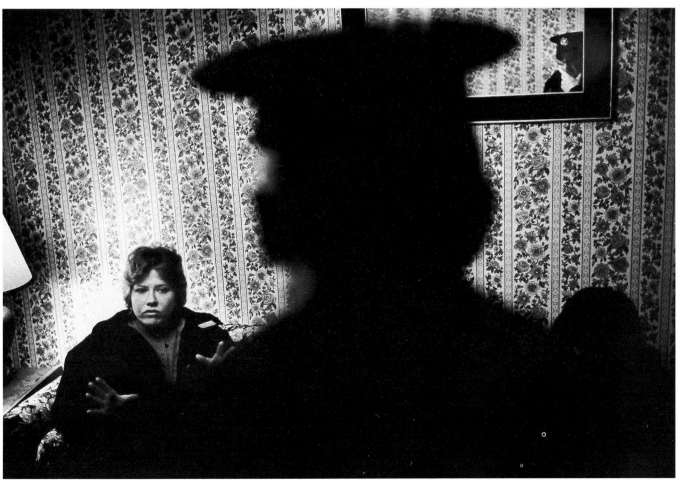

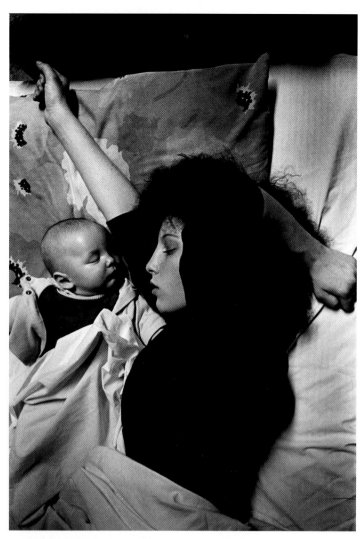

Figure 341
Donna Ferrato, "Young mother and baby son, first night in the shelter, Philadelphia, November 23, 1986, 1:30 A.M."; gelatin silver print (Visions)

Figure 342
Donna Ferrato, "Stabbed with a butcher knife by her boyfriend during a family quarrel, Emergency Room, Philadelphia, February 14, 1987, 11:20 P.M."; gelatin silver print (Visions)

Team Journalism

Photojournalism is most often a group effort. Whether for a newspaper, magazine, agency, or wire service, photojournalism is a process that necessitates the continual involvement of many people. As Howard Chapnick puts it:

> Photojournalism is a point of view of many people. . . . It's only in a book, perhaps, where the photographer has complete control, where his or her point of view comes through very clearly and distinctly. Otherwise, for the most part, it's diluted. It's a matter of team journalism, so that there are many points of view in every story: there's the writer, there's the photographer, there's the editor, there's the art director. And all this input makes for a completely different statement.[80]

Photo editors are an integral part of the system. Depending on the situation, photographers can act as their own photo editors, but most often their photographs pass by one or more other editors. For example, at *Newsweek*, Picture Editor Karen Mullarkey heads a large staff of picture editors. These editors are individually responsible for diverse areas such as art, society, domestic news, foreign news, or the international edition of the magazine. Mullarkey also works closely with the art director, senior editors, executive editor, editor, and editor-in-chief to produce the magazine.

Figure 343 (top)
Unidentified photographer, "A sister's agony," 1976; gelatin silver print (AP)
Hector Petersen's sister screams in grief at the killing of her brother by a police bullet June 16 during riots that began in the Soweto section of Johannesburg, South Africa. The anniversary of his death is observed every year in Soweto.

Figure 344 (bottom)
David Turnley, "Mrs. Winnie Mandela peers through bars on a gate that surrounds her Soweto home," 1986; gelatin silver print (*Detroit Free Press*/Black Star)
Winnie's husband, Nelson Mandela, has been in prison for the last 24 years for his anti-apartheid leadership role in the African National Congress.

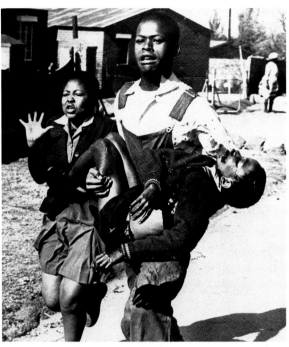

235

Figure 349
M. Sayad, "U.S. embassy, Tehran, Iran, November 9, 1979"; gelatin silver print (AP)
Demonstrators gather outside the U.S. embassy in Tehran, which is being held by revolutionary students, shouting anti-American slogans while the students wave to them from the top of the wall that is covered by slogans and posters.

Figure 350
Unidentified photographer, "One of the hostages held at the American Embassy, Tehran," 1979; gelatin silver print (AP)

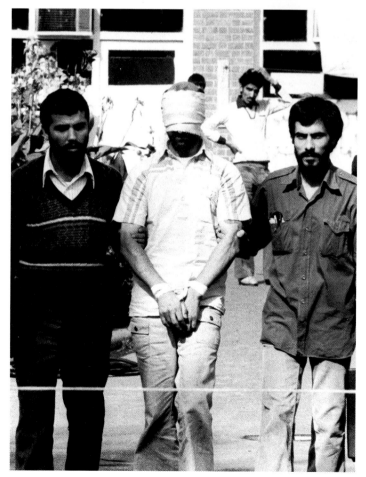

scene of a disaster, such as when the shuttle *Challenger* blew up. Buell describes the situation:

> In that case, the priority, the heat, the judgment falls on the person at the scene. . . . Now, that's the person who has to decide what's first because the guy in the monitor's chair [in New York] says, "Whatever you've got that's good goes next." . . . When the shuttle story first broke, the first collection of pictures went, just went right through.[84]

In other words, the transmitted pictures were not stopped in New York for editing and possible assignment to different regions of the United States; they went from Cape Canaveral onto the national wire to all the members of AP.

Both examples of outlets mentioned for photographs—newsmagazines and Associated Press—have advantages and disadvantages for the production of pictures. For example, the prestigious newsmagazines will assign one of their staff members or a freelancer to cover a story. The published picture will be well printed on glossy stock and reach a national, sometimes international, audience. Shifting magazine content, however, can force picture editors to cancel one assignment and to locate other photographs to accompany newly added stories, thus complicating deadlines. (This may mean that older photographs from an agency's or

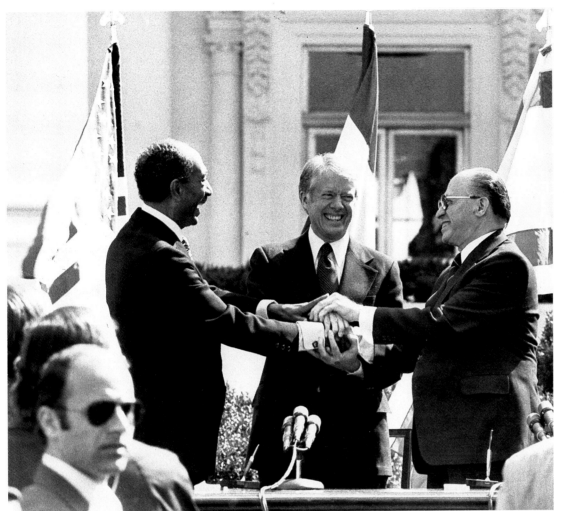

Figure 351 (left)
Unidentified photographer,
"Peace Brings Them Together,"
1979; gelatin silver print (AP)
*Egyptian President Anwar Sadat,
President Jimmy Carter, and Israeli
Prime Minister Menachem Begin
clasp hands on the north lawn of the
White House as they complete the
signing of the peace treaty between
Egypt and Israel.*

Figure 352 (above)
Bill Foley, "Egyptian President
Anwar Sadat speaks to Egyptian
Minister of Defense Abu Ghazala
as Vice-President Hosni Mubarak
listens," 1981; gelatin silver print
(AP)
*On the reviewing stand at the military
parade in Cairo commemorating the
eighth anniversary of the Yom Kippur
war.*

Figure 353
Mohamed Rachad El Koussy,
"Sadat: The parade of death,"
1981; gelatin silver print (AP)
*The parade was suddenly interrupted
when six Egyptian soldiers leaped from
a truck and opened machine-gun fire
on the presidential reviewing stand.
President Sadat and Egyptian Minis-
ter of Defense Abu Ghazala were
injured; Sadat later died from his
wounds.*

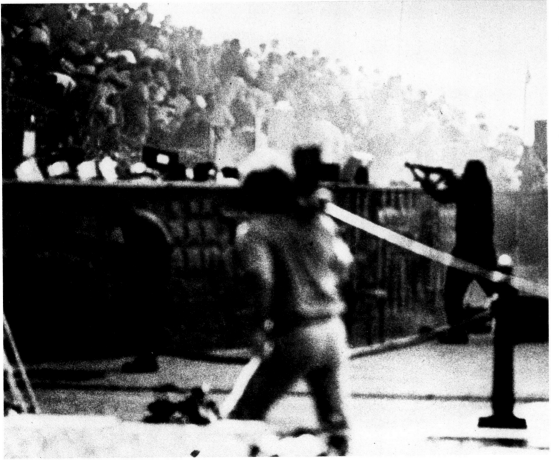

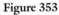

AP's files are used to make a new point.) Photographers must realize that only three or four pictures, at most, are generally published. Newsmagazines sometimes do release a photo essay, but not often. Aside from their longer cover stories, newsmagazines remain digests of the news in the same pattern that Henry Luce established at *Time* in 1923.

Working for Associated Press means that a photographer's pictures are more likely to be used—and used by more newspapers and magazines than those of any one magazine's staff photographer. The urgency of production, knowing that everything is needed immediately, can considerably weaken image quality, however. While the ideal is to transmit a picture that captures the essence of the situation, isolating the significant from the trivial, all too often speed kills. This problem is corrected to a degree because AP continues to cover a story as it unfolds and transmits newer, often better, photographs as they become available. Thus, looking at a day's or a week's transmitted pictures is like looking at a photographer's proof sheet: some images are weak and a few are outstanding. Crediting the photographer is also a potential problem. While AP does provide the photographer's name along with the caption information, it does not insist that newspapers print the name. So although the photographer's work is printed in a number of papers, chances are that many readers will not know who the photographer is.

240

Photographs from Cyprus and the Middle East.

Figure 354 (top)
Micha Bar-Am, "Holocaust survivors search for familiar names," 1981; gelatin silver print (IMP/GEH. Courtesy Magnum)

Figure 355 (bottom)
Don McCullin, "Cyprus, 1964"; gelatin silver print (IMP/GEH. Courtesy Don McCullin)

Figure 356 (opposite)
Micha Bar-Am, "Freed hostages return from Entebbe," 1976; gelatin silver print (IMP/GEH. Courtesy Magnum)
Israeli passengers held hostage in Uganda return home after being freed by Israeli commandos.

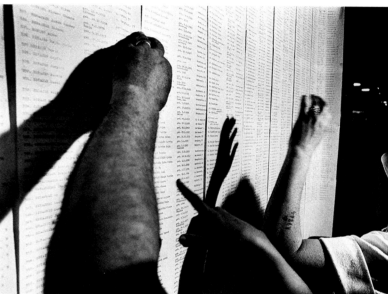

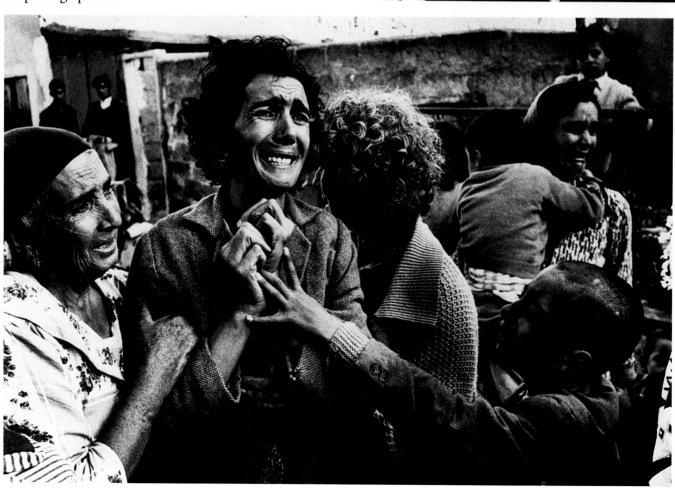

Figure 357 (top)
Janet Knott, "Palestinian refugees in Baqaa camp in Jordan line up outside the food distribution center for weekly provisions, which are given out on Thursdays," 1987; gelatin silver print (Courtesy *Boston Globe*)

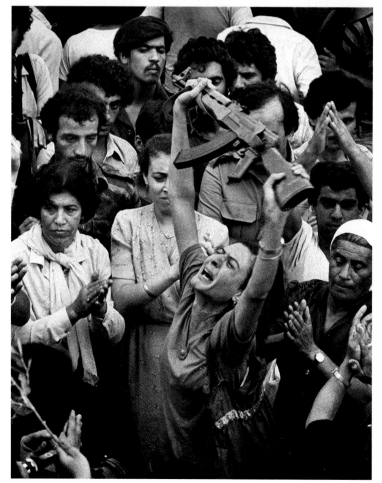

Figure 358 (bottom)
Paola Crociani, "Emotional departure," 1982; gelatin silver print (AP)
A Palestinian woman in Beirut dances in the street waving a rifle over her head the Sunday following the departure of her husband, a PLO fighter in the second group of men being transported to Tunisia via Cyprus.

Figure 359
Christopher Steele-Perkins, "Gaza Palestinian Hospital—Beirut, 1982"; gelatin silver print (Magnum)

Figure 360
Stan Grossfeld, "Palestinian children frightened by shelling are evacuated into trucks. Tripoli, Lebanon," 1983; gelatin silver print (Courtesy *Boston Globe*)

Ethics and Credibility

Publishing decisions by picture editors, whether about work by their own staff or from the AP, always hinge on a question of ethics, a subject that concerns all photojournalists. Ethics is concerned in the largest sense with a person's duty toward and moral obligations to humankind. In photography, the issue covers fairness, truthfulness, privacy, decency, and responsibility—all broad terms defined only when thought to have been abused.

Photojournalism consists of pictures *and* words. If the caption on the photograph is incorrect, the whole production is in doubt. Photographs are often ambiguous; unless the words clarify the situation and put it into perspective, the picture could easily be misunderstood. Captions and pictures that obscure the original context can throw doubt on the character of the subject and thus become unfair, untruthful, and irresponsible. As photographer Flip Schulke pointed out, the person pictured is "a real live human being with a job and a background and a family. I've taken pictures that I've wished I hadn't; that's why I edit. You can make anybody look bad—an instant in time can ruin a life every once in a while. [As photojournalists] we have a responsibility because we're stopping time."[85]

Cropping and picture choice are also considerations in determining ethical standards. Context can easily be altered by cutting significant subject matter from the image. For example, if a man holds a large stick, is he defending himself or attacking? Picture selection catches the eye of the public; sometimes they don't like what they see.

Occasionally a published photograph is deemed to be sensationalist, as when Pennsylvania State Treasurer R. Budd Dwyer committed suicide in his office at a press conference he had called (Figures 361–362). Dwyer had been convicted on charges of bribery, mail fraud, and racketeering, and the office was packed with local television video crews, photographers working for the AP, and newspaper photographers. Since he faced a huge fine and up to fifty-five years in prison, the press expected his resignation from office and a statement. Instead he pulled a .357 Magnum out of a paper bag, put it in his mouth, and pulled the trigger. Both UPI and AP photographers had photographs showing the entire episode, which took about fifteen seconds. UPI sent five pictures and AP transmitted six. The AP photographs included an advisory that the photos could be offensive to readers. Decisions made by newspaper staffs across the country brought to the fore questions about newsworthiness and the sensational nature of those pictures showing the impact of the bullet.

While photographs of suicides don't command more attention than other local incidents and are often withheld from publication, a government official killing himself in public made the circumstances news across the country.

244

Figure 361
Paul Vathis, "State Treasurer
Commits Suicide," 1986; gelatin
silver print (AP)

Figure 362
Paul Vathis, "Moment of Impact,"
1986; gelatin silver print (AP)

Some editors felt that using the impact picture would sensationalize a minor story. Others who used the stronger images reported receiving complaints about them but not about photographs showing bodies of demonstrators killed in the Philippines that appeared on the same page.[86] Apparently the sudden, graphic nature of Dwyer's death explains the difference in reactions.

The public's complaints are reminiscent of other controversial photographs, such as that of the dead soldiers at Buna Beach in *Life* magazine, the first picture of American war dead during World War II (Figure 185). The statement that accompanied the photograph made the argument that it was newsworthy because Americans must understand what war is and what other Americans were going through.

Concerned about recent tendencies in the medium, author and critic Fred Ritchin said during an interview that

> photojournalism used to be used for discovery, exploration, to tell people what the world was about. Today it's used more and more as illustration. I think that's dangerous. If photojournalism continues simply to illustrate what the words say, what the editors want, then it will rapidly dig its own grave and become more and more a second-class medium. Instead, it should be used to do expositions and explorations parallel to word journalism. And, if it needs at times to be labeled subjective, then why not? It's an extension of the medium, a way of dealing with it in a bigger way.[87]

At least since the days of the exploding flashgun early in the century, the presence of photographers at events has often been resented. Even the safe and fast strobe can disrupt the flow of events and call attention to the photographer. The most serious indictment of photographers comes when they are accused of being more than observers—if not participants, then catalysts to the situation as it develops. Two examples: Horst Faas and Michel Laurent stayed to report the torture and killing of three men in Dacca stadium (Figure 363) when other photographers had decided among themselves to leave, fearing they were seeing an event staged for the press. Faas maintained that similar things were occurring elsewhere in the city with or without cameras around, and, in any case, his job was to cover the news. In another instance, J. Ross Baughman was also accused of inciting torture by his presence in a Rhodesian cavalry unit known as Grey Scouts (Figure 364). Baughman's manner of identifying with his subjects, at least superficially, instead of maintaining a distance, was also criticized by other photojournalists.

Serious charges against photographers in the field are seldom resolved. In the incidents described above, all parties are sure they are correct and have strong feelings about the

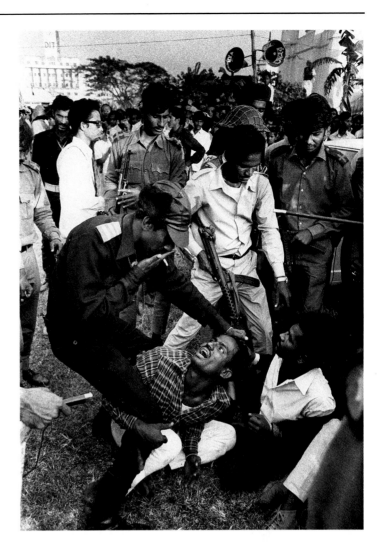

245

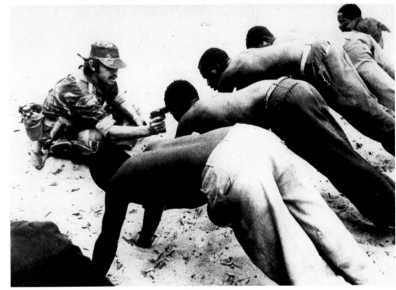

Figure 363 (top)
Horst Faas/Michel Laurent, "Torture in Dacca," 1971; gelatin silver print (AP)
Mukti Bahiri leader, in fur-brimmed forage cap, prepares cigarette to press it into face of execution victim as he kneels over him during torture in Dacca, December 18. Accused of rape and looting, the Pakistani militiamen were executed before a crowd of 5,000 men and children.

Figure 364 (bottom)
J. Ross Baughman, "Questioning—Rhodesian-style," 1977; gelatin silver print (AP)

other side. The accusations, arguments, and public debate do have a positive side—they remind everyone of the heavy responsibility a photojournalist bears. Unfortunately, the ultimate damage is to the fragile credibility of photojournalism itself. As Howard Chapnick wrote in his *Popular Photography* magazine column: "*Credibility. Responsibility.* These words give us the right to call photography a profession rather than a business. Not maintaining that credibility will diminish our journalistic impact and self-respect, and the importance of photography as communication."[88]

Credibility can also be destroyed by staging an event or by manipulating the print itself. We saw evidence that in his Civil War battlefield photographs, Alexander Gardner moved a gun and a soldier's corpse to make two different photographs. In more recent times, photographers who asked participants to "do it again" or to demonstrate a routine have been criticized. It has always been possible to retouch the negative or photograph, to add or to delete subject matter in the darkroom. In the 1980s sophisticated computers can do the same thing without the darkroom and almost without leaving a trace of the process.

Much concern has been voiced about the use of these machines in photojournalism. Does their very presence invite unethical alteration of photographs? Fred Ritchin observed that the threat to photography

is not in the technology but in the basic attitude that equates photojournalism with illustration. You start out using the computer to make formal, cosmetic changes, like color correction or extending a blue sky to drop in cover type. OK, you can argue that you haven't changed the intent of the picture. But it's more problematic when you start making changes to convey an editorial point of view. For example, you could say, "Let's make Reagan look older. After all, there must be times when he looks quite old, so why not just do it with a computer?"

If, as an editor, what you wanted was real exploratory journalism, in which you're discovering things you don't already know, then the computer isn't as much of a threat because it can't reveal those things. But if you're already using photos to depict only what you want to depict, then why not use the computer to touch them up, or to manufacture them?[89]

Clearly, the ethical standards for the machine's use have to come from above. If the management doesn't enunciate its criteria for acceptable journalism, no consistent policy will emerge on its own. This was as true in 1900 as it is today. As Hal Buell of AP said: "I don't think your ethics can be any better or worse using electronic methods than they are using the classical methods. Ethics is in the mind. It is not in the tools you use."[90]

New Technology: The Plus Side

New technology for editing images, such as the Scitex, Crosfield, or AP's "electronic darkroom" machines, mean that the work can be done better and faster than ever before. With the introduction of the SVC (still video camera) (Figure 365), it also means that an image can pass from the camera's magnetic disk (the disk replaces film), through the editing process, and onto a page of type without ever existing as a print. This is a radical change: it is the first time in the 150-year history of photography that optical-chemical systems invented by L. J. M. Daguerre in France and William Henry Fox Talbot in England have been bypassed.

If starting from a print, on the electronic editing machines, the picture is converted into digital information and displayed on a screen consisting of thousands (or millions) of picture elements called pixels. Depending on the sophistication of the particular system, either each pixel or specified larger areas of the screen image can be altered. The process is swift and the results can be seen immediately. The picture can be enhanced, lightened, darkened, color-corrected, and cropped. On the Scitex and Crosfield, to name two, colors can be changed and picture areas can be deleted, moved, or repeated.

Picture quality remains constant because there is no negative: each print or reproduction comes from the same original. For example, *Time* magazine is assembled in New York on the computer and sent to all the regional printing plants at the same time. Since each plant has a computerized printing system, the magazine can go straight onto the paper, bypassing any sort of duplication.

PhotoStream, announced in 1987 by Associated Press, is a system for transmitting pictures by satellite and fiber optics. It replaces Laserphoto, an updated version of the original Wirephoto. The two earlier systems took eight minutes to transmit a black-and-white photograph—no improvement on the time it took Professor Korn during his 1906 experiment in Germany. Color took thirty to forty minutes. With the current PhotoStream setup, black-and-white pictures arrive in a minute, color in three minutes.

Figure 365
Unidentified photographer, "Another Canon first." From *Canon Photokina News*, special Photokina edition, September 1986; halftone (IMP/GEH)

246

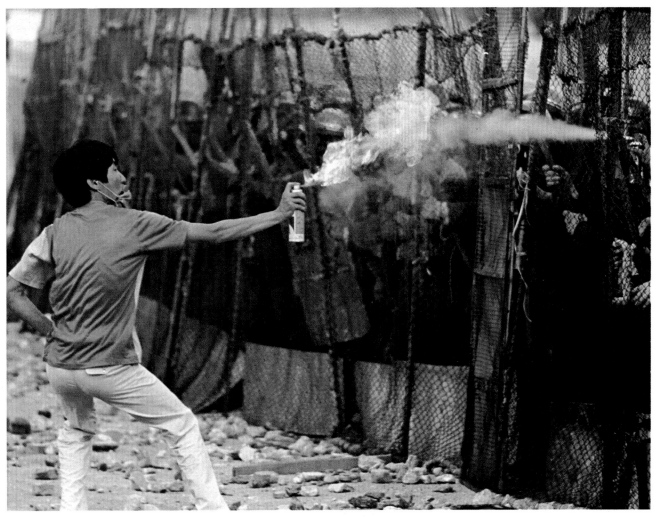

Figure 366

Itsuo Inouye, "South Korean student squares off in a duel with riot police as he uses a flaming-point spray can while one of the riot police, positioned behind protective netting, replies with a fire-extinguisher spray can during an antigovernment demonstration at Yonsei University in Seoul," 1987; chromogenic development print (AP)

Color

New technologies have also made color reproduction in newspapers and magazines a reality. There was a time when only advertisers could afford the expensive carbro or dye-transfer prints needed to make reliable reproductions. Four-color letterpress printing also cost a fortune, and it took seventy-two hours to make the engravings. Speaking of the 1950s, Arnold Drapkin, picture editor of *Time* magazine, said that if they pushed the printer to rush, they could get the engravings in forty-two hours, but then it took another two or three days to print them![91] Now, urgent, last-minute color pictures can be added to the magazine layout one hour before deadline.

Color is not new to photojournalism reproduction, but it had a very slow start. As far back as 1910, *The National Geographic Magazine* published "Scenes in Korea and China," the largest collection of color photographic reproductions that had ever been printed in a single issue of any magazine.[92] The magazine continued to pioneer the use of four-color engravings, generally from glass Autochrome plates.

Kodak introduced Kodachrome 35mm movie film in 1935. This film used in the new Leica 35mm camera revolutionized color photography. It would still be many years before printing technology made it possible to make repro-

ductions cheap enough for magazines to use color in any quantity. One author in 1954 bemoaned the lack of color in journalism, blaming its absence on the time lag in production. The delays were in part due to processing the film, making separations, retouching the negatives and positives, block making or etching cylinders, and revising and printing four-color sheets.[93] For large-circulation magazines the print run could be over a million or more copies. Because of the cost of production, the author concluded that "colour photography seems likely to remain in transparency form, locked away, unused, unknown."[94] Fortunately, advances in offset printing and the introduction of computers to the printing plant have proved him wrong.

Not all photographers or editors have embraced the predominant use of color by newsmagazines and increasing numbers of newspapers. They know that color as color carries its own message and that often it is not the message intended by the photographer. David Douglas Duncan commented that he had never shot color in a war situation

> because it is always misleading. [For example,] when you have two men lying side by side, and one is fatally wounded by a concussion and the other guy picked up a piece of shrapnel and is bleeding profusely, color is stealing the whole picture. I want to talk about the impact of the man who is dying. In black and white there is no false emotion being expressed. Color is very misleading.[95]

However, Duncan does feel that color has its place and can be handled well. He pointed to the work of Larry Burrows in Vietnam (Plate 8): "An aid station—the guy leaning back . . . like a piece of fallen sculpture, he's all gray . . . he looks like he's dead, but he isn't, he's just wounded. It is one of those pictures with all the elements: color, action, and composition completely correct. It's a great, great picture."[96]

Philip Jones Griffiths said that color photography was "the biggest single hindrance to photojournalism the world has ever seen."[97] Color, he feels, can either distract the viewer or, worse, cause the photographer to concentrate on formal color problems and forget that photography's greatest value is its ability to capture the moment of reality. Trying to render convincing photographs of poverty in some situations can become "starvation in primary colors."[98]

There's no doubt, though, that color can be well done and has been well done. Peter Magubane's photographs in his native South Africa use the color to give a sense of heat and struggle. The brightly colored flag of the African National Congress—a symbol of rebellion within white-ruled South Africa—serves as a contrast to the dusty, people-clogged landscape. Draped over coffins, the flag's intense colors carry a somber message.

Two other examples of how color can underscore a photograph's message are David Burnett's picture from Iran of a Shi'ite, his hands covered with blood (Plate 14), and Jim Nachtwey's image of three little girls (Plate 19). Burnett's pro-Khomeini demonstrator with red hands is probably the clearest example of a moment that would be lost in black and white—the high color of his face, contorted with emotion, framed by his own hands, red with blood. He is one of many in a crowd with hands raised, yet only his hands are red. The shadow of his left hand brings attention back to his face. In black and white, his contorted face at the photograph's center would carry the emotion; in color, the surprise of his hands deepens the impact, while the caption makes clear why his hands are red.

In one of Jim Nachtwey's photographs, three little girls in El Salvador stand behind a tree shielding their eyes from the dirt thrown up by a departing military helicopter. They are isolated by the thick, rust-colored dust. Two have on stiff, bright pastel dresses. The smallest child, at the back, wears blue jogging shoes with pink socks that match her dress. The helicopter, rising through bands of brown sediment, may be the easiest way for some to travel through the forests, but its military connotations mark it as being from a different world. A subtle photograph, subtly colored, taken in a part of the world often pictured in bloody conflict, it tells a similar story in a different way.

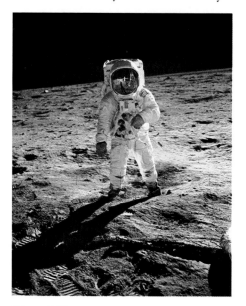

Figure 367
Neil A. Armstrong, "Astronaut Edwin E. Aldrin, Jr., lunar module pilot, is photographed walking near the lunar module during the *Apollo 11* extravehicular activity. An IM floor pad is at lower right." 1969; chromogenic development print (NASA)

A Continuing Dialogue

Efficient color reproduction and, more important, the new technologies that make it possible, have greatly changed the possibilities of photojournalism. Higher education has also altered the field considerably. Courses and majors are now offered at many universities, such as Ohio University and the University of Missouri. The legendary Missouri Workshop, begun in 1949 by Cliff Edom, has fine-tuned hundreds of photojournalists and would-be photojournalists. The photographic short courses begun in the 1930s remain strong and have been joined by NPPA's Flying Short Course, which transports small groups of selected news-paper, magazine, and freelance professionals around the country for one-day education seminars in five different cities.

While technology and education have modified the approach and methods of work, the goal of communication remains the same. Photojournalism as communication is an ongoing process: getting, delivering, and publishing the picture are not the end, but one part of the conversation that is news, and that, in turn, becomes history. Photojournalism lives in a larger world of ideas—it is never a monologue.

Technology is only part of the process. The passing of the traditional darkroom will certainly free photojournalism from the nineteenth century and prepare it for the twenty-first, but the responsibilities remain unchanged, and they are still immense: to see, to understand, and to share the story of history as it happens. ⊙

Figure 368
Dean Conger/NASA, "Alan Shepard after trip in *Mercury* capsule," 1961; gelatin silver print (NASA and Time Inc.)

Figure 369
Robert Kelley, "Waiting wives whose astronaut husbands are at launching," 1961; gelatin silver print (Time Inc.)

249

Plate 1
Unidentified photographer,
"Investiture of the Prince of Wales
at Carnarvon Castle." From
Penrose's Pictorial Annual,
1911–1912; four-color engraving
(IMP/GEH)

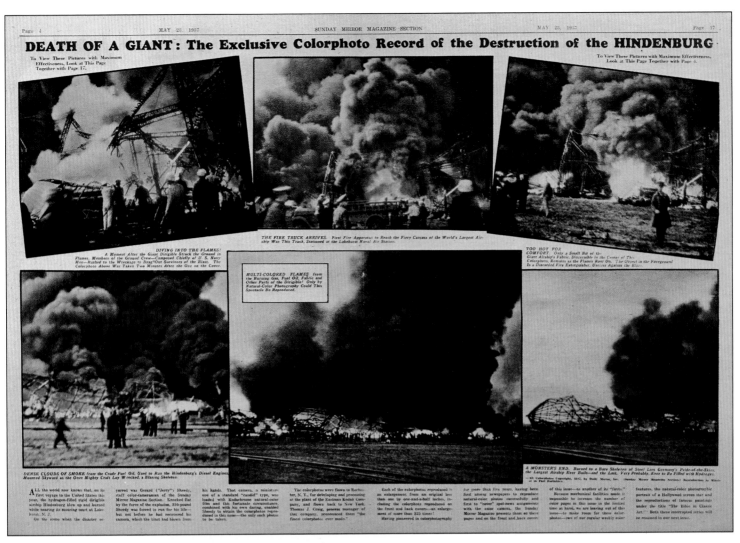

DEATH OF A GIANT: The Exclusive Colorphoto Record of the Destruction of the HINDENBURG

To View These Pictures with Maximum Effectiveness, Look at This Page Together with Page 17.

To View These Pictures with Maximum Effectiveness, Look at This Page Together with Page 4.

DIVING INTO THE FLAMES! A Moment After the Giant Dirigible Struck the Ground in Flames, Members of the Ground Crew—Composed Chiefly of U. S. Navy Men—Rushed to the Wreckage to Drag Out Survivors of the Blast. The Colorphoto Above Was Taken Two Minutes After the One on the Cover.

THE FIRE TRUCK ARRIVES. First Fire Apparatus to Reach the Fiery Carcass of the World's Largest Airship Was This Truck, Stationed at the Lakehurst Naval Air Station.

TOO HOT FOR COMFORT. Only a Small Bit of the Giant Airship's Fabric, Discernible in the Center of This Colorphoto, Remains as the Flames Roar On. The Object in the Foreground Is a Discarded Fire Extinguisher, Useless Against the Size.

MULTI-COLORED FLAMES from the Burning Gas, Fuel Oil, Fabric and Other Parts of the Dirigible! Only by Natural-Color Photography Could This Spectacle Be Reproduced.

DENSE CLOUDS OF SMOKE from the Crude Fuel Oil, Used to Run the Hindenburg's Diesel Engines, Mounted Skyward as the Once Mighty Craft Lay Wrecked, a Blazing Skeleton.

A MONSTER'S END. Burned to a Bare Skeleton of Steel Lies Germany's Pride-of-the-Skies, the Largest Airship Ever Built—and the Last, Very Probably, Ever to Be Filled with Hydrogen.

ALL the world now knows that, on its first voyage to the United States this year, the hydrogen-filled rigid dirigible airship Hindenburg blew up and burned while nearing its mooring mast at Lakehurst, N. J.

On the scene when the disaster oc-

curred was Gerard ("Jerry") Sheedy, staff color-cameraman of the Sunday Mirror Magazine Section. Knocked flat by the force of the explosion, 250-pound Sheedy was forced to run for his life—but not before he had recovered his camera, which the blast had blown from

his hands. That camera, a miniature one of a standard "candid" type, was loaded with Kodachrome natural-color film and the fortunate circumstance, combined with his own daring, enabled Sheedy to obtain the colorphotos reproduced in this issue—the only such photos to be taken.

The colorphotos were flown to Rochester, N. Y., for developing and processing at the plant of the Eastman Kodak Company, and then flown back to New York. Thomas J. Craig, process manager of that company, pronounced them "the finest colorphotos ever made."

Each of the colorphotos reproduced in an enlargement from an original less than one by one-and-a-half inches, including the colorphoto reproduced on the front and back covers—an enlargement of more than 225 times!

Having pioneered in colorphotography

for more than five years, having been first among newspapers to reproduce natural-color photos successfully and first to "cover" spot-news assignments with the color camera, the Sunday Mirror Magazine presents them on these pages and on the front and back covers

of this issue—as another of its "firsts."

Because mechanical facilities made it impossible to increase the number of color pages in this issue in the limited time at hand, we are leaving out of this issue—to make room for these color-photos—two of our regular weekly color

features, the natural-color photographic portrait of a Hollywood screen star and the reproductions of famous paintings under the title "The Bible in Classic Art." Both these interrupted series will be resumed in our next issue.

Plate 2
Gerard Sheedy, "Death of a Giant: The Exclusive Colorphoto Record of the Destruction of the *Hindenburg.*" From *Sunday Mirror Magazine Section,* May 23, 1937, pp. 16–17; halftone (IMP/GEH)

Plate 3
Unidentified photographer, "The Glory That Was Rheims." From *The Nations at War: A Current History,* 1915, p. 215; halftone (Visual Studies Workshop)

THE GLORY THAT WAS RHEIMS

Plate 4
Alexander Liberman, "L'armée rouge au travail." From *Vu,* July 10, 1935, cover; duotone (Coll. S. S. Phillips)

Plate 5 (opposite)
U.S. Government Printing Office, "Now—All Together," 1945; lithograph (Courtesy Joe Rosenthal)
The official U.S. Treasury poster for the Seventh War Loan Drive, from a painting by C. C. Beall of Joe Rosenthal's photograph. Commemorative stamp from same image is affixed to this particular small poster.

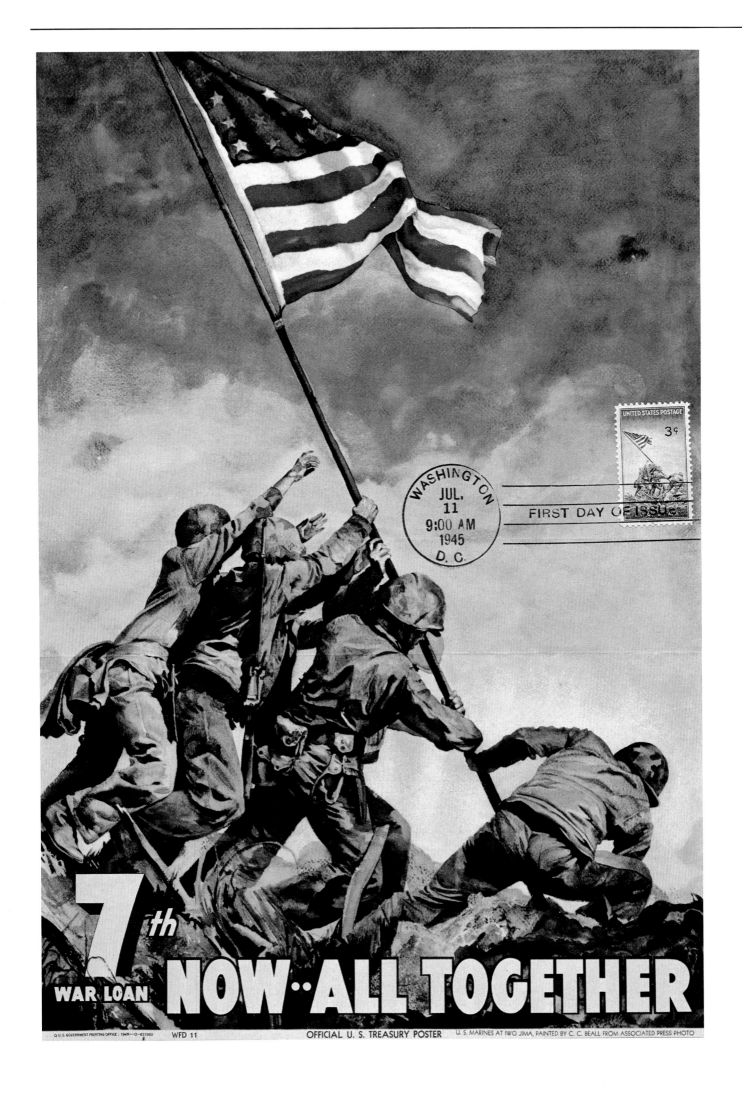

7th WAR LOAN

NOW··ALL TOGETHER

WASHINGTON JUL. 11 9:00 AM 1945 D.C.

FIRST DAY OF ISSUE

UNITED STATES POSTAGE 3¢

OFFICIAL U. S. TREASURY POSTER

U. S. MARINES AT IWO JIMA, PAINTED BY C. C. BEALL FROM ASSOCIATED PRESS PHOTO

WFD 11

Plate 6
Dmitri Kessel, "The coffin bearing
the body of Sir Winston Churchill
is borne slowly down the aisle of
Saint Paul's Cathedral in his fu-
neral ceremony in January 1965";
chromogenic development print
(Time Inc.)

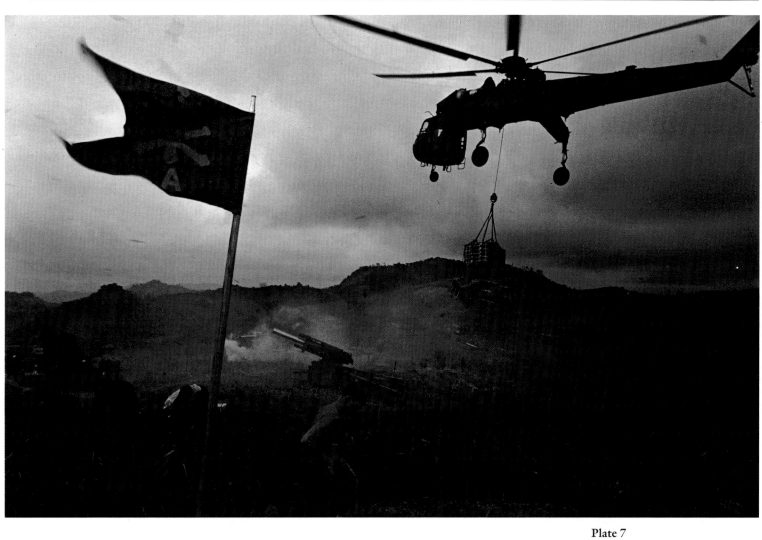

Plate 7
Larry Burrows, "Ammunition
airlift into besieged Khesanh,"
1968; dye imbibition (Kodak Dye
Transfer) (IMP/GEH. Courtesy
Time Inc.)

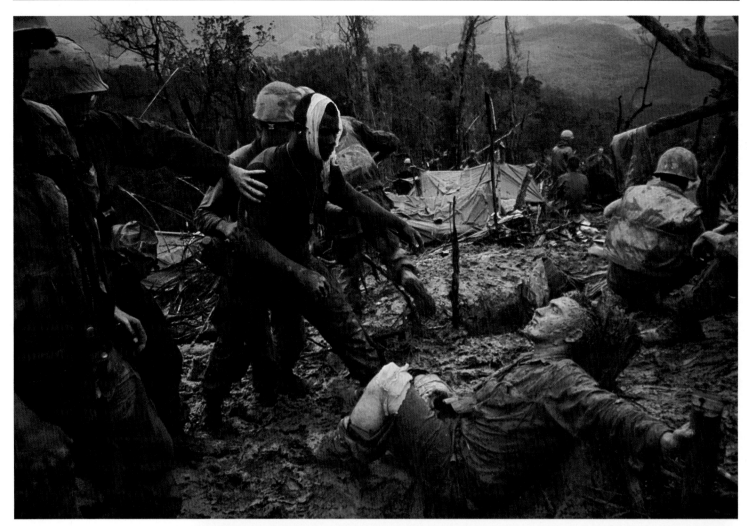

Plate 8
Larry Burrows, "Reaching Out
(during the aftermath of taking the
hill 484, South Vietnam)," 1966;
dye imbibition (Kodak Dye Trans-
fer) (IMP/GEH. Courtesy Time
Inc.)

Plate 9
Larry Burrows, "An American
Marine in the 'Demilitarized'
Zone," 1966; dye imbibition
(Kodak Dye Transfer) (Time Inc.)

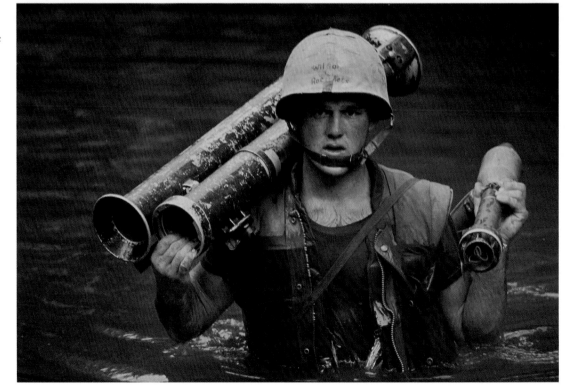

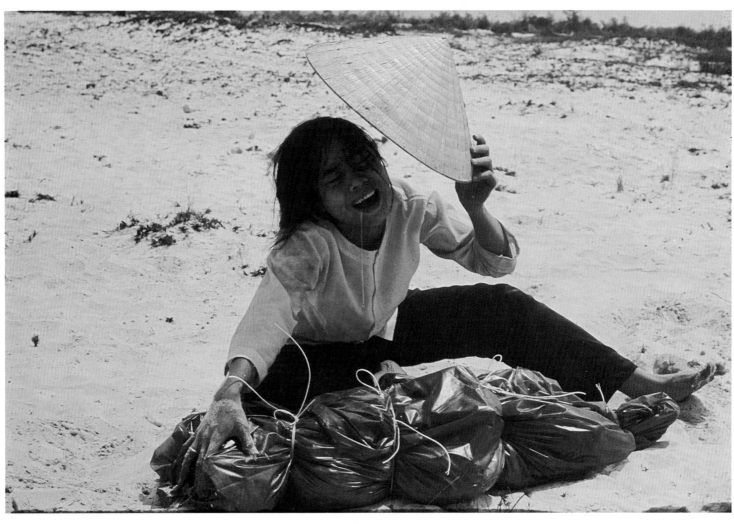

Plate 10
Larry Burrows, "Vietnamese
woman and the body of her son,"
1966; dye imbibition (Kodak Dye
Transfer) (Time Inc.)

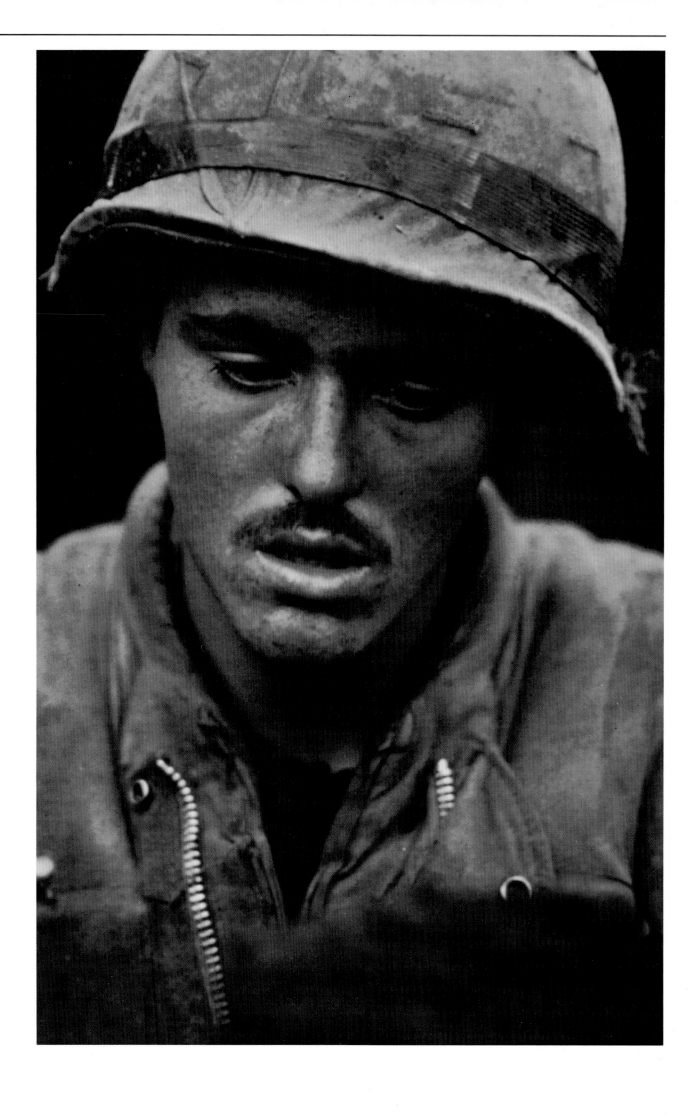

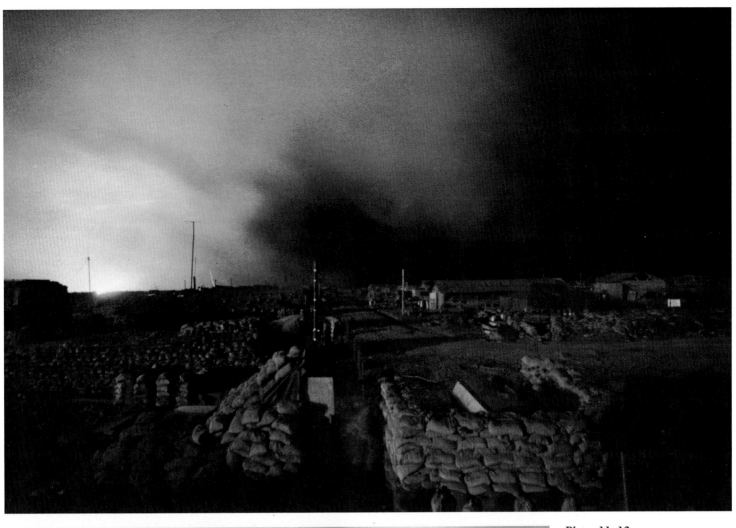

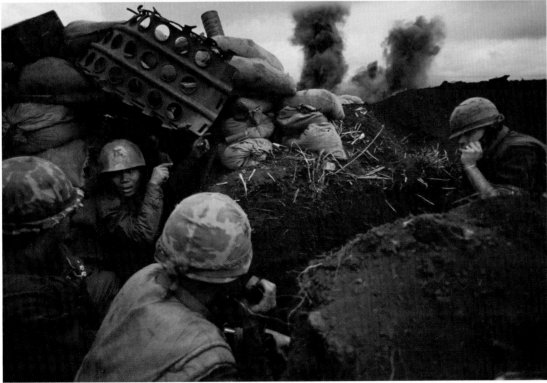

Plates 11–13
Robert Ellison, "Khesanh, Viet-nam War," 1968; chromogenic development prints (Black Star)

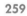

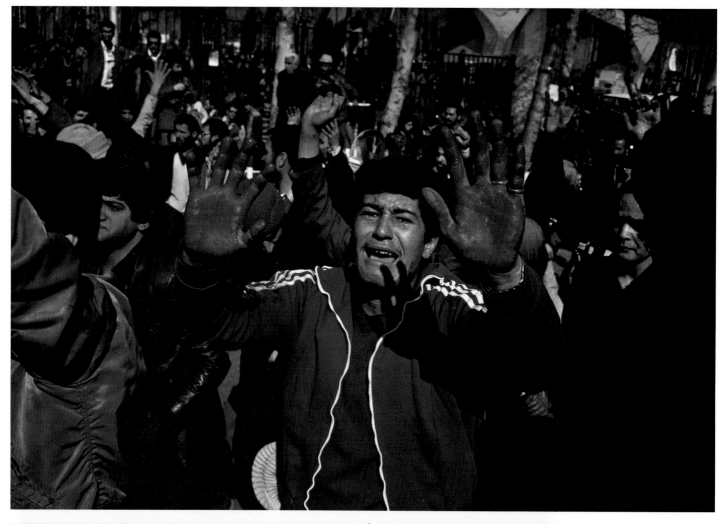

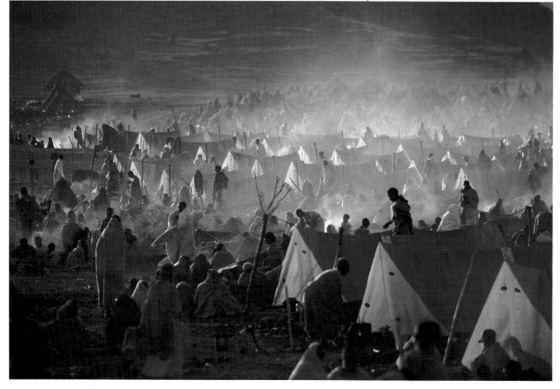

Plate 14
David Burnett, "Shi'ite after dipping his hands in the blood of a 'martyr' killed by the Shah's troops," 1979; chromogenic development print (IMP/GEH. Courtesy Contact)

Plate 15
David Burnett, "Korem Camp, Wollo, Ethiopia," 1984; chromogenic development print (Contact)

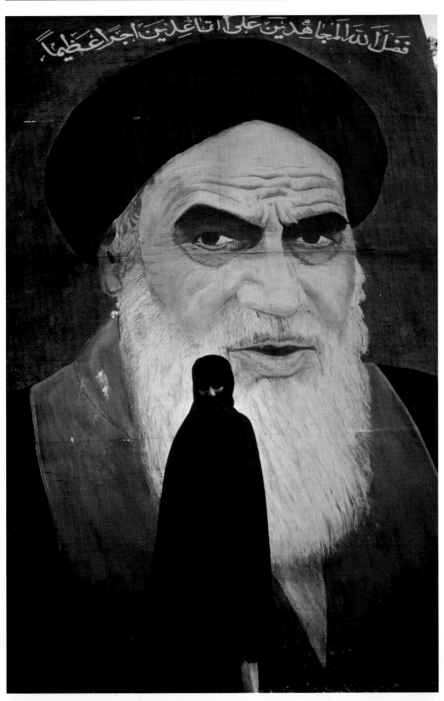

261

Plate 16
Olivier Rebbot, "Chador, Teheran, Iran," 1979; chromogenic development print (Contact)

Plate 17
David Burnett, "Pro-Shah meeting, Teheran, Iran," 1979; chromogenic development print (Contact)

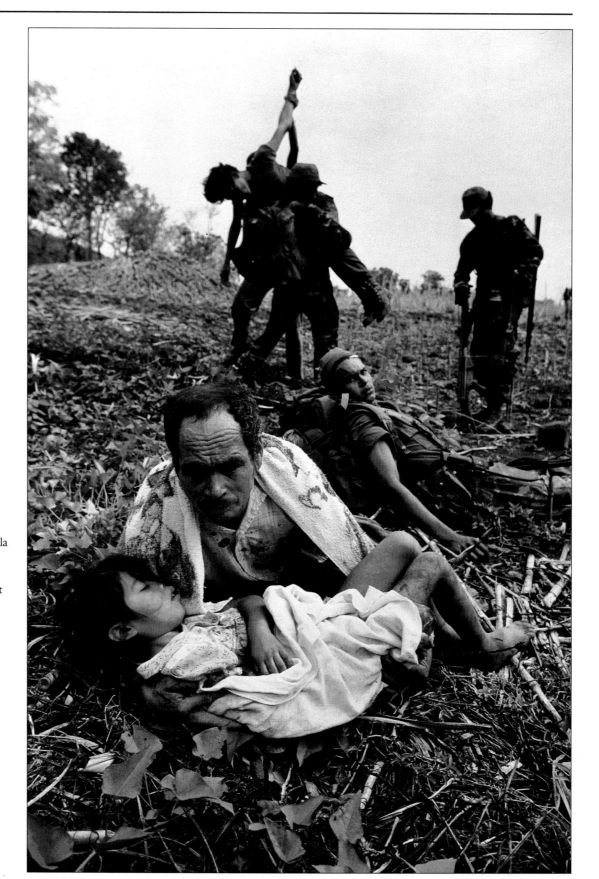

262 **Plate 18**
James Nachtwey, "After a guerrilla ambush in El Salvador, a father shields his wounded daughter," 1984; chromogenic development print (Magnum)

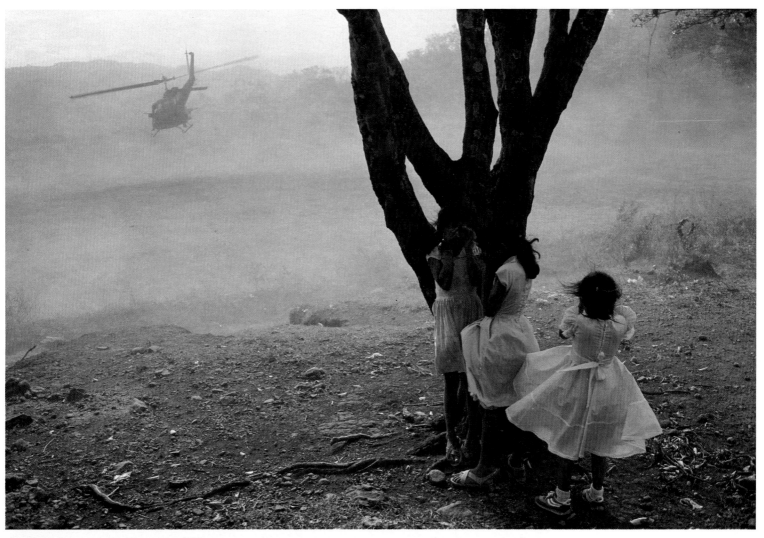

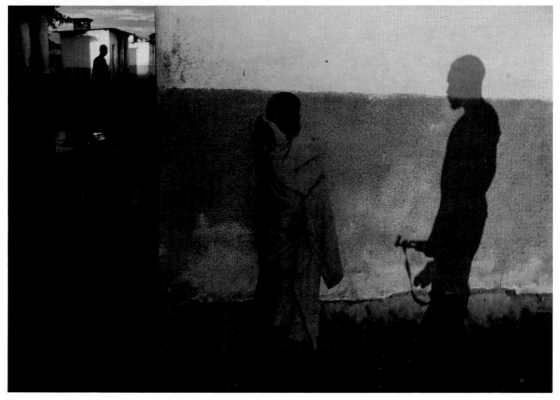

Plate 19
James Nachtwey, "On the holy day in El Salvador, little girls were caught in the wind generated by a helicopter taking off after picking up army officers," 1984; chromogenic development print (Magnum)

Plate 20
James Nachtwey, "Uganda, September 12, 1986"; chromogenic development print (Magnum) *Karamajong boy wrapped up in blanket in village of Nabilatuk during Ugandan army operation in search of cattle raiders. Dawn. Shadow on wall is an army soldier holding an AK-47 rifle.*

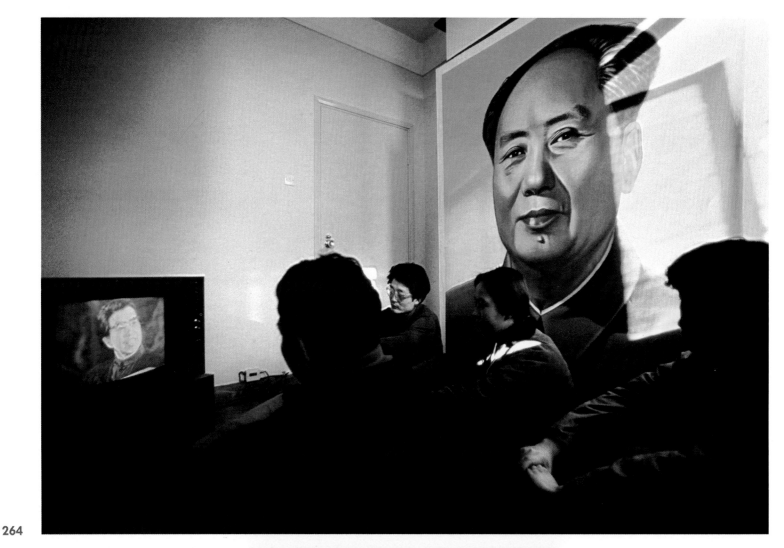

264

Plate 21
Liu Heung Shing, "Chinese students watching Jiang Qing (Mrs. Mao) on television during the trial of the Gang of Four," 1980; chromogenic development print (Contact)

Plate 22
Stephen Shames, "IRA gunman displays armaments," 1972; chromogenic development print (Visions)

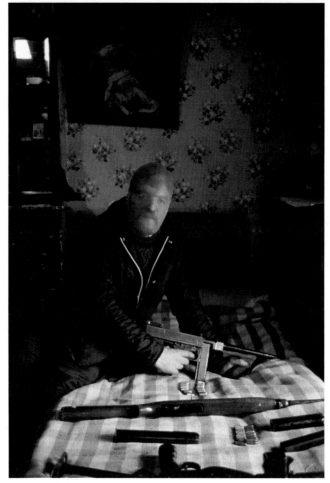

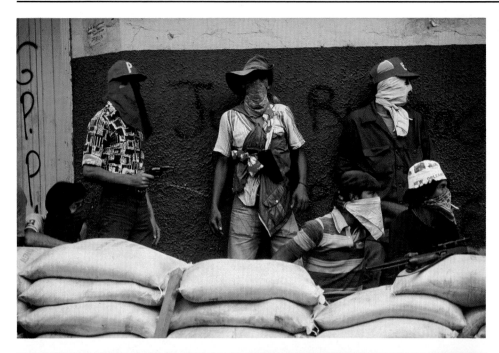

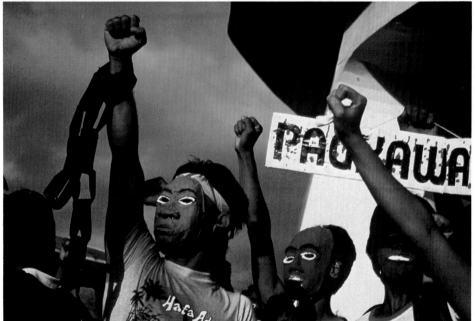

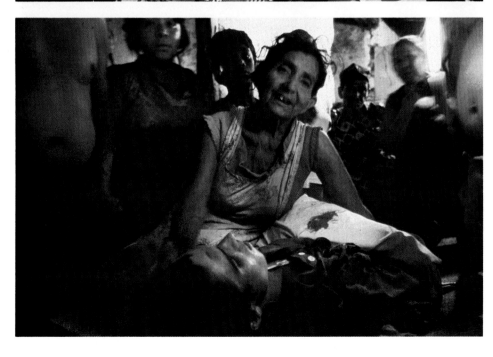

Plate 23
Susan Meiselas, "Awaiting counterattack by the guard in Matagalpa," 1978/79; chromogenic development print (Magnum)

Plate 24
Susan Meiselas, "Demonstrating against U.S. presence in the Philippines, held in front of Clark Air Force Base," 1985/86; chromogenic development print (Magnum)

Plate 25
Susan Meiselas, "Son killed by National Guard, El Salvador," 1980; chromogenic development print (Magnum)

Plate 26
Mary Ellen Mark, "Inside 'Die Place,'" 1985; chromogenic development print (Archive)
Bodies of children who died in the famine, wrapped in fabric.

Plate 27
Anthony Suau, "Ethiopia, 1984"; chromogenic development print (Black Star)

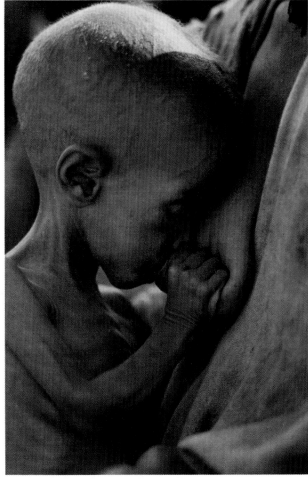

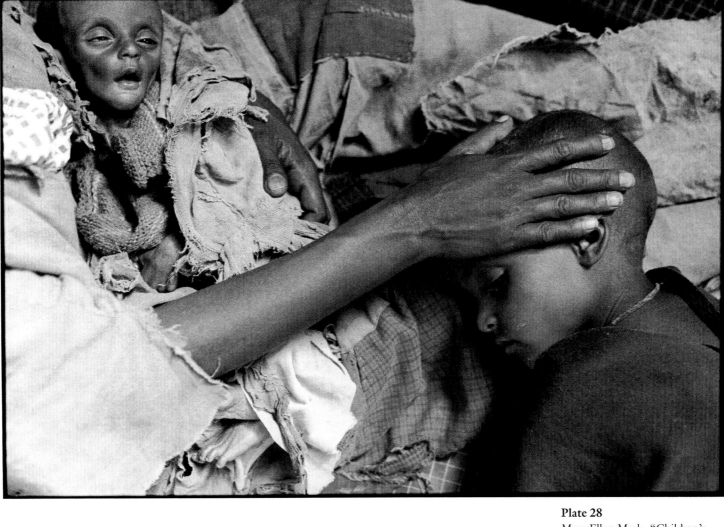

Plate 28
Mary Ellen Mark, "Children's
ward, Korem, Ethiopia," 1985;
chromogenic development print
(Archive)

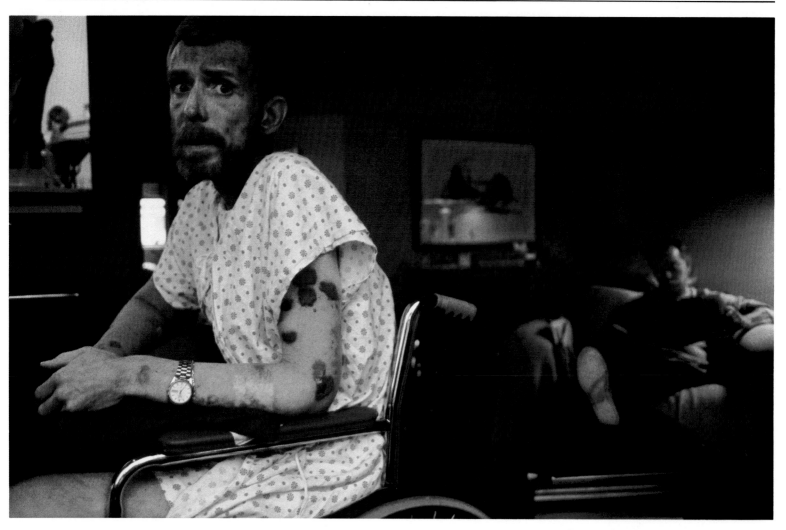

Plate 29 (above)
Alon Reininger, "San Francisco, California—November 1986. Patient with AIDS (P.W.A.) Ken Meeks"; chromogenic development print (Contact)
1986 World Press Photo of the Year.

Plate 30 (opposite, top)
Maggie Steber, "When hunger overcomes fear, Haiti, 1986"; chromogenic development print (J. B. Pictures Ltd.)

Plate 31 (opposite, bottom)
José Azel, "Worshippers bidding good-bye to Pope John Paul II as his helicopter takes off after open-air mass in Quetzaltenango, Guatemala," 1983; chromogenic development print (Contact)

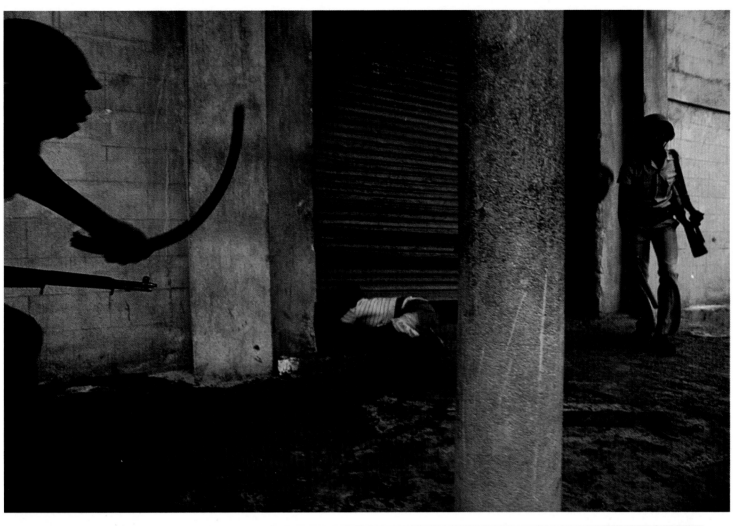

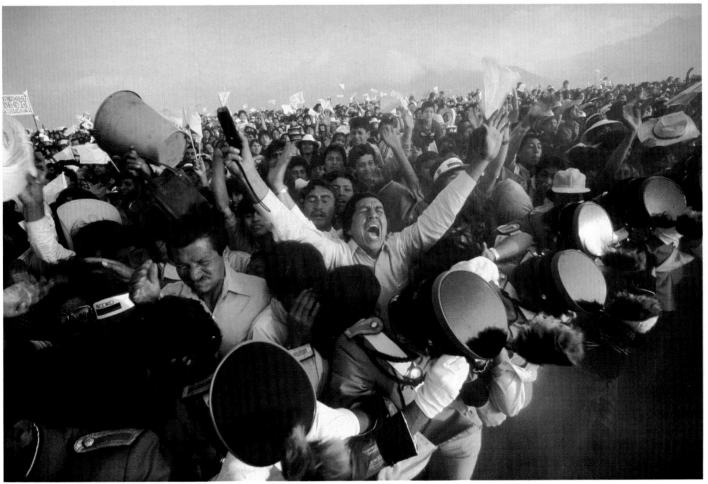

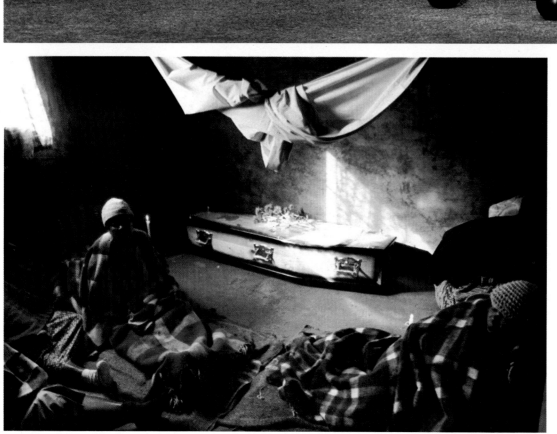

Plate 32 (top)
David Turnley, "A man picks up lawn-bowling balls for women at an exclusively all-white lawn-bowling club outside of Durban," 1986; chromogenic development print (*Detroit Free Press*/Black Star)
He receives small tips for his services.

Plate 33 (bottom)
David Turnley, "Relatives of a man who had been accidentally killed mourn his death on the day of his funeral," 1986; chromogenic development print (*Detroit Free Press*/Black Star)
They are farmworkers on the Jan Naude family farm outside Hennenman in the Orange Free State.

Plate 34 (opposite)
David Turnley, "A young woman bathes herself in her one-room home on the Jan Naude family farm outside Welkon," 1986; chromogenic development print (*Detroit Free Press*/Black Star)
Black farmworkers on Afrikaner farms bathe from buckets like this because there is no running water in their homes.

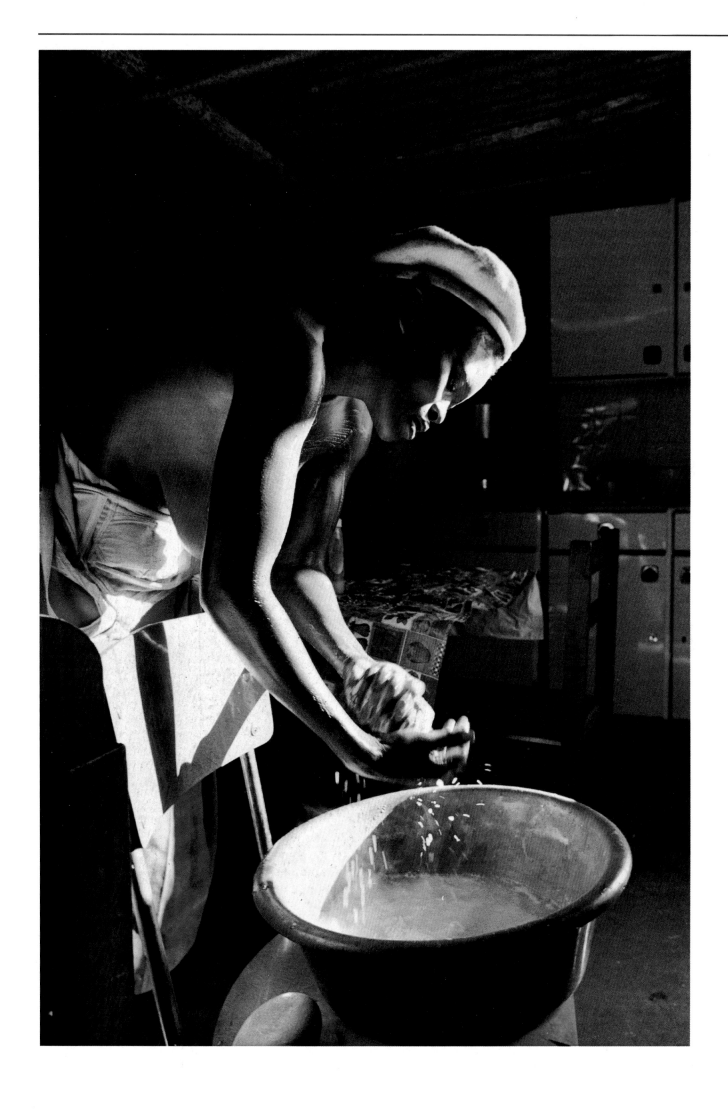

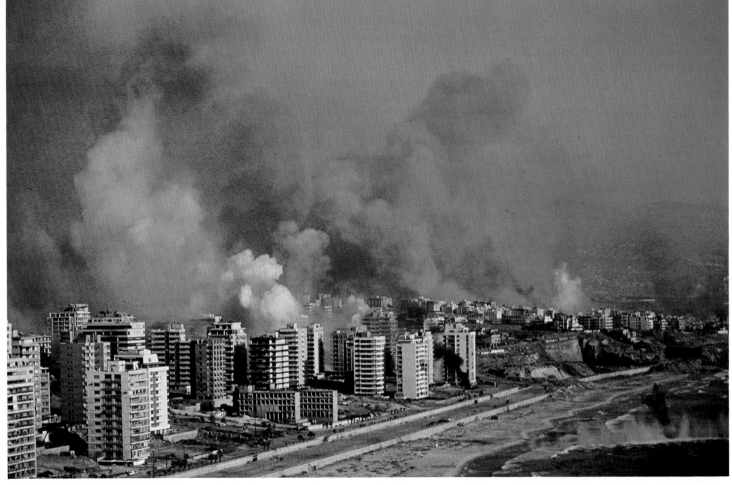

272

Plate 35
Catherine Leroy, "Beirut,
August 8, 1982. Israeli shelling
from the air, the ground,
sea . . ."; chromogenic develop-
ment print (Sipa)

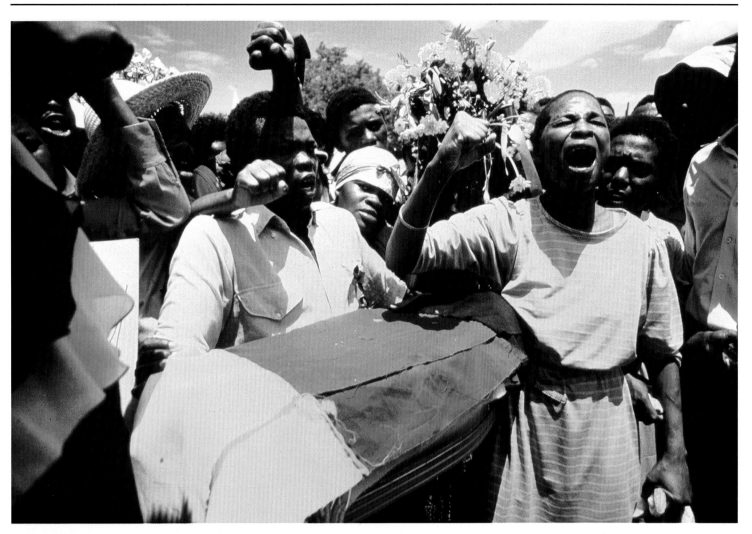

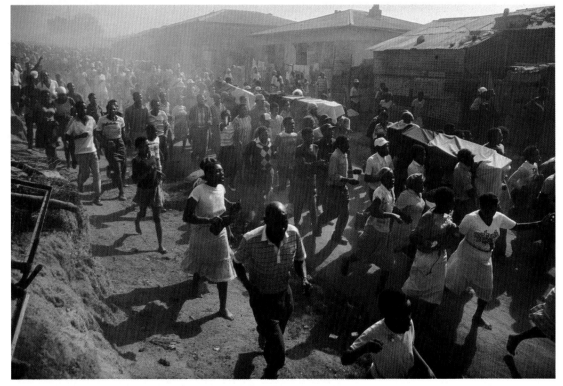

Plate 36
Peter Magubane, "Alexandria Township funeral," 1986; chromogenic development print (Time Inc.)

Plate 37
Peter Magubane, "Mamelodi funeral," 1985; chromogenic development print (Time Inc.)

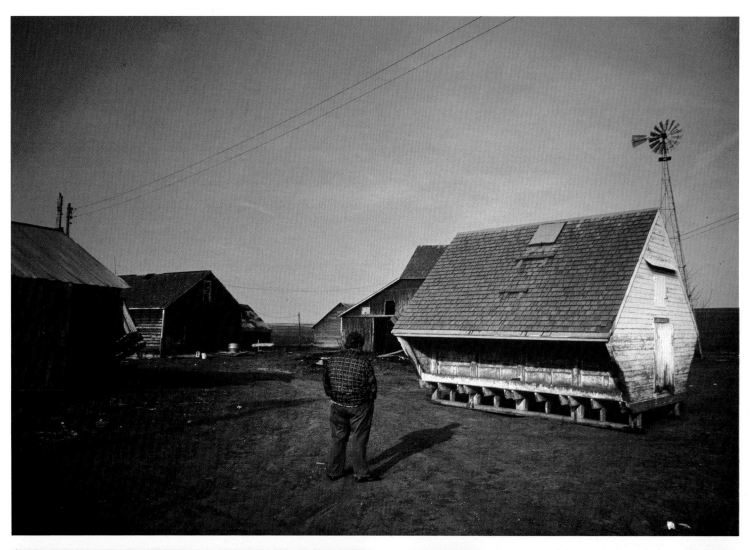

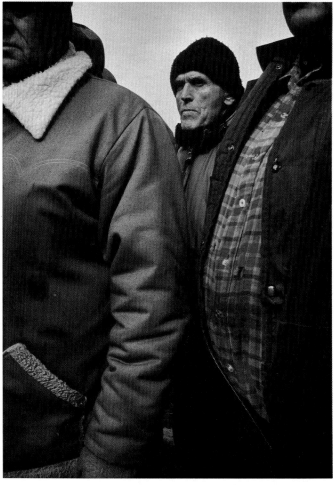

Plate 38 (top)
Jeff Jacobson, "Foreclosed farmer, Battle Creek, Iowa," 1983; chromogenic development print (Archive)

Plate 40 (right)
Jeff Jacobson, "Farm foreclosure, Flandreau, South Dakota," 1985; chromogenic development print (Archive)

Plate 39 (bottom, left)
Jeff Jacobson, "Farm auction, Chariton, Iowa," 1984; chromogenic development print (Archive)

Plate 41
Jeff Jacobson, "Republican Convention, Dallas, Texas," 1984; chromogenic development print (Archive)

Plate 42
Jeff Jacobson, "Congressional Medal of Honor, posthumous, Chesterfield, Mass.," 1983; chromogenic development print (Archive)

Unidentified photographer,
"President Nixon checks his
watch," 1974; gelatin silver print
(AP)
*Checking the time while shaking
hands with Belgians, President Nixon
heads for the royal palace and a lun-
cheon given by King Bandouin of
Belgium.*

"Subjects of strange . . . and of fearful interest"
Chapter title from Oliver Wendell Holmes. "Doings of the
Sunbeam." *Atlantic Monthly* (July 1863): 11.

1.
Daguerre, Louis Jacques Mandé. *An Historical and Descriptive
Account of the Various Processes of the Daguerreotype and the Diorama.*
(London: McLean and Nutt, 1839), p. 2. Facsimile edition, with
an added introduction by Beaumont Newhall, published under
the title *Daguerre* (New York: Winter House, 1971).

2.
Morse, Samuel F. B. Letter to the *New York Observer,* April 20,
1839; cited in Taft, Robert. *Photography and the American Scene.*
(New York: MacMillan, 1938), pp. 11–12.

3.
Poe, Edgar Allen. "The Daguerreotype." *Alexander's Weekly
Messenger* (January 15, 1840); reprinted in Trachtenberg, Alan.
Classic Essays on Photography. (New Haven: Leete's Island Books,
1980), pp. 33–38.

4.
Daguerre, p. 2.

5.
Daguerre (quoting François Arago), p. 22.

6.
The Edinburgh Review (January 1843); excerpted in Goldberg,
Vicki, editor. *Photography in Print.* (New York: Simon and
Schuster, 1981), pp. 64–65.

7.
Jammes, Marie-Thérèse, and Jammes, Andre. *En Egypte au temps
de Flaubert.* (Paris: Kodak-Pathé, 1976), unpaginated; Gernsheim,
Helmut, and Gernsheim, Alison. *L. J. M. Daguerre.* (New York:
Dover, 1968), p. 109.

8.
Gernsheim and Gernsheim, pp. 108–109.

9.
Weimar, Wilhelm. *Die Daguerreotype in Hamburg 1839–1860.*
(Hamburg: Museum für Kunst und Gewerbe, 1915), pp. 15–18.
This important work is reproduced in facsimile in Sobieszek,
Robert, editor, as *The Daguerreotype in Germany.* (New York: Arno
Press, 1979).

10.
Gernsheim and Gernsheim, plate 96; Weimar, plates 1–3.

11.
Weimar, pp. 15–18.

12.
Wistar, Caroline. "North-East Corner of Third and Dock streets,"
in Philadelphia Museum of Art. *Philadelphia: Three Centuries of
American Art.* (Philadelphia: Philadelphia Museum of Art, 1976),
p. 322; and Finkel, Kenneth. "Langenheim Daguerreotype,"
History of Photography (Oct. 1980): 336.

13.
Wistar, p. 322. John McAllister, Jr. (1786–1877), a prominent
Philadelphia retailer of scientific and optical instruments, had an
active, long-term interest in documenting the history of his native
city. Because of his trade, he also figured importantly in the early
development of photography in Philadelphia. McAllister
apparently acquired the Langenheim brothers' daguerreotype
soon after it was taken and subsequently donated it to the Library
Company of Philadelphia. For biographical particulars, see
Morris, Charles M. "Memorial Notice of John McAllister, Jr."

The Pennsylvania Magazine of History and Biography 2 (1878): 91–
95; and Finkel, Kenneth. *Nineteenth-Century Photography in
Philadelphia.* (New York: Dover, 1980), p. 2.

14.
Sobieszek, Robert A. *Masterpieces of Photography from the George
Eastman House Collections.* (New York: Abbeville Press, 1985), pp.
48–49.

15.
Rudisill, Richard. *Mirror Image: The Influence of the Daguerreotype
on American Society.* (Albuquerque, NM: University of New
Mexico Press, 1971), pp. 163–164.

16.
Wadsworth, Nelson B. *Through Camera Eyes.* (Provo, UT:
Brigham Young University Press, 1975), plate 24.

17.
Sobieszek, Robert A., and Appel, Odette. *The Spirit of Fact.*
(Boston and Rochester: David R. Godine and The International
Museum of Photography at George Eastman House, 1976), pp.
120–121.

18.
See, for example, Newhall, Beaumont. *The Daguerreotype in
America.* (New York: Dover, 1976), plates 13 and 26.

19.
Sobieszek, *Masterpieces,* p. 48.

20.
Sandweiss, Martha. *Masterworks of American Photography: The
Amon Carter Museum Collection.* (Birmingham, AL: Oxmoor
House, 1982), pp. 14–15.

21.
Taft, pp. 223–225, footnote 246a, pp. 484–485.

22.
Sandweiss, plates 5–8; pp. 136–137.

23.
Frost, John. *Pictorial History of Mexico and the Mexican War.*
(Philadelphia: DeSilver, 1862 [copyright 1848]), p. iv.

24.
Taft, pp. 224, 485.

25.
"Photographs from Sebastopol." *The Photographic and Fine Art
Journal* (Dec. 1855): 377; Fenton, Roger. "Narrative of a
Photographic Trip to the Seat of War in the Crimea." *The
Photographic and Fine Art Journal* (March 1856): 76–80.

26.
The Photographic and Fine Art Journal (May 1856): 141, 143.

27.
The Photographic and Fine Art Journal (Dec. 1855): 377.

28.
Holmes, Oliver Wendell. "The Stereoscope and the Stereograph."
Atlantic Monthly (June 1859): 748.

29.
Holmes, Oliver Wendell. "Sun-Painting and Sun-Sculpture."
Atlantic Monthly (July 1861): 25.

30.
Ibid., p. 27.

31.
The Photographic and Fine Art Journal (Feb. 1857): 63; (Nov.
1857): 347. Neither citation mentions Alexander Gardner by
name, but the first refers to the studio's new preference for full-

figure standing poses, while the second praises the incomparable quality of Brady's plain paper imperial portraits. Since these are the earliest references to this format in conjunction with Brady, the inference is that Gardner brought them about.

32.
The phrase is taken from Mathew Brady's 1869 published catalog, *Brady's National Photographic Collection of War Views and Portraits of Representative Men.* (New York: A. Alvord, 1869).

33.
Townsend, George. "Still Taking Pictures." *New York World* (April 12, 1891): 26.

34.
The American Journal of Photography (Aug. 1, 1861): 120.

35.
According to a postwar article in *Harper's New Monthly Magazine,* "the battle of Bull Run would have been photographed 'close-up' but for the fact that a shell from one of the rebel field-pieces took away the photographer's camera." See John Sampson. "Photographs from the Rockies." *Harper's New Monthly Magazine* 39, no. 232 (Sept. 1869): 465. William A. Frassanito's exhaustive research of Civil War photographs has not identified any authentic images from the first battle of Bull Run. In his opinion, efforts to photograph there were completely unsuccessful. Frassanito, William A. *Antietam.* (New York: Scribner, 1978), pp. 29–32.

36.
Humphrey's Journal 8, no. 9 (Sept. 1, 1861): 133.

37.
Townsend, p. 26.

38.
Cobb, Josephine. "Photographers of the Civil War." *Military Affairs* 26 (Fall 1962): 127–135. Cobb identifies many of the photographers active during the Civil War, including a number of those associated with Brady.

39.
On the basis of an agreement that may have been negotiated on his behalf by Alexander Gardner, E. & H. T. Anthony printed, mounted, and distributed Brady's cartes de visite of popular personalities and many of his war views.

40.
The Antietam photographs had been taken by Alexander Gardner, but in accordance with the studio convention of the period, they were publicly credited to Mathew Brady, his employer. Resentment over this may have precipitated the break between the two men. The fact that Gardner took possession of the Antietam negatives when he left Brady also suggests the real possibility that Brady could not make his payroll. Brady's credit records indicate that he was in continuous financial difficulties from the mid-1850s on, despite his international reputation and the volume of his business. R. G. Dun & Co., vol. 368, p. 442, Baker Library, Graduate School of Business Administration, Harvard University.

41.
Frassanito, *Antietam,* pp. 17, 288–289.

42.
Ibid., pp. 51–52.

43.
"The Battle of Antietam." *Harper's Weekly* (October 18, 1862): 663.

44.
Frassanito, pp. 178–179.

45.
"Brady's Photographs: Pictures of the Dead at Antietam." *New York Times* (October 20, 1862): 5.

46.
Ibid.

47.
Ibid.

48.
Holmes, Oliver Wendell. "Doings of the Sunbeam." *Atlantic Monthly* (July 1863): 11–12.

49.
Ibid. Italics supplied.

50.
See Gardner, Alexander. *Catalogue of Photographic Incidents of the War.* (Washington, DC: H. Polkinhorn, 1863), p. 8.

51.
A survey by the author of *Harper's Weekly* from April 1861 through August 1865 identified less than fifty views attributed to photographic sources, whereas wood engravings based on sketches by the artists in the field appeared weekly.

52.
"The Harvest of Death" (illustration). *Harper's Weekly* (July 22, 1865): 452; and "The Gettysburg Monument," ibid., p. 453.

53.
Gardner, Alexander. *Gardner's Photographic Sketch Book of the War,* 2 volumes. (Washington, DC: Philip and Solomons, 1866); and Barnard, George N. *Photographic Views of Sherman's Campaign.* (New York: Wynkoop and Hallenbeck, 1866). *Harper's Weekly,* noting that Barnard's *Photographic Views* sold for $100, regretted that the work could "not be popular" because of its expense. The *Sketch Book,* which contained a third again as many photographs as *Photographic Views,* could not have been less expensive. The sizes of the original editions are not known, but complete examples of both reproductions are rare today: the *National Union Catalogue: Pre-1956 Imprints* lists eleven copies of the *Sketch Book* and ten of *Photographic Views* in library collections. Another dozen complete copies of each work may exist in museum, corporate, and private collections. Both the *Sketch Book* and *Photographic Views* are highly desirable to collectors and command increasingly substantial prices in their infrequent appearances on the market.

54.
Gardner, preface (unpaginated); reprint edition (New York: Dover, 1959); all references are to this reprint edition.

55.
Gardner, plate 31, "Battery D, 2nd U.S. Artillery, in Action, Fredericksburg, 1863," and plates 35–44, from Gettysburg, are battlefield views; plates 36, 37, 41, 42, and 44 are of the dead on the Gettysburg battlefield; plate 93, "Ruins of Gaines' Mill, Va., April, 1865," and plate 94, "A Burial Party on the Battlefield of Cold Harbor, Va., April, 1865," show soldiers' remains from those battles.

56.
Gardner, plate 21, "Dunker Church, Battle-field of Antietam, Md."

57.
Ibid., plate 36.

58.
Ibid., plate 37, "Field Where General Reynolds Fell, Gettysburg, July, 1863."

59.
Frassanito, William. *Gettysburg: A Journey in Time*. (New York: Scribner, 1975), pp. 222–229. Reynolds was killed just inside McPherson's woods, on the northwestern end of the battlefield, on the first day of fighting. Frassanito believes that "Field Where General Reynolds Fell" was photographed in one of the fields between the Rose farm and the Emmitsburg Road, on the southern end of the battlefield, where fighting took place on July 2 and 3.

60.
This concept is central to propaganda photography: since the image exists, there is a ready acceptance of its subject matter as it is identified to be.

61.
Gardner, plate 40.

62.
Ibid.

63.
According to William Frassanito (*Gettysburg*, p. 238), Frederic Ray, art director of the *Civil War Times Illustrated*, was the first to publish on this. See Ray, Frederic. *Civil War Times* 3 (Oct. 1961): 19.

64.
Frassanito, *Gettysburg*, p. 192.

65.
Rosenblum, Naomi. *A World History of Photography*. (New York: Abbeville Press, 1984), pp. 200–207.

66.
Harper's Weekly (July 22, 1865): 456–457.

67.
"The Spot Where General James B. McPherson Fell, Near Decatur, Georgia," *Harper's Weekly* (Feb. 18, 1865): 101; "Ruins in the Heart of Charlestown," ibid. (July 8, 1865): 428; and "View of the Interior of Fort Sumter After Its Evacuation by the Rebels, February 18, 1865," ibid. (July 22, 1865): 460. The unusually accurate but mechanical rendering of detail and shadow in these woodcuts suggests that the images had been photographically, rather than manually, transferred to the blocks. This was a relatively new technique, which substantially reduced the production time required for woodblock illustrations while improving fidelity to the source image. For a discussion of this process, see Jussim, Estelle. *Visual Communication and the Graphic Arts*. (New York and London: R. R. Bowker, 1983), pp. 58–63, 344.

68.
Barnard, George N. "Note on the Photographs." *Photographic Views of Sherman's Campaign*. (New York: Dover, 1977), p. xviii; reprint of the original 1866 edition.

69.
Mathew Brady supplied thousands of carte de visite negatives to E. & H. T. Anthony and Company, which printed and published them on a mass-production basis. The terms of this arrangement are not completely certain, but Anthony retained the negatives after the Civil War. The Brady/Anthony negative archives somehow became divided sometime after 1865. A large segment was sold to Col. Arnold A. Rand and his business partner Gen. Albert Ordway, who attempted unsuccessfully to publish them; these negatives changed hands several times, until they were finally acquired by the Library of Congress in 1943. The second segment was discovered in the Anthony-Scoville (the descendent firm) warehouse at the turn of the century by Frederick Hill Meserve, who was in the process of building his important collection of historical American photographica. Meserve purchased the negatives, which became the nucleus of his archives and the major source for an iconography of the nineteenth century to which Meserve devoted much of his life. Most of the Meserve negatives were acquired by the National Portrait Gallery, Smithsonian Institution, in 1981. See Library of Congress. *Civil War Photographs 1861–1865*. (Washington, DC: Reference Dept., Library of Congress, 1961), pp. v–vi.

70.
In 1867, the Union Pacific Railroad commissioned Alexander Gardner to photograph the construction of its railway through Kansas. In 1868 he accompanied the Indian Peace Commission sent to Ft. Laramie, Wyoming, to negotiate treaties with the Brule, Oglala, and Miniconjou Sioux, the Crow, and the Northern Cheyenne and Arapahoe tribes, and took photographs in the Indian camps as well as in the council tent while negotiations were under way. See Sobieszek, Robert. "Conquest by Camera: Alexander Gardner's 'Across the Continent on the Kansas Pacific Railroad.'" *Art in America* (March–April 1972): 80–85; and DeMallie, Raymond J. "Scenes in the Indian Country: A Portfolio of Alexander Gardner's Stereographic Views of the 1868 Fort Laramie Treaty Council." *Montana* (Summer 1981): 42–59. For more on Timothy O'Sullivan's career, see Dingus, Rick. *The Photographic Artifacts of Timothy O'Sullivan*. (Albuquerque, NM: University of New Mexico Press, 1982), pp. 1–14; and Snyder, Joel. *American Frontiers: The Photographs of Timothy O'Sullivan*. (Millerton, NY: Philadelphia Museum of Art, 1981). For more on Barnard, see Beaumont Newhall's preface in Barnard, George N. *Photographic Views of Sherman's Campaign*. (New York: Dover, 1977), pp. iii–vii.

71.
Oliver Wendell Holmes published three extremely influential articles on stereoscopic photography: "The Stereoscope and the Stereograph." *Atlantic Monthly* (June 1859): 738–748; "Sun-Painting and Sun-Sculpture." *Atlantic Monthly* (July 1861): 13–29; "Doings of the Sunbeam." *Atlantic Monthly* (July 1863): 1–15. For a history of the stereograph in America, see Darrah, William Culp. *The World of Stereographs*. (Gettysburg, PA: W. C. Darrah, 1977).

72.
Darrah, p. 175.

73.
Underwood, Bert. "Five Days on the Macedonian Frontier." *Harper's Weekly* (May 22, 1897): 508–509, 523, 525; and Dawley, Thomas Rawlinson, Jr. "With the Cuban Insurgents," ibid., pp. 517–518.

74.
Moeller, Susan. "Shooting War: Photography and the American Experience of Combat." Ph.D. diss., Harvard University, 1987, p. 69.

"The Tyranny of the Pictorial"

1.
Tolstoy, Leo. *War and Peace.* (New York: Modern Library, n.d.), p. 1124.

2.
Barbara Norfleet, Harvard University sociologist and photographer, has lectured extensively on the subject. Maren Stange of Clark University has carefully documented who took each of the pictures ascribed to Riis. Alexander Alland, Jr.'s book on Riis emphasizes that Riis was ambivalent about immigrants and the poor.

3.
Campbell, Helen. *Darkness and Daylight.* (Hartford: Worthington, 1892), p. xi.

4.
Klein, Robert S. "The Antecedents of American Photo-journalism." Ph.D. diss., Columbia University, 1970, p. 65.

5.
Hinton, A. Horsley. "Photography for Illustration." *The Photogram* (Sept. 1894): 205.

6.
Mott, Frank. *A History of American Magazines.* (Cambridge: Harvard University Press, 1957), p. 13.

7.
Ives, Frederick. *The Autobiography of an Amateur Inventor.* (Philadelphia: privately printed, 1928), p. 31.

8.
Mott, Frank. *American Journalism: A History of Newspapers in the United States Through 250 Years 1690–1940.* (New York: MacMillan, 1956), p. 529.

9.
Ibid.

10.
Ibid., p. 533.

11.
Harper's Pictorial History of the War with Spain. (New York: Harper's, 1898), p. vii.

12.
Adams, W. I. Lincoln. *Preface to Cannon and Camera,* by John C. Hemment. (New York: Appleton, 1898), p. 1.

13.
Mott. *A History of American Magazines,* p. 236.

14.
Hare, James H., ed. *A Photographic Record of the Russo-Japanese War.* (New York: Collier, 1905), verso of title page.

15.
Kimball, Arthur Reed. "The Invasion of Journalism." *Atlantic Monthly* (July 1900): 125.

16.
Trachtenberg, Alan. "Ever—The Human Document." In *America and Lewis Hine.* (New York: Aperture, 1977), p. 126.

17.
Fissi, F. "Press Photography." *Penrose's Pictorial Annual Process Year Book* (1908–1909): 113.

18.
Schriever, J. B. *Commercial, Press, Scientific Photography.* (Scranton, PA: American School of Art and Photography, 1909), p. 242.

19.
Caldwell, Genoa, ed. *The Man Who Photographed the World: Burton Holmes Travelogues 1892–1938.* (New York: Abrams, 1977), p. 58.

20.
Sunderland, J. S. "The Progress of Newspaper Illustrations." *Penrose's Pictorial Annual Process Year Book* (1911–1912): 193.

21.
Lascelles, T. W. "Rotary Photogravure." *Penrose's Pictorial Annual Process Year Book* (1916): 17.

22.
New York Times Mid-Week Pictorial War Extra (Nov. 5, 1914): 23.

23.
Lewinski, Jorge. *The Camera at War: A History of War Photography from 1848 to the Present Day.* (New York: Simon and Schuster, 1980), p. 63.

24.
New York Times Mid-Week Pictorial (April 13, 1916): 7.

25.
Carnes, Cecil. *Jimmy Hare, News Photographer.* (New York: MacMillan, 1940), p. 274.

26.
Harper's Weekly (May 13, 1916): 528–529.

27.
Wheeler, H. D. "At the Front with Willie Hearst." *Harper's Weekly* (Oct. 9, 1915): 341.

28.
Collier's (Dec. 1918): recto of back cover.

29.
Marzolf, Marion. *Up from the Footnote: A History of Women Journalists.* (New York: Hastings House, 1977), p. 47.

European Visions

1.
Ullstein, Hermann. *The Rise and Fall of the House of Ullstein.* (New York: Simon and Schuster, 1943), pp. 78–79. Information on the *Berliner Illustrirte* and German photojournalism in general comes from conversations (many taped by Colin Osman) with its participants, including Stefan Lorant; Kurt Safranski's wife and daughter; Felix Man; Umbo; Simon Guttmann; Kurt Hutton's son; Tim Gidal; Wolfgang Weber; Harald Lechenperg; Martin Munkacsi's wife and daughter; Bernd Lohse; Fritz Goro; and others.

2.
Ibid., p. 76. Hermann Ullstein also wanted the *Berliner Morgenpost* to be more political, but this was similarly denied at the same meeting.

3.
Safranski, Kurt. "Dr. Salomon." *Popular Photography* 23 (1948): 56–59, 104–108.

4.
Rim, Carlo. *Le Grenier d'Arlequin: Journal 1916–1940.* (Paris: Denöel, 1981), p. 134.

5.
Information on Lucien Vogel comes in great part from conversations with his daughter, Mme. Paul Vaillant-Couturier, and Carlo Rim. Information on the magazine, *L'Assiette au beurre,* can be found in Ralph E. Shikes, *The Artist as Social Critic in*

Prints and Drawings from the Fifteenth Century to Picasso. (Boston: Beacon Press, 1969), pp. 233–238. Other information on *Vu* and related French magazines can be found in *Histoire Générale de la presse française.* Published under the direction of Claude Bellanger, Jacques Godechat, Pierre Guiral, Fernand Terron. *Tôme 3: De 1871 à 1940.* (Paris: Presses Universitaires de France, 1972), pp. 597–599. See also essay, "The French Picture Magazine, *Vu,*" in the exhibition brochure, *Picture Magazines before "Life."* (Woodstock, NY: 1982); and Yves Aubry, "Magazines et Photographie, 1928–1940." *Zoom, Le Magazine de l'image* 88 (1981): 85–91.

6.
Liberman, Alexander. Interview with Sandra Phillips, April 1982.

7.
Elson, Robert T. *Time Inc.: The Intimate History of a Publishing Enterprise, 1923–1941.* (New York: Atheneum, 1968), p. 272.

Bearing Witness

1.
Coleman, A. D. *The Grotesque in Photography.* (New York: Summit Books, 1977), p. 30.

2.
Bennett, Edna (quoting Willard Morgan). "History of 35mm 1936–1960." *Camera 35* 4 (Feb./March 1960): 61.

3.
Gramling, Oliver. *AP: The Story of News.* (New York: Farrar and Rinehart, 1940), p. 19.

4.
Wright, Jack. "The Story of Newspaper Photography." *American Annual of Photography* 56 (1942): 237.

5.
Cooper, Kent. *Kent Cooper and the Associated Press.* (New York: Random House, 1959), p. 133.

6.
Ibid., p. 136.

7.
Martin, Marcus J. *Wireless Transmission of Photographs.* (London: The Wireless Press, 1916), p. vii.

8.
Cummings, Thomas Harrison, ed. "Photography by Telegraph." *Photo Era* 9 (Aug. 1902): 91.

9.
Grimshaw, Robert. "Korn's Photographic Fac-Simile Telegraph." *Scientific American* (Feb. 16, 1907): 148.

10.
Ezickson, A. J. *Get That Picture.* (New York: National Library Press, 1938), p. 45.

11.
Gramling, p. 383.

12.
Cooper, p. 212.

13.
Ibid., p. 213.

14.
Ibid., p. 218.

15.
The cities outside New York City were Atlanta, Baltimore, Boston, Buffalo, Chicago, Cleveland, Dallas, Dayton, Denver, Des Moines, Detroit, Kansas City, Los Angeles, Miami, Milwaukee, Minneapolis, Oakland, Oklahoma City, Omaha, Philadelphia, St. Louis, San Francisco, Syracuse, Washington.

16.
Wide World became a part of The Associated Press in 1941.

17.
Newhall, Beaumont. Correspondence with B. M. Farrell. September 15, 1949. GEH Collection [AP Wirephoto Transmitter].

18.
Weegee [pseud. Arthur Fellig]. *Naked City.* (New York: DaCapo Press, 1975), p. 240.

19.
Cookman, Claude (quoting Joe Costa). *A Voice Is Born.* (Durham, NC: National Press Photographers Association, 1985), p. 4.

20.
Wright, p. 233.

21.
Ibid., p. 235.

22.
Cookman, p. 4.

23.
Ibid., p. 20.

24.
Ibid., p. 28.

25.
Ibid., p. 93.

26.
The first two short courses in news photography were conducted by Jack Price and A. Clarence Smith at the University of Oklahoma in 1937 and at Kent State University (Ohio) in 1938.

27.
Hecht, Ben, and MacArthur, Charles. *The Front Page.* (New York: Covici, Friede, 1928).

28.
Cookman, p. 102.

29.
Stettner, Lou. "Weegee—The Quintessential Nightworker." *Camera 35* 22 (Feb. 1978): 32.

30.
Weegee [pseud. Arthur Fellig]. *Weegee by Weegee.* (New York: DaCapo Press, 1975), p. 52.

31.
Miller, Sybil. Unpublished notes, forthcoming, on the R. C. Hickman Archive and the Hayes Collection, p. 5.

32.
"Black Dallas in the 1950's" (exhibition catalogue). The R. C. Hickman Collection, Barker Texas History Center, University of Texas at Austin, 1987.

33.
Editors, Time Inc. *Four Hours a Year.* (New York: Time Inc., 1936), p. 21.

34.
Hunter, Peter. "Dr. Erich Salomon: Father of Modern Photojournalism." *Camera 35* 2 (1958): 276.

35.
Wright, p. 236.

36.
Kobler, John. *Luce: His Time, Life and Fortune.* (New York: Doubleday, 1968), pp. 43–44.

37.
Halberstam, David. *The Powers That Be.* (New York: Dell, 1984), p. 91.

38.
Gibbs, Wolcott. "Profiles: Time . . . Fortune . . . Life . . . Luce." *The New Yorker* 12 (Nov. 1936): 21.

39.
Elson, Robert T. *Time Inc: The Intimate History of a Publishing Enterprise, 1923–1941.* (New York: Atheneum, 1968), p. 87.

40.
Kobler, p. 53.

41.
Wainwright, Loudon. *The Great American Magazine.* (New York: Knopf, 1986), p. 16.

42.
Elson, *Time Inc. . . . 1923–1941*, p. 169.

43.
Kobler, p. 149.

44.
Buell, Hal. Interview with Marianne Fulton, June 5, 1986.

45.
Kobler, p. 103.

46.
Elson, *Time Inc. . . . 1923–1941*, p. 237.

47.
Ibid., p. 225.

48.
Fielding, Raymond (quoting Oscar Levant). *The March of Time 1935–1951.* (New York: Oxford University Press, 1978), p. 6.

49.
Goldberg, Vicki. *Margaret Bourke-White: A Biography.* (New York: Harper & Row, 1986), p. 105.

50.
Editors, Time Inc., *Four Hours a Year*, p. 20.

51.
Wainwright (quoting Daniel Longwell), p. 25.

52.
Ibid., p. 16.

53.
Traub, James. "A Wonderful Life." *American Photographer* 17 (Dec. 1986): 48.

54.
Wainwright, p. 89.

55.
Ibid., p. 92.

56.
Duncan, David Douglas. Interview with Marianne Fulton, March 7, 1987.

57.
Whelan, Richard. *Robert Capa: A Biography.* (New York: Alfred A. Knopf, 1985), p. 174.

58.
Elson, *Time Inc. . . . 1923–1941*, p. 44.

59.
Wainwright, p. 33.

60.
Chapnick, Howard. Interview with Marianne Fulton, May 2, 1986.

61.
Ibid.

62.
Elson, *Time Inc. . . . 1923–1941*, p. 345.

63.
Ibid.

64.
Terkel, Studs (quoting Pauline Kael). *"The Good War."* (New York: Pantheon Books, 1984), p. 120.

65.
Bourke-White, Margaret. *Portrait of Myself.* (New York: Simon and Schuster, 1963), pp. 197–198.

66.
Mydans, Kunhardt. *Carl Mydans: Photojournalist.* (New York: Harry N. Abrams, 1985), pp. 23–24.

67.
Ibid., p. 24.

68.
Filan, Frank. " . . . as an AP Photographer at Tarawa Sees It." *AP World* (Jan. 1944): 9.

69.
Whelan, p. 193.

70.
Ibid., p. 194.

71.
Elson, *Time Inc. . . . 1923–1941*, p. 6.

72.
Goldberg, p. 269.

73.
Editors, *Life.* "Three Americans." *Life* (Sept. 20, 1943): 34.

74.
Elson, Robert T. *The World of Time Inc.: The Intimate History of a Publishing Enterprise, 1941–1960.* (New York: Atheneum, 1973), p. 49.

75.
Moyes, Norman Barr. *"Major Photographers and the Development of Still Photography in Major American Wars."* Ph.D. diss., Syracuse University, 1966, p. 273.

76.
Capa, Robert. *Slightly Out of Focus.* (New York: H. Holt, 1947), p. 151.

77.
Duncan, David Douglas. Interview with Marianne Fulton, March 7, 1987.

78.
Phillips, Christopher. *Steichen at War.* (New York: Harry N. Abrams, 1981), p. 45.

79.
Maddow, Ben. *Let the Truth Be the Prejudice.* (New York: Aperture, 1985), p. 17.

80.
Mydans, p. 13.

81.
Elson, *The World of Time Inc. . . . 1941–1960*, p. 56.

82.
Ibid.
83.
"Joe Rosenthal." *Current Biography* (1945) The H. W. Wilson Co., p. 517.
84.
Bourke-White, pp. 258–259.
85.
Sontag, Susan. *On Photography.* (New York: Farrar, Straus and Giroux, 1977), pp. 19–20.
86.
Rhodes, Richard. *The Making of the Atomic Bomb.* (New York: Simon and Schuster, 1986), p. 711.
87.
Coleman, A. D. "The Horrors of Hiroshima." *Light Readings: A Photography Critic's Writings, 1968–1978.* (New York: Oxford University Press, 1979), p. 38.
88.
Duncan, David Douglas. *This Is War!* (New York: Harper, 1951).
89.
Duncan, David Douglas. Interview with Marianne Fulton, March 7, 1987. (Mr. Duncan allows his photographs to be used only in books he himself publishes.)
90.
Ibid.
91.
Ibid.

Changing Focus
1.
Halberstam, David. *The Best and the Brightest.* (New York: Penguin Books, 1986), p. 147.
2.
Kennan, George F. *Memoirs 1950–1963.* (Boston: Atlantic Monthly Press, 1972), p. 190.
3.
Halberstam, *The Best and the Brightest,* p. 147.
4.
Janis, Eugenia Parry, and MacNeil, Wendy. "Robert Frank." *Photography within the Humanities.* (Danbury, NH: Addison House, 1977), p. 54.
5.
Ibid.
6.
Ibid., p. 56.
7.
Trachtenberg, Alan. "Camera Work." In *Photography: Current Perspectives.* Jerome Liebling, ed. (Rochester, NY: Light Impressions, 1979), pp. 224–225.
8.
Hicks, Wilson. *Words and Pictures.* (New York: Harper, 1952), p. 43.
9.
Evans, Harold. *Pictures on a Page.* (New York: Holt, Rinehart and Winston, 1978), p. 248.
10.
Edey, Maitland. "The Photo Essay." *American Photographer* 1 (Dec. 1978): 33.
11.
Bourke-White, Margaret. *Portrait of Myself.* (New York: Simon and Schuster, 1963), p. 349.
12.
Hicks, p. 50.
13.
Wainwright, Loudon. *The Great American Magazine.* (New York: Knopf, 1986), p. 110.
14.
Janis and MacNeil, "W. Eugene Smith," p. 98.
15.
Johnson, William S., ed. *W. Eugene Smith: Master of the Photographic Essay.* (New York: Harper and Row, 1981), p. 41.
16.
Ibid., p. 43.
17.
Hicks, p. 72.
18.
Hill, Paul, and Cooper, Thomas. "W. Eugene Smith." *Dialogue with Photography.* (New York: Farrar, Straus and Giroux, 1979), p. 280.
19.
Smith, W. Eugene. *W. Eugene Smith: Minamata: Life—Sacred and Profane.* (Tokyo: Soju-sha Publishing Co., 1973), unpaged.
20.
Smith, W. Eugene, and Smith, Aileen M. *Minamata.* (New York: Holt, Rinehart and Winston, 1975), p. 8.
21.
Cartier-Bresson, Henri. *The Decisive Moment.* (New York: Simon and Schuster, 1952), unpaged.
22.
Hill and Cooper, p. 76.
23.
Cartier-Bresson, Henri. *The World of Henri Cartier-Bresson.* (New York: Viking Press, 1968), unpaged.
24.
Janis and MacNeil, "Robert Frank," p. 56.
25.
Hill and Cooper, "George Rodger," p. 63.
26.
Peress, Gilles. Interview with Marianne Fulton, Feb. 19, 1987.
27.
Griffiths, Philip Jones. Interview with Marianne Fulton, Feb. 20, 1987.
28.
Elson, Robert T. *The World of Time Inc.: The Intimate History of a Publishing Enterprise, 1941–1960.* (New York: Atheneum, 1973), p. 483.
29.
Peress, Gilles. Interview with Marianne Fulton, Feb. 19, 1987.
30.
Bidermanas, Manuel, and Gourevitch, Jean-Michel. "Paris: Capitale de la Photographie." *Le Point* (March 5–11, 1984): 157.
31.
Pledge, Robert. Interview with Marianne Fulton, May 11, 1987.
32.
Ibid.

33.
Moore, Thomas. "The Saint" (quoting Raymond Depardon). *American Photographer* 5 (Sept. 1980): 52.

34.
Pledge, Robert. Interview with Marianne Fulton, May 11, 1987.

35.
Ibid.

36.
Ibid.

37.
1973 was also the year Goksin Sipahioglu left Gamma and founded Sipa Press.

38.
Pledge, Robert. Interview with Marianne Fulton, May 11, 1987.

39.
Ibid.

40.
Ibid.

41.
Moore, p. 54.

42.
Ibid., p. 42.

43.
Livingston, Kathryn. "Photographing Armageddon" (quoting Hal Buell). *American Photographer* 4 (Jan. 1980): 38.

44.
Laffont, Eliane. Interview with Marianne Fulton, Dec. 11, 1986.

45.
Archive Pictures was formed in 1981 by a group of photographers who had left Magnum: Charles Harbutt, Mary Ellen Mark, Abigail Heyman, Joan Lifton, Jeff Jacobson, and Mark Godfrey. J. B. Pictures was founded in 1984 by Jocelyn Benzakin, former picture editor for Sipa. Visions was incorporated in 1978 by J. Ross Baughman and Mark Greenberg.

46.
Lippmann, Walter. *Public Opinion.* (New York: Harcourt, Brace, 1922), p. 341.

47.
Ibid., p. 350.

48.
Gans, Herbert J. *Deciding What's News: A Study of CBS Evening News, NBC Nightly News, "Newsweek" and "Time."* (New York: Vintage Books, 1980), p. 22.

49.
Ibid., p. 31 (quoting Calvin Coolidge).

50.
Arlen, Michael J. *Living-Room War.* (Middlesex, England: Penguin Books, 1982), p. 107.

51.
Williams, Juan. *Eyes on the Prize* (quoting Richard Valeriani). (New York: Viking Press, 1987), p. 270.

52.
Schulke, Flip. Interview with Marianne Fulton, Sept. 9, 1987.

53.
Ibid.

54.
Ibid.

55.
Karnow, Stanley. *Vietnam: A History* (quoting Henry Kissinger). (New York: Viking Press, 1983), p. 9.

56.
Griffiths, Philip Jones. Interview with Marianne Fulton, Feb. 20, 1987.

57.
McCullin, Don. "A Life in Photographs." *Granta* 14 (Winter 1984): 186.

58.
Karnow, p. 523.

59.
Griffiths, Philip Jones. *Vietnam, Inc.* (New York: Macmillan, 1971), p. 4.

60.
Griffiths, Philip Jones. Interview with Marianne Fulton, Feb. 20, 1987.

61.
Ibid.

62.
Ibid.

63.
Eco, Umberto. "A Photograph." *Travels in Hyper Reality: Essays.* Trans. by William Weaver. (New York: Harcourt Brace Jovanovich, 1986), p. 216.

64.
Brown, Betty C. "The Third War of Horst Faas" (quoting Horst Faas). *Popular Photography* 58 (March 1966): 58.

65.
Faas, Horst. Interview with Marianne Fulton, Nov. 13, 1986.

66.
Karnow, p. 9.

67.
Fussell, Paul. *The Great War and Modern Memory.* (New York: Oxford University Press, 1975), p. 7.

68.
Wainwright, p. 363.

69.
Karnow, p. 489.

70.
Halberstam, David. *The Powers That Be.* (New York: Dell, 1984), p. 675.

71.
Karnow, p. 609.

72.
Ibid., p. 611.

73.
McCullin, Don. *Beirut: A City in Crisis.* (London: New English Library, 1983), p. 65.

74.
Turnley, David. Interview with Marianne Fulton, July 3, 1987.

75.
Ibid.

76.
Ibid.

77.
Polman, Dick. "Domestic Violence: The War Behind Drawn Curtains." [Philadelphia] *Inquirer* (July 26, 1987): 8–23, 31.

"Domestic Violence, Part Two: Victims of a Private War."
[Philadelphia] *Inquirer* (Aug. 2, 1987): 8–23.

78.
Ritchin, Fred. "Donna Ferrato: The Honey Moon's Killers [*sic*]."
Fotografia (Autumn 1986).

79.
Price, Larry. Interview with Marianne Fulton, Sept. 9, 1987.

80.
Chapnick, Howard. Interview with Marianne Fulton, May 2,
1986.

81.
Mullarkey, Karen. Interview with Marianne Fulton, July 5, 1986.

82.
Buell, Hal. Interview with Marianne Fulton, June 5, 1986.

83.
Ibid.

84.
Ibid.

85.
Schulke, Flip. Interview with Marianne Fulton, Sept. 9, 1987.

86.
See both "A Public Suicide," *Associated Press Managing Editors'
Photo and Graphics 1987 Report;* and "Minutes from Tragedy:
Reporting the Suicide," *News Photographer,* May 1987, for a more
complete exploration.

87.
Stern, Marilyn. "Fred Ritchin and the State of Photojournalism."
Photo District News 5 (Dec. 1985): 66.

88.
Chapnick, Howard. "Markets & Careers." *Popular Photography* 89
(Aug. 1982): 40, 42.

89.
Stern, p. 68.

90.
Bossen, Howard. "Zone V: Photojournalism, Ethics and the
Electronic Age." *Studies in Visual Communication* 2 (Summer
1985): 30.

91.
Drapkin, Arnold. Interview with Marianne Fulton, May 6, 1986.

92.
Grosvenor, Gilbert. *The National Geographic Society and Its
Magazine.* (Washington, DC: The Society, 1936), p. 13.

93.
Middleton, Michael. "Colour Photography in Journalism."
Penrose Annual (1954): 87.

94.
Ibid., p. 88.

95.
Duncan, David Douglas. Interview with Marianne Fulton,
March 7, 1987.

96.
Ibid.

97.
Griffiths, Philip Jones. Interview with Marianne Fulton, Feb. 20,
1987.

98.
Ibid.

Selected Bibliography

The bibliography constitutes a selection of material used in researching this book. It also includes complete references for the books mentioned in the Biographical References.

Articles

"ABA Wavers in Its Stand Against Courtroom Photos." *National Press Photographer* 11 (10): 6.

Abbas. Ma révolution en Iran." *Zoom* 61 (March 1979): 84–93.

"About and Around Wilson Hicks." *Infinity* 19 (Oct. 1970): whole issue.

Adams, Eddie. "Little People." *Zoom* 47 (Oct 1977): 52–57.

"AFP: Paris de 1944 à nos jours." *Zoom* 102 (Sept. 1983): 100–107.

Allen, Casey. "Behind the Scenes: An Interview with Picture Editor Alice Rose George." *Camera 35* 25 (June 1980): 70–71.

———. "Eddie Adams: Pulitzer Winning Press Photographer." *Camera 35* 20 (June 1976): 33–35, 60.

———. "J. Ross Baughman." *Camera 35* 25 (Aug. 1980): 36–41, 76.

Anson, Robert Sam. "Photojournalism Essay: The Way It Is." *American Photographer* 10 (March 1983): 86–87. AP World (all issues, 1944–1987).

Arendt, Paul. "Telegraphic Picture and Facsimile Transmission and Reception." *Siemens-Zeitschrift* 9 (1929): 3–32.

Arnett, Peter. "Tet Coverage: A Debate Renewed." *Columbia Journalism Review* 16 (Jan./Feb. 1978): 44–48.

Arnold, Rus. "Cornell Capa." *Camera 35* 16 (April 1972): 54–63.

———. "The Problem: Visual Literacy." *Infinity* 11 (Dec. 1962): 12–17.

———. "Profile: Cliff Edom." *Camera 35* 15 (June 1971): 28–31.

Aubry, Yves. "Magazines & Photographie 1928–1940." *Zoom* 88 (April 1982): 85–91.

———. "Stern Story." *Zoom* 55 (July 1978): 72–95.

Bailey, Ronald H. "The History of Carl Mydans." *American Photographer* 15 (Aug. 1985): 42–58.

———. "The Real McCombe: A Portrait of a Most Unusual, Difficult and Gentle Man." *American Photographer* 1 (Dec. 1978): 50–55.

Barrell, Sarah Webb. "First Lady of the 'Times'." *Camera 35* 19 (April 1975): 14–15.

———. "The Picture Picker." *Camera 35* 19 (Feb./Mar. 1975): 26–27, 67–68.

———. "The Summer of '73." *Camera 35* 18 (Oct. 1974): 54–61.

Beach, Nancy. "Doubts Dog Rhodesian Pulitzer Photos." *News Photographer* 39 (July 1984): 14–15.

Becker, Karin E. "Forming a Profession: Ethical Implications of Photojournalistic Practice on German Picture Magazines." *Studies in Visual Communication* 2 (Spring 1985): 44–60.

Benedek, Yvette. "Shlomo Arad." *American Photographer* 10 (March 1983): 96–102.

Bennett, Edna. "History of 35mm 1912–1936." *Camera 35* 4 (Dec./Jan. 1960): 23–35, 80, 81.

————. "History of 35mm 1936–1960." *Camera 35* 4 (Feb./ Mar. 1960): 55–60, 80.

Bidermanas, Manuel, and Gourevitch, Jean-Michel. "Paris: Capitale de la Photographie." *Le Point* (March 1984): 157.

Bigart, Homer. "Estes Goes on Trial in Texas with TV in Courtroom." *New York Times* (Sept. 25, 1962).

Blackwood, Roy E. "The Content of News Photographers' Roles Portrayed by Men and Women." *Journalism Quarterly* 60 (Winter 1983): 710–714.

Blumenfeld, Harold. "How UPI covered the Inauguration." *Camera 35* 21 (May 1977): 53–55, 64.

————. "Mr. Photo Press." *Camera 35* 21 (March 1977): 52–53, 56.

Bogre, Michelle. "George Karas." *American Photographer* (Feb. 1984): 56–63.

Bondi, Inge. "Chim's Way." *Camera 35* 14 (Dec./Jan. 1970): 35–43, 58–62.

Bossen, Howard. "Zone V: Photojournalism, Ethics and the Electronic Age." *Studies in Visual Communication* 2 (Summer 1985): 22–32.

Breithaupt, Frank. "Star Trek." *News Photographer* 35 (March 1980): 6–9.

Brinnin, John Malcolm. "Henri Cartier-Bresson: Portrait of the Artist, ca. 1947." *Camera Arts* 2 (Jan./Feb. 1982): 14–29, 110–113.

Broecker, W. L. "Henri Cartier-Bresson." *Infinity* 17 (Sept. 1968): 22–23, 29.

Brown, Betty C. "The Third War of Horst Faas." *Popular Photography* 58 (March 1966): 58.

Brucker, Herbert. "Let's Abolish Canon 35." *Saturday Review* 45 (Dec. 1962): 63–64, 73–74.

Buckland, Gail. "Beaton at War." *American Photographer* 10 (April 1983): 74–81.

Buell, Hal. Interview with Marianne Fulton, June 5, 1986.

Burnett, David. "David Burnett." *American Photographer* 19 (July 1987): 72–76.

Cala, Michael. "Photographs Don't Lie (But Photographers Sometimes Do!)." *Camera 35* 21 (Sept. 1977): 50–51, 60.

Callahan, Sean. "People Weekly." *American Photographer* 00 (June 1984): 39–53.

————. "Photojournalism." *American Photographer* 1 (Dec. 1978): 30–31.

————. "Photojournalism." *American Photographer* 10 (Jan. 1983): 49.

————. "Photojournalism: The Vivid Record of Our Triumphs and Failures." *American Photographer* 10 (March 1983): 49.

————. "Through a Lens, Darkly." *Columbia Journalism Review* 22 (Nov./Dec. 1983): 71–73.

"Cameras Gain Access in More States but Stumble in Federal Court Effort." *FOI Digest* 25 (May/June 1983): 8.

Capa, Cornell. "The Concerned Photographers ou la vérité contre l'objectivité." *Zoom* 16 (Feb. 1973): 78–95.

————. "Margin of Life." *Camera 35* 16 (April 1972): 46–53.

Chapnick, Howard. "Going, Going . . . Up?" *Camera Arts* (Nov./Dec. 1980): 36–43.

————. "Hal Buell Leads the Associated Press into the Future." *Popular Photography* 94 (July 1987): 40.

————. Interview with Marianne Fulton, May 2, 1986.

————. "Looking for Bang Bang." *Popular Photography* 89 (July 1982): 65–67, 99–102.

————. "Markets & Careers" [Computers]. *Popular Photography* 91 (April 1984): 24, 26, 88.

————. "Markets & Careers" [Credibility/Ethics]. *Popular Photography* 89 (Aug. 1982): 40, 42, 44.

————. "Markets & Careers" [Great Pictures]. *Popular Photography* 89 (Sept. 1982): 52, 58.

————. "Markets & Careers" [New Color]. *Popular Photography* 90 (May 1983): 32

————. "Markets & Careers" [Perceptiveness]. *Popular Photography* 88 (Oct. 1981): 62, 66.

————. "Markets & Careers" [Visual Literacy]. *Popular Photography* 90 (Oct. 1983): 22, 24.

————. "Markets & Careers" [Yoichi Okamoto]. *Popular Photography* (Aug. 1985): 22, 26.

————. "Showing Them in Missouri." *Popular Photography* 90 (Dec. 1983): 87–92, 160–163, 175.

Chapnick, Howard, and Anderson, David. "Two Party Politic." *Camera Arts* 1 (March/April 1981): 20–23, 104.

"Charles Rado." *Infinity* 20 (Nov. 1970): 21.

Clark, Willard. "Editor's Notebook." *Camera 35* 23 (Nov. 1978): 4.

————. "Editor's Notebook." *Camera 35* 24 (April 1979): 4.

Clarke, Gerald. "Freezing Moments in History." *Time* (Dec. 28, 1981): 28–29.

Cohen, Barney. "Photojournalism Feature: On the Second Front." *American Photographer* 10 (March 1983): 88–96.

Cohen, Daniel and Benezra, Karen. "Digitized News: How Real?" *Photo District News* 7 (May 1987): 18, 20, 22, 24.

Coleman, A. D. "At Last: The Photojournalist Is Given Control." *New York Times* (March 10, 1974).

————. "Context and Control." *Lens on Campus* 4 (Sept. 1982): 44–46.

————. "Democratizing Media." *Lens on Campus* 8 (Oct. 1986): 10–11.

————. "Most Photojournalism Isn't." *Lens on Campus* 7 (March 1985): 6–9.

Collier's (Dec. 1918): recto of back cover.

"Collin Jones: La révélation d'un photojournaliste." *Zoom* 57 (Oct. 1978): 22–35.

Considine, Bob. "Word Tribute to a Beloved Picture Man." *National Press Photographer* 12 (April 1957): 6.

"Contact Sheet: Photo Editors Tell Us Why." *Camera 35* 24 (April 1979): 34–35.

"The Crewl Camera." *Columbia Journalism Review* 4 (Spring 1965): 5–10.

Cummings, Thomas Harrison, ed. "Photography by Telegraph." *Photo Era* 9 (Aug. 1902): 90–91.

de Beketch, Serge. "Pimpants Pompiers." *Zoom* 54 (June 1978): 66–83.

de Cavne, A. "World Press Photo." *Zoom* 44 (May 1977): 84–89.

"The Decisive Decade." *American Photographer* 13 (Dec. 1984): 39–57.

Demetrios, Gregory. "Larry Burrows: J'ai toujours peur de faire du fric avec la souffrance des autres!" *Zoom* 4 (Sept. 1970): 46–53.

DePiante, Robert. "Convention: In Miami." *National Press Photographer* 23 (Oct. 1968): 4–10.

Digne, Danielle. "Gisele Freund." *Zoom* 77 (Aug./Sept. 1977): 46–49.

"A Disaster Unfolds." *AP Log* (Feb. 3, 1986).

Domke, Jim. "The Almost-Won." *Camera 35* 18 (Oct. 1974): 28, 65.

Drapkin, Arnold. Interview with Marianne Fulton, May 6, 1986.

Duncan, David Douglas. Interview with Marianne Fulton, March 7, 1987.

_____. "Okinawa, Threshold to Japan." *National Geographic* 137 (Oct. 1945): 411–412.

_____. "There Was a Christmas." *Life* 29 (Dec. 25, 1950): 8–15.

_____. "The Year of the Snake." *Life* 35 (Aug. 1953): 73–91.

Durniak, John. "Burning and Dodging." *Infinity* 17 (Sept. 1968): 13.

_____. "45 Minutes with Ralph Graves." *Infinity* 18 (Aug. 1969): 5–7.

_____. "The New Photojournalism." *Camera 35* 24 (April 1979): 23–24.

_____. The Pulitzer Puzzle." *Popular Photography* 91 (Oct. 1984): 64–65, 86–87, 113.

_____. "The Second Revolution in Chicago." *Infinity* 17 (Oct. 1968): 28.

_____. "Tell Tolstoy to Turn His Camera In." *Infinity* 21 (Jan. 1972): 4–7.

_____. "'This Week' Died; Did Anybody Cry?" *Infinity* 18 (Nov. 1969): 22–25.

Edelson, Michael. "Critics Corner." *Camera 35* 23 (Aug. 1978): 14–15.

_____. "Critics Corner." *Camera 35* 24 (May 1979): 16, 77.

_____. "The Diary of André Kertész." *Camera 35* 19 (Oct. 1975): 46–52.

Edey, Maitland. "The Photo Essay." *American Photographer* 1 (Dec. 1978): 32–38.

Edinger, Claudio. "Letter from El Salvador." *American Photographer* 9 (Dec. 1982): 98.

Edwards, Owen. "Sylvia Plachy Sees Things Her Way." *American Photographer* 10 (May 1983): 28, 30.

"Erich Salomon: Father of Modern Photojournalism." *Camera 35* 24 (April 1979): 36–41, 74, 75.

Ezan, Jean Pierre. "News: Gilles Caron: À côté de moi un type est tombé mort les mains dans les poches!" *Zoom* 2 (April 1970): 112–127.

Faas, Horst. Interview with Marianne Fulton, Nov. 13, 1986.

Faber, John. "On the Record . . ." *National Press Photographer* (1957–1964; 1967–1968): all issues.

Finkel, Kenneth. "Langenheim Daguerreotype." *History of Photography* (Oct. 1980): 336.

Fissi, F. "Press Photography." *Penrose's Pictorial Annual Process Year Book* (1908–1909): 113.

Gardlin, Martin. "Color Neg Power." *Photo District News* 7 (Feb. 1987): 1, 70.

_____. "Eddie Adams Talks Tough." *Photo District News* 7 (May 1987): 58.

Gelb-Courbet, Elizabeth. "Larry Price in El Salvador." *Photo District News* (April 1986): 108.

_____. "Run for Your Life." *Photo District News* 7 (May 1987): 115.

Gibbs, Wolcott. "Profiles: Time . . . Fortune . . . Life . . . Luce." *New Yorker* 12 (Nov. 1936): 20–25.

Goldberg, Vicki. "The Human Condition, Almost: Two New Photojournalists in Search of the Serious." *American Photographer* 19 (July 1987): 36–38.

_____. "The News About History." *American Photographer* 3 (July 1979): 16, 17.

Goldsmith, Arthur. "Forgotten Pictures of the Spanish Civil War." *Camera Arts* 1 (March/April 1981): 63–70, 101–102.

_____. "Happy 40th Birthday, ASMP!" *Popular Photography* 91 (Oct. 1984): 50–56.

Graham-Henry, Diane. "Stan Malinowski's New Magazine." *Photo District News* 7 (May 1987): 90, 92.

Gramling, Oliver. "In the Beginning: The Creation of the AP Wirephoto Network." *AP World,* 1984.

Griffiths, Philip Jones. Interview with Marianne Fulton, Feb. 20, 1987.

Grimshaw, Robert. "Korn's Photographic Fac-Simile Telegraph." *Scientific American* (Feb. 16, 1907): 148.

Grover, Jan Zita. "The First Living Room War: The Civil War in the Illustrated Press." *Afterimage* 2 (Feb. 1984): 8–11.

_____. "Philosophical Maneuvers in a Photogenic War." *Afterimage* 10 (April 1983): 4–6.

_____. "Star Wars: The Photographer as Polemicist in Vietnam." *Afterimage* 2 (Summer 1983): 20–24.

Grundberg, Andy. "Photojournalism Makes a Comeback." *New York Times* (Sept. 9, 1985).

Guerrin, Michel. "America, Your Photos Are French." *France Magazine* 1 (Summer 1985): 6–13.

Hall, James Baker. "Burk Uzzle: The Hustle Comes of Age." *Aperture* 77 (1976): 40–48.

Hansen, Edmund H. "The New Bartlane System of Radio Transmission of Pictures." *Popular Radio* 7 (May 1925): 407–412.

"Harald Lechenperg, Photojournalist." *Studies in Visual Communication* 2 (Spring 1985): 61–75.

Hardt, Hanno, and Ohrn, Karin B. "The Eyes of the Proletariat: The Worker-Photography Movement in Weimar Germany." *Studies in Visual Communication* 7 (Summer 1981): 46–57.

Harper's Weekly (May 13, 1916): 528–529.

Hartley, Craig H. "Ethical News: Gathering Values of the Public and Press Photographers." *Journalism Quarterly* 60 (Summer 1983): 301–304.

Held, Jean-François. "Donald McCullin: Le meilleur reportage de 1971, Les réfugiés Pakistanais." *Zoom* 11 (March/April 1972): 26–33.

Heller, Steven. "Photojournalism's Golden Age." *Print* 38 (Sept./Oct. 1984): 68–79, 116, 118.

Heyman, Therese Thau, and Minick, Joyce. "Dorothea Lange." *American Photographer* 2 (Feb. 1979): 44–56.

Hilton, W. W. "25 ans de World Press Photo." *Zoom* 88 (April 1982): 92–97.

Hinton, A. Horsley. "Photography for Illustration." *The Photogram* (Sept. 1894): 205.

Hoberman, J. "American Abstract Sensationalism." *Art Forum* 19 (Feb. 1981): 42–49.

Holmes, Oliver Wendell. "The Stereoscope and the Stereograph." *Atlantic Monthly* (June 1859): 748.

_____. "Sun-Painting and Sun-Sculpture." *Atlantic Monthly* (July 1861): 25, 27.

Hood, Robert E. "The Deadly Métier." *Infinity* 15 (June 1966): 5, 28–30.

"Huet Wounded." *National Press Photographer* 22 (Nov. 1967): 16.

Hughes, Jim. "Olympic Tradition." *Camera Arts* 3 (March 1983): 2, 87.

_____. "Vital Signs." *Camera Arts* 3 (March 1983): 34–49.

Hunter, Peter. "Dr. Erich Salomon: Father of Modern Photojournalism." *Camera 35* 2 (1958): 268–277.

Hurley, F. Jack. "Pie Town, N.M., 1940." *American Photographer* 10 (March 1983): 76–85.

Hutten, Marc. "Agence France Presse: The First French Connection." *France Magazine* 2 (Fall 1985): 28–30.

"L'Indochine des journalistes." *Zoom* 7 (May 1971): 20–27.

Infinity [letters to the editor about Wilson Hicks] 21 (Dec. 1970): 7, 20–21.

Jay, Bill. "Donald McCullin." *Zoom* 11 (March/April 1972): 124–125.

Kahan, Robert S. "Magazine Photography Begins: An Editorial Negative." *Journalism Quarterly* 45 (Winter 1965): 53–59.

Kaplan, Michael. "An Island of Despair: Photographing the Violence and Tragedy of Haiti." *American Photographer* 20 (April 1988): 76–77.

Kaufman, Fred. "Camera Coverage of the Estes Trial." *National Press Photographer* 18 (Jan. 1963): 12.

"Kay Lawson: Photojournalist. A Woman's Point of View." *Camera 35* 4 (Feb./March 1960): 30–35, 82.

Kelley, Robert W. "An Eye for Pictures." *Camera 35* 2 (1958): 301–303, 326–327.

_____. "For Alfred Eisenstaedt . . . The Name of the Game Is Fun." *Camera 35* 2 (1958): 132–133.

Kelly, Margie. "Hauptman Trial 'Facts' Reconsidered." *FOI Digest* 21 (Jan./Feb. 1979): 4.

Kerrick, Jean S. "News Pictures, Captions and the Point of Resolution." *Journalism Quarterly* 36 (Spring 1959): 183–188.

Kimball, Arthur Reed. "The Invasion of Journalism." *Atlantic Monthly* (July 1900): 125.

King, V. "In Charles Rado's Footsteps: An Interview with Jim Sage, New Director of Rapho-Guillumette." *Infinity* 20 (Oct. 1971): 29–30.

Klein, Robert S. "The Antecedents of American Photojournalism." Ph.D. diss., Columbia University, 1970.

Laffont, Eliane. Interview with Marianne Fulton, Dec. 11, 1986.

Lange, Dorothea, and Jones, Pirkle. "Death of a Valley." *Aperture* 8 (1960): 128–164.

Lascelles, T. W. "Rotary Photogravure." *Penrose's Pictorial Annual Process Year Book* (1916): 17.

Laskin, Daniel. "The Louisville Sluggers." *Camera Arts* 3 (April 1983): 8–10, 14–16, 80–83.

Lax, Eric. "Lorant's Vision." *American Photographer* 12 (June 1984): 60–67.

Leab, Daniel J. "Movie News." *Columbia Journalism Review* 16 (March/April 1978): 56–58.

Lehman, Rosamond. "Black Star of New York City." *The Commercial Photographer* 12 (Nov. 1936): 54–58.

"Let the Courtroom Cameras Roll." *New York Times* (May 14, 1986).

"'Life': Le meilleur du meilleur." *Zoom* 67 (Nov. 1979): 24–41.

Lippard, Lucy R. "Hinesight." *Voice* (Dec. 25, 1984): 114.

Livingston, Kathryn. "Photographing Armageddon." *American Photographer* 4 (Jan. 1980): 34–39.

Lyons, Nathan. Correspondence with Maynard D. McFarlane, Sept.–Oct., 1967 [picture transmission].

McCoy, Dan. "A Time with Durniak." *Camera 35* 17 (May 1973): 39–41, 72–73.

McCoy, Max. "The News from Missouri: Troubling Trends in the Pictures of the Year." *American Photographer* 19 (July 1987): 24.

MacCrae, Michael. "Dr. Snaps." *American Photographer* 12 (May 1984): 32–43.

McCullin, Don. "The Eye of the Storm: Beirut." *Aperture* 97 (Winter): 48–63.

_____. "Homecoming." *American Photographer* 3 (Nov. 1979): 32–43.

_____. "A Life in Photographs." *Granta* 14 (Winter 1984): 171–196.

McFarland, Captain M. D. "The Bartlane System of Telegraphic Picture Transmission." *The Commercial Photographer* (1925): 57–59.

McGill, Douglas C. "Women Rank High in Photojournalism." *New York Times* (Nov. 9, 1986).

Mack, Emily A. "The Myth Named Smith." *Camera 35* 4 (Dec./Jan. 1960): 44–47, 74–79.

Maddow, Ben. "The Passion of St. Eugene." *American Photographer* 15 (Dec. 1985): 43–63.

Maingois, Michael. "Reporters: Un film de Raymond Depardon." *Zoom* 82 (April 1982): 114–116.

Mark, Mary Ellen. "Falkland Road." *American Photographer* 6 (April 1981): 60–68.

Markus, David. "Moving Pictures." *American Photographer* 14 (May 1985): 50–63.

————. "War Watch: Iran, Iraq." *American Photographer* 15 (Sept. 1985): 78–80.

"Maryland Rescinds Order Allowing Cameras in Court." *FOI Digest* 23 (March/April 1981): 8.

Mehling, Reuben. "Attitude-Changing Effect of News and Photo Combinations." *Journalism Quarterly* 36 (Spring 1959): 189–198.

Meisner, Arnold. "Working Techniques of Three Photojournalists." *Camera 35* 24 (April 1979): 58–61.

Middleton, Drew. "Islam's Forgotten War." *American Photographer* 15 (Sept. 1985): 64–77.

Middleton, Michael. "Colour Photography in Journalism." *Penrose Annual* (1954): 86–88.

Miller, Gary. "AP Meets Buck Rogers and Finds Happiness." *Camera 35* 18 (Feb./March 1974): 35–37, 76–77.

"Minutes from Tragedy: Reporting the Suicide." *News Photographer* (May 1987).

Mitchel, Julio. "5th Ave." *Camera 35* 16 (July/Aug. 1972): 38–45.

Moeller, Susan D. "Life and Death." *Views* 8 (Summer 1987): 6–9.

————. "Profile: George Silk." *Views* 8 (Summer 1987): 10–11.

Molotch, Harvey, and Evans, Harold. "Pictures on a Page: Photojournalism and Picture Editing." *Studies in Visual Communication* 8 (Spring 1982): 86–88.

Moore, Thomas. "The Saint." *American Photographer* 5 (Sept. 1980): 42–55

Morris, John G. "The New Look in Newspapers." *National Press Photographer* 21 (June 1966): 8–12, 14, 15.

Moyes, Norman Barr. "Major Photographers and the Development of Still Photography in Major American Wars." Ph.D. diss., Syracuse University, 1966.

Mullarkey, Karen. Interview with Marianne Fulton, July 5, 1986.

"Narrative of a Photographic Trip to the Seat of War in the Crimea." *Photographic and Fine Arts Journal* (1856): 76–80.

National Geographic Magazine 21 (Nov. 1910): 903–926.

"Navy, Civil Air Patrol Stops Photogs at Crash Site." *National Press Photographer* 13 (July 1958): 1, 22.

"New Executive Set-Up in AP Newsphotos." *AP World* (Autumn 1965): 3.

"The New Magnum Photographers." *Camera 35* 12 (Aug./Sept. 1968): 28–35.

New York Times Magazine (Sept. 8, 1985): 19.

New York Times Mid-Week Pictorial (April 13, 1916): 7.

New York Times Mid-Week Pictorial War Extra (Nov. 15, 1914): 23.

Newhall, Beaumont. Correspondence with B. M. Farrell, Sept. 15, 1949. GEH Collection [AP Wirephoto Transmitter].

"News Photogs Should Defend Right to Work." *Canon 35 Publisher's Auxiliary* (Aug. 4, 1956): 6.

Novak, Joe. "Books in Review: '*Homecoming*' by Don McCullin." *Camera 35* 25 (June 1980): 22–23.

"NPPA Camera 'Canons' Define Behavior in Courtroom." *National Press Photographer* 13 (Jan 1958): 12.

O'Connor, Maura. "Perspective." *Photo District News* 7 (May 1987): 136.

Olander, William. "Art & Social Change." *Allen Memorial Art Museum, Oberlin College Bulletin* 40 (1982–1983).

Olson, John. "An Era Died." *Infinity* 20 (May 1971): 11–14.

O'Neil, Denis. "On the Warpath." *American Photographer* 15 (Sept. 1985): 38–51.

Osman, Colin. "Kurt Hutton 1893–1960." *Creative Camera Yearbook 1976* (London, 1975).

Peress, Gilles. Interview with Marianne Fulton, Feb. 19, 1987.

"The Photo Essay." *Camera 35* 9 (Aug./Sept. 1965): 28–31.

"Photographs from Sebastopol." *Photographic and Fine Arts Journal* (1885): 377.

"Photography in the Courtroom." *The California Publisher* (Aug. 1957): 21.

"Photo-Journalistic Breakthrough." *Infinity* 10 (March 1961): 3–16, 18.

Pierce, Bill. "Photographing Violence." *Popular Photography* 90 (Nov. 1983): 92–96, 126.

Pierce, Don. "Backup Camera Saved Dramatic Photos." *Tulsa Tribune* (Feb 5, 1986).

"Piling Up the Evidence on Canon 35." *National Press Photographer* 11 (March 1956): 11–13.

Pledge, Robert. "Donald McCullin: I Want to Be the Toughest War Photographer in the World." *Zoom* 10 (Feb. 1972): 99–117.

————. Interview with Marianne Fulton, May 11, 1987.

————. "News Raymond Depardon le profil du photographie journaliste de 1980." *Zoom* 5 (Dec. 1970): 100–111.

Poe, Edgar Allen. "The Daguerreotype." *Alexander's Weekly Messenger* (Jan. 15, 1840): 2.

Polman, Dick. "Domestic Violence: The War Behind Drawn Curtains." [Philadelphia] *Inquirer* (July 26, 1987): 8–23, 31.

————. "Domestic Violence, Part Two: Victims of a Private War." [Philadelphia] *Inquirer* (Aug. 2, 1987): 8–23.

Price, Larry. Interview with Marianne Fulton, Sept. 9, 1987.

"Public Suicide, A." *Associated Press Managing Editors' Photo and Graphics 1987 Report*.

Range, Peter Ross. "One Straight Shooter." *American Photographer* 13 (July 1984): 34–47.

Reese, Kay. "Legend in Our Times: Charles Rado, A Photographic Fame Maker." *Infinity* 20 (Oct. 1971): 22–28.

Reidy, John J. "Color Photo Wire Transmission." *National Press Photographer* 12 (March 1957): 23.

Rice, Shelley. "W. Eugene Smith: A Dream Life." *Lens on Campus* 8 (April 1986): 14–17.

Richards, Eugene. "Dorrie's Journey." *American Photographer* 6 (June 1981): 48–61.

Richardson, Nan. "An Eye for an Eye: Northern Ireland." *Aperture* 97 (Winter): 28–47.

Ritchin, Fred. "Beirut: The Photographers' Story." *Camera Arts* 3 (Jan 1983): 24–35, 91–93.

———. "Donna Ferrato: The Honey Moon's Killers [*sic*]." *Fotografia* (Autumn 1986).

———. "The Future of Photojournalism." *Aperture* 100 (Fall): 42–50.

———. "The Photographing of Conflict." *Aperture* 97 (Winter): 22–27.

Roberts, Bruce. "Does Your Newspaper Look Different Lately?" *Camera 35* 8 (Dec./Jan. 1964): 21–25, 68–69.

Roth, Evelyn. "Screen Gems." *American Photographer* 11 (Aug. 1983): 81–84.

Rothschild, Norman. "New Trends in Speedlight Units." *Camera 35* 2 (1958): 129–131, 148.

Rothstein, Arthur. "Photojournalism: Alive and Well!" *Infinity* 21 (Jan. 1972): 18–21.

———. "Setting the Record Straight." *Camera 35* 22 (April 1978): 50–51.

Schreibner, Norman. "Fred W. McDarrah." *Camera 35* 16 (Nov. 1972): 47–49, 74–76.

Schulke, Flip. Interview with Marianne Fulton, Sept. 9, 1987.

Schuneman, R. Smith. "Art or Photography. A Question for Newspaper Editors of the 1890's." *Journalism Quarterly* 42 (Winter 1965): 43–52.

Schwalberg, Carol. "Tribute to Eisie." *Camera 35* 7 (Feb./March 1963): 20–25, 52–53.

Shames, Laurence. "Everything's Crazy, Everything's Fine." *American Photographer* 10 (March 1983): 50–65.

———. "Susan Meiselas." *American Photographer* 6 (March 1981): 42–55.

Shawcross, William, and Hodgson, Frances. "Sabastiao Salgado: Man in Distress." *Aperture* 108 (Fall 1987): 2–31.

Singletary, Michael W., and Lamb, Michael. "News Values in Award-Winning Photos." *Journalism Quarterly* 61 (Spring 1984): 104–108, 233.

Smith, Henry Holmes. "Two for the Photojournalist." *Aperture* 8 (1960): 188–192.

Smith, Terence. "Images of Israel" [Micha Bar-Am, photographer]. *New York Times Magazine* (Oct. 31, 1982): 40–44.

Smith, W. Eugene, and Smith, Aileen. "Death-Flow from a Pipe." *Life* (June 2, 1972): 74–81.

"Speed Graphic Still Tops Among Working Photogs!" *National Press Photographer* 11 (Oct. 1956): 3.

Stern, Marilyn. "Fred Ritchin and the State of Photojournalism." *Photo District News* 5 (Dec. 1985): 64–66, 68.

Stettner, Lou. "Merely Mortal." *Camera 35* 19 (April 1975): 24–25, 66.

———. "Weegee: The Quintessential Nightworker." *Camera 35* 22 (Feb. 1978): 32–37.

Stevens, Nancy. "The Spoils of Photojournalism." *American Photographer* 1 (Dec. 1978): 56–60.

Strother, Bill. "Tube Time in Newspaperland." *News Photographer* 36 (Jan. 1981): 6–16.

Sullivan, Nick. "Tony Ray-Jones: Pioneer of the New Photojournalism." *Camera 35* 24 (April 1979): 42–47, 72–73.

Sunderland, J. S. "The Progress of Newspaper Illustrations." *Penrose's Pictorial Annual Process Year Book* (1911–1912): 193.

Suro, Roberto. "Sicily and the Mafia." *New York Times Magazine* (May 18, 1986): 47–55, 62–65.

Swoyer, A. E. "The Versatility of the Telephoto Lens." *Photo Era* 33 (Aug. 1914): 60–65.

Tardy, Herve. "Fifty Years of Black Star." *Photo District News* (Dec. 1985): 82, 84.

———. "GAMMA." *Zoom* 46 (Aug./Sept. 1977): 80–97.

———. "News Photography Goes Electronic." *Photo District News* 6 (Nov. 1986): 1, 32.

"Three Americans." *Life* (Sept. 20, 1943): 34, 35.

Townsend, George. "Still Taking Pictures." *New York World* (April 12, 1891): 26.

Trachtenberg, Alan. "Camera Work." *Photography: Current Perspectives*. Jerome Liebling, ed. The Massachusetts Review, Inc., 1978.

Traub, James. "A Wonderful Life." *American Photographer* 17 (Dec. 1986): 44–59.

Tsang, Kuo-Jen. "News Photos in *Time* and *Newsweek*." *Journalism Quarterly* 61 (Autumn 1984): 578–584.

Turnley, David. Interview with Marianne Fulton, July 7, 1987.

"Vietnam Inc." *Zoom* 25 (July 1974): 34–43.

"W. Eugene Smith." *Camera 35* 14 (April/May 1970): 37–42.

"W. Eugene Smith." *Zoom* 7 (May 1971): 64–65.

Waugh, William. "Wirephoto's Ninth Baby Is New California Net." *AP World* (Winter 1949–1950): 21.

Weiss, Philip. "Invasion of the Gannettoids." *City Newspaper* 16 (March 12, 1987): 5, 6.

Wheeler, H. D. "At the Front with Willie Hearst." *Harper's Weekly* (Oct. 9, 1915): 341.

Whelan, Richard. "Capa: The Man Behind the Myth." *American Photographer* 15 (Oct. 1985): 42–57.

Wilcox, Walter, "The Staged News Photograph and Professional Ethics." *Journalism Quarterly* 38 (Autumn 1961): 497–504.

"World Press Photo." *Zoom* 97 (April 1983): 68–73.

"World Press Photo 1980." *Zoom* 70 (April 1980): 30–47.

Wright, Jack. "The Story of Newspaper Photography." *American Annual of Photography* 56 (1942): 230–24.

Books

Ackerman, Carl William. *George Eastman*. Boston: Houghton Mifflin, 1930.

Alland, Alexander. *Jacob A. Riis: Photographer and Citizen*. Millerton, NY: Aperture, 1974.

———. *Jessie Tarbox Beals: First Woman News Photographer*. New York: Camera Graphic Press, 1978.

Appel, Alfred. *Signs of Life*. New York: Knopf, 1983.

Arlen, Michael J. *Living-Room War*. Harmondsworth, Middlesex, England: Penguin Books, 1982.

Barnard, George N. *Photographic Views of Sherman's Campaign.* New York: Dover, 1977.

"Black Dallas in the 1950's" (exhibition catalog). The R. C. Hickman Collection, Barker Texas History Center. Austin: University of Texas Press, 1987.

Bourke-White, Margaret. *Portrait of Myself.* New York: Simon and Schuster, 1963.

Brassaï. *The Secret Paris of the 30s.* New York: Pantheon Books, 1976.

Brown, Theodore M. *Margaret Bourke-White: Photojournalist.* Ithaca, NY: Andrew Dickson White Museum of Art, Cornell University, 1972.

Bull, Deborah, and Lorimer, Donald. *Up the Nile: A Photographic Excursion.* New York: C. N. Potter, 1979.

Caldwell, Erskine, and Bourke-White, Margaret. *You Have Seen Their Faces.* New York: Viking Press, 1937; and New York: Arno Press, 1975.

Caldwell, Genoa, ed. *The Man Who Photographed the World: Burton Holmes Travelogues 1892–1938.* New York: Abrams, 1977.

Campbell, Helen. *Darkness and Daylight.* Hartford: Worthington, 1892.

Capa, Cornell, ed. *The Concerned Photographer.* New York: Grossman, 1968.

————. *The Concerned Photographer,* Vol 2. New York: Grossman, 1972.

Capa, Cornell, and Whelan, Richard. *Robert Capa: Photographs.* New York: Knopf, 1985.

Capa, Robert. *Slightly Out of Focus.* New York: H. Holt, 1947.

Caputo, Philip. *Del Corso's Gallery.* New York: Dell, 1984.

Carlson, Oliver. *The Man Who Made News: James Gordon Bennett.* New York: Duell, Sloan and Pearce, 1942.

Carnes, Cecil. *Jimmy Hare, News Photographer.* New York: MacMillan, 1940.

Cartier-Bresson, Henri. *The Decisive Moment.* New York: Simon and Schuster, 1952.

————. *Henri Cartier-Bresson: Photographer.* Boston: New York Graphic Society, 1979.

————. *The World of Henri Cartier-Bresson.* New York: Viking Press, 1968.

Coe, Brian. *Cameras: From Daguerreotypes to Instant Pictures.* New York: Crown, 1978.

Coleman, A. D. *The Grotesque in Photography.* New York: Summit Books, 1977.

————. *Light Readings: A Photography Critic's Writings 1968–1978.* New York: Oxford University Press, 1979.

Cookman, Claude. *A Voice Is Born.* Durham, NC: National Press Photographers Association, 1985.

Cooper, Kent. *Kent Cooper and the Associated Press.* New York: Random House, 1959.

Costa, Joe. *Beginner's Guide to Color Photography.* New York: Greenberg, 1955.

————. *The Complete Book of Press Photography.* New York: National Press Photographers Association, 1950.

Costigan, Daniel. *The Principles and Practice of Facsimile Communication.* Philadelphia: Chilton, 1971.

Daguerre, Louis Jacques Mandé. *An Historical and Descriptive Account of the Various Processes of the Daguerreotype and the Diorama.* Paris: A. Giroux, 1839.

Daniel, Pete, and Smock, Raymond. *A Talent for Detail: The Photographs of Miss Frances Benjamin Johnston 1880–1910.* New York: Harmony Books, 1974.

Darrah, William C. *The World of Stereographs.* Gettysburg, PA: W. C. Darrah, 1977.

Davidson, Bruce. *Bruce Davidson Photographs.* New York: Agrinde Publications, 1979.

————. *East 100th Street.* Cambridge, MA: Harvard University Press, 1970.

————. *Subway.* New York: Aperture, 1986.

Dimbleby, Jonathon. *The Palestinians* [photographs by Don McCullin]. London: Quartet Books, 1980.

Downey, Fairfax Davis. *Richard Harding Davis: His Day.* New York: Charles Scribner's Sons, 1933.

Duncan, David Douglas. *This Is War!* New York: Harper, 1951.

————. *Yankee Nomad.* New York: Holt, Rinehart and Winston, 1966.

Earle, Edward W., ed. *Points of View: The Stereograph in America—A Cultural History.* Rochester, NY: Visual Studies Workshop, 1970.

Eco, Umberto. "A Photograph." In *Travels in Hyper Reality: Essays.* Translated by William Weaver. New York: Harcourt Brace Jovanovich, 1986.

Edey, Maitland. *Great Photographic Essays from "Life."* Boston: New York Graphic Society, 1978.

Edidin, Stephen Robert. "The Photographs of James Wallace Black" (exhibition catalog), Williamstown, MA: Williams College Museum of Art, 1977.

Eisenstaedt, Alfred. *Eisenstaedt on Eisenstaedt.* New York: Abbeville Press, 1985.

Elson, Robert T. *Time Inc: The Intimate History of a Publishing Enterprise, 1923–1941.* New York: Atheneum, 1968.

————. *The World of Time Inc: The Intimate History of a Publishing Enterprise, 1941–1960.* New York: Atheneum, 1973.

Evans, Harold. *Pictures on a Page.* New York: Holt, Rinehart and Winston, 1978.

Ezickson, A. J. *Get That Picture.* New York: National Library Press, 1938.

Fielding, Raymond. *The March of Time 1935–1951.* New York: Oxford University Press, 1978.

Forsee, Aylesa. *Famous Photographers.* Philadelphia: Macrae Smith, 1968.

————. *The Americans.* New York: Grossman, 1969.

Frank, Robert. *Les Américains.* Paris: Robert Delpire, 1958.

Frank, Robert. *The Lines of My Hand.* Lustrum Press, 1972.

Frassanito, Willliam A. *Antietam: The Photographic Legacy of America's Bloodiest Day.* New York: Scribner, 1978.

————. *Gettysburg: A Journey in Time.* New York: Scribner, 1975.

Freed, Leonard. *Police Work*. New York: Simon and Schuster, 1980.

Freedman, Jill. *Circus Days*. New York: Harmony Books, 1975.

_____. *Firehouse*. Garden City, NY: Doubleday, 1978.

_____. *Street Cops*. New York: Harper and Row, 1981.

Friedman, Thomas L. *War Torn*. New York: Pantheon Books, 1984.

Frost, John. *Pictorial History of Mexico and the Mexican War*. Richmond, VA: Harold and Murray, 1848.

Fussel, Paul. *The Great War and Modern Memory*. New York: Oxford University Press, 1975.

Galbraith, John Kenneth. *The Anatomy of Power*. Boston: Houghton Mifflin, 1985.

Gans, Herbert J. *Deciding What's News: A Study of CBS Evening News, NBC Nightly News, "Newsweek" and "Time."* New York: Vintage Books, 1980.

Gee, Helen. *Photography of the Fifties: An American Perspective*. Tucson, AZ: Center for Creative Photography, University of Arizona, 1980–1981.

Genthe, Arnold. *As I Remember*. New York: Reynal and Hitchcock, 1936.

Gernsheim, Helmut, and Gernsheim, Alison. *L. J. M. Daguerre*. Cleveland: World Pub. Co., 1956.

Gidal, Tim. *In the Forties*. London: Expression Printers, 1981.

_____. *In the Thirties: Photographs by Tim Gidal*. The Isador and Sarah Palevsky Design Pavilion, April–May 1975, The Israel Museum, No. 134.

_____. *Modern Photojournalism: Origin and Evolution, 1910–1933*. New York: Macmillan, 1973.

Goldberg, Vicki. *Margaret Bourke-White: A Biography*. New York: Harper and Row, 1986.

Goldberg, Vicki, ed. *Photography in Print: Writings from 1816 to the Present*. New York: Simon and Schuster, 1981.

Gould, Lewis L., and Greffe, Richard. *Photojournalist: The Career of Jimmy Hare*. Austin, TX: University of Texas Press, 1977.

Goulden, Joseph C. *Korea: The Untold Story of the War*. New York: McGraw-Hill, 1982.

Gramling, Oliver. *AP: The Story of News*. New York: Farrar and Rinehart, 1940.

Gribayedoff, Valerian. *The French Invasion of Ireland in '98*. New York: C. P. Somerby, 1890.

Griffiths, Philip Jones. *Vietnam Inc*. New York: Macmillan, 1971.

Grossfeld, Stan. *Eyes of the Globe*. Chester, CT: Globe Pequot Press, 1985.

_____. *Nantucket: The Other Season*. Chester, CT: Globe Pequot Press, 1982.

Grosvenor, Gilbert. *The National Geographic Society and Its Magazine*. Washington, DC: The Society, 1936.

Halberstam, David. *The Best and the Brightest*. New York: Penguin Books, 1986.

_____. *The Powers That Be*. New York: Dell, 1984.

_____. *The Reckoning*. New York: Morrow, 1986.

Hamblin, Dora Jane. *That Was the "Life."* New York: W. W. Norton, 1977.

Hardy, Bert. *Bert Hardy: Photojournalist*. Introduction by Tom Hopkinson. London: Gordon Fraser Gallery [for] the Arts Council of Great Britain, 1975.

Hare, James H., ed. *A Photographic Record of the Russo-Japanese War*. New York: Collier, 1905.

Harper's Pictorial History of the War with Spain. New York: Harper's, 1898.

Hartley, Craig Hilliard. *The Reaction of Photojournalists and the Public to Hypothetical Ethical Dilemmas Confronting Press Photographers*. Austin, TX: University of Texas Press, 1981.

Heartfield, John. *Photomontages of the Nazi Period*. Essay by Wieland Herzfelde, translated by Eva Bergoffen, all other translations from German by Nancy Reynolds. New York: Universe Books, 1977.

Hecht, Ben, and MacArthur, Charles. *The Front Page*. New York: Covici, Friede, 1928.

Hemment, John C. *Cannon and Camera*. New York: Appleton, 1898.

Heyman, Therese Thau. *Celebrating a Collection: The Work of Dorothea Lange*. Oakland, CA: Oakland Museum, 1978.

Hicks, Wilson. *Words and Pictures*. New York: Harper, 1952.

Hill, Paul, and Cooper, Thomas. *Dialogue with Photography*. New York: Farrar, Straus and Giroux, 1979.

Hills, Lee, and Sullivan, Timothy J. *Facsimile*. New York: McGraw-Hill, 1949.

Hine, Lewis Wickes. *America and Lewis Hine: Photographs 1904–1940*. [Exhibition] foreword by Walter Rosenblum, biographical notes by Naomi Rosenblum, essay by Alan Trachtenberg. New York: Aperture, 1977.

Hohenberg, John, ed. *The Pulitzer Prize Story*. New York: Columbia University Press, 1971.

Hopkinson, Tom, ed. and with an introduction by. *"Picture Post" 1938–1950*. Harmondsworth, Middlesex, England: Penguin, 1970.

Hopkinson, Tom, and editors of *Life*. *South Africa*. New York: Time Inc., 1964.

Hurn, David. *David Hurn, Photographs*. Introduction by Tom Hopkinson. London: Arts Council of Great Britain, 1979.

ICP Library of Photographers. *Lucien Aigner*. (New York: International Center of Photography, 1979).

Ives, Frederick. *The Autobiography of an Amateur Inventor*. Philadelphia: privately printed, 1928.

Jackson, Mason. *The Pictorial Press: Its Origin and Progress*. London: Hurst and Blackett, 1855.

Janis, Eugenia Parry, and MacNeil, Wendy. *Photography within the Humanities*. Danbury, NH: Addison House, 1977.

Johnson, Jill. *Soweto Speaks*. Photographs by Peter Magubane. London: Wildwood House, 1981.

Johnson, William S. *Aigner's Paris*. (Stockholm: Fotografiska Museet, 1982).

_____. *W. Eugene Smith: A Chronological Bibliography, 1934–1980*. Tucson, AZ: Center for Creative Photography, University of Arizona, 1980–1981.

293

Johnson, William S., ed. *W. Eugene Smith: Master of the Photographic Essay.* New York: Harper and Row, 1981.

Johnston, Frances Benjamin. *A Talent for Detail: The Photographs of Miss Frances Benjamin Johnston 1880–1910.* New York: Harmony Books, 1974.

Juergens, George. *Joseph Pulitzer and "The New York World."* Princeton, NJ: Princeton University Press, 1966.

Jussim, Estelle. *Frederic Remington: The Camera and the Old West.* Fort Worth, TX: Amon Carter Museum, 1983.

_____. *Visual Communication and the Graphic Arts: Photographic Technologies in the Nineteenth Century.* New York: R. R. Bowker, 1974.

Kahan, Robert S. *Antecedents of American Photojournalism.* Ph.D. diss., University of Wisconsin, 1969. Ann Arbor, MI: University Microfilms International, 1978.

Karnow, Stanley. *Vietnam: A History.* New York: Viking Press, 1983.

Kennan, George F. *Memoirs 1950–1963.* Boston: Atlantic Monthly Press, 1972.

Kessel, Dmitri. *On Assignment: Dmitri Kessel, Life Photographer.* New York: Abrams, 1985.

Kobler, John. *Luce: His Time, Life and Fortune.* New York: Doubleday, 1968.

Korn, Arthur. *Handbuch der Phototelegraphie und Telautographie.* Leipzig: O. Nemnich, 1911.

Lange, Dorothea, and Taylor, Paul Schuster. *An American Exodus.* New York: Reynal and Hitchcock, 1939.

Leekley, Sheryle, and Leekley, John. *Moments: The Pulitzer Prize Photographs Updated 1942–1982.* New York: Crown, 1982.

Lewinski, Jorge. *The Camera at War: A History of War Photography from 1848 to the Present Day.* New York: Simon and Schuster, 1980.

Life Editors. *Larry Burrows: Compassionate Photographer.* New York: Time-Life Books, 1972.

Lippmann, Walter. *Public Opinion.* New York: Harcourt, Brace, 1922.

Longford, Gerald. *The Richard Harding Davis Years: A Biography of Mother and Son.* New York: Holt, Rinehart and Winston, 1961.

Lorant, Stefan. *The Glorious Burden: The History of the Presidency and Presidential Elections from George Washington to James Earl Carter, Jr.* Lenox, MA: Author's Edition, Inc., 1976.

_____. *I Was Hitler's Prisoner.* Harmondsworth, Middlesex, England: Penguin, 1939.

_____. *Pittsburgh: The Story of an American City,* 3rd edition. Lenox, MA: Author's Edition, Inc., 1980.

_____. *Sieg Heil! An Illustrated History of Germany from Bismarck to Hitler.* New York: Bonanza Books, 1979.

Lynch, Dorothea. *50 Hours.* Long Island City, NY: Many Voices Press, 1983.

Lynch, Dorothea, and Richards, Eugene. *Exploding into Life.* New York: Aperture/Many Voices Press, 1986.

Mabee, Carleton. *The American Leonardo: A Life of Samuel F. B. Morse.* New York: Knopf, 1943.

Macarole, Dorothy. *Children of Europe.* London: Gollancz, 1949.

McCombe, Leonard. *You Are My Love.* New York: Sloane, 1952.

McCullin, Don. *Beirut: A City in Crisis.* London: New English Library, 1983.

_____. *Hearts of Darkness.* London: Secker and Warburg, 1980.

_____. *Homecoming.* London: MacMillan, 1979.

_____. *Is Anyone Taking Notice?* Cambridge, MA: MIT Press, 1973.

MacLeish, Archibald. *Land of the Free.* New York: Harcourt, Brace, 1938.

Maddow, Ben. *Let the Truth Be the Prejudice.* New York: Aperture, 1985.

Magubane, Peter. *Black Child.* New York: Knopf, 1982.

Man, Felix H. *Man with Camera.* New York: Schocken Books, 1984.

Mandela, Zindzi, and Magubane, Peter. *Black As I Am.* Los Angeles: Guild of Tutors Press, 1973.

Martin, Marcus J. *Wireless Transmission of Photographs.* London: The Wireless Press Ltd., 1916.

Martin, Rupert, ed. *Floods of Light: Flash Photography 1851–1981.* London: The Photographer's Gallery, 1982.

Marzolf, Marion. *Up from the Footnote: A History of Women Journalists.* New York: Hastings House, 1977.

Mattison, Harry; Meiselas, Susan; Rubenstein, Fae, eds. *El Salvadore: Work of Thirty Photographers.* Text by Carolyn Forche. New York: Writers and Readers Publisher Cooperative, 1983.

Meiselas, Susan. *Carnival Strippers.* New York: Pantheon, 1976.

_____. *Nicaragua: June 1978–July 1979.* New York: Pantheon, 1981.

Morris, Aldon D. *The Origin of the Civil Rights Movement.* New York: The Free Press, 1984.

Mott, Frank. *American Journalism: A History of Newspapers in the United States Through 250 Years 1640–1940.* New York: MacMillan, 1956.

_____. *A History of American Magazines.* Cambridge: Harvard University Press, 1957.

Museum of Modern Art. *Brassaï.* Greenwich, CT: New York Graphic Society, 1968.

Mydans, Carl. *More than Meets the Eye.* New York: Harper, 1959.

Mydans, Carl, and Mydans, Shelly. *The Violent Peace.* New York: Atheneum, 1968.

Mydans, Kunhardt. *Carl Mydans: Photojournalist.* New York: Harry N. Abrams, 1985.

Nasib, Selim. *Beirut: Frontline Story.* Photographs by Christopher Steele-Perkins. London: Pluto, 1983.

Newhall, Beaumont. *The Daguerreotype in America.* New York: Duell, Sloan and Pearce, 1961; New York: Dover, 1976.

Ohrn, Karen Becker. *Dorothea Lange and the Documentary Tradition.* Baton Rouge: Louisiana State University Press, 1980.

Palmer, R. R., and Cotton, Joel. *A History of the Modern World.* New York: Knopf, 1978.

Peress, Gilles. *Telex Iran.* Millerton, NY: Aperture, 1983.

_____. *Telex Persan.* Paris: Contrejour, 1984.

Phillips, Christopher. *Steichen at War.* New York: Harry N. Abrams, 1981.

Phillips, John. *It Happened in Our Lifetime: A Memoir in Words and Pictures*. Boston: Little, Brown, 1985.

———. *A Will to Survive*. New York: Dial Press, 1977.

Phillips, Sandra S; Travis, David; and Naef, Weston J. *André Kertész Of Paris and New York*. New York: Thames and Hudson, 1985.

Price, Jack. *News Photography*. New York: Industries Publishing Co., 1932.

Rhodes, Richard. *The Making of the Atomic Bomb*. New York: Simon and Schuster, 1986.

Riboud, Marc. *Face of North Vietnam*. New York: Holt, Rinehart and Winston, 1970.

Richards, Eugene. *Below the Line: Living Poor in America*. Mount Vernon, NY: Consumers Union, 1987.

———. *Dorchester Days*. Wollaston, MA: Many Voices Press, 1978.

———. *Few Comforts or Surprises: The Arkansas Delta*. Cambridge, MA: MIT Press, 1973.

Riis, Jacob August. *How the Other Half Lives*. New York: Charles Scribner's Sons, 1919.

———. *The Making of an American*. New York: MacMillan, 1940.

Rosenblum, Naomi. *A World History of Photography*. New York: Abbeville Press, 1984.

"Rosenthal, Joe." *Current Biography*. Bronx, NY: H. H. Wilson, 1945, pp. 515–518.

Said, Edward W. *Covering Islam*. New York: Pantheon Books, 1981.

Salgado, Sebastiao. *Other Americas*. New York: Pantheon Books, 1986.

———. *Sahel: L'Homme en détresse*. Paris: Prisma Press, 1986.

Salomon, Erich. *Erich Salomon*. Millerton, NY: Aperture, 1978.

———. *Portrait of an Age*. New York: Collier Books, 1975.

Schriever, J. B. *Commercial, Press, Scientific Photography*. Scranton, PA: American School of Art and Photography, 1909.

Schulke, Flip, and McPhee, Penelope Ortner. *King Remembered*. New York: W. W. Norton, 1986.

Shawcross, William. *Nam*. New York: Knopf, 1983.

Shikes, Ralph E. *The Artist as Social Critic in Prints and Drawings from the Fifteenth Century to Picasso*. Boston: Beacon Press, 1969.

Sipley, Louis Walton. *Photography's Great Inventors*. Philadelphia: American Museum of Photography, 1965.

Smith, W. Eugene. *W. Eugene Smith: Minamata: Life—Sacred and Profane*. Tokyo: Soju-sha Publishing Co., 1973.

Smith, W. Eugene, and Smith, Aileen M. *Minamata*. New York: Holt, Rinehart and Winston, 1975.

Snijders, M. L. *Joden van Amsterdam*. Amsterdam: Bij, 1958.

Sobieszek, Robert A. *Masterpieces of Photography from the George Eastman House Collections*. New York: Abbeville Press, 1985.

Sontag, Susan. *On Photography*. New York: Farrar, Straus and Giroux, 1977.

Steele-Perkins, Christopher, and Smith, Richard. *The Teds*. London: Travelling Light/Exit, 1979.

Steffens, Lincoln. *The Autobiography of Lincoln Steffens*. New York: Harcourt, Brace, 1931.

Steichen, Edward. *A Life in Photography*. Garden City, NY: Doubleday, 1963.

Stewart, Kenneth, and Tebbel, John. *Makers of Modern Journalism*. New York: Prentice-Hall, 1952.

Szarkowski, John, ed. *From the Picture Press*. New York: Museum of Modern Art, 1973.

Taft, Robert. *Photography and the American Scene: A Social History 1839–1889*. New York: MacMillan, 1938.

Talese, Gay. *The Kingdom and the Power*. New York: World Pub. Co., 1969.

Taylor, G. Herbert. *My Best Photograph and Why*. New York: Dodge Publishing Company, 1937.

Tebbel, John. *The American Magazine*. New York: Hawthorn Books, 1969.

Terkel, Studs. *"The Good War."* New York: Pantheon Books, 1984.

"Three Centuries of American Art" (exhibition catalog). Philadelphia: Philadelphia Museum of Art, 1976.

Time Inc. editors. *Four Hours a Year*. New York: Time Inc., 1936.

Tolstoy, Leo. *War and Peace*. New York: Modern Library, n.d.

Trachtenberg, Alan. *America and Lewis Hine*. New York: Aperture, 1977.

Tuchman, Gaye. *Making News: A Study in the Construction of Reality*. New York: The Free Press, 1980.

Ullstein, Hermann. *The Rise and Fall of the House of Ullstein*. New York: Simon and Schuster, 1943.

Vermazen, Susan, ed. *War Torn*. Introduction by Thomas L. Friedman. New York: Pantheon Books, 1984.

Wainwright, Loudon. *The Great American Magazine*. New York: Knopf, 1986.

Walsh, George; Naylor, Colin; Held, Michael, eds. *Contemporary Photographers*. New York: St. Martin's Press, 1982.

Weegee [pseud. Arthur Fellig]. *Naked City*. New York: DaCapo Press, 1975.

———. *Weegee*. Millerton, NY: Aperture, 1978.

———. *Weegee by Weegee*. New York: DaCapo Press, 1975.

Weimar, Wilhelm. *Die Daguerreotypie in Hamburg 1839–1860*. Facsimile by Sobieszek, Robert, ed., *The Daguerreotype in Germany*. New York: Arno Press, 1979.

Wentzel, Volkmar. *Memories in Black and White: Images of the World—Photography at the National Geographic Society*. Washington: National Geographic Society, 1981.

Whelan, Richard. *Robert Capa: A Biography*. New York: Knopf, 1985.

Williams, Juan. *Eyes on the Prize*. New York: Viking Press, 1987.

Wood, James Playsted. *Magazines in the United States*. New York: The Ronald Press, 1971.

Compiled by Nancy Levin, these are short biographies of most people discussed in the text, including photographers, inventors, writers, and photo editors. Significant photojournalism awards are also described.

Abbreviations Used in This Section

AP Associated Press
ASMP American Society of Magazine Photographers
ICP International Center of Photography
NPPA National Press Photographers Association
OPC Overseas Press Club
UPI United Press International

Edward T. Adams *(American, b. 1934)* Won 1969 Pulitzer Prize, while covering Vietnam war for AP, for shocking photograph of Brig. Gen. Ngoc Loan firing bullet into Vietcong prisoner's head, one of most significant images to come out of the long war. Career began at *New Kensington* [Pennsylvania] *Dispatch.* Marine combat photographer, Korean war. Worked on Michigan and Philadelphia newspapers before joining AP (1962). In 1973 joined *Time* magazine staff, where he remained until rejoining AP, becoming their first special correspondent (1977). Founding member of Contact Press Images (1976); affiliated until 1981. Now works on commercial assignments while covering stories as contract photographer for *Parade* and *Time.*

Lucien Aigner *(American, b. Hungary, 1901)* Studied theater and acting in Berlin, assistant cameraman to Stefan Lorant (1921–1922). Law degree, University of Budapest, reporter for *Az Est* (1924). Became photographer, manager for photographer James Abbe, Paris (1926–1928). Paris correspondent, bureau chief for *Az Est,* Paris (1927–1939). Contributed to British, German, French magazines (1928–1939). Under contract for *Life,* Paris (1939). Moved to U.S., worked as freelancer. Announcer for and director of Voice of America (1947–1953). Operated portrait studio (1954–1976). Traveled, studied photography, made films, lectured, and exhibited work (1956–present). Awarded grants, National Endowment for the Arts (1975, 1977). See ICP's *Lucien Aigner,* J. P. Aigner, editor (1979), and W. Johnson's *Aigner's Paris* (1982).

American Society of Magazine Photographers (ASMP) Awards Established in 1953. Supported by grants from Eastman Kodak and Nikon. Nine categories include Philippe Halsman Award for Photojournalism, Emerging Talent Award, and Ansel Adams Book Award. Prizes also awarded in advertising, corporate, and creative photography, editing, art direction, invention, and manufacturing. Nominations must be made by general members of ASMP in good standing. Jury consists of distinguished ASMP members from the U.S.

Noah Steiner Amstutz *(American, active 1880s–1910)* Mechanical and electrical engineer, Amstutz was one of first to send halftone picture over wire successfully, in May 1891. Invented Akrograph (patented 1896), machine for automatically producing relief engravings directly from gelatin relief photographic print. Brought legal suit (1928) against American Telephone and Telegraph, claiming that company had infringed upon his 1911 and 1912 patents for transmitting photographs by wire.

Member of Royal Photographic Society and Society of Arts in London, associate member of American Institute of Electrical Engineers, and worked in research department of Inland Printer.

Frederick Scott Archer *(British, 1813–1857)* Inventor of wet collodion process (1851), allowing photographers to make high-quality glass-plate negatives from which many photographs of same image could be printed. Born in Bishop Stortford, England, apprenticed to London silversmith, became sculptor. Began photographing around 1847. First used new wet-plate process in making views of town of Kenilworth, now in collection of Royal Photographic Society.

James Francis Jewell Archibald *(American, 1871–unknown)* War correspondent. Covered almost every major military action, 1890–1915, in China, Cuba, the Sudan, South Africa, and Venezuela. With Russian army in Russo-Japanese War for *Collier's Weekly,* went on to Morocco, Albania, Lisbon, and China again. Detained in 1915 by British government, while traveling from U.S. to Europe, for allegedly carrying dispatches to enemy governments of Austria and Germany. Released September 1915, but dispatches confiscated. Wrote novels and plays about his army experiences.

José Azel *(American, b. Cuba 1953)* Contact Press Images photographer since 1982, known for photographs of the visit of Pope John Paul II to Central America (1983) and of Olympic athletes (1984) for which he won awards from World Press Photo Foundation. Studied literature and journalism. Joined staff of *Miami Herald* (1977–1981). Worked in New Zealand, Brazil, Alaska, and Kenya, pursuing "broad geographic reportage." See *Camera International,* spring 1987, for photographs and more information.

Alexander Bain *(Scottish, active 1840s)*, **Frederick Bakewell** *(British, active 1850s)* Physicist Bain called "father of facsimile" because his electromechanical recording telegraph (1842) established basic elements of present-day facsimile equipment. Used pendulum attached to electrical wire circuit to mark paper, producing exclusively black marks with no gradation in tone. Received British Patent 9745 for his "electrochemical recording telegraph" (1843). In 1850, Bakewell demonstrated early "cylinder and screw" facsimile that eventually replaced Bain's system and formed basis for most present-day facsimile systems. For more information, see *Facsimile,* by Hills and Sullivan (1949), and *Fax: The Principles and Practice of Facsimile Communication,* by Costigan (1971).

Micha Bar-Am *(Israeli, b. Germany, 1930)* Middle East correspondent for *New York Times* since 1974 and acting curator for photography at Tel Aviv Museum. In 1936 family moved from Germany to Palestine. Served in underground army during 1948 War for Independence. After photographing Dead Sea Scrolls archaeological expedition, joined staff of Israeli Army newspaper *Bamahane* (1956–1967). Selected by government to document Adolf Eichmann trial (1961). Met Magnum photographer Cornell Capa and together covered Six-Day War (1967) and jointly continue to work on books and exhibitions. Associate member Magnum (1967). Worked regularly for *New York Times* since 1968. Earned 1985 Neiman Foundation Fellowship in photo-

journalism and taught at Harvard University. See article on Bar-Am in Smith's "Images of Israel," *New York Times Magazine,* October 31, 1982.

George N. Barker *(American, d. 1894)* "The eminent photographer of Niagara Falls." Worked as Daguerrean photographer until closing his studio in 1865. Also known for photographs of western big-game expeditions. Underwood & Underwood published his stereograph sets on the Iroquois and Onondaga Indians, Centennial Exposition of 1876, and Johnstown flood.

Oskar Barnack *(German, 1879–1936)* Designed prototype of 35mm camera, the Ur-Leica, or Original Leica (1913), distributed to public in 1925. Small size, metal body, and use of cinematographic film were innovations. For more information on 35mm cameras and on Leica design, see Coe's *Cameras: From Daguerreotypes to Instant. Pictures* (1978), and for more information about Barnack see L.W. Sipley's *Photography's Great Inventors* (1965) and the *ICP Encyclopedia of Photography* (1984).

George N. Barnard *(American, 1819–1902)* Daguerreotypes of burning mills at Oswego, New York (1853), widely reproduced in newspapers as engravings. Worked for Mathew Brady, Alexander Gardner, and a Mississippi military division. Photographs that were published in *Gardner's Photographic Sketch Book of the War* (1866), *Harper's Weekly,* and his own book, *Photographic Views of Sherman's Campaign* (1866), became well-known images of battlefields, military machinery, and terrible devastation of southern states during Civil War. Long career in photography is described in *Photographic Views of Sherman's Campaign,* with new preface by Beaumont Newhall (1977).

Harry Guy Bartholomew *(British, 1885–1962),* **Maynard Deedes MacFarlane** *(American, b. England 1895)* Together created Bartlane system of photographic transmission and sent first photograph over Atlantic Ocean using Western Union transatlantic cable (1920). Bartholomew joined London *Daily Mirror* (1904) as reporter and art director. As chairman (1944–1951) introduced comic strips and bold headlines, changed format from broadsheet to tabloid. MacFarlane, former Royal Air Force captain, worked on Bartlane system in England (1920–1923). He was manager of Bartlane department of News Syndicate Company, New York (1924–1935), and chief engineer of Record-O-Tone, Inc., followed by four years at his own laboratory. Worked on atomic energy during World War II.

Letizia Battaglia *(Italian, b. 1935)* Since 1969, working with Palermo newspaper *L'Ora,* first as journalist then as photographer. Cofounder of Guiseppe Impastato center documenting mafia brutality and the poverty of the Sicilian people. Photographs published worldwide, including May 18, 1986, *New York Times Magazine* story "Sicily and the Mafia," with Franco Zecchin. Since 1975 worked with Zecchin through their own news service and gallery. Shared 1985 W. Eugene Smith Grant in Humanistic Photography with Donna Ferrato. Editor of *Il Laboratorio D'If* and *Fotografia.*

J. Ross Baughman *(American, b. 1953)* Cofounder of New York agency Visions Photo Group, known for obtaining stories by becoming completely identified with subjects. Employed this method to create in-depth photo essays on a local Nazi group, the Ku Klux Klan, and a transvestite bar while attending Kent State University and working for *Lorain* [Ohio] *Journal.* In covering Rhodesian civil war for AP (1977), rode with Grey Scout cavalry unit documenting its cruel treatment of black prisoners and earning 1978 Pulitzer Prize in feature photography. Left AP and founded Visions, July 1978, with Mark Greenberg, former editor at AP. Visions specializes in investigative "high risk" feature stories, requiring long-term support from publishers. Baughman photos published in *Life, Der Stern, Paris Match,* and *Newsweek.*

Jessie Tarbox Beals *(American, b. Canada, 1870–1942)* One of America's first female press photographers. As schoolteacher pursued photographic portrait business during summers. Taught husband to photograph and together they became itinerant photographers (1900). Traveled U.S., then she joined staff of *Buffalo Inquirer* (1902). At *Inquirer* scooped nation with exclusive of famous murder trial. Only woman with full press credentials at 1904 St. Louis World's Fair. Moved to New York City. Published in *New York Herald, Harper's Bazaar, Town and Country, Vogue.* At age fifty-six moved to California and photographed estates. Later returned to New York. See Alland's *Jessie Tarbox Beals: First Woman News Photographer* (1978).

Edouard Bélin *(French, 1876–1963)* Invented Belinograph wire service (1914). Studied in Vienna. Worked in Paris photographic studios. Demonstrated 1907 patent by sending photographs by wire from Paris to Lyons to Bordeaux to Paris in twenty-two minutes on January 22, 1908. Sent photo across Atlantic to Annapolis, Maryland, on August 5, 1921. Major innovation was use of photoelectric cell on transmitter (1926). Also invented Krypto-Belinograph to preserve secrecy of radio and telegraphic messages. Bélin's story is included in Sipley's *Photography's Great Inventors* (1965).

James Gordon Bennett *(American, b. Scotland, 1795–1872)* Founder and editor of *New York Herald* (1835). Established first international network of correspondents by sending crew of reporters to Europe (1838). During Civil War maintained staff of sixty-three war correspondents; leader in use of illustrations. Came to U.S. 1819, worked on a number of newspapers before founding *Herald.* Biographies include *The Man Who Made News: James Gordon Bennett* by O. Carlson (1942) and *Makers of Modern Journalism* by K. N. Stewart and J. Tebbel (1952).

James Wallace Black *(American, 1825–1896)* Made stereographs of fire that destroyed most of Boston's business district (1872), printed as wood engravings in newspapers and magazines throughout the country. Forty-four of over 150 views were also published as *Ruins of the Great Fire in Boston, November 1872.* Born in New Hampshire, went to Boston in late 1840s hoping to become a painter. In 1853 listed in directories as daguerreotypist but by 1869 large part of business became making, distributing, and

presenting lantern slides. See Edidin's *The Photographs of James Wallace Black,* exhibition catalog from Williams College Museum of Art, 1977.

Walter Bosshard *(Swiss, 1892–1975)* Photographed in India, the Orient, America, the Balkans, and Africa during his long career. Studied art history and education in school before joining an expedition to India with German photographer (1929). For *München Illustrierte Presse* remained in India the following year, then covered China and Mongolia and Arctic flight of *Graf Zeppelin* during next two years. From 1939 worked under exclusive contract with *Neue Zürcher Zeitung* photographing the war and the founding of the United Nations (1945). Lived in China (1946–1949) and covered Korean war until injured (1953). Since 1961 lived in Spain. Between 1950 and 1962 Bosshard wrote/photographed at least eight books. Biography can be found in T. Gidal's *Modern Photojournalism: Origin and Evolution 1910–1933* (1973).

Margaret Bourke-White *(American, 1904–1971)* One of America's best-known photographers. *Life* magazine staffer from its inception, provided first cover photo and story. Studied photography under Clarence White (1920), began career as architectural and industrial photographer, Cleveland (1927). Premier photographer for Henry Luce's new *Fortune* magazine (1929). In 1936 joined staff of *Life,* remained for thirty years. First female official photographer for U.S. Air Force, covering World War II (1942–1945). With her husband, writer Erskine Caldwell, published *You Have Seen Their Faces* (1937). Wrote other books, including autobiography, *Portrait of Myself* (1963). Stricken with Parkinson's disease, forced to retire from photography (1959). See *The Photographs of Margaret Bourke-White* (1972) and biographies by Theodore M. Brown and Vicki Goldberg.

Mathew B. Brady *(American, 1823–1896)* Employed teams of photographers to document American Civil War; also known for portraits published as *The Gallery of Illustrious Americans* (1866). Learned photography from Samuel F. B. Morse and J. W. Draper, New York City, before opening first portrait studio (1844). Brady's staff, including Tim O'Sullivan and Alexander Gardner, amassed collection of more than 7,000 negatives before 1863, from which war photographs were printed and sold in sets and bound volumes. Surviving glass-plate negatives stored at National Archives, Washington, D.C.

Brassaï *(French, b. Gyula Halász, Hungary, 1899–1984)* Served in Austro-Hungarian Army (1917–1918). Studied art in Budapest and Berlin (1918–1922). Moved to Paris, worked as painter, sculptor, and journalist (1924–1930). Changed name to Brassaï (1925). Kertész introduced him to photography (1926). Freelance photographer of street life, cafés, and artists published in *Le Minotaure, Verve, Harper's Bazaar* (1930–1940). Published *Paris at Night* (1933). Worked for *Picture Post, Lilliput, Coronet, Labyrinthe,* and other publications (1936–1963). Worked in Picasso studio photographing and sketching (1940–1945); resulted in book *Conversations with Picasso.* Designed for ballet, worked in film, continued to photograph until death. See his book *The Secret Paris of the 30s* (1976) or Museum of Modern Art monograph *Brassaï,* with text by L. Durrell (1968).

Hal Buell *(American, b. 1931)* Assistant General Manager of Newsphotos at Associated Press. Studied journalism at Northwestern University. Worked for *Stars and Stripes* during military service in Japan (1954–1956). Joined AP's Chicago bureau on general assignment (1956). Moved to AP home office, New York (1957). In 1959 named Asia photo editor and assigned to Tokyo. Returned to New York (1963). Head of entire AP picture operation since 1977 in present position. Named Editor of the Year (1972) by the NPPA and received the organization's highest honor, the Joseph A. Sprague Memorial Award (1981). Also author of five children's books on Southeast Asia.

Earle L. Bunker *(American, 1913–1975)* Staff photographer *Omaha* [Nebraska] *World Herald* (1938–1975). Won 1944 Pulitzer Prize for photograph of reunion of World War II battalion leader with his wife and child at an Iowa airport. "Homecoming" reproduced in *Life, Newsweek,* and Red Cross publication. Joined *Omaha Bee-News* (1929), worked there eight years before moving to *Omaha World Herald.*

David Burnett *(American, b. 1946)* Cofounder and member of Contact Press Images (1976). Holds many of photojournalism's highest awards. Career began when supplied feature, news, and sports photographs to local newspapers while high school student in Salt Lake City. Continued to freelance while attending Colorado College, majoring in political science. Summer internship with *Time* magazine led to job at *Time*'s Caribbean bureau in Miami upon graduation (1968). In Vietnam (1970–1972) covered stories for *Time, Life,* and *New York Times.* Contract photographer for *Life* (1970–1972). Joined French-based agency Gamma (1973). For story on coup d'etat in Chile (1973) shared Robert Capa Gold Medal with Raymond Depardon and Chas Gerretsen. Has photographed Iranian revolution, Cambodian refugees, and 1984 Summer Olympics, among hundreds of assignments.

Henry Frank Leslie "Larry" Burrows *(British, 1926–1971)* Covered Vietnam war for *Time* and *Life* for nine years, creating many powerful photo essays, including famous story on bloody mission of marine helicopter *Yankee Papa 13.* Defied label of war photographer. Proved expertise as *Life*'s chief color copyist of fine art. Began work in *Life* labs, London, at age sixteen. Did alternative military service in Yorkshire coal mines (1943). In 1945 returned to *Life,* covering local stories and copying art. First war coverage in British invasion of Egypt (1956), then drawn to conflicts in the Congo and Vietnam. Died in crash of South Vietnamese Air Force helicopter over Laos, February 1971. For detailed biography see *Larry Burrows: Compassionate Photographer,* introduction by R. Graves (1972).

Cornell Capa *(American, b. Kornell Friedmann, Hungary, 1918)* Executive director of International Center of Photography. Award-winning photojournalist, author, editor, and filmmaker. Became photographic printer in Paris (1936), joining his brother, Robert Capa, following his lead and changing his name. Immigrated to U.S. (1937). Member of PIX photo agency and printer for *Life* magazine (1937–1941). Served in Air Force Photo Intelligence (1945). Upon return from war, became staff photographer at *Life* (1948–1954). Documented American politics; also specialized in coverage of Latin America. Brother, Robert, died in Indo-

china. Cornell became a member of Magnum (1954). After deaths of David Seymour, Werner Bischof, and his own brother, Robert, Capa created the International Fund for Concerned Photography, Inc. (1966). Transferred to permanent home, International Center of Photography in New York, in 1974. Author of *The Concerned Photographer,* vols. 1 and 2, and many other books.

Robert Capa *(American, b. André Friedmann, Hungary, 1913–1954)* War photographer and cofounder of Magnum agency. First story published in *Berliner Illustrirte Zeitung* (1931). Became Berlin correspondent for Dephot agency, then moved to Paris (1933). In Paris, with girlfriend, Gerta Taro, created persona of great American photographer, Robert Capa, under whose name they sold prints. Soon assumed this identity and changed name to Capa. Immigrated to U.S. (1939). During career covered wars in Spain, China, Israel, Europe, and Indochina, publishing stories in *Vu, Picture Post, Life, Collier's,* and *Holiday* magazines, among others. Founded Magnum in 1947 and served as president from 1948 until his death. In 1954, on assignment for *Life* in Indochina, Capa was killed by a landmine—the first photographer to die in what would become the Vietnam war. Memorials included establishment of the Robert Capa Gold Medal by the Overseas Press Club of America and *Life,* and the International Fund for Concerned Photography, Inc. Books by Capa include autobiography, *Slightly Out of Focus* (1947). For complete biography and list of publications, see Whelan's *Robert Capa: A Biography* (1985).

Gilles Caron *(French, 1939–1970)* Imprisoned for refusing to fight in Algerian War (1965), then bought Pentax and joined Agence APIS. Covered celebrities and features (1965–1967) before joining Gamma under Raymond Depardon, just months after it was founded (1967). Propelled Gamma into realm of international photojournalism with stories including Israeli Six-Day War, war and famine in Biafra, riots in Paris and Mexico, invasion of Czechoslovakia, and fighting in Northern Ireland (1967–1968). Died in Cambodia in 1970. For more information on Caron, see *Zoom,* No. 2, 1970, and *Gilles Caron: Reporter 1967–1970* by Depardon (1978).

Peter J. Carroll *(American, 1911–1966)* AP photographer and World War II correspondent. Covered the war from D-Day to surrender of Nazi Germany in 1945. Photo of U.S. troops marching under the Arch of Triumph in Paris was used on three-cent postage stamp.

Henri Cartier-Bresson *(French, b. 1908)* Cofounder of Magnum photographic cooperative agency. Has long been associated with pursuit of a single photograph that exists for its own sake and captures a "decisive moment." Work has appeared in *Life, Harper's Bazaar, Vu,* and other widely circulated magazines. Legacy is generation of photographers inspired to join in his pursuit. Studied under Cubist master André Lhote. Photography career began in 1931 when he purchased new Leica and was first published in *Vu* magazine. In 1930s studied cinema with Paul Strand and Jean Renoir, creating documentary about Spanish war hospitals (1937). Was taken prisoner when France fell to Germans in 1940. Escaping three years later, joined photographic unit of the French underground. With Robert Capa, David Seymour, George Rodger, and William Vandivert founded Magnum. In next two

decades earned many awards for excellent reportage on death of Gandhi and stories on U.S.S.R., China, and Cuba. In 1966 left Magnum to pursue personal projects, including two documentaries for CBS television. His books include *The Decisive Moment* (1952), *The World of Henri Cartier-Bresson* (1968), *Henri Cartier-Bresson: Photographer* (1979).

Al Chang *(American, b. Hawaii, 1925)* U.S. Army combat photographer for twenty years before retiring with rank of master sergeant (1965). Joined AP (1965). Two months later was wounded in the head while covering fighting between U.S. paratroopers and Vietcong near Saigon. After bullet removed from over left eye, Chang returned to photograph rest of fight. Also wounded in chest (1966). Awarded Purple Heart (1966).

William Wisner Chapin *(American, 1857–1928)* One of earliest photographers to have color reproductions published in national magazine, "Glimpses of Korea and China," *National Geographic* (1910). A wealthy banker from Rochester, New York, he pursued photography and travel in his spare time. While vacationing in Asia made autochrome photographs for *National Geographic* (1909), later wrote accompanying article. In 1912 represented National Geographic Society on another trip to Asia.

Howard Chapnick *(American, b. 1923)* President of Black Star photo agency, author of monthly column "Profiles" in *Popular Photography.* Influential editor, contest judge, and teacher in international photojournalism. Active member W. Eugene Smith Memorial Foundation, Inc., Board of Trustees. Began at Black Star as messenger boy while studying accounting at New York University (1941). Graduated, joined staff (1942). Assumed present position after retirement of Black Star founders (1964). NPPA presented Chapnick with the Joseph A. Sprague Memorial Award, citing leadership in photo coverage of civil rights in 1960s, as a publisher of photo books, "and for donating countless hours to groups, individuals and through seminars at the Missouri Workshop."

Edward Clark *(American, b. 1911)* Began work at *Nashville Tennessean* at age eighteen, having accident with flash powder explosion in first week on job. Sold photos to publications in U.S., England, Denmark, and Holland while working on this newspaper. Photographs of World War I hero Sgt. Alvin York signing up for "Old Man's Draft" in World War II ran in *Life* in 1942. Joined *Life* staff (1943). Based in Nashville, Paris, Los Angeles, and Washington. Photographed daily life in Soviet Union (1956).

Allan Douglass Coleman *(American, b. 1943)* Freelance media critic, lecturer, and teacher. Author of *The Grotesque in Photography* (1977) and *Light Readings: A Photography Critic's Writings, 1968–1978.* On editorial board of *Lens on Campus,* writes column "Light Readings." Formerly critic with *Village Voice, New York Times,* and *Camera 35.* As vice-president of Photography Media Institute, Inc., New York–based nonprofit organization, co-authored guide to audio-visual programming for photographic education. Founded *Views: A New England Journal of Photography* (1979); today is editor emeritus. Received Art Critics' Fellowship from National Endowment for the Arts (1975), first ever awarded to writer on photography, for study of grotesque in photography.

Kent Cooper *(American, 1880–1965)* General manager of AP (1925–1948), changed modern journalism by setting up network for wire transmission of photographs. Began career with his own news service serving eighteen Indiana newspapers, using telephone to call in stories (1905). Joined United Press (1907) and Associated Press (1910). Created AP Wirephoto (1935). Created AP Feature department and Washington and Hollywood bureaus. Coined phrase "the right to know." In advisory capacity, influential in establishing modern news system in Japan after World War II. See autobiography, *Kent Cooper and the Associated Press* (1958).

Joseph Costa *(American, b. Italy, 1904)* Founder and first president of National Press Photographers Association, chairman of the board (1948–1964), and editor of NPPA magazine, *News Photographer* (1946–1967), now editor emeritus. Won many honors in photojournalism education. Faculty of Famous Photographers School and visiting lecturer at universities. Staff photographer for *New York Morning World* (1920–1927) and *New York News* (1927–1946). While photo supervisor at King Features Syndicate also chief photographer for *Sunday Mirror Magazine* (1946–1963). Illustrations editor of World Book Encyclopedia Science Service, Inc., Houston (1967–1969). Edited *The Complete Book of Press Photography* (1950) and wrote *Beginner's Guide to Color Photography* (1955.) See Cookman's *A Voice Is Born* (1985).

Kenyon Cox *(American, 1856–1919)* Academic artist who studied painting in Paris with Carolus Duran and Gêrome, 1877–1882. Also known for his vehement critical articles against modern art, particularly that in the Armory show. Taught at Art Students League.

Leon Daniel *(American, b. Rumania, d. 1974)* Cofounder of PIX, Inc., photo agency with Alfred Eisenstaedt (1933). Remained with agency until it was dissolved upon his retirement (1969). Worked in AP's Berlin bureau before rise of Nazis forced him to immigrate to U.S. (1933).

Bruce Davidson *(American, b. 1933)* Attended Rochester Institute of Technology (1951–1954) and Yale University (1955). Military service in U.S. Army (1955–1957). *Life* magazine photographer (1957). Joined Magnum and worked as freelance photographer (1958). Published in *Life, Réalités, DU, Esquire, Queen, Look, Vogue.* Received Guggenheim Fellowship to document civil rights movement (1962). Documented one city block over period of two years (1966–1968), funded by National Endowment for the Arts grant; resulted in book *East 100th Street.* Made films *Living Off the Land* (1970) and *Isaac Singer's Nightmare* (1973). Photographed color series on New York subways (1980–1982). See *Bruce Davidson Photographs*, introduction by Henry Geldzahler (1979).

Richard Harding Davis *(American, 1864–1916)* Served on Philadelphia newspapers (1886–1889) before joining *New York Sun* (1889–1893). Managing Editor *Harper's Weekly*, splitting duties between deskwork in New York and reporting of world events (1893–1896). Hired by Hearst to cover Cuban war for *New York Journal* with illustrator Frederic Remington (1896). Infuriated because one Remington illustration totally sensationalized a report, Davis left Hearst and went over to Pulitzer's *Herald* (1897–1900). Worked for London *Times, Daily Mail, Collier's, Scribner's.* Arrested as British spy but avoided prosecution (1914). Wrote plays and novels. Biographies include F. Downey's *Richard Harding Davis: His Day* (1933) and G. Langford's *The Richard Harding Davis Years: A Biography of Mother and Son* (1961).

Raymond Depardon *(French, b. 1942)* Photographer and filmmaker, created new kind of photo agency in France that began era of aggressive, activitist reporting and improved the rights of photographers during late 1960s. Gamma agency, cofounded by Depardon, Hughes Vassal, Jean Monteux, Leonard de Raemy, and Hubert Henrotte, gave photographers 50 percent of the revenue from their photographs and allowed them to own the copyright. Also revolutionized credit line, naming photographer and agency. Won Robert Capa Gold Medal for coverage of Chile coup d'état (1971). Henrotte and followers broke away from Gamma (1973), leaving Depardon to rebuild and expand agency. Made several well-known films, including one calling attention to female hostage in Chad. Resigned from Gamma, joined Magnum (1978).

Max Desfor *(American, b. 1913)* Covered World War II and Korean war for AP. His photograph of Korean refugees scrambling over wreckage of bridge over Taedong River won 1951 Pulitzer Prize. At AP as staff photographer then photo editor (1933–1954). Became supervising editor of Wide World Photos, AP's feature syndicate (1954–1968). In 1968 stationed in Tokyo as Asia photo editor. Retired from AP (1978), joined *U.S. News and World Report* as photo editor (1979). Photo director of *U.S. News* until retirement (1984).

Arnold Drapkin *(American, b. 1931)* Former picture editor at *Time* magazine. Studied illustration, sculpture, and photography at New York City School of Art and Design; graduated 1949. Began as copyboy at *Time* (1950), became first layout artist in newly formed color-page production department (1951). In 1952 began two years' military service as public information specialist, making photographic assignments and editing and releasing pictures for the media. Returned to *Time* (1954), worked in all areas of graphic design. Was contributing editor, color director, and color editor before assuming position as picture editor. Retired 1987. Won NPPA Joseph A. Sprague Memorial Award (1983).

David Douglas Duncan *(American, b. 1916)* Prolific photographer of artists, nature, war. *Life* staff photographer (1946–1956) also published in *Collier's, McCall's, National Geographic,* among other periodicals. Marine combat photographer, World War II; earned military honors, including Purple Heart and Distinguished Flying Cross. Most compelling photographs taken during Korean war with his former marine division on ten-day march in subzero temperatures. Earned Robert Capa Gold Medal and named Photographer of the Year for coverage of Vietnam war (1968). Has written many books on war, Picasso, and art, as well as his autobiography, *Yankee Nomad* (1966).

Arnold Genthe (*American, b. Germany, 1869–1942*) Photographed ruins of San Francisco after 1906 earthquake. Educated in Germany, came to U.S. in 1896. Operated San Francisco portrait studio (1897–1906) and operated another studio in Carmel, California (1902–1911). In San Francisco often photographed in Chinatown. In New York as freelance magazine photographer concentrated on dance and theatrical portraits (1911–1942). Autobiography *As I Remember* (1936). Retrospective exhibition catalog published by Staten Island Museum (1975).

Tim N. Gidal (*Israeli, b. Ignatz Nachum Gidalewitsch, Germany, 1909*) From era of great German illustrated newspapers, Gidal drew upon experience to write *Modern Photojournalism: Origin and Evolution 1910–1933*. First photographed for *Münchner Illustrierte Presse* (1929–1933). Studied economics, history, and international law before immigrating to Palestine (1936). As freelance photographer experimented with color films; published in American, British, and French magazines (1936–1938) until joining *Picture Post*, London (1938–1940). Contributed to *Lilliput, Life, Look*, and the British army's *Parade*. Immigrated to U.S. (1947). Taught at New School for Social Research (1955–1958). Moved to Israel (1971), where he teaches at Hebrew University, Jerusalem. Author of children's social-studies books and filmstrips. See *'In the Thirties': Photographs by Tim Gidal*, exhibition catalog, Israeli Museum, Jerusalem, 1975, and *In the Forties*.

Victor Gribayédoff (*American, b. Russia, 1858–1908*) Illustrated his articles at *New York Sun* (1881), becoming one of earliest newspaper illustrators. Pen-and-ink drawings exposing corruption published in *Leslie's Illustrated Weekly*. Became a photographer, using photographs as subjects for drawings and later submitting photos themselves for publication. Around 1895, founded bureau for placing stories and photographs in newspapers. In 1897 moved to Paris. With concealed camera, was only person to photograph Dreyfus trial successfully. Last worked for an American newspaper during Russo-Japanese War as correspondent for *Collier's* in Siberia. Author of *The French Invasion of Ireland* (1890).

Philip Jones Griffiths (*British, b. Wales, 1936*) Known for book *Vietnam Inc.* (1971). Became freelance photographer for *Manchester Guardian* and other publications while studying pharmacy in college. Worked as cameraman filming television documentaries until becoming full-time photographer (1961). Work appeared in *Town, Queen, Look, Life, McCall's, Sunday Times Magazine* (London), and *New York Times*. Joined Magnum (1966), covering Vietnam war (1966–1968 and 1970–1971). Traveled to many other countries photographing feature stories. After 1974 concentrated on making documentary films. Also served as Magnum's president. For bibliography see *Contemporary Photographers*, Walsh, Naylor, and Held, editors; 1982.

Stan Grossfeld (*American, b. 1951*) Director of photography, *Boston Globe*, and recipient of consecutive Pulitzer Prizes (1984, 1985). Started as photographer for *Newark* [New Jersey] *Star Ledger* (1973). Joined *Globe* (1975) and has since won numerous awards, including Overseas Press Club prize for "best photo-

graphic reporting from abroad." Known for photographs of Ethiopia, United States–Mexican border, Lebanon. Author of *Eyes on the Globe* (1985) and *Nantucket: The Other Season* (1982).

Simon Guttmann (*Hungarian, b. 1890*) While living in Berlin founded vanguard theater group; member of literary and philosophy clubs associated with Expressionist artists and writers (1910). Went to Zurich during World War I, associated with Dada. Returned to Germany, founded Deutscher Photodienst (Dephot), an early photo agency (1928). By 1931 Dephot included Umbo, Felix Man, Harald Lechenperg, Walter Bosshard, Kurt Hutton. Robert Capa started career as darkroom assistant, received first assignment from Dephot. Later Capa had many assignments from Guttmann. In 1932 Dephot went bankrupt and was reorganized by Guttmann under the name Degephot. Guttmann placed photo stories for Ullstein publications during 1930s. See R. Whelan's *Robert Capa: A Biography* (1985).

Ernst Haas (*American, b. Austria, 1921–1986*) Studied medicine and graphic arts in Vienna (1940–1944). Became photographer and met director of Czech agency DU (1945); worked for DU through 1947. Reported return of war captives (1947). Freelanced in Paris and New York (1948–1950). Joined Magnum at invitation of Robert Capa (1949). Worked for *Life* and other international magazines (1950–1960). Began color photography (1958) and became known as a master of this field. President of American Society of Magazine Photographers (1960). Did four television programs on "The Art of Seeing" (1962). Left Magnum (1962). Documented the filming of numerous motion pictures. Recipient of many awards. See C. Capa's *The Concerned Photographer*, Vol. 2, text by Michael Edelson (1972).

Ronald L. Haeberle (*American, b. 1941*) Studied photography, Ohio University (1962). Drafted into U.S. Army one semester short of graduation. Trained as mortarman, worked as clerk in Hawaii, became combat photographer. Photographed My Lai massacre as army photographer, submitting pictures taken on military equipment to army and keeping color photos taken on his own camera (March 1968). On return to U.S. submitted color pictures to *Cleveland Plain Dealer*, confirming rumors of massacre that had circulated in press. Returned to civilian life, completed work at Ohio University. No longer a photographer (1969).

James H. Hare (*British, 1856–1946*) Camera manufacturer, editor, and photographer for *Illustrated American* and war correspondent for *Collier's Weekly*. Covered five wars (1898–1918). Claimed many firsts in "snapshot" photography. Originally employed by father, a camera manufacturer, prior to a dispute regarding the use of dry plates (1874). Working for a London manufacturer, began to photograph in spare time. With small hand-held cameras made photographs and sold them to London newspapers. Accepted invitation to work in New York City for E. & H. T. Anthony and Co. (1889) and became photojournalist at *Illustrated American* (1890). In 1898 fire destroyed newspaper, so joined *Collier's*. Authorized biography by Cecil Carnes, *Jimmy Hare: News Photographer* (1940), and biography by Gould and Greffe, *Photojournalist: The Career of Jimmy Hare* (1977), provide accounts of his exploits in pursuit of news photographs.

James Denny Hayes *(American, 1892–1953)*, **James Durwood Hayes** *(American, b. 1916)*, **Johnny Hayes** *(American, b. 1914)* Father and two sons worked as photojournalists in Dallas area (1929–1960s). Published exclusively in *Dallas Times Herald*. Careers span history of press photography from use of 8 x 10 glass-plate negatives and flash powder to trusty 4 x 5 camera accompanied by flashbulbs. One famous exclusive was autopsies of Bonnie and Clyde (1933). The Hayes collection is located at the Dallas Public Library.

William Randolph Hearst *(American, 1863–1951)* Owner of publishing empire that exerted great influence over American newspapers and magazines (1880s–1930s); changed shape of American journalism with sensational and ruthless business practices. Using illustrations and bold headlines, altered look of journalistic publications. With jingoistic reporting, manipulated foreign affairs and local politics. Empire built upon success of *San Francisco Examiner* and grew as it moved into New York City market with *Morning Journal*. By 1925 Hearst owned newspapers in every section of U.S. Bought many widely circulated magazines, including *Cosmopolitan* and *Harper's Bazaar* (1900–1910), and expanded into newsreels and movies. Also pursued political career. See Mott's *American Journalism* (1941).

John Heartfield *(German, b. Helmut Herzfeld, 1891–1968)* Designer of photomontages for covers of *AIZ* (1929–1933, 1933–1938). Key figure in Berlin Dada group, working closely with George Grosz. Writer, set designer, filmmaker, artist, graphic designer. Deprived of German citizenship by Nazis for anti-government writings and artwork (1934). Fled to Prague then to London to escape extradition to Germany after continuing activities (1938). Returned to Germany (1950), honored for peace work, called "an artist of the people." Exhibited throughout the world. See his book *Photomontages of the Nazi Period* (1977).

John C. Hemment *(American, d. 1927)* Was well known for photographic exploits in Cuba during Spanish-American War. Sent to Havana by U.S. government before war, commissioned to photograph wreckage of battleship *Maine* after explosion on board. Then photographed Spanish fortifications, which led to arrest on charges of spying. Wrote *Cannon and Camera* (1898) about war experiences.

R. C. Hickman *(American, b. 1922)* Dallas photographer (1950s–1970s), recorded all aspects of black community for *Dallas Star Post, Jet* magazine, a number of eastern newspapers, and the NAACP. Learned photography during World War II while serving in U.S. Army at Saipan. Archives located at Eugene C. Barker Texas History Center, University of Texas at Austin.

Wilson Hicks *(American, 1897–1970)* Joined staff of *Life* magazine as photo editor just three months after it was founded (1937); executive editor from World War II until 1950. Inspired choice of photographers for assignments resulted in *Life's* best photo essays, including W. Eugene Smith's "A Country Doctor" and Leonard McCombe's "Career Girl." Began career at *Kansas City Star* as editor of Sunday rotogravure section. Joined AP

(1928) and eventually became head of Wirephoto. Wrote important book, *Words and Pictures: An Introduction to Photojournalism* (1952). Taught at University of Miami (1957–1970), codirecting annual photojournalism conferences there beginning in 1957. See *The Great American Magazine* by Loudon Wainwright.

Lewis Wickes Hine *(American, 1874–1940)* "Reformer with a camera," Hine made pictures of immigrants arriving at Ellis Island, published 1908. Photographs of child-labor conditions in U.S. (1911–1916) essential for persuading the public that child-labor laws were necessary. During World War I photographed for Red Cross in Europe, and upon return documented construction of Empire State Building (1930–1931) and Tennessee Valley Authority projects (1936). Published in many periodicals, including *Survey, Graphic,* and *Red Cross Magazine*. Concise biography and introduction to Hine's work may be found in *America and Lewis Hine: Photographs 1904–1940* (1977).

Burton Holmes *(American, 1870–1958)* Photographer and cinematographer (1892–1940s). Popular travel lecturer and author of eighteen-volume series of travel books as well as *The Traveller's Russia* (1934). Made early motion pictures in Japan and Russia (1899), documented building of Panama Canal in stills and movies, and covered World War I in a self-styled uniform. Made fifty-two travel shorts a year for Paramount Studios (1915–1921) and then joined Metro-Goldwyn-Mayer to perform same service. Flamboyant character is described in *The Man Who Photographed the World: Burton Holmes Travelogues 1886–1938*, edited by G. Caldwell with an introduction by Irving Wallace (1977).

Oliver Wendell Holmes *(American, 1809–1894)* Author, photographer, inventor of stereoscopic viewer most widely used in nineteenth century (1859). Coined term *stereograph*. Wrote three well-known articles on photography for *Atlantic Monthly* (1859, 1861, 1863). First gave brief history of photography and recommended establishment of national or local stereograph libraries; second was "Sun-Painting and Sun-Sculpture with a Stereoscopic Trip Across the Atlantic"; and third described process of coating photographic paper with albumen at E. & H. T. Anthony and Co. Also wrote on photography for other publications. See Robert Taft's *Photography and the American Scene 1839–1889: A Social History* (1938).

Henry Thomas Hopkinson *(British, b. 1905)* Editor, teacher, and author. Studied at Oxford (BA 1927, MA 1930). Editor of *Lilliput* (1941–1946), *Picture Post* (1940–1950), feature editor of *News Chronicle* (1954–1956), and editor of *Drum* magazine, South Africa (1958–1961). Director for Africa, International Press Institute (1962–1966). Professor of journalism, University of Minneapolis, Minnesota (1968–1969), and senior fellow in press studies at the University of Sussex, England (1967–1969). Director of Centre for Journalism Studies at University College, Cardiff, Wales (1970–1975). Wrote introductions to books on the photography of David Hurn (1979) and Bert Hardy (1975) as well as *Picture Post 1938–1950* (1970), and authored along with editors of *Life, South Africa* (1964).

Stephen Henry Horgan *(American, 1854–1941)* First published halftone in 1880. Was art director, *New York Herald* (1893), where head pressman thought that "any man who thought a halftone could be printed on a fast daily newspaper press was crazy." Was fired and joined *Tribune.* Patented design for plates that could withstand pressures of high-speed web presses (1897). Worked with color separation and Bell Lab experiments with color photograph wire transmission (1924). See "Where Halftone Began," a three-part article by Horgan in *The Inland Printer,* February, April, and June 1927, for more information about the creation of the halftone, and Jussim's *Visual Communication and the Graphic Arts* (1974).

Robert Houston *(American, b. 1935)* Met Howard Chapnick of Black Star and Gordon Parks of *Life,* both of whom were very influential to his career (1967). First *Life* assignment on civil rights movement in Washington (1968). Staff photographer *Metropolitan* magazine, Baltimore (1980–1981). Filmmaking and photography instructor, Cultural Arts Program, Baltimore (1980–present). Since 1968 also working as freelance photographer. See monograph *Legacy to an Unborn Son* (1970).

Henri Huet *(French, b. Vietnam, 1928–1971)* Born in Vietnam, grew up in Normandy. Returned to Vietnam with French Navy as cameraman (1949–1952). After service, stayed in Vietnam as photographer for U.S. Information Service. Joined AP (1965). Won Robert Capa Gold Medal from Overseas Press Club (1967). Wounded at Con Thein, spent months recovering at U.S. hospitals (1967). Transferred to Tokyo (1969). Killed in helicopter crash, Laos, February 1971, along with three other photographers, one journalist, and South Vietnamese soldiers.

Kurt Hutton *(British, b. Kurt Hubschmann, Germany, 1893–1960)* Studied law at Oxford (1911–1913). German cavalry officer, World War I. Began career as portrait photographer working in Berlin studio (1923–1930). Became photojournalist, joined Dephot (1929–1934). Immigrated to England (1934). Staff photographer at *Weekly Illustrated* (1934–1937) and at *Picture Post* (1938–1940, 1941–1950). Held as enemy alien in 1940–1941. Became naturalized citizen (1949). Retired 1951. See "Kurt Hutton 1893–1960," *Creative Camera Yearbook 1976* (London, 1975).

Herbert Ingram *(British, 1811–1860)* Founder (1842) and publisher of the widely circulated *Illustrated London News,* he was inspired by public demand for newspapers with engravings of a famous murder trial while a news agent and bookseller in Nottingham, England, in 1830s. Had served as apprentice to journeyman printer and decided to go to London to establish his own newspaper. Elected to Parliament (1856). Died in shipwreck on Lake Michigan (1860). See *The Pictorial Press: Its Origin and Progress* by Mason Jackson (1855).

Itsuo Inouye *(Japanese, b. 1950)* Studied photography (1972–1974). Began career at AP as copyboy (1974). Darkroom staff, AP (1976–1986). Became photographer early 1986. Traveled extensively in Asia, covering Pope John Paul II and Philippine revolution. Photographs of student demonstrations and anti-government strikes in Korea published widely (1987).

International Fund for Concerned Photography After deaths of David Seymour, Werner Bischof, and his own brother, Robert, Cornell Capa created International Fund for Concerned Photography, Inc. (1966), to preserve the life's work of photographers who "reveal the human condition, commenting on contemporary events and improving understanding among people." In 1974 transferred publishing and exhibition programs to International Center of Photography, permanent home for the Concerned Photography archives and a museum with an emphasis on documentary and humanistic photography.

Frederic Eugene Ives *(American, 1856–1937)* Trained as printer in Ithaca, New York, and Philadelphia, where made first halftones working with Stephen Horgan (1886). By 1890s working with highly refined color separation and developed first series of three-color cameras (1892). In 1920s patented basic ideas that led to introduction of Kodachrome film (1935).

Robert H. Jackson *(American, b. 1934)* Graduated from Southern Methodist University with degree in business (1956). Freelance photographer (1956–1958). Military service, U.S. Army (1958–1959). On the staff of *Dallas Times Herald* (1960–1968) when he photographed the killing of Lee Harvey Oswald. These photographs earned him a Pulitzer Prize (1964). Staff photographer *Denver Post* (1968–1969). Returned to *Times Herald* (1969–1974). Freelance photographer (1974–1980) until became staff photographer for *Colorado Springs Gazette Telegraph* (1980–present).

Charles Fenno Jacobs *(American, 1904–1975)* By early 1930s was freelance photographer, New York, contributing to *U.S. Camera* and other magazines. Also photographed for the Farm Security Administration. One of six original members of Steichen's Naval Photographic Unit (1941–1944). After war, freelanced for *Fortune* magazine, traveling throughout the world. Editor *Skipper* magazine, Annapolis, Maryland. In early 1960s retired from photography to open gourmet restaurant in New Hampshire. See C. Phillips's *Steichen at War* (1981).

Jeff Jacobson *(American, b. 1946)* Graduated from University of Oklahoma (journalism; 1968) and Georgetown University Law School (1971). Practiced law in Atlanta (1971). Attended Apeiron Photography Workshop, Millerton, New York, and met Charles Harbutt (1972). Gradually became involved in photography. Stringer for *Time,* Boston (1976). Nominated for Magnum membership by Harbutt (1979). Published mainly in *Geo, Yankee,* and *Fortune* (1980–1983). Affiliated with Archive Pictures. See "American Rituals," *Camera Arts,* April 1983.

John H. Johnson *(American, b. 1918)* Editor, publisher, and president of Johnson Publishing Co., Inc., Chicago, producing *Ebony* (1945), *Jet* (1951), and other magazines. Born in Arkansas, studied at University of Chicago and Northwestern University. Began publishing at age twenty-four. Now one of most successful black businessmen in America.

Frances Benjamin Johnston *(American, 1864–1952)* One of the earliest female photojournalists. Regular contributor to *Demorest's Family Magazine* (1889–1890s). For more than fifteen years covered presidents and Washington society, earning title of "Photographer of the American Court." Completed stories on Pennsylvania coal mines and Kentucky's Mammoth Cave and competed with J. C. Hemment for exclusive on Admiral Dewey (1899). Commission to photograph Washington, D.C., schools led to extensive reports on black and American Indian schools, including Hampton and Tuskegee Institutes, beginning in 1899. After 1910, well known for portraiture and architectural photography. Published *The White House* (1893) and books on southern colonial architecture (1930s). Donated photographs and manuscripts to Library of Congress (1949). Biography: *A Talent for Detail: The Photographs of Miss Frances Benjamin Johnston 1880–1910*, by Daniel and Smock (1974).

Victor Jorgenson *(American, b. 1913)* One of six original photographers with Steichen's Naval Photographic Unit in World War II (1942–1944). Career began as reporter for *Portland Oregonian* (1934). Held several editorial positions before leaving to join navy (1942). Freelanced after war. Spent eighteen months in Africa for *Fortune*. Contributed to *Saturday Evening Post*, *Collier's*, *Redbook*, and other magazines. Active in ASMP. Retired in 1981. See C. Phillips's *Steichen at War* (1981).

David Hume Kennerly *(American, b. 1947)* Photographer for *Oregon Journal* (1966) and the *Portland Oregonian* (1967). With UPI in Los Angeles (1967–1968), New York (1968–1969), Washington (1969–1970), Saigon (1971–1972). Contract photographer in Southeast Asia for *Life* and *Time* (1973). Since 1973 based in Washington for *Time*. Awarded 1972 Pulitzer Prize for feature photography of Vietnam war. Appointed by Gerald Ford to photograph his presidency (1974–1977). See autobiography, *Shooter* (1979).

André Kertész *(American, b. Hungary, 1894–1985)* Began to photograph (1912) while working at Hungarian Stock Exchange. Continued to photograph in Hungarian Army (1914–1918), published first picture in 1917. After moving to Paris (1925), freelanced and published in German, French, and British publications. Bought 35mm Leica (1927), always used this format. Major contributor to *Art et médecine* (1930–1936). Came to New York under contract with Keystone Studio (1936). Broke contract and freelanced for *Harper's Bazaar*, *Vogue*, *Town and Country*, *American Magazine*, *Collier's*, *Coronet*, and *Look*. Exclusive contract with Condé Nast publications (1949–1962). Independent after 1962. Became U.S. citizen (1944). Essay in *André Kertész: Of Paris and New York* (1985) by S. S. Phillips is excellent source of information.

Dmitri Kessel *(American, b. Ukraine, 1902)* Immigrated to U.S. (1923). By early 1930s was leading industrial photographer, New York, and was published in *Fortune*. Started accepting assignments from *Life* (1936). Became staff photographer, *Life*. Traveled around the world in pursuit of stories. Remained on staff until magazine suspended publication in 1972. Continued to photo-graph for *Smithsonian* and other magazines. See autobiography, *On Assignment: Dmitri Kessel, Life Photographer* (1985), with foreword by E. K. Thompson.

Janet Knott *(American, b. 1952)* Graduated from Barnard College with a degree in English literature. Freelance photographer, North Shore of Massachusetts, contributing to *Beverly Times* (1975). Darkroom technician, *Boston Globe* (1976–1978). Staff photographer, *Boston Globe* (1978–present). Awarded World Press Photo Spot News First Prize for photograph of explosion of space shuttle *Challenger* (1986). Frequent winner of Boston Press Photographers Association awards. See *Photo Graphis* (Switzerland) 1986 for more photographs by Knott.

Kurt Korff *(German, 1876–1938)* Editor of *Berliner Illustrirte Zeitung* (1918–1933), director of House of Ullstein German publishing empire. Vastly improved *BIZ* content and quality of photographic illustrations and applied these techniques to create other illustrated magazines for Ullstein. Fled Germany (1934). Hired by Henry Luce as "secret weapon" in development of *Life*. Initiated inexperienced crew in well-developed German photo-editing techniques. Introduced talented European photographers including Alfred Eisenstaedt to *Life*. Prepared guidelines on ideal content of picture magazine. Left *Life* shortly before first issue (1936). Until death worked for Hearst. See Korff's obituary, January 31, 1938, *New York Times*; W. Hicks's *Words and Pictures*; and T. Gidal's *Modern Photojournalism: Origin and Evolution 1910–1933* (1973).

Dr. (Prof.) Arthur Korn *(American, b. Germany, 1870–1945)* Transmitted photographs directly by means of light-sensitive scanner, used commercially by *Daily Mirror* to send photograph between London and Paris (1907). Demonstrated apparatus at University of Munich (1904) and in Paris for *L'Illustration* (1906). By 1912 system used throughout Europe. In 1923 sent photograph across Atlantic. Worked on reconnaissance for German Army, World War I, sending sketches of strategic areas from airplanes to ground stations. Left Germany for U.S. (1939). Taught college math and physics in New Jersey until became researcher for The Times Telephoto Equipment Company, Inc. (1945). Early process explained in February 16, 1907, *Scientific American* and in his book *Handbuch der Phototelegraphie und Telautographie* (1911).

Germaine Krull *(French, b. Poland, 1897–1985)* Educated in Paris, studied photography in Munich (1916–1918). Worked in Munich and Berlin as portrait photographer. Freelance architecture and industrial photographer, published in German and French magazines (1921–1924). Moved to Paris and worked for *Vu*, *Arts et métiers graphiques*, *Voilà*, *Marianne*, *Bifur*, *L'Art vivant*, *Jazz*, *Art et médecine*, and *Synthèse* (1924–1932). Associated with writers and painters of avant-garde. Only photographer to exhibit in Salon d'Automne, Paris (1926). Traveled throughout Europe for commercial and journalistic assignments. War correspondent and photographer for Free French publications in Africa, Germany, and Italy (1941–1945). Moved to Indochina and Orient (1946–1965). Lived with refugees from Tibet who follow Dalai Lama from 1965 until her death.

Eliane Laffont *(French, b. 1942)* A cofounder and the U.S. director of Sygma photo agency. Representative for the Gamma agency in New York (1970–1973), but left along with a number of Gamma's photographers to form Sygma (1973). Photo editor at revived *Look* magazine (1980–1981) and participant as an editor in "Day in the Life" projects. Before joining Gamma, worked in public relations and in travel industry.

Robert Landry *(American, 1913–1960) Life* magazine photographer (1941–1947) known for photographs of Japanese attack on Pearl Harbor. Began career as publicity photographer for *Los Angeles Examiner.* Head of Los Angeles bureau International News Photos (1937). Freelance magazine photographer after leaving *Life* in 1947. Died while working as a still photographer on the movie *The Guns of Navarone* in London.

Dorothea Lange *(American, 1895–1965)* Worked for Farm Security Administration photographing migrants, sharecroppers, and tenant farmers (1935–1939). Photographs "Migrant Mother" and "White Angel Breadline" became symbols of the Depression. Studied photography under Clarence White. Assistant to Arnold Genthe before moving to San Francisco from New York (1918). In Bay Area operated a portrait studio (1919–1965). After seeing her street photographs, economist Paul Taylor asked Lange to illustrate reports for state Rural Rehabilitation Administration, leading to FSA appointment. Images were published in *San Francisco News,* stirring public support for government funding for migrant workers (1935–1936). Staff member of *Life* (1954), two essays published. Work appears in books *Land of the Free,* verse by Archibald MacLeish (1938), *An American Exodus,* with Paul S. Taylor (1939), and *Death of a Valley,* with Pirkle Jones (1960). Biographies include the Oakland Museum's *Celebrating a Collection: The Work of Dorothea Lange,* by Therese Thau Heyman (1978). See also *Executive Order 9066* by Conant for the Japanese internment work.

Frederick Langenheim *(American, b. Germany, 1809–1879),* **William Langenheim** *(American, b. Germany, 1807–1874)* Brothers introduced daguerreotype, calotype, and lantern slide to U.S. As founders of American Stereoscopic Company, were first major producers of stereoscopic views in this country (1850). Came to U.S. (1841). Opened portrait studio in Philadelphia and photographed leading American citizens. Photographed Niagara Falls, creating five separate panoramas (1845). Traveled beginning in 1855 collecting views to reproduce in stereo, on glass, porcelain, and paper. Sold company to E. & H. T. Anthony (1861).

Lisa Larsen *(American, b. Germany, 1925–1959)* Apprenticed to *Vogue* magazine, later freelanced through Graphics House agency with work published in *New York Times Magazine, Parade, Glamour, Vogue, Charm,* and *Holiday.* Staff photographer, *Life* (1949–1959). Well known for photographs of Outer Mongolia (1956) and of Russian Premier Khrushchev. Named NPPA Magazine Photographer of the Year and given Overseas Press Club award for "best photographic reporting from abroad" (1958).

Michel Laurent *(French, 1945–1975)* Worked for AP and in 1973 joined Gamma agency in Paris. Won 1972 Pulitzer Prize with another AP photographer, Horst Faas, for photograph of soldiers bayoneting "traitors" after 1971 India-Pakistan War. Also worked with Faas on photo essay "Death in Dacca," which won them many awards. Photographed hunger in Biafra and civil war in Jordan. Last journalist or photographer to be killed covering thirty-year Indochina, or Vietnam, war: died in April 1975 near Saigon.

Harald Lechenperg *(German, b. Austria, 1904)* Editor in chief of *Berliner Illustrirte Zeitung* (1937–1949) and editor of *Quick* and *Weltbild* (1949). Began career (1927) when traveled through Sahara with typewriter and glass-plate camera. During next twenty years published in *Die Woche, Leipziger Illustrierte, Miroir du Monde, The Illustrated London News,* and his own *BIZ.* Joining Dephot agency (1929–1933), worked as reporter for Scherl publishers in India and Africa. In 1935 came to United States for eleven months, writing articles on Civilian Conservation Corps, tennis championships, modeling agencies, first computers at MIT, and U.S. Army maneuvers. After World War II, made more than twenty documentary films for broadcast on German television. See *Studies in Visual Communication,* Vol. 11, No. 2, 1985.

Catherine Leroy *(French, b. 1944)* First major story covered was war in Vietnam, where she became first female photographer to make parachute jump with marines (1966–1968). Imprisoned by North Vietnamese during Tet offensive (1968). Made documentary film on Les Halles section of Paris (1970) and "The Last Patrol," about Vietnam veterans (1972). Joined Sipa Press agency (1974). Covered Turkish invasion of Cyprus, fall of Saigon, and civil war in Lebanon (1974). First woman to win Robert Capa Gold Medal for coverage of street combat in Beirut (1976). Contract photographer for *Time* (1982). Published *God Cried,* with Tony Clifton, on Lebanon (1982). Continued to cover international news. Sipa Press Middle East correspondent based in Cairo (1987). See Lewinski's *The Camera at War* (1978).

Frank Leslie *(American, b. Henry Carter, England, 1821–1880)* British engraver and illustrator, came to America (1848), founded what was to become *Leslie's Illustrated Newspaper* (1855). Started in family glove business at age seventeen. Provided illustrations for London newspapers in spare time after 1838, using Leslie name to keep hobby secret from his family. Began engraving career in London. In U.S. made innovations in illustration reproduction, including the use of large engraving plates capable of printing a double page. Reduced time needed to carve engraving plate from two weeks to twenty-four hours by cutting plate into thirty-two equal squares and assigning each section to a different engraver. Leslie newspaper empire included eight titles, including two women's journals edited by his wife.

Alexander Liberman (Alexandre) *(American, b. Russia, 1912)* Multitalented designer, trained in architecture and painting, and self-taught as a photographer. Began to design magazines as assistant to Cassandre in Paris (1931–1932). Was art director then managing editor of *Vu* under Lucien Vogel (1933–1936), art director of *Vogue,* New York (1943–1946), and editorial director

from 1962 of Condé Nast Publications. Author of photography and fashion books. See "Liberman Staying in Vogue," *New York Times*, May 12, 1979.

Stefan Lorant *(American, b. Hungary, 1901)* Among editors who ushered in modern photojournalism through leadership of magazines *Münchner Illustrierte Presse*, London's *Weekly Illustrated, Lilliput*, and *Picture Post*. Left Hungary to escape fascism (1919). In Vienna became film cameraman, scriptwriter, and director. In 1925 was writing magazine articles in Berlin and by 1928 was type chief of *Münchner Illustrierte Presse*. Imprisoned as threat to Nazis (1933). When released, returned to Budapest and edited a Sunday magazine. Moved to London, became editor, *Weekly Illustrated*. Published *Lilliput* magazine (1937) so successfully that it was bought out within year. Buyer then financed *Picture Post*, edited by Lorant (1938). Came to U.S. (1940). Author of *I Was Hitler's Prisoner* (1934), *The Glorious Burden* (1976), *Pittsburgh* (1980), *Sieg Heil* (1974), and biographies of historical American figures. Since 1980 working on autobiography.

Henry Robinson Luce *(American, b. China, 1898–1967)* Magazine editor-publisher, founder of *Time* (1923), *Fortune* (1930), *Life* (1936), and *Sports Illustrated* (1954). Born in China, son of Presbyterian missionary. Attended Yale and later studied one year at Oxford. Along with Yale classmate Briton Hadden, started *Time*, weekly newsmagazine that launched his publishing empire. Produced newsreel "March of Time" (1931–1954). Personal vision led to creation of two great magazines in 1930s that became showcases for American photojournalism. Personally hired Margaret Bourke-White as first photographer for *Fortune* and later developed guiding doctrine of *Life*. Retired as editor in chief of all Time Inc. publications in 1964. For information see Kobler's *Luce* (1968).

Samuel Sidney McClure *(American, b. Ireland, 1857–1949)* Editor-publisher of *McClure's Magazine* (1893–1914). *McClure's* known for its series on corruption by muckrakers Ida Tarbell and Lincoln Steffens. McClure came to the United States at age nine, grew up in Indiana. Secured first magazine job editing *The Wheelman*, publication for cyclists, in Boston. Started news syndicate (1884) after working for other magazines, buying rights to stories for $100 to $200 and selling them to many newspapers for profit. Published autobiography (1914) and also books on political science.

Leonard McCombe *(American, b. England, 1923)* *Life* magazine photographer. Most notable essay on career woman, "The Private Life of Gwyned Filling" (1948). Became professional photographer in England working for *Picture Post* (1939–1945). Immigrated to America and joined staff of *Life* with contract forbidding him to use flash (1945). Magazine Photographer of the Year (1949, 1954). Published book *You Are My Love* (1952). Naturalized U.S. citizen. Resigned from *Life* and from photography to work on his farm (1972). See "The Real McCombe," *American Photographer*, December 1978.

Don McCullin *(English, b. 1935)* First story published in London *Observer* (1961). Prestigious awards presented for coverage of war in Cyprus, joined London *Sunday Times* (1964). Photographed conflicts in the Congo, Indochina, Cambodia, Biafra, India-Pakistan, Northern Ireland, and Vietnam. Returned to England to photograph native country (1979). Books include *Homecoming* (1979), *Hearts of Darkness* (1980), *The Palestinians* (1980), *Beirut: A City in Crisis* (1983), *Is Anyone Taking Notice?* (1973).

Peter Magubane *(Zambian, b. South Africa, 1932)* Worked for *Drum* magazine, South Africa (1954–1963), starting as tea server and driver until learning from other photographers. Covered African National Congress at Bioemfontein (1955). For "The Children of the Farms" essay was awarded press photography awards (1958). Freelance photographer in U.S. (1963–1965). On staff of *Rand Daily Mail*, Johannesburg (1967–1969). Banned to his home for five years (1969–1974). Resumed work for *Rand Daily Mail* (1975), reported Soweto uprising, won awards in South Africa and England (1976). Since 1978 worked for *Time* magazine and as freelancer. Books include *Black As I Am* (1978), *Soweto Speaks* (1979), *Black Child* (1982). In pursuit of photographic stories was imprisoned more than six months, held in solitary confinement for 586 days, banned to his home for five years, and beaten.

Felix H. Man *(British and German, b. Hans Felix Siegismund Baumann, 1893–1985)* "Essayist of the ordinary." Worked closely with editor Stefan Lorant in Germany and England. Born in Germany, studied painting, art history. In German Army (1914–1918) created reportage "Truce on the Western Front" (1915). Caricaturist and photographer (1927). Hired by Ullstein newspapers (1929). *Münchner Illustrierte Presse* and *Berliner Illustrirte Zeitung* published more than one hundred Man essays between 1929 and 1934, including most famous, "A Day in the Life of Mussolini" (1931). Immigrated to England (1934), collaborated with Lorant at *Weekly Illustrated* and as chief photographer at *Picture Post* (1938–1945). Color specialist at *Picture Post* until 1958. Illustrated autobiography, *Man with Camera* (1984).

Mary Ellen Mark *(American, b. 1941)* Called "social documentarian" because photo essays explore people on edge of mainstream society. Published in *Look, Life, Vanity Fair, Paris Match, New York Times Magazine, Esquire, Rolling Stone*, and London *Sunday Times Magazine*, as well as photographic magazines. Associate member Magnum (1976–1981), joined Archive Pictures, Inc. (1981). Awarded highest prizes for her work, including the Friends of Photography Photographer of the Year (1987). Photographed in Turkey in 1965–1966 under Fulbright Scholarship. Also earned grants to support work on "Bar Series" (1977) and "Mother Theresa" (1981). Photographed during shooting of documentary film *Street Wise*. Teaches at international workshops. For bibliography and bio, see "The Unflinching Eye," *New York Times Magazine*, July 12, 1987.

Susan Meiselas *(American, b. 1948)* Magnum photographer, covered Nicaraguan revolution (1978–1979), winning Robert Capa Gold Medal for story that appeared almost simultaneously in *Geo, Time, New York Times Magazine, Paris Match*, and other

publications throughout the world (1979). Studied at Sarah Lawrence and Harvard, majoring in education. Taught photography to children in the South Bronx and South Carolina. First book, *Carnival Strippers* (1976), represented work of three summers spent with traveling shows in New England. Magnum associate member (1976). Went to Nicaragua in 1978, nearly a year before the revolution began, when few photographers were in the country. Continues to cover Central America. See her *Nicaragua: June 1978–July 1979* and *El Salvador: Work of Thirty Photographers* (co-editor, 1983).

Julio Mitchel *(American, b. Cuba, 1942)* Assistant professor of art at Cooper Union in New York City. Came to U.S. in 1960. Specializes in photographing extended essays on subjects that range from wars in Northern Ireland to illegal child boxing to a ward for the chronically ill in a Manhattan hospital. Also photographed impoverished Jewish community on New York's Lower East Side, and jazz musicians. Earned grants from National Endowment for the Arts, New York Foundation, and New York State Council for the Arts. For more information on Mitchel's work, see "Julio Mitchell: Climbing the Mountain. A conversation on the first plateau" by A. D. Coleman in *Photo Metro* (a San Francisco–based magazine), May 1984.

Charles Moore *(American, b. 1931)* Combat photographer with U.S. Marine Corps in mid-1950s. Studied photography at Brooks Institute in California on GI Bill. Chief photographer at *Montgomery Advertiser* and *Alabama Journal* (1957–1962). Represented by Black Star since 1962. Freelance photographer, covering civil rights demonstrations (1962–1966). Awarded citations from the ASMP and Aviation and Space Writers Works for coverage of air war in Vietnam (1964–1966). Received many assignments from *Life* (1962–1972). Since 1972 freelance photographer based in San Francisco. Author of *The Mother Lode* (1983). Photographs published in Schulke and McPhee's *King Remembered* (1986).

Ralph Morse *(American, b. 1918)* *Life* magazine photographer who by age twenty was covering assignments; joined staff in 1942. Covered World War II, including Guadalcanal, D-Day invasion, liberation of Paris, and German surrender at Rheims. Spent six hours floating in ocean, keeping another man afloat after ship sank at Battle of Savo Island. Covered Mercury astronaut program for *Life* (1959).

Samuel Finley Breese Morse *(American, b. 1791–1872)* Invented one of the first working telegraphs in 1835 and by 1838 had developed Morse code, an alphabet composed of dots and dashes to be used with the telegraph. Lobbied Congress to pay for first U.S. telegraph line from Baltimore to Washington (1843). Network of telegraph lines created in following decades was vital to later use of wire telegraphic transmission of photographs. Learned photography from Daguerre. Also well-known painter. Founder and first president of National Academy of Design. *The American Leonardo: A Life of Samuel F. B. Morse* (C. Mabee, 1943) recounts Morse's contributions to art and science.

Karen Mullarkey *(American, b. 1942)* *Newsweek* photo editor since 1985. Began journalism career as assistant to director of photography at *Life* magazine (1967) and later coordinator of the Apollo space program coverage for *Life*. Spent four years at *Psychology Today* as art assistant and photography designer (1971–1975). Photo editor at *Rolling Stone* magazine (1975–1978). Also senior editor at *Look* magazine. Head of special project for *New West* magazine before moving to New York and becoming photo editor at its sister publication, *New York* magazine (1980–1984). Earned numerous awards for magazine design.

Martin Munkacsi *(American, b. Hungary, 1896–1963)* Studied painting in Hungary before becoming sports reporter for *Az Est*, Budapest, at age seventeen. Photojournalist in Berlin's Ullstein publishing firm (1927–1934), creating photo essays for *BIZ*, *Die Dame*, and *Studio*. Covered first flight of *Graf Zeppelin* aboard the ship for *BIZ* and met William Randolph Hearst during voyage (1929). In 1934 came to U.S. under exclusive contract with Hearst and became famous for outdoor fashion photographs. Completed series "How America Lives" for *Ladies' Home Journal*. In 1941 one of the best-paid photographers in U.S. Books by Munkacsi include *Fool's Apprentice* (1945) and *Nudes* (1951). Involvement in photojournalism described in T. Gidal's *Modern Photojournalism: Origin and Evolution 1910–1933* (1973) and in G. H. Taylor's *My Best Photograph and Why* (1937).

Carl Mydans *(American, b. 1907)* Graduated from Boston University with journalism degree (1930) and began career writing for newspapers. Photograph published in *Time* magazine April 1935. Shortly thereafter, *Time* editor recommended him for appointment to Farm Security Administration. After one year, joined *Life* as one of original four photographers. With journalist wife, Shelley, covered World War II. Both imprisoned for twenty-one months in Shanghai and Manila by Japanese, gaining their freedom in prisoner exchange (1943). Served as news bureau chief for both *Time* and *Life* in Tokyo. Covered Korean war; was later assigned to London and Moscow. Retired from *Life* just before it suspended publication in 1972. Works as contract photographer for *Time*. Author of *More than Meets the Eye* (1959), *The Violent Peace*, and *Carl Mydans: Photojournalist* (1985), his autobiography.

James Allen Nachtwey *(American, b. 1948)* Three-time winner of Robert Capa Gold Medal. First photographer to win this award and NPPA Magazine Photographer of the Year in same year (1984). Covered Boston busing crises while a student at Dartmouth. Moved to *Albuquerque [New Mexico] Journal* (1976). Returned to New York in 1980. Became contract photographer with Black Star agency (1981). First international assignment in Belfast during Irish Republican Army hunger strikes and death of Bobby Sand (1981). Since then has traveled to areas of conflict: Lebanon, the Sinai, Nicaragua, El Salvador, Sri Lanka, and the Philippines. Known for the quality of his color images. Joined Magnum (1986). For biography and photographs, see "On the Warpath," *American Photographer,* September 1985.

Yoichi Robert Okamoto *(American, 1915–1985)* Graduated Colgate University (1938). Personal photographer to President Lyndon B. Johnson at White House (1964–1969). Was photo officer

at American Embassy, Vienna (1948–1954). Chief of Pictures, U.S. Information Agency, Washington, D.C. (1958–1964). Won awards from White House Press Photographers Association and citations from ASMP, Syracuse University, and the U.S. Information Agency, among other organizations.

Timothy H. O'Sullivan *(American, 1840–1882)* Explored the West for government agencies; also known for work with Brady and Gardner on Civil War. Work appears in *Gardner's Photographic Sketch Book of the War* (1866). Photographer with U.S. Government Fortieth Parallel Survey (1867), Darien Survey (1869), and Geographical Surveys West of One-Hundredth Meridian (1871–1874). Last major work was to document Indians at Shoshone Falls, Idaho (1874). Throughout his life created hundreds of large-format views and stereographs.

Richard F. Outcault *(American, 1863–1928)* Creator of comic strips "The Yellow Kid" (1896) and "Buster Brown" (1902). Introduced first full-page color comic, "Hogan's Alley" (1893). Other papers copied "The Yellow Kid" strip and became known as "Yellow Kid Journals." Rivalry among these papers caused sensationalism to spread to the editorial sections, inspiring the term *yellow journalism*. Career began when he went to New York after graduation and submitted funny pictures with jokes attached to small magazines. Syndicated comic strips through Chicago-based Outcault Advertising Company.

The Overseas Press Club Awards The Overseas Press Club presents three awards for photographic reporting from abroad. The Robert Capa Gold Medal is presented to photographers who have made stories "requiring exceptional courage and enterprise." For the "best photographic reporting from abroad" for magazines and books the Olivier Rebbot award is presented, and there is also a prize for photographic reporting for newspapers and wire services. OPC also awards prizes for television and radio coverage of foreign stories, and presents the Madeline Dane Ross award for stories that display concern for the human condition in any journalistic medium.

Gordon Parks, Sr. *(American, b. 1912)* Kansas-born photographer contributing to Farm Security Administration (1942–1943), photographer and filmmaker for Standard Oil Co. (1945–1948), and staff photographer for *Life* magazine (1948–1961). With *Life* made well-known essays on Harlem street gangs; militant blacks; "Flavio," a Brazilian child; among others. Also writer, musician, and filmmaker. Films include *Flavio* (1962), *The Learning Tree* (1969), *Shaft* and *Shaft's Big Score* (1972), *The Super Cops* (1974), and *Leadbelly* (1976). Director of editorial office of *Essence* magazine, New York (1970–1973). Recipient of many honorary degrees and journalism awards.

Gilles Peress *(French, b. 1946)* Magnum photographer (1974), recipient of W. Eugene Smith Grant in Humanistic Photography (1985). Known for photographs of Iran and continued coverage of Northern Ireland. Studied political science before beginning to channel political activity into photography (1970). First photo story on mining region of southwest France. Later covered earthquakes, immigrants throughout Europe, peasants in Burgundy,

and political conflict in Northern Ireland. Moved to New York (1975), photographed American politics and social conditions while covering world news events. Intrigued by American hostage crisis, went to Iran (1980). Results published in *New York Times* as portfolio without text; photographs later published in first book, *Telex: Iran* (1983). Articles on Peress in London *Sunday Times Magazine*, May 26, 1974, and December 8, 1974. Portfolio of photographs can be found in *Aperture 97*.

John Phillips *(British, b. Algeria, 1914)* First *Life* overseas staff photographer and reporter (1936). With family moved to France (1925). Apprentice to municipal photographer during summer vacations, Nice (1927–1934). Moved to England (1934). Took odd photographic assignments from London *Sunday Express*. Career at *Life* spanned fifty years. Covered World War II, Israel's independence, the fall of Hungary to Communists, royalty, movie stars, artists, and industrialists. See his *It Happened in Our Lifetime* (1985) or *A Will to Survive* (1977).

Picture of the Year Awards Established 1942. Sponsored by the University of Missouri, Columbia, and the National Press Photographers Association with a grant from Canon. Annual competition in over thirty categories within newspaper, magazine, photo-essay, and editing divisions. Judged by editors, photographers, and academicians. Students and professionals may enter.

Robert Pledge *(French, b. England, 1942)* Family moved from London to France (1951). Studied anthropology and linguistics before beginning work as reporter for monthly magazine *Jeune Afrique* (1967). In 1970 went to Chad with Gilles Caron, Raymond Depardon, and Michel Honorin for the French agency Gamma to cover war story. Ambushed and spent three weeks in "detention." Upon return to France, Pledge joined the staff of *Zoom*. Accompanied Depardon to New York to set up American office of Gamma in 1973, remained until 1976. Left Gamma to cofound Contact Press Images the following year. Contact celebrated tenth anniversary in 1987 with simultaneous exhibitions in France and New York. Devotes time to photojournalism, working with competitions and foundations. For more information on Robert Pledge or Contact, see *Camera International*, Spring 1987, and *Photo District News*, June 1986.

Press Photo of the Year Contest Established 1956. Sponsored by World Press Photo Holland Foundation. Annual competition in nine categories awarding fifty-eight prizes. Major prizes include the Golden Eye Trophy for the best single picture and best picture story in each category, the Premier Award for the Press Photo of the Year chosen from the winners in each category, and the Oskar Barnack Award for best picture story "which expresses more than any other entry in the most perceptive and illustrative way the relationship between man and his environment." International jury of photography professionals. Traveling exhibition and World Press Photo Year Book containing all prize-winning pictures produced annually. Photojournalists throughout the world may enter.

Larry C. Price *(American, b. 1954)* Director of photography, *Philadelphia Inquirer,* since 1987. Won Pulitzer Prizes for spot news photograph of execution of thirteen Liberian political figures (1981) and for feature photographs from El Salvador and Angola (1985). Studied journalism, University of Texas at Austin, graduating in 1977. Staff, *El Paso Times* (1977–1979). Hired by *Fort Worth Star-Telegram* (1979) and sent to Africa the following year. Joined *Philadelphia Inquirer* as photographer (1983–1986), became director of photography for *Philadelphia Inquirer Magazine* (1986–1987) until assuming present position.

Joseph Pulitzer *(American, b. Hungary, 1847–1911)* Editor-publisher of *New York World* beginning in 1883. Founded *New York Evening World* in 1887. Until death was crusader for editorial independence of newspapers. Became newspaper publisher when he bought St. Louis German language paper (1871). Created *St. Louis Post-Dispatch* and began to amass great fortune (1878). Forced to leave St. Louis for New York when his editor killed a man in a political dispute, causing great scandal (1882). In his will endowed Columbia University School of Journalism, founded 1912, and established Pulitzer Prizes to be awarded annually for fiction, drama, history, biography or autobiography, general nonfiction, poetry, journalism, and music. The Pulitzer Prize for news photography was established in 1940; the feature photography category was created in 1967. For more information on Pulitzer, see G. Juergens, *Joseph Pulitzer and the "New York World"* (1967). A complete history of the Pulitzer Prizes is in the two-volume *The Pulitzer Prize Story.* The work of the photography winners is reproduced in *Moments: The Pulitzer Prize Photographs Updated 1942–1982,* by S. and J. Leekley (1982).

The Pulitzer Prizes Endowment from Joseph Pulitzer to Columbia University School of Journalism established Pulitzer Prizes to be awarded annually for fiction, music, drama, history, biography, or autobiography, general nonfiction, poetry, and journalism. The Pulitzer Prize for news photography was established in 1940, the feature photography category in 1967. Nominations come from agencies, newspapers, and the general public. Juries, appointed by Columbia University on the recommendation of the Pulitzer Prize Advisory Board comprised of professionals in the field. Amateur and professional photographers may be nominated. Photographs must have been published in a U.S. newspaper.

Olivier Rebbot *(French, 1949–1981)* Began career in photojournalism in 1974. Covered Guatemala, Lebanon, Cambodia, Iran, Nicaragua, Bolivia, Cuba, and El Salvador. Died February 1981 of wounds sustained while covering guerrilla fighting in El Salvador. The Olivier Rebbot Memorial Award presented annually by the OPC honors "best photographic reporting from abroad" for books and magazines. For photographs, see *War Torn* by S. Vermazen (1984). Work distributed by Contact Press Images.

Alon Reininger *(American, b. Palestine, 1947)* Began photographing during military service. Studied photography and cinematography in New York. Stringer for UPI (1973), covering Yom Kippur War. Worked for Gamma agency in New York (1974–1976). First major essay on North Sea oil industry's impact on Scotland and Norway for *Time* (1975). Joined Contact Press

Images (1976). Photographed stories on political struggles in southern Africa and Central America, among others. Beginning in 1982 he worked on extensive project on the AIDS virus and its repercussions in American society, receiving the United Nations World Health Organization's 40th Anniversary Award (1987). Also won World Press Photo of the Year (1986) and ASMP Philippe Halsman Photojournalism Award (1987).

Frederic Remington *(American, 1861–1909)* Newspaper illustrator, artist who contributed to *Century Magazine, Harper's Weekly, Outing Magazine, Scribner's, Cosmopolitan,* and *Collier's Weekly* (1881–1905). Well known for drawings of subjects from American West and war correspondence on Cuba, the Philippines, and South Africa. Often used photographs of events for subjects of drawings. In 1888 Remington illustrated Theodore Roosevelt's articles "Ranch Life and the Far West." In 1905 *Collier's* commissioned paintings for reproduction and sale as series of prints. The success of this project convinced him to pursue painting as mainstay of career. For more information, see E. Jussim's *Frederic Remington: The Camera and the Old West* (1983).

James Ricalton *(American, 1844–1929)* War correspondent–photographer, hunter, and world traveler. Worked for Underwood & Underwood for twenty-five years. Before becoming correspondent, was first principal of Maplewood, New Jersey, school. While principal, befriended Thomas Edison and was hired by Edison to search for perfect fiber for incandescent lamp. Searched for a year in remote regions of China, testing over 140 kinds of bamboo. Upon return, hired by Underwood & Underwood to cover Russo-Japanese War (1904). Adventures are recounted in his obituary in *New York Times,* October 29, 1929.

Eugene Richards *(American, b. 1944)* Writer and photographer whose range of social concerns includes war and social conditions, personal struggles with cancer. War photographs from Beirut and El Salvador appear in S. Vermazen's *War Torn* (1984). Received 1982 W. Eugene Smith Grant in Humanistic Photography. Also director of Many Voices Press, photography teacher, and member of Magnum agency. His books include *Few Comforts or Surprises: The Arkansas Delta* (1973), *Dorchester Days* (1978), *50 Hours: The Birth of Henry Harry* (1983), *Exploding into Life* (1983), and *Below the Line* (1987).

Jacob A. Riis *(American, b. Denmark, 1849–1914)* "The Emancipator of the Slums" photographed sweatshops, tenements, and overcrowded schools as a reporter for *New York Tribune,* AP, and *New York Evening Sun.* Among first photographers to use flash powder, enabling him to work in interiors and in exteriors at night. Emigrated from Denmark in 1870, lived in poverty in New York City until found a job as a reporter in 1873. Series of reports on slum life resulted in establishment of Tenement House Commission. Book *How the Other Half Lives* (1890) argued for social reform. Primarily author after 1890, writing books and articles, including autobiography, *The Making of an American* (1901). For more information, see Alland's *Jacob A. Riis: Photographer and Citizen* (1974).

Fred Ritchin *(American, b. 1952)* Former picture editor of *New York Times Magazine* (1979–1982), executive editor of *Camera Arts* magazine (1982–1985). Founder Photojournalism and Documentary program at the International Center of Photography, New York, and director for three years (1983–1986). Currently teaches at New York University. Articles and essays by Ritchin have appeared in *New York Times Magazine, Village Voice, Camera Arts,* and *Aperture.*

George Rodger *(British, b. 1908)* Cofounder of Magnum cooperative in Paris (1947); *Life* magazine staff photographer; known for photographs of World War II and Africa. Educated in England, lived in U.S. 1929–1936. Became photographer with BBC television (1936–1938). Freelance photographer associated with Black Star in London (1939). War correspondent for *Life* magazine while fulfilling military service, earning eighteen medals (1939–1945). Continued with *Life* and *Ladies' Home Journal* (1945–1947). Between 1947 and 1980 made fifteen expeditions to Africa doing stories for *National Geographic, Life, Holiday, Paris Match,* and other publications. Photographs are exhibited widely and appear in many books.

Joe Rosenthal *(American, b. 1911)* While AP photographer, won 1945 Pulitzer Prize for photograph of marines raising American flag on Iwo Jima. First job at Newspaper Enterprise Service, San Francisco, led to work as reporter (1932). In 1934, photographs of waterfront strikers were published nationwide. Chief photographer, Acme Newspictures' local bureau (1935). Joined Wide World Photos, AP (1936). Despite failing eye exam, joined marines as photographer (1943). Accredited AP war photographer (1944). Filed stories from heaviest Pacific battle zones. Returned 1945 to work at *San Francisco Chronicle* until retirement (1981). For more complete information, see *Current Biography, 1945.*

Michael Rougier *(Canadian, b. France, 1925)* Began photographing at sixteen; studied at University of British Columbia; joined Royal Canadian Air Force. Photographer for *Montreal Standard,* then joined staff of *Life* (1947). Covered Korean war, stationed in Tokyo, for *Life* (1951–1954). Overseas Press Club awarded him its 1950 prize for "best photographic reporting from abroad" and the NPPA named him Magazine Photographer of the Year for 1953. Earned many awards for photos of the last days of the war in 1954. Other stories covered for *Life* include Latin American revolutions, the Hungarian uprising against the U.S.S.R. (1956), vanishing sand dunes in Indiana, and an Antarctic scientific expedition (1964).

Lothar Rübelt *(Austrian, b. 1901)* Viennese-born photographer known for sports pictures. With brother Ekkihard photographed sporting events from point of view of the athlete. Known for ability to produce prints for publication very swiftly (1919–1927). Ekkihard killed in accident while the brothers were filming movie, *With a Motorcycle over the Clouds,* in Dolomite Mountains (1927). Lothar began using Leica (1929). Served as war photographer with German air force in World War II. Worked for publicity company (1940–1942). Resumed activity as sports photographer after the war. Awarded Gold Medal of Merit by Republic of Austria (1959).

Arthur Brown Ruhl *(American, 1877–1935)* "Roving reporter" and photographer who covered everything from theater to revolutions. Part of special team of photographer-correspondents for *Collier's Weekly* (1904–1913). In Mexico for *New York Tribune* when U.S. Navy landed at Veracruz (1914), but returned to *Collier's* (1915) and covered World War I in Europe, including Russia (1916–1917) and France (1918). For the *New York Evening Post* was war correspondent in the Baltic states and Poland (1919–1920). Worked with American Relief Administration in Russia (1922–1923). Berlin correspondent for *New York Herald Tribune* (1925–1926). Studied at Harvard University, was distance runner and staff member of student publications, including *Lampoon* and *Advocate.*

Cornelius Ryan *(American, b. Ireland, 1920–1974)* Author of best-selling books on World War II *The Longest Day, The Last Battle,* and *A Bridge Too Far.* Joined Reuters News Agency as reporter (1941). War correspondent for London *Daily Telegraph* (1943–1945). Opened Tokyo bureau for *Daily Telegraph* (1945). Covered D-Day invasion, atomic bomb tests in Pacific, and war of independence in Palestine for his newspaper and *Time* magazine. Became American citizen (1950). Later worked for *Newsweek, Collier's,* and *Reader's Digest.*

Kurt Safranski *(American, b. Germany, d. 1962)* A director of Ullstein German publishing empire, director of Hearst Magazines, and cofounder of Black Star agency. At House of Ullstein, directed Germany's largest publications, including *Berliner Illustrirte Zeitung.* Came to America (1934). Along with Kurt Korff, provided expert advice to Henry Luce when *Life* magazine was in early stages. Cofounded Black Star agency with Kornfeld and Mayer, creating one of earliest and most active American photography distributors (1936). Directed Black Star until 1957. Retired, taught photojournalism at New School for Social Research, New York. T. Gidal's *Modern Photojournalism: Origin and Evolution 1910–1933* (1973) recounts contributions to the field.

Sebastiao Ribeiro Salgado *(Brazilian, b. 1944)* Began to photograph while touring Africa as economic adviser (1970). In 1982 earned W. Eugene Smith Grant in Humanistic Photography for essay on Latin American peasants. For photographs of Sahel drought and famine won highest photojournalism awards in 1985–1986. Briefly member of Sygma (1974), then of Gamma (1975–1979), and finally of Magnum since 1979. Photographs appear in *Aperture*'s "Witness to Crisis" (fall 1987) and in publications including *Sahel: L'Homme en détresse* (1986), *The Other America* (1986), and stories in world's foremost magazines and newspapers. Has advanced degrees in economics.

Erich Salomon *(German, 1886–1944)* Father of "candid photography." Photographed inner sanctum of world politics and Hollywood glamour (1927–1937). One of first of generation to adopt 35mm camera. Began photography career after struggling to maintain law practice during German depression (1927). Worked for Ullstein Verlag, publishing empire that dominated German press, then given opportunity to photograph murder trial. Cameras were forbidden, but Salomon hid silent and small 35mm Ermanox in derby hat and captured exclusive. Known through-

out Europe and U.S. Fled from Nazi Germany, taking refuge in Holland (1937). In 1943 family was discovered by Nazis. Salomon, wife, and one son perished at Auschwitz (1944). For more information, see *Portrait of an Age* (1975) or the Aperture monograph *Erich Salomon* (1978).

Thomas Sande (*American, 1905-1943*) Apprentice at Underwood & Underwood, became staff photographer at age nineteen. Covered arrivals of British royalty, yacht races, and flights of Lindbergh and Chamberlain across the Atlantic. Joined AP in 1931, covered Hauptmann trial, first inauguration of President Roosevelt, and many sporting events. Specialty was baseball. His photograph was first to be sent by AP Wirephoto in 1937.

David "General" Sarnoff (*American, b. Russia, 1891-1971*) President (1930-1947) and chairman of the board (1947-1970) of RCA Corporation. Created its broadcasting division, the National Broadcasting Company (1926). Instrumental in developing RCA's television research beginning in 1923, and appeared in first public TV broadcast in U.S. from New York World's Fair (1939). Championed RCA's color television research and development. Came to national prominence during the sinking of the *Titanic* on April 14-15, 1912: working as Manhattan telegraph operator, received first distress messages from the sinking ship and maintained contact all through the night. Subsequently joined Marconi Co. and served as commercial manager until the company was taken over by RCA (1919). Served at Pentagon during World War II, earning the rank of brigadier general from which he drew the nickname "General."

314

Kyoichi Sawada (*Japanese, 1936-1970*) UPI photographer, covered Vietnam war and won 1966 Pulitzer Prize for photographs of conflict. Died in Cambodia on October 28, 1970, while on assignment. For more information, see *Time*, November 9, 1970.

Flip Schulke (*American, b. 1930*) Now based in Miami, covered civil rights movement as freelance photographer, contributing stories to *Life*, *Jet*, and *Ebony* magazines and to Black Star news agency. Met Martin Luther King, Jr., while on assignment for *Jet* and soon became family friend, photographing King during his crusade throughout the country (1950s). Following King's assassination, covered funeral, capturing image of Coretta Scott King behind veil, which appeared on cover of *Life*. Taught photography at University of Miami. Underwater photographer for *National Geographic*. Began to cover political arena once again in the 1970s. Also made photographic study of Soviet and American space programs and history of hometown, New Ulm, Minnesota.

Paul Schutzer (*American 1930-1967*) Studied Cooper Union Art School, Law School of Long Island University. Freelance photographer until joining staff of *Life* (1956). Part of *Life* team in Lebanon (1958). Won award for coverage of President Eisenhower from White House Photographers and named News Photographer of the Year (1959). Moved to Paris (1961). Photographed building of Berlin Wall, Algerian War, Iran earthquake. Covered marines in Vietnam (1965). Volunteered to cover Israeli Six-Day War and requested special permission from Israeli Defense Minister, Moshe Dayan, to accompany front-line assault on Gaza Strip, during which he was killed (1967).

David Seymour (*"Chim," American, b. David Szymin, Poland, 1911-1956*) "Chim" became photojournalist in early 1930s. Lived in Paris, sharing flat and darkroom with Robert Capa and Henri Cartier-Bresson. Contributed to picture magazine *Regards*. Worked closely with reporters to document Spanish Civil War and spread of fascism in France. Published in *Vu* and *Life* through Alliance photo agency. In New York when war was declared in Europe, preventing his return (1939). Changed name, became American citizen (1942), earned Bronze Star for army service. Cofounded Magnum agency (1947). Accepted UNESCO assignment to document plight of children after war (1948); images were published in *Children of Europe* (1949). President of Magnum in the 1950s. Worked closely with Cornell Capa in Israel. While covering Suez, was killed by an Egyptian soldier's bullet in November 1956. For more information, see C. Capa, *The Concerned Photographer*, Vol. 1 (1967).

Stephen Shames (*American, b. 1947*) While student at University of California, Berkeley, started photographing with student group (1967-1968). Stringer for AP (1968-1969), covering student protests, Black Panthers, and other stories. Freelance photographer based in San Francisco (1969-1972), Vancouver (1972-1976), and New York (1977-1986). Covered stories in Northern Ireland, Israel, Lebanon, Egypt, and the Philippines. Joined staff of *Philadelphia Inquirer* (1986). Has completed long-term photographic projects, including stories on child poverty, juvenile jails, social problems in a Bronx neighborhood. Participated in Michael Evans's "Homeless in America" project (1987), published as a book in 1988.

Gerard Sheedy (*American, active 1937*) Photographer for *New York Sunday Mirror*. Made the only color photographs of the *Hindenburg* disaster on May 6, 1937. Using a roll of newly introduced 35mm Kodachrome film, took pictures under dark, rainy skies using long exposures. Film flown to Kodak in Rochester, New York, the only place it could be processed, and returned in time to be published on Sunday, May 23, 1937. The *Mirror* was the first newspaper to cover spot news in color. See article by John Faber in *News Photographer*, April 1981.

Liu Heung Shing (*American, b. Hong Kong, 1951*) Elementary education in China, high school in Hong Kong. Enrolled in photography course with Gjon Mili at Hunter College in New York City while pursuing journalism and political science major. Became Mili's apprentice and began working for *Time* magazine on assignments in China (1976). Joined AP (1981). Published *China After Mao* (1983). Currently distributes photographs through Contact Press Images.

Aaron Siskind (*American, b. 1903*) Known for two separate careers in photography: first included documentary photographs of Harlem made in 1930s, second was personal abstract photography. Received first camera as honeymoon present (1930). As

member of Film and Photo League (1932–1941) formed Feature Group to pursue independent photographic projects focused on social issues, including "Harlem Document" and "The Most Crowded Block in the World" (1935). In 1940s turned to abstract photography, associated with New York School painters such as Barnett Newman and Franz Kline. Moved to Chicago (1951). Published first book, *Photographs* (1959). Taught photography and served as director of photography department at Institute of Design, Chicago (1951–1971). Taught at Rhode Island School of Design (1971–1976). Retired from teaching (1976). Continues to photograph.

Moneta Sleet, Jr. *(American, b. 1926)* First black male to win Pulitzer Prize (1969) with photograph of Coretta Scott King and daughter, Bernice, during funeral service for Dr. Martin Luther King, Jr. Graduated from Kentucky State College (1947) and earned master's degree in journalism from New York University (1950). Began to photograph for Johnson Publications, publishers of *Ebony* and *Jet* magazines, among others, during early days of the civil rights movement (1955). Featured in *Black Photographers Annual*. Thirty-year career was honored in retrospective exhibition organized by the New York Public Library and Schomburg Center for Research in Black Culture (1987).

W. Eugene Smith *(American, 1918–1978)* Master of photographic essay who championed rights of journalist to determine how his work was presented in order to preserve truth. Career began in Wichita, Kansas, where as a high school student he was encouraged by AP photojournalist Frank Noel. Joined *Newsweek* (1937) before becoming freelance photographer for Black Star (1938–1939). Worked for *Life* (1939–1942, 1944–1954); best known for "Country Doctor," "Nurse Midwife," and "Spanish Village." Between terms at *Life*, worked as war correspondent in the Pacific for Ziff-Davis publications. After 1954 worked as freelance photographer, making an encyclopedic essay on city of Pittsburgh (1955). Along with wife, Aileen, Smith photographed his most compelling documentary, *Minamata*. This story, about a fishing village poisoned by chemical waste, was published in *Life* in 1971, in *U.S. Camera* in 1974, and as a book in 1975. In his memory an annual grant in humanistic photography is presented for projects that would meet his high standards of journalistic responsibility. For more information, see *Let Truth Be the Prejudice* by B. Maddow (1985), and for bibliography see *W. Eugene Smith: A Chronological Bibliography, 1934–1980* by W. S. Johnson (1980).

The W. Eugene Smith Memorial Fund, Inc. Grants in Humanistic Photography. First fellowship granted 1980. "Provides one or more grants to a photographer or photographers whose past performance or current submitted work, either proposed or in progress, merits support according to stringent standards of responsible journalistic ability, dedication, integrity and demonstrated artistic skills. . . . Priority given to those projects which might not otherwise be underwritten through more traditional avenues of funding." Applicants must submit portfolio and attend personal interview; open to international photographers.

Emmanuel Sougez *(French, 1889–1972)* Born in Bordeaux, where he studied painting and began photographing (1904). Head of photographic department of *L'Illustration* and contrib-

uted to *Arts et métiers graphiques* and *Camera*. Photographed art and archaeology, portraits, landscapes, and nudes using large-format camera and Rolleiflex.

Christine Spengler *(French, b. 1945)* Sygma photographer known for work in Vietnam, Middle East, Africa. Raised in Spain, studied Spanish and French literature. Decided to become reporter-photographer after being imprisoned during visit to Chad (1970). Photographed Londonderry and Belfast with Don McCullin, sold work to Sipa Press (1972). In Bangladesh for Sipa, Northern Ireland for *Time* and *Newsweek* (1972–1973). Freelanced in Vietnam, joined AP. Photo of Vietnamese woman shining boots of American GI made front page of *New York Times* (1973). Opened Cambodia office of AP, photographed U.S. bombing of Phnom Penh (1973–1974). Joined Sygma while working in Spain (1976). In next decade covered Northern Africa, South America, women in Iran, Basques in Spain.

Maggie Steber *(American, b. 1949)* Worked for AP 1973–1978. Photographed war in Rhodesia (Zimbabwe) for Sipa agency in 1978. Best known for work in Cuba and Haiti. Began going to Haiti in 1980 and won Alicia Patterson award to continue her coverage. Pictures have been published in *U. S. News and World Report*, *Newsweek*, and *Connoisseur*. Won the Leica Medal of Excellence and the World Press Photo Award for spot news 1987. See article in *American Photographer* I, Witness section, April 1988, "An Island of Despair: Photographing the Violence and Tragedy of Haiti." Steber has been represented by J. B. Pictures since 1986.

Christopher Steele-Perkins *(British, b. 1947)* Magnum photographer (1983). Studied psychology, worked as photographer and editor of student newspaper, University of Newcastle (1967–1970). Freelance photographer covering theater, part-time lecturer in psychology (1971). Begins to accept magazine assignments, and shoots first overseas story for relief organizations in Bangladesh (1972). Awarded grant to document deprivation in Britain's inner cities as part of EXIT group (1973–1975), later published as *Survival Programs* (1982). Organized Young British Photographers exhibition (1975). Worked on book projects and with Agence Viva, Paris (1976–1979). Published *The Teds* (1979). Became associate member of Magnum, worked in Central America, South Africa (1981). Published *Beirut: Frontline Story* (1982).

Edward Steichen *(American, b. Edouard Jean Steichen, Luxembourg, 1879–1973)* Famous for work in successive photography careers. Came to U.S. in 1881. As young painter-photographer cofounded Photo Secession (1902) and designed cover of periodical *Camera Work*. In the U.S. Army in World War I was commander of Photographic Division of Aerial Photography for American Expeditionary Forces (1914–1918); commissioned by navy to create similar photographic division to document war at sea in 1941. Navy photographs widely distributed in mass-circulation magazines. Also organized two exhibitions, "Road to Victory" (1941) and "Power in the Pacific" (1944) for Museum of Modern Art. Retired from navy with rank of captain. Between wars became well known for commercial and fashion photographs published in *Vogue* and *Vanity Fair*. As director of photography at

Museum of Modern Art (1947–1962), curated show *"The Family of Man"* (1955). For general bibliography, see *A Life in Photography* by Steichen (1981), and for his contributions to photojournalism, see C. Phillips's *Steichen at War* (1981).

Carl Ferdinand Stelzner *(German, 1805–1894)* Learned photography from Daguerre and became one of first to make photographs of a news event when he captured images of the great fire of Hamburg (1842). Worked with Herman Biow. Born in Hamburg, studied painting, and worked as miniature portraitist before going to France to study with Daguerre (1939). Returned to Hamburg (1840), where he established photography studio. Went blind due to exposure to silver iodide and mercury used in work (1854).

George A. Strock *(American, 1911–1977)* Brought back one of most talked-about combat pictures of World War II, depicting three American soldiers lying dead in the sand on Buna Beach, New Guinea. Published by *Life* magazine (1943), it was first photograph of dead Americans to be released by American military censors. At John C. Fremont High School, California, enrolled in one of first high school photojournalism courses ever offered in U.S. Photographer for Civilian Conservation Corps and for *Los Angeles Times* before joining *Life* in 1940. Became a freelance photojournalist after the war, making 180-degree and 360-degree photographs of sporting events and art objects.

Anthony Suau *(American, b. 1956)* Studied photojournalism, graduated with high honors from the Rochester Institute of Technology (1979). After summer internship joined photographic staff of *Chicago Sun-Times* (1979). Went to *Denver Post*, working under direction of Rich Clarkson. Awarded 1984 Pulitzer Prize in feature photography for portfolio including early photographs of mass starvation in Ethiopia. Joined Black Star (1984), contributing stories on starvation in Africa and "Killer Volcanoes" in the Cameroons for *National Geographic*. Covered events in Israel, Pakistan, Afghanistan, South Korea, and the Philippines, as well as Colombia. Winner of numerous awards, including the 1984 Pulitzer Prize in feature photography and the World Hunger Foundation award (1984 and 1986) for coverage of famine in Ethiopia and Eritrea. Work and career featured on one-hour public television program "Inside Story," November 24, 1986.

Maurice Tabard *(French, 1897–1984)* Best known for advertising, fashion, and portrait photographs. Studied photography at New York Institute of Photography (1918). Assistant photographer in Bachrach Studios, Cincinnati and Washington (1922–1928). Studied painting with Carlos Baca-Flor (1927–1928). Freelance magazine, fashion, and advertising photographer for *Jardin des Modes, Vu, Bifur, Art et Decoration, Arts et métiers graphiques,* and other magazines (1928–1938). Darkroom and camera man for Patho Films, Gaumont Films, and the French government (1932–1936). Freelanced in South of France (1939–1945). Staff photographer for *Harper's Bazaar* in England, Scotland, and America (1946–1948). Returned to Paris (1951), continuing to freelance and teach until 1965.

Ida Minerva Tarbell *(American, 1857–1944)*, **Lincoln Steffens** *(American, 1866–1936)* Journalists who wrote articles that exposed corruption in government and large corporations; part of group labeled muckrakers by President Theodore Roosevelt (1906). Tarbell began career as journalist at the *Chautauquan* monthly (1882–1891). Joined staff of *McClure's Magazine* (1894–1906), where she wrote famous exposé on Standard Oil Company. Was associate editor of *American Magazine* (1906–1915). Author of several books, including an autobiography, *All in a Day's Work* (1939). Steffens was city editor of *New York Commercial Advertiser* (1898–1902), managing editor of *McClure's Magazine* (1902–1906), and associate editor of *American Magazine* (1906–1907). Contributed articles and editorial direction to *Everybody's Magazine* (1907–1911). Author of several books, including *The Autobiography of Lincoln Steffens* (1931).

Edward Kramer Thompson *(American, b. 1907)* Managing editor at *Life* (1949–1961) and founding editor of *Smithsonian* magazine (1969–1981). Personally edited more than 600 issues of *Life*. Earned 1968 Editor of the Year award, National Press Photographers Association. Graduated at age nineteen from University of North Dakota. Came to *Life* from *Milwaukee Journal* and worked with Wilson Hicks, making picture assignments and developing coverage of military stories (1937). In 1938 produced lengthy essay on Southern Railroad with Alfred Eisenstaedt. During World War II, expertise was channeled into creation of military intelligence magazine, *Impact*. After war, became assistant managing editor, finally managing editor at *Life*. Further information available in *The Great American Magazine*, by L. Wainwright (1986).

David Turnley *(American, b. 1955)* Self-taught photographer, graduated with French major from University of Michigan. Worked at chain of four weekly newspapers in Detroit suburbs for two years before becoming staff photographer at *Detroit Free Press* (1980). Won awards for photo essays on an elderly farm couple (1980) and for war coverage in Lebanon and an essay on Palestinians (1982). Also recognized for photographs of Indira Gandhi funeral (1985). Since 1985 stationed in South Africa for *Free Press* with support from the Black Star agency. Best known for South African photographs published in *Life, Time, Newsweek, New York Times Magazine,* as well as *Detroit Free Press,* winning international recognition.

Umbo *(German, b. Otto Umbehr, 1902–1980)* Photojournalist under Simon Guttmann at Dephot agency, Berlin (1928). Staff photographer for Ullstein publishers (1938–1943). As freelance photojournalist contributed to *Quick, Der Spiegel,* and *Picture Post* (1945–1980). Studied art at Staatliches Bauhaus and worked in theater, film, graphic design, and glass and as a performer before becoming a photojournalist. For more information, see T. Gidal's *Modern Photojournalism: Origin and Evolution 1910–1933* (1973) and *Contemporary Photographers,* edited by Walsh, Naylor, and Held (1982).

Bert Elias Underwood *(American, 1862–1943)*, **Elmer Underwood** *(American, 1860–1947)* Underwood & Underwood founded in 1882 by two brothers to distribute stereographic

views. By 1896, when Underwood & Underwood photographs of Greco-Turkish War appeared in *The Illustrated London News* and *Harper's Weekly,* firm had branched out to become a news agency with staff of photographers around the world. Shortly before World War I, began to supply commercial photographs and portraits. Stereographic division sold to Keystone View Co. (1921). Firm was divided into four separate companies (1931). Elmer was apprentice and journeyman printer from age fourteen until he opened periodical printing business (1877). Bert began selling stereographs while attending college in Ottawa, Kansas, where firm was founded. See Darrah's *The World of Stereographs* (1977).

Huynh Cong "Nick" Ut *(American, b. Vietnam, 1951)* Won many awards in 1973, including a Pulitzer Prize and World Press Photo Award, for photograph of young Vietnamese girl running naked down a road near Saigon, having torn off her napalm-burned clothes as she ran. Joined AP's Saigon bureau shortly after death of brother, photographer Huynh Thanh My (1965). After working in darkroom for three months, became photographer covering battles throughout his country. Came to U.S. just before fall of South Vietnam (1975). Soon assigned to AP's Tokyo bureau. Transferred to Los Angeles (1977). American citizen (1984).

Paul Vathis *(American, b. 1925)* Awarded 1962 Pulitzer Prize for photo of John F. Kennedy and Dwight D. Eisenhower walking away down path at Camp David. Associated Press photographer since 1949 stationed in Philadelphia, Pittsburgh, and Harrisburg, Pennsylvania. Covered Eisenhower presidency, governor's conferences, political conventions, sports. In 1987 photographed press conference where Pennsylvania state treasurer committed suicide by shooting himself in mouth.

Lucien Vogel *(French, 1886–1954)* Forty-year career as one of the most creative members of the French press, an innovator in magazine design and illustration. Began as editor at *Art et Decoration.* Created *La Gazette du Bon Ton* (1928), causing revolution of high culture in Paris by utilizing work of artists and employing "luxurious" printing techniques. Started *Vu,* pictorial weekly employing best editors and designers and providing an important forum for work of contemporary photographers (1928). In 1930s *Vu* became more politically active until conservatives took control (1936). Also directed *Art et médecine* (1930–1936), founded *Jardin des modes* and *Lu,* and was instrumental in directing *Arts Ménagers.* For more information, see D. Travis and S. S. Phillips, *André Kertész: Of Paris and New York* (1985).

Stanley Washburn *(American, 1878–1950)* Journalist and author, war correspondent with over twenty armies in over one hundred battles. Began career at Minneapolis newspapers. Covered Russo-Japanese War for *Chicago Daily News* (1904–1906). Headed expedition to explore British Columbia (summers of 1909, 1910). During World War I went to Europe for *Collier's Weekly* (1914) and to Russia for London *Times.* At the request of the Russian Embassy, he was detailed by the U.S. State and War departments to make a lecture tour through America, presenting the case of Russia in that war (1914–1915). With French and Rumanian armies (1916). Served as military adviser to Secretary of State Robert Lansing, made advisory railroad mission to Russia (1917), conducted military intelligence (1918), and continued to aid U.S. State Department through 1926.

Wolfgang Weber *(German, 1902–1985)* Studied ethnology and musicology. Joined expedition to Kilimanjaro to document tribal music and make photographic reports (1926). Became photojournalist, doing stories "Struggle with the Desert" and "Foreign Industry on the Battlefields" for *Berliner Illustrirte Zeitung* (c. 1927). Traveled around the world for *BIZ* (1937). Left Germany to avoid military service (1940–1944). Returned to Berlin and worked for *Neue Illustrierte* (1944–1945). Moved to Cologne (1946), continuing to work for *Neue Illustrierte* until 1963. Made travel reports for German television after 1964.

Weegee *(American, b. Arthur H. Fellig, Austria, 1899–1968)* Widely known for night photographs of street scenes in New York (1920s–1950s). Speed Graphic and flashgun in hand, specialized in fires and crimes, photographing more than 5,000 murders during lifetime. Worked in darkroom of Acme Newspictures (1924–1935). In 1935, quit Acme to freelance. Car became studio and darkroom while police allocated desk in precinct house for meetings. Staff photographer for *PM* magazine (1940–1945). In 1945 published *Naked City* and developed cult following. Celebrity status brought film roles, speaking engagements, and exhibitions. Photographed advertisements for *Vogue, Holiday, Life, Look,* and *Fortune.* For more information, see *Weegee by Weegee* (1961, reprinted 1975), and Aperture monograph *Weegee,* introduction by A. Talmey (1978).

Paul Wolff *(German, 1887–1951)* Known for demonstrating usefulness of Leica camera and 35mm format for journalistic assignments as early as 1928. Trained as dentist, became amateur photographer. Won Leica camera in Frankfurt Photography Exhibition (1926). Experimented with developers and films to overcome coarse grain of the small-format film. Opened portrait studio with friend Alfred Tritshier (c. 1930), making landscape and industrial photographs as well. Published book *Meine Erfahrungen mit der Leica* ("My Experiences with a Leica") (1934). Contributed 35mm photographs to German and French magazines (c. 1935). Published book on color photography with Leica (1948).

This picture list is a more complete guide to the credits given at the end of each caption. It is alphabetized by the name of the individual, institution, or agency that provided prints for book reproduction. Copyrights, permissions, and special collections are listed within each source note. All numbers are figure numbers unless otherwise noted.

The photographs that open the five essays are details of images shown within each chapter. For identification, see Figure 18 (page 17), Figure 66 (page 58), Figure 98 (page 86), Figure 229 (page 171), and Figure 340 (page 233).

Abbreviations

AP	The Associated Press
Archive	Archive Pictures Inc.
Contact	Contact Press Images
G.E.	General Electric Company
IMP/GEH	International Museum of Photography at George Eastman House
Magnum	Magnum Photos, Inc.
NASA	National Aeronautics and Space Administration
Time Inc.	Time Incorporated
Visions	Visions Picture Group

Amon Carter Museum, Fort Worth, TX, Courtesy, 8

AP (all AP photographs have been generously donated to the IMP/GEH): 127, 130, 131, 132, 133, 136, 137, 139, 165, 170, 172, 173, 175, 176, 178, 180, 182, 184, 190, 191, 192, 193, 209, 214, 215, 216, 217, 218, 221, 222, 223, 225, 226, 227, 231, 232, 235, 236, 256, 269, 280, 282, 284, 285, 297, 300–302, 304, 305, 312, 343, 349, 350, 351, 352, 358, 361, 362, 363, 364, 366, p. xvii

AP/*Dallas Times Herald*, 286

AP/*Omaha World-Herald*, 208

AP/*Valley Daily News, Tarentum*, 311

AP/Time Inc., 298

AP/United States Army, 229

AP/The White House, 287

AP/Wide World Photos, 84, 85, 86, 87

AP/Sygma, 353

Aperture, 1984, 314

Archive: Mary Ellen Mark, 330, 332, Plates 26, 28; Jill Freedman, 335; Jeff Jacobson, Plates 38, 39, 40, 41, 42

Battaglia, Letizia, 337, 338

Bettmann Archive, 69, 79

Bettmann Newsphotos–UPI and Reuter Photo Libraries at Bettmann Archive, 299

Black Star: © W. Eugene Smith 1948, 245–250; © W. Eugene Smith 1972, 251, 252; © Charles Moore, 271, 272; © Bob Fitch, 278; © Robert Houston, 281; © David Turnley, *Detroit Free Press*, 344, Plates 32, 33, 34; © Robert Ellison, Plates 11, 12, 13; © Anthony Suau, Plate 27

Brown Brothers, Sterling, PA, 53

Burton Holmes International, Los Angeles, CA, 67

Contact: © 1987 David Burnett/Contact, Plate 15, Plate 17

Contact: © 1986 Olivier Rebbot/Contact, Plate 16

Contact: © 1987 Liu Heung Shing/Contact, Plate 21

Contact: © 1987 Alon Reininger/Contact, Plate 29

Contact: © 1987 Jose Azel/Contact, Plate 31

Dallas Public Library, The Hayes Collection, 144, 146, 147

Forman, Stanley J./*Boston Herald*, 1976, 309

Frank, Robert, copyright; Courtesy Pace/MacGill Gallery, New York, 238, 239, 240, 241, 242

Franklin D. Roosevelt Library and Museum, Courtesy Detroit News Photo, 162

Gamma-Liaison/Gilles Caron, 257, 258, 259, 260

Grossfeld, Stan/*The Boston Globe*, 347, 360

Hayes, Johnny, Courtesy of, 145

Hutton, P., collection of, 118, 121

319

Index

320

321

The Contributors

MARIANNE FULTON, Associate Curator of Photographic Collections at the International Museum of Photography at George Eastman House, has prepared more than fifty exhibitions by international photographers such as Don McCullin, Gilles Peress, and Letizia Battaglia and Franco Zecchin, as well as "Steichen: A Centennial Tribute" and "Symbolism in Photography: 1890–1920." She has lectured in Europe, Asia, and the Middle East on twentieth-century photography for the U.S. Information Agency and other institutions. Fulton is the author of *The Wise Silence: Photographs by Paul Caponigro* and *Lucien Clergue*, both published by New York Graphic Society Books.

ESTELLE JUSSIM is an award-winning author of books on the history, aesthetics, and social impact of photography, including *Stopping Time*, *Slave to Beauty*, *Landscape as Photograph*, and *Visual Communication and the Graphic Arts*. A well-known lecturer, Jussim is especially interested in printing and illustration, the mass media, and theories of visual information. She is a member of the graduate faculty of Simmons College in Boston.

COLIN OSMAN, editor and publisher of *Creative Camera* from 1965 to 1986, researched, wrote, and edited issues for that publication on such subjects as the European picture magazines, the Photo League of New York, and the South African picture magazine, *Drum*. He has also contributed articles and portfolios to such volumes as Lemagny and Roille's *History of Photography* and *Art in Exile*, as well as having written articles on photography for many popular magazines and a column on amateur filmmaking. He has an extensive personal library, including a large collection of magazines from the 1930s through the 1950s.

SANDRA S. PHILLIPS, Curator of Photography at the San Francisco Museum of Modern Art, received her doctorate from City University of New York for her study of André Kertész. She wrote the lead essay for *André Kertész: Of Paris and New York*, the catalog for the retrospective at the Art Institute of Chicago and the Metropolitan Museum of Art, New York. *Picture Magazines before "Life,"* a project she organized for the Center for Photography in Woodstock, New York, included her article "The French Magazine *Vu*." Phillips has also written on Man Ray's Paris years for an exhibition at the Smithsonian Institution.

WILLIAM F. STAPP has been Curator of Photography at the National Portrait Gallery of the Smithsonian Institution since 1976, when he was engaged to found the photography collection there. Recognized as an authority on daguerreotypes, American portrait photography, and Mathew Brady and his circle, he has done extensive research on Civil War photography and nineteenth-century photographically illustrated documentary publications. The author of *Picture It!*, a history of photography for young adults, and *Robert Cornelius: Portraits from the Dawn of Photography*, as well as numerous articles, Stapp is currently working on scholarly studies of Mathew Brady and John Beasly Greene.

326

Edited by Terry Reece Hackford
Editor assisted by Robin Jacobson
Copyedited by Peggy Freudenthal
Production coordinated by Amanda Wicks Freymann
Designed by James Stockton
Set in ITC Galliard by American Typesetting, Inc.
Color Separations by Color Tech Corp.
Printed by Arcata Graphics/Halliday
Bound by Horowitz/Rae Book Manufacturers, Inc.